Nomenclature for Museum Cataloging

A System for Classifying Man-Made Objects

Nomenclature for Museum Cataloging

A System for Classifying Man-Made Objects

Robert G. Chenhall

American Association for State and Local History
Nashville 1978

Publication of this book was made possible in part by funds
from the sale of the Bicentennial State Histories

Library of Congress Cataloging in Publication Data

Chenhall, Robert G 1923–
 Nomenclature for museum cataloging.

 Includes index.
 1. Museum registration methods. I. Title.
AM139.C49 069'.52 77–20097
ISBN 0–910050–30–9

Copyright © 1978 Robert G. Chenhall
Published by
American Association for State and Local History
1400 Eighth Avenue South
Nashville, Tennessee 37203

Printed in the United States of America

Contents

Preface

The need for a book of this type was first brought to my attention by Ron Kley during a meeting at the New York State Museum in February, 1974; Ron has continued to be an important part of the project ever since. On many occasions, he has brought us back to the world of cataloging reality by his pithy and humorous criticism.

The support we have had from the Strong Museum has been as generous as anyone could possibly hope for in an undertaking of this kind. The Director, Jerry Swinney, and the Board of Trustees recognized that the lexicon was a necessary adjunct to the computerized cataloging program at the museum. But they also saw it as an opportunity to make a valuable contribution to the larger museum community.

The same enthusiasm was expressed by personnel from the National Endowment for the Arts when they were approached about the possibility of providing funding for the work. A generous matching grant was received from the Endowment to defray partially the museum's added costs for personnel, travel, and computer processing.

It is impossible to express adequately our debt to the many people who have been involved in the preparation and review of the word lists that comprise the bulk of the lexicon. Some of them have given so generously of their time that I know their own work must have suffered. In one way or another, each of the following institutions and individuals has participated:

Air and Space Museum, Smithsonian Institution,
 Robert Mikesh, E. T. Wooldridge;
Buffalo and Erie County Historical Society,
 Walter Dunn;
Copyright Office, Library of Congress,
 Robert Stevens;

Corning Museum of Glass,
 Carol Hull, Jane Shadel Spillman;
Greenfield Village and Henry Ford Museum,
 Don Adams, Peter Cousins, Robert Eliason, Paul Leskinen, Larry McCans, Randy Mason, Walter Simmons, Robert Springer, Kenneth Wilson;
Idaho Historical Society,
 Robert Romig;
International Museum of Photography at Eastman House,
 Andrew Eskind;
Maine State Museum,
 Ron Kley;
Mariner's Museum,
 John Sands;
Mercer Museum, The Bucks County Historical Society,
 Lynne Poirier, Mary Case;
Merrimack Valley Textile Museum,
 Lawrence Gross;
Museum of the American Indian, Heye Foundation,
 Alexander Draper, Vincent Wilcox;
Museum of History and Technology,
 Smithsonian Institution,
 Craddock Goins, Melvin Jackson, Uta Merzbach, Kathy Peterson, John White;
Museum of Natural History,
 Smithsonian Institution,
 William Fitzhugh, Gary Gautier;
National Gallery,
 David Scott;
National Park Service,
 Larry Lankton, Harold Peterson;
New York Museum of Transportation,
 Michael Storey;
New York State Museum,
 Robert Mulligan, Geoffrey Stein, Jan Plog, John Watson;

Peabody Museum, Harvard University,
 Dan Jones, Stephen Williams;
Royal Ontario Museum,
 Loris Russell;
Strong Museum,
 Lawrence Belles, Jo-Ann Bishop, George Bow-
 ditch, Elaine Challacombe, Edward Polk Doug-
 las, Elizabeth Dunbar, Bruce Eldridge, Richard
 Flint, Susan Hart, Isabel Herdle, Linda Hotra,
 Barbara Jendrick, Bernard Murphy, Mary-Ellen
 Perry, Sandra Stone, Blair Whitton, Margaret
 Whitton, Jean Winnie;
U.S. Postal Service (Ret.),
 William Gordon;
Winterthur Museum,
 Kenneth Ames.

The persons who have worked most directly with
me on the project are: Mindy Oksenhorn and Au-
drey Volkmann, who have typed and retyped so
many word lists that I am sure they thought it would
never end; Cile Nix, who developed all of the sec-
tions of the lexicon where we could not persuade
another museum specialist to get involved; and
Carole Rush, who did all of the computer pro-
gramming and processing, critically edited the
manuscript, and proofread and criticized all of the
word lists.

The three individuals who have been my most
thorough and constant critics but always in a con-
structive and supportive manner are Jerry Swinney,
Carole Rush, and my wife, Barbara.

Many people have asked about our plans for
future revisions of the lexicon. If the structure upon
which it is based is sound, this should not be
necessary for a number of years. However, I will be
glad to accept and file for future reference any
suggestions for change which are sent to me
through the publisher's office.

Robert G. Chenhall

Nomenclature for Museum Cataloging

A System for Classifying Man-Made Objects

Chapter 1
What's in a Name?
Why Is a Lexicon Needed?

Among all the creatures on this planet, mankind alone has the capability of communicating with others of his species by means of verbal symbols. By convention and historic accident, symbols (we call them *words*) such as *Barbara* and *Robert, Baltimore* and *Los Angeles*, *sofa* and *fire engine* have become concise, shorthand references to real persons, real places, and real things.

Our communication is efficient because we usually use as few words as possible in a given set of circumstances. But it also can be quite precise, especially in those areas where there are standardized and therefore consistent conventions for the expression of complex relationships in a few words—e.g., the systems of family names, given names, and social security numbers; the systems of city and state names and zip code numbers.

The words that identify man-made objects are also efficient for day-to-day communication. The jargon of a trade, for example, is a perfectly satisfactory basis for communicating with others in the same occupation. However, there are no standardized ways of expanding that jargon so as to communicate precise information about such things as a tradesman's tools to persons not associated with the particular craft. As an aid to more precise communication, a standardized way of naming man-made objects would be extremely useful.

A *lexicon* is a standardized word list. As the term is used here, it is synonymous with the special definition of a *thesaurus* developed by the American National Standards Institute[1]: ". . . a

compilation of words and phrases showing synonymous, hierarchical, and other relationships and dependencies. The [function of a lexicon] is to provide a standardized vocabulary for information storage and retrieval."

In this book, a structured system for the naming of man-made objects is presented. This system is organized, internally consistent, and hierarchical. It includes an expandable, standardized word list for the storage and retrieval of information about man-made objects (i.e., a lexicon), but it is much more than just a lexicon. It is a system which:

1. Provides a structured terminology for the naming of all man-made objects. Systems for the identification of natural history specimens are already available and are not included here.

2. Can be expanded by the user in a controlled manner. The names of many thousands of objects are included in the lexicon, but those which are not—parts of objects, man-made substances normally consumed in a short period of time, miniatures, models, sets, etc.—can readily be added by the user. There is a place in this system for the name of any man-made object.

3. Gives definitions for major artifact categories and classification terms, and references to publications where the user can find definitions of object names. However, this is not intended to be a dictionary.

4. Includes terminology that will be most useful in North America, since the lexicon terms are expressed in twentieth century American English. However, the concepts and the structure are certainly adaptable to British usage and translatable into other languages.

1. Ref. (05), pages 2,9.

5. Provides terminology for the naming of objects in museums. The system will be useful for research purposes. But it is not designed as a composite classification device which encompasses all significant object attributes. Rather, it is a system of names, designed primarily for museum cataloging purposes.

In summary, this is a structured, terminological system for the naming of man-made artifacts; a system which includes a partial lexicon, expandable by the user.

The lexicon in this book is intended to be used with any museum cataloging system, whether manual or computerized. Phrases such as "information storage and retrieval" today usually imply "storage in and retrieval from a computer file," and it is true that computers have forced us to be much more precise and careful with our terminology than most of us have been in the past. But *we are concerned here with the informational content of museum catalogs, not the techniques that are used for recording and retrieving information*. To a large extent, content is independent of the system of processing. Examples will be given to illustrate the use of the lexicon with manually prepared (i.e., written or typed) card catalogs, and the concepts are equally applicable to systems that employ edge-punched cards, "peek-a-boo" cards, or any of a variety of other semimechanical or electronic data processing devices. The method used to store and retrieve data is not significant here. It is the content and organizational structure of the data which are important.

The Museum Cataloging Process

Museum activities may conveniently be grouped, on the basis of when they are performed, into three major categories (see Figure 1):

Initial Activities. When an artifact is first acquired, a number of things happen. The object must be accessioned, identified, registered, and possibly, restored. In some museums, a photograph is routinely taken as one of these initial activities.

Ongoing Activities. Once the first surge of activity is over, most museum objects rest in storage until such time as they are needed for a

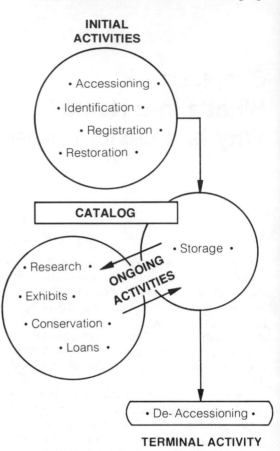

Figure 1. Museum Activities

research project or for an exhibit, either at home or (on loan) in some other museum, or unless a deterioration in the condition of the object indicates that some conservation effort is needed. It is these ongoing activities which are the essential business of the museum. Appropriate groups of artifacts must be readily locatable in storage in order for the ongoing activities to be performed efficiently, and this is possible only where the initial activities have been carried out properly to begin with.

Terminal Activity. Eventually, practically all museum objects are disposed of in one way or another. The terminal activity of deaccessioning must be mentioned in order to make the cycle complete, although it is not significant to this discussion.

The only reason for creating any sort of record

is in order to provide various individuals with information they will probably need to carry out certain defined activities. In museums, the catalog record is the primary locus for information about the artifacts—information which is presumed to be necessary or at least helpful to employees in the process of performing the ongoing activities of the institution. Ordinarily, research, exhibits, conservation, and loans cannot be based solely upon the catalog. But the catalog is usually the only record available to assist in locating the groups of artifacts which might be appropriate for any of these activities. In most museums it is a very important tool.

Normally, a museum catalog consists of a collection of data about physical objects in which: (1) each record comprises the recorded observations about one object and (2) each observation expresses a classification of the object according to an attribute (or dimension) that is distinct from all other attributes.[2] Attributes may be thought of as standardized frames within which different kinds of observations are expressed. These standardized frames usually are called *data categories*. The cataloging process always involves the recording of data about an object according to a number of different data categories—perhaps some combination of the following: a registration or accession number (or both), a functional classification, an object name, a style or type name, a subject that is represented, an artist or artisan name, a maker or manufacturer, the materials from which the object is constructed, techniques of construction, place of origin, date of origin, etc.

The definition of each data category in clear, precise, unambiguous terms is an essential part of any systematic cataloging procedure. Probably the most common fault with museum catalogs is the fact that the data categories used to record the information initially do not express attributes that are distinct from all other attributes, and the reason this is so is that the data categories were not clearly defined to begin with. How many museum catalogs are there, for example, which include major subdivisions something like the following:

2. There are some exceptions to this general statement. See Ref. (33), pages 47–71, for more complete discussion.

Objects made of wood
Objects made of tin
Objects made of cast iron
Objects made of leather
Firearms and cutlery
Clocks and watches
American art pottery
Other containers.

These major subdivisions employ three different and inconsistent data categories (materials, function, and country of origin) as bases for organizing the records. A catalog arranged this way cannot function as an efficient and systematic tool for locating groups of artifacts appropriate to the ongoing activities of a museum. Eventually it will break down due to its lack of internal consistency.

A second important concept in the museum cataloging process is the idea that *the content of the information recorded in each data category must be carefully controlled*. With most data categories the success of the cataloging effort requires that the entries: (1) be recorded using a consistent word sequence, spacing, and punctuation; (2) consist entirely of terms taken from carefully controlled word lists (authority files); or (3) both.

With some data categories (e.g., any category which calls for the entry of a date or a proper name), the only requirement is to set forth rules about how the entries are to be recorded. This is not a complicated process. Usually, it means nothing more than specifying consistent punctuation and data sequencing. For example, in an American historical museum, any four-digit numeral written in a data category called Date of Origin would probably be assumed to be *anno Domini* in the Gregorian system. To eliminate confusion, it might be necessary to specify that *anno Domini* is assumed and, perhaps, that *circa* or (*ca.*) always means "plus or minus ten years" and that a range of dates always is expressed as two four-digit numerals connected by a hyphen. However, these are problems which are relatively easy to resolve if they are considered within the context of each defined data category.

With other data categories the problems of content are not always solved as easily as they are with dates and names. Functional classification, object name, style name, subject, materials, and techniques are all categories of information

about museum artifacts which can be systematically and dependably controlled for meaningful searching of a catalog only if the information is recorded on each record initially by selecting terms from prescribed word lists or authority files. But there are only a limited number of style names, for example, when the collection which one is cataloging consists entirely of eighteenth century furniture. Likewise, an experienced curator can readily develop a set of terms for the techniques used to create American Indian baskets. Subject is a little more complicated, but it usually consists of either proper names or a set of "themes" which the institution might want to consider for exhibit purposes, and a delimited list of themes can be created with a little effort. With each of these data categories the terms are significant primarily within each museum; an interinstitutional consensus is seldom important.

Functional classification and object name are another question entirely. Both for purposes of cataloging within a museum and for the exchange of information between museums, the need for authority files is even greater with these data categories than it is with the categories of style, subject, materials, and techniques. But it is not a simple matter to create a list of terms for the classification and naming of the objects in most museums. Especially in historical and ethnographic museums, a major part of the initial activity of Identification (see Figure 1) is nothing more than answering the question, "What do you call it?" and all too often the answer is determined entirely on an *ad hoc* basis—that is, the object is called whatever the particular individual who is doing the cataloging on a given day happens to think it is called. Identical objects may be given different names by other catalogers, and at times different names by the same cataloger on different days. The certain result is confusion and the breakdown of the catalog as a source of needed information.

Identification of Museum Artifacts

Classification and naming may be considered as the activity of artifact identification. What is the object called? More importantly, though, classification and naming are identification according to some *internally consistent and generally accepted system of nomenclature.* The system initiated by the Swedish botanist Carolus Linnaeus is a system for the identification of natural science specimens. Other identification systems are used for other purposes.

Identification is an essential museum activity regardless of the nature of the collection— natural science, art, history, technology, archaeology, ethnography—for it is the activity of placing a particular object into a meaningful category *vis-à-vis* the rest of the perceived world of experience. Unless this is done properly, the artifact or specimen, especially in a large museum, may just as well not be in the collection at all, for there will be no systematic way of locating it when it is needed for a research project or an exhibit or a loan. Identification and, with most collections, registration (the latter is sometimes omitted with natural science specimens) provide the only data about a museum object which are carried over to every record of the object. Whatever other information there may be on a record, the document will be meaningless unless the object which the record represents can be identified within a framework of some system of nomenclature (and, usually, within some system of registration) and unless all like objects are identified in the same way.

Some examples will help to clarify how the identification activity is performed and some of the problems that are involved. If someone brings a "pretty rock" into a museum, a Curator of Geology will readily identify it using some precise scientific name such as *Azurite*. If a Curator of Ornithology collects a specimen of the Eastern bluebird, the specimen will be identified on the museum records as *Siália sialis*. In each of these cases there is a generally accepted and internally consistent system of nomenclature which the curator can use for the identification of the particular specimen. However, if a Curator of Land Transportation acquires a new (to the museum) 1924 Model T Ford roadster, the question immediately arises: Should this artifact be identified as a transportation device? A land transportation device? An automobile? A car? Or should it be cataloged as a roadster? As a Ford? As a model T? At the same time, a Curator of Furniture could be struggling with the same kinds of problems with regard to a Renaissance Revival chair. Is it furniture? Is it a chair? Is it a dining chair? An armchair? A side chair?

These illustrations are not unusual. They serve

only to point up the fact that there is at the present time no system of symbols—that is, no system of words or names—that is generally accepted as a basis for the identification of man-made artifacts. There are detailed systems available for the classification of some kinds of objects—e.g., ordnance equipment used by the U.S. Army, well-drilling bits, the chipped flint tools used by prehistoric man—but there is no system of identification which even attempts to encompass the entire range of mankind's material objects.

It appears as though there are two interrelated reasons why no one has attempted to create the equivalent of a Linnaean system for the identification of man-made artifacts:

1. A *basis* for a rational system of nomenclature has never been suggested. Some unifying theme must be adopted as a rationale for the system before any word lists are created or else the terminological structure will not be internally consistent.

2. The *need* for a rational system of nomenclature apparently was not recognized prior to the invention of computers and the initial attempts to create computerized museum catalogs. Many manual cataloging systems (particularly large ones) are breaking down or have broken down. But the reason for the breakdown most often is that they were not consistent in their structure and nomenclature rather than that they were manual systems. Ever faster and more sophisticated techniques of processing verbal data have helped us to recognize, but not to solve, the more basic problems of precision and consistency. We have now gone full circle and see that many of the catalogs previously maintained with manual systems of recording, storing, and retrieving information could have been substantially more useful than they were if the objects had been identified initially using a more precise system of nomenclature.

In summary, this book presents what apparently is the first attempt to create: (1) an organized, internally consistent, hierarchical system for the classification and naming of man-made objects and, on the basis of this, (2) an expandable list of terms which can be used as a dependable authority file for the naming of artifacts. However, a word of caution. No book, no list of terms, no written words, can ever do the actual job of identifying any object. The process of identification, *per se*, is one of the key functions implied by the job title "Curator." But once a Curator of Ornithology, for example, has identified a specimen in hand as an Eastern bluebird, a book can provide the authoritative identification symbol (*Siália sialis*), to use on any written record pertaining to that specimen.

The same thing is true of this book. It will not *identify* a man-made object. That must always remain a human function. But once an object has been identified, the lexicon included here will provide the authoritative identification symbol to use on any written record pertaining to that artifact. In museums, the most common written, artifactual record is the catalog. Therefore, the main purpose of the lexicon is to provide an authority file for the identification of man-made artifacts on museum catalog records. But it is not limited to this. It can be used in any situation where a precise and consistent structure of verbal symbols is needed to identify man-made objects.

Chapter 2
A Logical System for Naming Things

The Rationale of the Lexicon

In another publication[1] I suggest that common names of objects could be organized into first broad and then more narrow classifications on the basis of known or presumed function, with the functional categories adapted from some authoritative reference such as the *Outline of Cultural Materials*.[2] The *Outline* does serve as a good point of beginning, but in attempting to use it this way one quickly realizes that (1) it covers all of mankind's activities, not just the physical objects that have resulted from those activities, and (2) it classifies both activities and objects on the basis of seven different principles. It does not provide any *single* rationale that can be used as a basis for a precise system of nomenclature.

The lexicon in this book is based upon the assumption that *every man-made object was originally created to fulfill some function or purpose* and, further, that *original function is the only common denominator that is present in all of the artifacts of man, however simple or complex*. At the top or highest level in any hierarchy of classifying and naming man-made artifacts there can be no consistent organizing principle other than the known (or presumed) reason why each object was originally created.

The concept of *original* function is an important part of this statement. For example, trade symbols such as the familiar barber pole or the cigar store Indian were created originally to be visual,

nonverbal signs that identified particular kinds of retail establishments. Only in recent years have they become artistic or decorative objects. Similar statements could be made about many of today's "collectibles." The reasons for owning an object may change through time, just as styles do, but the function the object was created to fulfill remains constant. Since original function is the only unchanging attribute present in all man-made objects, it is the only characteristic which can be used as a basis for systematic classification.

Some of the objects created by man (fortunately, not too many) were originally intended to serve more than a single purpose. These are most commonly found among utilitarian objects which were also used for advertising or sales promotional purposes: Coca-Cola signs that are also serving trays or mirrors or thermometers; glass rolling pins that were sold filled with confectioners' sugar; and so on. Also, there is some aversion on the part of archaeologists to inferring the function of a prehistoric artifact when the original purpose for creating the object cannot be determined with certainty. However, original purpose, *known or inferred*, is still the only characteristic that is common to all man-made objects, even to the purpose of a whimsy, which can be described negatively as a "do-nothing."

Curatorial judgment must be exercised to determine the primary original function of each particular artifact. But, with a few guidelines in problem areas, the principle of original function has been found to be a workable rationale for the classification and naming of man-made objects. It is important also to recognize the fact that so far

1. Ref. (33), page 69.
2. Ref. (79).

8

no viable alternative to this rationale has been suggested.

The Structure of the Lexicon

The museum lexicon described here consists of three hierarchically related levels of terminology: (1) a controlled list of major categories; (2) a controlled list of classification terms; and (3) an open-ended list of object names.

Major categories are a very limited set of functional divisions which allow objects to be logically grouped into a few easily remembered classes. In a manual filing system these might serve as the labels on file drawers or the tabs that separate major groups of catalog cards. Major categories are important primarily as a frame of reference for considering the totality of man's artifactual creations.

Classification terms are carefully defined subdivisions of the major categories which make it possible to separate artifacts into more refined functional classes. In the aggregate they comprise a word list or authority file which is used during the identification process. In a card catalog, for example, the classification term appropriate to a particular artifact might be recorded in one of the upper corners of each card, since this is the term that would be used as a basis for filing (or locating) the card within the major category file drawer. In a computerized catalog a data category called Functional Classification would be a separate field in each record.

Object names are the words used to identify particular artifacts. Object names may be thought of as further subdivisions of the classification terms. In a card catalog the object name might be recorded in the upper corner of each card opposite from the corner used for the classification term. Filing would be done, first, by classification in term and then, within each classification term, by object name. In a computerized catalog the data category Object Name would be a separate field.

The principal working structure of the lexicon, like the structure of the Linnaean system of biological classification, is binomial. In the Linnaean system the two main levels of terminology always stand for a genus classification and, within the genus classification, a species name. Here, the analogous levels of terminology are a functional classification term and, at the next lower level, hierarchically related, an object name. *An object name is only appropriate and meaningful as a subdivision of a particular classification term.* The two levels of terminology cannot be separated.

Even though object names are considered as subdivisions of classification terms, there are important distinctions between the two levels of terminology:

1. Classification terms are carefully predefined and should be used without modification; the list of object names is open-ended so that it can be expanded by the user.

2. Classification terms, like major categories, are based upon the single rationale of original function; an object name sometimes implies function (e.g., the function of shears is to shear), but this is more the exception than the rule. The common names used to identify man-made objects are extremely variable.

3. Classification terms are worded so that each term is unique—that is, it appears only once in the entire lexicon structure; an object name may appear as a subdivision of more than one classification term if the word or phrase is normally used to identify more than one kind of object. (Identical object names under different classification terms do not imply alternate classifications for the same object.)

The bulk of the lexicon—the listings which contain the object name terms—is contained in Chapters 6 and 7. Chapter 6 is the basic, hierarchically organized arrangement of the entries. It contains the major categories, each one defined, and within each major category a listing of classification terms, also defined. At the next lower level, object names are arranged alphabetically within each classification term, along with all notes, references, related term entries, and "use" entries. Chapter 6 is the only complete listing of every major category, classification term, object name, definition, note, etc. In Chapter 7, object name terms are listed in alphabetic sequence regardless of where they appear in the hierarchically arranged listing. With each object name there is a cross-reference to the classifica-

tion term within which that name is listed in the hierarchical section.

Grammatical Conventions

In order for the lexicon to serve as an effective cataloging tool, it is essential that the user understand the rules that were followed in compiling the word lists. These are of two types: (1) grammatical conventions—standards for the capitalization of terms, abbreviations, word sequences, etc.; and (2) content conventions—primarily standards for the inclusion and exclusion of terms. In general, the grammatical conventions discussed in this section follow the *American National Standard Guidelines for Thesaurus Structure, Construction and Use*.[3] The content conventions which appear in the two following sections have, for the most part, evolved out of necessity as the lexicon was being created.

Capitals and Lowercase Terms

Throughout the lexicon, words in solid capital letters indicate classification terms and object names which are acceptable for the identification of museum artifacts. Object names in lowercase letters mean that the particular word or phrase should not be used for the identification of museum artifacts. In all cases, lowercase terms are followed by cross-references to guide the reader to a preferred term or to tell the reader how to identify this kind of object.

There are several reasons why unacceptable terms have been included in the lexicon. Most often, it is in order to resolve conflicts concerning:

—Synonymity (a selection from among alternate words which might be used to identify an object),

—Spelling (alternate spellings which are commonly used for the same word or phrase),

—Word order (possible confusion as to whether words should be used in inverted order or direct order—see the section on "Word Sequencing," page 12),

3. Ref. (05).

—Foreign or archaic words (for which there are synonyms in twentieth century American English), or

—Word combinations (alternate conventions as to whether two words should be combined and indexed as one).

In each of these situations, the lowercase term and the preferred (capitalized) term appear in both the hierarchical and the alphabetic lexicon listings (Chapters 6 and 7). For example, the word HIGHCHAIR, according to our authority, is one word, not two. However, if a person were searching a museum catalog to locate all chairs, the fact that *highchair* is one word could easily be missed or forgotten. Therefore, a lowercase term, *Chair, High*, is included in both of the lexicon listings, with a cross-reference to HIGHCHAIR. Thus, in both the hierarchical listing (Chapter 6) and the complete alphabetic listing (Chapter 7), all references to chairs of any kind can easily be located.

Finally, there are a few cases in which lowercase terms appear only in the alphabetic listing because there is no single classification term that would be appropriate. In these situations, another way of dealing with the concept is suggested rather than just an alternate word or phrase.

Singular, Plural, and Collective Terms

Classification terms always appear in the lexicon in a singular rather than plural form. Users are strongly encouraged to use classification terms exactly as they are and not to modify them for any reason whatsoever. Even the change from singular to plural form when cataloging a group of physically separable objects on one record should be avoided. The loss of strict consistency leads to many pitfalls.

Object names also are normally included in the lexicon in singular form. Museums usually catalog individual items. Therefore, the singular terminology was adopted as the standard lexicon convention, even for those artifacts which we customarily think of as belonging together in pairs or sets. For example, the entries are BEAD, not beads; MARBLE, not marbles; SANDAL, not sandals; and SHOE, not shoes. The only exception to this general rule is collective nouns that

identify a single object—e.g., SCISSORS, TWEEZERS, PLIERS, and TONGS. With a computerized cataloging system it is *essential* that a term be entered exactly the same way each time it is used and that this be the *same* form of the term used for retrieval. With any cataloging system this is a wise rule to follow. However, it does not mean that the user is forced to catalog a group or pair or set of items as if they were a single object. There are a number of situations in which the lexicon can be adapted to the needs of each particular museum by the addition of new object names. This is one of them (see the section on "Object Names Which Can Be Added by the User," page 16). The letters "S" or "ES" may be appended to any object name in the lexicon when a single catalog record is used to record the information about a pair of items or a group of related items. Thus, BEADS, MARBLES, SANDALS, and SHOES would be acceptable object names for cataloging purposes, even though these exact words do not appear in the lexicon word lists.

Multiple objects also may be cataloged on a single record by adding the word SET or the word COLLECTION to any valid object name in the lexicon. Thus, terms such as KNIFE SET and SPOON SET would be appropriate object names for groups of artifacts created originally to be used together and cataloged together on one record, even though these exact phrases do not appear in the lexicon. Likewise, terms such as SPOON COLLECTION, STAMP COLLECTION, and TRADE CARD COLLECTION would be appropriate object names to use when cataloging, on one record, a group of objects that were not necessarily created to be used together but where each of them would be individually identified with the same object name. The words SET and COLLECTION do not appear in the lexicon except when the object name used to identify the group of items is different from the object name that would be used to identify an individual item in the set. For example, FLATWARE SET is given as a valid term. The objects in a FLATWARE SET are knives, forks, spoons, etc.—all words which are different from the word *flatware*. Games are a special situation. They appear in the lexicon only with the word SET (e.g., CHESS SET, CRIBBAGE SET). Individual pieces (e.g., CHESSMAN, CRIBBAGE BOARD) would be acceptable object names to add as parts (see page 16).

Abbreviations in the Lexicon Listings

Several abbreviations will be found in the lexicon listings. These symbols always have the meanings given below:

def *Definition.* In Chapters 3, 5, and 6, immediately following each major category term and each classification term, carefully worded definitions of the terms are given.

rt *Related term.* Related terms are object names which identify similar, though not quite identical, artifacts. They are not alternate object names which might be used to identify a single artifact. Rather, they are acceptable terms which the user of the lexicon should consider in place of (for cataloging purposes) or in addition to (for searching purposes) the object name where the rt reference appears.

ref *Reference.* A ref entry means that the user should refer to the indicated numeric entry in the Bibliography.

T&E *Tools and Equipment.* This is the name of Major Category 4. Each classification term within Category 4 consists of the name of an activity or material followed by the abbreviation T&E. For example, WOODWORKING T&E means "woodworking tools and equipment."

LTE *LAND TRANSPORTATION EQUIPMENT.* This is a classification term within the major category Transportation Artifacts (Category 6). When it is further subdivided, the number of words in the term become quite lengthy. Therefore, it is abbreviated LTE.

In addition to the abbreviations given above, the words note and use have special meanings, as follows:

A note within the lexicon listings means either an explanation of the special way a classification term or an object name may be further subdivided or a limitation on the way the word or phrase should be used.

The use entry is a command that appears only with object names that are unacceptable, as evidenced by their entry as lower case terms. The use entry tells the reader the alternate term to use in place of an unacceptable entry or

suggests a range of terms from which to select a more appropriate object name.

Word Sequencing

A hierarchical structure, which expands from major categories down to a larger number of classification terms and from classification terms down to a larger number of object names, appears to be the best way to achieve the lexicon objectives. When the object name consists of a single word, the three levels of terminology complete the structure. However, when the object name is a multiword phrase, the sequencing of the two or more words in a consistent manner can be very difficult. The main reason for this, of course, is that words do not always have exactly the same meaning in every context. Used in one way a particular word may be a valid name for a class of objects, perhaps a name which can be further subdivided. But used in another way the same word may be meaningless except as a secondary part of a multiword phrase. The word *animal*, for example, when used alone, expresses the generic idea of a biological creature, a mammal. But no one familiar with the English language would be tempted to classify, on a functional basis, a *carousel animal* as a subdivision of the larger term *animal*. The conflicts of reasoning that are involved with the sequencing of object name words have made this one of the most difficult problems to deal with in the creation of the lexicon.

In thesaurus construction there are only two rules for sequencing words. One is called *inverted entry*; the other is referred to as *direct entry*. For example, an object identified in spoken English as a *jack plane* would appear in the lexicon as PLANE, JACK if the principle of inverted entry were followed, and as JACK PLANE if the lexicon were organized using the principle of direct entry.

We have found it helpful to use precise terms to express the placement of each particular word in the sequence. Thus, a word which is part of a multiword object name phrase may be:

—A *primary word*: The first word in the phrase; the word that is used for sorting, searching, or indexing the phrase in a normal, left-to-right, letter-by-letter comparison of terms. In the example above, PLANE is the primary word if the principle of inverted entry is followed; JACK is the primary word if it is a direct entry sequence.

—A *secondary word:* Any word which follows a primary word in both spoken English and the lexicon. In direct entry, a multiword phrase consists of one primary word and one or more secondary words, separated by spaces but no intervening punctuation. In the example given, PLANE would be the secondary word if the principle of direct entry were followed; there would be no secondary word if the entry were inverted.

—A *suffix qualifier:* A word which expresses a subsidiary or subclass of the objects identified by the primary word. The basic format for inverted entry is one primary word followed by a comma and then one or more suffix qualifiers. With inverted entry, JACK would be a suffix qualifier —i.e., a subclass of the larger term PLANE. In this example, there would be no suffix qualifier with direct entry.

Both direct and inverted entries will be found in the lexicon. *The general rule of object name sequencing has been to invert entries if the primary word could stand alone within the classification term where it appears and if it would have the same meaning alone that it has as part of the multiword phrase.* The exceptions to the inverted entry rule, where direct entry has prevailed, are as follows:

1. *Useless Broad Categories.* Frequently, an acceptable object name contains a word that could stand alone as the name of a group of man-made artifacts, but the word conveys such a broad classification of objects that it would be meaningless in a museum catalog. When any of the words in the list below appear as part of multiword object names, they are always treated as secondary words:

APPARATUS
ATTACHMENT
CARRIER
CONTAINER
COVER
DEVICE
EQUIPMENT
FRAGMENT
MACHINE
MAKER

POLE
ROD
SECTION
STAFF
STAND
STICK

2. *Nonobject Names*. Included in many multiword object names are individual words which, if used alone: (1) would not convey the name of a man-made artifact or (2) would suggest an artifact substantially different from the object identified by the multiword phrase. An IRISH MAIL, for example, has nothing to do with an object called *mail*. Similarly, the word *circle* would not stand alone as the name of a man-made artifact, even though a REPEATING CIRCLE is a valid object name, and related words such as SQUARE and TRIANGLE are acceptable alone. In the following examples, the italicized words are secondary words as parts of these multiword object names, even though some of them may appear as primary words in other contexts:

NAPIER'S *BONES*
SILENT *BUTLER*
ROLLER *COASTER*
CAKE *DECORATOR*
WRIST *DEVELOPER*
DARNING *EGG*
POSITION *FINDER*
SHIN *GUARD*
ARTIFICIAL *HORIZON*
CUFF *LINK*
STATION *POINTER*
AIR *POISE*
BODY *PROTECTOR*
LINEN *PROVER*
HAIR *RECEIVER*
COILED-SPRING *RIDER*
TEA *SERVICE*
BAND *SHELL*
MAIL *SLOT*
SAWING *TACKLE*
CURVE *TRACER*.

It is not always easy to see whether or not a word could stand alone with the same meaning it has in a multiword phrase. The important thing is not the word itself but the word *in the context of both the multiword phrase and the classification term*. The questions to ask are whether there is a class of objects of which this is a part and whether this word expresses the name for that class of objects. A few of the words which normally appear as primary words in the lexicon are:

CHOPPER
CLEANER
CRUSHER
CURLER
CUTTER
DETECTOR
HOLDER
INDICATOR
LIFTER
MARKER
OPENER
PACKER
PRESS
PRINTER
RECORDER
TESTER.

3. *Parts of Objects*. A number of object names in the lexicon identify artifacts which were originally created to be physically attached as parts of other objects. Presumably, there will be many additional names for parts of objects added to the lexicon copies used by particular museums. Regardless of any other sequencing rule, parts of larger objects normally are named using the name of the artifact to which the part was attached as the primary word and the part name as a secondary word (exceptions are made with Buildings and some Transportation Artifacts—see pages 22 and 30). Some examples will illustrate how part names appear or can be added to the lexicon with the part name as a secondary word:

COLUMN and COLUMN *BASE*
LAMP and LAMP *BURNER*
WINDOW and WINDOW *FRAME*
BICYCLE and BICYCLE *LAMP*
INKWELL and INKWELL *LINER*
SCROLL and SCROLL *ROD*.

Note that some of the words which are secondary words here could be primary words in another context (e.g., BURNER, BUNSEN; BURNER, INCENSE) and that in these examples the word LAMP appears both as a primary and a secondary term.

4. *Closely Associated Objects*. As an extension of the "parts" concept, a word may appear in the lexicon as a secondary word if the object it

identifies is closely associated in use with another man-made artifact even though the two objects may not have been physically attached to each other in any permanent way. Again, it is the context which is important. In the following list, the secondary words could be primary words in another context, but the multiword object name would most likely be thought of and searched for with the associated object name:

> SADDLE *BLANKET* (associated with SAD-DLE)
> VIOLIN *CASE* (associated with VIOLIN)
> TIE *CLIP* (also TIE *TACK*; both associated with TIE)
> CAP *PISTOL* (also CAP *EXPLODER*; both associated with CAP).

5. *Sports Equipment and Games.* With Recreational Artifacts (Category 8), a special extension of the "parts" concept has been made in order to make the equipment that is used in any sport or game locatable by the name of the sport or game. This cannot be followed completely since the name of the event is not always a part of the object name (e.g., CATCHER'S *MASK*). However, artifacts such as the following are always named with the name of the sport or game as the primary term:

> SOCCER *BALL* (BALL is a primary word as a TOY but in SPORTS EQUIPMENT it is always a secondary word)
> BASEBALL *BAT*
> CROQUET *MALLET*
> GOLF *GLOVE*
> HOCKEY *PUCK*

6. *Multiple Objects Cataloged as a Unit.* In naming two or more physically separable artifacts on one catalog record, the composite identifying phrase must, of necessity, list one first and the other second even though each word would be a primary word if the artifacts were cataloged separately. The following are acceptable multiword object names:

> BACKHOE/FRONT-END LOADER
> CUP AND SAUCER
> MORTAR AND PESTLE

In summary, the user of the lexicon must remember that: (1) unless one of the six stated exceptions clearly applies, the general rule is to invert multiword object names if the primary word

could stand alone within the classification term where it appears and if it would have the same meaning alone that it has in the multiword phrase; and (2) no particular word can be thought of as just a primary word, a secondary word or a suffix qualifier. Any word is meaningless, for lexicon purposes, except within the hierarchy of a particular classification term.

Classification Conventions

Classification terms are very carefully defined in the lexicon, and most of the time a person cataloging a particular group of artifacts will be dealing with things which naturally fall into one or another of the classification terms provided. In fact, a curator's responsibility often is defined by a job title such as Curator of *Furniture*, Curator of *Clothing,* Curator of *Transportation* or, perhaps, Curator of *Water Transportation*. In addition, Chapter 3 is devoted entirely to a discussion of various kinds of problems which might arise in connection with each of the major categories and the classification terms which are subsidiary to each major category. Nevertheless, there are a number of classification conventions that can best be considered as part of this overall discussion.

Decorated Utilitarian Objects

In this lexicon, an artifact which was created originally for the primary purpose of serving some utilitarian function is classified according to that function, no matter how highly decorated it may be or how skillfully it may have been crafted. Art objects, by definition, are limited to artifacts which were created originally to serve an aesthetic function only.

Decorated utilitarian objects, of course, are an important part of what a museum collects. A decorated chest of drawers, for example, may have greater research value and be useful in more different kinds of exhibits than a chest of drawers which is void of decoration. Nevertheless, the user of the lexicon should always identify an artifact first according to its primary or major utilitarian function, ignoring decoration and all other nonfunctional attributes.

Parts and Accessories

An object which is a part of another object,

associated with another object in use or related to another object as an accessory, normally is identified using the same classification term as the object with which it is associated.

Reference has already been made to objects which were created originally to be parts of other objects or used in close association with other objects. Both of these are situations in which the item being identified is named, in part, with the same object name as the object with which it is associated, and the logic of using the same classification term for both is not difficult to accept.

In addition to associated artifacts which are named using the same words, there is another group for which the object names of the items are in no way similar. These are called *accessories*. They are objects which are necessary or desirable adjuncts to the functioning of something else, but they are named using different terminology. For example, an ANDIRON and a COAL SCUTTLE are not parts of any artifact which is included in the lexicon as a TEMPERATURE CONTROL DEVICE. Nevertheless, they are classified within this context because they function primarily as accessories to the control of temperature.

There are a few exceptions to this general rule. With a BUILDING, for example, there are many items which could be part of or associated with any of the named building types. Therefore, these items are classified separately, either as a BUILDING FRAGMENT (in Category 1) or using one of the classification terms in Category 2, Building Furnishings. The same thing is true with some Transportation Artifacts. For example, a PROPELLER, an OAR, or an ANCHOR theoretically could have been created so as to be usable on several different kinds of ships or boats. For this reason, WATER TRANSPORTATION ACCESSORY is a classification term separate from WATER TRANSPORTATION EQUIPMENT. CLOTHING ACCESSORY is also a separate classification term; and in a few instances (e.g., with electronic components) parts and accessories have a generalized utility which makes it desirable to classify them under appropriate T&E classification terms rather than in the same place as the artifacts with which they are associated.

In spite of all these exceptions, though, the great majority of all parts and accessories are either included in the lexicon or can be added by the user as subdivisions of the same classification term as the item with which the part or accessory is associated.

Multiple-Use Objects

There are a few man-made artifacts which were created originally to serve more than a single utilitarian function. These objects should be classified according to the first or primary purpose for which they were originally created, the function that would appear to have been most important to the maker. However, they should also be cross-referenced in the catalog record so as to be retrievable according to the alternative classification term as well. For example, the reason for creating a Coca-Cola sign that is also a thermometer or a serving tray is, first and foremost, for its advertising value. The same thing is true of a paperweight which has an advertising message embedded in glass or a hat fabricated from material which contains the logo of a beer manufacturer. All of these objects would be classified under ADVERTISING MEDIUM and cross-referenced according to appropriate alternative classification terms. Functional objects presented as mementos—e.g., a regulation sword or revolver which bears an engraving such as "Presented to Colonel John A. Johns, hero of the Battle of Mud Flats"—are artifacts which were originally created as utilitarian objects. Therefore, they would be classified as such and cross-referenced in the catalog record under DOCUMENTARY ARTIFACT.

Curatorial judgment is sometimes required in order to determine what the first or primary function of an object may have been. Glass rolling pins, for example, were sometimes sold containing a product such as confectioner's sugar. They were, thus, a PRODUCT PACKAGE. But some glass rolling pins appear to have been manufactured and sold purely as FOOD PROCESSING T&E. The facts must govern the determination of the first or primary function of the object.

Object Name Conventions

Object Names Included and Excluded

The general rule regarding inclusion or exclusion of object names has been to include a term only if it is the word or phrase that normally would be used to identify a group of artifacts using twentieth-century American English. Thus, non-

English words, British English words, and archaic U.S. English words which are synonymous or nearly synonymous with words that would probably be used to identify the same objects in the United States today have generally been excluded. However, foreign terms which have no exact American English equivalent are included in the lexicon if the objects they symbolize are commonly collected (e.g., NETSUKE), and many names of antique, no-longer-used objects will be found in the lexicon (e.g., a SPINNING WHEEL, a CROZE, a BOTTLE JACK).

Object names have been included or excluded from the lexicon by asking, "Is this a precise name for a collectible man-made object, using twentieth-century American English?" But the attempt to provide the user of the lexicon with a list of terms in which a particular artifact can be identified, as nearly as possible, with one and only one classification term/object name combination has meant that at times arbitrary decisions have had to be made on matters of synonymity, generality, and specificity. For example, when two terms appear to be synonymous or nearly synonymous names for the same artifact, we have not hesitated to include one of them as the acceptable name and show the other as a lowercase term, cross-referenced to the acceptable name with a use statement. To the best of our ability, we have been consistent in the way we have gone about making these decisions, but language at best is neither consistent nor precise. When it has been necessary to sacrifice one for the other, precision has taken precedence over consistency.

The distinction between terms which are acceptable and not acceptable is not always easy to recognize. Two words may be synonymous if the objects they identify are viewed from the standpoint of function but different if they are viewed from the standpoint of physical structure or appearance. Or, two terms may mean the same thing as far as function and appearance are concerned but be different words for the object at different points in time. In each case the deciding factor ultimately has been based upon the apparent answer to the question, "What is the object that the term identifies?" If identification of the object itself, apart from provenance and use after it was created, requires an object name that is distinctive, then we have tried to provide such a term somewhere in the lexicon or as an allowable addition to the lexicon.

Object Names Which Can be Added by the User

Whenever a word or phrase that is not in the lexicon is used to catalog an artifact or when an object name is used with a classification term other than the one with which it appears in the lexicon, it is important that the new term be manually added to that museum's lexicon copy. In each case, the new term should be added to both the hierarchical word list (Chapter 6) and the alphabetic word list (Chapter 7). Remember, the purpose of the lexicon is to communicate between a cataloger and the unknown person who will use the catalog in the future. The same set of classification term/object name entries must be available to both.

Several types of object names may be added by the user of the lexicon, if needed to catalog particular artifacts, even though they are not included in the present lexicon listings:

Multiple Objects. Whenever the suffix "S" (or "ES") is added to the object name on a particular catalog record, it is the same as adding a completely new object name to the lexicon. The same thing is true when the words SET or COLLECTION are used as secondary words. In both cases terms should be manually added to the museum's lexicon copy.

Parts of Objects. Artifacts originally created to be a physical part of some other object have, in most cases, been excluded from the lexicon. There are a few exceptions, included either because the particular parts are commonly found in collections (e.g., a LAMP BASE, a LAMP MANTLE) or as examples of how such items should be recorded. However, it would be patently impossible to include all of the parts for all of the artifacts listed as valid object names. As an example, consider what the lexicon would be like if all of the parts which go into the production of an automobile were included. Parts names should be added when needed.

Representational Objects. In this lexicon, an object is assigned to only one functional classification in the hierarchy, and that assignment is made according to the original function which the object was created to fulfill. However, some artifacts are created in the *form* of a utilitarian object but for a *purpose* substantially different from that indicated by the classification term within which the object name is listed. The phrase "rep-

resentational object," as it is used here, means a model or a miniature or any other "representation" of an object for some purpose other than the function conveyed by the classification term within which the word or phrase appears in the lexicon. Most representational objects are utilitarian objects reproduced as toys, works of art, advertising media, etc. For example, a SOFA created to be used in a doll house is a TOY which represents a SOFA designed to be functional FURNITURE. As in all cases of object identification, the first step is to determine the correct classification of the artifact being named. Once this has been done, it is not hard to locate an appropriate object name.

With the classification terms TOY (Major Category 8) and ADVERTISING MEDIUM (Major Category 5) and with Art Objects (Major Category 7), virtually any man-made artifact name could be added by the user as an acceptable object name for cataloging purposes. In addition, there are at least two other classification terms (PERSONAL SYMBOL, Category 3, and DOCUMENTARY ARTIFACT, Category 5) within which object names may be selected from elsewhere in the lexicon in order to identify an artifact with the most appropriate classification term/object name combination. Some of the special kinds of models and miniatures (see page 18) may also appropriately be added within the same classification terms as the objects they represent.

An artifact created as a representation of something other than a man-made object will usually be either (1) a biological creature or thing (e.g., a human being, an animal, a bird, a tree) or (2) an event or scene (e.g., a circus, a farm, a battlefield). Representations of biological creatures should be identified with an object name which deliniates the type of creature—i.e., one of the object names provided under the classification term TOY (FIGURE, ANIMAL, DOLL) or some comparable term. A more specific characterization, if desired, should be recorded either as a subdivision of the creature type or in a separate data category.

Representations of events or scenes may be identified in a number of ways, depending upon the *object* (not the scene) being cataloged. These are: (1) In the same manner as a GAME (see page 34). That is, the word or words which best describe the event or scene may be used as the primary word(s) of the object name, followed by the word SET as a secondary word. Thus, with

the examples above, the object names would be: CIRCUS SET, FARM SET, and BATTLEFIELD SET; (2) as a MODEL or MINIATURE (see page 18); and (3) as a DIORAMA, a MINIATURE ROOM, or a DOLL HOUSE.

Expendable Supplies. Objects or substances which normally are consumed in a relatively short period of time have generally been excluded from the lexicon because they are not usually things that museums are interested in collecting and cataloging. Normally, it is the containers for substances which are cataloged (in Category 10) rather than the substances themselves. However, expendable supplies in the form of either man-made objects or substances (e.g., rope, a light bulb) or partially processed natural materials (e.g., a roughhewn log, a preform from which a flint tool would be made) are sometimes cataloged as museum artifacts and should be added to the user's lexicon copy when needed.

Special Collections. Museum personnel are often confronted with the necessity of cataloging a collection of artifacts in some special way—perhaps using the terminology of a narrowly defined discipline or a classification scheme that has been developed for a particular group of items. For example, an ethnomusicologist working in a non-Western culture might wish to record a group of instruments using either the native term for each instrument or a special set of research terms. There should be no hesitation in adding new object names as necessary to catalog special collections. But new terms should be manually added to the museum's lexicon copy as subdivisions of the appropriate classification terms.

Special Problems

Souvenirs, Mementos, Novelties, Ornaments and Bric-a-brac

Souvenirs and *mementos* are actually many different kinds of objects, and they should be classified and named differently, depending upon the original function of the object that is being identified. The words *souvenir* and *memento* should not be used as object names. An object created to commemorate a person, place, or event with written or pictorial informa-

tion should be classified as a DOCUMENTARY ARTIFACT (even though it may not always be a document in the narrow sense) and named a PLATE, a SPOON, a RING, a COMMEMORATIVE COIN, or whatever might be appropriate. A utilitarian object which has become a memento through an association in the mind of a particular person should be classified and named according to the original function which the object was intended to fulfill.

The terms NOVELTY, ORNAMENT, and BRIC-A-BRAC are all acceptable object names to use when identifying certain kinds of objects. However, they should be used only as subdivisions of certain classification terms:

NOVELTY is an acceptable object name within the classification terms ADVERTISING MEDIUM and TOY, but it should be used only when there is no other object name that adequately identifies the artifact.

ORNAMENT may be a valid object name in a number of situations. The appropriate classification term will depend upon the kind ornament that is being identified. For example, ORNAMENT, HAIR is proper as ADORNMENT; ORNAMENT, CEILING is a BUILDING FRAGMENT; a CAROUSEL ORNAMENT is part of a CAROUSEL and thus a RECREATIONAL DEVICE. The word ORNAMENT, as COMMERCIAL DECORATIVE ART, is a primary word to which several different suffix qualifiers might be added: e.g., ORNAMENT, CHRISTMAS TREE; ORNAMENT, HALLOWEEN.

BRIC-A-BRAC is the only appropriate term to use when identifying miscellaneous small decorative objects such as those sometimes found in a Victorian parlor. BRIC-A-BRAC is always classified as COMMERCIAL DECORATIVE ART. It should not be used with any other classification term.

Fractur and Scrimshaw

Fractur and *scrimshaw* create special kinds of problems because the words themselves mean different things to different people and sometimes different things in different circumstances.

Fractur is the name given to a *technique* by which Pennsylvania Dutch immigrants applied a stylized German script around the borders of such things as birth certificates, family trees, and song books. It is sometimes used in conversation as a reference to the objects so decorated, but it

is not a valid term for either the classification or the naming of artifacts on museum records.

The word *scrimshaw* can mean any of the following: (a) a nonutilitarian object made by New England whaling men from whalebone or baleen; (b) any object produced by New England whaling men out of whalebone or baleen; or (c) any object crafted by the New England whalers, regardless of the materials used. In the lexicon, utilitarian objects are classified and named according to function, and this is a concept which consciously ignores materials, techniques of construction, and circumstances in which objects may have been produced. A scrimshaw object which seems to have been created for no apparent utilitarian function would be classified as ORIGINAL ART and named, perhaps, a WHIMSY. Utilitarian objects may be identified using any number of classification term/object name combinations. The word *scrimshaw* should never be used in the naming of an object.

If it is important to be able to retrieve all of the records on fractur or scrimshaw artifacts in a particular collection, some method of cross-referencing the records according to the data category Technique of Manufacture must be provided.

Models and Miniatures

The words *model* and *miniature* are a common part of our vocabulary, and they are frequently used, in spoken English, as a part of the naming of artifacts. We often refer, for example, to a "ship model" or to "miniature furniture"; and what we most often mean is a scaled-down reproduction of the real thing, normally nonfunctional in the sense of not being capable of performing the same functions as the full-sized object.

Almost any man-made object can be reproduced on a smaller scale than the original. With a classification term/object name combination that implies a small-sized object (e.g., with a TOY and, usually, with ORIGINAL ART) the words *model* and *miniature* are not really necessary. With a miniature painting, however, the classification term and the object name would be the same for both the miniature and the full-sized artifact. Therefore, the word MINIATURE must be added as a suffix qualifier to the object name PAINTING.

With models and miniatures that are classified as TOY or ORIGINAL ART, the one word MODEL

or MINIATURE, if needed, should be appended to the appropriate object name as a suffix qualifier (e.g., AIRPLANE, MODEL; SOFA, MINIATURE).

In addition to models and miniatures which are classified as TOY or ORIGINAL ART, there are also several other special kinds of models:

SALES MODEL—A model designed to assist in demonstrating the functioning of a product. Note that this is not the same as a SALES SAMPLE.

PATENT MODEL—A model used as a basis for obtaining a protective patent on a product.

DESIGN MODEL[4]—A model of a ship, a building, etc., constructed before the object it represents, either in lieu of plans (i.e. a half model, a plating model) or as a basis for discussion of detailed plans (i.e., a drawing room model).

EXHIBITION MODEL[4]—A scale model constructed after the object it represents has been completed.

PRODUCT MODEL—A representation of a product package, a product symbol, or a product logo for advertising purposes; may be three-dimensional or bas-relief and any size; sometimes called a *point-of-purchase (pop)* model.

INSTRUCTIONAL MODEL—A model created to assist in demonstrating either an abstract principle (e.g., the functioning of an inclined plane) or the inner workings of a complex mechanism such as an internal-combustion engine.

TOPOGRAPHIC MODEL—A scaled-down facsimile of some portion of the natural environment; usually, a detailed, three-dimensional map.

ANATOMICAL MODEL—A facsimile of some

portion of the human anatomy; usually used as a teaching tool.

With the first four kinds of models listed above (SALES, PATENT, DESIGN, and EXHIBITION), the classification term/object name combination used to identify a model is the same as the terms that would be used to identify the corresponding full-sized object but with the addition of the special model term as a suffix qualifier. For example, the undercarriage of a wagon, two feet long, with moving parts throughout, created originally to demonstrate the superiority of a brand of real wagon undercarriages, would be classified as LTE, ANIMAL-POWERED, and named a WAGON UNDERCARRIAGE, SALES MODEL. Likewise, an exhibition model of the *Queen Mary* would be identified by the classification term WATER TRANSPORTATION EQUIPMENT, and the object name PASSENGER VESSEL, EXHIBITION MODEL.

The terms PRODUCT MODEL, INSTRUCTIONAL MODEL, TOPOGRAPHIC MODEL, and ANATOMICAL MODEL identify products, ideas, and natural phenomena rather than small-sized nonfunctional reproductions of other man-made objects. They are phrases which can be used alone as valid object names or they may be further subdivided—PRODUCT MODEL to indicate a product class and the others to convey the idea or phenomenon displayed.

A PRODUCT MODEL is always classified as an ADVERTISING MEDIUM. A TOPOGRAPHIC MODEL is a DOCUMENTARY ARTIFACT. An INSTRUCTIONAL MODEL or an ANATOMICAL MODEL may be valid with any number of classification terms, usually within the major category Tools and Equipment.

Reproductions and Replicas

We tend to think of reproductions and replicas in terms of famous art works, but the same principles apply to other kinds of objects as well: coins and other exchange media, documents, etc.

A *reproduction* may be defined as a copy or likeness that is done in commercial quantities, usually in a medium somewhat different from the original. For example, a reproduction of a famous oil painting may be created by photo-offset methods so as to produce a large number of printed copies; or a new mold of a well-known statue may be created so as to produce a large number of small-sized plaster-of-paris copies.

4. The terms DESIGN MODEL and EXHIBITION MODEL are adapted from the field of naval history. In this field, distinctions are also made between *original* and *contemporary* models, depending upon whether the object was constructed at the same time as the ship it represents or at some later time. However, these distinctions go beyond what is necessary for precise object name terminology.

Normally, when a reproduction is cataloged, the classification term and object name that best define the artifact in hand are not the same as the terms that would be used to identify the original. A print of an original painting, prepared by photo-offset methods, for example, is a PRINT, not a PAINTING. It should be named as such and classified as COMMERCIAL DECORATIVE ART. This would apply regardless of the fact that it is a reproduction of a PAINTING, which in itself would be classified as ORIGINAL ART. The fact that the one is a reproduction would be recorded in the catalog record, along with the title, the name of the artist, and other pertinent information. However, the word *reproduction* is not usually necessary as a part of the object name.

A *replica* is somewhat different from a reproduction. Both are copies of something else, but a replica is an attempt to create an object which, as nearly as possible, exactly duplicates the original. It is done in the same medium and to the same scale as the original object. Sometimes a replica is created as a new, perhaps unlimited, series from the same molds that were used with the original limited edition. When a replica is being identified, it is necessary to include the word REPLICA as part of the object name so that there can be no possible confusion with the original in the catalog records. The procedure for achieving this is to use exactly the same classification term/object name combination that would be used for cataloging the original but to append the word REPLICA to the object name as a suffix qualifier. A replica of a valuable coin, for example, would be identified with the classification term EXCHANGE MEDIUM, and the object name COIN, REPLICA.

Authorities and References

Authorities used in the preparation of the lexicon are of several types. In addition to the numerous individuals who have developed or critically reviewed the word lists, both specific and general bibliographic authorities have been consulted regularly. The former are included in the lexicon word lists as references, i.e., as numeric <u>ref</u> entries that follow the definition of each classification term. They are publications to which the user can turn for precise definitions of the object names in that section of the lexicon. General bibliographic authorities are books that

have been used extensively in the creation of the lexicon, but they are not organized so as to be useful references when dealing with particular classification terms.

Webster's Third New International Dictionary of the English Language, Unabridged,[5] has been our court of last resort on all matters of form: the preferred spelling of words, hyphenation, whether a phrase is one word or two, whether a word from another language is now accepted as English, etc. In a project such as this it is essential that some authority be used as a constant point of reference in such matters. Also, we have gone back to *Webster's* every time we have had to resolve a difficult definition problem. As a general rule, for an object name to be included in the lexicon, it must be a word or phrase that is sufficiently well accepted in the American language to appear in *Webster's*. The only major exception to this is in the general area of specialized tools.

Other general references which were helpful as sources for definitions and/or illustrations of many specific objects are:

The American Heritage Dictionary of the English Language[6]—Always a clear, concise source of information about usage in the United States.

Encyclopaedia Britannica[7]—A very good place from which to obtain an overall perspective about a class of objects.

Sears Roebuck Catalog, 1908[8]; *Sears Roebuck Catalog, 1965*[9]; *Montgomery Ward Catalog, 1894–95*[10]; and *Butler Brothers Catalog, 1908*[11]—Useful in sorting out the names that were and are used for many thousands of common household items in America. The catalogs, of course, are not organized so as to be usable as specific references, but they nevertheless were very helpful.

Knight's American Mechanical Dictionary[12] and *Appleton's Cyclopaedia of Applied Mechanics*[13]—Good general guides to the specialized heavy equipment that was being used at the time the United States was becoming a major industrial country.

5. Ref. (128).	8. Ref. (106).	11. Ref. (28).
6. Ref. (02).	9. Ref. (105).	12. Ref. (65).
7. Ref. (44).	10. Ref. (77).	13. Ref. (06).

Chapter 3
Major Artifact Categories: Definitions

In this chapter we will consider each of the eleven major artifact categories and the logic by which it is separated from the other ten. In addition, we will discuss the rationale for some of the less obvious classification terms which are included as subdivisions of the major artifact categories. In a few cases, aspects of cataloging that go beyond the data categories of classification term and object name will also be discussed so as to clearly distinguish these from other data categories such as Style or Type name, Materials, Techniques, and Subject represented.

In most cases the user of the lexicon should have no difficulty in locating the major artifact category and classification term appropriate for the cataloging of a particular artifact. A DRESS, for example, is without question identifiable as a Personal Artifact (Category 3), and an examination of the classification terms within Category 3 leaves no doubt about the correct classification term, CLOTHING. Most man-made objects can readily be identified within the lexicon structure by working down through the hierarchy from major artifact category to classification term to object name.

But there are always the exceptions. What should be done, for example, with an article of clothing that is closely associated with a particular occupation or activity (e.g., a UNIFORM, a BLACKSMITH'S APRON, a BALLET SLIPPER, a CRASH HELMET)? Are these Personal Artifacts (Category 3) or are they Tools and Equipment (Category 4) and Recreational Artifacts (Category 8)? Or what about a tool that is used only by persons who are involved with a particular activity (e.g., a SPIKE MAUL, which is designed specifically for use in laying railroad track)? Whenever there is any doubt about the major

artifact category or classification term which best describes the original function of an artifact, the user should locate the appropriate major artifact category first; and, for this purpose, *the major artifact categories should be looked upon as though they were ranked hierarchically*. Thus, since Personal Artifacts rank ahead of both Tools and Equipment and Recreational Artifacts, a UNIFORM, a BLACKSMITH'S APRON, a BALLET SLIPPER, and a CRASH HELMET all appear in the lexicon as Personal Artifacts and, within this, under the classification term CLOTHING. Likewise, since Tools and Equipment rank ahead of Transportation Artifacts, a SPIKE MAUL appears in the lexicon as METALWORKING T&E.

The general rule of ranking the major artifact categories should be applied whenever an artifact conceivably could be considered under more than one category. However, the test must be made for each artifact individually regardless of any other objects with which it might originally have been used. For example, even though a SPIKE MAUL could be, and therefore is, defined as a tool, a RAIL SECTION could not be classified as anything but a RAIL TRANSPORTATION ACCESSORY (Category 6).

Within major artifact categories, classification terms are arranged in alphabetic sequence. They are not ranked hierarchically. In determining whether an artifact should be identified within a particular classification term, it is necessary to carefully examine the definition of the classification term under consideration as well as the definitions of all classification terms cross-referenced by a "see also" statement. If there is still doubt, the appropriate sections of this chapter should be reread.

Category 1: Structures

<u>def</u> Artifacts originally created to serve as shelter from the elements or to meet some other human need in a relatively permanent location

The primary purpose of the lexicon is to provide an authority file of terminology for use in cataloging portable artifacts when they are located within a museum. However, this approach to the cataloging of portable objects also extends to the cataloging of all kinds of structures—i.e., artifacts such as historic and prehistoric buildings and other types of objects which were constructed originally to remain in one location. The reasons for cataloging a structure are many. Normally, the cataloging will be done with the object in the location where it was originally erected (i.e., *in situ*). This may be prior to the destruction of the structure as part of an archaeological excavation or a land clearing project; or it may be because the structure has some historic importance and, therefore, is slated to be reconstructed for exhibition purposes, either *in situ* or in some other location.

The two primary characteristics that distinguish most structures from other major classes of objects are relative permanence and relatively large size. However, neither of these characteristics apply to every structure. For example, even though most structures are relatively permanent, the functional characteristics of a BUILDING (i.e., to shelter) have been extended somewhat to include shelters that may be less than permanent; and there are some relatively small objects included in several of the Category 1 classification terms (e.g., small buildings, barbwire, a storage cyst). Also, there are many large, but portable, artifacts which are identifiable within classification terms elsewhere in the lexicon (e.g., Transportation Artifacts, Category 6).

Category 1 contains only four classification terms but each of these requires further discussion.

BUILDING

Whenever an entire building is cataloged, it should be identified with the classification term BUILDING and the object name that best describes the original function of the structure as a whole: COURTHOUSE, CHURCH, INN, etc., or, in the case of an archaeological edifice, CHARNEL HOUSE, STORAGE BUILDING, and so on.

With objects which were created originally to be parts of buildings or accessories to the operation of buildings, the classification term BUILDING FRAGMENT or one of the classification terms in Category 2 should be used. Contrary to the usual procedure, parts and accessories for buildings are not identified using the same classification term as the objects with which they are associated. The reason for this unusual treatment is that building fixtures, fragments, and furnishings are, for the most part, artifacts which can be associated with almost any of the named buildings.

Buildings, like other artifacts, are often loosely identified with words that are actually expressions of some data category other than object name—Style, Materials, Techniques, etc. For example, words like *salt box, Federalist,* and *Spanish colonial* are sometimes used in conversation as if they were adequate names for buildings. However, precision of cataloging demands that these terms be reserved for the data category we call Style. Likewise, words such as *cobblestone, stucco, clapboard*, and *adobe brick* are proper terms to use within a data category we might call Materials and/or Technique. But they are not proper words to use for the naming of buildings.

BUILDING FRAGMENT

The object name terminology included in the lexicon assumes that, in most situations, the cataloging of building fragments will involve structural or decorative segments of buildings, not portions of buildings which might be defined by functional room names. By the time a room is displayed as a museum artifact, it usually will have been removed from its original context and converted into a "restoration of a room." The lexicon structure assumes that *original* building fragments are the only objects which would be salvaged and cataloged. Therefore, object names have been included under the classification term BUILDING FRAGMENT so that the parts of an original room which would probably be salvaged (e.g., a WINDOW, a FIREPLACE FACADE, a CEILING ORNAMENT) can be identified. Complete rooms and those parts of a room

which would be more likely to be restored than to be removed intact (e.g., the "behind the scenes" structure of pipes, electrical wiring, and rough framing; complete walls, floors, and ceilings) are not included in the lexicon as valid object names, although they could be added by the user if needed. Plumbing, heating, and lighting fixtures are treated in the lexicon as Building Furnishings (Category 2).

SITE FEATURE

In addition to buildings, there is a wide range of other structures which are created to be permanently attached to some portion of the earth's surface in order to serve a human need other than shelter. Often these are objects associated with a particular building, in the sense of being nearby and probably used by the occupants of the building. But they are, nevertheless, physically separate. Relatively permanent structures such as a trellis, a fence, or an outdoor fire pit usually are features of a building site. Therefore, they are identified using the classification term SITE FEATURE.

UNCLASSIFIED STRUCTURE

Structures which do not provide shelter themselves and are not associated in any direct way with a building can be very important. But they are not very numerous. For this reason, they have been grouped together in the lexicon as subdivisions of the classification term UNCLASSIFIED STRUCTURE. All of the artifacts included within this category would be classifiable elsewhere were it not for the fact that they were constructed originally to remain in a fixed location. For example, a BRIDGE or DOCK might be Transportation Artifacts, and a STADIUM might be viewed as SPORTS EQUIPMENT. However, these possible functions are all secondary to the fact that the artifacts also can be, and therefore they are, identified as Structures (Category 1).

Category 2: Building Furnishings

det Artifacts originally created to be used in or around buildings for the purpose of provid-

ing comfort, care, and pleasure to the occupants

The concept of a Building Furnishing may be loosely thought of as any object that is used in or around a building. The separation between Structures (Category 1) and Building Furnishings (Category 2) can be made on the basis of the relative permanence of the former and the relative portability of the latter. Building Furnishings can be distinguished from other major artifact categories, and especially from Tools and Equipment (Category 4), in that they benefit humans by providing for their comfort and care rather than being used in the process of carrying on an active endeavor. It might be possible, for example, to think of the implements that are used in food preparation, food service, and other housekeeping activities as a part of Building Furnishings. These classes of implements, though, are used by humans as tools to aid in the performance of defined classes of activities, whereas most of the artifacts included within Category 2, though they *benefit* mankind, are not *used by* mankind other than in passive activities such as sleeping or sitting.

Most of the classification terms included within Category 2 require no explanation in addition to the definition. However, a few of them need to be clarified.

FURNITURE

Within the classification term FURNITURE, the listing of object names is reasonably complete, and the user should be extremely cautious about adding new terms. For example, appliances are often thought of as FURNITURE, largely because of their size. However, large and small objects alike are classified in this lexicon according to function, and an object which functions as a FOOD PROCESSING T&E or HOUSEKEEPING T&E (Category 4) appears in the lexicon under those classification terms regardless of size. Appliances should not be added as new object names within the classification term FURNITURE.

With most of the Category 2 classification terms, the object name is sufficient to complete the identification of a majority of the objects. Style names can be very important, though, especially with FURNITURE. The names given to various styles of furniture are usually easy to determine

when a person is cataloging a typical or classical example. Words such as *Chippendale, Queen Anne,* etc., are well-known style names which can be properly used to further describe FURNITURE that has been identified with an object name such as SOFA or DINING CHAIR, but they should not be used as object names. Also, specialists in the field of nineteenth century furniture continuously remind us that during the Victorian Era style names are not well defined. Therefore, names like *Queen Anne Type* may sometimes be an important part of the style name vocabulary. The user of the lexicon should maintain a list of all terms that are used to describe FURNITURE according to the data category Style. This list will serve as an authority file of style names in the same way that the lexicon serves as an authority file of object names.

HOUSEHOLD ACCESSORY

HOUSEHOLD ACCESSORY is a classification term that includes all of the small furnishings or minor utilitarian objects that are found, primarily, within the home. At times it may be difficult to decide whether an artifact was intended originally to be utilitarian at all, rather than purely decorative. An object that was created originally to be just a household decoration—one which could not function in any other way—should be considered as an Art Object (Category 7); an object which conceivably could have a passive utilitarian function of some kind other than just decoration should be classified as a HOUSEHOLD ACCESSORY (Category 2). For example, an ANTIMACASSAR does provide protection for furniture; a JARDINIERE and a VASE do function to hold plants.

LIGHTING DEVICE

Any artifact originally created to provide light, and not a part of some other object, should be identified with the classification term LIGHTING DEVICE. This applies to all portable lamps of any kind, to the relatively permanent light fixtures found in or around a home, and to objects such as a STREET LAMP which might be considered a structure. Most possible alternate classifications for other special-purpose lighting devices (e.g., the several kinds of special theater lights) would

involve a major artifact category that is lower in the hierarchy. Parts, of course, should be classified and named with the objects to which they were created to be attached (e.g., an AUTOMOBILE HEADLIGHT with AUTOMOBILE in LTE, MOTORIZED, Category 6).

Lighting devices are generally subdivided according to the fuel burned and the placement of the object (e.g., LAMP, KEROSINE TABLE). Several style names are included in the lexicon as lowercase unacceptable terms which direct the user to the fuel and placement combinations that the names imply. These style names should not be used as object names, and the user should not use the name of a manufacturer (e.g., Lamp, Tiffany) as part of an object name.

PLUMBING FIXTURE

A PLUMBING FIXTURE may be defined as an artifact which was originally created to be attached, more or less permanently to water and sewer lines within a building. The lines themselves are usually embedded within the walls, floors, and ceilings of a building. If it were necessary to catalog any of these, they would be identified as a BUILDING FRAGMENT (Category 1).

The plumbing fixtures we have in buildings today are identified, in almost all instances, with object names different from the names of the artifacts which fulfilled the same purposes in the past. The corresponding portable objects are included in the lexicon under the classification term HOUSEHOLD ACCESSORY. This separation of portable and more or less permanent artifacts under two different classification terms is different from the treatment accorded to a LIGHTING DEVICE or a TEMPERATURE CONTROL DEVICE.

TEMPERATURE CONTROL DEVICE

A TEMPERATURE CONTROL DEVICE is defined as an artifact used to control the temperature within a building though not a structural part of the building itself (i.e., not a FIREPLACE). It includes stoves and heaters of all types except those that were created to perform some other specific function (e.g., a COOK STOVE appears as FOOD PROCESSING T&E). Likewise, it includes all generalized objects used for cooling a

building but not an ICEBOX or a RE-FRIGERATOR. Also included within this classification term are all types of portable accessories that would be used with any TEMPERATURE CONTROL DEVICE.

Category 3: Personal Artifacts

def Artifacts originally created to serve the personal needs of individuals as clothing, adornment, body protection, grooming aids, or symbols of beliefs or achievements

All of us have a certain group of objects which we think of as our "personal property." These are not personal property in the legal sense (e.g., stocks and bonds), but objects other than tools which we normally possess for our exclusive, individual use. With most objects we could readily segregate those things which are personal from those which are nonpersonal. The former certainly would include CLOTHING, ADORNMENT, and TOILET ARTICLES. The concept of PERSONAL GEAR may not be quite as obvious. Yet most of us would readily agree that objects such as our eyeglasses, our purses, and our personal smoking equipment indeed are very personal.

The user of the lexicon should have no difficulty with Personal Artifacts except in the areas of the following three classification terms.

CLOTHING

Because of the large number of object names required to identify articles of clothing, this classification term has been subdivided into FOOT-WEAR, HEADWEAR, OUTERWEAR, and UNDERWEAR. CLOTHING ACCESSORY is a separate classification term that includes artifacts which are not CLOTHING, *per se*, but are closely associated in use with one of the CLOTH-ING subclassifications (e.g., a SHOEHORN, a BUTTONHOOK). In this sense, the word *accessory* means the same thing as it does elsewhere in the lexicon. In addition, though, CLOTHING ACCESSORY also includes a large number of objects which are functional accouterments—i.e., they are actually "worn" but not for the purpose of covering the human body (e.g., a BELT, a TIE TACK). In this usage, a CLOTHING ACCES-

SORY is somewhat different from other accessories.

Clothing styles seem to change regularly and rapidly. Whenever a particular style becomes popular, there is a tendency to refer to it as if that were the name of a new kind of object. A blazer, for example, is a style of COAT, not the name of a new object. Care should be taken to avoid adding clothing style names to the lexicon as if they were new object names.

PERSONAL SYMBOL

PERSONAL SYMBOL is a concept developed while putting the lexicon together. It is intended as a classification term that encompasses all of those objects which function as symbols to an individual. They may be symbols of a role, membership, status, or position; they may be awards received for past achievements; or they may be symbols of a personal belief (religious or secular), whether or not the symbol is ever displayed to the outside world. The two significant facts are conveyed in the classification term itself: the object must be *personal*, and it must be a *symbol* of a belief, achievement, status, or membership.

In addition to the object names included in the lexicon within the classification term PERSONAL SYMBOL, appropriate object names may be added from CLOTHING and ADORNMENT or other classification terms when the object names identify representational objects which were created primarily for their personal symbolic value. Examples of clothing or adornment created originally to be a PERSONAL SYMBOL rather than body covering are an ACADEMIC GOWN or a CROWN. A MASONIC RING or a RELIGIOUS PENDANT are symbolic ornamentation.

The classification term PERSONAL SYMBOL should not be used to identify personal souvenirs and mementos (see page 17), documents (see DOCUMENTARY ARTIFACT, Category 5), or artifacts created originally to be used in a public ceremony (see CEREMONIAL ARTIFACT, Category 9).

Category 4: Tools and Equipment

def Artifacts originally created to be used in carrying on an activity such as an art, craft,

trade, profession, or hobby; the tools, implements, and equipment used in the process of modifying available resources for some human purpose

The idea of tools as a major category of human artifacts is readily understandable, and with most tool-type objects there is no problem in placing them within this category. Tools are those objects used by individuals as a means of earning a livelihood, regardless of whether that person is considered a laborer, a craftsman, a professional, or a technician. Because the same tools are used by an individual engaged in an activity for profit or for pleasure, we have extended the concept of a livelihood to include hobbies as well. Category 4 is intended to include any object, large or small, actively used in a constructive (as opposed to a passive or a recreational) activity.

The implements which mankind uses to make a living comprise, in the aggregate, by far the largest single major artifact category. Category 4 contains forty separate classification terms—almost half of the total in all of the eleven major categories; and within these classification terms are included by far the largest number of object names in the entire lexicon.

With some tools and equipment, classification terms are provided so as to group in one place all of those objects which might be used when working on a particular kind of material—wood, metal, glass and plastics, leather, paint, stone, textiles, etc. With other categories of tools, the classification term cannot be defined in terms of materials. However, in every case, there is a class of activities which serves as a common denominator for the T&E classification.

Tools and Equipment can range from the simplest of hand implements (e.g., the tools of a prehistoric flint knapper; the BROADAX and AWL of the frontiersman) to the most complicated of modern electronic machinery. Most tools and equipment are somewhere between these extremes. In general, there is a group of tools identifiable by a function performed, and the name of this group is included in the lexicon as a valid object name (e.g., HAMMER, SAW, PLANE), but with the suggestion that the general term be used to identify a particular artifact only if a more specific term is unknown. Where the object can be precisely identified, the specialized object names are given as suffix qualifiers. For example, there are approximately two pages of special names applicable for the precise identification of different types of saws.

Most of the T&E Classification terms are defined so as to include only the tools used in a specific activity—i.e., they are intended to include only special-purpose tools. However, a few of them are worded in such a way as to encompass a class of objects only if they are used for a variety of unspecified particular purposes—i.e., only if they are general-purpose tools. WEIGHTS & MEASURES T&E and TIMEKEEPING T&E, for example, include a large number of objects that were created originally for measuring distances and weight. But specific, special-purpose measuring devices (e.g., a SURVEYOR'S CHAIN) are included in other T&E classifications. WEIGHTS & MEASURES T&E is defined to include only general-purpose weighing and measuring devices. MECHANICAL T&E, OPTICAL T&E, and TIMEKEEPING T&E are also general-purpose classification terms. Likewise, UNCLASSIFIED T&E, GENERAL is defined to provide for those tools which are so general-purpose that they do not fit comfortably within any one of the other T&E classification terms (e.g., a SCREWDRIVER, PLIERS). UNCLASSIFIED T&E, SPECIAL is something different. It includes those specialized tools which are so few in number that there is no reason for a separate classification term to accommodate each of them (e.g., a FENCE JACK, a SNOW KNOCKER).

The name of a craft, trade, profession, or occupation is sometimes used as a suffix qualifier to specify a particular tool name. However, this has been limited to those situations where the craft name is a recognized part of the generally accepted term for the object (e.g., a COOPER'S ADZ, a DRESSMAKER'S SHEARS) or where the suffix qualifier is necessary in order to distinguish one tool from another (e.g., a CURRIER'S BEAM from a TANNER'S BEAM). Whenever the name of a craft, trade, profession, or occupation appears as a part of the object name, it is expressed in the singular possessive form.

With most tools and equipment there should be no problem in determining which of the classification terms to use for the identification of a specific object. The definitions are as precise as possible, and they cover almost every possible situation. However, in a few cases it will be

necessary to focus one's thinking upon the available T&E classification terms rather than, perhaps, the name of a trade or craft. For example, there is no term within which all farrier's tools are classified. Some farrier's tools are, in fact, METALWORKING T&E and some of them are the same tools that would be used by a farmer or, today, by a veterinarian—i.e., they properly belong under ANIMAL HUSBANDRY T&E. Another example of a tool that could be a problem is a SLEDGE. This is a tool that is commonly used by many different crafts, and it might be thought of as WOODWORKING T&E, MINING T&E, or even as a PUBLIC ENTERTAINMENT DEVICE (it was used, of course, to drive the stakes in the "big top"). But, a SLEDGE is primarily for driving metal; it is therefore classified in the lexicon as METALWORKING T&E.

ARMAMENT T&E

Many different types of weapons have been used by mankind over the ages, usually for the purpose of obtaining food but often also for purposes of warfare and sport. Since the same weapon is sometimes employed for any of these purposes, all weapons have been combined under a single classification term, with subdivisions by major types of armament: FIREARM, EDGED, BLUDGEON, ARTILLERY, AMMUNITION, and BODY ARMOR. ARMAMENT ACCESSORY is a separate, related classification term.

ARMAMENT T&E, FIREARM, includes both shoulder arms and hand guns. ARTILLERY includes all heavy-duty weapons created for military use but not self-propelled Transportation Artifacts (e.g., a TANK, a LANDING CRAFT) or Communications Artifacts. AMMUNITION includes all types of explosive devices and their components (e.g., a MINE, a MISSILE or a HAND GRENADE as well as a CARTRIDGE or a BULLET).

Within the sub-class, ARMAMENT T&E, FIREARM, provision has been made to structure object names so that the first word or words indicate the type of gun according to the delimited list of terms provided, and the word or words which follow indicate a subdivision according to the system that is used for igniting the powder. In almost every case, the ignition system term can be selected from the following list:

MATCHLOCK
WHEELLOCK
FLINTLOCK
SNAPHANCE
MIQUELET
PERCUSSION LOCK
PILL LOCK
PIN-FIRE
RIM-FIRE
TEAT-FIRE
NEEDLE-FIRE
CENTER-FIRE
AIR

In addition to the object name (including, if appropriate, the ignition system), several other data categories are necessary in order to prepare a complete catalog record for an ARMAMENT T&E artifact. Some of these are categories common to other objects as well—e.g., Country of Origin, Manufacturer's Name, Model Number or designation (this is the equivalent of Style with many artifacts) and Date of Origin. Other categories of information which may also be necessary for a complete description of either a firearm or an artillery piece include the serial number, the caliber of the weapon, the magazine system and the load system. These can be handled as a part of the general description of the artifact in most catalog systems. But if there is any likelihood that it might be desirable to sort or summarize all armaments in the collection according to, say, caliber, then caliber should be provided as a separate data category when the catalog information is recorded initially.

MEDICAL & PSYCHOLOGICAL T&E

MEDICAL & PSYCHOLOGICAL T&E is defined so as to include only artifacts originally created specifically for the purpose of diagnosing and treating humans. This definition, of course, excludes tools used with animals; and it also excludes tools created to be used in the study of phenomena related to humans in particular ways. For example, the tools used by a physical anthropologist or biologist for taking skeletal measurements are BIOLOGICAL T&E, not MEDICAL & PSYCHOLOGICAL T&E; the tools used for the study of light and sound are OPTICAL T&E and ACOUSTICAL T&E, even though the tools for

testing sight and hearing are included in MEDICAL & PSYCHOLOGICAL T&E.

Some of the object names included in MEDICAL & PSYCHOLOGICAL T&E may seem unusual from the standpoint of twentieth-century medical practice (e.g., the tools used in bloodletting). However, we are concerned with any artifact originally created for the purpose stated in each classification term definition. This has nothing to do with the actual effectiveness of a tool in accomplishing that purpose. (Note also that astrological devices are included within ASTRONOMICAL T&E.) Also, tools used in the testing or treatment of psychological abnormalities are a part of MEDICAL & PSYCHOLOGICAL T&E, but objects created to assist in learning about the human psyche are BIOLOGICAL T&E, and teaching devices are classified as DATA PROCESSING T&E.

POWER PRODUCTION T&E

POWER PRODUCTION T&E is intended to be used only for those objects which were originally created for the purpose of producing power, and then only when the power production device is an independent unit, not part of a larger object which would be identified within some other classification term. For example, a freestanding DIESEL ENGINE or a STEAM TRACTION ENGINE would be correctly classified as POWER PRODUCTION T&E. However, a steam-powered ROLLER is classified in the lexicon as CONSTRUCTION T&E, and a STEAM LOCOMOTIVE is RAIL TRANSPORTATION EQUIPMENT. An OVERSHOT WATERWHEEL is classified as POWER PRODUCTION T&E, if it is identified separately, but if the machinery of a flour mill is being cataloged as a unit (perhaps including an overshot waterwheel), the classification term FOOD PRODUCTION T&E would be used.

Category 5: Communication Artifacts

def Artifacts originally created for the purpose of facilitating human communication

Communication devices could be considered as Tools and Equipment—as one or more classification terms within Category 4. However, they comprise a special subset of tools which for a number of reasons are best segregated into a major artifact category. The idea behind this major artifact category is to group in one place all of those artifacts which were created originally for the primary purpose of communicating meaningful information to human beings regardless of the reason for the communication. DATA PROCESSING T&E is closely related. Sometimes data processing devices also store and communicate information that is meaningful to humans. But the distinction is that DATA PROCESSING T&E are designed primarily *to process* information, whereas Communication Artifacts are designed primarily *to store and/or communicate* information that is meaningful to humans.

Communication Artifacts include some objects which are designed to contain or hold information which later will be seen or heard by humans (e.g., street signs, printed or written documents); some objects which were created to facilitate the obtaining of information from storage (e.g., a SLIDE PROJECTOR, a PHONOGRAPH); and some objects which assist in the direct communication of one person to another or to a group (e.g., a telephone, a television). In most cases, human communication is either visual or auditory. Therefore, there is also a close connection between Communication Artifacts and both OPTICAL T&E and ACOUSTICAL T&E. OPTICAL T&E, in particular, includes some artifacts which enhance the optical powers of humans (e.g., binoculars, a magnifying glass). But these are not objects used to communicate messages. Communication Artifacts are those objects which were created originally for the primary purpose of communicating *meaningful* information to human beings.

ADVERTISING MEDIUM, DOCUMENTARY ARTIFACT, AND WRITTEN COMMUNICATION EQUIPMENT are classification terms within Category 5 which require additional discussion. In addition, there are a number of specific objects which could be thought of as Communication Artifacts. But only in certain instances do they belong here. For example:

1. An AUTOMOBILE HORN and a LOCOMOTIVE WHISTLE are both designed to facilitate human communication. However, they are also parts of other artifacts named in the lexicon. They should both be classified and named as "parts" (see pages 13, 14 and 16).

2. A NAVIGATIONAL BUOY is created for no reason other than as a tool to aid navigation. It

should be identified using the classification term SURVEYING & NAVIGATIONAL T&E. A bell designed specifically to be installed in a buoy would, likewise, be identified as SURVEYING & NAVIGATIONAL T&E. The correct object name here would again be that of a part—i.e., NAVIGATIONAL BUOY BELL.

3. A LIGHTHOUSE is included in the lexicon as a BUILDING, even though it serves the same general purpose as a BUOY. Ordinarily a LIGHTHOUSE BEACON would be thought of as a BUILDING FRAGMENT, but because of the special problem with light fixtures permanently installed in buildings (see page 24), it is included in the lexicon as a LIGHTING DEVICE (Category 2).

The kinds of objects discussed in the three preceding paragraphs are things which a curator might want to retrieve for an exhibit on human communication. Therefore, they are objects which, if possible, should be cross-referenced to SOUND COMMUNICATION EQUIPMENT or VISUAL COMMUNICATION EQUIPMENT when they are cataloged in a museum. However, they should not be identified using these phrases as classification terms.

Many of the Communication Artifacts in use today are assembled from parts and components or subassemblies which are interchangeable. For example, implements such as an oscilloscope are used in the manufacture and repair of a wide variety of electronic devices, including SOUND COMMUNICATION EQUIPMENT and VISUAL COMMUNICATION EQUIPMENT; and components such as an audio amplifier often are interchangeable from one electronic device to another. For this reason, general-purpose tools, parts, and components of all electrical and electronic devices are classified in the lexicon as ELECTRICAL & MAGNETIC T&E. Nevertheless, objects created originally as parts of specific, named Communication Artifacts are included within the appropriate classification term in Category 5. For example, a TELEVISION PICTURE TUBE is a special-purpose part, correctly classified with a TELEVISION as TELECOMMUNICATION EQUIPMENT.

ADVERTISING MEDIUM

The classification term ADVERTISING MEDIUM involves a question as to whether the medium, *per se*, is of primary importance or whether the objects, products, services, and events being advertised should take precedence. Both are important, for it is possible that the user of the catalog might wish to retrieve, say, all TRADE CARD CATALOGs or POSTERs on one occasion and, at another point in time, all advertising media concerned with animal-powered transportation or with political campaigns.

It is suggested that the user of the lexicon identify advertising artifacts using the classification term ADVERTISING MEDIUM and the object name that best indicates the type of advertising medium (e.g., HANDBILL, POSTER, TRADE SIGN) rather than a class of objects, products, services, or events being advertised. A separate data category such as Subject or Theme should be used to indicate the product class and, if desired, the specific kind of object, service, or event. For example, if one is cataloging a POSTER which was put out by the manufacturer of a brand of wagons and surreys, the correct classification term to use would, of course, be ADVERTISING MEDIUM. Within this, the object name would be POSTER. The words LTE, Animal-Powered; Wagon; and Surrey, would be recorded as three separate and indexable terms within the data category Subject or Theme.

The object names included in the lexicon under the classification term ADVERTISING MEDIUM are words that are regularly used to identify artifacts created for this purpose. However, many additional kinds of objects have been used to advertise objects, products, or services. Additional object names may be selected from elsewhere in the lexicon whenever necessary to identify a representational object—i.e., something created for the purpose of serving as an ADVERTISING MEDIUM but in the form of some other object.

DOCUMENTARY ARTIFACT

In most museums, libraries are cataloged using precise techniques that have evolved over a period of many years and terminology that is quite different from the terminology of museum catalogs. However, there are often situations where an object created originally as a document (e.g., a book, a manuscript) is cataloged by a museum not for its content but primarily for its value as an object.

In general, a DOCUMENTARY ARTIFACT can be defined as any object which contains or stores, in printed, written, or pictorial form, information which can be "read" for meaningful content by humans. In other words, it is any artifact which was created originally as a vehicle for the storage of "documentary" information. In a few cases, the same kind of an object could be either an Art Object (Category 7) or a DOCUMENTARY ARTIFACT, depending upon the reason for which it was probably created. For example, a PHOTOGRAPHIC PRINT most often is created for no purpose other than to document an event such as a family gathering. Even formal family portraits are most often documentary in nature. However, a PHOTOGRAPHIC PRINT may also be a work of ORIGINAL ART. With a PAINTING, the reverse is generally true: the usual classification is ORIGINAL ART, but sometimes a PAINTING is nothing more than a DOCUMENTARY ARTIFACT.

There are a few instances (e.g., a commemorative COIN, a souvenir PLATE) in which a representational object may be correctly classified as a DOCUMENTARY ARTIFACT and, perhaps, cross-referenced to the classification term where the object name is found as a term for identifying a utilitarian object. Also, there are many instances of artifacts created originally to be utilitarian objects but later "inscribed" in some way with documentary information (e.g., the RIFLE or SWORD that is inscribed to commemorate an historic military event). These remain utilitarian objects and should be classified as such, even though it may also be desirable to cross-reference them to the classification term DOCUMENTARY ARTIFACT. As with any other artifact, the original function which the object was created to perform should be the basis for the classification term that is used to identify the artifact.

WRITTEN COMMUNICATION EQUIPMENT

The object names included within the classification term WRITTEN COMMUNICATION EQUIPMENT are in a certain sense tools which are used in the process of creating written documents. The classification term could be included within Category 4, Tools and Equipment, along with DRAFTING T&E, PRINTING T&E, and DATA PROCESSING T&E. However, it has been left in Category 5 primarily because the term includes

the word *communication*. The object names included within this classification term would not be changed either way.

Category 6: Transportation Artifacts

<u>def</u> Artifacts originally created as vehicles for the transporting of passengers or freight

From the earliest of times, one of the major classes of man-made artifacts has been those objects which make it possible to move people and things about the earth, either with less effort or more quickly than is possible with human effort alone. In any system for the classification of man-made artifacts, transportation is always an important part of the structure. Transportation Artifacts, like Communication Artifacts, could be considered as a special subset of Tools and Equipment (Category 4). However, the subset is sufficiently distinctive, in terms of the function of the objects, the usual size of the objects, and the number of objects, to warrant setting it apart in a major artifact category.

This category contains only four defined classification terms: one each for artifacts which transport persons and cargo through the air, on land, on rails, and on water. However, each of the four defined classification terms is further subdivided so as to separate transportation equipment from transportation accessories; and LAND TRANSPORTATION EQUIPMENT is also subdivided according to the source of power—i.e., animal, human, or motorized. In order to avoid the use of extremely long classification terms, LAND TRANSPORTATION EQUIPMENT, when subdivided, is also shortened to LTE. Thus, in the lexicon, LAND TRANSPORTATION EQUIPMENT, ANIMAL-POWERED appears as LTE, ANIMAL-POWERED.

The reason for separating accessories from transportation equipment is the same as the reason for separating BUILDING FRAGMENT, LIGHTING DEVICE, PLUMBING FIXTURE, and TEMPERATURE CONTROL DEVICE from BUILDING: namely, these are artifacts which most often cannot be identified as parts of or accessories to specific objects identified as transportation equipment. For example, almost any WATER TRANSPORTATION ACCESSORY could be a part of or associated in use with a number of

different objects named as WATER TRANSPOR-TATION EQUIPMENT.

When the artifact being identified is known to have been created originally to be a part of a specific item of transportation equipment named separately in the lexicon, then the part should be identified using the appropriate equipment classification term and, as the primary object name word(s), the name of the artifact which it was created to be part of. It should be treated the same as a part anywhere else in the lexicon structure. However, when the artifact being identified is a "general-purpose" item in the sense that it could have been used with several different transportation equipment objects, it should be classified within the appropriate accessory classification term and named as a separate item. An AUTOMOBILE FENDER or an AIRPLANE WING, for example, are both parts of specific artifacts—i.e., parts of artifacts that could be identified with only one classification term/object name combination. Therefore, these parts should be classified and named in the same way as parts of other objects named in the lexicon. However, a WHIP, a FUEL PUMP, an OAR, or a BINNACLE should be separately named within the appropriate transportation accessory classification term.

With many items of transportation equipment, the object name provided in the lexicon listings is an appropriate way of naming an object. But additional data categories will be required in order to describe the artifact adequately. For example, with an AIRPLANE, Manufacturer and Style, interpreted as "model number," are the most significant categories. With an AUTOMOBILE, the three data categories, Date of Manufacture, Manufacturer and Style are most important, with Style used to designate "body style" (e.g., roadster, sedan, coupe, touring car). With other transportation artifacts (e.g., a WAGON, a BICYCLE), style may or may not be important. But the manufacturer's name and the date the object was made (a four-digit numeral) would be just as significant as with an AUTOMOBILE.

WATER TRANSPORTATION EQUIPMENT

There are some special rules which must be followed with WATER TRANSPORTATION EQUIPMENT. The first word(s) of the object name should always be the name of the functional type

of vessel that is being identified. That is, it should be one of the object names taken from the list in the lexicon. If the artifact is a sailing vessel (other than a MAN-OF-WAR—see below), the number of masts and the type of rigging should be added to the functional vessel name as a suffix qualifier term. Any number of functional types of vessels can be rigged in several different ways (e.g., a GENERAL CARGO VESSEL, a FISHERMAN, or a WHALER could all be rigged as a 2 MAST SCHOONER or as a 3-MAST BARK). But for most purposes the rigging is subsidiary to the vessel type rather than the other way around.

Consistency of form and punctuation is important. The following format should always be followed:

(functional object name)	(comma)	(number of masts)	(rigging term)
FISHERMAN	,	1-MAST	SLOOP
PRIVATEER	,	3-MAST	BARK

Rigging terms should, like any other controlled vocabulary, be taken from a list such as the following:

BARK
BARKENTINE
BRIG
BRIGANTINE
CLIPPER
CLIPPER SCHOONER
CUTTER
FORE-&-AFT
KETCH
LUG-LATEEN
SCHOONER
SHIP
SLOOP
SQUARE
TOPSL SCHOONER
YAWL

The term *man-of-war* has several meanings. In a general sense, it implies any vessel created for military purposes. However, a number of different functional types of vessels that have been created for this purpose are named separately in the lexicon. Therefore, the object name MAN-OF-WAR should be used in a more limited way to identify a full-rigged ship-of-the-line only. Since

this usage implies rigging as well as the functional type of vessel, the addition of the rigging term as a suffix qualifier to MAN-OF-WAR would be redundant.

Category 7: Art Objects

<u>def</u> Artifacts originally created for aesthetic purposes or as a demonstration of creative skill and dexterity; the essential ingredient is that the artifact was created for no apparent utilitarian purpose

The classification and naming of art objects has presented more problems than those encountered with any of the other ten major artifact categories. The reasons for this difficulty are clearly spelled out in one of Ben Shahn's essays[1]:

> The scholars speak of art in terms of class and category, and under headings of which the artist may never have heard. While he himself may have read extensively about art—and I think that most artists do read a great deal about art, and know a great deal about it—while he may have looked at scores of paintings, have dwelt upon them and absorbed them, his interest has been a different one; he has absorbed visually, not verbally. The idea of classifying such work would never have occurred to him, because to him the work is unique; it exists in itself alone. It is its distinction from other art, not its commonality with other art, that interests him.

But having explained why there are difficulties in the classification of works of art does not obviate the necessity for such classification. Registrars in art museums must do their work, just as artists must do theirs, and this requires that works of art be cataloged, in some way, along with other artifacts. Also, art museums are not the only places where works of art are found. Many, perhaps most, museums have some art objects among their collections. These must be cataloged along with a wide variety of other man-made artifacts and specimens from nature.

Artists and art historians are not different from other tradesmen, craftsmen, and professionals in the fact that they regularly use a form of language (a jargon) that is not always consistent or understandable to the outsider. For example, an art object is often identified by the name of the artist (a Picasso, a Renoir). At other times, though, it may be identified by the medium employed—the materials and techniques that were used to create the piece (a collage, an oil, a watercolor)—or by some other distinguishing characteristic. All of these express categories of information that are necessary for a complete description of a work of art, but the terms cannot all be included in a systematic nomenclature such as this lexicon, where internal consistency is essential.

The definition of the major category Art Objects is a satisfactory point of beginning if the user of the lexicon will keep two things firmly in mind. The first is the fact that an art object, by definition, is an object which was originally created for no utilitarian purpose except to be aesthetically pleasing. Many utilitarian objects are decorated—that is, in addition to performing their intended functions as furniture, as transportation devices, or whatever, they have also been used as vehicles for the expression of someone's aesthetic impulses. However, decorated utilitarian objects are not considered as art objects for purposes of artifact identification. Art objects must have been created for the primary purpose of providing aesthetic pleasure.

The second point that must be remembered is that all art objects are identified in the lexicon structure within one or the other of only two classification terms: ORIGINAL ART and COMMERCIAL DECORATIVE ART. At one point in the evolution of the lexicon, separate classification terms also were provided for primitive art and folk art. These were later eliminated, and it is important for the user to understand why, so that they will not again be added back to the lexicon copies of individual museums.

The term *primitive art* most often means art objects that have come from some culture other than our own—i.e., art that is not a part of the Western tradition. Examples which come to mind are the masks of the Dogon, a tribe from West Central Africa, or Eskimo soapstone carvings, or any of a wide variety of other objects which an art museum might exhibit as "art from exotic

1. Ref. (107), page 22–23.

places." The concept has become institutionalized by the naming of museums such as The Museum of Primitive Art in New York City. However, in spite of this institutionalization, there are several reasons why the concept cannot be used as a basis for artifact identification. In the first place, much of what we think of as primitive art is not art at all in the context of this lexicon. The objects had a utilitarian function of some kind when they were originally created. The masks of the Dogon, for example, were created originally as ceremonial objects, which in this lexicon structure would be identified within the framework of Societal Artifacts (Category 9). At The Museum of Primitive Art, objects such as these are identified for cataloging purposes according to the functions they performed in the societies where they originated, even though they may be exhibited as art objects here in the United States. Artifacts such as the Eskimo soapstone carvings are a little different. They were created as art objects and would be classified as such within the lexicon terminology. But they were not created as primitive art. The Eskimo probably did not have a concept of art for purely aesthetic purposes prior to his contact with the white world. The Eskimo carvings that we see today were created as art in the Western sense of the word, applying stylistic concepts and ideas which could be adapted from the forms of nature and the utilitarian objects which were a part of the Eskimo tradition. In any case, there is no such thing as *primitive* Eskimo art, and in the truest sense of the word, there is no such thing as primitive art at all.

Folk art is the same as primitive art in many respects. Many of the objects that are considered as prime examples of folk art are artifacts created originally to have some utilitarian function in the lexicon structure. For example, a WEATHERVANE is included in the lexicon within the classification term METEOROLOGICAL T&E, and a BARN is a BUILDING. Folk art which is nonutilitarian should be identified with the same classification terms and object names that would be appropriate for any other like objects. Thus, the classification term that would be used to identify a so-called "primitive" painting on a catalog record might be either ORIGINAL ART or DOCUMENTARY ARTIFACT (many primitive paintings are portraits commissioned primarily to document how a family or an individual looked at

a particular point in time—see page 30), and the object name would be PAINTING. The concept of folk art can most effectively be handled by considering it, for cataloging purposes, as a cross-reference according to the data category Style.

Primitive art and folk art have now been eliminated from the lexicon entirely. We strongly suggest that they not be added back either as classification terms or as object names. Within the definitions of ORIGINAL ART and COMMERCIAL DECORATIVE ART, as these terms are defined here, there is an adequate framework for the classification and naming of all objects which can be considered as having been originally created to be art objects.

It is not hard to distinguish between ORIGINAL ART and COMMERCIAL DECORATIVE ART when cataloging a particular object. However, the distinction is a little difficult to express in words. ORIGINAL ART, obviously, is intended to include any art object and any nonutilitarian craft object that is one of a kind. But, it is also defined so as to encompass a limited series of like objects. The intent is to consider as ORIGINAL ART objects such as a numbered and usually controlled series of prints that are run off from a wood block. Often the individual prints are signed personally by the artist and inscribed to show both the total number in the series and the number of that particular print. But how many prints comprise a "limited" series and how much control must be exercised by the artist for a particular object to be identified as ORIGINAL ART? These questions have intentionally been left unanswered. An experienced curator is the only one who can make such a determination, and it must be made on the basis of the facts in each particular case.

Quality may be very important in evaluating a work of art, either for financial or for aesthetic purposes. But it should not be considered when deciding how to classify a particular object. Extremely fine works of art often are reproduced for mass distribution in thousands of copies. These reproductions would be classified as COMMERCIAL DECORATIVE ART. On the other hand, the mediocre efforts of a Sunday afternoon painter would all be considered as ORIGINAL ART.

Data categories other than Classification and Object Name will almost always be necessary in order to provide an adequate catalog record for

an art object, Some of the most important of these are Style, Materials, and Technique (the last two may be combined and called Medium if desired). We have already discussed style names to some extent. "Folk" is a valid style name, as are the better-known classical art terms and words such as "Pop" and "Kitsch."[2] The terms to use for describing materials and techniques are many and varied, especially within the classification term, ORIGINAL ART. The following list is intended only to provide a few ideas as to the type of terminology that might be appropriate:

Beadwork
Caning
Cloisonné
Crewel
Crocheting
Embroidery
Engraving
Etching
Gilding
Glasswork
Knitting
Macramé
Needlepoint
Needlework
Quilting
Scissor Cutting
Tatting
Tie-dyeing
Tolework
Tooling
Weaving.

Terms such as these express the data categories Materials and Technique. They should not be added to the lexicon as valid object names.

Category 8: Recreational Artifacts

def Artifacts originally created to be used as toys or in carrying on the activities of sports, games, gambling, or public entertainment

2. Ref. (27), page 64, provides a good starting point for the creation of a controlled list of style names for art objects.

Recreational Artifacts are an easily definable major category of man-made artifacts. There are a few areas where identification of a particular artifact might involve some confusion between this major category and one of the other ten, but in most cases the biggest questions will be matters of word sequencing and whether or not the addition of a new object name is justified. There are many additional object names which can be added by the user within the classification terms RECREATIONAL DEVICE, SPORTS EQUIPMENT and TOY, largely for the same reasons as given below for GAME.

GAME

Within the classification term GAME there are many words given for the identification of game sets (CAROM SET, CHESS SET, PARCHESI SET, etc.). However, there are hundreds of different kinds of games that have been produced over the years, and these names are listed only as common examples of the way in which the game sets should appear. The names of other game sets should be added whenever necessary for the identification of a particular game that is not named in the lexicon. Likewise, there will be many instances within individual museums where a person will wish to identify and catalog not an entire game set but only certain parts of a game set—a CHECKERBOARD, for example, or some other part of a particular game. Part names, of course, are acceptable additions here just as they are anywhere else in the lexicon.

Games frequently need to be grouped so that, for example, all board games or all card games can be located without regard for the names of the games. The data category Style should be used to accomplish this grouping. Style names should be selected from a controlled vocabulary such as the following:

Ball
Board
Bowling
Card
Catapult
Educational
Flip
Magnetic
Marble

Ring (i.e., ring toss)
Spinning
Sporting (i.e., auto race, horse race)
Table
Target.

A few of the words in this list are the same words that appear as acceptable object names. However, in each case, when they are used as style names they imply something different from their meanings when used alone as object names. For example, a BALL may be a TOY, but there are also many ball-type games which are identified using other object names.

SPORTS EQUIPMENT

In many cases (though not always) the object names that best identify SPORTS EQUIPMENT include the name of the sport. With these items the name of the sport is always treated as the primary word, just as it is with the name of a GAME. Thus, many of the objects associated with a sport can be found together (e.g., BASEBALL and BASEBALL BAT; GOLF CART, GOLF CLUB, and GOLF GLOVE).

There are several kinds of objects, invented for the purpose of being transportation devices, which have been discovered to be adaptable for carrying on an exciting type of sport. The general rule is to treat such objects as Transportation Artifacts, since Category 6 is above Category 8 in the hierarchical structure of the major artifact categories. However, objects created originally as sporting devices (e.g., a BOBSLED, ALPINE SKIS) are classified as SPORTS EQUIPMENT even though they move a person from one location to another.

TOY

A TOY is an artifact originally created to be a plaything. Some toys were designed originally as unique objects which can be identified for cataloging purposes using the object names that are listed as subdivisions of the classification term TOY. Examples are KITE, CAP PISTOL, a KIDDIE CAR. However, there are also many items created to be playthings which are actually small-sized, child-level representations of persons, animals, or adult utilitarian artifacts. The identification of a representational TOY is the same as with any other representational object (see page 16). The user should identify a toy reproduction of a utilitarian object with the classification term TOY and the object name of the full-sized functional object. Representations of persons and animals should be identified, if appropriate, with the classification term TOY (there are some other possibilities—e.g., COMMERCIAL DECORATIVE ART and ORIGINAL ART) and one of the following object names: DOLL, MECHANICAL DOLL, MECHANICAL TOY, FIGURE or ANIMAL. With the latter two terms the additional word SET will also be appropriate at times. Likewise, a TOY representation of an event or scene will most often be recorded as a SET (e.g., CIRCUS SET, BATTLEFIELD SET).

With toys, the data category Style can be extremely important. For example, an artifact identified by the object name MECHANICAL DOLL or MECHANICAL TOY often will be further described by recording on the catalog record one or more of the following style names, which are based upon the method of activating the object:

Clockwork
Gravity
Manual
Musical
Phonograph
Pull
Spring-wound
Steam
Walking
Wind.

An artifact identified by the object name FIGURE may be further subdivided to record the characterization of the person (e.g., Soldier, Cowboy, Indian). Likewise an ANIMAL may be further described by recording the common name of the species represented (e.g., Dog, Horse, Lion, etc.). Alternatively, this characterization may be recorded in a separate data category.

Steps are being taken to standardize the terms that are used for the designation of DOLL styles. The United Federation of Doll Collectors has appointed a special Glossary Committee for this purpose. The report of this committee has not yet been published, but the following words will probably be defined as the recommended list of

words to use when describing a DOLL according
to the data category Style:

American Artist
Bald Head
Bathing Doll
 use Frozen Charlotte
Bebe
Belton
 use Bald Head
Bonnet
 use Hatted
Byelo Baby
Character Face
Clockwork
Coiffure
 use Milliner Model
Crèche
 use Religious
Dollhouse
Fortune Teller
French Fashion
Frozen Charlotte
Googly-Eye
Half Doll
Half Figure
Hatted
International
Kewpie
Milliner Model
Miniature
 use Dollhouse
Montangari
Multi-Face
Multi-Head
Musical
Novelty
Parian, Decorated
Parian, Undecorated
Pedlar
Peg Wooden
Pet Name
Phonograph
Portrait
Queen Anne
Regional
Religious
Spring-wound
Trousseau
 use Wardrobe Doll
Tuck Comb
Twirling

Walking
Wardrobe Doll.

Category 9: Societal Artifacts

def Artifacts originally created to be used in
carrying on government, fraternal, re-
ligious, or other organized and sanc-
tioned societal activities

Societal Artifacts are objects created to aid in
the functioning of an organized society. They are
objects which are used (1) as a means of main-
taining social control—i.e., for the purpose of
keeping individuals within the accepted bounds
of proper behavior; (2) as a part of any ritual or
ceremony; and (3) as a medium of exchange—to
facilitate commercial activities.

CEREMONIAL ARTIFACT

Any object created to be used in a societal
activity which is conducted in a consistent and
prescribed manner should be considered as a
CEREMONIAL ARTIFACT. Most religious ac-
tivities are ceremonial in nature, and objects
(other than Personal Artifacts, Category 3)
created to be used in carrying on a religious
ceremony are included within this classification
term. But the concept is broader than just reli-
gious artifacts. In addition, it is intended to in-
clude any object which is associated in any way
with a group ceremony, religious or not.

Many activities associated with the functioning
of government are ceremonial in nature. How-
ever, there are a few governmental artifacts
which will not fit within the definition of a CERE-
MONIAL ARTIFACT. The separate classification
term GOVERNMENTAL ARTIFACT has been in-
cluded to provide for these items.

Category 10: Packages and Containers

def Artifacts originally created to be used for
packing and shipping goods and com-
modities, and containers for which a pre-
cise function cannot be determined.

Packages and containers are objects originally created for the purpose of holding or containing some other object or product or substance. The concept *container* is straightforward and uncomplicated. But the identification of containers for cataloging purposes involves a number of interrelated and confusing problems. For example:

1. Sometimes containers are created to hold specific objects, products, or substances; sometimes they are designed to be more nearly general purpose.

2. Containers designed to hold specific products or substances often are thought of in terms of the product or substance, even though the container is usually all that is left to be identified and cataloged.

3. Containers for man-made objects are closely associated in use with the objects they were designed to hold. But containers for products or substances have no comparable point of reference for identification purposes.

Because of these problems, three types of containers are distinguished in the lexicon structure: (1) The special-purpose container created primarily to protect an object or to store a commodity prior to its use or consumption; (2) The special-purpose container created primarily as a means of packaging a known product in order to offer it for sale; and (3) The general-purpose container created to package an unknown product or to store something that cannot be determined by examining the container. A type (1) container may be further differentiated as: (1a) A special-purpose container which is identified with a distinctive objective name, or (1b) A special-purpose container which is identified, in part, by the object name of the artifact it was created to contain. Containers with distinctive names (i.e., type 1a) appear throughout the lexicon as subdivisions of appropriate classification terms. For example, SUITCASE and TOBACCO POUCH are object names within the classification term, PERSONAL GEAR, and a GATHERING BASKET is classified as AGRICULTURAL T&E. Special-purpose containers identified, in part, by the object name of the artifact they are created to contain, are considered as accessories, closely associated in use with other objects. Therefore, they are identified with the same classification

term and primary object name word as the object with which they are associated. The name of the container is appended as a secondary word. For example, a TROMBONE CASE, though not listed in the lexicon, would be added by the user in the same place as a TROMBONE under MUSICAL T&E, BRASS. In a similar manner, any CASE, BOX, BAG, CRATE, or other container name would be added as a secondary word and classified with the object the container is designed to hold.[3]

PRODUCT PACKAGE

PRODUCT PACKAGE is the classification term which should be used to identify an artifact that was originally created to be used as a container for the packaging of a known class of objects or commodities when they were offered for sale. The object name words included under PRODUCT PACKAGE are, in some cases, the same as the words used with the other three types of containers. However, before an object is classified as a PRODUCT PACKAGE, the commodity or substance which it originally contained should be identified. One of the object names included as a PRODUCT PACKAGE in the lexicon should be selected as a primary word and the commodity or substance name should be named as a suffix qualifier. Thus, a whiskey bottle and a tobacco tin would be identified with the classification term PRODUCT CONTAINER and the object names BOTTLE, WHISKEY and TIN, TOBACCO.

UNCLASSIFIED CONTAINER

UNCLASSIFIED CONTAINER is the classification term which should be used to identify any object which obviously was intended to be used as a container but which cannot be identified as a

3. The word sequence in a multiword object name for a container can be very confusing. Search the alphabetic listing on each word of a proposed new term in order to determine that the object name does not already exist in the lexicon in another form before adding it as a new term.

special-purpose container or a PRODUCT PACKAGE. For example, the original intended function of containers recovered from archaeological sites often cannot be determined. Also, some containers are created to be multipurpose, and it is sometimes impossible to tell the nature of the commodity or product which a PRODUCT PACKAGE originally contained. The object names included within the classification term UNCLASSIFIED CONTAINER are carefully defined and should be used as indicated. Specifically, do not use the words *basket* or *pot*, unqualified, as object names. With secondary words or suffix qualifiers, these words do appear in the lexicon as acceptable object names (e.g., GLUE POT, MUSTARD POT, and GATHERING BASKET). But when they are used alone they are expressions of techniques for the making of a BOWL or a TRAY; they are not object names. The danger of a classification term such as UNCLASSIFIED CONTAINER is that it will be used uncritically.

If containers are carefully considered in the light of the four paragraphs above, the user should not have too much difficulty in finding a precise combination of classification term/object name to use for the identification of a specific item. Other data categories—e.g., Style, Type, Materials, Techniques of Construction—are all important. However, there should be no problem in separating these from the object names provided in the lexicon.

Category 11: Unclassifiable Artifacts

def Artifacts originally created to serve a human purpose which cannot be identified at the time the object is cataloged

There are two kinds of situations in which it is not possible to identify the original function for which an artifact was created. These are provided for in the lexicon by the two classification terms in Category 11.

ARTIFACT REMNANT

A remnant of an object often can be identified as man-made (e.g., a pottery SHERD, a TEXTILE FRAGMENT) even though the artifact in hand is not complete enough to allow the cataloger to identify the original function of the complete item. Object names are provided in the lexicon for the terms to use in identifying an ARTIFACT REMNANT.

FUNCTION UNKNOWN

This is the classification term to use for the identification of a complete or whole object created originally for some human purpose that cannot be determined by the cataloger. These artifacts are sometimes fondly called problematicals; and the word PROBLEMATICAL is the only object name given in the lexicon as an acceptable subdivision of FUNCTION UNKNOWN.

Chapter 4
Major Artifact Categories and Classification Terms, without Definitions

Category 1: Structures
 BUILDING
 BUILDING FRAGMENT
 SITE FEATURE
 UNCLASSIFIED STRUCTURE

Category 2: Building Furnishings
 BEDDING
 FLOOR COVERING
 FURNITURE
 HOUSEHOLD ACCESSORY
 LIGHTING DEVICE
 PLUMBING FIXTURE
 TEMPERATURE CONTROL DEVICE
 WINDOW OR DOOR COVERING

Category 3: Personal Artifacts
 ADORNMENT
 CLOTHING
 CLOTHING, FOOTWEAR
 CLOTHING, HEADWEAR
 CLOTHING, OUTERWEAR
 CLOTHING, UNDERWEAR
 CLOTHING ACCESSORY
 PERSONAL GEAR
 PERSONAL SYMBOL
 TOILET ARTICLE

Category 4: Tools and Equipment
 ACOUSTICAL T&E
 AGRICULTURAL T&E
 ANIMAL HUSBANDRY T&E
 ARMAMENT T&E
 ARMAMENT T&E, FIREARM
 ARMAMENT T&E, EDGED
 ARMAMENT T&E, BLUDGEON
 ARMAMENT T&E, ARTILLERY

ARMAMENT T&E, AMMUNITION
ARMAMENT T&E, BODY ARMOR
ARMAMENT ACCESSORY
ASTRONOMICAL T&E
BIOLOGICAL T&E
CHEMICAL T&E
CONSTRUCTION T&E
DATA PROCESSING T&E
DRAFTING T&E
ELECTRICAL & MAGNETIC T&E
FISHING & TRAPPING T&E
FOOD PROCESSING T&E
FOOD SERVICE T&E
FORESTRY T&E
GLASS & PLASTICS T&E
HOUSEKEEPING T&E
LEATHERWORKING T&E
MASONRY T&E
MECHANICAL T&E
MEDICAL & PSYCHOLOGICAL T&E
MERCHANDISING T&E
METALWORKING T&E
METEOROLOGICAL T&E
MINING T&E
MUSICAL T&E
MUSICAL T&E, BRASS
MUSICAL T&E, PERCUSSION
MUSICAL T&E, STRINGED
MUSICAL T&E, WOODWIND
MUSICAL T&E, UNCLASSIFIED
NUCLEAR PHYSICS T&E
OPTICAL T&E
PAINTING T&E
PAPERMAKING T&E
PHOTOGRAPHIC T&E
POWER PRODUCTION T&E
PRINTING T&E
SURVEYING & NAVIGATIONAL T&E
TEXTILEWORKING T&E
THERMAL T&E
TIMEKEEPING T&E
WEIGHTS & MEASURES T&E
WOODWORKING T&E
UNCLASSIFIED T&E, GENERAL
UNCLASSIFIED T&E, SPECIAL

Category 5: Communication Artifacts
ADVERTISING MEDIUM
DOCUMENTARY ARTIFACT
SOUND COMMUNICATION EQUIPMENT
TELECOMMUNICATION EQUIPMENT
VISUAL COMMUNICATION EQUIPMENT
WRITTEN COMMUNICATION EQUIPMENT

Category 6: Transportation Artifacts
 AEROSPACE TRANSPORTATION
 AEROSPACE TRANSPORTATION EQUIPMENT
 AEROSPACE TRANSPORTATION ACCESSORY
 LAND TRANSPORTATION
 LTE, ANIMAL-POWERED
 LTE, HUMAN-POWERED
 LTE, MOTORIZED
 LAND TRANSPORTATION ACCESSORY
 RAIL TRANSPORTATION
 RAIL TRANSPORTATION EQUIPMENT
 RAIL TRANSPORTATION ACCESSORY
 WATER TRANSPORTATION
 WATER TRANSPORTATION EQUIPMENT
 WATER TRANSPORTATION ACCESSORY

Category 7: Art Objects
 COMMERCIAL DECORATIVE ART
 ORIGINAL ART

Category 8: Recreational Artifacts
 GAME
 PUBLIC ENTERTAINMENT DEVICE
 RECREATIONAL DEVICE
 SPORTS EQUIPMENT
 TOY

Category 9: Societal Artifacts
 BEHAVIORAL CONTROL DEVICE
 CEREMONIAL ARTIFACT
 EXCHANGE MEDIUM
 GOVERNMENTAL ARTIFACT

Category 10: Packages and Containers
 PRODUCT PACKAGE
 UNCLASSIFIED CONTAINER

Category 11: Unclassifiable Artifacts
 ARTIFACT REMNANT
 FUNCTION UNKNOWN

Chapter 5
Major Artifact Categories and Classification Terms, with Definitions

Category 1: Structures
Artifacts originally created to serve as shelter from the elements or to meet some other human need in a relatively permanent location

BUILDING
An artifact originally created to be a relatively permanent, usually enclosed, shelter from the elements; may include a fragile or portable shelter (e.g., a tent, a wigwam); see also UNCLASSIFIED STRUCTURE

BUILDING FRAGMENT
An artifact originally created to be a structural or decorative segment of a building (e.g., a fireplace, a wall section, a window frame)

SITE FEATURE
An artifact originally created to be a permanent feature of a building site though not a building itself and not physically attached to a building (e.g., a gate, a beehive oven, an underground storage cyst); see also UNCLASSIFIED STRUCTURE

UNCLASSIFIED STRUCTURE
An artifact originally created to be a relatively permanent structure serving some human need other than shelter and not associated with a building; see also BUILDING and SITE FEATURE

Category 2: Building Furnishings
Artifacts originally created to be used in or around buildings for the purpose of providing comfort, care and pleasure to the occupants

BEDDING
An artifact originally created to be used on a bed or in association with sleeping

FLOOR COVERING
 An artifact originally created to be a relatively portable
 covering for the floor of a building; includes rugs and
 carpeting but not permanently attached tile or linoleum
 (see BUILDING FRAGMENT, Category 1)

FURNITURE
 An artifact originally created to be a relatively
 permanent though movable furnishing for living quarters,
 an office or a public building; includes outdoor furniture
 but excludes functional appliances; see also other
 classification terms within Building Furnishings

HOUSEHOLD ACCESSORY
 An artifact originally created to be placed in or around a
 building for some relatively minor utilitarian purpose;
 includes small furnishings (e.g., a soap dish, a
 spittoon), special household containers (e.g., a vase, a
 wastebasket), furniture protection objects (e.g., an
 antimacassar, a table cover); does not include purely
 decorative artifacts (see Art Objects, Category 7) or
 devices used in a productive housekeeping activity (see
 Tools and Equipment, Category 4)

LIGHTING DEVICE
 An artifact originally created to provide illumination;
 includes lighting accessories (e.g., a candlesnuffer, a
 wick), general purpose portable lighting devices (e.g., a
 kerosine lantern) and specialized fixtures such as
 streetlamps and theater lighting devices

PLUMBING FIXTURE
 An artifact originally created to be attached,
 more-or-less permanently, to water and sewer lines,
 usually within a building; see HOUSEHOLD ACCESSORY for
 portable objects which serve comparable purposes

TEMPERATURE CONTROL DEVICE
 An artifact originally created to control the temperature
 within a building; does not include relatively permanent
 structural parts of a building (see BUILDING FRAGMENT,
 Category 1) or devices to control temperature for some
 purpose other than human comfort (e.g., FOOD PROCESSING
 T&E, Category 4)

WINDOW OR DOOR COVERING
 An artifact originally created to be a window or door
 covering; does not include relatively permanent structural
 parts of a building (see BUILDING FRAGMENT, Category 1)

Category 3: Personal Artifacts
 Artifacts originally created to serve the personal needs
 of individuals as clothing, adornment, body protection,
 grooming aids, or symbols of beliefs or achievements

ADORNMENT
> An artifact originally created to be worn on the human body or on clothing as decoration or ornamentation rather than as body covering; see also PERSONAL SYMBOL and PERSONAL GEAR

CLOTHING
> An artifact originally created to be used as covering for the human body; includes underwear, outerwear, headwear, footwear and also accessories (e.g., a belt, a cuff link); see also PERSONAL SYMBOL

PERSONAL GEAR
> An artifact originally created to be used by an individual as a carrying device (e.g., a wallet, a knapsack), a protective apparatus (e.g., an umbrella, goggles), a personal or physical aid (e.g., a cane, eyeglasses), or as personal smoking equipment (e.g., a pipe)

PERSONAL SYMBOL
> An artifact originally created to be a symbol of a personal belief, achievement, status or membership; includes articles of adornment or clothing worn primarily for their symbolism (e.g., a fraternal ring, a military gorget, an academic gown, a crown); see also DOCUMENTARY ARTIFACT (Category 5) and CEREMONIAL ARTIFACT (Category 9)

TOILET ARTICLE
> An artifact originally created to be used for human body care and grooming

Category 4: Tools and Equipment
> Artifacts originally created to be used in carrying on an activity such as an art, craft, trade, profession or hobby; the tools, implements and equipment used in the process of modifying available resources for some human purpose

ACOUSTICAL T&E
> An artifact originally created to be used in the study of sound and its effect upon hearing; see also SOUND COMMUNICATION EQUIPMENT (Category 5) and MEDICAL & PSYCHOLOGICAL T&E

AGRICULTURAL T&E
> An artifact originally created to be used in farming or gardening; includes implements used in planting, harvesting and storing crops and in processing food for animals but not for humans (see FOOD PROCESSING T&E); does not include equipment used in caring for animals (see ANIMAL HUSBANDRY T&E) or in working with forest products (see FORESTRY T&E) or in fabricating textiles (see TEXTILEWORKING T&E)

ANIMAL HUSBANDRY T&E
An artifact originally created to be used in the care, breeding and study of animals; includes instruments used in the practice of veterinary medicine, tools used in the psychological study of animals, and tools used by a farrier to work on animals; does not include equipment used in processing animal products for human use (see FOOD PROCESSING T&E) or tools used by a farrier to fabricate metal products (see METALWORKING T&E)

ARMAMENT T&E
An artifact originally created to be used for hunting, target shooting, warfare or self-protection; includes firearms, artillery, bladed and striking weapons; does not include objects designed for transporting troops or supplies (see Transportation Artifacts, Category 6)

ASTRONOMICAL T&E
An artifact originally created to be used in the observation, measurement and recording of objects and events outside of the earth's atmosphere; see also OPTICAL T&E and SURVEYING & NAVIGATIONAL T&E

BIOLOGICAL T&E
An artifact originally created to be used in the observation, measurement and recording of the physiological or anatomical aspects of organisms for purposes other than diagnosis or treatment; see also MEDICAL & PSYCHOLOGICAL T&E and ANIMAL HUSBANDRY T&E

CHEMICAL T&E
An artifact originally created to be used in the study and/or manufacture of substances based upon their compositon, structure and molecular properties; see also MECHANICAL T&E and NUCLEAR PHYSICS T&E

CONSTRUCTION T&E
An artifact originally created to be used in the construction, repair, maintenance or demolition of buildings, highways and other structural facilities; see also other T&E classifications for specialized tools used in construction trades

DATA PROCESSING T&E
An artifact originally created to be used for processing data by manual, mechanical or electronic means; includes numerical and word-processing devices (e.g., an abacus, a digital computer), process-control devices (e.g., an analog computer) and learning devices (e.g., a teaching machine); see also Communication Artifacts (Category 5) and DRAFTING T&E

DRAFTING T&E
An artifact originally created to be used for precision drawing (e.g., a T-square, a drafting table); includes instruments used to record surveying and navigational

observations; does not include general-purpose writing or lettering tools (see WRITTEN COMMUNICATION EQUIPMENT in Category 5, and PAINTING T&E); see also DATA PROCESSING T&E

ELECTRICAL & MAGNETIC T&E
An artifact originally created to be used in the observation, measurement and recording of electrical and magnetic phenomena; includes tools, equipment and components used in the manufacture, installation and repair of electrical and electronic devices (e.g., an electrician's pliers, an oscilloscope); does not include electrical or electronic devices created to serve other specific purposes (e.g., sound communication, telecommunication or data processing); see also POWER PRODUCTION T&E

FISHING & TRAPPING T&E
An artifact originally created to be used in the taking of fish, land animals, birds or reptiles by any means other than weaponry (see ARMAMENT T&E); see also WATER TRANSPORTATION EQUIPMENT (Category 6)

FOOD PROCESSING T&E
An artifact originally created to be used in the processing, storage or preparation of food or beverages for human consumption; includes hand tools (e.g., a spider, a coffee mill), appliances (e.g., an icebox, a cook stove), and equipment used to process natural or synthetic substances (e.g., a bottle capper, a milk pasteurizer); see also AGRICULTURAL T&E, ANIMAL HUSBANDRY T&E and FOOD SERVICE T&E

FOOD SERVICE T&E
An artifact originally created to be used in the service or consumption of food or beverages by humans; see also FOOD PROCESSING T&E

FORESTRY T&E
An artifact originally created to be used in cutting, handling or processing timber in its rough form or in harvesting forest crops such as bark, saps, gums, resins, rubber; does not include equipment for cartage (see Transportation Artifacts, Category 6) or for manufacturing products from wood (see WOODWORKING T&E and PAPERMAKING T&E); see also AGRICULTURAL T&E

GLASS & PLASTICS T&E
An artifact originally created to be used in the process of fabricating objects from glass, clay, rubber, synthetic resins, plastics or wax; see also MASONRY T&E

HOUSEKEEPING T&E
An artifact originally created to be used as an implement or appliance in a cleaning or laundering activity, whether carried on in a home, in a public building or as a commercial enterprise

LEATHERWORKING T&E
 An artifact originally created to be used in the
 processing of furs or hides or the fabricating of leather
 products (e.g., a fleshing knife, a last)

MASONRY T&E
 An artifact originally created to be used in working with
 stone, concrete, mortar or plaster or in the forming of
 objects to be later used in masonry construction (e.g., in
 the making of brick, tile or concrete block); see also
 GLASS & PLASTICS T&E

MECHANICAL T&E
 An artifact originally created to be used in the study,
 measurement or utilization of the static and dynamic
 properties of solids, liquids and gases; includes
 general-purpose mechanical devices (e.g., a wedge, a
 hoist) as well as devices used to measure mechanical
 properties (e.g., a tensiometer, a pressure gauge); does
 not include specialized artifacts created to serve other
 specific purposes (e.g., a sledge); see also CHEMICAL T&E

MEDICAL & PSYCHOLOGICAL T&E
 An artifact originally created to be used in the
 examination, testing, diagnosis and treatment of humans;
 includes dental tools, objects used in the testing of
 sight and hearing, and objects used for psychological
 testing or treatment; does not include objects used in the
 general study of physical phenomena (see OPTICAL T&E,
 ACOUSTICAL T&E, BIOLOGICAL T&E and CHEMICAL T&E) or the
 tools of veterinary medicine (see ANIMAL HUSBANDRY T&E)

MERCHANDISING T&E
 An artifact originally created to be used in the selling
 of goods or services; does not include objects used for
 advertising purposes (see ADVERTISING MEDIUM, Category 5)

METALWORKING T&E
 An artifact originally created to be used for casting,
 forging, machining or fabricating metals or metal products
 (e.g., a planishing hammer, a swage block, a cold chisel);
 see also MINING T&E

METEOROLOGICAL T&E
 An artifact originally created to be used in the
 observation, measurement and recording of atmospheric
 phenomena

MINING T&E
 An artifact originally created to be used in extracting
 minerals and other solids, liquids or gases from the
 natural environment; includes equipment used in
 underground and surface mines, quarries, oil and water
 wells, as well as in prospecting and in supplemental
 processing operations such as breaking, milling, washing,

cleaning or grading; see also Transportation Artifacts
(Category 6), CONSTRUCTION T&E, MECHANICAL T&E and
METALWORKING T&E

MUSICAL T&E
 An artifact originally created to be used in the
 production of music (e.g., a French horn, a snare drum, a
 zither); does not include objects used to reproduce sound
 (see SOUND COMMUNICATION EQUIPMENT, Category 5)

NUCLEAR PHYSICS T&E
 An artifact originally created to be used in the study of
 nuclear structure and elementary particles; see also
 CHEMICAL T&E and POWER PRODUCTION T&E

OPTICAL T&E
 An artifact originally created to be used in the
 observation, measurement and recording of light; includes
 general-purpose optical equipment (e.g., binoculars, a
 microscope); does not include specialized artifacts
 created to serve other specific purposes (e.g., a visual
 acuity chart, an astronomer's telescope); see also VISUAL
 COMMUNICATION EQUIPMENT (Category 5) and MEDICAL &
 PSYCHOLOGICAL T&E

PAINTING T&E
 An artifact originally created to be used in painting,
 either as an art form or for decorative purposes; includes
 the tools of related arts and crafts such as drawing,
 lettering, gilding and paperhanging; see also WRITTEN
 COMMUNICATIONS EQUIPMENT (Category 5), DRAFTING T&E and
 PRINTING T&E

PAPERMAKING T&E
 An artifact originally created to be used in the
 manufacturing of paper or the fabrication of paper
 products

PHOTOGRAPHIC T&E
 An artifact originally created to capture permanently a
 visual image by optical and chemical means (e.g., a
 camera, a film-processing tank, an enlarger); see also
 VISUAL COMMUNICATION EQUIPMENT (Category 5)

POWER PRODUCTION T&E
 An artifact originally created to generate, convert or
 distribute power

PRINTING T&E
 An artifact originally created to imprint or reproduce
 written, photographic or artistic material; includes
 specialized tools used for bookbinding, engraving,
 etching, lithography, intaglio, silk-screening, etc.
 (e.g., a handpress, an engraver's block, a photocopier);
 see also WRITTEN COMMUNICATION EQUIPMENT (Category 5),
 PAINTING T&E and PAPERMAKING T&E

SURVEYING & NAVIGATIONAL T&E
An artifact originally created to be used in determining either the position of the observer relative to known reference points or the form and extent of a region (i.e., surface land, subsurface land, water or air); includes instruments for taking both linear and angular measurements; does not include devices for making calculations (see DATA PROCESSING T&E) or for recording data (see DRAFTING T&E); see also ASTRONOMICAL T&E

TEXTILEWORKING T&E
An artifact originally created to be used in the making of thread, yarn or cordage, or in the creation of objects from natural fibers or from cloth; includes basketmaking tools, sailmaking tools, weaving tools, needleworking implements, etc.; see also AGRICULTURAL T&E

THERMAL T&E
An artifact originally created to be used in the observation, measurement and recording of heat and its effects; does not include specialized artifacts created to serve specific purposes (e.g., a meteorological thermometer)

TIMEKEEPING T&E
An artifact originally created to be used in the observation, recording and measurement of time; does not include specialized artifacts created to serve other specific purposes (e.g., a chronometer)

WEIGHTS & MEASURES T&E
An artifact originally created to be used in the observation, recording and measurement of mass (weight) or physical dimensions such as length, area and volume; includes general-purpose measuring devices (e.g., a precision balance, a folding rule); does not include specialized artifacts created to measure time (see TIMEKEEPING T&E) or other physical attributes (see ACOUSTICAL T&E, BIOLOGICAL T&E, CHEMICAL T&E, MECHANICAL T&E and OPTICAL T&E) or to serve other specific purposes (e.g., a sextant)

WOODWORKING T&E
An artifact originally created to be used in the process of fabricating objects out of wood (e.g., a saw, an ax, a chisel)

UNCLASSIFIED T&E, GENERAL
An artifact originally created to be used in a variety of activities or in working with diverse materials (e.g., a screwdriver, pliers)

UNCLASSIFIED T&E, SPECIAL
An artifact originally created to be used in such a specialized activity or with such a unique material that it cannot be accommodated within any other T&E classification (e.g., a snow knocker, a fence jack)

Category 5: Communication Artifacts
Artifacts originally created for the purpose of
facilitating human communication

ADVERTISING MEDIUM
An artifact originally created to call the attention of
the public to a product, service, or event; see also
MERCHANDISING T&E (Category 4) and DOCUMENTARY ARTIFACT

DOCUMENTARY ARTIFACT
An artifact originally created to be a vehicle for
conveying printed, written or pictorial information for
some purpose other than advertising (see ADVERTISING
MEDIUM); includes documents and also artifacts displaying
commemorative information on materials other than paper
(e.g., a commemorative coin, a souvenir plate); see also
Art Objects (Category 7)

SOUND COMMUNICATION EQUIPMENT
An artifact originally created to amplify or store music,
spoken words or other sounds that are meaningful for human
communication; see also ACOUSTICAL T&E, ELECTRICAL &
MAGNETIC T&E and MUSICAL T&E (Category 4) and
TELECOMMUNICATION EQUIPMENT

TELECOMMUNICATION EQUIPMENT
An artifact originally created to facilitate communicating
at a distance, usually by means of electronic equipment;
includes telephone, telegraph, radio and television
equipment; see also DATA PROCESSING T&E and ELECTRICAL &
MAGNETIC T&E (Category 4)

VISUAL COMMUNICATION EQUIPMENT
An artifact originally created to be used as a visual sign
or signaling device, or as a means of viewing photographic
or other visual images; see also OPTICAL T&E and
PHOTOGRAPHIC T&E (Category 4) and ADVERTISING MEDIUM

WRITTEN COMMUNICATION EQUIPMENT
An artifact originally created to facilitate communication
between people by means of written documents; see also
DRAFTING T&E, PAINTING T&E and PRINTING T&E (Category 4),
and DOCUMENTARY ARTIFACT

Category 6: Transportation Artifacts
Artifacts originally created as vehicles for the
transporting of passengers or freight

AEROSPACE TRANSPORTATION
An artifact originally created to transport people or
goods above the surface of the earth

LAND TRANSPORTATION
An artifact originally created to transport people or
goods on the surface of land (not on rails)

RAIL TRANSPORTATION
> An artifact originally created to transport people or
> goods on or along a fixed track

WATER TRANSPORTATION
> An artifact originally created to transport people or
> goods on water

Category 7: Art Objects
> Artifacts originally created for aesthetic purposes or as
> a demonstration of creative skill and dexterity; the
> essential ingredient is that the artifact was created for
> no apparent utilitarian purpose

COMMERCIAL DECORATIVE ART
> An artifact originally created in commercial quantities to
> serve primarily as non-utilitarian household decoration;
> see also HOUSEHOLD ACCESSORY (Category 2)

ORIGINAL ART
> An artifact originally created as one of a kind, or as one
> of a limited series, to provide aesthetic pleasure or as a
> demonstration of creative skill and dexterity

Category 8: Recreational Artifacts
> Artifacts originally created to be used as toys or in
> carrying on the activities of sports, games, gambling or
> public entertainment

GAME
> An artifact originally created to be used in a competitive
> activity based upon chance, problem-solving and
> calculation as opposed to physical effort, and conducted
> according to rules; includes all forms of gambling
> devices; see also SPORTS EQUIPMENT and TOY

PUBLIC ENTERTAINMENT DEVICE
> An artifact originally created to be used in the
> production of non-competitive spectator entertainment; see
> also SPORTS EQUIPMENT

RECREATIONAL DEVICE
> An artifact originally created to be used in a
> participatory, usually non-competitive, recreational
> activity other than an athletic game or exercise; includes
> equipment for which a use charge is normally made (e.g., a
> carousel, a pinball machine) as well as the free
> facilities of a public park (e.g., a swing, a slide); also
> includes the same types of equipment when privately owned;
> see also SPORTS EQUIPMENT

SPORTS EQUIPMENT
> An artifact originally created to be used in a physical
> activity that is often competitive; includes equipment

used in all forms of athletic games and exercises, whether the participant is a professional or an amateur and the activity is an individual or a team sport; see also GAME, TOY and RECREATIONAL DEVICE

TOY
>An artifact originally created to be a plaything; may be representational (i.e., a small-sized reproduction of a functional object, a person or a creature) or non-representational (e.g., a ball, a top, a kite); a toy is created primarily to be played with, a craft object is primarily for display (see ORIGINAL ART, Category 7); see also GAME, SPORTS EQUIPMENT and RECREATIONAL DEVICE

Category 9: Societal Artifacts
>Artifacts originally created to be used in carrying on governmental, fraternal, religious or other organized and sanctioned societal activities

BEHAVIORAL CONTROL DEVICE
>An artifact originally created to be used in controlling the behavior of people who are judged in violation of the rules of society

CEREMONIAL ARTIFACT
>An artifact originally created to be used in a ritual that is conducted in a consistent and usually prescribed manner; includes: (1) any religious artifact, other than a personal devotional object (see PERSONAL SYMBOL, Category 3), (2) any object used in a ceremony concerned with either personal life crises (e.g., birth, puberty, sickness, death) or group crises (e.g., the need for rain, a harvest festival), or (3) any object used in the ceremonial activities of a fraternity, lodge, club, governmental or military organization (e.g., the pennon of a Girl Scout troop); see also GOVERNMENTAL ARTIFACT

EXCHANGE MEDIUM
>An artifact originally created to be used as a medium of exchange (e.g., a coin, currency, shell money) or as an instrument for obtaining specially-defined services (e.g., a postage stamp, a transportation token)

GOVERNMENTAL ARTIFACT
>An artifact originally created to be used in carrying on the non-ceremonial activities of a governmental organization; see also DOCUMENTARY ARTIFACT (Category 5) and CEREMONIAL ARTIFACT

Category 10: Packages and Containers
>Artifacts originally created to be used for packing and shipping goods and commodities, and containers for which a precise function cannot be determined

PRODUCT PACKAGE
An artifact originally created to be a container for a
known product usually when it is offered for sale

UNCLASSIFIED CONTAINER
An artifact originally created to be a container for items
which cannot be identified from an examination of the
container

Category 11: Unclassifiable Artifacts
Artifacts originally created to serve a human purpose
which cannot be identified at the time the object is
cataloged

ARTIFACT REMNANT
A segment or incomplete part of an artifact originally
created to fulfill some human function which cannot be
determined or even inferred from the fragment

FUNCTION UNKNOWN
An artifact originally created to be used for some
unidentified human activity

Chapter 6
Hierarchical Listing of Major Artifact Categories, Classification Terms, and Object Names

<u>Category 1: Structures</u>
Artifacts originally created to serve as shelter from the
elements or to meet some other human need in a relatively
permanent location

BUILDING
 <u>def</u> An artifact originally created to be a relatively
 permanent, usually enclosed, shelter from the elements;
 may include a fragile or portable shelter (e.g., a tent, a
 wigwam); see also UNCLASSIFIED STRUCTURE
 <u>ref</u> (19) (46) (88) (117) (131)

 AIRPORT
 <u>note</u> use for the complex of a landing field and
 associated buildings: e.g., HANGAR; TERMINAL;
 TOWER, CONTROL
 APARTMENT
 <u>rt</u> PUEBLO
 AQUARIUM
 ARMORY
 BAND SHELL
 BARN
 <u>note</u> may be further subdivided to indicate specific
 type: e.g., BARN, TOBACCO; -,HOPCURING
 Belvedere
 <u>use</u> GAZEBO
 BLOCKHOUSE
 Building, Ceremonial
 <u>use</u> more specific term: e.g., CHURCH,
 MEETINGHOUSE, TEMPLE
 Building, Civic
 <u>use</u> more specific term: e.g., FIREHOUSE, POLICE
 STATION, JAIL, COURTHOUSE, POST OFFICE, TOWN
 HALL
 Building, Commercial
 <u>use</u> more specific term (e.g., HOTEL, INN,
 RESTAURANT) or the word SHOP or STORE followed
 by the product or service sold (e.g., SHOP,
 BARBER; -,MILLINERY; -,BLACKSMITH; STORE,
 DRUG; -,GROCERY; -,FURNITURE)

BUILDING (cont.)

Building, Cultural
 use more specific term: e.g., MUSEUM, THEATER
Building, Defense
 use more specific term: e.g., ARMORY, BLOCKHOUSE,
 FORT
Building, Educational
 use more specific term: e.g., SCHOOL, LIBRARY,
 MUSEUM
Building, Farm
 use more specific term (e.g., HOUSE; BARN; COOP,
 CHICKEN; CORNCRIB; SILO) or, for a group of
 related farm buildings, FARMSTEAD
Building, Health
 use more specific term: e.g., HOSPITAL
Building, Industrial
 use PLANT, INDUSTRIAL
BUILDING, OFFICE
BUILDING, RECREATIONAL
Building, Residential
 use HOUSE or another more specific term: e.g.,
 HOGAN, WICKIUP
BUILDING, STORAGE
Building, Transportation
 use more specific term: e.g., AIRPORT, DEPOT,
 TERMINAL
Cabin
 use HOUSE
CASTLE
Chalet
 use HOUSE
CHURCH
COOP, CHICKEN
CORNCRIB
Cottage
 use HOUSE
COURTHOUSE
Crib, Corn
 use CORNCRIB
CRIB, TOOL
DEPOT
 rt TERMINAL
DUPLEX
Factory
 use PLANT, INDUSTRIAL
FARMSTEAD
 note use for the buildings and adjacent service
 areas of a farm; broadly, a farm with its
 buildings
FIREHOUSE
FORT
GARAGE
GATEHOUSE

BUILDING (cont.)

GAZEBO
GREENHOUSE
HOGAN
HOSPITAL
HOTEL
HOUSE
HOUSE, CHARNEL
 rt MAUSOLEUM
HOUSE, FRUIT-DRYING
HOUSE, HOG
HOUSE, POWDER
HOUSE, TOLL
ICEHOUSE
INN
JAIL
KENNEL
KIVA
LEAN-TO
LIBRARY
LIGHTHOUSE
LODGE
MAUSOLEUM
 rt HOUSE, CHARNEL
MEETINGHOUSE
MILL
MONUMENT
 rt SHRINE
MUSEUM
OUTHOUSE
PADDOCK
Pagoda
 use TEMPLE
PAVILLION
PERGOLA
PLANETARIUM
PLANT, INDUSTRIAL
POLICE STATION
POST OFFICE
Privy
 use OUTHOUSE
PUEBLO
 rt APARTMENT
PUMPHOUSE
RESTAURANT
ROUNDHOUSE
SALOON
SCHOOL
SHAFTHOUSE
SHED
 note may be further subdivided to indicate specific
 type: e.g., SHED, CATTLE; -,SHEEP

BUILDING (cont.)

```
SHOP
     note normally subdivided according to product or
          service sold: e.g., SHOP, BAKERY; -,SHOE
SHRINE
     rt   MONUMENT
SILO
SMOKEHOUSE
SNOWSHED
SPRINGHOUSE
STABLE
STABLE, LIVERY
STORE
     note normally subdivided according to product or
          service sold: e.g., STORE, DEPARTMENT;
          -,HARDWARE; -,GROCERY
Store, Retail
     use  more specific term: e.g., STORE, GROCERY
SYNAGOGUE
TAVERN
TEMPLE
TENT
TEPEE
TERMINAL
     rt   DEPOT
THEATER
TOWER, CONTROL
TOWN HALL
Warehouse
     use  BUILDING, STORAGE
WICKIUP
WIGWAM
WOODSHED
```

BUILDING FRAGMENT
 def An artifact originally created to be a structural or
 decorative segment of a building (e.g., a fireplace, a
 wall section, a window frame)
 ref (19) (88) (117)

```
     ANTEFIX
     ARCADE
     BALCONY
     BALUSTER
     BALUSTRADE SECTION
          rt   HANDRAIL SECTION
     Banister
          use  BALUSTRADE SECTION or BALUSTER
     BAR
     BARGEBOARD SECTION
     BAR RAIL
```

BUILDING FRAGMENT (cont.)

 BASEBOARD SECTION
 Belfry
 use TOWER, BELL
 BOARD
 BRACKET
 BUILDING FACADE
 BULKHEAD
 BUTTRESS
 CABINET, MEDICINE
 CEILING SECTION
 CHIMES, DOOR
 Chimney
 use more specific term: e.g., CHIMNEY POT, FLUE,
 FIREPLACE
 Chimneypiece
 use OVERMANTEL
 CHIMNEY POT
 COLUMN
 COLUMN BASE
 COLUMN CAPITOL
 COLUMN SHAFT
 CORNICE SECTION
 CUPOLA
 DOOR
 DOOR, ACCORDION
 DOOR, SCREEN
 DOORBELL
 DOOR CAP
 DOORCASE
 DOOR ENFRAMEMENT
 note use for entire structure: i.e., DOORCASE and
 DOORFRAME plus, possibly, other parts such as
 the DOOR, FANLIGHT, SIDELIGHT, etc.
 DOORFRAME
 DOORKNOB
 DOOR PANEL
 DORMER
 DUMBWAITER
 ELEVATOR
 ENTABLATURE
 FANLIGHT
 rt WINDOW SASH
 FINIAL
 FIRE ESCAPE
 FIREPLACE
 note use only for entire structure: i.e., brickwork
 and FIREPLACE FACADE or MANTEL; see also
 TEMPERATURE CONTROL DEVICE (Category 2)
 FIREPLACE FACADE
 note use for composite interior face consisting of
 the MANTEL, the interior decoration below the
 MANTEL, and OVERMANTEL if present

BUILDING FRAGMENT (cont.)

 FIREPOLE
 FLUE
 GALLERY
 GARGOYLE
 GRILL
 GRILL, VENTILATOR
 GRILL, WINDOW
 HANDRAIL SECTION
 rt BALUSTRADE SECTION
 HASP
 HINGE
 KNOCKER
 LACTORIUM
 LATCH
 LIGHTNING ROD
 LINOLEUM SECTION
 LINTEL
 LOCK, DOOR
 LOCK, WINDOW
 MAIL SLOT
 MANTEL
 Mantelshelf
 use MANTEL
 MILKING PARLOR
 MOLDING SECTION
 NEWEL
 ORNAMENT, CEILING
 OVERMANTEL
 PANELING SECTION
 PILASTER
 PILLAR
 PIPE
 PORCH
 PORTICO
 PULPIT
 RADIATOR CASE
 RAMPART SECTION
 ROOF SECTION
 SCREEN, WINDOW
 Screen door
 use DOOR, SCREEN
 SCUTCHEON
 SEAT, WINDOW
 SHINGLE
 SIDELIGHT
 rt WINDOW SASH
 SILL
 SKYLIGHT
 rt WINDOW SASH
 Smokestack
 use FLUE

BUILDING FRAGMENT (cont.)

 SPIRE
 STAGE
 Stained glass window
 use WINDOWPANE, LEADED
 STAIRCASE
 STALL, CATTLE
 STANCHION
 STOOP
 TILE
 TOWER
 TOWER, BELL
 TURRET
 VENTILATOR
 VERANDA
 WALLPAPER FRAGMENT
 WALL SECTION
 WINDOW
 note use for the composite structure: i.e., WINDOW
 FRAME, WINDOW SASH, WINDOW CAP, etc.
 WINDOW CAP
 WINDOW FRAME
 WINDOWPANE
 WINDOWPANE, LEADED
 WINDOW SASH
 rt FANLIGHT; SIDELIGHT; SKYLIGHT
 Window seat
 use SEAT, WINDOW
 WINDOW SILL

SITE FEATURE
 def An artifact originally created to be a permanent feature
 of a building site though not a building itself and not
 physically attached to a building (e.g., a gate, a beehive
 oven, an underground storage cyst); see also UNCLASSIFIED
 STRUCTURE

 BARBWIRE SECTION
 rt FENCE SECTION
 BIRDBATH
 BIRD FEEDER
 BIRDHOUSE
 BOMB SHELTER
 CELLAR, ROOT
 CISTERN
 CYST, STORAGE
 DOGHOUSE
 Feeder, Bird
 use BIRD FEEDER
 FENCE SECTION
 rt BARBWIRE SECTION

SITE FEATURE (cont.)

 FIREPIT
 FLAGPOLE
 GATE
 GATEWAY
 METATE, BASIN
 OVEN, BEEHIVE
 POST, FENCE
 POST, HITCHING
 TRELLIS

UNCLASSIFIED STRUCTURE
 def An artifact originally created to be a relatively
 permanent structure serving some human need other than
 shelter and not associated with a building; see also
 BUILDING and SITE FEATURE

 AMPHITHEATER
 AQUEDUCT
 ARCH
 AVIARY
 BILLBOARD
 Bleacher
 use GRANDSTAND
 BOOTH, TELEPHONE
 BRIDGE
 rt TRESTLE
 BRIDGE, COVERED
 CAGE, ANIMAL
 DAM
 DOCK
 EARTHWORK
 Fireplug
 use HYDRANT
 FLOODGATE
 FLUME
 rt SLUICE; PENSTOCK
 GRANDSTAND
 GUARDRAIL SECTION
 HYDRANT
 LOCK
 MANHOLE COVER
 MINE
 MOUND
 PALISADE
 PAVEMENT SECTION
 PIER
 POOL, SWIMMING
 QUARRY
 Race
 use FLUME

UNCLASSIFIED STRUCTURE (cont.)

RESERVOIR
SLUICE
 rt FLUME
SPILLWAY
STADIUM
TAILRACE
TOWER
 note may be further subdivided to indicate specific
 type: e.g., TOWER, TRANSMITTING; -,WATER;
 -,OBSERVATION
TRESTLE
 rt BRIDGE
UTILITY POLE
WHARF

Category 2: Building Furnishings

Artifacts originally created to be used in or around
buildings for the purpose of providing comfort, care and
pleasure to the occupants

BEDDING

> def An artifact originally created to be used on a bed or in
> association with sleeping

 BAG, SLEEPING
 BEDSPREAD
 BLANKET
 CANOPY
 COMFORTER
 Coverlet
 use BEDSPREAD
 DUST RUFFLE
 GROUND CLOTH
 HAMMOCK
 HEADREST
 MAT, SLEEPING
 MATTRESS COVER
 NET, MOSQUITO
 PILLOW
 PILLOW, THROW
 PILLOWCASE
 PILLOW SHAM
 QUILT
 SHEET

FLOOR COVERING

> def An artifact originally created to be a relatively portable
> covering for the floor of a building; includes rugs and
> carpeting but not permanently attached tile or linoleum
> (see BUILDING FRAGMENT, Category 1)

 CARPET SECTION
 DOORMAT
 MAT
 MAT, BATH
 RUG
 RUG, LINOLEUM
 Rug, Scatter
 use RUG, THROW
 RUG, THROW
 RUNNER
 STAIR ROD
 STAIR TREAD

FURNITURE

> def An artifact originally created to be a relatively
> permanent though movable furnishing for living quarters,

an office or a public building; includes outdoor furniture
but excludes functional appliances; see also other
classification terms within Building Furnishings

ref (35) (36) (37)

Armchair
 use more specific term: e.g., CHAIR, EASY; -,DINING
Armoire
 use WARDROBE
BACKREST
BARSTOOL
Basket stand
 use TABLE, KNITTING
BASSINET
BED
BED, BUNK
BED, CANOPY
BED, FIELD
BED, FOLDING
BED, FOUR-POSTER
BED, HALF-TESTER
Bed, Murphy
 use BED, FOLDING
Bed, Plantation
 use BED, CANOPY
BED, SLEIGH
BED, SOFA
 note use for a sofa, lounge or similar item which
 folds out to become a bed
BED, TRUNDLE
BED, WATER
BEDROOM SUITE
BEDSPRINGS
BENCH
BENCH, BUCKET
BENCH, CIRCULAR
BENCH, GARDEN
Bench, Hooded
 use SETTLE
Bench, Mammy
 use CRADLE/ROCKER
BENCH, PARK
BENCH, PICNIC
BENCH, WINDOW
BOOKCASE
Box springs
 use BEDSPRINGS
Breakfront
 use more specific term: e.g., BOOKCASE; CABINET,
 CHINA
Buffet
 use SIDEBOARD

FURNITURE (cont.)

Bureau
 use CHEST OF DRAWERS
CABINET
 rt CUPBOARD
CABINET, CHINA
CABINET, CORNER
Cabinet, Curio
 use CABINET, VITRINE
CABINET, FILING
CABINET, GUN
CABINET, MEDICINE
CABINET, PHONOGRAPH
CABINET, RADIO
CABINET, VITRINE
CANDLESTAND
CANTERBURY
 rt RACK, MAGAZINE
CART, TEA
 rt TABLE, TEA
CELLARETTE
CHAIR
 note use only if specific type is unknown
CHAIR, ALTAR
Chair, Arm
 use more specific term: e.g., CHAIR, EASY; -,DINING
CHAIR, BALLROOM
CHAIR, BARBER'S
Chair, Bent-wire
 use CHAIR, SODA FOUNTAIN
CHAIR, CHILD'S
 note may be further subdivided to indicate specific
 type: e.g., CHAIR, CHILD'S ROCKING
CHAIR, CORNER
Chair, Deck
 use CHAIR, FOLDING
CHAIR, DENTIST'S
CHAIR, DESK
CHAIR, DINING
CHAIR, EASY
CHAIR, FIREPLACE
CHAIR, FOLDING
CHAIR, GARDEN
Chair, Gondola
 use CHAIR, DINING
CHAIR, HALL
Chair, High
 use HIGHCHAIR
CHAIR, INVALID
Chair, Morris
 use CHAIR, RECLINING
CHAIR, MUSIC

FURNITURE (cont.)

CHAIR, OCCASIONAL
 <u>note</u> use for any chair that is not part of a set
 and cannot be named by any other term in this
 list
CHAIR, PLATFORM ROCKING
CHAIR, PORTER'S
CHAIR, RECLINING
CHAIR, ROCKING
Chair, Side
 <u>use</u> more specific term: e.g., CHAIR, HALL;
 -,DINING; -,OCCASIONAL
CHAIR, SLIPPER
CHAIR, SODA FOUNTAIN
Chair, Spa
 <u>use</u> CHAIR, TOURING
CHAIR, STENOGRAPHER'S
CHAIR, STEP
Chair, Swivel
 <u>use</u> more specific term: e.g., CHAIR, STENOGRAPHER'S
CHAIR, TABLET-ARM
CHAIR, TOURING
CHAIR, WING
CHAIR/TABLE
Chaise lounge
 <u>use</u> LOUNGE
CHEST, BLANKET
CHEST, CAMPAIGN
Chest, High
 <u>use</u> CHEST OF DRAWERS
Chest, Hope
 <u>use</u> CHEST, BLANKET
CHEST OF DRAWERS
 <u>rt</u> CHIFFOROBE; DRESSING CASE; CHEST ON FRAME
Chest on chest
 <u>use</u> CHEST OF DRAWERS
CHEST ON FRAME
 <u>rt</u> CHEST OF DRAWERS
Chiffonier
 <u>use</u> CHEST OF DRAWERS
CHIFFOROBE
 <u>rt</u> CHEST OF DRAWERS; WARDROBE
Child's furniture
 <u>use</u> CHILD'S as a qualifier with any acceptable
 furniture term: e.g., CHAIR, CHILD'S ROCKING
COATRACK
 <u>rt</u> RACK, HAT
COAT-TREE
 <u>rt</u> HALLSTAND
COMMODE
Couch
 <u>use</u> SOFA

FURNITURE (cont.)

 Couch, Painting
 use LOUNGE
 CRADLE
 CRADLE/ROCKER
 Credenza
 use SIDEBOARD
 CRIB
 CUPBOARD
 rt CABINET
 CUPBOARD, CORNER
 CUPBOARD, HANGING
 CUPBOARD, PRESS
 Davenport
 use SOFA
 DAYBED
 rt LOUNGE
 DESK
 DESK, CAMPAIGN
 DESK, DROP-FRONT
 rt SECRETARY
 DESK, QUARTER-CYLINDER
 DESK, ROLLTOP
 DESK, SLANT-TOP
 DESK, TAMBOUR
 DINING SUITE
 Divan
 use SOFA, SETTEE or LOVE SEAT
 Dresser
 use CHEST OF DRAWERS
 DRESSING CASE
 rt TABLE, DRESSING; CHEST OF DRAWERS
 Dressing glass
 use MIRROR, CHEVAL
 Dressing table
 use TABLE, DRESSING
 Dumbwaiter
 use TABLE, TIER
 EASEL
 ETAGERE
 rt WHATNOT
 FENDER
 Fireguard
 use FENDER
 FOOTSTOOL
 rt OTTOMAN; HASSOCK
 GLIDER
 HALLSTAND
 rt COAT-TREE
 Hall-tree
 use COAT-TREE
 HASSOCK
 rt OTTOMAN; FOOTSTOOL

FURNITURE (cont.)

Highboy
 use CHEST OF DRAWERS
HIGHCHAIR
HUNT BOARD
 rt SIDEBOARD
Hutch
 use more specific term: e.g., CABINET, CORNER;
 CABINET, CHINA
Kas
 use WARDROBE
Klismos
 use CHAIR, DINING
Lectern
 use PODIUM
Looking glass
 use MIRROR, CHEVAL
LOUNGE
 rt DAYBED
LOVE SEAT
 note use for any chair, settee or sofa seating two
 persons side-by-side
 rt SOFA, CONVERSATIONAL
Lowboy
 use TABLE, DRESSING
MATTRESS
Meridienne
 use LOUNGE
MIRROR
 note use only if specific type is unknown
MIRROR, CHEVAL
Mirror, Dressing
 use MIRROR, CHEVAL
Mirror, Girandole
 use MIRROR, WALL
Mirror, Mantel
 use MIRROR, WALL
Mirror, Tabernacle
 use MIRROR, WALL
MIRROR, WALL
Nightstand
 use TABLE, NIGHT
OTTOMAN
 rt HASSOCK; FOOTSTOOL
PARLOR SUITE
PEDESTAL
PEW
PLAYPEN
PODIUM
Press, Linen
 use CUPBOARD, PRESS
PRIE-DIEU

FURNITURE (cont.)

RACK, GUN
RACK, HAT
 rt COATRACK
RACK, LUGGAGE
RACK, MAGAZINE
 rt CANTERBURY
RACK, TOWEL
Recamier
 use LOUNGE
SAFE
SCREEN
SCREEN, POLE
SEAT, GARDEN
SECRETARY
 rt DESK, DROP-FRONT
Server
 use TABLE, SERVING
SETTEE
 note use for a sofa that is all wood with an open
 or upholstered back
 rt SOFA
SETTLE
SHAVING STAND
Shrank
 use WARDROBE
SIDEBOARD
 rt HUNT BOARD
SOFA
 rt SETTEE
SOFA, CONVERSATIONAL
 note use for a sofa that seats two persons facing
 in opposite directions
 rt LOVE SEAT
Sofa bed
 use BED, SOFA
STEPS, BED
STEPS, LIBRARY
STOOL
Stool, Bar
 use BARSTOOL
Stool, Camp
 use STOOL, FOLDING
STOOL, FOLDING
STOOL, GOUT
STOOL, KITCHEN
STOOL, MILKING
STOOL, STEP
TABLE
 note use only if specific type is unknown; any
 table name may be further subdivided to
 indicate table structure: e.g., TABLE, DINING
 TRESTLE; -,CENTER PEDESTAL; -,COFFEE BUTTERFLY

69

FURNITURE (cont.)

 Table, Banquet
 use TABLE, DINING
 Table, Butler's
 use TABLE, TIER
 TABLE, CARD
 TABLE, CENTER
 Table, Chair
 use CHAIR-TABLE
 TABLE, COFFEE
 TABLE, CORNER
 TABLE, DINING
 TABLE, DRESSING
 note use for a small table or stand with drawers or
 compartments mounted on legs which may
 sometimes have an attached mirror
 rt DRESSING CASE
 Table, Drop-leaf
 use more specific term: e.g., TABLE, DINING
 TABLE, DRUM
 Table, End
 use more specific term: e.g., TABLE, WRITING;
 TABLE, CORNER
 TABLE, GAME
 TABLE, GARDEN
 TABLE, GROOMING
 TABLE, KITCHEN
 TABLE, KNITTING
 TABLE, LIBRARY
 TABLE, NESTING
 TABLE, NIGHT
 TABLE, PEMBROKE
 TABLE, PICNIC
 TABLE, PIER
 TABLE, RENT
 TABLE, SERVING
 TABLE, SEWING
 Table, Side
 use more specific term: e.g., TABLE, NIGHT; TABLE,
 TIER
 TABLE, SOFA
 Table, Stacking
 use TABLE, NESTING
 TABLE, TEA
 rt CART, TEA
 TABLE, TIER
 TABLE, TILT-TOP
 TABLE, TRIPOD
 TABLE, VESTING
 Table, Work
 use TABLE, SEWING
 TABLE, WRITING

FURNITURE (cont.)

 TABORET
 Tete-a-tete
 use SOFA, CONVERSATIONAL
 Torchere
 use CANDLESTAND
 VALET
 Vanity
 use TABLE, DRESSING
 Wagon, Tea
 use CART, TEA
 WARDROBE
 rt CHIFFOROBE
 WASHSTAND
 WHATNOT
 rt ETAGERE
 WHATNOT SHELF

HOUSEHOLD ACCESSORY
 def An artifact originally created to be placed in or around a
 building for some relatively minor utilitarian purpose;
 includes small furnishings (e.g., a soap dish, a
 spittoon), special household containers (e.g., a vase, a
 wastebasket), furniture protection objects (e.g., an
 antimacassar, a table cover); does not include purely
 decorative artifacts (see Art Objects, Category 7) or
 devices used in a productive housekeeping activity (see
 Tools and Equipment, Category 4)

 ANTIMACASSAR
 AQUARIUM
 ARMOR, PARLOR
 ASHTRAY
 AVIARY
 BAG, ICE
 BASIN
 BEDPAN
 BELLPULL
 BIRDCAGE
 BOOKEND
 BOOTJACK
 BOTTLE, HOT-WATER
 BOW, FIRE
 BOWL, BULB
 BOWL, FLOWER
 BOX, BIBLE
 BOX, CIGARETTE
 BOX, DEED
 BOX, JEWELRY
 Box, Strong
 use STRONGBOX

HOUSEHOLD ACCESSORY (cont.)

BOX, TRINKET
BURNER, INCENSE
CACHEPOT
Calling card tray
 use CARD RECEIVER
CARD RECEIVER
CHAIR THROW
CLOTHESHORSE
COATHANGER
CUSHION
Cuspidor
 use SPITTOON
CUTTER, CIGAR
DISH, SOAP
DOILY
DOORSTOP
DRILL, FIRE
FLOWERPOT
FOOTSCRAPER
FROG
HOLDER, MATCH
HOLDER, SPILL
HOLDER, TISSUE
HOLDER, WATCH
HUMIDOR
HYDRIA
 rt JAR, WATER
JAR, BELL
JAR, SLOP
Jar, Tobacco
 use HUMIDOR
JAR, WATCH
JAR, WATER
 rt HYDRIA
JARDINIERE
 rt PLANTER
JARDINIERE BASE
KEY
LADDER
Ladder, Step
 use STEPLADDER
LAMBREQUIN
MAT, TABLE
MOUSETRAP
PADLOCK
PAN, DOUCHE
PITCHER
PLANTER
 rt JARDINIERE
POT, CHAMBER
RACK, PIPE

HOUSEHOLD ACCESSORY (cont.)

 RACK, PLATE
 RACK, RECORD
 RACK, SPOON
 SCARF, BUREAU
 SCARF, PIANO
 SMOKER'S STAND
 SPITTOON
 STEPLADDER
 STRONGBOX
 SWATTER, FLY
 TABLE COVER
 Table mat
 use MAT, TABLE
 TABLE RUNNER
 Tidy
 use ANTIMACASSAR
 TOILET SET
 Trap, Mouse
 use MOUSETRAP
 Tray, Calling card
 use CARD RECEIVER
 URINAL
 URN
 VASE
 note may be further subdivided to indicate specific
 type: e.g., VASE, BUD; -,WEED
 WALL POCKET
 WARMER, BED
 WARMER, FOOT
 Washbasin
 use BASIN
 WASTEBASKET

LIGHTING DEVICE
 def An artifact originally created to provide illumination;
 includes lighting accessories (e.g., a candlesnuffer, a
 wick), general purpose portable lighting devices (e.g., a
 kerosine lantern) and specialized fixtures such as
 streetlamps and theater lighting devices
 ref (102)

 Basket, Fire
 use CRESSET
 BEACON, LIGHTHOUSE
 Borderlight
 use STRIPLIGHT
 CANDELABRUM
 rt CANDLESTICK; SCONCE; MENORAH
 CANDLE
 CANDLELIGHTER

LIGHTING DEVICE (cont.)

> CANDLESNUFFER
> CANDLESTICK
>> rt CANDELABRUM; SCONCE
> CANDLESTICK, MINER'S
> CHANDELIER
>> note normally subdivided according to fuel
>> rt LAMP
> Control board
>> use LIGHTING CONSOLE
> CRESSET
> DIMMER
> EXTINGUISHER, CANDLE
> FINIAL
> FLASHLIGHT
> FLOODLIGHT
> FOOTLIGHT
> Gasolier
>> use CHANDELIER with an appropriate subdivision
> GIRANDOLE
> Holder, Candle
>> use CANDELABRUM or CANDLESTICK or SCONCE
> HOLDER, LAMP
> HOLDER, RUSHLIGHT
>> rt HOLDER, TAPER
> HOLDER, SPLINT
> HOLDER, TAPER
>> rt HOLDER, RUSHLIGHT
> HOLDER, TORCH
> LAMP
>> note normally subdivided according to fuel; may be
>> further subdivided to indicate placement or
>> use: e.g., LAMP, KEROSINE TABLE; -,ELECTRIC
>> FLOOR; -,ELECTRIC SAFETY (i.e., a miner's
>> safety lamp)
>> rt LANTERN; CHANDELIER
> Lamp, Argand
>> use LAMP, OIL
> Lamp, Astral
>> use LAMP, OIL
> Lamp, Betty
>> use LAMP, SEMILIQUID
> LAMP, BURNING-FLUID
>> note use for any lamp designed to burn a mixture of
>> alcohol and camphene
> LAMP, CAMPHENE
> Lamp, Carcel
>> use LAMP, OIL
> Lamp, Crusie
>> use LAMP, SEMILIQUID
> LAMP, ELECTRIC

LIGHTING DEVICE (cont.)

 LAMP, GAS
 note use for any lamp designed to burn acetylene,
 coal gas, water gas or natural gas
 Lamp, Hitchcock
 use LAMP, OIL
 LAMP, KEROSINE
 Lamp, Mantel
 use more specifc term: e.g., LAMP, KEROSINE: -,OIL
 Lamp, Moderator
 use LAMP, OIL
 LAMP, OIL
 note use for any lamp designed to burn whale oil,
 seal oil, colza oil, or rosin oil
 Lamp, Rumford
 use LAMP, OIL
 LAMP, SEMILIQUID
 note use for any lamp designed to burn lard,
 tallow, grease
 Lamp, Solid-fuel
 use more specific term: e.g., CANDLE, RUSHLIGHT,
 SPLINT
 Lamp, Wanzer
 use LAMP, OIL
 LAMP BASE
 Lamp bulb
 use LIGHT BULB
 LAMP BURNER
 LAMP CHIMNEY
 LAMP FONT
 LAMP GLOBE
 LAMP HARP
 LAMP MANTLE
 LAMP PENDANT
 LAMP REFLECTOR
 LAMP SHADE
 Lamp stand
 use HOLDER, LAMP
 LANTERN
 note normally subdivided according to fuel: e.g.,
 LANTERN, KEROSINE; -,ELECTRIC
 rt LAMP
 LIGHT BULB
 LIGHTING CONSOLE
 RUSHLIGHT
 SAFE, CANDLE
 SCONCE
 rt CANDELABRUM; CANDLESTICK
 SCONCE, MIRRORED
 SEARCHLIGHT
 Snuffer, Candle
 use CANDLESNUFFER

LIGHTING DEVICE (cont.)

> SPLINT
> SPOTLIGHT
> STREETLAMP
> STRIPLIGHT
> Taper
> > use CANDLE
> Wax jack
> > use HOLDER, TAPER
> WICK

PLUMBING FIXTURE
> def An artifact originally created to be attached,
> more-or-less permanently, to water and sewer lines,
> usually within a building; see HOUSEHOLD ACCESSORY for
> portable objects which serve comparable purposes

> Bath, Hip
> > use BATH, SITZ
> BATH, SITZ
> BATHTUB
> BIDET
> CONDITIONER, WATER
> DISPOSER
> FAUCET
> FOOTBATH
> FOUNTAIN
> FOUNTAIN, DRINKING
> Garbage disposal
> > use DISPOSER
> HEATER, WATER
> Lavatory
> > use more specific term: e.g., TOILET, SINK
> PUMP, SUMP
> PUMP, WATER
> SINK
> SPRINKLER HEAD
> TOILET
> TUB, LAUNDRY

TEMPERATURE CONTROL DEVICE
> def An artifact originally created to control the temperature
> within a building; does not include relatively permanent
> structural parts of a building (see BUILDING FRAGMENT,
> Category 1) or devices to control temperature for some
> purpose other than human comfort (e.g., FOOD PROCESSING
> T&E, Category 4)

> ANDIRON
> BELLOWS

TEMPERATURE CONTROL DEVICE (cont.)

 BROOM, FIREPLACE
 CONDITIONER, AIR
 DEHUMIDIFIER
 FAN, ELECTRIC
 FIREBOARD
 Firedog
 use ANDIRON
 FIRESET
 FIRESET STAND
 FURNACE
 GRATE, FIREPLACE
 HEATER
 note normally subdivided according to fuel used:
 e.g., HEATER, COAL; -,OIL; -,NATURAL GAS;
 -,BASEBOARD WATER
 HUMIDIFIER
 LOG CARRIER
 Pistol, Tinder
 use TINDERPISTOL
 POKER
 PUNKA
 RADIATOR
 SCREEN, FIRE
 SCUTTLE, COAL
 SHOVEL, FIREPLACE
 Spark guard
 use SCREEN, FIRE
 STEEL
 STOVE
 note normally subdivided according to fuel used:
 e.g., STOVE, WOOD; -, COAL
 TINDERBOX
 TINDERPISTOL
 TONGS, FIREPLACE
 WOODBIN

WINDOW OR DOOR COVERING
 def An artifact originally created to be a window or door
 covering; does not include relatively permanent structural
 parts of a building (see BUILDING FRAGMENT, Category 1)

 AWNING
 BLIND, VENETIAN
 Canopy
 use AWNING
 CURTAIN
 CURTAIN ROD
 Drape
 use DRAPERY
 DRAPERY

77

WINDOW OR DOOR COVERING (cont.)

> Festoon
> > use SWAG
> Holdback
> > use TIEBACK
> PORTIERE
> SHADE, ROMAN
> SHADE, SPRING-PULL
> SHADE PULL
> SHUTTER
> SWAG
> TIEBACK
> VALANCE

Category 3: Personal Artifacts
Artifacts originally created to serve the personal needs
of individuals as clothing, adornment, body protection,
grooming aids, or symbols of beliefs or achievements

ADORNMENT
 def An artifact originally created to be worn on the human
 body or on clothing as decoration or ornamentation rather
 than as body covering; see also PERSONAL SYMBOL and
 PERSONAL GEAR
 ref (132)

 ANKLET
 ARMLET
 Bangle
 use BRACELET
 Barrette
 use ORNAMENT, HAIR
 BEAD
 BODKIN
 rt ORNAMENT, HAIR
 Boutonniere
 use PIN, LAPEL
 BRACELET
 BRELOQUE
 BROOCH
 Cameo
 use more specific term: e.g., BROOCH
 CHATELAINE
 Comb
 use ORNAMENT, HAIR
 CORSAGE
 Earplug
 use EAR SPOOL
 EARRING
 EAR SPOOL
 FERRONIERE
 FRONTLET
 GORGET
 HAIRPIECE
 rt WIG
 Kanzashi
 use ORNAMENT, HAIR
 Kogai
 use ORNAMENT, HAIR
 LABRET
 LAVALIERE
 LOCKET
 NECKLACE
 NOSE PLUG
 ORNAMENT, HAIR
 rt BODKIN
 PENDANT
 PIN, LAPEL

ADORNMENT (cont.)

PIN, SCATTER
RING
RING, NOSE
Sautoir
 use PENDANT
TIARA
Toupee
 use HAIRPIECE
WIG
 rt HAIRPIECE
WIG STAND

CLOTHING
 def An artifact originally created to be used as covering for
the human body; includes underwear, outerwear, headwear,
footwear and also accessories (e.g., a belt, a cuff link);
see also PERSONAL SYMBOL
 ref (132)

CLOTHING, FOOTWEAR

BOOT
 note may be further subdivided to indicate specific
 type: e.g., BOOT, COWBOY; -,RIDING; -,HIP;
 -,SKI
CHOPINE
CLOG
CRAKOW
ESPADRILLE
GAITER
GETA
HUARACHE
JACKBOOT
Klomp
 use SABOT
LOAFER
MOCCASIN
MUKLUK
Mule
 use SLIPPER
Nylon
 use STOCKING
PAC
Patten
 use CLOG
Poulaine
 use CRAKOW
PUMP
RUBBER

CLOTHING, FOOTWEAR (cont.)

 SABOT
 SANDAL
 Scuff
 use SLIPPER
 SHOE
 note use only for objects which contain the word
 SHOE in the name; may be further subdivided to
 indicate specific type: e.g., SHOE, TOE;
 -,TRACK; -,TENNIS; -,DECK
 SLIPPER
 SLIPPER, BALLET
 Sneaker
 use SHOE with suitable qualifier: e.g., SHOE,
 TENNIS
 SOCK
 SPAT
 STOCKING
 TABI
 THONG

CLOTHING, HEADWEAR

 Amice
 use HOOD
 Bandana
 use KERCHIEF
 BARBETTE
 BEANIE
 rt SKULLCAP
 BERET
 rt TAM-O-SHANTER
 BIGGIN
 BIRETTA
 BOATER
 BONNET
 Bowler
 use DERBY
 Calot
 use BEANIE
 CAP
 note use only for objects which contain the word
 CAP in the name; may be further subdivided to
 indicate specific type: e.g., CAP, BATHING;
 -,FORAGE; -,GARRISON; -,GOB; -,MOURNING;
 -,MINER'S
 Cap, Flat
 use FLATCAP
 CAUL
 rt HAIRNET
 CORNET

CLOTHING, HEADWEAR (cont.)

 DERBY
 EARMUFFS
 EYESHADE
 FEDORA
 FEZ
 FLATCAP
 Gibus
 use HAT, TOP
 HAIRNET
 rt CAUL
 HAT
 note use only for objects which contain the word
 HAT in the name; may be further subdivided to
 indicate specific type: e.g., HAT, HARD;
 -,PANAMA; -,PICTURE; -,TOP; -,TRICORN
 Hat, Derby
 use DERBY
 Hat, Homberg
 use HOMBERG
 Hat, Safety
 use more specific term: e.g., HAT, HARD
 HATBAND
 HAVELOCK
 HEADBAND
 Headkerchief
 use KERCHIEF
 HELMET
 note may be further subdivided to indicate specific
 type: e.g., HELMET, CRASH; -,DIVER'S: -,PITH
 HENNIN
 HOMBERG
 HOOD
 Kepi
 use CAP, FORAGE
 KERCHIEF
 LAPPET
 Mantilla
 use SCARF
 MONTERA
 NIGHTCAP
 ORLE
 PERIWIG
 Peruke
 use PERIWIG
 PILLBOX
 SCARF
 SHAKO
 SKULLCAP
 rt BEANIE
 Snood
 use HAIRNET

CLOTHING, HEADWEAR (cont.)

 SOMBRERO
 SWEATBAND
 TAJ
 TAM-O-SHANTER
 rt BERET
 THOLIA
 Topee
 use HELMET, PITH
 TOQUE
 TURBAN
 VEIL
 Wimple
 use KERCHIEF
 Yarmulke
 use SKULLCAP
 Yashmak
 use VEIL

CLOTHING, OUTERWEAR

 ABA
 rt TOGA; CAFTAN
 ALB
 APRON
 note may be further subdivided according to
 functional activity if appropriate: e.g.,
 APRON, BLACKSMITH'S
 BATHROBE
 BLOUSE
BODICE← BOLERO
 BOMBACHAS
 BREECHES
 Breeches, Jodhpur
 use BREECHES, RIDING
 BREECHES, RIDING
 BREECHES, TRUNK
 BUNTING
 BURKA
 BURNOUS
 rt CLOAK
 CAFTAN
 rt ABA; TOGA
 CAPE
 CAPOTE
 Carrick
 use GREATCOAT
 CASSOCK
 CHALWAR
 CHAPERON
 CHAPS

CLOTHING, OUTERWEAR (cont.)

CHASUBLE
Chemise
 <u>use</u> DRESS
Choli
 <u>use</u> BLOUSE
CLOAK
 <u>rt</u> BURNOUS
COAT
 <u>note</u> may be further subdivided to indicate specific
 type: e.g., COAT, CUTAWAY; -,FROCK;
 -,LABORATORY
Coat, Morning
 <u>use</u> COAT, CUTAWAY
COATEE
CODPIECE
Cope
 <u>use</u> CLOAK
COSTUME, CLOWN
COSTUME, DANCE
COSTUME, HALLOWEEN
COSTUME, HARLEQUIN
COSTUME, MAGICIAN'S
COSTUME, SANTA CLAUS
COSTUME, THEATER
 <u>note</u> use for any article of clothing created for
 use in a theatrical performance
COTTA
COVERALLS
CULOTTES
DALMATIC
Dashiki
 <u>use</u> BLOUSE
DIRNDL
Doublet
 <u>use</u> JERKIN
DRESS
 <u>rt</u> GOWN
DRESS, FOLK
 <u>note</u> use for ethnic clothing worn on special
 occasions such as weddings and festivals
Duster
 <u>use</u> HOUSECOAT
GOWN
 <u>note</u> may be further subdivided to indicate specific
 type: e.g., GOWN, BAPTISMAL; -,DRESSING;
 -,EVENING; -,WEDDING
Gown, Night
 <u>use</u> NIGHTGOWN
GREATCOAT
HABIT
 <u>note</u> may be further subdivided to indicate specific
 type: e.g., HABIT, MONK'S; -,NUN'S

CLOTHING, OUTERWEAR (cont.)

 Hose, Trunk
 use BREECHES, TRUNK
 HOUSECOAT
 JACKET
 note may be further subdivided to indicate specific
 type: e.g., JACKET, BUSH; -,MESS; -,PEA;
 -,SMOKING
 Jacket, Dinner
 use TUXEDO
 JERKIN
 JUMPER
 KILT
 KIMONO
 KNICKERS
 Lederhosen
 use SHORTS
 LEGGING
 LOINCLOTH
 MACKINAW
 MANIPLE
 MUU-MUU
 Negligee
 use NIGHTGOWN
 NIGHTGOWN
 OILSKINS
 rt RAINCOAT; SLICKER
 OVERALLS
 note may be further subdivided according to
 functional activity if appropriate: e.g.,
 OVERALLS, PAINTER'S; -,CARPENTER'S
 OVERCOAT
 PAJAMAS
 Paltock
 use TUNIC
 PANNIER
 Pantaloons
 use PANTS
 PANTS
 PANTSUIT
 PARKA
 Peignoir
 use NIGHTGOWN or GOWN, DRESSING
 PINAFORE
 PONCHO
 Puttee
 use LEGGING
 RAINCOAT
 rt SLICKER; OILSKINS
 Robe
 use BATHROBE or GOWN, DRESSSING
 ROMPER

CLOTHING, OUTERWEAR (cont.)

Sarape
 use PONCHO
SARI
SARONG
SHAWL
SHIRT
 note may be further subdivided to indicate specific
 type: e.g., SHIRT, POLO
Shirt, T
 use T-SHIRT
SHORTS
SKIRT
 note may be further subdivided to indicate specific
 type: e.g., SKIRT, HOOP; -,HULA
Slacks
 use PANTS
SLICKER
 rt RAINCOAT; OILSKINS
SMOCK
Spatterdash
 use LEGGING
STOLE
SUIT
 note may be further subdivided to indicate specific
 type: e.g., SUIT, BATHING; -,EXPOSURE;
 -,DIVER'S; -,SPACE
Suit, Pants
 use PANTSUIT
SUNSUIT
SURPLICE
SWEATER
TABARD
TIGHTS
TOGA
 rt ABA; CAFTAN
Topcoat
 use OVERCOAT
Trousers
 use PANTS
T-SHIRT
TUNIC
Tutu
 use COSTUME, DANCE
TUXEDO
UNIFORM
 note may be further subdivided to indicate specific
 type: e.g., UNIFORM, NURSE'S; -,NAVAL OFFICER'S
VEST
WAISTCOAT
Wrapper
 use GOWN, DRESSING

CLOTHING, UNDERWEAR

BELT, GARTER
BINDER, OBSTETRICAL
BLOOMERS
BODYSTOCKING
BRASSIERE
BRIEFS
BUSTLE
CAMISOLE
CORSET
Crinoline
 use PETTICOAT
DIAPER
DRAWERS
FARTHINGALE
GIRDLE
Leotard
 use BODYSTOCKING
PANNIER
PANTALETTES
PANTIES
PANTYHOSE
PETTICOAT
SHORTS
SHORTS, BOXER
SLIP
STAY
SUIT, UNION
SUPPORTER
UNDERSHIRT

CLOTHING ACCESSORY

AGAL
APPLICATOR, SHOE-POLISH
ASCOT
BANDOLIER
BELT
BELT, SAM BROWNE
BIB
BOA
BOX, BOOTBLACKING
 rt SHOESHINE KIT
BRUSH, CLOTHES
BUCKLE
BUFFER, SHOE
BUTTON
BUTTONHOOK
Canion
 use GARTER

CLOTHING ACCESSORY (cont.)

CLASP
COLLAR
 rt RUFF; RUCHE
COLLAR, ROMAN
CRAVAT
CUFF
CUFF LINK
Cummerbund
 use SASH
DICKEY
FIBULA
FICHU
GARTER
GLOVE
HATPIN
HOLDER, HATPIN
Hook, Button
 use BUTTONHOOK
JABOT
MITT
MITTEN
MUFF
MUFFLER
 rt SCARF, NECK
NECKERCHIEF
NECKTIE
Obi
 use SASH
RUCHE
 rt COLLAR
RUFF
 rt COLLAR
SACHET
SASH
SCARF, NECK
 rt MUFFLER
SHOEHORN
SHOESHINE KIT
 rt BOX, BOOTBLACKING
SHOE TREE
STICKPIN
Stretcher, Shoe
 use SHOE TREE
STUD
SUSPENDERS
TIE, BOW
Tie, Neck
 use NECKTIE
TIE, STRING
TIE CLIP
Tiepin
 use STICKPIN

CLOTHING ACCESSORY (cont.)

> TIE TACK
> WRISTLET

PERSONAL GEAR
> def An artifact originally created to be used by an individual
> as a carrying device (e.g., a wallet, a knapsack), a
> protective apparatus (e.g., an umbrella, goggles), a
> personal or physical aid (e.g., a cane, eyeglasses), or as
> personal smoking equipment (e.g., a pipe)
> ref (126) (132)

> ATTACHE CASE
> BACKPACK
> Bag, Beaded
> use PURSE
> BAG, DITTY
> BAG, DUFFLE
> Bag, Hand
> use PURSE
> Bag, Musette
> use HAVERSACK
> BAG, SALLY
> BAG, SCHOOL
> Bag, Shoulder
> use HAVERSACK
> BANDBOX
> BASKET, BURDEN
> BASKET, PACK
> BASKET, TRINKET
> BELT, MONEY
> BOTTLE, PILGRIM
> BOTTLE, SMELLING
> BOTTLE, SNUFF
> Box, Band
> use BANDBOX
> Box, Pill
> use PILLBOX
> Box, Snuff
> use SNUFFBOX
> BOX, TOBACCO
> BRACE
> BRIEFCASE
> CANE
> CANTEEN
> Carpetbag
> use SUITCASE
> CASE, CARD
> CASE, CIGAR
> CASE, CIGARETTE
> CASE, JEWELRY

PERSONAL GEAR (cont.)

 CASE, KEY
 CASE, MEDICINE
 CASE, PHOTOGRAPH
 CHAIN, KEY
 CHATELAINE
 CHEST, SEA
 CLIP, MONEY
 CRUTCH
 CUSHION, AIR
 DENTURES
 EARPHONE
 EARPLUG
 EAR TRUMPET
 ETUI
 EYEGLASSES
 False teeth
 use DENTURES
 FAN
 FLABELLUM
 FLASK, POCKET
 FOB
 Glasses, Eye
 use EYEGLASSES
 GLASSES, OPERA
 GOGGLES
 note may be further subdivided to indicate specific
 type: e.g., GOGGLES, WELDER'S
 Handbag
 use PURSE
 HANDKERCHIEF
 HATBOX
 HAVERSACK
 HEADRING
 HEARING AID
 HOLDER, CIGAR
 HOLDER, CIGARETTE
 HOOKAH
 Inro
 use CASE, MEDICINE
 Jackknife
 use KNIFE, POCKET
 KNAPSACK
 KNIFE, PIPE
 KNIFE, POCKET
 LENS, CONTACT
 LIGHTER
 MONOCLE
 rt QUIZZING GLASS
 NETSUKE
 NOSE PLUG
 PACIFIER

PERSONAL GEAR (cont.)

 PACK FRAME
 PARASOL
 Penknife
 <u>use</u> KNIFE, POCKET
 PILLBOX
 Pince-nez
 <u>use</u> EYEGLASSES
 PIPE
 PIPE CASE
 POCKET
 Portmanteau
 <u>use</u> SUITCASE
 POUCH, TOBACCO
 PROSTHESIS
 PURSE
 QUIZZING GLASS
 <u>rt</u> MONOCLE
 Reticule
 <u>use</u> PURSE
 RING, KEY
 RING, TEETHING
 SAFE, MATCH
 SATCHEL
 SCRIBE SET
 SHOESHINE KIT
 SHOOTING STICK
 SNUFFBOX
 SUITCASE
 SWAGGER STICK
 Toggle bead
 <u>use</u> NETSUKE
 TRUNK
 TRUSS
 Tus
 <u>use</u> CANTEEN
 UMBRELLA
 Valise
 <u>use</u> SUITCASE
 Vinaigrette
 <u>use</u> BOTTLE, SMELLING
 WALKER
 Walking stick
 <u>use</u> CANE
 WALLET
 WARMER, HAND
 WHEELCHAIR
 Yatate
 <u>use</u> SCRIBE SET

PERSONAL SYMBOL

 def An artifact originally created to be a symbol of a
 personal belief, achievement, status or membership;
 includes articles of adornment or clothing worn primarily
 for their symbolism (e.g., a fraternal ring, a military
 gorget, an academic gown, a crown); see also DOCUMENTARY
 ARTIFACT (Category 5) and CEREMONIAL ARTIFACT (Category 9)

 ref (132) (136)

Aiguillette
 use SHOULDER LOOP
AMULET
ARMBAND, MOURNING
ARMILLA
Atef
 use PSCHENT
Badge
 use more specific term: e.g., PIN, PATCH or MEDAL
BANDOLIER
BEADS, ROSARY
BLANKET, SHOULDER
BRAID, MILITARY
Coat of arms
 use more specific term: e.g., RING, PLAQUE, SHIELD
CROSIER
Cross
 use PENDANT, RELIGIOUS
CROWN
Crucifix
 use PENDANT, RELIGIOUS or PLAQUE, RELIGIOUS
CUP, LOVING
DIADEM
Emblem
 use more specific term: e.g., PIN, PATCH or MEDAL
EPAULET
GAVEL
GORGET
GOWN, ACADEMIC
GUN, PRESENTATION
HAT, ECCLESIASTIC
HEADDRESS
HOOD, ACADEMIC
MACE
MEDAL
 note may be further subdivided to indicate specific
 type: e.g., MEDAL, GOOD CONDUCT; -,FRATERNAL;
 -,OLYMPIC; -,RELIGIOUS
Medallion
 use MEDAL
Menat
 use AMULET
Merit badge
 use PATCH, MERIT-BADGE

PERSONAL SYMBOL (cont.)

> Military insignia
>> <u>use</u> more specific term: e.g., GORGET, SHOULDER
>> LOOP, SHOULDER MARK, PIN, PATCH, or MEDAL
>
> MITER
> MORTARBOARD
> ORB
> PATCH
>> <u>note</u> use for cloth badge or emblem sewn to a sleeve
>> or bandolier; may be further subdivided to
>> indicate specific type: e.g., PATCH,
>> REGIMENTAL; -,MERIT-BADGE
>
> PENDANT, RELIGIOUS
> PIN
>> <u>note</u> may be further subdivided to indicate specific
>> type: e.g., PIN, SORORITY; -,CAPTAIN'S
>
> PLAQUE
>> <u>note</u> may be further subdivided to indicate specific
>> type: e.g., PLAQUE, RELIGIOUS
>
> PSCHENT
> RIBBON, CAMPAIGN
> RIBBON, PRIZE
> RING
>> <u>note</u> may be further subdivided to indicate specific
>> type: e.g., RING, FRATERNAL; -,SIGNET
>
> ROCHET
> Sash
>> <u>use</u> BANDOLIER
>
> Scapular
>> <u>use</u> PENDANT, RELIGIOUS
>
> SCEPTER
> Seal
>> <u>use</u> more specific term: e.g., RING, SIGNET
>
> SHOULDER LOOP
> SHOULDER MARK
> SHROUD
> STATUETTE TROPHY
> Sword, Court
>> <u>use</u> SWORD, PRESENTATION
>
> SWORD, PRESENTATION
> TALISMAN
> TALLITH
> Trophy
>> <u>use</u> CUP, LOVING; STATUETTE TROPHY or other object
>> name from lexicon (e.g., TRAY, SERVING)
>
> WIG, BARRISTER'S

TOILET ARTICLE
 def An artifact originally created to be used for human body
 care and grooming

 ATOMIZER
 Bottle, Barber's
 use BOTTLE, TOILET
 Bottle, Cologne
 use BOTTLE, TOILET
 Bottle, Perfume
 use BOTTLE, TOILET
 BOTTLE, TOILET
 Box, Powder
 use BOX, PUFF
 BOX, PUFF
 BRUSH, NAIL
 BRUSH, SHAVING
 BUFFER
 CASE, MANICURE
 CLIPPERS, HAIR
 CLIPPERS, NAIL
 COMB
 COMPACT
 COSMETIC CONTAINER
 CURLER
 DRESSER SET
 DRYER, HAIR
 EYECUP
 EYEDROPPER
 FILE, NAIL
 HAIRBRUSH
 HAIRPIN
 HAIR RECEIVER
 IRON, CURLING
 MANICURE SET
 MIRROR, HAND
 MUG, SHAVING
 OINTMENT CONTAINER
 PENCIL, EYEBROW
 PIN, BOBBY
 POMANDER
 PUFF, POWDER
 RAZOR
 RAZOR BOX
 SCISSORS, BARBER'S
 SCISSORS, MANICURE
 SCRATCHER, BACK
 SHEARS, THINNING
 STRIGIL
 STROP
 TOOTHBRUSH
 TOOTHPICK

TOILET ARTICLE (cont.)

 TOWEL, BATH
 TOWEL, BEACH
 TOWEL, FACE
 TOWEL, FINGERTIP
 TOWEL, HAND
 TRAY, DRESSER
 TWEEZERS
 WASHCLOTH

Category 4: Tools and Equipment

Artifacts originally created to be used in carrying on an activity such as an art, craft, trade, profession or hobby; the tools, implements and equipment used in the process of modifying available resources for some human purpose

ACOUSTICAL T&E

def An artifact originally created to be used in the study of sound and its effect upon hearing; see also SOUND COMMUNICATION EQUIPMENT (Category 5) and MEDICAL & PSYCHOLOGICAL T&E

ref (38) (66)

```
ACOUMETER
Acousimeter
     use  AUDIOMETER
AMPLIFIER, AUDIO
     rt    FUNNEL-HORN; RESONATOR
ANALYZER, SOUND
ANALYZER/SYNTHESIZER, CLANG
AUDIOMETER
AUDIO-OSCILLATOR
Auditory apparatus
     use  more specific term: e.g., GENERATOR, SOUND;
          AMPLIFIER, AUDIO; ANALYZER, SOUND;
CAGE, SOUND
DIFFERENCE-TONE APPARATUS
FUNNEL-HORN
     rt    AMPLIFIER, AUDIO
GENERATOR, SOUND
HAMMER, SOUND
HARMONOMETER
HELMET, SOUND
KYMOSCOPE
LAMELLA
LOGOGRAPH
MASKER
MEASURER, SOUND
     note use for a sound generator with scales
OPEIDOSCOPE
ORGAN, LABORATORY
PENDULUM, SOUND
PERIMETER, SOUND
PHONELESCOPE
PHONODEIK
Phonometer
     use ACOUMETER
PHONO-PROJECTOSCOPE
PHONORGANON
PHONOSCOPE
PHOTOPHONE
PSEUDOPHONE
RADIOPHONE
```

ACOUSTICAL T&E (cont.)

 RECEIVER, SOUND
 RECORDER, SOUND
 REPRODUCER, SOUND
 RESONATOR
 rt AMPLIFIER, AUDIO
 SONOMETER
 SPECTROGRAM, SOUND
 SPECTROGRAPH, SOUND
 STIMULATOR, SOUND
 STROBILION
 note use for an instrument that records vibrational
 patterns
 TONOMETER
 TONOSCOPE
 TOPOPHONE
 TRANSMITTER, SOUND
 TUBE, QUINCKE'S
 TUNING FORK
 VARIATOR, STERN
 VIBROSCOPE
 WHEEL, SAVART
 WHISTLE, GALTON

AGRICULTURAL T&E
 def An artifact originally created to be used in farming or
 gardening; includes implements used in planting,
 harvesting and storing crops and in processing food for
 animals but not for humans (see FOOD PROCESSING T&E); does
 not include equipment used in caring for animals (see
 ANIMAL HUSBANDRY T&E) or in working with forest products
 (see FORESTRY T&E) or in fabricating textiles (see
 TEXTILEWORKING T&E)
 ref (7) (45) (98) (135)

 Avarrancator
 use PRUNER, TREE
 BALER, COTTON
 BALER, HAY
 BALER, PICKUP HAY
 BARROW, APPLE
 Basket, Berry
 use BASKET, GATHERING
 BASKET, COTTON
 Basket, Egg-gathering
 use BASKET, GATHERING
 Basket, Fruit-picking
 use BASKET, GATHERING
 BASKET, GATHERING
 BASKET, WINNOWING
 BEARDER, BARLEY

97

AGRICULTURAL T&E (cont.)

BILLHOOK
> rt HOOK, PRUNING

BINDER, CORN

BINDER, GRAIN

Binder, Row
> use BINDER, CORN

Binder, Twine
> use BINDER, GRAIN

Binder, Wire
> use BINDER, GRAIN

BLOWER, ENSILAGE

Blower, Forage
> use BLOWER, ENSILAGE

Blower, Impeller
> use BLOWER, ENSILAGE

Blower, Silage
> use BLOWER, ENSILAGE

Blower, Silo
> use BLOWER, ENSILAGE

Boat, Stone
> use STONEBOAT

BOILER, FEED

Broadcaster, Aircraft
> use SEEDER, CENTRIFUGAL

Broadcaster, Centrifugal
> use SEEDER, CENTRIFUGAL or SEEDER, HAND CENTRIFUGAL

Broadcaster, Knapsack
> use SEEDER, HAND CENTRIFUGAL

Broadcaster, Rotary
> use SEEDER, CENTRIFUGAL or SEEDER, HAND CENTRIFUGAL

Broadcaster, Seedbox
> use SEEDER, SEEDBOX or SEEDER, HAND SEEDBOX

Broadcaster, Wheelbarrow
> use SEEDER, HAND SEEDBOX

Cart, Tractor grain
> use TRAILER, FARM

CHISEL, GRAFTING

CHISEL, PRUNING

Chopper, Ensilage
> use CUTTER, ENSILAGE

CHOPPER, FEED
> rt CUTTER, ENSILAGE

Chopper, Fodder
> use CHOPPER, FEED

Chopper, Hay
> use CHOPPER, FEED

Chopper, Silage
> use CUTTER, ENSILAGE

Chopper, Stalk
> use CHOPPER, FEED

Chopper, Stover
> use CHOPPER, FEED

98

AGRICULTURAL T&E (cont.)

 CLEANER, COTTONSEED
 CLEANER, DRAIN
 Cleaner, Grain
 use MILL, FANNING
 COLD FRAME
 COMBINE
 Combine, Corn picker/sheller
 use COMBINE
 Combine, Corn-head
 use COMBINE
 COMBINE, GREEN PEA
 COMBINE, PEANUT
 Combine, Pull-type
 use COMBINE
 Combine, Self-propelled
 use COMBINE
 Combine, Side-hill
 use COMBINE
 CONDITIONER, HAY
 rt MOWER/CONDITIONER
 COOKER, FEED
 CORNHUSKER, HAND
 Cradle, Barley
 use SCYTHE, CRADLE
 Cradle, Grain
 use SCYTHE, CRADLE
 CROOK, HAY
 Crook, Throw
 use TIER, CORN SHOCK
 Crusher, Corn-and-cob
 use GRINDER, FEED
 CUBER, HAY
 Cultipacker
 use ROLLER, LAND
 CULTIVATOR
 note use for an animal- or machine-drawn cultivator
 on which the operator rides; may be further
 subdivided to indicate size: e.g., CULTIVATOR,
 4-ROW
 Cultivator, Chisel
 use CULTIVATOR, FIELD
 CULTIVATOR, FIELD
 note use for an animal- or machine-drawn machine
 designed for field preparation rather than
 cultivation
 CULTIVATOR, GARDEN
 note use for any cultivator pushed by hand
 CULTIVATOR, HAND
 note use for a hand tool employed in garden
 cultivation

AGRICULTURAL T&E (cont.)

CULTIVATOR, ROTARY
 note use for a power-driven machine employed for
 weed control and shallow mulching between rows
 of closely-spaced row-crops
Cultivator, Straddle-row
 use CULTIVATOR
CULTIVATOR, WALKING
 note use for an animal-drawn cultivator behind
 which the operator walks
Cultivator, Wheel-hoe
 use CULTIVATOR, GARDEN
CUTTER, ENSILAGE
 rt CHOPPER, FEED
Cutter, Feed
 use CHOPPER, FEED
Cutter, Flail
 use SHREDDER, FLAIL
Cutter, Fodder
 use CHOPPER, FEED
CUTTER, POTATO SEED
CUTTER, ROOT
Cutter, Silage
 use CUTTER, ENSILAGE
CUTTER, STALK
Cutter, Stover
 use CHOPPER, FEED
Cutter, Thistle-and-dock
 use SPUD, WEEDING
Cutter, Vegetable
 use CUTTER, ROOT
CUTTER, WEED
Cutter and blower, Ensilage
 use BLOWER, ENSILAGE
DERRICK, GRAIN-STACKING
DIBBLE
Dibble board
 use DIBBLE
DIBBLING MACHINE
DIGGER, POTATO
Digger, Thistle
 use SPUD, WEEDING
DISTRIBUTOR, FERTILIZER
Drag, Hay
 use RAKE, HAY-BUNCHING
Drag, Plank
 use DRAG, SMOOTHING
DRAG, SMOOTHING
Drill, Barrow
 use DRILL, SEED
Drill, Disk
 use DRILL, SEED

AGRICULTURAL T&E (cont.)

Drill, Fertilizer
 use DRILL, SEED
Drill, Garden
 use DRILL, SEED
Drill, Grain
 use DRILL, SEED
Drill, Hand
 use DRILL, SEED
Drill, Hoe
 use DRILL, SEED
Drill, Press
 use DRILL, SEED
DRILL, SEED
Drill, Shoe
 use DRILL, SEED
Drill, Walking
 use DRILL, SEED
Drill, Wheelbarrow
 use DRILL, SEED
DRYER, CROP
Dryer, Grain
 use DRYER, CROP
DUSTER, DRY-POWDER
Duster, Hand
 use DUSTER, DRY-POWDER
Duster, Potato
 use DUSTER, DRY-POWDER
Duster, Saddle-gun
 use DUSTER, DRY-POWDER
Duster, Tobacco
 use DUSTER, DRY-POWDER
Edger, Lawn
 use EDGER, TURF
EDGER, TURF
ELEVATOR, AUGER
ELEVATOR, BALE
Fan, Dutch
 use MILL, FANNING
Fan, Winnowing
 use BASKET, WINNOWING or MILL, FANNING
FEEDER, ROOT
Filler, Silo
 use BLOWER, ENSILAGE
FLAIL
Flail, Threshing
 use FLAIL
Flamethrower
 use WEEDER, FLAME
FORK
 note use only if specific type is unknown
FORK, ALFALFA

101

AGRICULTURAL T&E (cont.)

```
        FORK, BAILING-PRESS
        FORK, BARLEY
        FORK, BEET
        FORK, CABBAGE-HARVESTING
        Fork, Chaff
                use  FORK, HEADER
        FORK, COTTONSEED
        Fork, Digging
                use  FORK, SPADING
        FORK, ENSILAGE
        Fork, Garden
                use  FORK, SPADING
        Fork, Grain
                use  FORK, HEADER
        Fork, Grapple
                use  FORK, HAY-LIFTING
        Fork, Harpoon
                use  FORK, HAY-LIFTING
        Fork, Hay
                use  HAYFORK
        FORK, HAY-LIFTING
        FORK, HEADER
        Fork, Horse hay
                use  FORK, HAY-LIFTING
        Fork, Lock-lever
                use  FORK, HAY-LIFTING
        FORK, MANURE
        Fork, Pitch
                use  HAYFORK or FORK, MANURE
        FORK, POTATO-DIGGING
        Fork, Silage
                use  FORK, ENSILAGE
        FORK, SPADING
        Fork, Straw
                use  FORK, BARLEY
        FORK, VEGETABLE SCOOP
        Furnace, Agricultural
                use  BOILER, FEED
        Gaff, Hay
                use  CROOK, HAY
        Gatherer, Fruit
                use  PICKER, FRUIT
        GERMINATOR
        GRINDER, FEED
        GRINDER, SOIL
        GRINDER/MIXER, FEED
        Gun, Dusting
                use  DUSTER, DRY-POWDER
        Gun, Insect powder
                use  DUSTER, DRY-POWDER
        HARROW, ACME
```

102

AGRICULTURAL T&E (cont.)

 HARROW, DISK
 Harrow, Drag
 use HARROW, SPIKE-TOOTH
 Harrow, Spading
 use HOE, ROTARY
 HARROW, SPIKE-TOOTH
 HARROW, SPRING-TOOTH
 HARROW, TINE-TOOTH
 HARVESTER, BEAN
 HARVESTER, CORN SLED
 HARVESTER, FORAGE
 HARVESTER, ONION
 HARVESTER, POTATO
 HARVESTER, SUGAR-BEET
 HARVESTER, SUGARCANE
 HARVESTER, TOMATO
 Harvester/thresher
 use COMBINE
 HAYFORK
 HAY-LOADER
 HAY-LOADER, BALE
 HEADER, GRAIN
 HOE
 note use only if specific type is unknown
 HOE, BEET-THINNING
 Hoe, Bog
 use HOE, GRUB
 Hoe, Broad
 use HOE, GARDEN
 Hoe, Bunching
 use HOE, BEET-THINNING
 HOE, CELERY
 HOE, CORN
 HOE, COTTON
 Hoe, Cultivator
 use HOE, WEEDING
 Hoe, Dutch
 use HOE, SCUFFLE
 HOE, GARDEN
 HOE, GRAPE
 Hoe, Grass
 use HOE, MEADOW
 HOE, GRUB
 HOE, HOP
 Hoe, Horse
 use CULTIVATOR, ROW-CROP
 HOE, MATTOCK
 HOE, MEADOW
 Hoe, Narrow
 use HOE, GRUB
 HOE, NURSERY

AGRICULTURAL T&E (cont.)

```
Hoe, Plantation
     use   HOE, COTTON
Hoe, Planter
     use   HOE, COTTON
HOE, ROTARY
HOE, SCUFFLE
Hoe, Shuffle
     use   HOE, SCUFFLE
HOE, SUGAR BEET
HOE, TOBACCO
HOE, TURNIP
HOE, WARREN
HOE, WEEDING
Hoe, Wheel
     use   CULTIVATOR, WHEEL
Hook, Bagging
     use   HOOK, REAPING
Hook, Bill
     use   BILLHOOK
Hook, Bramble
     use   HOOK, BRUSH
HOOK, BRUSH
Hook, Bush
     use   HOOK, BRUSH
HOOK, CORN
     rt    KNIFE, CORN
Hook, Fagging
     use   HOOK, REAPING
Hook, Garden
     use   HOOK, NURSERY
HOOK, GRASS
Hook, Grub
     use   HOOK, POTATO
Hook, Hay
     use   CROOK, HAY
HOOK, HAY-BALE
HOOK, HEDGE
Hook, Husking
     use   CORNHUSKER, HAND
HOOK, MANURE
HOOK, NURSERY
HOOK, POTATO
HOOK, PRUNING
     rt    BILLHOOK
HOOK, REAPING
     rt    SICKLE
Hook, Shrubbery
     use   HOOK, NURSERY
Hook, Sith
     use   MATHOOK
Hook, Vine
     use   HOOK, NURSERY
```

AGRICULTURAL T&E (cont.)

Hummeler
 use BEARDER, BARLEY
Husker, Corn
 use CORNHUSKER, HAND or HUSKER/SHREDDER, CORN
HUSKER/SHREDDER, CORN
Husking machine
 use HUSKER-SHREDDER, CORN
INJECTOR, FERTILIZER
IRON, GRAFTING
JAR, SEED
KNIFE, BAND-CUTTER
KNIFE, BEET-TOPPING
Knife, Budding
 use KNIFE, GRAFTING
KNIFE, CORN
 rt HOOK, CORN
KNIFE, GRAFTING
KNIFE, HAY
 rt SPADE, HAY
Knife, Potato
 use CUTTER, POTATO-SEED
KNIFE, PRUNING
KNIFE, SUGARCANE
 rt MACHETE
KNIFE, TOBACCO
LADDER, FRUIT-PICKING
LEVELER, LAND
LIFTER, SOD
Lifter, Stump
 use PULLER, STUMP
Linter, Cottonseed
 use CLEANER, COTTONSEED
LOADER, CORN-SHOCK
Loader, Hay
 use HAY-LOADER
MACHETE
 rt KNIFE, SUGARCANE
MALLET, GRAFTING
MATHOOK
MATTOCK
MIDDLEBUSTER
Mill, Attrition
 use GRINDER, FEED
Mill, Fan
 use MILL, FANNING
MILL, FANNING
Mill, Feed
 use GRINDER, FEED
Mill, Hammer
 use GRINDER, FEED
Mill, Winnowing
 use MILL, FANNING

AGRICULTURAL T&E (cont.)

 MIXER, FEED
 MOWER
 MOWER, GANG-REEL
 MOWER, LAWN
 Mower, Semimounted
 use MOWER
 Mower, Tractor-drawn
 use MOWER or MOWER, GANG-REEL
 Mower, Tractor-mounted
 use MOWER
 MOWER/CONDITIONER
 rt CONDITIONER, HAY
 Mowing machine
 use MOWER
 Packer, Surface
 use ROLLER, LAND
 Peg, Husking
 use CORNHUSKER, HAND
 PICKER, CORN
 PICKER, COTTON
 PICKER, FRUIT
 PICKER, SWEET CORN
 PICKER/HUSKER, CORN
 PICKER/SHELLER, CORN
 Pin, Husking
 use CORNHUSKER, HAND
 Pitchfork
 use HAYFORK or FORK, MANURE
 PLANTER
 note use for a horse-drawn planter on which the
 operator rides and for a machine-drawn
 planter; may be further subdivided to indicate
 specific crop: e.g., PLANTER, POTATO
 Planter, Bed
 use PLANTER or PLANTER, WALKING
 Planter, Drill
 use PLANTER or PLANTER, WALKING or PLANTER, GARDEN
 PLANTER, GARDEN
 note use for a planter pushed by hand
 PLANTER, HAND
 note use for a planter carried by hand
 Planter, Lister
 use PLANTER or PLANTER, WALKING
 Planter, Precision
 use PLANTER
 Planter, Riding
 use PLANTER
 PLANTER, WALKING
 note use for an animal-drawn planter behind which
 the operator walks
 Planter, Walking-stick
 use PLANTER, HAND

106

AGRICULTURAL T&E (cont.)

Planter, Wheel
use PLANTER, GARDEN
Planting bar
use DIBBLE
Planting spud dibble
use DIBBLE
Planting stick
use DIBBLE
PLOW, BOG-CUTTER
Plow, Chisel
use PLOW, SUBSOIL
PLOW, DISK
PLOW, GARDEN
Plow, Lister
use MIDDLEBUSTER
Plow, Middlebuster
use MIDDLEBUSTER
PLOW, MOLDBOARD
Plow, One-way wheatland
use PLOW, DISK
Plow, Peat
use PLOW, BOG-CUTTER
PLOW, SHOVEL
PLOW, SUBSOIL
POT, SMUDGE
Press, Hay-baling
use BALER, HAY
PRUNER, TREE
PULLER, STUMP
Pulverizer, Surface
use ROLLER, LAND
RAKE
note use only if specific type is unknown
Rake, Buck
use RAKE, HAY-BUNCHING
Rake, Bull
use RAKE, HAND HAY
RAKE, CLOVER
RAKE, COMMON HAY
RAKE, CRANBERRY
RAKE, DUMP HAY
RAKE, FINGER-WHEEL HAY
Rake, Flip-flop
use RAKE, REVOLVING HAY
Rake, Floral
use RAKE, GARDEN
RAKE, GARDEN
Rake, Grain
use RAKE, HAND HAY
RAKE, GRAIN-BINDER'S
RAKE, HAND HAY

AGRICULTURAL T&E (cont.)

RAKE, HAY-BUNCHING
RAKE, LAWN
Rake, Man
 use RAKE, HAND HAY
RAKE, ONION
RAKE, REAPER-PLATFORM
Rake, Reel-type hay
 use RAKE, SIDE-DELIVERY HAY
RAKE, REVOLVING HAY
RAKE, SIDE-DELIVERY HAY
Rake, Spring-tooth hay
 use RAKE, DUMP HAY
Rake, Sweep
 use RAKE, HAY-BUNCHING
REAPER
Reaper, Hand-rake
 use REAPER
Reaper, Self-rake
 use REAPER
Reaper/mower
 use REAPER
RIDDLE, GRAIN
Riddle, Winnowing
 use RIDDLE, GRAIN
Roller, Corrugated
 use ROLLER, LAND
ROLLER, GARDEN
ROLLER, LAND
Roller, Lawn
 use ROLLER, GARDEN
SAW, PRUNING
SCISSORS, VINE
SCOOP, FEED
Scoop, Grain
 use SHOVEL, GRAIN
Scoop, Potato
 use FORK, VEGETABLE SCOOP
Scoop, Winnowing
 use BASKET, WINNOWING
SCRAPER, COTTON
SCYTHE
Scythe, Brush
 use SCYTHE
SCYTHE, CRADLE
SCYTHE, FLEMISH
Scythe, Grass
 use SCYTHE
Scythe, Hainault
 use SCYTHE, FLEMISH
Scythe, Weed
 use SCYTHE

AGRICULTURAL T&E (cont.)

Seeder, Broadcast
 <u>use</u> SEEDER, CENTRIFUGAL; SEEDER, HAND CENTRIFUGAL;
 SEEDER, HAND SEEDBOX; or SEEDER, SEEDBOX
SEEDER, CENTRIFUGAL
 <u>note</u> use for an animal- or machine-powered
 centrifugal seeder
Seeder, Endgate
 <u>use</u> SEEDER, CENTRIFUGAL
SEEDER, HAND CENTRIFUGAL
 <u>note</u> use for a hand-powered centrifugal seeder
SEEDER, HAND SEEDBOX
 <u>note</u> use for a hand-carried or -pushed seedbox
 seeder
Seeder, Rotary
 <u>use</u> SEEDER, CENTRIFUGAL or SEEDER, HAND CENTRIFUGAL
SEEDER, SEEDBOX
 <u>note</u> use for an animal- or machine-powered seedbox
 seeder
Seeder, Wheelbarrow
 <u>use</u> SEEDER, HAND SEEDBOX
Separator
 <u>use</u> THRESHER/SEPARATOR
SETTER, SEEDLING
SHAKER, TREE
Shears, Garden
 <u>use</u> SHEARS, HEDGE
SHEARS, HEDGE
SHELLER, CORN
SHOCKER, CORN
SHOVEL, GRAIN
Shovel, Potato
 <u>use</u> FORK, VEGETABLE SCOOP
SHREDDER, FLAIL
Shredder, Stalk
 <u>use</u> CUTTER, STALK
SICKLE
 <u>rt</u> HOOK, REAPING
Sickle, Grass
 <u>use</u> HOOK, GRASS
Sieve, Grain
 <u>use</u> RIDDLE, GRAIN
Sieve, Winnowing
 <u>use</u> RIDDLE, GRAIN
Sith
 <u>use</u> SCYTHE, FLEMISH
SLICER, EAR-CORN
Sling, Grain
 <u>use</u> SLING, HAY
SLING, HAY
Snapper, Corn
 <u>use</u> PICKER, CORN

AGRICULTURAL T&E (cont.)

```
SOIL-TESTING KIT
Sower, Broadcast
     use  SEEDER, CENTRIFUGAL or SEEDER, SEEDBOX
Sower, Seedbox
     use  SEEDER, SEEDBOX
SPADE, DITCHING
SPADE, DRAIN-TILE
SPADE, GARDEN
SPADE, HAY
     rt   KNIFE, HAY
SPADE, PEAT
Spade, Turf
     use  LIFTER, SOD
Spotting board
     use  DIBBLE
Sprayer, Bucket
     use  SPRAYER, HAND
Sprayer, Flame
     use  WEEDER, FLAME
SPRAYER, HAND
Sprayer, Knapsack
     use  SPRAYER, HAND
SPRAYER, POWER
Sprayer, Wheelbarrow
     use  SPRAYER, HAND
Spreader, Garden manure
     use  SPREADER, WHEELBARROW
SPREADER, MANURE
     note use for an animal- or machine-drawn spreader
SPREADER, WHEELBARROW
     note use for a hand-pushed spreader
SPRINKLER, IRRIGATION
Sprinkler, Knapsack
     use  SPRAYER, HAND
Spud, Dandelion
     use  SPUD, WEEDING
SPUD, WEEDING
Stacker, Cable
     use  STACKER, HAY
Stacker, Derrick
     use  STACKER, HAY
STACKER, HAY
Stacker, Overshot
     use  STACKER, HAY
Stacker, Swinging
     use  STACKER, HAY
Stacker, Tripod
     use  STACKER, HAY
STACK-MAKER, HAY
STONEBOAT
     rt   SLEDGE
```

AGRICULTURAL T&E (cont.)

 STRIPPER, COTTON
 STRIPPER, GRAIN
 Subsoiler
 use PLOW, SUBSOIL
 TEDDER, HAY
 Thresher, Groundhog
 use THRESHING MACHINE
 Thresher, Peanut
 use THRESHING MACHINE
 Thresher, Portable
 use THRESHER/SEPARATOR
 Thresher, Simple
 use THRESHING MACHINE
 Thresher, Stationary
 use THRESHER/SEPARATOR
 THRESHER/SEPARATOR
 THRESHING MACHINE
 Tier, Corn
 use TIER, CORN-SHOCK
 Tier, Corn-fodder
 use TIER, CORN-SHOCK
 TIER, CORN-SHOCK
 TILLER, GARDEN ROTARY
 TILLER, ROTARY
 TRACTOR, FARM
 TRACTOR, GARDEN
 TRAILER, FARM
 Trailer, Tractor-drawn
 use TRAILER, FARM
 TRANSPLANTER, HAND
 TRANSPLANTING MACHINE
 note may be further subdivided to indicate specific
 crop transplanted: e.g., TRANSPLANTING
 MACHINE, TOBACCO
 TROWEL, GARDEN
 Trowel, Nursery
 use TROWEL, GARDEN
 VINER, PEA
 Wagon, Tractor-drawn
 use TRAILER, FARM
 WEEDER, FLAME
 WEEDER, ROD
 WEEDER, SPRING-TOOTH
 Whip, Brush
 use CUTTER, WEED
 WINDROWER
 Winnower
 use BASKET, WINNOWING or MILL, FANNING
 Winnowing machine
 use MILL, FANNING

ANIMAL HUSBANDRY T&E

 def An artifact originally created to be used in the care,
 breeding and study of animals; includes instruments used
 in the practice of veterinary medicine, tools used in the
 psychological study of animals, and tools used by a
 farrier to work on animals; does not include equipment
 used in processing animal products for human use (see FOOD
 PROCESSING T&E) or tools used by a farrier to fabricate
 metal products (see METALWORKING T&E)

 ref (110)

 note use as the object name either one of the following terms
 or, for a veterinarian's instrument that is functionally
 comparable to an instrument used on humans, an object
 name selected from MEDICAL & PSYCHOLOGICAL T&E

 Adjuster, Hoof
 use LEVELER, HOOF
 ALPENHORN
 APIARY
 BEEHIVE
 BEE SMOKER
 BLANKET, HORSE
 BOOT, LAWN
 BOX, BEE
 BRANDER, FREEZING
 BRANDER, HORN
 BROODER, POULTRY
 BROOM, STABLE
 BRUSH, ANIMAL
 BRUSH, PET
 BUFFER, HOOF
 Butteris
 use TRIMMER, HORSE-HOOF
 CAGE, ANIMAL
 CANE, STOCKMAN'S
 CATCHER, HOG
 CATCHER, POULTRY
 Cattle leader
 use LEADER, LIVESTOCK
 Cattle prod
 use PROD, STOCK
 CHAIN, CURB
 CHAIN, OBSTETRICAL
 CHISEL, HOOF
 Clinch
 use CLINCHING BLOCK
 Clincher
 use TONGS, CLINCHING
 CLINCHING BLOCK
 Clip, Cow
 use HOLDER, COW-TAIL
 CLIPPER, ANIMAL

112

ANIMAL HUSBANDRY T&E (cont.)

COLLAR, BARK-TRAINING
COLLAR, CHOKE
COLLAR, FLEA
COLLAR, PET
Comb, Curry
 use CURRYCOMB
COMB, MANE
COMB, PET
COOP, POULTRY-SHIPPING
COWBELL
CRATE, HOG-BREEDING
CROOK, SHEPHERD'S
CURRYCOMB
Cutter, Nail
 use NIPPERS, NAIL
CUTTERS, MOLAR
DEBEAKER
DEHORNER
DETECTOR, HEATMOUNT
DOCKER
DRENCHER
EMASCULATOR
EXTRACTOR, CALK
EXTRACTOR, FETAL
FECALYZER
FEEDBAG
FEED BUNKS
FEED CARRIER
FEEDER, ESOPHAGEAL
FEEDER, LIVESTOCK
FEEDER, POULTRY
FENCE CHARGER
FLOAT, DENTAL
Fountain, Poultry
 use WATERER, POULTRY
Fountain, Stock
 use WATERER, LIVESTOCK
GAG, CANINE MOUTH
GROOVER, HOOF
Gum, Bee
 use BEEHIVE
GUN, BALLING
Gun, Dose
 use DRENCHER
GUN, MARKING
GUN, TATTOO
HALTER, CATTLE
HAMMER, FARRIER'S DRIVING
HAMMER, FARRIER'S FITTING
Hammer, Shoeing
 use HAMMER, FARRIER'S DRIVING

ANIMAL HUSBANDRY T&E (cont.)

 HATCHER, POULTRY
 HOBBLE
 HOLDER, COW-TAIL
 HOOD, SWEAT
 HOOK, OX
 HORSESHOE
 note may be further subdivided to indicate specific
 type: e.g., HORSESHOE, COACH; -,HINGED;
 -,FRONT; -,MUD
 HORSESHOE PAD
 INCUBATOR, POULTRY
 INSEMINATION KIT
 IRON, BRANDING
 IV SET, LARGE-ANIMAL
 KICK STOP
 Knife, Dehorning
 use DEHORNER
 Knife, Farrier's
 use more specific term: e.g., KNIFE, HOOF; KNIFE,
 TOE
 KNIFE, HOOF
 Knife, Shoeing
 use KNIFE, HOOF
 KNIFE, SOLE
 KNIFE, TEAT
 KNIFE, TOE
 LEADER, LIVESTOCK
 LEASH
 LEVELER, HOOF
 LIFT, COW
 LITTER CARRIER
 MARKER, ANIMAL
 note use only if specific type is unknown: e.g.,
 GUN, MARKING; IRON, BRANDING
 MILK TUBE, SELF-RETAINING
 MUZZLE
 NAIL, HORSESHOE
 NET, ANIMAL
 Nippers, Hoof
 use PARER, HOOF
 NIPPERS, NAIL
 note use for tool to cut the toe nails of small
 animals
 Nosebag
 use FEEDBAG
 NOTCHER, EAR
 OXSHOE
 OX-SHOEING FRAME
 PARER, HOOF
 PATTERN, EAR
 PICK, HOOF

ANIMAL HUSBANDRY T&E (cont.)

 PILL AID
 PIN, PROLAPSE
 PINCERS, FARRIER'S
 PIPETTE, INTRAUTERINE
 Pistol, Paint-pellet
 use GUN, MARKING
 POKE
 PROD, STOCK
 PROTRACTOR, HOOF
 PULLER, CALF
 Pullers, Shoe
 use PINCERS, FARRIER'S
 Punch, Ear
 use NOTCHER, EAR
 RACK, HORSE-SHOEING
 RASP, HOOF
 Rasp, Tooth
 use FLOAT, DENTAL
 RING, ANIMAL-NOSE
 RING, RECTAL
 RINGER, ANIMAL-NOSE
 Saw, Dehorning
 use DEHORNER
 SCALE, LIVESTOCK
 SCOOP, SANI
 SCRAPER, SWEAT
 SHEARS, FETLOCK
 SHEARS, SHEEP
 SHOEING BOX
 SHOEING STAND
 Shoe spreader
 use TONGS, SHOE-SPREADING
 SHOW STICK
 Skep, Bee
 use BEEHIVE
 SLAPPER, LIVESTOCK
 SLITTER, TEAT
 SWITCH, FLY
 SYRINGE, DOSE
 TAG, ANIMAL
 TAG, EAR
 TATTOO SET
 TESTER, HOOF
 THERMOMETER, INCUBATOR
 TIE, CATTLE
 TONGS, CLINCHING
 Tongs, Farrier's
 use more specific term: e.g., TONGS, CLINCHING;
 TONGS, SHOE-SPREADING
 TONGS, SHOE-SPREADING
 Tooth key
 use SPECULUM, ANIMAL

ANIMAL HUSBANDRY T&E (cont.)

```
    TOURNIQUET, JUGULAR-VEIN
    TRIMMER, EAR
    TRIMMER, HORSE-HOOF
    TRIMMER, OX-HOOF
    TROCAR
    Trough, Feed
          use  FEEDER, LIVESTOCK
    Trough, Poultry water
          use  WATERER, POULTRY
    Trough, Watering
          use  WATERER, LIVESTOCK
    TWISTER, NOSE
    Twitch, Nose
          use  TWISTER, NOSE
    WATERER, LIVESTOCK
    WATERER, POULTRY
    WEANER, CALF
    WEIGHT, HORN
    WEIGHT, TOE
```

ARMAMENT T&E
def An artifact originally created to be used for hunting,
 target shooting, warfare or self-protection; includes
 firearms, artillery, bladed and striking weapons; does not
 include objects designed for transporting troops or
 supplies (see Transportation Artifacts, Category 6)
ref (61) (84) (93) (94) (97)

ARMAMENT T&E, FIREARM
ref (14) (15) (18) (34) (49) (50) (82) (95) (100)
 (101) (111) (113)
note the first word(s) of the object name should be the type
 of firearm, selected from the list of terms below; this
 should be further subdivided to indicate the ignition
 system and, if appropriate, the word, CONVERSION, to show
 that the ignition system has been modified: e.g., MUSKET,
 MATCHLOCK; RIFLE, LONG FLINTLOCK; RIFLE, WHEELLOCK
 CONVERSION; PISTOL, AUTOMATIC RIM-FIRE. (See text for
 major ignition system terms.)

```
    ARQUEBUS
          rt   MUSKET
    BLUNDERBUSS
    CANNON, HAND
    CARBINE
          rt   PETRONEL
    DERRINGER
          rt   PISTOL
    FLAMETHROWER
```

ARMAMENT T&E, FIREARM (cont.)

```
      FOWLER
      FUSIL
            rt    MUSKET
      Gun, Bird
            use   more specific term: e.g., RIFLE, SHOTGUN
      Gun, Burp
            use   GUN, SUBMACHINE
      Gun, Capture
            use   GUN, TRANQUILIZER
      GUN, COMBINATION
      GUN, DART
      GUN, FOLDING
      Gun, Game
            use   more specific term: e.g., RIFLE, SHOTGUN
      Gun, Grease
            use   GUN, SUBMACHINE
      GUN, HARPOON
      GUN, MACHINE
          note may be further subdivided according to size:
                e.g., GUN, LIGHT MACHINE; GUN, MEDIUM MACHINE;
                GUN, HEAVY MACHINE
      GUN, SUBMACHINE
      GUN, TRANQUILIZER
      Gun, Whaling
            use   GUN, HARPOON
      Handgun
            use   more specific term: e.g., PISTOL, REVOLVER
      Harquebus
            use   ARQUEBUS
      LAUNCHER, GRENADE
      MUSKET
            rt    ARQUEBUS; FUSIL
      MUSKETOON
      PEPPERBOX
      PETRONEL
            rt    CARBINE
      PISTOL
          note use only if specific type is unknown
            rt    REVOLVER; DERRINGER
      PISTOL, AUTOMATIC
      PISTOL, DUELLING
      PISTOL, HORSEMAN'S
      Pistol, Machine
            use   GUN, SUBMACHINE
      PISTOL, POCKET
      PISTOL, TARGET
      PISTOL/AX
      PISTOL/CARBINE
      PISTOL/CUTLASS
      PISTOL/KNIFE
      PISTOL/SWORD
```

117

ARMAMENT T&E, FIREARM (cont.)

 REVOLVER
 rt PISTOL
 RIFLE
 Rifle, Kentucky
 use RIFLE, LONG
 RIFLE, LONG
 RIFLE, MILITARY
 Rifle, Pennsylvania
 use RIFLE, LONG
 RIFLE, PLAINS
 RIFLE, TARGET
 RIFLE/AX
 RIFLE/MUSKET
 RIFLE/SHOTGUN
 SHOTGUN
 note any form of SHOTGUN may be further subdivided
 to indicate the number of barrels: e.g.,
 SHOTGUN, SINGLE-BARREL; -,DOUBLE-BARREL;
 -,MULTI-BARREL; -,REPEATING SINGLE-BARREL
 SHOTGUN, REPEATING
 SHOTGUN, SKEET
 SHOTGUN, TRAP
 Weapon, Automatic
 use GUN, MACHINE or GUN, SUBMACHINE

ARMAMENT T&E, EDGED
 ref (9) (26) (90) (91) (92)

 ANGON
 ARROW
 ARROWHEAD
 rt PROJECTILE POINT
 AX, BELT
 AX, BOARDING
 BARDICHE
 BASELARD
 BATTLE-AX
 BAYONET, KNIFE
 BAYONET, PLUG
 BAYONET, SOCKET
 BAYONET, SWORD
 BAYONET, TRIANGULAR
 BILL
 Bill hook
 use BILL
 BLOWGUN
 BOLO
 BOW
 BROADSWORD
 CLAYMORE

ARMAMENT T&E, EDGED (cont.)

CROSSBOW
CUTLASS
DAGGER
> <u>note</u> use only if specific type is unknown: e.g.,
> PONIARD, STILLETTO

DART
DIRK
Gig
> <u>use</u> SPEAR

GRAIN
HALBERD
HARPOON
KNIFE, BOWIE
KNIFE, THROWING
KRIS
LANCE
LANCE, WHALE
Misericord
> <u>use</u> DAGGER

PARTISAN
PIKE
PIKE, AWL
PIKE, BOARDING
POLEAX
PONIARD
PREFORM, PROJECTILE-POINT
PROJECTILE POINT
> <u>rt</u> ARROWHEAD

RAPIER
SABER
SABER, FENCING
> <u>rt</u> FENCING EPEE; FENCING FOIL

SPEAR
SPEAR, EEL
SPEAR, FISH
SPEAR, SQUID
SPONTOON
STILLETTO
SWORD
> <u>note</u> use only if specific type is unknown: e.g.,
> SABER, CLAYMORE

SWORD, HUNTING
TOMAHAWK

ARMAMENT T&E, BLUDGEON

BLACKJACK
BOLA
BOOMERANG
BRASS KNUCKLES

ARMAMENT T&E, BLUDGEON (cont.)

 CLUB
 HAMMER, WAR
 MACE
 POGAMOGGAN
 SHILLELAGH
 SLINGSHOT

ARMAMENT T&E, ARTILLERY

 ARTILLERY, BREECH-LOADING
 note use only if specific type is unknown
 ARTILLERY, MUZZLE-LOADING
 note use only if specific type is unknown: e.g.,
 CARRONADE, FALCONET
 BALLISTA
 BAZOOKA
 CANNON
 CANNON, PETRONEL
 CANNON, SERPENTINE
 CARRONADE
 CATAPULT
 CULVERIN
 DEMI-CANNON
 DEMI-CULVERIN
 FALCON
 FALCONET
 GUN, ANTIAIRCRAFT
 GUN, ANTITANK
 GUN, FIELD
 GUN, GARRISON
 GUN, GATLING
 GUN, RAILWAY
 GUN, RECOILESS
 GUN, SEA-COAST
 GUN, SEIGE
 GUN, SELF-PROPELLED
 GUN, SWIVEL
 GUN/HOWITZER
 HOWITZER
 MANGONEL
 MINION
 MORTAR
 PERRIER
 PETARD
 RAM, BATTERING
 RIFLE, FIELD
 RIFLE, SEA-COAST
 ROBINET
 SAKER
 TANK DESTROYER
 TREBUCKET

ARMAMENT T&E, AMMUNITION

Ball, Minie
 use BULLET, MINIE
BALL, MUSKET
Bb
 use CAP, BB
BOMB, AIR-TO-AIR
BOMB, AIR-TO-SURFACE
BOMB, AIR-TO-UNDERWATER
Bomb, Antiaircraft
 use BOMB, AIR-TO-AIR
BULLET
 note use only if specific type is unknown
BULLET, ARMOR-PIERCING
BULLET, CONTROLLED-EXPANSION
BULLET, EXPANDING
BULLET, INCENDIARY
BULLET, MINIE
BULLET, TRACER
CANISTER ROUND
CANNONBALL
CAP, BB
CARCASS
CARTRIDGE
 note may be further subdivided according to
 ignition system: e.g., CARTRIDGE, RIM-FIRE
CARTRIDGE, CASELESS
CARTRIDGE, DUMMY
CHARGE, DEPTH
DART, AERIAL
GRAPESHOT
GRENADE, ANTIPERSONNEL
GRENADE, ANTITANK
GRENADE, INCENDIARY
MINE
 note may be further subdivided by LAND or SEA and
 PORTABLE or FIXED: e.g., MINE, PORTABLE LAND
Minieball
 use BULLET, MINIE
MISSILE, AIR-TO-AIR
MISSILE, AIR-TO-SURFACE
MISSILE, AIR-TO-UNDERWATER
MISSILE, AIR-TO-WATER
Missile, Antiaircraft
 use MISSILE, SURFACE-TO-AIR
Missile, Antimissile
 use MISSILE, SURFACE-TO-AIR or MISSILE, AIR-TO-AIR
Missile, Ballistic
 use more specific term: e.g., MISSILE, AIR-TO-AIR
MISSILE, SURFACE-TO-AIR
MISSILE, SURFACE-TO-SURFACE

ARMAMENT T&E, AMMUNITION (cont.)

 MISSILE, UNDERWATER-TO-SURFACE
 PRIMER
 Rocket
 use MISSILE
 SHELL, ARTILLERY
 SHELL, SHOTGUN
 SHOT, BAR
 SHOT, CASE
 TORPEDO
 TORPEDO, AERIAL

ARMAMENT T&E, BODY ARMOR
 ref (17) (68) (115)

 ARMELTS
 BACKPLATE
 BASCINETE
 BREASTPLATE
 BURGONET
 Collar
 use GORGET
 GAUNTLET
 GORGET
 HAT, KETTLE
 HELM
 HELMET
 LEG-HARNESS
 MAIL
 MORION
 PAULDRON
 PLATE
 SABOTON
 SALLET
 SPAUDLER
 VAMBRACE
 VEST, BULLETPROOF
 VEST, FLAK
 ZISCHAGGE

ARMAMENT ACCESSORY

 ADAPTER, BARREL
 ADAPTER, GRIP
 AIMING POST
 Ammunition belt
 use BELT, AMMUNITION
 ARM GUARD
 ARMOR
 note use only for entire suit of armor; see also
 separate items: e.g., HAUBERK, JAMBEAU, HEAUME

ARMAMENT ACCESSORY (cont.)

 AUGER, FUZE
 BAG, HUNTING
 BALDRIC
 BANDOLIER
 BAND SET
 BASTILLE
 BAZOOKA PANTS
 BELT, AMMUNITION
 BELT, CARTRIDGE
 BELT, CARTRIDGE-BOX
 BELT, LINK
 BELT, SWORD
 BIPOD
 BOX, AMMUNITION
 BOX, CARTRIDGE
 BOX, PATCH
 BRAKE, MUZZLE
 BUCKET
 note may be further subdivided to indicate specific
 type: e.g., BUCKET, TAR; -,GREASE
 BUCKLER
 CALIPERS, GUNNER'S
 CALIPERS, SHELL
 CALL, GAME
 CALTROP
 CAP, MUSKET
 CAP, MUZZLE
 CAP, PERCUSSION
 Cartridge belt
 use BELT, CARTRIDGE
 CASE, CARTRIDGE
 CASE, GUN
 CAT
 CHARGER, NIPPLE
 CHEST, AMMUNITION
 CHEVAL-DE-FRISE
 CLAY BIRD
 CLEANING ROD
 CLIP, CARTRIDGE
 CRADLE, CANNON
 CUTTER, CAKE
 CUTTER, FUZE
 CUTTER, SPRUE
 CUTTER, WAD
 DECOY
 DETECTOR, MINE
 DIE, LOADING
 rt LOADING TOOL
 DISPENSER, CAP
 ELEVATING BAR
 EXTRACTOR, FUZE

ARMAMENT ACCESSORY (cont.)

 EXTRACTOR HOOP
 FALSE MUZZLE
 FLAG, WIND
 FLASH HIDER
 FLASH SUPPRESSOR
 FLASK, POWDER
 FLASK, PRIMING
 FLASK, SHOT
 FORK, HOT-SHOT
 GAUGE, BULLET
 GAUGE, VENT
 GAUGE, WIND
 GIMLET, FUZE
 GIMLET, GUNNER'S
 GLOVE, TARGET SHOOTER'S
 GOUGE, FUZE
 GRATE, HOT SHOT
 GUN-CLEANING KIT
 GYROJET
 HANDSPIKE
 HAVERSACK, GUNNER'S
 HOLDER, CARTRIDGE
 HOLDER, SHELL
 HOLSTER
 HOOK, SHELL
 HORN, POWDER
 JACKET, TARGET SHOOTER'S
 JAG
 KEG, POWDER
 Key, Nipple
 use WRENCH, NIPPLE
 KNOCKOUT ROD
 LEVEL, GUNNER'S
 LINSTOCK
 LOADING TOOL
 rt DIE, LOADING
 LOCK, CANNON
 LOCKER, ARMS
 LUBRICATOR-SIZER
 MACHINE REST
 MAGAZINE
 MALLET, FUZE
 MEASURE, POWDER
 MITTEN, TARGET SHOOTER'S
 MOLD, BALL
 MOLD, BULLET
 MOLD, FUZE
 MOLD, PORTFIRE
 MOLD, ROCKET
 MOLD, WAD
 PATTERN, CARTRIDGE

ARMAMENT ACCESSORY (cont.)

PENDULUM, BALLISTIC
PERCUSSION TUBE
PINCERS, GUNNER'S
PORTFIRE STOCK
POUCH, CAP
POUCH, GUNNER'S
POUCH, PRIMER
POUCH, SHOT
PRESS, CARTRIDGE-CASE
PRESS, PRIMING
PRICKER
PRIMER, NIPPLE
PRIMING WIRE
PULLER, BULLET
PUNCH, VENT
QUIVER
QUOIN
RACK, ARMS
RACK, BOMB
RAKE, HOT-SHOT
REAMER, CHAMBER
REAMER, FUZE-PLUG
RECOIL BUFFER
REMOVER, CASE
REMOVER, DENT
ROCKET-DRIVING MACHINE
RULE, TRUNNION
SAFETY, GRIP
SAW, FUZE
SCABBARD
 note may be further subdivided to indicate weapon
 held: e.g., SCABBARD, DAGGER
Scope, Rangefinder
 use SIGHT, TELESCOPE
Scope, Sniper's
 use SIGHT, TELESCOPE
Scope, Target
 use SIGHT, TELESCOPE
SCRAPER, BAND
SCRAPER, BARREL
SCRAPER, MORTAR
SCRAPER, SHELL
SEARCHER, VENT
SEATER, BULLET
SETTER, FUZE
SHEARS, PORTFIRE
SHEATH
SHIELD
SIGHT
 note may be further subdivided to indicate specific
 type: e.g., SIGHT, GLOBE; -,MICROMETER;

ARMAMENT ACCESSORY (cont.)

 -,MILITARY; -,TANG; -,TELESCOPE; -,VERNIER;
 -,WINDGAUGE
SIGHT DISK
SIGHT EXTENSION
SIGHT MOUNT
SILENCER
SLED, ARTILLERY
SLEEVE, GUNNER'S
SLING
SLING KEEPER
SNAP CAP
SPACER
SPIKE, CANNON
STABILIZER
STARTER, BULLET
TAP, FUZE
TARGET
 note may be further subdivided to indicate specific
 type: e.g., TARGET, ARCHERY; -,SKEET
TELESCOPE, SPOTTING
TESTER, POWDER
TESTUDO
Tetrahedron
 use CALTROP
THROAT PROTECTOR
THUMBSTALL
TINDERBOX
TINDERBOX, POCKET
TONGS, LOADING
TONGS, ROCKET
TONG TOOL
TRAP
TRAP, BULLET
Trap, Cartridge
 use TRAP, BULLET
TRAP, HAND
TRAY, BALL
TRIGGER SHOE
TRIPOD
TRUNNION
TURRET, MACHINE GUN
VENT COVER
VISE, BREECHING
VISE, LOCK-SPRING
Weight, Barrel
 use STABILIZER
WORM
WRENCH, BREECHING
WRENCH, COCK
WRENCH, COCK-AND-HAMMER
WRENCH, FRONT-SIGHT

ARMAMENT ACCESSORY (cont.)

 WRENCH, FUZE
 WRENCH, GUN-CARRIAGE
 WRENCH, MUZZLE
 WRENCH, NIPPLE
 WRIST GUARD

ASTRONOMICAL T&E
 def An artifact originally created to be used in the
 observation, measurement and recording of objects and
 events outside of the earth's atmosphere; see also OPTICAL
 T&E and SURVEYING & NAVIGATIONAL T&E
 ref (116)

 AETHRIOSCOPE
 ARMILLARY SPHERE
 ASTRODICTICUM
 ASTROLABE
 Astrolage
 use ASTROLABE
 ASTROMETER
 ASTROPATROTOMETER
 ASTROSCOPE
 CAMERA, SCHMIDT
 rt TELESCOPE, REFLECTING
 CHROMATOSCOPE
 CLOCK, ASTRONOMICAL
 CLOCK, SIDEREAL
 CORONOGRAPH
 Cosmolabe
 use ASTROLABE
 COSMOSPHERE
 CYANOMETER
 DIPLEIDOSCOPE
 ECLIPSAREON
 GEODESCOPE
 HELIOMETER
 HELIOSCOPE
 INTERFEROMETER, RADIO
 MAGNETOGRAPH
 MERIDIAN CIRCLE
 METEOROSCOPE
 MIRROR
 ORRERY
 PHOTOHELIOGRAPH
 PHOTOMETER, PHOTOELECTRIC
 PLANETARIUM
 PLANISPHERE
 PRISM, OBJECTIVE
 PYRHELIOMETER
 QUADRANT, ASTRONOMICAL

127

ASTRONOMICAL T&E (cont.)

> SELENOTROPE
> SIDEROSTAT
> SPECTROHELIOGRAPH
> Speculum
>> <u>use</u> MIRROR
> SPHEROSCOPE
> TELENGISCOPE
> TELEPOLARISCOPE
> TELESCOPE
> TELESCOPE, ACHROMATIC
> TELESCOPE, CASSEGRAIN
> TELESCOPE, EQUATORIAL
> TELESCOPE, GALILEAN
> TELESCOPE, ORBITING
> TELESCOPE, RADIO
> TELESCOPE, REFLECTING
>> <u>note</u> use only if specific type is unknown: e.g.,
>> TELESCOPE, CASSEGRAIN
> TELESCOPE, REFRACTING
>> <u>note</u> use only if specific type is unknown: e.g.,
>> TELESCOPE, ACHROMATIC; TELESCOPE, GALILEAN
> Telescope, Schmidt
>> <u>use</u> CAMERA, SCHMIDT
> TELESCOPE, SOLAR
> TELESPECTROSCOPE

BIOLOGICAL T&E
> <u>def</u> An artifact originally created to be used in the
> observation, measurement and recording of the
> physiological or anatomical aspects of organisms for
> purposes other than diagnosis or treatment; see also
> MEDICAL & PSYCHOLOGICAL T&E and ANIMAL HUSBANDRY T&E
> <u>ref</u> (30) (43) (58) (96) (114) (129)

> AEROSCOPE
> AESTHESIOMETER
> AMMONIA-ABSORPTION APPARATUS
> AUXANOMETER
> BACTERIOSCOPE
> BATH, DEHYDRATING
> BATH, EMBEDDING
> BLOWPIPE
> CENTRIFUGE, HUMAN
> CHAMBER, HELIOTROPIC
> CHROMATROPE
> CLINOSTAT
> COAGULOMETER
> CONCHOMETER
> CONFORMATEUR
> COUNTING APPARATUS

BIOLOGICAL T&E (cont.)

 CRANIOMETER
 CULTURE APPARATUS, ANAEROBIC
 DISH, CULTURE
 DISH, PETRI
 Esthesiometer
 use AESTHESIOMETER
 FILTER, SEITZ
 FILTER, SERUM
 FLASK, CULTURE
 FORCEPS, DISSECTING
 GERMINATION BOX
 GRANOMETER
 HEMACYTOMETER
 HEMAGLOBINOMETER
 INCUBATOR
 KAHN TEST APPARATUS
 LYSIMETER
 MICROTOME
 NEEDLE, DISSECTING
 OSMOSCOPE
 PENCIL, SKIN-MARKING
 PHOTOSYNTHOMETER
 POSTUROMETER
 POTOMETER
 RESPIROMETER
 SCISSORS, DISSECTING
 SHAKING APPARATUS
 STAINING APPARATUS
 STETHOGONIOMETER
 TASEOMETER
 TUBE, CULTURE
 VAN SLYKE APPARATUS

CHEMICAL T&E
 def An artifact originally created to be used in the study
 and/or manufacture of substances based upon their
 compositon, structure and molecular properties; see also
 MECHANICAL T&E and NUCLEAR PHYSICS T&E
 ref (30) (43) (58) (96) (129)

 ACETOMETER
 ACTINOGRAPH
 ACTINOMETER
 ADENY'S APPARATUS
 ALCOHOLOMETER
 Alembic
 use DISTILLING APPARATUS
 ALKALIMETER
 AMMONIAMETER
 ANTHROCOMETER

CHEMICAL T&E (cont.)

 APOPHOROMETER, CHEMICAL
 AQUAMETER
 ARGENTOMETER
 ATMOLYSER
 AZOTOMETER
 BAROMETER TUBE, SIPHON
 BAROMETER TUBE, STRAIGHT
 BASIN, FLUSHING
 BASIN, RINSING
 BATH, WATER
 BEAKER
 note may be further subdivided to indicate specific
 type: e.g., BEAKER, GRIFFEN; -,BERZELIUS;
 -,PHILLIPS
 BLANCHIMETER
 BOTTLE
 note may be further subdivided to indicate specific
 type: e.g., BOTTLE, ASPIRATOR; -,CENTRIFUGE;
 -,REAGENT; -,GAS-WASHING
 BRUSH
 note may be further subdivided to indicate specific
 type: e.g., BRUSH, PIPETTE; -,BURETTE
 BULB
 note may be further subdivided to indicate specific
 type: e.g., BULB, ABSORPTION; -,CONNECTING
 BURETTE
 note may be further subdivided to indicate specific
 type: e.g., BURETTE, MOHR; -,GEISSLER;
 -,STOPCOCK; -,TITRATION
 BURNER
 note may be further subdivided to indicate specific
 type: e.g., BURNER, ARGAND; -,BUNSEN
 BURNER TIP
 CALCIMETER
 CARBOLIMETER
 CARBONOMETER
 CARBUROMETER
 CATALYTIC APPARATUS
 CATHETOMETER
 CEMENT VICAT APPARATUS
 CENTRIFUGE, CHEMICAL
 CENTRIFUGE, CLINICAL
 CHLOROMETER
 CHYOMETER
 CLAMP
 note may be further subdivided to indicate specific
 type: CLAMP, STOPCOCK; -,HOSECOCK; -,SUSPENSION
 Colorimeter
 use COMPARATOR
 COMPARATOR
 note may be further subdivided to indicate specific

CHEMICAL T&E (cont.)

 type: e.g., COMPARATOR, HIGH-PHOSPHATE SLIDE;
 -,HYDROGEN-ION; -,NESSLER TUBE
CONE, IMHOFF
CONE SUPPORT, IMHOFF
CRUCIBLE
DASYMETER
DESSICATOR
DIFFUSIOMETER
DILATOMETER
DISH
 note may be further subdivided to indicate specific
 type: e.g., DISH, PETRI; -,EVAPORATING
DISTILLING APPARATUS
 rt FLASK, DISTILLING; RECEIVER; RETORT
DOSIMETER
EFFLUENT SAMPLER
ELACOMETER
EXTRACTOR
FLASK
 note may be further subdivided to indicate specific
 type: e.g., FLASK, BOILING; -,CULTURE;
 -,DISTILLING; -,ERLENMEYER; -,FILTERING
FLOAT TEST APPARATUS
FUNNEL
FURNACE, CEMENT-TEST
GAUGE, AMMONIA
GRADUATE
HALOMETER
HOLDER, RETORT
HOT EXTRACTION APPARATUS
HOT WATER GEYSER
 note use for apparatus attached to wall with water
 and gas tap
HYDROPHORE
HYDROSCOPE
INDICATOR, VOLUME-CHANGE
INDICATOR, WATER-STABILITY
LAMP, SPIRIT
LEVELING BOARD
LOGOMETER
MANOMETER
MELANOSCOPE
Micromanometer
 use MANOMETER
MORTAR
NATROMETER
NEEDLE, GILLMORE
NITROMETER
OSMOMETER
PENETROMETER
PERCOLATOR

131

CHEMICAL T&E (cont.)

PESTLE
PHOSPHOROSCOPE
PIPE, DRAUGHT
 note use for funnel collecting gases over
 experiment table
PIPETTE
 note may be further subdivided to indicate specific
 type: e.g., PIPETTE, ABSORPTION; -,VOLUMETRIC
RECEIVER
 rt DISTILLING APPARATUS
RETORT
 rt DISTILLING APPARATUS
SACCHARIMETER
SALIMETER
Salinometer
 use SALIMETER
SHAKER, PIPETTE
SHAKER, WATER BATH
SIPHON
SPINTHARISCOPE
STIRRER
STOPCOCK
TABLE, FLOW
TESTER, FINENESS
TESTER, SOUNDNESS
TITHONOMETER
TITRATOR
TITROMETER
TONGS
 note may be further subdivided to indicate specific
 type: e.g., TONGS, FLASK; -,BEAKER; -,MERCURY;
 -,CASSEROLE; -,UTILITY
TRIPOD
TROUGH, PNEUMATIC
TUBE
 note may be further subdivided to indicate specific
 type: e.g., TUBE, CENTRIFUGE; -,COMBUSTION;
 -,CULTURE; -,TEST
TUBING
 note may be further subdivided to indicate specific
 type: e.g., TUBING, ADAPTER
VAPORIMETER
WASHER, GLASSWARE
WATCH GLASS
WATER ANALYSIS SET
 note use for composite unit: i.e., reagents, flask,
 tongs, measuring cylinders, color standards,
 etc.

132

CONSTRUCTION T&E
 def An artifact originally created to be used in the
 construction, repair, maintenance or demolition of
 buildings, highways and other structural facilities; see
 also other T&E classifications for specialized tools used
 in construction trades

 BACKHOE
 BACKHOE/FRONT-END LOADER
 Ball, Headache
 use BALL, WRECKING
 BALL, WRECKING
 BATCH PLANT
 Blade
 use GRADER
 BUCKET, CLAMSHELL
 BUCKET, DRAGLINE
 BULLDOZER
 note use for composite unit: i.e., a TRACTOR with
 BULLDOZER BLADE attached
 BULLDOZER BLADE
 Compacter
 use ROLLER or TAMPER
 Ditching machine
 use TRENCHING MACHINE
 Dozer
 use BULLDOZER
 Drill
 note see MINING T&E
 Excavator
 use more specific term: e.g., BACKHOE, TRENCHING
 MACHINE
 GRADER
 GUNNITE MACHINE
 Jackhammer
 use DRILL, PERCUSSIVE AIR under MINING T&E
 LOADER, FRONT-END
 PILE DRIVER
 RAKE, GRADING
 ROLLER
 SAW, CONCRETE
 SCARIFIER
 SCRAPER
 SHOVEL, POWER
 SPREADER, ASPHALT
 Steamroller
 use ROLLER
 TAMPER
 TIERING MACHINE
 TRACTOR
 TRENCHING MACHINE
 TRENCHING MACHINE, ROTARY

133

DATA PROCESSING T&E
 <u>def</u> An artifact originally created to be used for processing
 data by manual, mechanical or electronic means; includes
 numerical and word-processing devices (e.g., an abacus, a
 digital computer), process-control devices (e.g., an
 analog computer) and learning devices (e.g., a teaching
 machine); see also Communication Artifacts (Category 5)
 and DRAFTING T&E
 <u>ref</u> (62) (75) (109)

 ABACUS
 Accounting machine
 <u>use</u> BOOKKEEPING MACHINE
 ADDING MACHINE
 ANALYZER
 <u>note</u> use only if specific type is unknown
 <u>rt</u> COMPUTER, ANALOG
 ANALYZER, DIFFERENTIAL
 ANALYZER, HARMONIC
 ANALYZER, NETWORK
 ANGLEOMETER
 ASSEMBLY UNIT
 AUDIO-RESPONSE UNIT
 AUTOMATON
 BOOKKEEPING MACHINE
 BOOKKEEPING MACHINE, MAGNETIC-CARD
 Buffer, Peripheral
 <u>use</u> STORE, BUFFER
 BURSTER
 CABLE
 CALCULATING ROD
 CALCULATOR
 <u>note</u> may be further subdivided to indicate specific
 type: e.g., CALCULATOR, DESK; -,POCKET
 CALCULATOR, PROGRAMMABLE
 CARD, EDGE-NOTCH
 CARD, PUNCH
 Card controller
 <u>use</u> PROCESSOR, CARD
 CENTRAL PROCESSOR
 CHAD
 Charactron
 <u>use</u> DISPLAY UNIT, VISUAL
 COLLATOR
 COMPARATOR
 COMPUTER, ANALOG
 <u>rt</u> ANALYZER
 COMPUTER, DIGITAL
 <u>note</u> use for the composite system of the CENTRAL
 PROCESSING UNIT and associated peripheral
 equipment

DATA PROCESSING T&E (cont.)

COMPUTER, HYBRID
<u>note</u> use for a computer which combines analog and
digital features
Computer, Micro
<u>use</u> MICROCOMPUTER
Computer, Mini
<u>use</u> MINICOMPUTER
Computer, Satellite
<u>use</u> more specific term for external processing
unit: e.g., MINICOMPUTER
CONSOLE
CONTROL UNIT, PERIPHERAL
CONVERTER
<u>note</u> may be further subdivided to indicate specific
type: e.g., CONVERTER, DIGITAL-TO-ANALOG;
-,ANALOG-TO-DIGITAL; -,CARD-TO-TAPE
COUPLER
Data phone
<u>use</u> COUPLER
Dataplotter
<u>use</u> PLOTTER
Data-processing machine
<u>use</u> more specific term: e.g., COMPUTER, ANALOG
DATA SET
DECODER
DISK, MAGNETIC
DISK UNIT
DISPLAY UNIT, VISUAL
<u>note</u> use only for a CRT output display unit which
cannot function as an interactive terminal
DRUM, MAGNETIC
ENCODER
GENERATOR
<u>note</u> may be further subdivided to indicate specific
type: e.g., GENERATOR, FUNCTION; -,PRIME NUMBER
GRADUATOR
HOLOMETER
INTEGRATOR
<u>rt</u> PLANIMETER
Keypunch
<u>use</u> PUNCH, KEYBOARD
Main frame
<u>use</u> CENTRAL PROCESSOR
Memory
<u>use</u> more specific term: e.g., CORE; DISK; DRUM,
MAGNETIC
MICROCOMPUTER
MINICOMPUTER
MULTIPLEXOR
<u>rt</u> VARIOPLEX
Napier's bones
<u>use</u> CALCULATING ROD

DATA PROCESSING T&E (cont.)

ORTHOSCANNER
 rt READER, CHARACTER
PATCH
Pen, Light
 use STYLUS, LIGHT
PERFORATOR
Peripheral equipment
 use more specific term: e.g., DRIVE, DISK; READER,
 OPTICAL CHARACTER
PINBOARD
PINBOARD MACHINE
PLANIMETER
 rt INTEGRATOR
PLOTTER
Plug board
 use PATCH
Posting machine
 use BOOKKEEPING MACHINE
PRINTER
 note may be further subdivided to indicate specific
 type: e.g., PRINTER, MATRIX; -,LINE;
 -,ON-THE-FLY; -,SERIAL
PRINTER, KEYBOARD
Processor, Central
 use CENTRAL PROCESSOR
Punch, Card
 use PUNCH, KEYBOARD
PUNCH, GANG
PUNCH, KEYBOARD
PUNCH, SPOT
PUNCH, SUMMARY
PUNCHBOARD
READER, CARD
READER, CHARACTER
 rt ORTHOSCANNER
READER, TAPE
RECORDER, FILM
REPRODUCER, CARD
REPRODUCER, TAPE
SCALE
Scanner, Optical
 use READER, CHARACTER
SENSING/PUNCHING UNIT, CARD
SIMULATOR
SLIDE RULE
SORTER, CARD
SPHEROMETER
Storage
 use STORE or more specific term: e.g., DISK,
 MAGNETIC

DATA PROCESSING T&E (cont.)

> STORE
> > note use only if specific type is unknown: e.g.,
> > DISK, MAGNETIC; TAPE, MAGNETIC; DRUM, MAGNETIC
> STORE, BUFFER
> STYLUS, LIGHT
> TABULATING MACHINE
> TAPE, MAGNETIC
> TAPE, PAPER
> TAPE UNIT
> TEACHING MACHINE
> TELEPRINTER
> TERMINAL
> > note may be further subdivided to indicate specific
> > type: e.g., TERMINAL, CRT; -,TYPEWRITER;
> > -,MAGNETIC-TAPE
> TEST-SCORING DEVICE
> TYPEWRITER
> > note should be further subdivided to indicate
> > specific type: e.g., TYPEWRITER, CONSOLE;
> > -,MAGNETIC-CARD; -,MAGNETIC-TAPE
> VARIOPLEX
> > rt MULTIPLEXOR
> VERIFIER

DRAFTING T&E
> def An artifact originally created to be used for precision
> drawing (e.g., a T-square, a drafting table); includes
> instruments used to record surveying and navigational
> observations; does not include general-purpose writing or
> lettering tools (see WRITTEN COMMUNICATION EQUIPMENT in
> Category 5, and PAINTING T&E); see also DATA PROCESSING
> T&E
> ref (55) (64)

> ARCOGRAPH
> BROOK'S CURVE
> CAMPYLOMETER
> CENTROLINEAD
> CHARTOMETER
> COMPASS, BEAM
> COMPASS, BOW
> COMPASS, PROPORTIONAL
> CONOGRAPH
> > note use only if specific type is unknown: e.g.,
> > ELLIPSOGRAPH
> CURVE
> CYCLOIDOGRAPH
> CYCLOMETER
> CYMOGRAPH
> DIVIDERS

137

DRAFTING T&E (cont.)

 DIVIDERS, CHART
 DIVIDING ENGINE
 DRAFTING MACHINE
 ECCENTROLINEAD
 Eidograph
 use PANTOGRAPH
 ELLIPSOGRAPH
 Elliptograph
 use ELLIPSOGRAPH
 Geometric model
 use INSTRUCTIONAL MODEL
 HELICOGRAPH
 HYALOGRAPH
 ISOGRAPH
 MICROGRAPH
 ODONTOGRAPH
 PANTOGRAPH
 PEN, RULING
 PERSPECTOGRAPH
 Plagiograph
 use PANTOGRAPH
 Planigraph
 use PANTOGRAPH
 PROTRACTOR
 RHUMBOSCOPE
 ROTAMETER
 RULE, PARALLEL
 RULING ENGINE
 SCALE, ARCHITECT'S
 SECTOGRAPH
 SECTOR
 SPIROGRAPH
 SPRING BOW
 STYLUS
 TABLE, DRAFTING
 TRACER, CURVE
 Trammel points
 use COMPASS, BEAM
 TRIANGLE
 T-SQUARE

ELECTRICAL & MAGNETIC T&E
 def An artifact originally created to be used in the
 observation, measurement and recording of electrical and
 magnetic phenomena; includes tools, equipment and
 components used in the manufacture, installation and
 repair of electrical and electronic devices (e.g., an
 electrician's pliers, an oscilloscope); does not include
 electrical or electronic devices created to serve other
 specific purposes (e.g., sound communication,

telecommunication or data processing); see also POWER
PRODUCTION T&E
ref (42) (66) (67)

ACTUATOR
AMMETER
AMPLIFIER
 note may be further subdivided to indicate specific
 type: e.g., AMPLIFIER, CARRIER;
 -,RADIO-FREQUENCY; -,DC
BATTERY, DRY-CELL
BOX, CONTROL
BREAKER, CIRCUIT
BRIDGE, WHEATSTONE
CAPACITOR
 note may be further subdivided to indicate specific
 type: e.g., CAPACITOR, ELECTROLYTIC; -,VARIABLE
CIRCUIT BOARD
 note use only if specific function is unknown:
 e.g., OSCILLATOR
Condenser
 use CAPACITOR
DECLINOMETER
ELECTRODE
ELECTROMETER
FLUXMETER
GALVANOMETER
GALVANOSCOPE
GENERATOR, ELECTROSTATIC
INDIGOMETER
INDUCTOMETER
INSULATOR
JAR, BATTERY
MAGNET
MODULATOR
MODULATOR, SINGLE SIDE-BAND
OSCILLATOR
OSCILLOGRAPH
OSCILLOSCOPE
PLATYMETER
PLIERS, ELECTRICIAN'S
PLIERS, NEEDLENOSE
POTENTIOMETER
RADIOMETER
REGULATOR, VOLTAGE
RELAY
RESISTOR
RHEOMETER
RHEOSCOPE
RHEOSTAT
RHEOTOME
SHIELD, MAGNETIC

ELECTRICAL & MAGNETIC T&E (cont.)

 SIDEROSCOPE
 SOCKET, TUBE
 Solenoid
 use SWITCH, SOLENOID
 STRIPPER, WIRE
 SWITCH
 SWITCH, SOLENOID
 TESTER, CIRCUIT
 TESTER, TUBE
 THERMOAMMETER
 TRANSFORMER
 TRANSFORMER, IMPEDENCE
 TRANSISTOR
 TUBE, VACUUM
 VOLTMETER

FISHING & TRAPPING T&E
 def An artifact originally created to be used in the taking of
 fish, land animals, birds or reptiles by any means other
 than weaponry (see ARMAMENT T&E); see also WATER
 TRANSPORTATION EQUIPMENT (Category 6)
 ref (16) (99)

 CREEL
 DIPPER, WHALE-OIL
 DREDGE, CRAB
 DREDGE, OYSTER
 DREDGE, SCALLOP
 EELPOT
 FISHHOOK
 FISHING ROD
 FLOAT
 FORK, BLUBBER
 GAFF, FISH
 GAFF, SEALING
 HOE, CLAMMING
 HOOK, BLUBBER
 JIG
 KNIFE, MINCING
 LILY IRON, SWORDFISH
 LONGLINE
 LURE
 NET
 NET, BLANKET
 NET, BOTTOM-SET
 NET, BRAIL
 NET, CASTING
 NET, CRAB
 NET, DIP
 NET, DRIFT

FISHING & TRAPPING T&E (cont.)

 NET, FYKE
 NET, GILL
 Net, Hoop
 use NET, CRAB
 NET, POUND
 rt TRAP, FISH
 NET, PURSE SEINE
 NET, REEF
 Net, Scoop
 use NET, DIP
 NET, SEINE
 NET, THROW
 NET, TRAWL
 PLOW
 POT, CRAB
 Pot, Eel
 use EELPOT
 POT, FISH
 rt TRAP, FISH
 POT, LOBSTER
 POT, TRY
 RAKE, HERRING
 RAKE, SHELLFISH
 REEL, FISHING
 Seine
 use NET, SEINE or NET, PURSE SEINE
 SINKER
 rt WEIGHT, NET
 SKIMMER, WHALE-OIL
 SNARE
 SPADE, BLUBBER
 SPADE, BONE
 TONGS, CLAM
 TONGS, OYSTER
 TRAP
 note may be further subdivided to indicate specific
 type: e.g., TRAP, BEAR; -,BEAVER; -,MOLE
 TRAP, CRAB
 TRAP, FISH
 rt NET, POUND; POT, FISH
 Trap, Lobster
 use POT, LOBSTER
 Trawl
 use LONGLINE or NET, TRAWL
 WAIF
 WEIGHT, NET
 rt SINKER
 WEIR
 WHEEL, FISH

FOOD PROCESSING T&E
 <u>def</u> An artifact originally created to be used in the
 processing, storage or preparation of food or beverages
 for human consumption; includes hand tools (e.g., a
 spider, a coffee mill), appliances (e.g., an icebox, a
 cook stove), and equipment used to process natural or
 synthetic substances (e.g., a bottle capper, a milk
 pasteurizer); see also AGRICULTURAL T&E, ANIMAL HUSBANDRY
 T&E and FOOD SERVICE T&E

 ACIDIMETER
 AERATOR, MILK
 AGITATOR, FLOUR-BLEACHING
 ALEUROMETER
 AUGER, FRUIT
 AUTOCLAVE, CANNING
 Ax, Killing
 <u>use</u> AX, SLAUGHTERING
 AX, SLAUGHTERING
 BAG, PASTRY
 BAG-CLOSING MACHINE
 Bag-sewing machine
 <u>use</u> BAG-CLOSING MACHINE
 BAG-TYING MACHINE
 Basket, Cheese
 <u>use</u> STRAINER, WHEY
 BASKET, COOKING
 BASKET, DOUGH-RISING
 BASKET, MORTAR
 BASKET, RING
 BASKET, STORAGE
 BEATER, SEED
 BEEHIVE TOOL
 Bell jack
 <u>use</u> BOTTLE JACK
 BLENDER
 BLENDER, FLOUR
 BLENDER, PASTRY
 BOILER, DOUBLE
 Bolter, Cloth
 <u>use</u> BOLTER, SIEVE
 BOLTER, SIEVE
 BOTTLE JACK
 BOTTLING MACHINE
 <u>rt</u> CAPPER, BOTTLE
 BOWL
 BOWL, BUTTER-WORKING
 BOWL, CHOPPING
 BOWL, MIXING
 BOX, BREAD
 BOX, CHEESE
 BOX, SALT

FOOD PROCESSING T&E (cont.)

> BRAZIER
> BROILER
> BRUSH, KITCHEN
> BRUSH MACHINE
> BUTTER WORKER
> BUTYROMETER
> Cabinet, Creamery
> > use SEPARATOR, CREAM--GRAVITY
> CADDY
> CAKE DECORATOR
> CALCULATING DISK, ACKERMANN'S
> CALDRON
> Caldron, Scalding
> > use SCALDER, HOG
> CAN, CREAM
> CAN, MILK
> CANDLER, EGG
> CANISTER
> > note may be further subdivided to indicate specific
> > type: e.g., CANISTER, SUGAR
> CAPPER, BOTTLE
> > rt BOTTLING MACHINE
> CAPPING MACHINE, CAN
> Cartoning machine
> > use PACKAGING MACHINE, DAIRY
> CASK, BREAD
> CASK, WATER
> CASSEROLE
> CHOPPER, FOOD
> CHOPPER, POTATO
> CHURN
> > note may be further subdivided to indicate specific
> > type: e.g., CHURN, BUTTER; -,OIL-TEST
> CLEANER, BAG
> CLEAVER
> Cockle machine
> > use CYLINDER, COCKLE
> CODDLER
> COFFEE MAKER
> > note use for any coffee-brewing utensil
> COLANDER
> CONDENSER, MILK
> CONDITIONER, GRAIN
> Conditioner, Wheat
> > use CONDITIONER, GRAIN
> COOKER, PRESSURE
> Cooler, Brine
> > use COOLER, DAIRY
> COOLER, DAIRY
> COOLER, LARD
> Cooler, Milk
> > use COOLER, DAIRY

FOOD PROCESSING T&E (cont.)

 Cooler, Tubular
 use COOLER, DAIRY
 Cooler, Unit
 use COOLER, DAIRY
 Cooling cylinder, Lard
 use ROLL, LARD
 CORER, APPLE
 CORER, PINEAPPLE
 CORKER, BOTTLE
 CORKSCREW
 CROCK
 CROCK POT
 CRUSHER, COTTONSEED
 CRUSHER, ICE
 Cup, Custard
 use RAMEKIN
 CUP, MEASURING
 CURLER, BUTTER
 CUTTER, BONE
 CUTTER, BUTTER
 CUTTER, CIDER CHEESE
 CUTTER, COOKIE
 Cutter, Curd
 use KNIFE, CURD
 Cutter, Green bone
 use CUTTER, BONE
 CUTTER, NOODLE
 CUTTER, SLAW
 CUTTING BOARD
 CYLINDER, COCKLE
 DASHER
 DIPPER
 DISH, BAKING
 DISH, CHAFING
 DISH, SOUFFLE
 Double boiler
 use BOILER, DOUBLE
 DREDGER
 Dryer, Milk
 use EVAPORATOR, MILK
 DRYER, TANKAGE
 DUST COLLECTOR
 note may be further subdivided to indicate specific
 type: e.g., DUST COLLECTOR, CYCLONE; -,TUBULAR
 DUSTER, BRAN
 EGGBEATER
 ELECTRIFIER, FLOUR-BLEACHING
 ELEVATOR, GRAIN
 Emulsior, Milk
 use HOMOGENIZER, MILK
 EVAPORATOR, MILK

FOOD PROCESSING T&E (cont.)

 EVAPORATOR, SUGAR
 EXTRACTOR, HONEY
 FEEDER, BLENDING
 FEEDER, FLOUR-BLEACHING
 FEEDER, ROLL
 FILLER, MILK-BOTTLE
 FILTER, MEAT-EXTRACT
 FIRKIN
 FOOD COVER
 FORK, CURD
 FORK, TOASTING
 FREEZER
 Freezer, Brine
 use FREEZER, ICE-CREAM
 Freezer, Direct-expansion
 use FREEZER, ICE-CREAM
 FREEZER, ICE-CREAM
 FRYER, DEEP-FAT
 FUNNEL
 GALACTOMETER
 GAMBREL
 GLUCOMETER
 Grader, Bean
 use SORTER, BEAN
 GRADER, EGG
 GRATER
 GRIDDLE
 GRINDER, BONE
 GRINDER, BRAN
 GRINDER, MEAT
 Grinder, Middlings
 use MILL, MIDDLINGS
 Hammer, Killing
 use HAMMER, SLAUGHTERING
 HAMMER, SLAUGHTERING
 HAMMER, STEAK
 HEATER, MILK
 Heater, Wheat
 use CONDITIONER, GRAIN
 HOIST, DRESSING
 HOLDER, BAG
 Holder, Grain bag
 use HOLDER, BAG
 HOMOGENIZER, MILK
 HULLER, BEAN
 HULLER, CLOVER
 Huller, Pea
 use HULLER, BEAN
 ICEBOX
 INFUSER, TEA
 IRON, PATTY

FOOD PROCESSING T&E (cont.)

IRON, ROSETTE
IRON, WAFER
IRON, WAFFLE
Jackscrew
 use BOTTLE JACK
JAR, CANNING
JAR, COOKIE
JAR, FOOD-STORAGE
 note use only if specific product stored is unknown
JAR, SPICE
JUG
Juicer
 use REAMER, JUICE
KETTLE
KETTLE, LARD-RENDERING
Kettle, Lard-settling
 use TANK, LARD-SETTLING
Kettle, Tea
 use TEAKETTLE
KNIFE, BONING
KNIFE, BREAD
KNIFE, BUTCHER
KNIFE, CHEESE
KNIFE, CHEF'S
KNIFE, CHOPPING
KNIFE, CURD
KNIFE, GRAPEFRUIT
KNIFE, HAM
KNIFE, OYSTER
KNIFE, PARING
KNIFE, POULTRY-KILLING
KNIFE, SKINNING
Knife, Slaughtering
 use KNIFE, STICKING
KNIFE, STICKING
LACTOBUTYROMETER
LACTOMETER
LADLE
LADLE, BUTTER
LADLE, MILK
MAGNET, SPOUT
MANO
MASHER
 note may be further subdivided to indicate specific
 type: e.g., MASHER, POTATO
MAUL, MEAT
Meat-ax
 use CLEAVER
METATE
MILKING MACHINE
MILL, APPLE

FOOD PROCESSING T&E (cont.)

 Mill, Bone-grinding
 use CUTTER, BONE
 MILL, BUHR
 MILL, COFFEE
 Mill, Colloid milk
 use HOMOGENIZER, MILK
 MILL, CURD
 MILL, FLOUR
 MILL, HAMMER
 MILL, MIDDLINGS
 MILL, NUT
 MILL, ROLLER
 Mill, Stone
 use MILL, BUHR
 MIXER, ICE-CREAM
 MOLD, BUTTER
 MOLD, CANDY
 Mold, Chocolate
 use MOLD, CANDY
 MOLD, GELATIN
 MOLD, ICE-CREAM
 MOLD, JELLY
 MORTAR
 Mortar, Samp
 use MORTAR, STAMP
 MORTAR, STAMP
 MORTAR AND PESTLE
 OENOMETER
 Olla
 use JAR, FOOD-STORAGE
 OPENER, BOTTLE
 OPENER, CAN
 Oven, Dutch
 use PAN, ROASTING
 OVEN, MICROWAVE
 PACKAGING MACHINE, DAIRY
 note use for a machine that packages any dairy
 product
 PACKER, BARREL
 Packer, Bran
 use PACKER, BARREL
 PACKER, BUTTER
 Packer, Feed
 use PACKER, BARREL
 Packer, Flour
 use PACKER, BARREL
 PACKING MACHINE, CAN
 PADDLE
 note may be further subdivided to indicate specific
 type: e.g., PADDLE, APPLE BUTTER
 Paddle, Butter
 use SPADE, BUTTER-WORKING

FOOD PROCESSING T&E (cont.)

 PAIL, MILKING
 Pan
 use SAUCEPAN
 PAN, ANGEL FOOD CAKE
 PAN, BREAD
 PAN, BUNDT
 PAN, CAKE
 PAN, CREPE
 PAN, FRYING
 rt SPIDER
 PAN, JELLY ROLL
 PAN, MILK
 PAN, MUFFIN
 PAN, OMELET
 PAN, PIE
 PAN, ROASTING
 PAN, SPRING-FORM
 PARER, FRUIT
 PASTEURIZER, MILK
 PEEL
 PEELER, VEGETABLE
 Percolator
 use COFFEE MAKER
 PESTLE
 Piggin, Milking
 use PAIL, MILKING
 PIOSCOPE
 PITTER, CHERRY
 PLANSIFTER
 PLATE, HOT
 Plate, Pie
 use PAN, PIE
 POACHER
 Poleax
 use AX, SLAUGHTERING
 POPPER, CORN
 Pot
 use SAUCEPAN
 POTHOLDER
 Poultry killer
 use KNIFE, POULTRY-KILLING
 PRESS
 note may be further subdivided to indicate specific
 type: e.g., PRESS, FRUIT; -,LARD; -,BUTTER;
 -,CHEESE; -,BEESWAX; -,ANIMAL-OIL; -,TANKAGE
 Press, Knuckle-joint
 use PRESS, ANIMAL-OIL
 Printer, Butter
 use PRESS, BUTTER
 PUMP, MILK
 PURIFIER, MIDDLINGS

FOOD PROCESSING T&E (cont.)

> Quern
> use METATE or PESTLE
> RACK, SPICE
> RACK, WINE
> RAKE, CURD
> RAKE, POMACE
> RAMEKIN
> REAMER, JUICE
> REEL, CENTRIFUGAL
> REEL, HEXAGONAL
> REEL, ROUND
> REFRIGERATOR
> Refrigerator, Dairy
> use COOLER, DAIRY
> RETORT, CANNING
> RICER
> ROLL, LARD
> ROLLING PIN
> ROTISSERIE
> SAMPLER, MILK
> SAUCEPAN
> SCALDER, HOG
> SCALE, AUTOMATIC MILL
> SCALE, BALLINGS BEER
> SCALE, GRAIN
> Scale, Hopper
> use SCALE, GRAIN
> SCALE, MILK
> SCOOP
> note may be further subdivided to indicate specific
> type: e.g., SCOOP, ICE-CREAM; -,MARROW;
> -,CRANBERRY; -,CURD
> SCOTCH HAND
> SCOURER, GRAIN
> Scourer, Wheat
> use SCOURER, GRAIN
> SCRAPER, CORN
> SCRAPER, HOG
> Screen, Revolving
> use SCREEN, ROLLING
> SCREEN, ROLLING
> SEPARATOR, CREAM
> SEPARATOR, DISK
> SEPARATOR, GRADING
> SEPARATOR, MAGNETIC
> SEPARATOR, MILLING
> SEPARATOR, OAT
> SEPARATOR, RECEIVING
> Separator, Warehouse
> use SEPARATOR, RECEIVING
> SHAKER, FLOUR

FOOD PROCESSING T&E (cont.)

 SHEET, COOKIE
 SIEVE
 <u>rt</u> SIFTER
 SIFTER
 <u>rt</u> SIEVE
 SIFTER, SQUARE
 SINK, DRY
 Sizer, Potato
 <u>use</u> SORTER, POTATO
 SKEWER
 Skillet
 <u>use</u> SPIDER or PAN, FRYING
 SKIMMER
 SKIMMER, CREAM
 SLICER, CHEESE
 SLICER, FRUIT
 Smokejack
 <u>use</u> BOTTLE JACK
 SMUTTER
 SORTER, BEAN
 Sorter, Pea
 <u>use</u> SORTER, BEAN
 SORTER, POTATO
 SPADE, BUTTER-WORKING
 SPATULA
 SPIDER
 <u>rt</u> PAN, FRYING
 SPOON, BASTING
 SPOON, CADDY
 SPOON, MEASURING
 SQUEEZER, LEMON
 STEAMER
 Steamer, Wheat
 <u>use</u> CONDITIONER, GRAIN
 Sterilizer, Bottle
 <u>use</u> WASHER, MILK-BOTTLE
 STILL
 STILL, SOLAR
 STIRRER
 <u>note</u> may be further subdivided to indicate specific
 type: e.g., STIRRER, APPLE BUTTER; -,CURD
 STOVE
 <u>note</u> may be further subdivided according to fuel
 used: e.g., STOVE, GAS; -,WOOD; -,ELECTRIC
 STOVE, PORTABLE
 <u>note</u> may be further subdivided to indicate fuel
 used: e.g., STOVE, PORTABLE ALCOHOL;
 -,PORTABLE GAS
 Strainer, Cream
 <u>use</u> STRAINER, MILK
 STRAINER, GRAVY

FOOD PROCESSING T&E (cont.)

 STRAINER, MILK
 STRAINER, WHEY
 STUFFER, SAUSAGE
 Table, Kneading
 use TROUGH, DOUGH
 TABLE, STEAM
 Tank, Cooling
 use TANK, MILK STORAGE
 TANK, LARD-BLEACHING
 TANK, LARD-RENDERING
 TANK, LARD-SETTLING
 TANK, MEAT-EXTRACT
 TANK, STORAGE
 note use only if specific product stored is unknown
 Tea caddy
 use CADDY
 TEAKETTLE
 TESTER, ACIDITY
 Tester, Babcock
 use TESTER, MILK
 TESTER, MILK
 TESTER, OVERRUN
 TESTER, SEDIMENT
 THERMOMETER
 note may be further subdivided to indicate specific
 type: e.g., THERMOMETER, MEAT: -,MILK; -,CANDY
 TIMER, KITCHEN
 TOASTER
 TOWEL, DISH
 TRAMMEL
 Trier, Butter
 use TRIER, CHEESE
 TRIER, CHEESE
 TROUGH, DOUGH
 TROUGH, MEAT-SALTING
 Trough, Scalding
 use SCALDER, HOG
 Truck, Bag-holder
 use HOLDER, ´BAG
 TUBE, MILK
 Tube, Teat
 use TUBE, MILK
 VAT, CHEESE
 Vat, Cooling
 use VAT, STORAGE
 Vat, Cream
 use VAT, CHEESE
 VAT, MEAT-BOILING
 VAT, MEAT-PICKLING
 VAT, PICKLING
 VAT, STORAGE

151

FOOD PROCESSING T&E (cont.)

```
WARMER, PLATE
WASHER, EGG
WASHER, GRAIN
WASHER, MILK-BOTTLE
WASHER, MILK-CAN
Washer, Wheat
      use  WASHER, GRAIN
WHEEL, JAGGING
Whip, Egg
      use  WHISK
WHISK
Windlass, Slaughtering
      use  HOIST, DRESSING
WOK
Wrapping machine
      use  PACKAGING MACHINE, DAIRY
ZYMOSISMETER
```

FOOD SERVICE T&E

def An artifact originally created to be used in the service
or consumption of food or beverages by humans; see also
FOOD PROCESSING T&E

```
BASKET, CAKE
BASKET, PICNIC
BELL, SERVICE
BEVERAGE SET
BOTTLE, CONDIMENT
BOTTLE, NURSING
Bottle, Thermos
      use  BOTTLE, VACUUM
BOTTLE, VACUUM
BOWL
BOWL, BRIDE'S
BOWL, CEREAL
BOWL, FINGER
BOWL, FRUIT
BOWL, PUNCH
BOWL, SALAD
BOWL, SOUP
BOWL, SUGAR
BOX, KNIFE
Box, Lunch
      use  PAIL, DINNER
Bridge set
      use  LUNCHEON SET
BUCKET, ICE
CAKE STAND
CANTIR
CARAFE
      rt  DECANTER
```

FOOD SERVICE T&E (cont.)

 CARVING SET
 CASTER
 CHARGER
 CHEST, SILVER
 CHOPSTICK
 CHOPSTICK CASE
 COASTER
 COFFEEPOT
 COMPOTE
 CONDIMENT SET
 note use for a set consisting of mustard jar,
 saltshaker, pepperbox, etc.
 COOLER, WATER
 COOLER, WINE
 COZY
 CRUET
 CRUET STAND
 CUP
 CUP, CAUDLE
 CUP, CHOCOLATE
 CUP, DEMITASSE
 CUP, MUSTACHE
 CUP, PUNCH
 CUP, SAKI
 Cup, Tea
 use TEACUP
 CUP AND SAUCER
 CUP AND SAUCER, DEMITASSE
 DECANTER
 rt CARAFE
 DEMITASSE SET
 DISH, BONBON
 DISH, BONE
 DISH, BUTTER
 DISH, CANDY
 DISH, CELERY
 DISH, CHEESE
 DISH, CHILD'S
 DISH, CHILD'S FEEDING
 DISH, RELISH
 DISH, VEGETABLE
 DISH, WASTE
 Dish set
 use TABLEWARE SET
 Dome, Cheese
 use DOME, FOOD
 DOME, FOOD
 Effigy
 use only as a subdivision of another term: e.g.,
 BOWL, EFFIGY; PITCHER, EFFIGY
 EGGCUP

FOOD SERVICE T&E (cont.)

 EPERGNE
 Ewer
 use PITCHER
 FLAGON
 FLATWARE SET
 FLATWARE SET, CHILD'S
 FORK
 FORK, BERRY
 FORK, CARVING
 FORK, CHILD'S
 FORK, COLD-MEAT
 FORK, DESSERT
 FORK, DINNER
 FORK, FISH
 FORK, FISH-SERVING
 FORK, LEMON
 FORK, LUNCHEON
 FORK, OYSTER
 FORK, PICKLE
 FORK, SALAD
 FORK, SARDINE
 Fork, Table
 use FORK, DINNER
 FOUNTAIN, DRINKING
 FOUNTAIN, SODA
 GLASS
 Glass, Ale
 use GLASS, MALT-BEVERAGE
 Glass, Beer
 use GLASS, MALT-BEVERAGE
 GLASS, CHAMPAGNE
 GLASS, COCKTAIL
 GLASS, CORDIAL
 Glass, Flip
 use BEAKER
 Glass, Flute
 use GLASS, CHAMPAGNE
 Glass, Goblet
 use GOBLET
 Glass, Hock
 use GLASS, WINE
 Glass, Liqueur
 use GLASS, CORDIAL
 GLASS, MALT-BEVERAGE
 rt STEIN; TANKARD
 GLASS, PARFAIT
 GLASS, SHERBET
 GLASS, SHOT
 rt JIGGER
 GLASS, SODA FOUNTAIN
 GLASS, SWEETMEAT

FOOD SERVICE T&E (cont.)

 GLASS, TRICK
 GLASS, WINE
 GOBLET
 GONG
 Gravy boat
 use SAUCEBOAT
 HOLDER, NAPKIN
 HOLDER, PLACECARD
 Holder, Spoon
 use SPOONER
 HOLDER, TOOTHPICK
 HORN, DRINKING
 JAR, GINGER
 Jar, Mustard
 use POT, MUSTARD
 JAR, PICKLE
 JAR, WINE
 JIGGER
 rt GLASS, SHOT
 Jug
 use PITCHER
 KNIFE
 KNIFE, BUTTER
 KNIFE, CAKE
 KNIFE, CARVING
 KNIFE, DESSERT
 KNIFE, DINNER
 KNIFE, FISH
 KNIFE, FRUIT
 KNIFE, ICE-CREAM
 KNIFE, LUNCHEON
 KNIFE, STEAK
 Knife, Table
 use KNIFE, DINNER
 KNIFE REST
 LADLE
 note use only if specific type is unknown
 LADLE, GRAVY
 LADLE, MAYONNAISE
 LADLE, PUNCH
 LADLE, SAUCE
 LADLE, SOUP
 LAGYNOS
 rt PITCHER
 Lemonade set
 use BEVERAGE SET
 LIFTER, TODDY
 LUNCHEON SET
 note use for matching set of place mats, coasters,
 centerpiece, etc., or for a relatively small
 tablecloth and matching napkins
 rt TABLECLOTH SET

155

FOOD SERVICE T&E (cont.)

MAT, PLACE
MESS KIT
MILL, PEPPER
Muffineer
 use SHAKER, SUGAR
MUG
NAPKIN
NAPPY
NUTCRACKER
NUTPICK
PAD, TABLE
PAIL, DINNER
Passglas
 use BEAKER
Pepperbox
 use SHAKER, PEPPER
PITCHER
PITCHER, CREAM
PITCHER, SYRUP
PITCHER, WATER
PLATE, BUTTER
PLATE, BUTTER-PAT
PLATE, CUP
PLATE, DESSERT
PLATE, DINNER
PLATE, LUNCHEON
PLATE, SALAD
PLATE, SERVING
PLATE, SOUP
PLATE, VEGETABLE
PLATEAU
PLATTER
Pokal
 use GOBLET
PORRINGER
PORRO
POT, CHOCOLATE
Pot, Coffee
 use COFFEEPOT
POT, HOT-WATER
POT, MUSTARD
Pot, Pepper
 use PEPPERBOX
POT, POSSET
Pot, Tea
 use TEAPOT
PYRAMID, DESSERT
RACK, TOAST
Rhyton
 use HORN, DRINKING
RING, NAPKIN

156

FOOD SERVICE T&E (cont.)

Roemer
　　　use GOBLET
Rummer
　　　use GOBLET
SALTCELLAR
SALT & PEPPER SET
SALTSHAKER
SALVER
Samovar
　　　use URN, COFFEE
SAUCEBOAT
SAUCER
SCOOP, ALMOND
SCOOP, CHEESE
SERVER, CHEESE
SERVER, PIE
SERVER, TOMATO
Serviette
　　　use NAPKIN
SHAKER, COCKTAIL
SHAKER, PEPPER
Shaker, Salt
　　　use SALTSHAKER
SHAKER, SUGAR
SHEARS, GRAPE
SILENT BUTLER
SNIFTER
SPOON
SPOON, BABY
SPOON, BERRY
SPOON, BONBON
SPOON, CHILD'S
SPOON, CLARET
SPOON, DEMITASSE
SPOON, DESSERT
SPOON, FRUIT
SPOON, GRAPEFRUIT
SPOON, MUSTARD
SPOON, OLIVE
SPOON, PIERCED SERVING
SPOON, SALT
SPOON, SERVING
SPOON, SHERBET
SPOON, SODA
SPOON, SOUP
SPOON, SUGAR
Spoon, Table
　　　use TABLESPOON
Spoon, Tea
　　　use TEASPOON
SPOON AND SALT SET

FOOD SERVICE T&E (cont.)

 SPOONER
 STEIN
 rt TANKARD; GLASS, MALT-BEVERAGE
 SUGAR AND CREAMER
 Sugar shell
 use SPOON, SUGAR
 SWEEPER, CRUMB
 SWIZZLE STICK
 TABLECLOTH
 TABLECLOTH SET
 note use for a matching set of napkins and
 tablecloth
 rt LUNCHEON SET
 TABLESPOON
 TABLEWARE SET
 note use for any matched set of cups, saucers,
 plates, etc.
 TANKARD
 rt STEIN; GLASS, MALT-BEVERAGE
 TANTALUS
 TAZZA
 TEA BALL
 TEACUP
 TEAPOT
 TEA SERVICE
 Tea set
 use TEA SERVICE
 TEASPOON
 Toddy stick
 use SWIZZLE STICK
 TONGS, ASPARAGUS
 TONGS, ICE
 TONGS, SANDWICH
 TONGS, SUGAR
 TRAY, BED
 TRAY, BREAD
 TRAY, SERVING
 TRAY, SPOON
 Trencher
 use PLATTER
 TRIVET
 TUMBLER
 TUREEN
 TYG
 URN, COFFEE
 URN, TEA
 VASE, CELERY
 Waster
 use DISH, WASTE
 Water set
 use BEVERAGE SET

FORESTRY T&E

<u>def</u> An artifact originally created to be used in cutting,
handling or processing timber in its rough form or in
harvesting forest crops such as bark, saps, gums, resins,
rubber; does not include equipment for cartage (see
Transportation Artifacts, Category 6) or for manufacturing
products from wood (see WOODWORKING T&E and PAPERMAKING
T&E); see also AGRICULTURAL T&E

ADZ, MARKING
AUGER, RAFT
AX, BARKING
AX, FELLING
 <u>rt</u> AX, TURPENTINE
AX, MARKING
AX, TURPENTINE
 <u>rt</u> AX, FELLING
BAR, TOMMY
BITCHES, JOBBER'S SONS
BRIER
BUCKET, SAP
Bucket, Sugar
 <u>use</u> BUCKET, SAP
BUCKSAW
CALIPERS, TIMBER
CHISEL, BARKING
DENDROMETER
DIPPER, TURPENTINE
Dog, Hewing
 <u>use</u> DOG, LOG
DOG, LOG
Dog, Post
 <u>use</u> DOG, LOG
DOG, RAFT
DOG, RING
DOG, SPAN
Dog, Timber
 <u>use</u> DOG, LOG
DOLLY, TIMBER
Drug
 <u>use</u> DOLLY, TIMBER
GO-DEVIL
HACK, TURPENTINE
HAMMER, MARKING
HOOK, CANT
HOOK, SWAMP
IRON, BARKING
JETHRO
Knife, Race
 <u>use</u> SCRIBE, TIMBER
MILL, BARK
PARBUCKLE

FORESTRY T&E (cont.)

>PEAVY
>PICKAROON
>PIKE, JAM
>PIKE, POLE
>RING, SNUB
>RULE, LOG
>Saw, Buck
>>use BUCKSAW
>SAW, CHAIN
>SAW, SALLY
>SAW, TWO-HANDED CROSSCUT
>Saw, Woodcutter's
>>use BUCKSAW
>SCALE, TIMBER
>SCRAPER, TREE
>SCRAPER, TURPENTINE
>SCRIBE, TIMBER
>Shackle, Drag
>>use DOG, SPAN
>SHACKLE, RAFT
>SLED, LOG
>Spile
>>use SPOUT, SAP
>SPOUT, SAP
>SPUD, BARKING
>TONGS
>TONGS, SKIDDING
>WANAGAN
>WHEELS, LOG
>Wheels, Timber
>>use WHEELS, LOG
>WRAPPER

GLASS & PLASTICS T&E
>def An artifact originally created to be used in the process
>of fabricating objects from glass, clay, rubber, synthetic
>resins, plastics or wax; see also MASONRY T&E
>ref (24) (83) (112)

>ARMATURE
>BATTLEDORE
>BENCH, GAFFER'S
>BLOCK CARRIAGE
>BLOWIRON
>BLOWIRON RACK
>Blowpipe
>>use BLOWIRON
>BLUNGER
>BOSS
>BOX, CHEST

GLASS & PLASTICS T&E (cont.)

 CALENDER
 rt COATING MACHINE
 CAME
 CART, BATCH
 CHAIR, BALL-HOLDER'S
 CHAIR, GAFFER'S
 CLAMP
 CLAPPER STICKS
 COATING MACHINE
 note may be further subdivided to indicate specific
 type: e.g., COATING MACHINE, ROLL; -,SPREAD;
 -,METALLIZING
 rt CALENDER
 CRIMPER
 Crucible
 use POT
 CUP, SLIP-TRAILING
 CUT-DOWN BOARD
 CUT LINER
 CUTTER, GLASS
 CUTTER, TOGGLE
 CUTTING MACHINE, FOAM
 CUTTING TOOL, FOAM
 DRILL, FLEXIBLE-SHAFT
 DUMMY
 DUMMY, DIP
 ENGRAVING MACHINE
 EXTRUDER
 FLANGE
 FLARING TOOL
 FLASK, SNAP
 FOAM MACHINE
 FOOTSTICKS
 FORMING BLOCK
 FORMING MACHINE
 note may be further subdivided to indicate specific
 type: e.g., FORMING MACHINE, VACUUM;
 -,PRESSURE; -,DRAPE
 FURNACE, ANNEALING
 FURNACE, MELTING
 FURNACE, REHEATING
 Glory hole
 use FURNACE, REHEATING
 GRAPHITE SLAB
 Grozer
 use PLIERS, GLASS
 GUN, SPRAY
 HANGER
 HEATER, CALROD
 HEATER, STRIP
 INCISING TOOL

GLASS & PLASTICS T&E (cont.)

IRON, GATHERING
Jack
 use PUCELLAS
Kettle plate
 use PLATE, CUT-OFF
KIDNEY
KILN
 note may be subdivided according to fuel: e.g.,
 KILN, ELECTRIC; -,GAS; -,WOOD
KILN, MOLD
KILN, POT
KNIFE, CHEST
KNIFE, ELECTRIC
KNIFE, FETTLING
KNIFE, STOPPING
LADLE
 note may be further subdivided to indicate specific
 type: e.g., LADLE, WAX
LATHE
LAWN
LOOP TOOL
MARVER
MASK
 note may be further subdivided to indicate specific
 type: e.g., MASK, LIP; -,CAP; -,PLUG
METERING MACHINE
MILL, PUG
Modeling tool
 use more specific term: e.g., LOOP TOOL; RIB TOOL
MOLD
 note may be further subdivided to indicate specific
 type: e.g., MOLD, PREPEG; -,MAT; -,TRANSFER;
 -,PIG
MOLD, CANDLE
MOLD, DIP
MOLD, PRESS
MOLDING MACHINE, BLOW
MOLDING MACHINE, COMPRESSION
MOLDING MACHINE, INJECTION
MOLDING MACHINE, ROTATIONAL
MOLDING MACHINE, SLUSH
NEEDLE TOOL
OPENER, FID-LEAD
OVEN, CURING
Paddle
 use BATTLEDORE
PAN, BLOCKING
PAN, DRIP
PIG
PINCERS
PLATE, CUT-OFF

GLASS & PLASTICS T&E (cont.)

 PLIERS, GLASS
 PONTIL
 POT
 POT-SETTING CARRIAGE
 POT-SETTING TOOL
 PREFORM MACHINE
 PRESS, MOLD
 PRESS, VACUUM
 PUCELLAS
 PUMPING MACHINE
 Punty
 use PONTIL
 RAKE
 REAMER
 REEL, CANDLE-DIPPING
 RIB TOOL
 ROLLER, IMPREGNATING
 SAGGER
 SCRAPER
 SCROLLER
 SHEARS
 Slip trailer
 use CUP, SLIP-TRAILING
 SNAPDRAGON
 SPATULA
 STAMPING MACHINE
 STEAM STICK
 STILT
 STYLUS
 SYRINGE
 TONGS, DIPPING
 TONGS, RAKU
 TOOL BOARD
 TRACER
 TRAY, CUT-OFF
 Tub, Ball-holder's
 use TUB, IRON-COOLING
 TUB, IRON-COOLING
 TUNGSTEN ROD
 TURNING TOOL
 TWEEZERS
 V-BLOCK
 WHEEL, BANDING
 WHEEL, BENCH
 WHEEL, COPPER-ENGRAVING
 WHEEL, CUTTING
 WHEEL, GRINDING
 rt WHEEL, LAPPING
 WHEEL, KICK
 WHEEL, LAPPING
 rt WHEEL, GRINDING

163

GLASS & PLASTICS T&E (cont.)

>WHEEL, POLISHING
>Wheel, Potter's
>>use more specific term: e.g., WHEEL, BENCH; WHEEL,
>>KICK
>WHEEL, TABLESTAND
>WINDING MACHINE, FILAMENT

HOUSEKEEPING T&E
>def An artifact originally created to be used as an implement
>or appliance in a cleaning or laundering activity, whether
>carried on in a home, in a public building or as a
>commercial enterprise

>ASHPAN
>BASKET, LAUNDRY
>BEATER, RUG
>BOTTLEBRUSH
>BROOM
>BROOM, ELECTRIC
>BROOM, WHISK
>BRUSH, SCRUB
>BRUSH, WINDOW
>Bucket
>>use PAIL
>CAN, TRASH
>CLEANER, VACUUM
>CLOTHESPIN
>DRYER
>Drying rack
>>use RACK, DRYING
>DUSTPAN
>HAMPER
>IRON
>IRON, FLUTING
>IRONING BOARD
>MANGLE
>MOP
>PAIL
>PRESS, LINEN
>RACK, DRYING
>SADIRON
>SPRINKLER
>STRETCHER, CURTAIN
>SWEEPER, CARPET
>TRIVET
>WASHBOARD
>WASHING MACHINE
>WRINGER, CLOTHES
>WRINGER, MOP

LEATHERWORKING T&E
- def An artifact originally created to be used in the
processing of furs or hides or the fabricating of leather
products (e.g., a fleshing knife, a last)
- ref (63) (134)

AWL
 note may be further subdivided to indicate specific
 type: e.g., AWL, PEG; -,SCRATCH
BEAM, CURRIER'S
BEAM, TANNER'S
BEAMING MACHINE
BEATING MACHINE
BENCH, COBBLER'S
BENCH, HARNESS MAKER'S
BEVELER, EDGE
BEVELER, SAFETY
BRUSHING MACHINE
BUFFING MACHINE
CAGE, DRYING
CANE, BEATING
CARD
CARDING MACHINE
CHISEL, DIAGONAL-THONGING
CHISEL, THONGING
Clicker
 use DIE-CUTTING MACHINE
COT
CREASER, EDGE
CUTTER, CLINCH
CUTTER, EDGE
CUTTER, REVOLVING-WHEEL
DE-BURRING MACHINE
DEHAIRING MACHINE
DIE-CUTTING MACHINE
DRUM, SAWDUST
DRYING MACHINE
FEATHER, TIPPING
FID
Fingerstall
 use COT
FLESHING MACHINE
GAUGE, DRAW
 rt GAUGE, PLOUGH
GAUGE, PLOUGH
 rt GAUGE, DRAW
GOUGE, ADJUSTABLE
GOUGE, ADJUSTABLE-V
HAFT, SEWING
HAMMER, COBBLER'S
HAMMER, HEEL
HAMMER, TURN-SHOE

165

LEATHERWORKING T&E (cont.)

> IRONING MACHINE
> JACK, GLAZING
> JACK, LAST
> KICKER
> KNIFE, BEAMING
> KNIFE, BEVEL-POINT SKIVING
> KNIFE, FLESHING
> KNIFE, HEAD
> KNIFE, ROUND-HEAD
> KNIFE, SKIVING
> KNIFE, SQUARE-POINT
> KNIFE, STRETCHING
> KNIFE, UNHAIRING
> LACING PONY
> LAST
> MAUL, RAWHIDE
> NEEDLE
> > <u>note</u> may be further subdivided to indicate specific
> > > type: e.g., NEEDLE, SPLIT-LACING; -,LACING
> PEN, PYROGRAPHY
> PINCERS, LASTING
> PLIERS, LACING
> POINT, PYROGRAPHY
> PRINTING BLOCK
> PULLING MACHINE
> PUNCH, ARCH
> Punch, Belt
> > <u>use</u> PUNCH, REVOLVING
> PUNCH, OBLONG
> PUNCH, OVAL DRIVE
> PUNCH, REVOLVING
> PUNCH, ROUND DRIVE
> PUNCH, ROUND-HOLE
> PUNCH, STRAP-END
> PUNCH, STRAP-END V
> RIVET
> RIVETING MACHINE
> SCRAPER
> SETTER
> > <u>note</u> may be further subdivided to indicate specific
> > > type: e.g., SETTER, GROMMET; -,RIVET
> SEWING MACHINE
> SHEARING MACHINE
> SHEARS, LEATHER
> Skife
> > <u>use</u> BEVELER, SAFETY
> SKIVING MACHINE
> SLICKER
> > <u>note</u> may be further subdivided to indicate specific
> > > type: e.g., SLICKER, CIRCLE EDGE
> SPLITTING MACHINE

LEATHERWORKING T&E (cont.)

> STEEL, FINGER
> STEEL, TURNING
> STENCIL
> note use for a silkscreeen or metal stencil in the
> process of spotting or marking furskins
> STITCHING GROOVER
> STRETCHING MACHINE
> Strip ease
> use GAUGE, DRAW
> TOGGLING FRAME
> VAT
> note may be further subdivided to indicate specific
> type: e.g., VAT, BLEACHING; -,DYEING;
> -,PICKLING
> WHEEL, POLISHING/SANDING
> WRINGER

MASONRY T&E
> def An artifact originally created to be used in working with
> stone, concrete, mortar or plaster or in the forming of
> objects to be later used in masonry construction (e.g., in
> the making of brick, tile or concrete block); see also
> GLASS & PLASTICS T&E
> ref (74)

> AX, BRICK
> AX, MASON'S
> Ax, Stone
> use AX, MASON'S
> AX, TOOTH
> BILLET
> BIT, TUNGSTEN-CARBIDE
> BRICK MACHINE
> note may be further subdivided to indicate specific
> type: e.g., BRICK MACHINE, CHAMBERLAIN
> BURIN
> rt GRAVER
> BUSHHAMMER
> CAVIL
> CHISEL
> note use only if specific type is unknown
> CHISEL, CUTTING
> CHISEL, OCTAGONAL
> CHISEL, PITCHING
> CHISEL, SPLITTING
> CHISEL, STRAIGHT
> CHISEL, TOOTH
> Darby
> use FLOAT, LONG

MASONRY T&E (cont.)

DRILL
 <u>note</u> may be further subdivided to indicate specific
 type: e.g., DRILL, OCTAGONAL; -,ROUND
FEATHER
FINISHING MACHINE, CONCRETE
FLOAT
FLOAT, LONG
GRAVER
 <u>rt</u> BURIN
HAMMER, AX
Hammer, Bush
 <u>use</u> BUSHHAMMER
HAMMER, CRANDALL
HAMMER, FACE
HAMMER, PATENT
Handsaw
 <u>use</u> SAW, STONE
HAWK
HOD
JOINTER
Jumper
 <u>use</u> DRILL
KILN, BRICK
KILN, LIME
LEVEL, MASON'S
LEWIS
LINE PIN
MIXER, CEMENT
MOLD, BRICK
NIPPERS, TILE
PICK, FLINTING
PICK, MASON'S
PICK, MILL
PLUG
POINT
RAKER
RULE, JOINTING
SAW, BRICK
SAW, STONE
SCREED
SPOON, MUD
TROUGH, MIXING
TROWEL
 <u>note</u> may be further subdivided to indicate specific
 type: e.g., TROWEL, POINTING; -,SMOOTHING;
 -,GROUTING
ZAX

MECHANICAL T&E

def An artifact originally created to be used in the study,
measurement or utilization of the static and dynamic
properties of solids, liquids and gases; includes
general-purpose mechanical devices (e.g., a wedge, a
hoist) as well as devices used to measure mechanical
properties (e.g., a tensiometer, a pressure gauge); does
not include specialized artifacts created to serve other
specific purposes (e.g., a sledge); see also CHEMICAL T&E

ref (66) (67) (129)

ACCELEROMETER
BATOREOMETER
BATTERY, GRAVITY
BRAKE, BAND
CENTRIFUGAL RAILWAY
COME-ALONG
 rt JACK, PULLING
CONVEYOR
 note may be further subdivided to indicate specific
 type: e.g., CONVEYOR, BUCKET; -,BELT
CRANE
DENSIMETER
Derrick
 use CRANE
DUCTILEMETER
DYNAMOMETER
FALL MACHINE
FLYWHEEL
FRICTION SLIDE
GAUGE
 note normally subdivided to indicate substance
 being measured: e.g., GAUGE, STEAM-PRESSURE
GRAVIMETER
GYROSCOPE
Gyrostat
 use GYROSCOPE
HOIST
 note use for any lifting machine which operates
 with ropes and pulleys
 rt WINDLASS
HYDRODYNAMOMETER
HYDROMETER
INCLINED PLANE
JACK, HOISTING
JACK, LIFTING
JACK, PULLING
 rt COME-ALONG
JAR, VACUUM
KINEGRAPH
LEVER
LIFT, HYDRAULIC

MECHANICAL T&E (cont.)

 LITRAMETER
 Oleometer
 <u>use</u> HYDROMETER
 OPERAMETER
 OSCILLATING TABLE
 PENDULUM
 PIEZOMETER
 POLYTROPE
 Psychrometer
 <u>use</u> HYDROMETER
 PULLEY
 PYCNOMETER
 SCLEROMETER
 SCREW, ARCHIMEDIAN
 SPRING, SPIRAL
 STEREOMETER
 STROBOSCOPE
 TACHOMETER
 Tackle
 <u>use</u> HOIST
 TENSIMETER
 TENSIOMETER
 TONOMETER
 TOP, INERTIA
 Tribometer
 <u>use</u> DYNAMOMETER
 TURBIDIMETER
 TURNBUCKLE
 VELOCIMETER
 VISCOMETER
 Viscosimeter
 <u>use</u> VISCOMETER
 VOLUMINOMETER
 WEDGE
 Winch
 <u>use</u> HOIST or WINDLASS
 Winding engine
 <u>use</u> WINDLASS
 WINDLASS
 <u>note</u> use for a hauling or lifting drum around which
 a rope or chain is wound.
 <u>rt</u> HOIST
 WIND TUNNEL

MEDICAL & PSYCHOLOGICAL T&E
 <u>def</u> An artifact originally created to be used in the
 examination, testing, diagnosis and treatment of humans;
 includes dental tools, objects used in the testing of
 sight and hearing, and objects used for psychological
 testing or treatment; does not include objects used in the

general study of physical phenomena (see OPTICAL T&E, ACOUSTICAL T&E, BIOLOGICAL T&E and CHEMICAL T&E) or the tools of veterinary medicine (see ANIMAL HUSBANDRY T&E)

ref (41) (66) (67) (114) (122) (123) (124)

ACUTOMETER
ADJUSTING CONE
AFTER-IMAGE APPARATUS
ALBUMINOMETER
AMALGAMATOR
AMALGAM CARRIER
AMBLYOSCOPE
AMPUL
ANAGLYPH
ANATOMICAL MODEL
ANOMOLOSCOPE
ANTIRRHEOSCOPE
ARTICULATOR, DENTAL
ASPIRATOR
ASTROMETEOROSCOPE
ATOMIZER
AUDIPHONE
AURISCOPE
AUTOCLAVE
AXOMETER
BAND, DENTAL
BANDAGE
BESIDOMETER
BIOMETER
BIOSCOPE
BOTTLE, SERUM
BOTTLE, SPECIMEN
BUR, DENTAL
BURNISHER, DENTAL
CAMPIMETER
CANNULA
CARDIOGRAPH
CARVER, DENTAL
CASTING MACHINE, DENTAL METALS
CATHETER
CEPHALOMETER
CHART, VISUAL-ACUITY
CHEILVANGROSCOPE
CHISEL, DENTAL
CLAMP, DENTAL
CLIMATOMETER
COLOR MIXER
COMPRESSOR/DEHYDRATOR, DENTAL
CONTOURING INSTRUMENT, DENTAL
COUNTER, BLOOD
COUNTING CHAMBER
CUIRASS

MEDICAL & PSYCHOLOGICAL T&E (cont.)

 CUP, AMALGAM
 CUP, DENTAL WASTE
 CURETTE
 note may be further subdivided to indicate specific
 type: e.g., CURETTE, ALVEOLAR; -,PERIODONTAL
 CURING UNIT, DENTURE
 Cystoscope
 use URETHROSCOPE
 DEHYDRATOR, DENTAL
 DENTAL DISK, ABRASIVE
 DISPENSER, DENTAL
 DRILL, DENTAL
 ECHOSCOPE
 ELEVATOR, MALAR
 ELEVATOR, PERIOSTEAL
 ELEVATOR, ROOT
 ENDOSCOPE
 EQUINOCTIAL
 EVACUATOR, DENTAL
 EXCAVATOR, DENTAL
 EXPLORER, DENTAL
 FACIOMETER
 FILE, DENTAL
 FIRST AID KIT
 FLEES' BOX
 FLUOROSCOPE
 FORCEPS
 FORCEPS, CATCH
 FORCEPS, DENTAL
 FORCEPS, SPENCER WELLS
 GALLIPOT
 GLOBULIMETER
 GOLD-FOIL CARRIER
 GONIOMETER
 GONIOSCOPE
 HAEDROMOGRAPH
 HAEMACHROMETER
 HAEMACYTOMETER
 HAEMATOMETER
 HAEMOSCOPE
 HOE, PERIODONTAL
 Indiscope
 use OPHTHALMOSCOPE
 INHALATOR
 INHALER
 IRON LUNG
 JAR, SPECIMEN
 KERATOME
 KERATOMETER
 LANCET, BLOOD
 LARYNGOSCOPE

172

MEDICAL & PSYCHOLOGICAL T&E (cont.)

LENCOSCOPE
LENS, STENOPAIC
LENS SET
 note use for visual testing apparatus including
 lenses and disks (red, blank, pin-hole, etc.)
LITHOTRITE
MALLET, ORAL SURGERY
MANOPTOSCOPE
MASK, SURGICAL
Meatoscope
 use SPECULUM
METABOLISM APPARATUS
METROSCOPE
MIRROR, EYE-OBSERVATION
MIRROR, MOUTH-EXAMINING
MIXER, DENTAL-CASTING
MIXING SLAB, DENTAL
MOUTHPIECE, SALIVA-EJECTOR
MULTIPLE-IMAGE APPARATUS
MULTIPLE ROD, MADDOX
MYDYNAMOMETER
MYOGRAPH
NEEDLE, BLOOD-COLLECTING
NEEDLE, INOCULATING
NEEDLE, SUTERING
ONCOMETER
OPHTHALMOMETER
OPHTHALMOSCOPE
OPSIOMETER
Optometer
 use OPSIOMETER
ORTHOSCOPE
OSTEOPHONE
OTACOUSTIC
OTOSCOPE
PACEMAKER
PELVIMETER
PERIMETER
PERSPECTOSCOPE
PHENAKISTOSCOPE
PHRENOGRAPH
Plastograph
 use ANAGLYPH
PLETHYSMOGRAPH
Pneometer
 use SPIROMETER
POLYGRAPH
PROBE
PROPHYLAXIS UNIT, DENTAL
PSEUDOSCOPE, LENTICULAR
 rt STEREOSCOPE

MEDICAL & PSYCHOLOGICAL T&E (cont.)

 PUMP, BREAST
 PUPILOMETER
 RESUSCITATOR
 RETINOSCOPE
 RETRACTORS
 RHINOSCOPE
 SAW, DENTAL
 SAW, SURGICAL
 SCALPEL
 SCARIFICATOR
 SCISSORS, BANDAGE
 SCISSORS, SURGICAL
 SPATULA, DENTAL
 SPECULUM
 SPHYGMOMANOMETER
 SPIROGRAPH
 SPIROMETER
 SPLINT, JAW
 SPLINT, THOMAS
 SPLINT SET, ARCHWIRE
 SPREADER, JAW
 STALAGMOMETER
 STEREOGRAM
 STEREOGRAPH
 STEREOSCOPE
 rt PSEUDOSCOPE, LENTICULAR
 STEREOSCOPE/PSEUDOSCOPE
 Sterilizer
 use AUTOCLAVE
 STETHOMETER
 STETHOSCOPE
 STOMATOSCOPE
 STRABISMOMETER
 SYRINGE
 TEMPLATE, DENTAL
 TENACULUM
 TEST, COLOR-PERCEPTION
 TESTER, COLOR-SENSE
 TETANOMETER
 THAUMATROPE
 THERMOMETER
 TONOMETER
 TONSILLOTOME
 TRAY, DENTAL ACCESSORY
 TREPHINE
 TRIMMER, GINGIVAL
 TROPOSTEREOSCOPE
 TUBE, STOMACH
 UREA APPARATUS
 UREOMETER
 URETHROSCOPE

MEDICAL & PSYCHOLOGICAL T&E (cont.)

 URICOMETER
 URINOMETER
 URINO-PYCNOMETER
 VAPORIZER
 VISIOMETER

MERCHANDISING T&E

 def An artifact originally created to be used in the selling
 of goods or services; does not include objects used for
 advertising purposes (see ADVERTISING MEDIUM, Category 5)

 BIN, STORAGE
 BOTTLE, APOTHECARY
 BOX, MONEY
 CASH REGISTER
 COUNTER
 DISPLAY STAND
 HOLDER, STRING
 JAR, APOTHECARY
 JAR, CONFECTIONARY
 Jar, Ring
 use JAR, CONFECTIONARY
 MANIKIN
 rt DOLL
 MONEY CHANGER
 NIPPERS, TICKET
 RACK, DISPLAY
 SALES SAMPLE
 note normally subdivided to indicate type of
 product: e.g., SALES SAMPLE, CLOTH
 SALES-SAMPLE CASE
 note normally subdivided to indicate type of
 product: e.g., SALES-SAMPLE CASE, BUTTON
 SALES-SAMPLE KIT
 note normally subdivided to indicate type of
 product: e.g., SALES-SAMPLE KIT, COSMETICS
 TABLE, DISPLAY
 Till
 use BOX, MONEY
 TURNSTILE
 VENDING MACHINE
 note may be further subdivided to indicate product:
 e.g., VENDING MACHINE, CANDY; -,CARD;
 -,CIGARETTE

METALWORKING T&E

 def An artifact originally created to be used for casting,
 forging, machining or fabricating metals or metal products
 (e.g., a planishing hammer, a swage block, a cold chisel);

```
          see also MINING T&E
ref       (39)    (47)    (52)    (70)    (108)    (110)    (120)
note      the list of object names within this classification term
          includes only a small number of general terms for heavy
          machinery; if the name of a special-purpose artifact does
          not appear on this list, it may be added by the user,
          either as a subdivision of one of the listed terms (e.g.,
          POLISHING MACHINE, BAYONET) or as a new entry

          AMALGAMATOR
                  note use only if specific type is unknown: e.g.,
                       TABLE, AMALGAMATING; BARREL, AMALGAMATING
          ANVIL
          ANVIL, CONCAVE
          ANVIL, NAILMAKER'S
          ANVIL, SCYTHE-SHARPENING
                  rt    STONE, SCYTHE-SHARPENING
          ARRASTRA
          AWL, ARMORER'S
          BARREL, AMALGAMATING
          BEADING MACHINE
          BEAKIRON
                  rt    SWAGE, ANVIL
          BELLOWS, BLACKSMITH'S
                  rt    BLOWER, BLACKSMITH'S
          BENCH PLATE
          BENDER, TIRE
          Bickern
                  use   BEAKIRON
          Bick iron
                  use   BEAKIRON
          BIT
                  note use for a boring implement designed to be
                       inserted in a DRILL; use only if specific type
                       is unknown
          BIT, FLAT
          BIT, STRAIGHT-FLUTED
          BIT, TWIST
          BLACKSMITH'S STAND
          BLOWER, BLACKSMITH'S
                  rt    BELLOWS, BLACKSMITH'S
          BLOWING ENGINE
          Blowtorch
                  use   TORCH, GASOLINE; -,PROPANE; -,KEROSINE
          BOLT
          BOLT-CLIPPER MACHINE
          Bolt cutter
                  use   CUTTER, BOLT
          Bolt-header machine
                  use   HEADING MACHINE, BOLT
          Bolt-heading tool
                  use   HEADING TOOL, BOLT
```

METALWORKING T&E (cont.)

BORING MACHINE
BORING TOOL
BOX, BLACKSMITH'S TOOL
BRADING MACHINE
BRAKE
 rt FOLDING MACHINE
BRAZIER
BREECHING MACHINE
BROACH
BROACHING MACHINE
BUFFING MACHINE
BURNISHER
BURRING MACHINE
CENTERDRILL
CHARGING BOX
CHARGING MACHINE
CHISEL, COLD
 note use only if specific type is unknown: e.g.,
 CHISEL, CAPE; -,DIAMOND-POINT; -,FLAT
CHISEL, HOT
 rt CREASER, HOT
CHUCK, DRILL
CHUCK, LATHE
CHUCK, TAP
Clipper, Bolt
 use CUTTER, BOLT
CONCENTRATOR
 note use only if specific type is unknown
CONCENTRATOR, CYCLONE
CONCENTRATOR, ELECTROMAGNETIC
CONCENTRATOR, FLOTATION
CONCENTRATOR, JIG
CONCENTRATOR, SHAKING-TABLE
CONE MACHINE
CONVERTER
Copper, Soldering
 use IRON, SOLDERING
COUNTERBORE
COUNTERSINK
CREASER, HOT
 rt CHISEL, HOT
CREASING MACHINE
Crimper
 use CRIMPING MACHINE
CRIMPING MACHINE
CUTTER, BAR
CUTTER, BOLT
CUTTER, CLINCH
Cutter, Gear
 use CUTTING MACHINE, GEAR
Cutter, Nail
 use NIPPERS, NAIL

METALWORKING T&E (cont.)

CUTTER, PIPE
CUTTER, WASHER
CUTTER, WIRE
Cutting machine, Die
 use DIE-CUTTING MACHINE
CUTTING MACHINE, GEAR
CUTTING MACHINE, NAIL
Cutting machine, Screw
 use SCREW-CUTTING MACHINE
DIE
DIE, TOE-CALK WELDING
DIE-CUTTING MACHINE
Dingelstuck
 use ANVIL, SCYTHE-SHARPENING
DOG, LATHE
 note may be further subdivided to indicate specific
 type: e.g., DOG, LATHE--BENT TAIL;
 -,LATHE--CLAMP
Dog, Tiring
 use TONGS, TIRE-PULLING
DOLLY
DOUBLE-SEAMING MACHINE
DRIFT
 note use for a cutting tool; do not confuse with
 PIN, DRIFT or PUNCH, DRIFT
DRILL
 note use for a rotating device designed to hold a
 BIT in a fixed position; use only if specific
 type is unknown; e.g., DRILL PRESS; DRILL, HAND
DRILL, ELECTRIC PORTABLE
DRILL, HAND
DRILL PRESS
 note may be further subdivided to indicate specific
 type: e.g., DRILL PRESS, MULTIPLE-SPINDLE;
 -,SENSITIVE; -,GANG; -,BLACKSMITH'S
Drop forge
 use HAMMER, DROP
Drop hammer
 use HAMMER, DROP
Engine, Blowing
 use BLOWING ENGINE
EXTRUDER
FILE
 note may be further subdivided to indicate specific
 type: e.g., FILE, FLAT; -,MILL; -,SQUARE
FLANGE
FLATTER
 rt HAMMER, SET
FOLDING MACHINE
 rt BRAKE
FORGE, AMERICAN

METALWORKING T&E (cont.)

 FORGE, BLACKSMITH'S
 FORGE, CATALAN
 FORGE, CHAMPLAIN
 Forge, Drop
 use HAMMER, DROP
 FORMING MACHINE
 FULLER
 note may be further subdivided to indicate specific
 type: e.g., FULLER, TOP; -,CREASING
 FURNACE, ANNEALING
 FURNACE, BASIC OXYGEN
 FURNACE, BLAST
 FURNACE, ELECTRIC
 FURNACE, HEARTH
 FURNACE, MUFFLE
 FURNACE, REVERBERATORY
 Furnace, Shaft
 use FORGE, CATALAN
 FURNACE, SOLDERING
 Gage
 use GAUGE
 GAUGE
 note may be further subdivided to indicate specific
 type: e.g., GAUGE, CENTER; -,DRILL;
 -,SCREW-PITCH; -,THREAD; -,WIRE
 Gauge, Tiring
 use TRAVELER
 Gear-cutting machine
 use CUTTING MACHINE, GEAR
 GRINDER
 rt GRINDSTONE
 GRINDER, CYLINDRICAL
 GRINDER, MOWER-KNIFE
 GRINDER, PLANER KNIFE
 GRINDER, SURFACE
 GRINDER, TOOL
 GRINDSTONE
 rt GRINDER
 GROOVER, HAND
 GROOVING MACHINE
 HACKSAW
 HACKSAW, POWER
 HAMMER
 note use only if specific type is unknown
 rt SLEDGE
 HAMMER, BALL-PEEN
 note use only if specific type is unknown
 HAMMER, BLAST
 Hammer, Board
 use HAMMER, DROP

179

METALWORKING T&E (cont.)

Hammer, Chipping
 <u>use</u> more specific term: e.g., HAMMER, BALL-PEEN;
 HAMMER, STRAIGHT-PEEN
HAMMER, CROSS-PEEN
 <u>note</u> use only if specific type is unknown
HAMMER, DROP
HAMMER, FARRIER'S SHARPENING
HAMMER, FARRIER'S TURNING
HAMMER, FILE-CUTTER'S
HAMMER, FOOT-POWERED
HAMMER, HELVE
HAMMER, PLANISHING
HAMMER, PLOW
Hammer, Power
 <u>use</u> more specific term: e.g., HAMMER, HELVE or
 TRIP-HAMMER
HAMMER, RAISING
HAMMER, RIVETING
Hammer, Rounding
 <u>use</u> HAMMER, FARRIER'S TURNING
HAMMER, SET
 <u>rt</u> FLATTER
HAMMER, SETTING
 <u>rt</u> HAMMER, SWAGE
Hammer, Shoe-turning
 <u>use</u> HAMMER, FARRIER'S TURNING
Hammer, Sledge
 <u>use</u> SLEDGE
HAMMER, STEAM
HAMMER, STRAIGHT-PEEN
 <u>note</u> use only if specific type is unknown
Hammer, Striking
 <u>use</u> SLEDGE
HAMMER, SWAGE
 <u>rt</u> HAMMER, SETTING
Hammer, Tilt
 <u>use</u> HAMMER, HELVE
Hammer, Trip
 <u>use</u> TRIP-HAMMER
HAMMER, WHEELWRIGHT'S IRONING
HARDY
 <u>note</u> may be further subdivided to indicate specific
 type: e.g., HARDY, SIDE-CUTTING; -,STRAIGHT
HEADING MACHINE, BOLT
HEADING TOOL
 <u>note</u> use only if specific type is unknown
HEADING TOOL, BOLT
HEADING TOOL, NAIL
HEATER, BRANDING-IRON
HOLDER, DIE
HOLDER, SCYTHE-SHARPENER

METALWORKING T&E (cont.)

Hone
> use WHETSTONE
Horn, Mower's
> use HOLDER, SCYTHE-SHARPENER
HORSE, NAILMAKER'S ANVIL
IMPACTOR
IRON, SNARLING
IRON, SOLDERING
JAMB PLATE
> rt SCREW PLATE
JIG
Keeve
> use CONCENTRATOR
Key, Cotter
> use PIN, COTTER
KNURLING TOOL
LADLE
> note use only if specific type is unknown
LADLE, CINDER
LADLE, HOT-METAL
LADLE, SLAG
LATHE
> note use only if specific type is unknown
LATHE, CHUCKING
> note use for a lathe that turns work held on a face
> plate or chuck, rather than work turned
> between centers
LATHE, ENGINE
> note use for a lathe which has a slide rest and a
> power feed on the carriage
LATHE, FOOT
> note use for a lathe operated by a treadle
LATHE, HAND
> note use for a lathe in which the lathe tool is
> hand-held
LATHE, SCREW-CUTTING
> note use for a lathe with a second feed on the
> carriage to allow for cutting threads
LATHE, TURRET
> note use for a multi-tooled lathe
Levando
> use CONCENTRATOR
MANDREL
MASK, WELDER'S
MAUL, SPIKE
MILL, RAIL
MILL, ROLLING
MILL, SAMPLING
MILL, SLITTING
MILL, STAMPING
MILL, STEEL

METALWORKING T&E (cont.)

MILL, TUBE
MILL, WIRE
MILLER INDEX
MILLING MACHINE
> note may be further subdivided to indicate specific
> type: e.g., MILLING MACHINE, DUPLEX;
> -,HORIZONTAL SPINDLE; -,VERTICAL SPINDLE

MOLD
> note may be further subdivided to indicate specific
> type: e.g., MOLD, BASIN; -,BUTTON; -,PIG;
> -,TEASPOON

Nail-cutting machine
> use CUTTING MACHINE, NAIL

Nail header
> use HEADING TOOL, NAIL

NIPPERS, NAIL
NIPPERS, PULLING
NIPPERS, SHEET METALWORKER'S
NUT
NUT-TAPPER MACHINE
Oilstone
> use WHETSTONE

OVEN, COKE
PAN, AMALGAMATING
Pig
> use MOLD, PIG

PIN, COTTER
PIN, DRIFT
PLANER
> rt SHAPER

Plate, Amalgam
> use TABLE, AMALGAMATING

POKER
POLISHING MACHINE
Press, Drill
> use DRILL PRESS

PRESS, PUNCH
PRESS, STAMPING
PRESSING MACHINE, BULLET
PRITCHEL
PUNCH, BACKING-OUT
Punch, Bob
> use COUNTERSINK

PUNCH, CENTER
PUNCH, DRIFT
PUNCH, DRIVE CALK
PUNCH, FORE
PUNCH, HOLLOW
Punch, Pin
> use PUNCH, BACKING-OUT

PUNCH, PRICK

METALWORKING T&E (cont.)

 RABBLE
 RAKE, BLACKSMITH'S
 REAMER
 note may be further subdivided to indicate specific
 type: e.g., REAMER, PIPE-BURRING
 RETORT, AMALGAM
 RIFLING MACHINE
 RING, TONG
 RIVET
 RIVET-MAKING MACHINE
 ROASTER
 ROLLER
 SAW, BAND
 SAW, CIRCULAR
 Saw, Hack
 use HACKSAW
 SCRAPER
 note may be further subdivided to indicate specific
 type: e.g., SCRAPER, FLAT; -,HALF-ROUND;
 -,HOOK; -,THREE-CORNERED
 SCREEN
 SCREW
 note may be further subdivided to indicate specific
 type: e.g., SCREW, MACHINE; -,SHEET METAL
 SCREW-CUTTING MACHINE
 SCREW PLATE
 rt JAMB PLATE
 Scythe sharpener
 use ANVIL, SCYTHE-SHARPENING or STONE,
 SCYTHE-SHARPENING
 Separator
 note see Mining T&E for separators for metals
 SETTING-DOWN MACHINE
 SHAPER
 rt PLANER
 Sharpener, Knife
 use STEEL or WHETSTONE
 Sharpener, Scythe
 use STONE, SCYTHE-SHARPENING or ANVIL,
 SCYTHE-SHARPENING
 Sharpener, Sickle-bar
 use GRINDER, MOWER-KNIFE
 SHEARING MACHINE
 note use only if specific type is unknown: e.g.,
 SHEARS, CIRCLE; SHEARS, LEVER; SHEARS, SQUARING
 SHEARS, BENCH
 SHEARS, CIRCLE
 SHEARS, LEVER
 SHEARS, SQUARING
 SHOVEL, BLACKSMITH'S
 Shrinker, Tire/axle
 use UPSETTER, TIRE/AXLE

METALWORKING T&E (cont.)

 SINTERING MACHINE
 SKIMMER
 SLAG CAR
 SLEDGE
 <u>note</u> use for a large, usually two-handed, hammer;
 may be further subdivided to indicate specific
 type: e.g., SLEDGE, CROSS-PEEN; -,DOUBLE-FACE;
 -,STRAIGHT-PEEN
 <u>rt</u> HAMMER; MAUL, POST
 SLEDGE, SHOE-TURNING
 Sledgehammer
 <u>use</u> SLEDGE
 SNIPS, SHEET METALWORKER'S
 SOCKET SET
 SOLDERING MACHINE, CAN
 SPOON, BLACKSMITH'S
 SPRINKLER, BLACKSMITH'S
 STAKE
 <u>note</u> use only if specific type is unknown
 STAKE, BLOWHORN
 STAKE, CANDLEMOLD
 STAKE, CREASING
 STAKE, DOUBLE-CREASING
 STAKE, HATCHET
 STAKE, HOLLOW-MANDREL
 STAKE, NEEDLE CASE
 STAKE, PLANISHING
 STAKE, SQUARE
 STAMP
 STEEL
 <u>rt</u> WHETSTONE
 STONE, SCYTHE-SHARPENING
 <u>rt</u> ANVIL, SCYTHE-SHARPENING
 STRAIGHTENING MACHINE
 Strickle
 <u>use</u> STONE, SCYTHE-SHARPENING
 SWAGE
 <u>note</u> use only if specific type is unknown
 SWAGE, ANVIL
 <u>rt</u> BEAKIRON
 SWAGE, BOLT-HEADING
 SWAGE, BOTTOM
 SWAGE, COLLENDER
 SWAGE, CREASING
 SWAGE, FORMING
 SWAGE, HALF-ROUND TOP
 SWAGE, HATCHET
 SWAGE, MANDREL
 SWAGE, NECKING
 SWAGE, NUT
 SWAGE, SPRING

METALWORKING T&E (cont.)

SWAGE, TOP
SWAGE, TOP-AND-BOTTOM
SWAGE, TOP-AND-BOTTOM-JOINED
SWAGE, V-SHAPED
SWAGE BLOCK
Swedge
 <u>use</u> SWAGE
Table, Air
 <u>use</u> CONCENTRATOR
TABLE, AMALGAMATING
TAP
 <u>note</u> may be further subdivided to indicate specific
 type: e.g., TAP, BOTTOM; -,PLUG; -,TAPER
TAP AND DIE SET
TAPPING MACHINE
TEMPLATE
THREADING MACHINE, PIPE
TIRE-BENDING MACHINE
TONGS
 <u>note</u> use only if specific type is unknown
Tongs, Anvil
 <u>use</u> TONGS, PICKUP
TONGS, BENDING
TONGS, BOLT
 <u>rt</u> TONGS, HOLLOW-BIT; TONGS, ROUND-LIP
TONGS, BOX
 <u>rt</u> TONGS, DOUBLE BOX
TONGS, BOX HAMMER
 <u>rt</u> TONGS, HAMMER
TONGS, BRAZING
TONGS, CHAIN
TONGS, CLIP
TONGS, CROOK-BIT
 <u>rt</u> TONGS, SIDE
TONGS, DOUBLE BOX
 <u>rt</u> TONGS, BOX
TONGS, DRAWING
TONGS, DROP HAMMER FORGING
Tongs, Eye
 <u>use</u> TONGS, HAMMER
TONGS, FLAT
TONGS, GAD
TONGS, HALF-ROUND
TONGS, HAMMER
 <u>rt</u> TONGS, BOX HAMMER
TONGS, HOLLOW-BIT
 <u>rt</u> TONGS, BOLT; TONGS, ROUND-LIP
TONGS, HOOP
TONGS, NAIL
TONGS, PICKUP
 <u>note</u> may be further subdivided to indicate specific

METALWORKING T&E (cont.)

 type: e.g., TONGS, PICKUP-SINGLE;
 -,PICKUP-LIGHT; -,PICKUP-DOUBLE
TONGS, PINCER
Tongs, Right-angle bit
 use TONGS, SIDE
TONGS, ROOFING
TONGS, ROUND-LIP
 rt TONGS, BOLT; TONGS, HOLLOW-BIT
TONGS, SHOE
TONGS, SIDE
 rt TONGS, CROOK-BIT
Tongs, Straight-lip
 use TONGS, FLAT
TONGS, TIRE
TONGS, TIRE-PULLING
Tongs, V-lip
 use TONGS, HOLLOW-BIT
TORCH
 note may be further subdivided according to fuel
 used: e.g., TORCH, ACETYLENE; -,PROPANE;
 -,GASOLINE; -,KEROSINE; -,OXYACETYLENE;
 -,OXYHYDROGEN
TRAVELER
TRIP-HAMMER
TUB, SLACK
TURNING MACHINE
UPSETTER, TIRE/AXLE
VISE
 note may be further subdivided to indicate specific
 type: e.g., VISE, BLACKSMITH'S; -,BENCH;
 -,LEG; -,FARRIER'S WELDING
VISE, MACHINE
Welder, Arc
 use WELDER, ELECTRIC
WELDER, ELECTRIC
Welder, Gas
 use TORCH, GASOLINE or TORCH, PROPANE
Wheel, Tire-measuring
 use TRAVELER
WHETSTONE
 rt STEEL
WIRING MACHINE
Wrench, Adjustable-end
 use WRENCH, CRESCENT
WRENCH, CARRIAGE NUT
WRENCH, CRESCENT
WRENCH, MONKEY
WRENCH, OPEN-END
WRENCH, PIPE
WRENCH, SOCKET
WRENCH, TAP

METEOROLOGICAL T&E

 <u>def</u> An artifact originally created to be used in the observation, measurement and recording of atmospheric phenomena

 AEROMETER
 AIR POISE
 ANEMOGRAPH
 ANEMOMETER
 ANEMOSCOPE
 ANEROIDOGRAPH
 BALLOON, WEATHER
 BAROGRAPH
 BAROMETER

 <u>note</u> may be further subdivided to indicate specific type: e.g., BAROMETER, ANEROID; -,MERCURY

 BAROSTAT
 CEILOMETER
 CLOUD CHAMBER
 DIAPHANOMETER
 DROSOMETER
 GAUGE, PRECIPITATION
 HYGROGRAPH
 HYGROMETER
 Hygrophant

 <u>use</u> HYGROMETER

 KONISCOPE
 METEOROGRAPH
 METEOROMETER
 METER, AIR
 MIRROR, CLOUD
 NEPHOSCOPE
 OMBROMETER
 OZONOMETER
 PAGOSCOPE
 PLUVIOGRAPH
 PLUVIOMETER
 RADIOSONDE
 RAWIN SET
 RECORDER, SUNSHINE
 SEISMOGRAPH
 SEISMOPHONE
 Sympiesometer

 <u>use</u> BAROMETER

 TASIMETER
 THERMOMETER
 TROMOMETER
 UDOMETER
 WEATHERVANE

MINING T&E

 <u>def</u> An artifact originally created to be used in extracting
 minerals and other solids, liquids or gases from the
 natural environment; includes equipment used in
 underground and surface mines, quarries, oil and water
 wells, as well as in prospecting and in supplemental
 processing operations such as breaking, milling, washing,
 cleaning or grading; see also Transportation Artifacts
 (Category 6), CONSTRUCTION T&E, MECHANICAL T&E and
 METALWORKING T&E

 <u>ref</u> (65) (121)

 AIR LEG
 AMBULANCE CAR
 AMIGO
 ASSAY APPARATUS
 Auger
 <u>use</u> DRILL, ROTARY
 BAG, ORE
 BAG, TAMPING
 BAILER
 BALANCE, ASSAY
 BALANCE, BOB
 BALANCE, WATER
 BAR
 BAR, BORING
 BAR, CLAYING
 BAR, MINER'S
 BAR, QUARRY
 BAR, RIGGING
 BAR, STRETCHER
 BAR, TAMPING
 BAR, WAGON-PINCH
 BARN
 BASKET, ORE
 BIN, ORE
 BIT
 <u>note</u> may be further subdivided to indicate specific
 type: e.g., BIT, CORE; -,DIAMOND; -,TUNGSTEN
 CARBIDE
 Blaster
 <u>use</u> DETONATOR
 BLOWING MACHINE
 BOGIE
 BOILER
 <u>note</u> may be further subdivided to indicate specific
 type: e.g., BOILER, CORNISH; -,HAYCOCK
 BOLT, LEWIS
 BOLT, RAG
 BOLT, ROOF
 BREATHING APPARATUS
 Bucket, Sinking
 <u>use</u> KIBBLE

MINING T&E (cont.)

CADGER
CAGE
CAGE, MAN
CAN, SAFETY CARBIDE
Canary
 use DETECTOR, GAS
CAP, BLASTING
CAP, TIMBER
CARRIAGE, TUNNEL
CASING
CHANGKOL
CHANNELER
CHARCOAL PIT
CLASSIFIER
Concentrator
 note see METALWORKING T&E for concentrators
CONTINUOUS MINER
Cornish roll
 use CRUSHER, ROLLER
CRIB, CRIBBING
CRIMPER, BLASTING CAP
Crossbar
 use CAP, TIMBER
CRUSHER, BALL
Crusher, Chilean
 use CRUSHER, ROLLER
CRUSHER, GYRATORY
CRUSHER, HAMMER
CRUSHER, JAW
CRUSHER, ORE
 note use only if specific type is unknown
CRUSHER, ROLLER
CRUSHER, STAMP
CUTTER, CHANNEL BAR
CUTTER, COAL
CUTTER, JET-PIERCING
CUTTING MACHINE
DART, SPRING
DERRICK
Detector, Firedamp
 use DETECTOR, GAS
DETECTOR, GAS
DETONATOR
DIAL, MINER'S
DIP BOX
DIVINING ROD
DREDGE
 note use only if specific type is unknown
DREDGE, BUCKETLINE
DREDGE, SUCTION

MINING T&E (cont.)

DRILL
 <u>note</u> use only if specific type is unknown
 <u>rt</u> HANDSTEEL
Drill, Calyx
 <u>use</u> DRILL, SHOT
DRILL, CHURN
DRILL, CORE
 <u>note</u> use only if specific type is unknown
DRILL, DIAMOND
Drill, Drifter
 <u>use</u> DRILL, PERCUSSIVE AIR
DRILL, GANG
DRILL, JETTING
DRILL, PERCUSSIVE
 <u>note</u> may be further subdivided to indicate method
 of activation: e.g., DRILL, PERCUSSIVE AIR
Drill, Pole
 <u>use</u> DRILL, CHURN
DRILL, ROTARY
 <u>note</u> may be further subdivided to indicate method
 of activation: e.g., DRILL, ROTARY AIR;
 -,ROTARY HYDRAULIC
DRILL, SHOT
DRILL, SINKER
DRILL, STOPPER
DRILL, TURBO
Drill, Well
 <u>use</u> more specific term: e.g., DRILL, CHURN;
 -,ROTARY
DULANG
ELEVATOR, HYDRAULIC
E-machine
 <u>use</u> BLOWING MACHINE
ENGINE, MAN
Exploder
 <u>use</u> DETONATOR
FAN, VENTILATION
FISHING TOOL
FISHPLATE
FLOTATION CELL
FORK, SLUICE
FUSE, DETONATING
GAD
 <u>rt</u> MOIL
GADDER
GALVANOMETER, BLASTING
Gas detector
 <u>use</u> DETECTOR, GAS
GEIGER COUNTER
GEOPHONE
Giant, Hydraulic
 <u>use</u> MONITOR, HYDRAULIC

MINING T&E (cont.)

Gin
 <u>use</u> HOIST, MINE
GIN POLE
GIRT
GOVERNOR
GRAPNEL
GRIZZLY
Grout machine
 <u>use</u> INJECTOR, CEMENT
Hammer, Air
 <u>use</u> DRILL, PERCUSSIVE AIR
HAMMER, HAND
HANDSTEEL
 <u>rt</u> DRILL
HOIST, MINE
HOOK, GRAB
HOOKAH
Hoppit
 <u>use</u> KIBBLE
HORN, MINER'S
HURDY-GURDY
Igniter
 <u>use</u> DETONATOR
INDICATOR, DRIFT
INJECTOR, CEMENT
IRON, BUCKING
ITA
Jackhammer
 <u>use</u> DRILL, PERCUSSIVE AIR
Jackleg
 <u>use</u> AIR LEG
JUMBO
KEG
KELLEY
KIBBLE
KUA
LAGGING
LIFT, DRAWING
LOADER
LOADING MACHINE
LOCOMOTIVE, MINE
LOG
 <u>note</u> may be further subdivided to indicate specific
 type: e.g., LOG, NEUTRON
Long tom
 <u>use</u> SEPARATOR
MAN CAR
Man car
 <u>use</u> MINE CAR
Mechanical miner
 <u>use</u> CONTINUOUS MINER

191

MINING T&E (cont.)

MILL
> note may be further subdivided to indicate specific
> type: e.g., MILL, FLINT; -,STAMP

Mill, Quartz
> use MILL, STAMP

Mill, Steel
> use MILL, FLINT

MILLBRACE

MINE CAR

MOIL
> rt GAD

MONITOR, HYDRAULIC

Motor
> use LOCOMOTIVE, MINE

Mucking machine
> use LOADER

NEEDLE, DIPPING

Ore car
> use MINE CAR

PAN, MINER'S

PHANAROGRISONMETER

PHOTOCLINOMETER

PICK

PICK, DOUBLE-POINTED

PICK, DRIFTING

Pick, Holing
> use PICK, UNDERCUTTING

PICK, POLL

PICK, UNDERCUTTING

PICKER

PRESSING MACHINE

PRICKER

PUMP
> note may be further subdivided to indicate specific
> type: e.g., PUMP, CENTRIFUGAL;
> -,DOUBLE-ACTION; -,SUBMERSIBLE

QUARRYING MACHINE
> note use only if specific type is unknown: e.g.,
> DRILL, GANG; CUTTER, CHANNEL BAR; CUTTER,
> JET-PIERCING

RAIL BENDER

RIFFLES

Rocker
> use SEPARATOR

ROLLING MACHINE, FLAT GLASS

SAMPLER, SIDEWALL

SCRAPER, HOE

SCREEN, TROMMEL

SEPARATOR
> note use only if specific type is unknown

SEPARATOR, CRADLE

MINING T&E (cont.)

 SEPARATOR, ELECTROMAGNETIC
 SEPARATOR, ELECTROSTATIC
 SEPARATOR, FRAME
 SEPARATOR, JIGGING-MACHINE
 SEPARATOR, WASHER
 SHAFTSET
 SHEAVE, WINDING
 SHIELD
 Single jack
 use HAMMER, HAND
 SKIP
 SLUICE BOX
 SLUSHER
 SNATCH PLATE
 SNORE
 SPADE, GRAFTING
 SPINNING LINE
 SPIRAL WORM
 SPLITTER, SAMPLE
 SPOON
 SPRING POLE
 SPUD
 SQUIB, MINER'S
 STEMMER, TAMPING-BAR
 STRAKE, BLANKET
 STUFFING BOX
 STULL
 SUCKER ROD
 SUPPORTS, POWERED
 TIE, SLEEPERS
 TILLER
 TIMBER SET
 TORPEDO
 TRAM
 TRAY, ORE
 TRIPOD
 UNDERCURRENT
 Vanner
 use SEPARATOR
 VAT, CYANIDATION
 WASHER
 WASHER, DRY
 WEDGE, DEFLECTION
 Whipstock
 use WEDGE, DEFLECTION
 Widowmaker
 use DRILL

MUSICAL T&E
 def An artifact originally created to be used in the

production of music (e.g., a French horn, a snare drum, a
zither); does not include objects used to reproduce sound
(see SOUND COMMUNICATION EQUIPMENT, Category 5)

ref (11) (21)

note the names of many musical instruments are further
subdivided to indicate either a specific pitch (e.g.,
TRUMPET, E FLAT; -,F) or a relative range of pitch (e.g.,
SAXOPHONE, SOPRANO; -,ALTO; -,TENOR; -,BARITONE; -,BASS);
in most cases these general subdivisions are omitted from
the lists of object names included here but may be added
as necessary when cataloging specific instruments

MUSICAL T&E, BRASS

BASSOON, RUSSIAN
Bombardon
 use TUBA
BUCCIN
BUGLE
BUGLE, KEY
BUGLE, VALVE
CLAVICOR
Cor, Tenor
 use MELLOPHONE
CORNET
CORNETT
Cornopean
 use CORNET
EUPHONIUM
Flugelhorn
 use BUGLE, VALVE
HORN
HORN, ALTO
HORN, BARITONE
HORN, BASS
HORN, COACH
HORN, FRENCH
HORN, HUNTING
HORN, POST
HORN, TENOR
INVENTIONSHORN
MELLOPHONE
OPHICLEIDE
Sackbut
 use TROMBONE
SAXHORN
SERPENT
Sousaphone
 use TUBA
TROMBONE
TROMBONE, VALVE

MUSICAL T&E, BRASS (cont.)

> TRUMPET, CURVED
> TRUMPET, KEY
> TRUMPET, NATURAL
> TRUMPET, SLIDE
> TRUMPET, VALVE
> TUBA
> WAGNER TUBEN

MUSICAL T&E, PERCUSSION

> ANVIL
> BELL
> BRUSH, WIRE
> CASTANETS
> CELESTA
> CHAINS
> CHIMES
> CLAVES
> COWBELL
> CYMBAL
> DRUM
> DRUM, BASS
> DRUM, BONGO
> DRUM, SIDE
> DRUM, SNARE
> DRUM, TENOR
> GLOCKENSPIEL
> GONG
> JINGLES
> Kettledrum
> use TIMPANUM
> MARACAS
> MARIMBA
> RATCHET
> RATTLE
> SWITCH
> TABOR
> TAMBOURINE
> TAM-TAM
> TIMPANUM
> TOM TOM
> TRIANGLE
> VIBRAPHONE
> WHIP
> WOODBLOCK
> XYLOPHONE

MUSICAL T&E, STRINGED

AUTOHARP
BALALAIKA
BANJO
BARYTON
 rt VIOL, BASS
BASS, DOUBLE
CIMBALOM
 note may be further subdivided to indicate specific
 type: e.g., CIMBALOM, APPALACHIAN; -,HAMMERED
CITTERN
CLAVICHORD
CRWTH
DULCIMER
 note may be further subdivided to indicate specific
 type: e.g., DULCIMER, APPALACHIAN; -,HAMMERED
GUITAR
HARP
HARPSICHORD
HURDY-GURDY
HUSLA
KIT
 rt VIOLIN
LIRA
 rt VIOLA
LUTE
 rt THEOROBO
LYRE
LYRE-GUITAR
MANDOLIN
 rt MANDORE
MANDORE
 rt MANDOLIN
PIANO, BARREL
PIANO, GRAND
PIANO, PLAYER
Piano, Reproducing
 use PIANO, PLAYER
PIANO, SQUARE
PIANO, UPRIGHT
PIANO BENCH
PIANO STOOL
PLAYER PIANO ROLL
REBEC
 rt VIOLIN
SITAR
SPINET
THEOROBO
 rt LUTE
TRUMPET MARINE
VIOL
VIOL, BASS
 rt BARYTON

MUSICAL T&E, STRINGED (cont.)

 VIOL, CITHER
 VIOL, LYRA
 VIOLA
 <u>rt</u> LIRA
 VIOLA D'AMORE
 VIOLIN
 <u>rt</u> KIT; REBEC
 VIOLONCELLO
 VIRGINAL
 ZITHER

MUSICAL T&E, WOODWIND

 BAGPIPE
 <u>note</u> use only if specific type is unknown
 BAGPIPE, FRENCH CORNEMUSE
 BAGPIPE, FRENCH MUSETTE
 BAGPIPE, IRISH UNION-PIPE
 BAGPIPE, ITALIAN ZAMPOGNA
 BAGPIPE, NORTHUMBRIAN SMALL-PIPE
 BAGPIPE, SCOTTISH HIGHLAND
 BAGPIPE, SCOTTISH LOWLAND
 BAGPIPE, WESTERN FOLK
 BASSOON
 BASSOON, DOUBLE
 CALLIOPE
 CHALUMEAU
 CLARINET
 Cor anglais
 <u>use</u> HORN, ENGLISH
 CRUMHORN
 CURTAL
 DULCIAN
 FIFE
 FLAGEOLET
 FLAGEOLET, DOUBLE
 FLAGEOLET, TRIPLE
 FLUTE
 Hautboy
 <u>use</u> OBOE
 HORN, BASSET
 HORN, ENGLISH
 OBOE
 OBOE D'AMORE
 OCARINA
 OCTAVIN
 ORGAN, BARREL
 ORGAN, PIPE
 PANPIPE
 PICCOLO

MUSICAL T&E, WOODWIND (cont.)

 Pipe
 use BAGPIPE, FIFE or PANPIPE
 PIPE, PITCH
 PIPE, TABOR
 RACKET
 RECORDER
 SARRUSOPHONE
 SAXOPHONE
 SHAWM
 TAROGATO
 TENOROON

MUSICAL T&E, UNCLASSIFIED
 note use for mechanical, electronic and metal reed instruments
 and for all musical accessories

 ACCORDION
 BATON
 HARMONICA
 HARMONICA, GLASS
 HARP, JEW'S
 KAZOO
 Melodeon
 use ORGAN, REED
 MUSIC STAND
 ORCHESTRION
 ORGAN, ELECTRONIC
 ORGAN, REED
 ORGANETTE
 RHYTHMOMETER
 SAW, MUSICAL
 SYNTHESIZER
 THEREMIN

NUCLEAR PHYSICS T&E
 def An artifact originally created to be used in the study of
 nuclear structure and elementary particles; see also
 CHEMICAL T&E and POWER PRODUCTION T&E
 ref (3) (4)

 ACCELERATOR
 note use only if specific type is unknown: e.g.,
 BETATRON, PROTONSYNCHROTRON, VAN DE GRAAF
 ACCELERATOR, LINEAR
 Atom smasher
 use ACCELERATOR
 BEAM-TRANSPORT SYSTEM
 note use for a system of magnets and/or
 electrostatic devices used to move particles
 from one point to another

 198

NUCLEAR PHYSICS T&E (cont.)

 BETATRON
 BUBBLE CHAMBER
 CLOUD CHAMBER
 COCKCROFT WALTON
 COLLIMATOR
 CONDENSER, ROTATING
 CYCLOTRON
 note may be further subdivided to indicate specific
 type: e.g., CYCLOTRON, AVF
 DEFLECTOR
 note use for any device which distorts a particle
 orbit so it can be removed from the
 accelerator to strike a target
 DESICCATOR, BALANCE
 Donut
 use VACUUM CHAMBER
 Hilac
 use ACCELERATOR, LINEAR--HEAVY ION
 ISOCHRONOUS
 KLYSTRON
 Linac
 use ACCELERATOR, LINEAR
 MAGNET, BENDING
 MAGNET, QUADRUPOLE
 MAGNET, SEXTUPOLE
 PROTONSYNCHROTRON
 SEPARATOR, BEAM
 SPECTROGRAPH, MASS
 SPECTROMETER, MASS
 STATIC ELIMINATOR, BALANCE
 SYNCHROCYCLOTRON
 SYNCHROTRON
 note may be further subdivided to indicate specific
 type: e.g., SYNCHROTRON, ALTERNATING-GRADIENT;
 -,CONSTANT-GRADIENT; -,ZERO-GRADIENT
 TANDEM MACHINE
 VACUUM CHAMBER
 VAN DE GRAAF
 VIBRATION DAMPER, BALANCE

OPTICAL T&E
 def An artifact originally created to be used in the
 observation, measurement and recording of light; includes
 general-purpose optical equipment (e.g., binoculars, a
 microscope); does not include specialized artifacts
 created to serve other specific purposes (e.g., a visual
 acuity chart, an astronomer's telescope); see also VISUAL
 COMMUNICATION EQUIPMENT (Category 5) and MEDICAL &
 PSYCHOLOGICAL T&E
 ref (66) (67)

OPTICAL T&E (cont.)

ABSORPTIONMETER
Altiscope
 use PERISCOPE
Anastigmat
 use LENS, ANASTIGMATIC
ANORTHOSCOPE
APERTOMETER
BINOCULARS
CATOPTER
CHROMASCOPE
CHROMATOMETER
COLLIMATOR
COLORIMETER
CONDENSER
DICHROSCOPE
DYNACTINOMETER
DYNAMETER
EIKONOMETER
Engiscope
 use MICROSCOPE
FIELD GLASSES
FOCOMETER
GONIOPHOTOMETER
HOLOPHOTE
INTERFEROMETER
LENS
LENS, ANASTIGMATIC
LENS, WATER
Lucimeter
 use PHOTOMETER
MAGNIFYING GLASS
METROCHROME
MICROSCOPE
MICROSCOPE, BINOCULAR
MICROSCOPE, ELECTRON
MICROSPECTROSCOPE
OTHEOSCOPE
PERISCOPE
PHONEIDOSCOPE
PHOTODROME
PHOTOMETER
PHOTOMETER, POLARIZING
POLARIMETER
 rt POLARISCOPE
POLARISCOPE
 rt POLARIMETER
PSEUDOSCOPE
REDUCING GLASS
REFRACTOMETER
SCOTOSCOPE
SPECTROGRAPH

OPTICAL T&E (cont.)

 SPECTROMETER
 SPECTROPHOTOMETER
 SPECTROSCOPE
 STAUROSCOPE
 TACHISTOSCOPE
 TEINOSCOPE
 TELESCOPE
 Vivascope
 use TELESCOPE
 ZOOPRAXINOSCOPE

PAINTING T&E
 def An artifact originally created to be used in painting,
 either as an art form or for decorative purposes; includes
 the tools of related arts and crafts such as drawing,
 lettering, gilding and paperhanging; see also WRITTEN
 COMMUNICATIONS EQUIPMENT (Category 5), DRAFTING T&E and
 PRINTING T&E
 ref (72)

 AIRBRUSH
 Artist's model
 use LAY FIGURE
 BRUSH, LETTERING
 BRUSH, PAINT
 BRUSH, WALLPAPER
 COMB, GRAINING
 CRAYON
 CUP, PALETTE
 CUSHION, GILDER'S
 CUTTER, EDGE
 CUTTER, MAT
 EASEL
 GUN, SPRAY
 KNIFE, MAT
 KNIFE, PAINTING
 KNIFE, PALETTE
 KNIFE, PUTTY
 LAY FIGURE
 rt DOLL
 Mahlstick
 use MAULSTICK
 MAULSTICK
 MILL, BALL
 MILL, ROLLER
 MULLER
 PALETTE
 PEN, LETTERING
 PLIERS, STRETCHING
 ROLLER

PAINTING T&E (cont.)

 ROLLER, JOINT
 ROULETTE
 SAUCER, NEST
 SCRAPER, WALL
 SPATULA
 STUMP
 STYLOGRAPH
 TIP, GILDER'S

PAPERMAKING T&E
 def An artifact originally created to be used in the
 manufacturing of paper or the fabrication of paper
 products
 ref (20) (125)

 BAG-FORMING MACHINE
 BEATER, HOLLANDER
 BEATER, JORDAN
 BLEACHING CELL
 BLENDER, STOCK
 CALENDER
 CHIPPER
 COATING MACHINE
 CUTTER
 note may be further subdivided to indicate specific
 type: e.g., CUTTER, LEVER; -,ROTARY
 Cylinder machine
 use PAPER MACHINE
 DANDY ROLL
 DECKLE
 DIGESTER
 DRYER
 EDGE RUNNER
 FINISHER
 note may be further subdivided to indicate specific
 type: e.g., FINISHER, PEBBLING; -,FLINT-GLAZING
 Fourdrinier machine
 use PAPER MACHINE
 GLARIMETER
 Grinder
 use CHIPPER
 Guillotine
 use CUTTER
 MARKER, REAM
 OPACIMETER
 PACKING MACHINE, BLISTER
 PACKING MACHINE, SKIN
 PAPER MACHINE
 Paper-making machine
 use PAPER MACHINE

PAPERMAKING T&E (cont.)

 PRESS, SMOOTHING
 PULPER
 REWINDER
 SAVE-ALL
 SCORING MACHINE
 SKID
 SLITTER
 Stamper
 use PULPER
 SUCTION BOX
 SUPERCALENDER
 TESTER, MULLEN
 TESTER, SCHOPPER
 THICKENING MACHINE
 TRIMMER
 TRIMMER, BRACKET
 TRIP-HAMMER
 VAT
 WASHING MACHINE
 Yankee machine
 use PAPER MACHINE

PHOTOGRAPHIC T&E
 def An artifact originally created to capture permanently a
 visual image by optical and chemical means (e.g., a
 camera, a film-processing tank, an enlarger); see also
 VISUAL COMMUNICATION EQUIPMENT (Category 5)

 BLOTTER ROLL
 CABLE RELEASE
 CAMERA
 CAMERA, BOX
 CAMERA, FOLDING
 CAMERA, MOTION-PICTURE
 CAMERA, OBSCURA
 CAMERA, RANGEFINDER
 CAMERA, SINGLE LENS REFLEX
 CAMERA, STEREO
 CAMERA, VIEW
 CAMERA CASE
 CASE, DAGUERREOTYPE
 CONTACT-PRINTING FRAME
 DENSITOMETER
 DIAPHRAGM
 DRYER, FILM
 DRYER, PRINT
 EASEL
 ENLARGER
 FERROTYPE PLATE
 FILTER

203

PHOTOGRAPHIC T&E (cont.)

 FLASH ATTACHMENT
 FLASH ATTACHMENT, ELECTRONIC
 GAFFER
 HOLDER, CUT-FILM
 Holder, Plate
 use PLATEHOLDER
 HOLDER, ROLL-FILM
 IRON, TACKING
 KNIFE, FILM
 LENS
 LENS AND DIAPHRAGM
 LENS AND SHUTTER
 LENS, SHUTTER AND DIAPHRAGM
 METER, LIGHT
 PLATEHOLDER
 PRESS, DRY-MOUNTING
 PRINTER, CONTACT
 SAFELIGHT
 SHUTTER
 SHUTTER AND DIAPHRAGM
 SPLICER, FILM
 STIRRING ROD
 Strobe light
 use FLASH ATTACHMENT, ELECTRONIC
 TANK, FILM-PROCESSING
 THERMOMETER
 TIMER, DARKROOM
 TRAY, PRINT-PROCESSING
 TRIPOD
 WASHER, FILM
 WASHER, PRINT

POWER PRODUCTION T&E
 def An artifact originally created to generate, convert or
 distribute power

 BATTERY, SOLAR
 BOILER, STEAM
 COMPRESSOR
 note use only if specific type is unknown
 COMPRESSOR, BLOWING-ENGINE
 COMPRESSOR, DUPLEX AIR
 COMPRESSOR, ROTARY
 COMPRESSOR, SULLIVAN ANGLE
 COMPRESSOR, TURBO
 Dynamo
 use GENERATOR
 Engine, Compression-ignition
 use ENGINE, DIESEL
 ENGINE, DIESEL

POWER PRODUCTION T&E (cont.)

 ENGINE, GAS
 ENGINE, GASOLINE
 ENGINE, HOT-AIR
 ENGINE, LIQUID-FUEL
 note use only if specific type is unknown: e.g.,
 ENGINE, GASOLINE
 ENGINE, OIL-TRACTION
 ENGINE, RAMJET
 ENGINE, STEAM
 ENGINE, STEAM-GAS
 ENGINE, STEAM-TRACTION
 EXCITER
 FURNACE, SOLAR
 GENERATOR
 note may be further subdivided according to source
 of power: e.g., GENERATOR, GASOLINE; -,STEAM
 -,WATER
 GOVERNOR
 HANGER, SHAFT
 IDLER
 INSULATOR
 JACKSHAFT
 LINESHAFT
 Mill, Tread
 use TREAD, ANIMAL-POWERED or TREAD, HUMAN-POWERED
 MOTOR, ELECTRIC
 PANEL, SOLAR
 PENSTOCK
 rt FLUME
 POWER-PLANT, NUCLEAR
 REFLECTOR, SOLAR
 SHIELD, SOLAR
 SWEEP, ANIMAL-POWERED
 SWEEP, HUMAN-POWERED
 TABLE, ANIMAL-POWERED
 TRANSFORMER
 TREAD, ANIMAL-POWERED
 TREAD, HUMAN-POWERED
 Treadmill
 use TREAD, ANIMAL-POWERED or TREAD, HUMAN-POWERED
 TURBINE, HYDRAULIC
 TURBINE, IMPULSE
 TURBINE, INTERNAL-COMBUSTION
 TURBINE, STEAM
 Turbine, Tub
 use WATERWHEEL, TUB
 WATERWHEEL, BREAST
 WATERWHEEL, OVERSHOT
 WATERWHEEL, TUB
 WATERWHEEL, UNDERSHOT
 Wheel, Pelton
 use TURBINE, IMPULSE

POWER PRODUCTION T&E (cont.)

> WINDMILL

PRINTING T&E
> def An artifact originally created to imprint or reproduce
> written, photographic or artistic material; includes
> specialized tools used for bookbinding, engraving,
> etching, lithography, intaglio, silk-screening, etc.
> (e.g., a handpress, an engraver's block, a photocopier);
> see also WRITTEN COMMUNICATION EQUIPMENT (Category 5),
> PAINTING T&E and PAPERMAKING T&E
> ref (72)

> BACKSTRIPPING MACHINE
> BANDING MACHINE
> BATCHER/JOGGER MACHINE
> BINDING BOARD
> BINDING MACHINE
> BLANKET, OFFSET
> BODKIN
> BONE FOLDER
> BRAYER
> BURNISHER
> CASE, TYPE
> CASEMAKING MACHINE
> CASING-IN MACHINE
> CHASE
> COLLATING MACHINE
> Composing machine
> use TYPESETTER
> COMPOSING STICK
> CRAYON, LITHOGRAPHIC
> CUTTER, BOARD
> Cutter, Lead
> use CUTTER, SLUG
> CUTTER, PAPER
> CUTTER, SLUG
> DABBER
> DIE, BINDER
> DUPLICATOR
> rt MIMEOGRAPH
> ECHOPPE
> ENGRAVER'S BLOCK
> ENGRAVING PLATE
> rt WOOD BLOCK
> FILLET
> FOLDING MACHINE
> FRISKET
> GALLEY
> GAUGE, LINE
> GAUGE, PLATE

PRINTING T&E (cont.)

GAUGE, SAW
GAUGE, TYPE HIGH
GLUING MACHINE
GOFFER
HAMMER, BACKING
HANDPRESS
HECTOGRAPH
IMPOSING STONE
INKBALL
IRON, KNOCKING-DOWN
Job stick
 use COMPOSING STICK
KNIFE, ETCHING
KNIFE, FOLDING
KNIFE, PAPER
KNIFE, SHEETER
KNIFE, SKIVING
KNIFE, TAB-CUTTER
KNIFE, TRIMMER
LETTERPRESS
LEVIGATOR
LINOLEUM BLOCK
LITHOGRAPHIC POINT
LITHOGRAPH STONE
LITHO-PRESS
MACE-HEAD
MALLET
Mimeograph
 use DUPLICATOR
MITERING MACHINE
NEEDLE, ETCHING
NEEDLE, LOOPER
NIPPERS, BAND
NUMBERING MACHINE
PALLET
PEEL
PERFORATOR
Photocomposing machine
 use PHOTOTYPESETTER
PHOTOCOPIER
PHOTOTYPESETTER
PLATE, OFFSET
PLOUGH
POT, GLUE
Press, Arming
 use PRESS, BLOCKING
PRESS, BLOCKING
PRESS, BOOK
PRESS, CUTTING
PRESS, CYLINDER
PRESS, EMBOSSING

PRINTING T&E (cont.)

PRESS, ETCHING
Press, Fly
 use PRESS, EMBOSSING
Press, Hand
 use HANDPRESS
Press, Job
 use more specific term: e.g., LETTERPRESS
Press, Letter
 use LETTERPRESS
PRESS, LYING
PRESS, NEWSPAPER
PRESS, NIPPING
PRESS, OFFSET
PRESS, PLATEN
PRESS, STANDING
Printer, Electrostatic
 use PHOTOCOPIER
Printer, Xerographic
 use PHOTOCOPIER
PROCESSING MACHINE, OFFSET-PLATE
QUOIN
ROCKER
ROLLING MACHINE
ROULETTE
ROUND-BACKING MACHINE
ROUND-CORNERING MACHINE
RULING MACHINE
SCRAPER
SEWING FRAME
SEWING KEY
SEWING MACHINE, BOOK
SHEARS, BENCH
SHEET, PLATE-BACKING
SHOOTING STICK
SMASHING MACHINE, BOOK
SQUEEGEE
STOCK-COMPRESSING MACHINE
STOVE, FINISHING
SURFACER, SLUG
TAB-CUTTING MACHINE
TABLE, BINDERY
TABLE, ETCHING
TABLE, IMPOSING
TABLE, LAYOUT/STRIPPING
TABLE, LIGHT
TIPPING MACHINE
TRIMMING MACHINE, BOOK
TYPE
TYPE-CASTING MACHINE
TYPESETTER, COMPUTER
TYPESETTER, KEYBOARD

PRINTING T&E (cont.)

> Typesetter, Linotype
> > use TYPESETTER, KEYBOARD
>
> Typesetter, Monotype
> > use TYPESETTER, KEYBOARD
>
> Typesetter, Photo
> > use PHOTOTYPESETTER
>
> WOOD BLOCK
> > rt ENGRAVING PLATE
>
> Woodcut
> > use WOOD BLOCK

SURVEYING & NAVIGATIONAL T&E

> def An artifact originally created to be used in determining
> either the position of the observer relative to known
> reference points or the form and extent of a region (i.e.,
> surface land, subsurface land, water or air); includes
> instruments for taking both linear and angular measure-
> ments; does not include devices for making calculations
> (see DATA PROCESSING T&E) or for recording data (see
> DRAFTING T&E); see also ASTRONOMICAL T&E
>
> ref (55) (64) (127)

> ALIDADE
> ALTIMETER
> Ambulator
> > use WHEEL, SURVEYOR'S
>
> ANTENNA, RADAR
> APOMECOMETER
> ARTIFICIAL HORIZON
> ASTROLABE, MARINER'S
> BACKSTAFF
> BATHOMETER
> Bench mark
> > use more specific term: e.g., CAIRN; STAKE;
> > MARKER, CONCRETE
>
> BONING ROD
> BUOY, NAVIGATIONAL
> CAIRN
> CATHETOMETER
> CHAIN, SURVEYOR'S
> CHOROGRAPH
> CHRONOMETER
> CIRCUMFERENTOR
> > rt GRAPHOMETER; QUADRANT; OCTANT
>
> CLINOGRAPH
> CLINOMETER
> COMPASS
> > rt GYRO-COMPASS
>
> COMPASS, BOREHOLE
> COMPASS, CARLSON

SURVEYING & NAVIGATIONAL T&E (cont.)

```
    COMPASS, DIP
    COMPASS, RADIO
    COMPASS, SURVEYOR'S
    COMPENSATOR
    CROSS-STAFF
         rt   GROMA
    DEFLECTOR
    DIRECTION FINDER
    DIRECTION FINDER, RADIO
    DISTANCE FINDER
    DRIFTSIGHT
    ECHOMETER
    FATHOMETER
    Goniometer
         use  DIRECTION FINDER
    GRADIOMETER
    GRAPHOMETER
         rt   CIRCUMFERENTOR; QUADRANT
    GROMA
         rt   CROSS-STAFF; OPTICAL SQUARE
    GYRO-COMPASS
         rt   COMPASS
    Heliostat
         use  HELIOTROPE
    HELIOTROPE
    Hodometer
         use  WHEEL, SURVEYOR'S
    INCLINOMETER
    INDICATOR, AIRSPEED
    INDICATOR, BANK
    INDICATOR, CLIMB
    INDICATOR, DRIFT
    INDICATOR, POSITION
    INDICATOR, RATE-OF-CLIMB
    INDICATOR, TURN
    Indicator, Vertical-speed
         use  INDICATOR, RATE-OF-CLIMB
    LEVEL, SURVEYOR'S
    MAGNETOMETER
    MARKER, CONCRETE
    METER, ANGLE
    METER, YAW
    Nocturnal
         use  ASTROLABE, MARINER'S
    OCTANT
         rt   CIRCUMFERENTOR; SEXTANT
    Odometer
         use  WHEEL, SURVEYOR'S
    Omnimeter
         use  THEODOLITE
    OPISOMETER
```

SURVEYING & NAVIGATIONAL T&E (cont.)

 OPTICAL SQUARE
 rt GROMA
 ORIENTATOR
 OROGRAPH
 OSCILLOMETER
 PALINURUS
 PANTOMETER
 Perambulator
 use WHEEL, SURVEYOR'S
 PICKET POLE
 Plane table
 use TABLE, PLANE
 PLANIMETER
 PLATOMETER
 QUADRANT
 rt CIRCUMFERENTOR; GRAPHOMETER
 Radar unit
 use RECEIVER/DISPLAY, RADAR or RECEIVER/DISPLAY,
 LORAN
 RANGE FINDER
 RANGE FINDER, RADIO
 RECEIVER
 note may be further subdivided to indicate specific
 type: e.g., RECEIVER, LONG-WAVE BEACON; -,OMNI
 RECEIVER/DISPLAY, LORAN
 RECEIVER/DISPLAY, RADAR
 RECORDER, SCEPTRE
 REFLECTING CIRCLE
 REPEATING CIRCLE
 Rod
 use STADIA ROD
 SCALE, NAVIGATIONAL
 SEMICIRCLE
 SEMICIRCUMFERENTOR
 SEXTANT
 rt OCTANT
 Sonar unit
 use BATHOMETER or ECHOMETER
 SONDOGRAPH
 SPHEROGRAPH
 STADIA ROD
 STADIMETER
 STAKE
 STATION POINTER
 STATION STAFF
 TABLE, PLANE
 Tachymeter
 use THEODOLITE or ALIDADE or TRANSIT
 THEODOLITE
 rt TRANSIT
 TRANSIT
 rt THEODOLITE

211

SURVEYING & NAVIGATIONAL T&E (cont.)

 Trechometer
 use ODOMETER
 VERTIMETER
 Waywiser
 use WHEEL, SURVEYOR'S
 WHEEL, SURVEYOR'S
 ZENOMETER

TEXTILEWORKING T&E
 def An artifact originally created to be used in the making of
 thread, yarn or cordage, or in the creation of objects
 from natural fibers or from cloth; includes basketmaking
 tools, sailmaking tools, weaving tools, needleworking
 implements, etc.; see also AGRICULTURAL T&E
 ref (29) (54) (57) (69) (119)

 AWL
 rt FID
 BACKFILLING MACHINE
 Bag, Emery
 use CUSHION, EMERY
 BALLER
 BASKET, SEWING
 BATTEN
 BATT-MAKING MACHINE
 BEAMER
 BEATER, BASKETMAKER'S
 BEETLE
 BENCH, RIGGER'S
 BENCH, SAILMAKER'S
 BENCH-HOOK, RIGGER'S
 BLEACHING MACHINE
 BLENDER, FEEDER
 BLENDER, SANDWICH
 BOBBIN
 BODKIN
 rt FID
 BOLT, CLOTH
 rt TEXTILE FRAGMENT; SALES SAMPLE, CLOTH
 BONDING MACHINE, FOAM-FLAME
 BONDING MACHINE, WET-ADHESIVE
 BOWL, SCOURING
 BOX, PIN
 BOX, SEWING
 BRAIDER
 BREAKER, BALE
 BREAKER, FLAX
 BROCHE
 BRUSHING MACHINE
 BULKING MACHINE

TEXTILEWORKING T&E (cont.)

 BURLING MACHINE
 BURR REMOVER, BREAST
 BURR REMOVER, CRUSHER
 BURR REMOVER, PICKER
 BUTTON BREAKER
 CALENDER
 note may be further subdivided to indicate specific
 type: e.g., CALENDER, EMBOSSING: -,MOIRE
 CAP FRAME
 note may be further subdivided to indicate specific
 type: e.g., CAP FRAME, DRAWING; -,SLUBBING;
 -,ROVING
 CARD, HAND
 CARD CLOTHING, FILLET
 CARD CLOTHING, SHEET
 CARD CLOTHING MACHINE
 CARD DELIVERY, BAT-ROLLING
 CARD DELIVERY, ROLL DRUM
 rt CONDENSER
 CARD GRINDER
 CARDING MACHINE, COTTON
 CARDING MACHINE, WOOLEN
 CARDING MACHINE, WORSTED
 CARD-PUNCHING MACHINE
 CASE, NEEDLE
 CHALK, TAILOR'S
 CHINCHILLA MACHINE
 CLAMP, QUILTING-FRAME
 CLAMP, RIGGER'S
 CLAMP, SEWING
 CLAMP, WINDING
 CLEAVER, BASKETMAKER'S
 CLOTH PRESS, COLD
 CLOTH PRESS, HOT
 CLOTH PRESS, ROTARY
 CLOTH PRESS, SCREW-TYPE
 COATING MACHINE
 COMB
 note may be further subdivided to indicate specific
 type: e.g., COMB, NOBLE; -,FRENCH
 COMB, HAND
 CONDENSER
 rt CARD DELIVERY, ROLL DRUM
 CONDENSER, COTTON
 CONDENSER, GOULDING
 CONDENSER, RUB-APRON
 CONDENSER, RUB-ROLL
 CONDENSER, TAPE
 CRABBING MACHINE
 CREEL
 CRIMPING MACHINE

TEXTILEWORKING T&E (cont.)

CROCHETING MACHINE
CUSHION, EMERY
Darner
 <u>use</u> DARNING EGG
DARNING EGG
DECATING MACHINE
DISTAFF
DRAWING FRAME
 <u>note</u> use only if specific type is unknown: e.g.,
 THROSTLE FRAME, DRAWING
DRAWING-IN MACHINE
DRESSER
DRESS FORM
DRYER
 <u>note</u> may be further subdivided to indicate specific
 type: e.g., DRYER, LOOP; -,REEL
DUSTER
 <u>note</u> may be further subdivided to indicate specific
 type: e.g., DUSTER, BOX; -,CONE
DYEING MACHINE
EMBROIDERY MACHINE
FADEOMETER
FEED, CARDING
FELTING MACHINE
FID
 <u>rt</u> AWL; BODKIN
Finishing machine
 <u>use</u> more specific term: e.g., DECATING MACHINE;
 CALENDER, EMBOSSING
FLOAT-CUTTING MACHINE
FLOCKING MACHINE
FOLDING MACHINE
FULLING MACHINE
GARNETT MACHINE
GAUGE, NET
GIGGING MACHINE
GILL BOX
GIN, COTTON
Hackle
 <u>use</u> HATCHEL
HACK STAND
HAM, TAILOR'S
HATCHEL
HEAT-SETTING MACHINE
Heckle
 <u>use</u> HATCHEL
HEM RIPPER
Hetchel
 <u>use</u> HATCHEL
HOOK, CROCHET
HOOK, RUG

TEXTILEWORKING T&E (cont.)

 HOOK, TAMBOUR
 HOOP, EMBROIDERY
 KETTLE, DYEING
 KNIFE, BASKETMAKER'S PICKING
 KNIFE, SCUTCHING
 Knife, Swingling
 <u>use</u> KNIFE, SCUTCHING
 KNIFE, WILLOW
 KNIT/SEW MACHINE
 KNITTING MACHINE
 <u>note</u> use only if specific type is unknown
 KNITTING MACHINE, CIRCULAR
 KNITTING MACHINE, FLAT
 KNITTING MACHINE, LATCH-TYPE
 KNITTING MACHINE, SPRING-NEEDLE
 KNITTING MACHINE, WARP-TYPE
 KNOTTER
 LAP BOARD, BASKETMAKER'S
 LINEN PROVER
 LOOM
 <u>note</u> use only if specific type is unknown
 LOOM, BACKSTRAP
 LOOM, BELT
 LOOM, BROAD
 <u>note</u> use for any loom designed to weave a fabric
 54" or more in width
 LOOM, CAM
 LOOM, CARPET
 LOOM, COUNTER-BALANCE
 LOOM, COUNTER-MARCH
 LOOM, DOBBY
 Loom, Doup
 <u>use</u> LOOM, LENO
 LOOM, DRAW
 LOOM, HAND
 <u>note</u> use for any loom on which the actions of
 shedding, picking and beating are performed
 solely by hand and/or foot power; use only if
 specific type is unknown: e.g., LOOM, BELT;
 LOOM, COUNTER-BALANCE; LOOM, COUNTER-MARCH;
 LOOM, DRAW; LOOM, JACK
 LOOM, JACK
 LOOM, JACQUARD
 LOOM, LACE
 LOOM, LENO
 LOOM, PILE FABRIC
 LOOM, RAPIER
 LOOM, RIGID HEDDLE
 LOOM, SHUTTLELESS
 LOOM, SWIVEL
 LOOM, TABLET

TEXTILEWORKING T&E (cont.)

LOOM, TAPE
LOOM, WARP WEIGHTED
LOOM, WATER-JET
LUCET
MALLET, SERVING
MARLINSPIKE
MERCERIZING MACHINE
MILL, FULLING
NAPPER
NAPPING GIG
NEEDLE, DARNING
NEEDLE, KNITTING
NEEDLE, NETMAKING
NEEDLE, SAILMAKER'S
NEEDLE, SEWING
NIDDY NODDY
Opener-picker
 use PICKER
PACIFIC CONVERTER
PACKAGE-CHANGING MACHINE
 note use only if specific type is unknown: e.g.,
 SPOOLER, WINDER, REEL
PAD MACHINE
PALM, SAILMAKER'S
PATTERN
 note may be further subdivided to indicate specific
 item: e.g., PATTERN, STUFFED ANIMAL; -,PILLOW
PERLOCK MACHINE
PICKER
PIN, SAFETY
PIN, STRAIGHT
PINCUSHION
PLEATING MACHINE
PRESS, HOT-HEAD
Printing equipment
 use more specific term from PRINTING T&E
PUNCH, GROMMET
QUILLER
QUILTING FRAME
QUILTING MACHINE
QUILT PIECE
 rt TEXTILE FRAGMENT; SALES SAMPLE, CLOTH
REED
REEL
REEL, CLOCK
 rt SWIFT
Ribbon leader
 use BODKIN
RING FRAME
 note may be further subdivided to indicate specific
 type: e.g., RING FRAME, DRAWING; -,SLUBBING;
 -,ROVING

TEXTILEWORKING T&E (cont.)

ROPE-MAKING MACHINE
ROVING FRAME
 note use only if specific type in unknown: e.g.,
 RING FRAME, ROVING
SCISSORS
 rt SHEARS
SCISSORS, BUTTONHOLE
SCISSORS, EMBROIDERY
SCOURING TRAIN
Scutcher, Flax
 use KNIFE, SCUTCHING
SCUTCHING BOARD
Sewing bird
 use CLAMP, SEWING
SEWING MACHINE
SEWING SUPPLIES
 note use for any small object used in sewing or
 weaving: e.g., a needle, fasteners, eyelets,
 bias tape, ribbon
SHAVE, BASKET
SHAVE, BASKETMAKER'S UPRIGHT
SHEARING MACHINE
SHEARS
 rt SCISSORS
SHEARS, DRESSMAKER'S
SHEARS, PINKING
SHRINKING MACHINE, COMPRESSIVE
SHUTTLE
SHUTTLE, NETTING
SIMPLEX MACHINE
SKEINER
SLASHER
SLUBBER
SLUBBING BILLY
SLUBBING FRAME
 note use only if specific type is unknown: e.g.,
 CAP FRAME, SLUBBING
SPINDLE
SPINDLE WHORL
SPINNERET
SPINNING FRAME
 note use only for general category or if specific
 type is unknown: e.g., THROSTLE FRAME, CAP
 FRAME, RING FRAME
SPINNING JACK
SPINNING JENNY
SPINNING MULE
SPINNING WHEEL
 note may be further subdivided to indicate specific
 type: e.g., SPINNING WHEEL, FLAX; -,WOOL
SPOOL

TEXTILEWORKING T&E (cont.)

 SPOOLER
 Stapler, Break-stretch
 use PERLOCK MACHINE
 Stapler, Diagonal-cutting
 use PACIFIC CONVERTER
 Stapler, Turbo
 use PERLOCK MACHINE
 STILETTO
 STITCH-HEAVER, RIGGER'S
 STRAIGHTENER, CLOTH
 STRIPPER, BASKETMAKER'S
 STUFFER BOX
 SUEDING MACHINE
 Swatch
 use SALES SAMPLE, CLOTH or TEXTILE FRAGMENT or
 QUILT PIECE
 SWIFT
 rt REEL, CLOCK
 Swingle, Flax
 use KNIFE, SCUTCHING
 Tambour
 use HOOP, EMBROIDERY
 Teasel frame
 use NAPPER
 Teasel gig
 use NAPPING GIG
 TEASLE CROSS
 TEMPLE
 TENTER FRAME
 TERRY LOOP MACHINE
 TESTER, BURST
 TESTER, CRIMP
 TESTER, FINENESS
 TESTER, FIRE-RESISTANCE
 TESTER, NEP
 TESTER, SCORCH
 TESTER, SHRINKAGE
 TESTER, SLIVER
 TESTER, TEAR
 TESTER, TWIST
 TESTER, WASHFASTNESS
 TESTING EQUIPMENT
 note use only if specific type is unknown: e.g.,
 TESTER, NEP; FADEOMETER
 TEXTURING MACHINE, AIR JET
 TEXTURING MACHINE, STEAM JET
 THIMBLE
 THREAD COUNTER
 THREADER
 THROSTLE FRAME
 note may be further subdivided to indicate specific

TEXTILEWORKING T&E (cont.)

>> type: e.g., THROSTLE FRAME, DRAWING;
>> -,SLUBBING; -,ROVING

> THROWING MACHINE
> TINTOMETER
> TRAY, PIN
> TUFTING MACHINE
> TWISTER
> TWISTING FRAME
> TYING-IN MACHINE
> VAT
> WARPING BAR
> WASTE MACHINE
> Wheel, Godet
>> use WHEEL, STRETCHING
> WHEEL, HAND
> WHEEL, QUILLING
> WHEEL, STRETCHING
> WHEEL, TRACING
> WINDER
>> note may be further subdivided to indicate specific
>> type: e.g., WINDER, CONE; -,BOBBIN; -,SPOOL
> Workbasket
>> use BASKET, SEWING
> Yarn reel
>> use REEL, CLOCK

THERMAL T&E
> def An artifact originally created to be used in the
> observation, measurement and recording of heat and its
> effects; does not include specialized artifacts created to
> serve specific purposes (e.g., a meteorological
> thermometer)
> ref (66) (67)

> BOLOMETER
> CALORIMETER
> CHRONOTHERMOMETER
> CRYOMETER
> CRYOPHORUS
> EBULLIOSCOPE
> EVAPORIMETER
> GALVANOTHERMOMETER
> GEOTHERMOMETER
> Hydropyrometer
>> use PYROMETER
> HYPSOMETER
> PYROMETER
>> rt THERMOMETER
> Telethermometer
>> use PYROMETER

219

THERMAL T&E (cont.)

 THERMOCOUPLE
 THERMOGRAPH
 THERMOHYDROMETER
 THERMOMETOGRAPH
 THERMOMULTIPLIER
 THERMOSCOPE
 THERMOSTAT

TIMEKEEPING T&E
 <u>def</u> An artifact originally created to be used in the
 observation, recording and measurement of time; does not
 include specialized artifacts created to serve other
 specific purposes (e.g., a chronometer)

 CHRONOGRAPH
 Chronometer, Solar
 <u>use</u> SUNDIAL
 CHRONOSCOPE
 Clepsydra
 <u>use</u> CLOCK, WATER
 CLOCK
 <u>note</u> use only if specific type is unknown
 Clock, Alarm
 <u>use</u> more specific term
 CLOCK, CASE
 Clock, Grandfather
 <u>use</u> CLOCK, TALL CASE
 Clock, Grandmother
 <u>use</u> CLOCK, CASE
 CLOCK, SHELF
 <u>note</u> use for any clock designed to stand on a
 shelf, table, mantle or bracket
 CLOCK, TALL CASE
 CLOCK, TRAVEL
 CLOCK, TURRET
 CLOCK, WALL
 CLOCK, WATER
 CLOCK SET, GARNITURE
 HOROMETER
 METRONOME
 STOPWATCH
 SUNDIAL
 WATCH, PENDANT
 WATCH, POCKET
 Watch, Wrist
 <u>use</u> WRISTWATCH
 WRISTWATCH

WEIGHTS & MEASURES T&E
 <u>def</u> An artifact originally created to be used in the
 observation, recording and measurement of mass (weight) or
 physical dimensions such as length, area and volume;
 includes general-purpose measuring devices (e.g., a
 precision balance, a folding rule); does not include
 specialized artifacts created to measure time (see
 TIMEKEEPING T&E) or other physical attributes (see
 ACOUSTICAL T&E, BIOLOGICAL T&E, CHEMICAL T&E, MECHANICAL
 T&E and OPTICAL T&E) or to serve other specific purposes
 (e.g., a sextant)
 <u>ref</u> (66) (67)

 BALANCE
 <u>note</u> use only if specific type is unknown
 BALANCE, ANALYTICAL
 BALANCE, BERANGER
 BALANCE, DEMONSTRATION
 BALANCE, GRAM-CHAIN
 BALANCE, ROBERVAL
 BALANCE, SPECIFIC-GRAVITY
 BALANCE, TORSION
 BALANCE SCOOP
 BALANCE WEIGHT
 CALIPERS
 <u>note</u> use only if specific type is unknown
 CALIPERS, INSIDE
 CALIPERS, OUTSIDE
 COMPARATOR
 ERIOMETER
 EXTENSOMETER
 GAUGE
 GAUGE, RAILWAY
 GNOMON
 GONIOMETER
 MEASURE, TAPE
 <u>rt</u> RULE, RETRACTABLE
 METER STICK
 MICROMETER
 PACHYMETER
 PANYOCHROMETER
 RULE, FOLDING
 RULE, RETRACTABLE
 <u>rt</u> MEASURE, TAPE
 RULER
 SCALE, BALANCE
 SCALE, BATHROOM
 SCALE, COMPUTING
 SCALE, CYLINDER
 Scale, Drum
 <u>use</u> SCALE, CYLINDER
 SCALE, LEVER

WEIGHTS & MEASURES T&E (cont.)

> SCALE, PLATFORM
> SCALE, SPRING
> SCALE, TRIANGULAR
> STEELYARD
> Tape, Steel
> use MEASURE, TAPE or RULE, RETRACTABLE
> YARDSTICK

WOODWORKING T&E
> def An artifact originally created to be used in the process
> of fabricating objects out of wood (e.g., a saw, an ax, a
> chisel)
> ref (59) (76) (103) (133)

> ADZ
> note use only if specific type is unknown
> ADZ, BUNGING
> ADZ, CARPENTER'S
> ADZ, CLEAVING
> ADZ, COOPER'S
> ADZ, COOPER'S NAILING
> ADZ, COOPER'S NOTCHING
> rt KNIFE, HOOP-NOTCHING
> ADZ, COOPER'S ROUNDING
> Adz, Cooper's sharp
> use ADZ, COOPER'S TRIMMING
> ADZ, COOPER'S TRIMMING
> Adz, Dubbing
> use ADZ, LIPPED
> ADZ, GUTTERING
> rt PLANE, GUTTERING
> ADZ, HOLLOWING
> ADZ, LIPPED
> ADZ, SHIPWRIGHT'S
> Adz, Spout
> use ADZ, GUTTERING
> ADZ, TRUSSING
> rt HAMMER, COOPER'S
> ADZ, WHEELWRIGHT'S
> AUGER
> note use only if specific type is unknown
> rt REAMER; BIT
> Auger, Burn
> use IRON, WHEELWRIGHT'S BURNING
> Auger, Center-bit
> use AUGER, SPIRAL
> Auger, Cooper's bong-borer
> use AUGER, TAPER
> Auger, Expanding
> use AUGER, SPIRAL

222

WOODWORKING T&E (cont.)

 Auger, Nose
 use AUGER, SHELL
 Auger, Pipe
 use AUGER, TAPER or AUGER, SHELL or AUGER, SNAIL
 Auger, Pod
 use AUGER, SHELL or AUGER, SNAIL
 Auger, Pump
 use AUGER, TAPER or AUGER, SHELL or AUGER, SNAIL
 Auger, Screw
 use AUGER, SPIRAL
 AUGER, SHELL
 AUGER, SNAIL
 AUGER, SPIRAL
 Auger, Tap
 use AUGER, TAPER
 AUGER, TAPER
 Auger, Twist
 use AUGER, SPIRAL
 AWL
 note use only if specific type is unknown
 Awl, Brad
 use BRADAWL
 Awl, Flooring
 use BRADAWL
 AWL, MARKING
 rt KNIFE, MARKING; SCRIBER
 Awl, Scratch
 use AWL, MARKING
 Awl, Scribe
 use AWL, MARKING
 AWL, SQUARE
 AX
 note use only if specific type is unknown
 rt HATCHET
 Ax, Broad
 use BROADAX
 AX, COOPER'S
 AX, CRATEMAKER'S
 Ax, Goosewing
 use BROADAX
 Ax, Hewing
 use BROADAX
 AX, MAST & SPAR
 AX, MORTISING
 AX, SHIPWRIGHT'S
 AX, SIDE
 note use only if specific type is unknown: e.g.,
 BROADAX; AX, COOPER'S
 Bar, Pry
 use CROWBAR
 Bar, Wrecking
 use CROWBAR

WOODWORKING T&E (cont.)

BARREL TOPPER
BEDDING MACHINE
BEETLE
note use for a two-handed striking tool fitted with
a wooden head
rt MALLET; MAUL, POST
BELLOWS, COOPER'S
BENCH, CARPENTER'S
Bench, Saw-sharpening
use HORSE, SAW-SHARPENING
BENCH, WHEELWRIGHT'S
BENCH STOP
BEVEL BLOCK
BIT
note use for a boring implement designed to be
inserted in a BRACE or DRILL; use only if
specific type is unknown: e.g., BIT, ANNULAR;
-,TWIST
rt AUGER; REAMER
BIT, ANNULAR
rt SAW, CROWN
BIT, CENTER
BIT, COUNTERSINK
BIT, GIMLET
BIT, NOSE
BIT, SHELL
BIT, TWIST
Bitstock
use BRACE
BOLT
BORING MACHINE
BORING MACHINE, NAVE
BOX, CARPENTER'S TOOL
Box, Miter
use MITER BOX
BOX, SHIPWRIGHT'S CAULKING
BOX, SHIPWRIGHT'S OIL
BRACE
rt DRILL
BRAD
BRADAWL
Brake, Cleaving
use HORSE, FROE
BREASTPLATE
BROACH
rt REAMER
BROADAX
BROOM MACHINE
Bung flogger
use BUNGSTART
BUNGSTART

WOODWORKING T&E (cont.)

Celt
 use AX or ADZ
CHALK LINE
 rt REEL, CHALK
CHEESE-BOX MAKER
CHISEL
 note use only if specific type is unknown
 rt SLICK; GOUGE
CHISEL, BENT
Chisel, Broad
 use SLICK
Chisel, Bruzz
 use CHISEL, CORNER
Chisel, Cant
 use CHISEL, FIRMER
CHISEL, CARVING
 note may be further subdivided to indicate chief
 variations in shape of blade and cutting edge
CHISEL, CORNER
CHISEL, FIRMER
Chisel, Forming
 use CHISEL, FIRMER
Chisel, Framing
 use CHISEL, FIRMER
CHISEL, GOOSENECK
CHISEL, MORTISE
CHISEL, PARING
CHISEL, PARTING
CHISEL, RIPPING
 rt WEDGE
CHISEL, SKEW
Chisel, Slice
 use SLICK
CHISEL, TURNING
CHOPPING BLOCK, WHEELWRIGHT'S
CHUCK
CLAMP
 note use only if specific type is unknown
CLAMP, BROOMMAKER'S
CLAMP, C
CLAMP, CORNER
CLAMP, FLOORING
CLAMP, FURNITURE
Clamp, G
 use CLAMP, C
CLAMP, JOINER'S
CLAMP, SAW
CLAMP, SCREW
COMB, BROOMMAKER'S
Commander
 use BEETLE

WOODWORKING T&E (cont.)

CRADLE, HUB
Cramp
 use CLAMP
CRESSET
CROWBAR
CROZE
 rt PLANE
Cudgel
 use FROE CLUB
CUTTER, PEG
CUTTER, SHINGLE
Dip
 use GAUGE ROD
DOG
DOG, HOOPING
DOG, JOINER'S
DOG, SPOKE
DOVE-TAILING MACHINE
DOWEL
 rt TREENAIL; PEG
DOWEL CENTER
Dowel cutter
 use CUTTER, PEG
Dowel plate
 use CUTTER, PEG
DOWNSHAVE, COOPER'S
DRAWKNIFE
 rt DRAWSHAVE; JIGGER; SCORPER, CLOSED; SCORPER,
 OPEN; SPOKESHAVE
DRAWKNIFE, BACKING
DRAWKNIFE, BARKING
DRAWKNIFE, CHAMFERING
DRAWKNIFE, COOPER'S
DRAWKNIFE, HEADING
DRAWKNIFE, HOLLOWING
DRAWKNIFE, WHEELWRIGHT'S
DRAWSHAVE
 rt DRAWKNIFE; SPOKESHAVE
DRILL
 note use only for a rotating device designed to
 hold a BIT in a fixed position
 rt BRACE
Drill stock
 use DRILL
FILE
 rt RASP; FLOAT
FLOAT
 rt RASP; FILE
Flogger
 use BUNGSTART
FRAMING BLOCK

226

WOODWORKING T&E (cont.)

```
FRETSAW
        rt   SAW, COPING
FROE
FROE, COOPER'S
FROE, KNIFE
FROE, LATHMAKER'S
FROE CLUB
        rt   MALLET
FLOW
        use  FROE
GAUGE
        note use only if specific type is unknown
Gauge, Butt
        use  GAUGE, MARKING
GAUGE, CUTTING
Gauge, Grasshopper
        use  GAUGE, MONKEY
Gauge, Handrail
        use  GAUGE, MONKEY
GAUGE, MARKING
GAUGE, MONKEY
Gauge, Mortise
        use  GAUGE, MARKING
Gauge, Panel
        use  GAUGE, MARKING
Gauge, Patternmaker's
        use  GAUGE, MONKEY
GAUGE, RABBET
Gauge, Slitting
        use  GAUGE, CUTTING
GAUGE, STAVE
Gauge, Thumb
        use  GAUGE, MARKING
GAUGE, TURNER'S
GAUGE, WHEELWRIGHT'S ANGLE
GAUGE, WHEELWRIGHT'S RIM
GAUGE ROD
GIMLET
Glasspaper
        use  SANDPAPER
GLUE PLATE
GLUE POT
GOUGE
        note use only if specific type is unknown
        rt   CHISEL
GOUGE, CARVING
GOUGE, FIRMER
GOUGE, PARING
GOUGE, TURNING
GOUGE, WHEELWRIGHT'S
HAMMER
        note use only if specific type is unknown
```

227

WOODWORKING T&E (cont.)

 HAMMER, CLAW
 HAMMER, CLENCH
 HAMMER, COOPER'S
 rt ADZ, TRUSSING
 Hammer, Flooring
 use HAMMER, CLENCH
 HAMMER, FRAMING
 HAMMER, JOINER'S
 HAMMER, PATTERNMAKER'S
 Hammer, Roofing
 use HAMMER, CLENCH
 Hammer, Ship's maul
 use HAMMER, TOP MAUL
 HAMMER, TACK
 HAMMER, TOP MAUL
 HAMMER, VENEER
 HAND GUARD, BROOMMAKER'S
 Handsaw
 use more specific term: e.g., SAW, CROSSCUT; RIPSAW
 HATCHEL, BROOMMAKER'S
 HATCHET
 note use only if specific type is unknown
 rt AX
 HATCHET, CLAW
 HATCHET, HEWING
 HATCHET, LATHING
 HATCHET, SHINGLING
 HOLDFAST
 HOOK, BENCH
 HOOP DRIVER
 HORSE, FROE
 rt HORSE, SHAVING
 Horse, Saw
 use SAWHORSE
 HORSE, SAW-SHARPENING
 HORSE, SHAVING
 rt SHAVING BLOCK; HORSE, FROE
 Horse, Shingling
 use HORSE, FROE
 IRON, CHINCING
 IRON, COOPER'S BURNING
 IRON, FLAGGING
 Iron, Knocking-up
 use JUMPER
 IRON, MARKING
 IRON, RAISING
 rt JUMPER
 IRON, SHIPWRIGHT'S CAULKING
 IRON, WHEELWRIGHT'S BURNING
 JACK, MITER
 JIGGER
 rt DRAWKNIFE

WOODWORKING T&E (cont.)

JIGSAW
JOINTER
JOINTER-PLANER
JUMPER
 rt IRON, RAISING
Knife, Bench
 use KNIFE, BLOCK
KNIFE, BLOCK
KNIFE, CARVING
Knife, Chamfer
 use DRAWKNIFE, CHAMFERING
Knife, Froe
 use FROE, KNIFE
KNIFE, HOOP-NOTCHING
 rt ADZ, COOPER'S NOTCHING
Knife, Lathmaker's
 use FROE, KNIFE
KNIFE, MARKING
 rt AWL, MARKING
LADLE, SHIPWRIGHT'S CAULKING
LATHE
LATHE, BORING
LATHE, DUPLICATING
LATHE, SPOKE
LEVEL
LEVEL, PLUMB
Level, Spirit
 use LEVEL
MALLET
 note use for a one-handed striking tool fitted with
 a relatively soft (wooden, plastic or leather)
 head
 rt BEETLE; FROE CLUB
MALLET, CARPENTER'S
MALLET, CARVER'S
MALLET, SHIPWRIGHT'S
MALLET, SHIPWRIGHT'S CAULKING
MAUL, POST
 note use for a two-handed striking tool fitted with
 a cylindrical steel head
 rt BEETLE; SLEDGE
MITER BLOCK
MITER BOX
Miter jack
 use JACK, MITER
Miter-shooting block
 use JACK, MITER
MITER-SHOOTING BOARD
 rt SHOOTING BOARD
MOLDING BOX
MORTISER

WOODWORKING T&E (cont.)

 MORTISING MACHINE
 MOULDER
 NAIL
 NEEDLE, BROOMMAKER'S
 NUT
 PATTERN
 rt TEMPLATE
 PEG
 rt TREENAIL; DOWEL
 Pin
 use DOWEL or PEG
 PINCERS
 PLANE
 note use only if specific type is unknown
 rt CROZE
 PLANE, ASTRAGAL
 Plane, Badger
 use PLANE, RABBET
 PLANE, BANDING
 Plane, Beading
 use PLANE, ASTRAGAL
 PLANE, BLOCK
 PLANE, BULLNOSE
 PLANE, CENTERBOARD
 Plane, Chisel
 use PLANE, EDGE
 Plane, Chiv
 use PLANE, HOWELL
 PLANE, COMBINATION
 PLANE, COMPASS
 PLANE, COOPER'S STOUP
 PLANE, CORNICE
 Plane, Crown
 use PLANE, CORNICE
 Plane, Croze
 use CROZE
 PLANE, DADO
 rt PLANE, GROOVING
 PLANE, EDGE
 PLANE, FILLISTER
 PLANE, FLOOR
 Plane, Fore
 use PLANE, JACK
 PLANE, GROOVING
 rt PLANE, PLOW; PLANE, DADO
 PLANE, GUTTERING
 rt ADZ, GUTTERING
 Plane, Handrail
 use PLANE, STAIRBUILDER'S
 PLANE, HOLLOW
 rt PLANE, ROUND

230

WOODWORKING T&E (cont.)

 PLANE, HOWELL
 PLANE, JACK
 Plane, Jointer
 use PLANE, LONG-JOINTER or PLANE, SHORT-JOINTER
 Plane, Leveling
 use PLANE, SUN
 PLANE, LONG-JOINTER
 rt PLANE, TRYING; PLANE, SHORT-JOINTER
 PLANE, MITER
 PLANE, MODELING
 PLANE, MOLDING
 note use unless the PLANE can be identified as one
 of the following major sub-categories under
 MOLDING: PLANE, ASTRAGAL; PLANE, CENTERBOARD;
 PLANE, CORNICE; PLANE, HOLLOW; PLANE, ROUND
 Plane, Nosing
 use PLANE, MOLDING
 Plane, Old woman's tooth
 use PLANE, ROUTER
 PLANE, PANEL
 Plane, Panel-fielding
 use PLANE, RAISING
 Plane, Plough
 use PLANE, PLOW
 PLANE, PLOW
 rt PLANE, GROOVING
 Plane, Pull
 use PLANE, SHORT-JOINTER
 PLANE, RABBET
 note use unless the PLANE can be identified as one
 of the following major sub-categories under
 RABBET: PLANE, FILLISTER; PLANE, PANEL;
 PLANE, RAISING; PLANE, SHOULDER
 rt SAW, RABBET
 PLANE, RAISING
 Plane, Rebate
 use PLANE, RABBET
 PLANE, ROUGHING
 PLANE, ROUND
 rt PLANE, HOLLOW
 PLANE, ROUNDER
 PLANE, ROUTER
 rt ROUTER
 PLANE, SASH
 Plane, Scaleboard
 use PLANE, SPLINT
 PLANE, SCOOPMAKER
 PLANE, SHORT-JOINTER
 rt PLANE, TRYING; PLANE, LONG-JOINTER
 PLANE, SHOULDER
 Plane, Skew
 use PLANE, RABBET

WOODWORKING T&E (cont.)

```
        PLANE, SMOOTHING
        PLANE, SPLINT
        PLANE, STAIRBUILDER'S
        PLANE, SUN
        PLANE, TONGUE-AND-GROOVE
        PLANE, TOOTHING
        Plane, Topping
             use  PLANE, SUN
        PLANE, TRYING
             rt   PLANE, LONG-JOINTER; PLANE, SHORT-JOINTER
        PLANE, VIOLINMAKER'S
        Plane, Witchet
             use  PLANE, ROUNDER
        PLANER
        Plow
             use  PLANE, PLOW
        PRESS, VENEER
        PROFILING MACHINE
        PROP, SAWYER'S
             rt   SAWBUCK; SAWHORSE; SAWING TACKLE
        PULLER, NAIL
        PUNCH, CARVER'S
        PUNCH, COOPER'S
        PUNCH, HANDRAIL
        PUNCH, MARKING
        PUNCH, NAIL
        Punch, Rivet
             use  PUNCH, STARTING
        PUNCH, SHINGLE
        PUNCH, STARTING
        PUNCH, VENEER
        PUNCH, WOOD
        Rabbet
             use  PLANE, RABBET
        Rabbit
             use  PLANE, RABBET
        RASP
             rt   FILE; FLOAT
        REAMER
             rt   AUGER; BIT; BROACH
        REEL, CHALK
        Riffler
             use  FILE or RASP
        RIPSAW
        ROUNDER
        Rounding cradle
             use  BEVEL BLOCK
        Round shave
             use  SCORPER, CLOSED or SCORPER, OPEN
        ROUTER
             rt   PLANE, ROUTER
```

WOODWORKING T&E (cont.)

RULE, CALIPER
RULE, PATTERNMAKER'S
RULE, PROTRACTOR
SANDER
 note may be further subdivided to indicate specific
 type: e.g., SANDER, BELT; -,DISK
SANDPAPER
SAW
 note use only if specific type is unknown
SAW, ANGLE
SAW, BACK
 note use only if specific type is unknown: e.g.,
 SAW, BEAD; SAW, DOVETAIL
SAW, BAND
SAW, BEAD
SAW, BENCH
Saw, Board
 use SAW, OPEN-PIT or SAW, FRAMED-PIT
SAW, BOW
Saw, Bracket
 use FRETSAW
Saw, Buhl
 use FRETSAW
SAW, CARCASS
Saw, Chairmaker's
 use SAW, FELLOE
Saw, Circular
 use SAW, BENCH or SAW, RADIAL-ARM or SAW,
 ELECTRIC-PORTABLE
SAW, COMPASS
 rt SAW, KEYHOLE
SAW, COPING
 rt FRETSAW
SAW, CROSSCUT
SAW, CROWN
 rt BIT, ANNULAR
SAW, DOVETAIL
SAW, ELECTRIC-PORTABLE
SAW, FELLOE
SAW, FRAME
 note use only if specific type is unknown: e.g.,
 SAW, BOW; SAW, COPING
SAW, FRAMED VENEER
 rt SAW, VENEER
SAW, FRAMED-PIT
 rt SAW, OPEN-PIT
Saw, Fret
 use FRETSAW
Saw, Jig
 use JIGSAW
SAW, KEYHOLE
 rt SAW, COMPASS

233

WOODWORKING T&E (cont.)

 Saw, Lock
 <u>use</u> SAW, KEYHOLE
 Saw, Long
 <u>use</u> SAW, CROSSCUT
 SAW, MITER-BOX
 SAW, OPEN-PIT
 <u>rt</u> SAW, FRAMED-PIT
 SAW, PATTERNMAKER'S
 Saw, Pit
 <u>use</u> SAW, OPEN-PIT or SAW, FRAMED-PIT
 SAW, RABBET
 <u>rt</u> PLANE, RABBET
 SAW, RADIAL-ARM
 Saw, Rip
 <u>use</u> RIPSAW
 SAW, SABRE
 Saw, Scroll
 <u>use</u> FRETSAW
 Saw, Skill
 <u>use</u> SAW, ELECTRIC PORTABLE
 SAW, STAIRBUILDER'S
 SAW, TENON
 Saw, Thwart
 <u>use</u> SAW, CROSSCUT
 SAW, VELLUM
 SAW, VENEER
 <u>note</u> use for a saw to cut or shape veneers
 <u>rt</u> SAW, FRAMED VENEER
 SAWBUCK
 <u>rt</u> PROP, SAWYER'S; SAWHORSE; SAWING TACKLE
 SAWHORSE
 <u>rt</u> SAWBUCK; PROP, SAWYER'S; SAWING TACKLE
 SAWING TACKLE
 <u>rt</u> PROP, SAWYER'S; SAWBUCK; SAWHORSE
 SAWMILL, BAND
 SAWMILL, CIRCULAR
 SAWMILL, GANG
 SAWMILL, GATE-TYPE
 SAWMILL, MULEY
 SAWMILL, UP-AND-DOWN
 SAW-SET
 <u>rt</u> SAW WREST
 SAW WREST
 <u>rt</u> SAW-SET
 SCORPER, CLOSED
 <u>rt</u> DRAWKNIFE
 SCORPER, OPEN
 <u>rt</u> DRAWKNIFE
 SCRAPER
 SCREW
 SCREW BOX
 <u>rt</u> SCREW TAP

WOODWORKING T&E (cont.)

SCREW TAP
 rt SCREW BOX
SCRIBER
 rt AWL, MARKING
SHAFT STAND, WHEELWRIGHT'S
SHAPER
Shave
 use DRAWSHAVE or SPOKESHAVE
SHAVING BLOCK
 rt HORSE, SHAVING
SHAVING MACHINE
SHEARS, BROOMMAKER'S
SHINGLE BUTTER
SHOOTING BOARD
 rt MITER SHOOTING BOARD
SLICK
 rt CHISEL
SPIKE
SPOKESHAVE
 rt DRAWKNIFE; DRAWSHAVE
SPOTTING MACHINE
SQUARE
SQUARE, BEVEL
SQUARE, CARPENTER'S
SQUARE, MITER
SQUARE, SET
SQUARE, TRY
Tap
 use SCREW TAP
TEMPLATE
 rt PATTERN
TENONING MACHINE
TONGUE-AND-GROOVE MACHINE
TREENAIL
 rt PEG; DOWEL
TREENAILING MACHINE
Trenail
 use TREENAIL
TRIMMING MACHINE
Trunnel
 use TREENAIL
Turning box
 use MOLDING BOX
TWIBIL
VISE
 note may be further subdivided to indicate specific
 type: e.g., VISE, BROOMMAKER'S
WASHER
WEDGE
 rt CHISEL, RIPPING
WHEEL FRAME, WHEELWRIGHT'S

WOODWORKING T&E (cont.)

WHEELMAKING MACHINE
 note may be further subdivided to indicate specific
 type: e.g., WHEELMAKING MACHINE,
 SPOKE-TENONING; -,HUB-BORING; -,RIM-PLANING

UNCLASSIFIED T&E, GENERAL
 def An artifact originally created to be used in a variety of
 activities or in working with diverse materials (e.g., a
 screwdriver, pliers)
 ref (103)

ASPIRATOR
AUGER, POST-HOLE
 rt DIGGER, POST-HOLE
BOX, TOOL
CHEST, TOOL
DIGGER, POST-HOLE
 rt AUGER, POST-HOLE
FINGERTIP
HAMMER
HAMMERSTONE
HOOK, CEILING
HOOK, JAMB
KNIFE, UTILITY
Knife, X-acto
 use KNIFE, UTILITY
MITTEN, ASBESTOS
PINCHBAR
PLIERS
 note may be further subdivided to indicate specific
 type: e.g., PLIERS, VISE-GRIP
PLUMB BOB
POLLUTION-CONTROL DEVICE
 note may be further subdivided to indicate specific
 type: e.g., POLLUTION-CONTROL DEVICE, FILTER;
 -,PRECIPITATOR; -,SEPARATOR
RESPIRATOR
SCISSORS
SCREWDRIVER
SCREWDRIVER, OFFSET
SCREWDRIVER, PHILLIPS
SCREWDRIVER, RATCHET
SHOVEL
SHOVEL, ENTRENCHING
VISE
WORKBENCH

UNCLASSIFIED T&E, SPECIAL

def An artifact originally created to be used in such a
 specialized activity or with such a unique material that
 it cannot be accommodated within any other T&E
 classification (e.g., a snow knocker, a fence jack)

note examine all other T&E classifications carefully before
 using this classification; for example, pillbox-making
 tools are used with wood and therefore should be
 classified as WOODWORKING T&E

```
AX, FIRE
AX, ICE
BENCH, HORNWORKER'S
BORER, CORK
CADRAN, GEMMOLOGIST'S
CALKING GUN
CLAMP, HORNWORKER'S
CREEPER
DRAWKNIFE, HORNWORKER'S
EXTINGUISHER, FIRE
GONIOSTAT
GRAIL, HORNWORKER'S
        rt    FILE
HOOK, JACK
HOOK, WELL
HORSE, HORNWORKER'S
JACK, FENCE
KETTLE, HORNWORKER'S
KILN
MANDREL, HORNWORKER'S
MASK, GAS
MOLD, CIGAR
PRESS, CORK
PRESS, HORNWORKER'S
QUARNET, HORNWORKER'S
SAW, GAUGE-LEAF
SAW, ICE
SNOW KNOCKER
SPLITTING MACHINE, HORNWORKER'S
STRETCHER, FENCE-WIRE
TONGS, ICE
TOPPER, HORNWORKER'S
TWINNING MACHINE, HORNWORKER'S
```

Category 5: Communication Artifacts
Artifacts originally created for the purpose of
facilitating human communication

ADVERTISING MEDIUM
def An artifact originally created to call the attention of
the public to a product, service, or event; see also
MERCHANDISING T&E (Category 4) and DOCUMENTARY ARTIFACT
note the first word of the object name should be the type of
the advertisement selected from the list below; further
subdivisions may be used to indicate the type of
advertisement: e.g., BANNER, CIRCUS; POSTER, POLITICAL

 BANNER
 Broadside
 use POSTER or HANDBILL
 BUMPER STICKER
 CAMPAIGN BUTTON
 CARD, TRADE
 rt CARD, CALLING
 CATALOG
 Circular
 use HANDBILL
 COUPON
 DISPLAY PIECE
 Flier
 use HANDBILL or CATALOG
 HANDBILL
 rt POSTER
 Leaflet
 use HANDBILL
 MAGAZINE AD
 MARQUEE
 NEWSPAPER AD
 NOVELTY
 Placard
 use POSTER
 POSTER
 rt HANDBILL
 PREMIUM
 note use only for a non-utilitarian object given as
 a premium which cannot be named by a more
 specific object name; may be further
 subdivided to indicate the product package in
 which the premium was originally enclosed:
 e.g., PREMIUM, CIGARETTE
 PRODUCT MODEL
 SANDWICH BOARD
 SIGN, TRADE
 SYMBOL, TRADE
 note use for an object which by custom is
 considered as a visual symbol of a product or
 service: e.g., a barber pole, a cigar store
 figure

ADVERTISING MEDIUM (cont.)

> Trade card
> > use CARD, TRADE
>
> Window card
> > use POSTER

DOCUMENTARY ARTIFACT
> def An artifact originally created to be a vehicle for
> conveying printed, written or pictorial information for
> some purpose other than advertising (see ADVERTISING
> MEDIUM); includes documents and also artifacts displaying
> commemorative information on materials other than paper
> (e.g., a commemorative coin, a souvenir plate); see also
> Art Objects (Category 7)
>
> ref (40)
>
> note a collection may be named in accordance with an
> archivist's "title" entry, using a collective noun such
> as PAPERS, RECORDS, LETTERS, DIARIES, MANUSCRIPTS,
> CORRESPONDENCE, etc.; a single item should be named using
> a term from the following list or any other acceptable
> object name; some objects listed under this
> classification would be classified as WRITTEN
> COMMUNICATION EQUIPMENT prior to their use in
> transmitting written information: e.g., a postcard

> ALBUM, AUTOGRAPH
> ALBUM, PHOTOGRAPH
> AMBROTYPE
> BALLOT
> BANKBOOK
> BANK STATEMENT
> BILL-OF-SALE
> BLUEPRINT
> BOND
> BOOK
> BOOK, ACCOUNT
> BOOK, ADDRESS
> BOOKLET
> BOOKPLATE
> Brochure
> > use BOOKLET
>
> CALENDAR
> CARD, CALLING
> > rt CARD, TRADE
>
> CARD, CREDIT
> CARD, FLASH
> CARD, GREETING
> Card, Post
> > use POSTCARD
>
> CARD, UNION
> CARTE-DE-VISITE

DOCUMENTARY ARTIFACT (cont.)

 CERTIFICATE, BAPTISMAL
 CERTIFICATE, BIRTH
 CERTIFICATE, DEATH
 CERTIFICATE, MARRIAGE
 CERTIFICATE, MEMBERSHIP
 CERTIFICATE, STOCK
 CHART, FLOW
 CHART, NAVIGATIONAL
 CHECK, BANK
 COIN, COMMEMORATIVE
 CONTRACT
 DAGUERREOTYPE
 DAYBOOK
 DEED
 DIARY
 DIORAMA
 rt ROOM, MINIATURE
 DIORAMA, AUTOMATA
 DIPLOMA
 Ephemera
 use more specific term: e.g., PROGRAM, INVITATION,
 LETTER
 GLOBE
 INVITATION
 JOURNAL
 Lantern slide
 use TRANSPARENCY, LANTERN-SLIDE
 LEAFLET
 LEDGER
 LETTER
 LOG
 LOG, SHIP'S
 MAGAZINE
 Manual
 use BOOK or BOOKLET
 MANUSCRIPT
 MAP
 MEDAL, COMMEMORATIVE
 MEMORANDUM
 MICROFICHE
 MICROFILM
 MORTGAGE
 MUSIC, SHEET
 NEGATIVE, FILM
 NEGATIVE, GLASS-PLATE
 NEWSPAPER
 NEWSPAPER CLIPPING
 NOTE
 NOTEBOOK
 Pamphlet
 use BOOKLET

DOCUMENTARY ARTIFACT (cont.)

 PASSPORT
 PATENT
 Photograph
 use more specific term: e.g., PRINT, PHOTOGRAPHIC;
 TINTYPE; DAGUERREOTYPE; CARTE-DE-VISITE;
 PHOTOGRAPH, CABINET
 PHOTOGRAPH, CABINET
 PICTURE
 note use for any painting or drawing which is
 primarily documentary rather than an art object
 Playbill
 use PROGRAM, THEATER
 POSTCARD
 PRINT, PHOTOGRAPHIC
 PROGRAM
 note may be further subdivided to indicate specific
 type: e.g., PROGRAM, THEATER; -,DANCE
 RIBBON, COMMEMORATIVE
 ROOM, MINIATURE
 rt DIORAMA
 SCORECARD
 SCRAPBOOK
 SCROLL
 Slide
 use TRANSPARENCY, LANTERN-SLIDE or TRANSPARENCY,
 SLIDE
 Snapshot
 use PRINT, PHOTOGRAPHIC
 STEREOGRAPH
 note use for the pictorial object viewed in a
 stereoscope
 STEREOVIEW
 note use for the pictorial object viewed in a
 modern stereoviewer
 TAG, MERCHANDISE
 TELEGRAM
 TIMETABLE
 TINTYPE
 TOPOGRAPHIC MODEL
 TRANSPARENCY, LANTERN-SLIDE
 TRANSPARENCY, ROLL-FILM
 TRANSPARENCY, SLIDE

SOUND COMMUNICATION EQUIPMENT
 def An artifact originally created to amplify or store music,
 spoken words or other sounds that are meaningful for human
 communication; see also ACOUSTICAL T&E, ELECTRICAL &
 MAGNETIC T&E and MUSICAL T&E (Category 4) and
 TELECOMMUNICATION EQUIPMENT

SOUND COMMUNICATION EQUIPMENT (cont.)

AMPLIFIER, AUDIO
BELL
 note may be further subdivided to indicate specific
 type: e.g., BELL, CHURCH; -,SCHOOL
BULLHORN
BURGLAR ALARM
BUZZER
CYLINDER, MUSIC-BOX
DICTATING MACHINE
DISC, MUSIC-BOX
EARPHONE
FIRE ALARM
Fire bell
 use FIRE ALARM
Fire siren
 use FIRE ALARM
FOGHORN
INTERCOM
MEGAPHONE
MICROPHONE
MUSIC BOX, CYLINDER
MUSIC BOX, DISC
PHONOGRAPH
Projector, Sound
 use BULLHORN or AMPLIFIER, AUDIO
RATTLE, GAS
RECORD, PHONOGRAPH
RECORDER, TAPE
Record player
 use PHONOGRAPH
SIMULATOR, SOUND-EFFECTS
SIREN
SMOKE ALARM
SPEAKER
TAPE
TAPE CARTRIDGE
TAPE DECK
TRUMPET, FIREMAN'S
TURNTABLE
WHISTLE

TELECOMMUNICATION EQUIPMENT
 def An artifact originally created to facilitate communicating
 at a distance, usually by means of electronic equipment;
 includes telephone, telegraph, radio and television
 equipment; see also DATA PROCESSING T&E and ELECTRICAL &
 MAGNETIC T&E (Category 4)

ANTENNA
 note may be further subdivided to indicate specific
 type: e.g., ANTENNA, RADIO; -,TELEVISION

242

TELECOMMUNICATION EQUIPMENT (cont.)

 BOX, FIRE-ALARM
 CABLE, SUBMARINE
 CAMERA, TELEVISION
 FIRE-ALARM SYSTEM
 RADIO
 note use for any instrument used for the reception
 of audio messages only
 Radio, Cb
 use TRANSCEIVER
 RECORDER, FIRE-ALARM
 STOCK TICKER
 TELEGRAPH KEY
 TELEPHONE
 TELEVISION
 note use for any instrument used for the reception
 of both audio and video messages
 TRANSCEIVER
 note use for any instrument that permits
 transmission and reception of audio messages
 TRANSMITTER
 note may be further subdivided to indicate specific
 type: e.g., TRANSMITTER, RADIO; -,TELEVISION

VISUAL COMMUNICATION EQUIPMENT
 def An artifact originally created to be used as a visual sign
 or signaling device, or as a means of viewing photographic
 or other visual images; see also OPTICAL T&E and
 PHOTOGRAPHIC T&E (Category 4) and ADVERTISING MEDIUM

 FLAG, CODE
 FLAG, SEMAPHORE
 FLAG, SIGNAL
 FLARE, DISTRESS
 GRAPHOSCOPE
 Guidepost
 use SIGN, TRAFFIC
 GUN, FLARE
 HELIOGRAPH
 KINETOSCOPE
 LAMP, ALDIS
 LANTERN, BATTLE
 LANTERN, RAILROAD
 Light, Traffic
 use SIGNAL, TRAFFIC
 Magic lantern
 use PROJECTOR, LANTERN-SLIDE
 MEGALITHOSCOPE
 Megascope
 use PROJECTOR, LANTERN-SLIDE
 PISTOL, SIGNAL

243

VISUAL COMMUNICATION EQUIPMENT (cont.)

Pistol, Very
> use PISTOL, SIGNAL

POLEMOSCOPE

POT, SMUDGE

PROJECTOR, FILM STRIP

PROJECTOR, LANTERN-SLIDE

PROJECTOR, MOTION-PICTURE

PROJECTOR, OPAQUE

PROJECTOR, SLIDE

READER, MICROFICHE

READER, MICROFILM

ROCKET, SIGNAL

SEMAPHORE
> note may be further subdivided to indicate specific
> type: e.g., SEMAPHORE, RAILROAD

SIGN, TRAFFIC
> rt SIGNAL, TRAFFIC

SIGNAL, RAILROAD
> note use only if specific type is unknown: e.g.,
> SEMAPHORE, RAILROAD

SIGNAL, TRAFFIC
> rt SIGN, TRAFFIC

Stereopticon
> use PROJECTOR, LANTERN-SLIDE

STEREOSCOPE

STEREOVIEWER
> note use only for a "modern" stereoviewer

WRITTEN COMMUNICATION EQUIPMENT
> def An artifact originally created to facilitate communication
> between people by means of written documents; see also
> DRAFTING T&E, PAINTING T&E and PRINTING T&E (Category 4),
> and DOCUMENTARY ARTIFACT

BINDER, RING

Blackboard
> use CHALKBOARD

BLOTTER

BOOKMARK

BOX, FILE

BOX, POUNCE

BOX, STAMP

Box, Writing
> use DESK, PORTABLE

CASE, PENCIL

CASE, WRITING

CHALKBOARD

CHECK PROTECTOR

CLIP, PAPER

CLIPBOARD

WRITTEN COMMUNICATION EQUIPMENT (cont.)

CUTTER, PAPER
Desk, Lap
 use DESK, PORTABLE
DESK, PORTABLE
DESK SET
ERASER
FILE, PORTABLE
FOLDER, FILE
HOLDER, BRUSH
HOLDER, PEN
INKPAD
INKSTAND
INKWELL
INKWELL LINER
KNIFE, PAPER
LABEL MAKER
LAPBOARD
MAILBAG
MAILBOX
MAILING MACHINE
METER, POSTAGE
MOISTENER
Opener, Letter
 use KNIFE, PAPER
PAPERWEIGHT
PEN
PEN, BALL-POINT
PEN, FOUNTAIN
PENCIL
PEN WIPE
PORTFOLIO
PUNCH, PAPER
RACK, LETTER
Sandbox
 use BOX, POUNCE
SIGNET
 rt RING, SIGNET
Slate
 use CHALKBOARD
SOLANDER
SPINDLE
STAMP
 note may be further subdivided to indicate specific
 type: e.g., STAMP, DATE; -,NOTARY; -,MARKING
STAPLER
TRAY, PEN
TYPEWRITER
 note may be further subdivided to indicate specific
 type: e.g., TYPEWRITER, ELECTRIC; -,MANUAL
TYPEWRITER RIBBON

Category 6: Transportation Artifacts
Artifacts originally created as vehicles for the
transporting of passengers or freight

AEROSPACE TRANSPORTATION
def An artifact originally created to transport people or
goods above the surface of the earth
ref (10) (12) (71) (80) (137)

AEROSPACE TRANSPORTATION EQUIPMENT

Aircraft
use more specific term: e.g., AIRPLANE, AIRSHIP,
BALLOON
AIRPLANE
note may be further subdivided to indicate general
type: e.g., AIRPLANE, CIVILIAN; -,MILITARY
AIRSHIP
note may be further subdivided to indicate specific
type: e.g., AIRSHIP, BLIMP; -,NONRIGID;
-,PRESSURE-RIGID; -,RIGID; -,SEMIRIGID
Amphibian
use AIRPLANE
AUTOGYRO
BALLOON
note may be further subdivided to indicate major
type: e.g., BALLOON, BARRAGE; -,CAPTIVE; -,FREE
BELT, ROCKET
BIOSATELLITE
rt SATELLITE
Blimp
use AIRSHIP
CHAIR LIFT
Dirigible
use AIRSHIP
Drone
use AIRPLANE
Flying boat
use AIRPLANE
GLIDER
HELICOPTER
KITE
note use for a heavier-than-air aircraft propelled
by a towline
OBSERVATORY, ORBITING SOLAR
rt SATELLITE
ORNITHOPTER
Sailplane
use GLIDER
SATELLITE
rt BIOSATELLITE; OBSERVATORY, ORBITING SOLAR
SATELLITE, COMMUNICATIONS
SATELLITE, DATASPHERE

AEROSPACE TRANSPORTATION EQUIPMENT (cont.)

 SATELLITE, METEOROLOGICAL
 Seaplane
 use AIRPLANE
 SPACECRAFT
 SPACECRAFT, MANNED COMMAND-MODULE
 SPACECRAFT, MANNED LUNAR-MODULE
 SPACECRAFT, MANNED ORBITAL-WORKSHOP
 Spacecraft, Unmanned
 use SPACEPROBE
 SPACEPROBE

AEROSPACE TRANSPORTATION ACCESSORY
 note many objects used as accessories for aerospace
 transportation should be classified as T&E or
 Communication Artifacts; in particular, see SURVEYING &
 NAVIGATIONAL T&E and TELECOMMUNICATION EQUIPMENT

 AIRFRAME
 AIRLOCK MODULE
 AUTOMATIC PILOT
 BOMB SHACKLE
 ENGINE
 note may be further subdivided to indicate specific
 type: e.g., ENGINE, RADIAL; -,RECIPROCATING;
 -,TURBOJET; -,TURBOPROP
 Flight gear
 use more specific term elsewhere in lexicon; see
 also CLOTHING
 Ground support equipment
 use more specific term elsewhere in lexicon; see
 also UNCLASSIFIED STRUCTURE, Communication
 Artifacts and LTE, MOTORIZED
 Instrument, Flight
 use a term from SURVEYING & NAVIGATIONAL T&E or
 TELECOMMUNICATION EQUIPMENT for the name of a
 specific instrument
 LIGHT, AIRCRAFT
 LINE
 note may be further subdivided to indicate specific
 type: e.g., LINE, CONTROL; -,MAIN MOORING;
 -,MAST YAW
 NOSE CONE
 PARACHUTE
 note may be further subdivided to indicate specific
 type: e.g., PARACHUTE, CARGO; -,DROGUE;
 -,PERSONNEL
 PROPELLER
 note may be subdivided to indicate specific type:
 e.g., PROPELLER, ADJUSTABLE-PITCH;
 -,FIXED-PITCH

247

AEROSPACE TRANSPORTATION ACCESSORY (cont.)

 RECORDER, FLIGHT
 SHIELD, HEAT
 SIMULATOR, AIR-FLIGHT
 SIMULATOR, SPACE-FLIGHT
 SLED, ROCKET
 WIND SOCK
 WIRE
 note may be further subdivided to indicate specific
 type: e.g., WIRE, ANTIDRAG; -,ANTIFLUTTER;
 -,FAIRING; -,STAGGER

LAND TRANSPORTATION
 def An artifact originally created to transport people or
 goods on the surface of land (not on rails)

LTE, ANIMAL-POWERED
 ref (118) (130)

 AMBULANCE
 Bandwagon, Circus
 use WAGON, CIRCUS PARADE
 BAROUCHE
 rt CALECHE
 Booby
 use SLEIGH
 Brake
 use BREAK, SKELETON or BREAK, WAGONETTE
 BREAK, SKELETON
 BREAK, WAGONETTE
 BROUGHAM
 BUCKBOARD
 Buggy
 use RUNABOUT
 CAB
 CAB, HANSOM
 CABRIOLET
 rt CHAISE; VICTORIA
 CAISSON
 CALECHE
 rt BAROUCHE; CHAISE
 CARRIAGE
 note use only if specific type is unknown: e.g.,
 PHAETON, BROUGHAM, BAROUCHE
 CARRIAGE, CANNON
 Carriole
 use SLEIGH
 CART
 note use only if specific type is unknown
 Cart, Breaking
 use BREAK, SKELETON

LTE, ANIMAL-POWERED (cont.)

 CART, DOG
 CART, GOVERNESS
 CART, IRISH JAUNTING
 CART, LIFE-SAVING BEACH
 Cart, Ox
 use OXCART
 CHAISE
 rt CABRIOLET; CALECHE
 CHAISE, POST
 CHARIOT
 COACH
 note use only if specific type is unknown
 COACH, BERLIN
 COACH, CONCORD
 COACH, ROAD
 rt STAGECOACH; PARK DRAG
 Coach, Stage
 use STAGECOACH
 COACH, STATE
 Coach-and-four
 use more specific term: e.g., BREAK, WAGONETTE;
 COACH, ROAD
 CURRICLE
 CUTTER
 note use only if specific type is unknown
 CUTTER, ALBANY
 CUTTER, COUNTRY
 CUTTER, PORTLAND
 Diligence
 use STAGECOACH
 DOGSLED
 DRAY
 DROSHSKY
 FIRE APPARATUS
 note use only if specific type is unknown: e.g.,
 WAGON, HOOK-AND-LADDER
 Four-in-hand
 use BREAK, WAGONETTE
 GIG
 Hack
 use CAB or CAB, HANSOM
 HEARSE
 HOWDAH
 LANDAU
 LANDAULET
 LITTER
 rt TRAVOIS
 OMNIBUS
 OXCART
 Paddy wagon
 use WAGON, POLICE PATROL

LTE, ANIMAL-POWERED (cont.)

PARK DRAG
 rt COACH, ROAD
PHAETON
 note may be further subdivided to indicate specific
 type: e.g., PHAETON, SPIDER; -,STANHOPE;
 -,GEORGE IV
PLOW, SNOW
Pod
 use SLEIGH
PRAIRIE SCHOONER
 rt WAGON, CONESTOGA
PUMPER, HAND
PUMPER, STEAM
Pung
 use SLEIGH
REEL, HOSE
 rt WAGON, HOSE
ROCKAWAY
ROLLER, SNOW
RUNABOUT
Shay
 use CHAISE
Sled
 use SLEIGH
SLEDGE
SLEIGH
 note may be further subdivided to indicate specific
 type: e.g., SLEIGH, SURREY; -,RUNABOUT
SOCIABLE
STAGECOACH
 rt COACH, ROAD
SULKY
SURREY
Tally-ho
 use COACH, ROAD
TILBURY
TRAP
TRAVOIS
 rt LITTER
Trolley, Trackless
 use OMNIBUS
VICTORIA
 rt CABRIOLET
VIS-A-VIS
WAGON
 note use only if specific type is unknown
WAGON, BATTERY
WAGON, CHEMICAL
WAGON, CIRCUS PARADE
WAGON, CONESTOGA
 rt PRAIRIE SCHOONER

LTE, ANIMAL-POWERED (cont.)

 WAGON, DELIVERY
 WAGON, FARM
 WAGON, HOOK-AND-LADDER
 WAGON, HOSE
 rt REEL, HOSE
 WAGON, MORTAR
 WAGON, MOUNTAIN
 WAGON, PEDDLER'S
 WAGON, POLICE PATROL
 WATER TOWER
 WHISKY

LTE, HUMAN-POWERED
 ref (85) (87)

 BARROW
 BICYCLE
 note use only if specific type is unknown: e.g.,
 VELOCIPEDE; BICYCLE, ORDINARY; -,SAFETY
 BICYCLE, ORDINARY
 BICYCLE, SAFETY
 Bicycle, Side-by-side
 use SOCIABLE
 BICYCLE, TANDEM
 Boneshaker
 use VELOCIPEDE
 CARRIAGE, BABY
 CRADLE, BASKET
 CRADLE, BOARD
 CRADLE, SLAT
 Dandyhorse
 use DRAISINE
 DOLLY
 DRAISINE
 Highwheeler
 use BICYCLE, ORDINARY
 Hobbyhorse
 use DRAISINE
 Irish mail
 use QUADRICYCLE
 LITTER
 Ordinary
 use BICYCLE, ORDINARY
 PALANQUIN
 Penny farthing
 use BICYCLE, ORDINARY
 Perambulator
 use CARRIAGE, BABY
 PUMPER, HAND
 PUMPER, STEAM

LTE, HUMAN-POWERED (cont.)

Pushcart
 use BARROW
QUADRICYCLE
RICKSHAW
SEDAN
Sedan chair
 use SEDAN
SKI, ALPINE
SKI, CROSS-COUNTRY
SKI POLE
SLEDGE
 rt STONEBOAT
SNOWSHOE
SOCIABLE
STRETCHER
STROLLER
TRICYCLE
Tricycle, Side-by-side
 use SOCIABLE
TRICYCLE, TANDEM
TRICYCLE, TWO-TRACK
UNICYCLE
VELOCIPEDE
WHEELBARROW
YOKE

LTE, MOTORIZED
 ref (86)
 note any motorized vehicle may be powered by steam, gasoline
 or electricity; unless otherwise indicated, assume
 gasoline; early motorized vehicles follow carriage
 designs; see LTE, ANIMAL-POWERED for additional valid
 object names: e.g., PHAETON, STEAM

AMBULANCE
 rt TRUCK, CRASH
AMMUNITION CARRIER
AUTOMOBILE
BICYCLE, GASOLINE
BICYCLE, STEAM
BUS
CAMPER
Car
 use AUTOMOBILE
CAR, ARMORED
Crane, Gooseneck
 use ELEVATING PLATFORM
DOLLY
FIRE APPARATUS
 note use only if specific type is unknown: e.g.,
 TRUCK, PUMPER; -,PUMPER/LADDER

252

LTE, MOTORIZED (cont.)

 FORKLIFT
 GONDOLA CAR
 HEARSE
 Motorbike
 <u>use</u> BICYCLE, GASOLINE
 MOTORCYCLE
 MOTORCYCLE SIDECAR
 MOTOR SCOOTER
 PERSONNEL CARRIER
 Pickup
 <u>use</u> TRUCK, PICKUP
 PLOW, SNOW
 Quadruple
 <u>use</u> more specific term: e.g., TRUCK, PUMPER/LADDER
 RACING CAR
 SEMITRAILER
 <u>rt</u> TRAILER
 Snorkel
 <u>use</u> ELEVATING PLATFORM
 SNOWMOBILE
 SWEEPER, STREET
 TANK
 Telescoping platform
 <u>use</u> ELEVATING PLATFORM
 TELPHER
 TRACTOR, ARTILLERY
 TRAILER
 <u>rt</u> SEMITRAILER
 TRAILER, BOAT
 TRAILER, HOUSE
 TRICYCLE, GASOLINE
 TRICYCLE, STEAM
 Triple
 <u>use</u> more specific term: e.g., TRUCK, PUMPER/LADDER
 TRUCK
 TRUCK, AERIAL LADDER
 TRUCK, CRASH
 <u>rt</u> AMBULANCE
 Truck, Delivery
 <u>use</u> specific body type: e.g., TRUCK, DUMP;
 -,PANEL; -,TANK
 TRUCK, DUMP
 TRUCK, FLATBED
 TRUCK, HOOK-AND-LADDER
 Truck, Ladder
 <u>use</u> TRUCK, HOOK-AND-LADDER
 TRUCK, LIGHTING
 TRUCK, ORDNANCE WORKSHOP
 TRUCK, PANEL
 TRUCK, PICKUP
 TRUCK, PUMPER

LTE, MOTORIZED (cont.)

 TRUCK, PUMPER/AERIAL LADDER
 TRUCK, PUMPER/LADDER
 TRUCK, SMOKE EJECTOR
 TRUCK, STAKE
 TRUCK, TANK
 TRUCK, TOW
 TRUCK, TROOP
 TRUCK TRACTOR
 VAN
 VEHICLE, LUNAR ROVING
 Velocipede
 use BICYCLE, STEAM
 WATER TOWER

LAND TRANSPORTATION ACCESSORY
 ref (78)

 ANKLE BOOT, HORSE
 ARMOR, HORSE
 AUTOMOBILE HOOD ORNAMENT
 AUTOMOBILE VASE
 BAG, WATER
 BICYCLE BAG
 BICYCLE BELL
 BICYCLE LAMP
 BIT
 BLINDER
 Bow, Horse
 use YOKE, ANIMAL
 BRIDLE
 note may be further subdivided to indicate specific
 type: e.g., BRIDLE, SINGLE; -,TEAM
 CAPARISON
 CARRIAGE APRON
 CARRIAGE LAMP
 CINCH
 COLLAR, HORSE
 GIRTH
 HALTER
 HAME
 note may be further subdivided to indicate specific
 type: e.g., HAME, COVERED; -,PLATED
 HARNESS
 note use for a general transportation harness;
 normally subdivided to indicate vehicle
 pulled: e.g., HARNESS, BUGGY; -,RUNABOUT
 HARNESS, DOG
 HARNESS, DONKEY
 HARNESS, EXPRESS
 HARNESS, FARM

254

LAND TRANSPORTATION ACCESSORY (cont.)

Harness, Heavy truck
 use HARNESS, EXPRESS
HARNESS, PONY
Harness, Team
 use HARNESS, FARM
HARNESS, TRACK
HORN
JACK
 note may be further subdivided to indicate specific
 type: e.g., JACK, STAGECOACH; -,WAGON
KNEE CAP, HORSE
LAP ROBE
LICENSE PLATE
LUGGAGE CARRIER
METER, PARKING
Oxbow
 use YOKE, ANIMAL
PANNIER
PUMP
 note may be further subdivided to indicate specific
 type: e.g., PUMP, BICYCLE; -,AUTOMOBILE
PUMP, FUEL
QUIRT
REINS
 note may be further subdivided to indicate specific
 type: e.g., REINS, CHECK
SADDLE
 note may be further subdivided to indicate specific
 type: e.g., SADDLE, RIDING; -,STOCK; -,PACK
SADDLEBAG
SADDLE BLANKET
SADDLE PAD
SADDLE TREE
SCALE, TRUCK
SPUR
STIRRUP
Surcingle
 use GIRTH
TARPOT
TAXIMETER
TOOL KIT
 note may be further subdivided to indicate specific
 type: e.g., TOOL KIT, BICYCLE
WHIP
 note may be further subdivided to indicate specific
 type: e.g., WHIP, BUGGY; -,COACH; -,RIDING
YOKE, ANIMAL

RAIL TRANSPORTATION
 def An artifact originally created to transport people or

255

goods on or along a fixed track
ref (8)

RAIL TRANSPORTATION EQUIPMENT

BAGGAGE CAR
BOXCAR
BUSINESS CAR
 note use for any car created for use by an
 executive or government official
CABLE CAR
CABOOSE
Car
 use only as a secondary term within this
 classification
Chair car
 use COACH
Chair-lounge car
 use COACH
COACH
Commuter car
 use COACH or SELF-PROPELLED CAR
DINING CAR
 note use for any car designed to be used for food
 preparation and/or food service
Engine
 use LOCOMOTIVE
Express car
 use BAGGAGE CAR
FLATCAR
FREIGHT CAR
 note use only if specific type is unknown: e.g.,
 BOXCAR, STOCKCAR, FLATCAR, HOPPER CAR
HANDCAR
 rt VELOCIPEDE CAR
HOPPER CAR
Interurban
 use SELF-PROPELLED CAR, ELECTRIC
LOCOMOTIVE
LOCOMOTIVE, DIESEL-ELECTRIC
LOCOMOTIVE, DIESEL-HYDRAULIC
LOCOMOTIVE, ELECTRIC
LOCOMOTIVE, GASOLINE
LOCOMOTIVE, GASOLINE-ELECTRIC
LOCOMOTIVE, STEAM
LOCOMOTIVE, TURBINE
LOUNGE CAR
MAIL CAR
MONORAIL CAR
PIGGYBACK CAR
Pullman car
 use SLEEPING CAR

256

RAIL TRANSPORTATION EQUIPMENT (cont.)

 REFRIGERATOR CAR
 SELF-PROPELLED CAR, DIESEL
 SELF-PROPELLED CAR, ELECTRIC
 rt STREETCAR, ELECTRIC
 SELF-PROPELLED CAR, GAS-ELECTRIC
 SELF-PROPELLED CAR, GASOLINE
 SERVICE CAR
 note may be further subdivided to indicate specific
 type: e.g., SERVICE CAR, DYNAMOMETER;
 -,INSTRUCTIONAL; -,SNOWPLOW
 SLEEPING CAR
 SLEEPING/LOUNGE CAR
 STOCK CAR
 STREETCAR
 STREETCAR, ELECTRIC
 rt SELF-PROPELLED CAR, ELECTRIC
 STREETCAR, HORSE-DRAWN
 SUBWAY CAR
 TANK CAR
 TENDER
 TRAIN
 note use only when cataloging a complete rail unit
 of locomotive(s) and cars
 Tram
 use STREETCAR
 Trolley
 use STREETCAR, ELECTRIC
 Van
 use CABOOSE
 VELOCIPEDE CAR
 rt HANDCAR

RAIL TRANSPORTATION ACCESSORY

 CROSSTIE
 MAIL CRANE
 SPIKE
 SWITCH IRON
 TRACK SECTION

WATER TRANSPORTATION
 def An artifact originally created to transport people or
 goods on water
 ref (1) (25) (31) (32) (60) (73)

WATER TRANSPORTATION EQUIPMENT
 note the first word(s) of the object name should be the type
 of vessel; for sailing vessels further subdivisions may

be used to indicate the number of masts and the type of
rigging: e.g., MAN-OF-WAR, 2-MAST SCHOONER; WHALER,
3-MAST BARK. (See text for rigging terms and discussion
of models.)

AIRCRAFT CARRIER
Albemarle sound boat
 use SEINE BOAT, SHAD
BARGE
BARGE, TRAINING
BATEAU
 note use only for a flat-bottomed vessel with
 fore-&-aft bottom planks
 rt DORY, BANKS
Bateau, V-bottomed
 use SKIPJACK
BATHYSCAPH
BATTLESHIP
BLOCK ISLAND COWHORN
Boat
 use only as a secondary term: e.g., CANAL BOAT,
 BULL BOAT, SEINE BOAT
BUGEYE
BULL BOAT
 rt CORACLE
BUY BOAT, CHESAPEAKE BAY
CANAL BOAT
CANOE
 note may be further subdivided to indicate specific
 type: e.g., CANOE, CANVAS-COVERED;
 -,CHESAPEAKE BAY LOG; -,DECKED; -,DUGOUT;
 -,FOLDING; -,OUTRIGGER; -,SAILING
CARGO VESSEL, DRY-CARGO
 note use for carrier of dry bulk cargo
CARGO VESSEL, GENERAL
CARGO VESSEL, LNG
 note use for specialized cryogenic (e.g., liquid
 natural gas) carrier
CARGO VESSEL, OBO
 note use for multi-purpose bulk carrier (e.g., wet
 or dry cargo; ore-bulk oil)
CARGO VESSEL, WET-CARGO
CATAMARAN
CATBOAT, EASTERN
Clipper
 use only as a rigging term; see text
CORACLE
 rt BULL BOAT
CRAB BOAT, CHESAPEAKE BAY
CRUISER, GUIDED MISSILE
CRUISER, HEAVY
CRUISER, LIGHT

WATER TRANSPORTATION EQUIPMENT (cont.)

```
CUTTER
DELAWARE DUCKER
     rt   SKIFF, GUNNING
DELAWARE RIVER TUCKUP
DESTROYER
DESTROYER ESCORT
DHOW
DINGHY
     rt   TENDER, YACHT
DINGHY, BAHAMA
DINGHY, SAILING
     note use only if specific type is unknown; see also
          SAILBOAT
DORY
     note may be further subdivided to indicate specific
          type: e.g., DORY, BANKS; -,CHAMBERLAIN;
          -,SWAMPSCOTT
Dreadnought
     use  BATTLESHIP
DREDGE
DREDGE BOAT, CHESAPEAKE BAY
DRY DOCK, FLOATING
EXCURSION VESSEL
FELUCCA
FERRY
FIREBOAT
FISHERMAN
FRIENDSHIP SLOOP
FRIGATE
GALLEY
GARVEY
GONDOLA
GUIDEBOAT, ADIRONDACK
HAMPTON BOAT
HARBOR CRAFT
     note may be further subdivided to indicate specific
          type: e.g., HARBOR CRAFT, LIGHTER; -,REVENUE;
          -,SCOW; -,WATER HOY
HOVERCRAFT
HYDROFOIL
HYDROPLANE
     rt   RUNABOUT
ICEBOAT
ICEBREAKER
INFLATABLE BOAT
JUNK
KAYAK
     rt   UMIAK
LANDING CRAFT, PERSONNEL
LANDING CRAFT, UTILITY
LANDING SHIP, DOCK
```

WATER TRANSPORTATION EQUIPMENT (cont.)

 LANDING SHIP, UTILITY
 LAUNCH, GASOLINE
 rt RUNABOUT
 LAUNCH, NAPTHA
 LAUNCH, STEAM
 LIFEBOAT, COASTAL RESCUE
 rt SURFBOAT; LIFECAR
 LIFEBOAT, SHIP'S
 LIFECAR
 rt LIFEBOAT, COASTAL RESCUE; SURFBOAT
 LIGHTSHIP
 LOBSTER BOAT
 LONGBOAT
 MAN-OF-WAR
 note use only for a full-rigged ship of the line
 MELON SEED
 rt SKIFF, GUNNING
 MINELAYER
 MINESWEEPER
 NOANK SLOOP
 NO-MAN'S-LAND BOAT
 Oomiak
 use UMIAK
 PACKET
 PADDLE BOAT
 PASSENGER VESSEL
 PATROL GUNBOAT
 PATROL TORPEDO BOAT
 PEAPOD
 PETROLEUM-SERVICE VESSEL
 note use for offshore station tender
 PILOT BOAT
 PINKY
 PINKY, CROTCH ISLAND
 Pirogue
 use CANOE, DUGOUT
 PRAM
 PRAM, SAILING
 PRIVATEER
 note use for any privately-armed vessel
 PUNT
 RAFT
 RANGELEY BOAT
 REFRIGERATOR VESSEL
 RESEARCH VESSEL
 rt SUBMARINE, RESEARCH
 ROWBOAT
 note use only if specific type is unknown: e.g.,
 DORY, SKIFF, DINGHY
 RUNABOUT
 rt HYDROPLANE; LAUNCH, GASOLINE

WATER TRANSPORTATION EQUIPMENT (cont.)

 SAILBOAT
 note use only (1) with subdivision to indicate
 class name (e.g., SAILBOAT, COMET; -,PENGUIN)
 or (2) if specific type is unknown (e.g.,
 PRAM; DINGHY, SAILING; CATAMARAN)
 SAMPAN
 SANDBAGGER, HUDSON RIVER
 SCOW
 Scull
 use SHELL, SINGLE SCULL
 SEINE BOAT, MACKEREL
 SEINE BOAT, SHAD
 SHARPIE
 SHARPIE, NEW HAVEN
 SHELL
 note may be further subdivided to indicate specific
 type: e.g., SHELL, EIGHT-OARED; -,FOUR-OARED;
 -,PAIR with COXSWAIN; -,PAIR-OARED; -,PRACTICE
 WHERRY; -,SINGLE SCULL
 Skeeter
 use ICEBOAT
 SKIFF
 note use only if specific type is unknown
 SKIFF, CHESAPEAKE BAY
 Skiff, Crab
 use SKIFF, CHESAPEAKE BAY
 SKIFF, FLATIRON
 SKIFF, GUNNING
 rt DELAWARE DUCKER; MELON SEED
 Skiff, Oyster
 use SKIFF, CHESAPEAKE BAY
 SKIFF, SEABRIGHT
 SKIFF, ST. LAWRENCE RIVER
 SKIFF, YANKEE
 SKIPJACK
 SNEAK BOX
 Speedboat
 use RUNABOUT
 STRIKER BOAT, MENHADEN
 SUBMARINE
 SUBMARINE, ATTACK
 SUBMARINE, BALLISTIC MISSILE
 SUBMARINE, COMMERCIAL
 SUBMARINE, RESEARCH
 rt RESEARCH VESSEL
 SUBMARINE CHASER
 Submarine tender
 use TENDER, SUBMARINE
 SURFBOAT
 rt LIFEBOAT, COASTAL RESCUE; LIFECAR
 SURVEY VESSEL

261

WATER TRANSPORTATION EQUIPMENT (cont.)

 TENDER, BUOY
 TENDER, SUBMARINE
 TENDER, YACHT
 rt DINGHY
 TONGING BOAT, CHESAPEAKE BAY
 TRANSPORT
 Trawler
 use FISHERMAN
 TRIMARAN
 TUG-TOWBOAT
 UMIAK
 rt KAYAK
 WHALEBOAT
 WHALER
 WHALER, TANCOOK
 WHERRY, SALMON
 WHITEHALL
 YACHT
 YAWL-BOAT

WATER TRANSPORTATION ACCESSORY
 note many objects used as accessories for water transportation
 should be classifed as T&E or Communication Artifacts; in
 particular, see SURVEYING & NAVIGATIONAL T&E and Category 5

 ANCHOR
 note may be further subdivided to indicate specific
 type: e.g., ANCHOR, WOODEN STOCK; -,MUSHROOM
 rt KILLICK
 BAILER
 BATHYSPHERE
 BELL, SHIP'S
 BILLETHEAD
 BINNACLE
 BITT, MOORING
 BLOCK
 note may be further subdivided to indicate specific
 type: e.g., BLOCK, DOUBLE; -,SNATCH
 BOARD, GANGWAY
 BOARD, NAME
 BOARD, QUARTER
 BOARD, TRAIL
 BOLLARD
 Bumper
 use FENDER
 BUOY, BREECHES
 BUOY, MOORING
 CABLE
 CAPSTAN
 rt WINDLASS

WATER TRANSPORTATION ACCESSORY (cont.)

 CARVING, CATHEAD
 CARVING, PADDLEBOX
 CARVING, STERN
 CARVING, TAFFRAIL
 CASE, CHART
 CASK, HARNESS
 CHAIN, ANCHOR
 CHAIR, BOATSWAIN'S
 CHEST, SHIP'S MEDICINE
 CHOCK
 CLEAT
 CRADLE, BOAT
 CRUTCH, BOOM
 DAVIT, ANCHOR
 DAVIT, BOAT
 DEADEYE
 FAIRLEAD
 FENDER
 FIGUREHEAD
 GANGPLANK
 GUDGEON, RUDDER
 GUN, LINE-THROWING
 GUN, LYLE
 HAWSE PIPE
 HOLY STONE
 HOOK, BOAT
 HOOP, MAST
 INDICATOR, ENGINE-ROOM TELEGRAPH
 INDICATOR, RUDDER-POSITION
 JACKET, LIFE
 KILLICK
 rt ANCHOR
 LADDER, JACOB'S
 LEAD, SOUNDING
 LIGHT, ANCHOR
 LIGHT, MASTHEAD
 LIGHT, RUNNING
 LIGHT, SHIP'S
 note use only if specific type is unknown
 LIGHT, STERN
 LOG
 note may be further subdivided to indicate specific
 type: e.g., LOG, TAFFRAIL
 MOTOR, OUTBOARD
 OAR
 rt SWEEP
 OAR, SCULLING
 rt YULOH
 OAR, STEERING
 OARLOCK
 ORNAMENT, MASTHEAD

WATER TRANSPORTATION ACCESSORY (cont.)

ORNAMENT, PILOT-HOUSE
PADDLE
PADDLE, CANOE
PADDLE, DOUBLE-BLADED
PIN, BELAYING
PIN, THOLE
PINTLE, RUDDER
Pole
 use QUANT
PROJECTILE, LYLE GUN
PROPELLER
PUMP, BILGE
QUANT
RAIL, FIFE
RING, LIFE
ROPE
 note use only if specific type is unknown: e.g.,
 JIB SHEET; ANCHOR RODE
Rowlock
 use OARLOCK
SAIL
 note use only if specific type is unknown: e.g.,
 JIB, SPINNAKER, SPANKER, MAINSAIL
SHACKLE
SHACKLE, SWIVEL
SHEAVE
SWEEP
 rt OAR
TABLE, MESS
TELLTALE
WHEEL, STEERING
WHISTLE, STEAM
WINDLASS
 rt CAPSTAN
YULOH
 rt OAR, SCULLING

Category 7: Art Objects
Artifacts originally created for aesthetic purposes or as
a demonstration of creative skill and dexterity; the
essential ingredient is that the artifact was created for
no apparent utilitarian purpose

COMMERCIAL DECORATIVE ART
- def An artifact originally created in commercial quantities to
serve primarily as non-utilitarian household decoration;
see also HOUSEHOLD ACCESSORY (Category 2)
- ref (72)

Bell, Wind
 use WIND-BELL
BRIC-A-BRAC
BUST
Chime, Wind
 use WIND-BELL
FIGURINE
 note may be further subdivided to indicate
 non-human forms: e.g., FIGURINE, ANIMAL; -,BIRD
FIGURINE GROUP
FLORAL BOUQUET
FLORAL WREATH
FLOWER, ARTIFICIAL
FRUIT, ARTIFICIAL
Knick-knack
 use BRIC-A-BRAC
LANTERN, PAPER
LUSTER
MOBILE
MUSIC BOX
ORNAMENT
 note may be further subdivided to indicate specific
 type: e.g., ORNAMENT, CHANUKAH; -,CHRISTMAS
 TREE
ORNAMENT, GARDEN
PICTURE
 note may be further subdivided to indicate material
 or technique: e.g., PICTURE, WOVEN
PICTURE FRAME
PLAQUE
PRINT
Stevengraph
 use PICTURE, WOVEN
WIND-BELL

ORIGINAL ART
- def An artifact originally created as one of a kind, or as one
of a limited series, to provide aesthetic pleasure or as a
demonstration of creative skill and dexterity
- ref (72)

ORIGINAL ART (cont.)

> ASSEMBLAGE
> BUST
> COLLAGE
> DRAWING
> FIGURINE
> > <u>note</u> may be further subdivided to indicate
> > non-human forms: e.g., FIGURINE, ANIMAL; -,BIRD
> HANGING
> > <u>note</u> use for macrame, needlework, weaving and other
> > non-utilitarian craft items not otherwise
> > named (e.g., SAMPLER, TAPESTRY)
> MOBILE
> MONTAGE
> Okimono
> > <u>use</u> FIGURINE
> PAINTING
> PICTURE
> > <u>note</u> may be further subdivided to indicate material
> > or technique: e.g., PICTURE, CUT-PAPER;
> > -,HAIR; -,SHELL
> PLAQUE
> PRINT
> PRINT, PHOTOGRAPHIC
> > <u>note</u> other photographic objects included within the
> > DOCUMENTARY ARTIFACT classification (Category
> > 5) may also be used as acceptable ORIGINAL ART
> > object names when appropriate
> Sailor's valentine
> > <u>use</u> PICTURE, SHELL
> SAMPLER
> Sculpture
> > <u>use</u> more specific term: e.g., BUST, FIGURINE,
> > STATUE
> STATUE
> TAPESTRY
> WHIMSY
> WHIRLIGIG

Category 8: Recreational Artifacts
Artifacts originally created to be used as toys or in carrying on the activities of sports, games, gambling or public entertainment

GAME
 <u>def</u> An artifact originally created to be used in a competitive activity based upon chance, problem-solving and calculation as opposed to physical effort, and conducted according to rules; includes all forms of gambling devices; see also SPORTS EQUIPMENT and TOY
 <u>ref</u> (22) (23) (48)
 <u>note</u> an individual game piece may be separately named (e.g., CHESSMAN, DOMINO, CAROM PIECE) or identified by the general term, GAME PIECE

 BACKGAMMON SET
 BAGATELLE
 BINGO SET
 <u>rt</u> LOTTO SET
 Board
 <u>use</u> either as a secondary word following the name of a specific game (e.g., CRIBBAGE BOARD, PARCHESI BOARD) or for a multiple-game board use GAME BOARD
 Box, Dealing
 <u>use</u> SHOE
 CARD DECK
 CAROM SET
 CHECKER SET
 CHESS SET
 CHINESE CHECKER SET
 CRIBBAGE SET
 CROKINOLE SET
 DARTS
 DICE
 DICE CUP
 DIE
 DOMINOES
 GAME BOARD
 <u>note</u> use for a board utilized in multiple games or if specific game is unknown
 GAME BOX
 GAME PIECE
 <u>note</u> use for a piece utilized in multiple games or if specific game is unknown
 GAME SET
 <u>note</u> use for a set of games or if specific game is unknown
 JACKS
 JACKSTRAWS
 LOTTO SET
 <u>rt</u> BINGO SET
 MAH-JONGG

GAME (cont.)

 MARBLE
 MONOPOLY SET
 OUIJA SET
 PADDLE, CROUPIER'S
 PARCHESI SET
 Pick up sticks
 use JACKSTRAWS
 POKER CHIP
 POKER CHIP BLOCK
 QUOITS
 ROULETTE WHEEL
 SHOE
 SLOT MACHINE
 Squails
 use TIDDLYWINK SET
 TIDDLYWINK SET
 TIVOLI
 TRAY, GAMBLING

PUBLIC ENTERTAINMENT DEVICE
 def An artifact originally created to be used in the
 production of non-competitive spectator entertainment; see
 also SPORTS EQUIPMENT
 ref (56)

 AERIAL RIGGING
 ANIMAL STAND
 ARCH, PROSCENIUM
 BALANCING POLE
 Boom
 use BOOMERANG
 BOOMERANG
 Circus equipment
 use more specific term: e.g., BALANCING POLE;
 TRAPEZE; HIGH WIRE; ANIMAL STAND
 CURTAIN, STAGE
 CYCLORAMA
 DROP
 note may be further subdivided to indicate specific
 type: e.g., DROP, FLAT; -,ROLL; -,SCRIM
 Flat
 use DROP, FLAT
 GRIDIRON
 High wire
 use AERIAL RIGGING
 Magician's equipment
 use PROPERTIES, MAGICIAN'S
 MARIONETTE
 rt DOLL; PUPPET, HAND
 MASK

PUBLIC ENTERTAINMENT DEVICE (cont.)

PERIAKTOS
PROPERTIES
 note use for any decorative, floor or hand object
 that provides a realistic effect in a public
 production
PROPERTIES, ANIMAL
 note use for the general object category or if
 specific type is unknown: e.g., ANIMAL STAND
PROPERTIES, MAGICIAN'S
Props
 use PROPERTIES
PUPPET, HAND
 rt DOLL; MARIONETTE
Scenery
 use more specific term: e.g., FLAT, DROP, CYCLORAMA
Scenery unit
 use FLAT
SCIOPTICON
SET
 note use for a constructed stage setting, usually
 of painted scenes or hangings with their
 accessories
STAGE, JACKKNIFE
STAGE, PUPPET
STAGE, REVOLVING
STAGE, SLIP
Trapeze
 use AERIAL RIGGING
Vizard
 use MASK

RECREATIONAL DEVICE
 def An artifact originally created to be used in a
 participatory, usually non-competitive, recreational
 activity other than an athletic game or exercise; includes
 equipment for which a use charge is normally made (e.g., a
 carousel, a pinball machine) as well as the free
 facilities of a public park (e.g., a swing, a slide); also
 includes the same types of equipment when privately owned;
 see also SPORTS EQUIPMENT
 ref (21) (53) (81)

AMUSEMENT RIDE
 note use for any ride not identified by another
 general term: e.g., ROLLER COASTER, FERRIS
 WHEEL, CAROUSEL
Animal springdom
 use COILED-SPRING RIDER
ARCADE MACHINE
 note use for any machine not identified by another
 general term: e.g., PINBALL MACHINE

269

RECREATIONAL DEVICE (cont.)

Buck-a-bout
 use SEESAW, COILED-SPRING
CAROUSEL
CAROUSEL ANIMAL
CAROUSEL ORNAMENT
CLIMBER
 note may be further subdivided to indicate specific
 type: e.g., CLIMBER, ARCH; -,DOME
CLIMBING NET
COILED-SPRING RIDER
FERRIS WHEEL
GLIDER
JUKEBOX
 rt NICKELODEON
Jungle gym
 use CLIMBER
LADDER, HORIZONTAL
LADDER, ROPE
Merry-go-round
 use CAROUSEL
Monkey bars
 use LADDER, HORIZONTAL
MUTASCOPE
 rt PEEP-SHOW MACHINE
NICKELODEON
 rt JUKEBOX
PEEP-SHOW MACHINE
 rt MUTASCOPE
PILLOW RIDE
PINBALL MACHINE
Playground equipment
 use more specific term: e.g.,
POOL, WADING
Pull-a-way
 use WHIRL
ROLLER COASTER
Saddle mate
 use COILED-SPRING RIDER
SANDBOX
SEESAW
SLIDE
SLIDING POLE
SWING
SWING, CIRCLE
SWINGING GATE
TARGET, GALLERY
Teeter-totter
 use SEESAW
TRAPEZE
TUNNEL
WALKING BOARD
 rt BALANCE BEAM

RECREATIONAL DEVICE (cont.)

 WHIRL

SPORTS EQUIPMENT
 <u>def</u> An artifact originally created to be used in a physical
 activity that is often competitive; includes equipment
 used in all forms of athletic games and exercises, whether
 the participant is a professional or an amateur and the
 activity is an individual or a team sport; see also GAME,
 TOY and RECREATIONAL DEVICE
 <u>ref</u> (81) (89)
 <u>note</u> when equipment is identified by the name of the sport or
 activity in which it is used, that name should be the
 primary word and the name of the piece of equipment the
 secondary word: e.g., BASEBALL BAT, BOXING GLOVE,
 PUNCHING BAG

 ALPENSTOCK
 Aqualung
 <u>use</u> TANK, SCUBA
 AQUAPLANE
 BADMINTON RACKET
 BALANCE BEAM
 <u>rt</u> WALKING BOARD
 Ball
 <u>use</u> more specific term: e.g., TENNIS BALL, BOWLING
 BALL
 BANDERILLA
 BARBELL
 BARS, PARALLEL
 BASEBALL
 BASEBALL BAT
 BASKETBALL
 BASKETBALL BACKBOARD
 BASKETBALL HOOP
 Battledore
 <u>use</u> BADMINTON RACKET
 BILLIARD BALL
 BILLIARD BRIDGE
 BILLIARD CUE
 BILLIARD CUE RACK
 BILLIARD TABLE
 BLOCKING DUMMY
 BOBSLED
 BODY PROTECTOR
 BOWLING BALL
 BOWLING PIN
 BOXING GLOVE
 CABER
 Candlepin
 <u>use</u> BOWLING PIN

271

SPORTS EQUIPMENT (cont.)

 CLIMBING ROPE
 CRICKET BAT
 CROQUET MALLET
 CROQUET WICKET
 CURLING BROOM
 CURLING STONE
 DECK TENNIS RING
 DISCUS
 Duckpin
 use BOWLING PIN
 DUMBBELL
 ESTOQUE
 Exercise equipment
 use more specific term: e.g., DUMBBELL, BARBELL,
 ROWING MACHINE, INDIAN CLUB
 FENCING EPEE
 rt SABER, FENCING
 FENCING FOIL
 rt SABER, FENCING
 FENCING GLOVE
 FENCING MASK
 FINGER TABS
 FOOTBALL
 FOOTBALL HELMET
 FRISBEE
 GLOVE, FIELDER'S
 GLOVE, GOALIE'S
 GOLF CART
 GOLF CLUB
 GOLF GLOVE
 HAMMER
 HANDBALL
 HOCKEY PUCK
 HOCKEY STICK
 HORIZONTAL BAR
 HORSESHOE
 HURDLE
 INDIAN CLUB
 JAI ALAI BASKET
 JAVELIN
 KNEE DEVELOPER
 LACROSSE HELMET
 LACROSSE RACKET
 LACROSSE STICK
 LUGE
 MASK, CATCHER'S
 MASK, GOALIE'S
 MEDICINE BALL
 MITT, BASEMAN'S
 MITT, CATCHER'S
 MULETA

SPORTS EQUIPMENT (cont.)

PADS, HIP
PADS, SHOULDER
Passometer
 use PEDOMETER
PEDOMETER
Ping pong paddle
 use TABLE TENNIS PADDLE
PITON
PLASTRON
POOL TABLE
PRIZE RING
PUNCHING BAG
REGULATOR, SCUBA
REJON
ROWING MACHINE
SHIN GUARD
SHOTPUT
SHUFFLEBOARD CUE
SHUFFLEBOARD DISK
SHUTTLECOCK
SIDE HORSE
SKATE, ICE
SKATE, ROLLER
SKATE BOARD
SKI, WATER
Skiddle stick
 use BOWLING PIN
SLED
SNORKEL
SOCCER BALL
SOFTBALL
SPEEDBALL
STALL BAR
STARTING BLOCK
STRIKING BAG
SURFBOARD
SWIM FIN
SWIM MASK
SWINGING ROPE
TABLE TENNIS PADDLE
TACKLING DUMMY
Tank, Diver's
 use TANK, SCUBA
TANK, SCUBA
TENNIS BALL
TENNIS PADDLE
TENNIS RACKET
Tenpin
 use BOWLING PIN
TETHERBALL
TOBOGGAN

SPORTS EQUIPMENT (cont.)

 TRAMPOLINE
 VAULTING HORSE
 VAULTING POLE
 VOLLEYBALL
 WRIST DEVELOPER

TOY

 def An artifact originally created to be a plaything; may be
 representational (i.e., a small-sized reproduction of a
 functional object, a person or a creature) or
 non-representational (e.g., a ball, a top, a kite); a toy
 is created primarily to be played with, a craft object is
 primarily for display (see ORIGINAL ART, Category 7); see
 also GAME, SPORTS EQUIPMENT and RECREATIONAL DEVICE
 ref (48) (51) (104)
 note use as an object name either one of the following terms
 or, for a representational toy, any acceptable object
 name which indicates the basic toy (though not
 necessarily all the segments of the toy): e.g., use
 WAGON, FARM to name a toy farm wagon regardless whether
 horses are attached

 ANIMAL
 ANIMAL, MECHANICAL
 Automaton
 use DOLL, MECHANICAL or FIGURE, MECHANICAL or
 ANIMAL, MECHANICAL or MECHANICAL TOY
 BALL
 BANK, MECHANICAL
 BANK, SEMI-MECHANICAL
 BANK, STILL
 BEADS, STRINGING
 BEANBAG
 Bilboquet
 use CUP AND BALL
 BLOCK
 BLOCK, PARQUETRY
 BLOCK, TELESCOPIC
 CANDY CONTAINER
 CAP EXPLODER
 CAP PISTOL
 CARRIAGE, DOLL
 Chinese puzzle
 use BLOCK, PARQUETRY
 CONSTRUCTION SET, METAL
 CONSTRUCTION SET, WOODEN
 CONSTRUCTION TOY
 CUP AND BALL
 DIABOLO
 rt TOP

TOY (cont.)

 DOLL
 rt LAY FIGURE; MANIKIN; MARIONETTE; PUPPET, HAND
 DOLL, MECHANICAL
 Doll, Paper
 use PAPER DOLL
 DOLLHOUSE
 Eidoscope
 use KALEIDOSCOPE
 ENGINE, STEAM
 Engine, Train
 use LOCOMOTIVE
 Erector set
 use CONSTRUCTION SET, METAL
 FIGURE
 FIGURE, MECHANICAL
 rt MECHANICAL TOY
 FLIPPER-FLOPPER
 HOBBYHORSE
 note use for a stick horse and not for a rocking
 horse
 Hoola hoop
 use HOOP
 HOOP
 House, Doll
 use DOLLHOUSE
 IRISH MAIL
 JACK-IN-THE-BOX
 Jacob's ladder
 use FLIPPER-FLOPPER
 JUMP ROPE
 KALEIDOSCOPE
 KIDDIE CAR
 KITE
 LOCOMOTIVE
 MAGIC LANTERN
 MAGNET
 MARIONETTE
 rt DOLL; PUPPET, HAND
 MAROTTE
 Mechanical doll
 use DOLL, MECHANICAL
 MECHANICAL TOY
 note use only for a mechanically-activated toy
 which cannot be named by a more specific term
 in this classification (e.g., FIGURE,
 MECHANICAL; PULL TOY) or, for a
 representational object, by a term from some
 other classification (e.g., ROLLER COASTER;
 WAGON, FARM); normally used to name a
 mechanically-activated group of figures and/or
 animals

TOY (cont.)

 MOTOR, ELECTRIC
 Myrioscope
 use KALEIDOSCOPE
 NOISE MAKER
 NOVELTY
 Optic toy
 use more specific term: e.g., KALEIDOSCOPE,
 THAUMATROPE, ZOETROPE
 PAPER DOLL
 PAPER TOY
 PEDAL CAR
 Phantoscope
 use KALEIDOSCOPE
 PINWHEEL
 PIPE, BUBBLE
 PIPE, WHISTLE
 Pistol, Cap
 use CAP PISTOL
 POGO STICK
 Polygonoscope
 use KALEIDOSCOPE
 POPGUN
 PRAXINOSCOPE
 Projector, Lantern-slide
 use MAGIC LANTERN
 PULL TOY
 PUPPET, HAND
 rt DOLL; MARIONETTE
 Push toy
 use TRUNDLE TOY
 PUZZLE
 RATTLE
 ROCKING HORSE
 ROLLY-DOLL
 Sand toy
 use more specific object name
 SCOOTER
 SEWING CARD
 SLINKY
 SQUEAKER
 Stick horse
 use HOBBYHORSE
 STILT
 STROBOSCOPE
 STUFFED TOY
 Surprise box
 use JACK-IN-THE-BOX
 THAUMATROPE
 Tinker toys
 use CONSTRUCTION SET, WOODEN
 TOP
 rt DIABOLO

TOY **(cont.)**

> TOP, BOWSTRING
> TOP, GYROSCOPE
> TOP, PEG
> TOP, WHIP
> Toy soldier
> > <u>use</u> FIGURE
> TRICYCLE
> TRUNDLE TOY
> WAGON
> Wheel of life
> > <u>use</u> ZOETROPE
> WHIRLIGIG
> YO-YO
> ZOETROPE

Category 9: Societal Artifacts

Artifacts originally created to be used in carrying on governmental, fraternal, religious or other organized and sanctioned societal activities

BEHAVIORAL CONTROL DEVICE

def An artifact originally created to be used in controlling the behavior of people who are judged in violation of the rules of society

> BALL-and-CHAIN
> BELT, CHASTITY
> CANGUE
> CAP, DUNCE
> Cat-o-nine-tails
> > use WHIP
>
> CHAIR, ELECTRIC
> Club, Billy
> > use NIGHTSTICK
>
> CRADLE-WITH-SPIKES
> GALLOWS
> GRENADE, TEAR GAS
> GUILLOTINE
> HANDCUFFS
> HEADBAND, TIGHTENING
> Manacle
> > use SHACKLE
>
> NIGHTSTICK
> PADDLE
> PILLORY
> SCAVENGER'S DAUGHTER
> SHACKLE
> STOCKS
> STOOL, DUCKING
> STRAITJACKET
> STRAPPADO
> THUMBSCREW
> WHIP

CEREMONIAL ARTIFACT

def An artifact originally created to be used in a ritual that is conducted in a consistent and usually prescribed manner; includes: (1) any religious artifact, other than a personal devotional object (see PERSONAL SYMBOL, Category 3), (2) any object used in a ceremony concerned with either personal life crises (e.g., birth, puberty, sickness, death) or group crises (e.g., the need for rain, a harvest festival), or (3) any object used in the ceremonial activities of a fraternity, lodge, club, governmental or military organization (e.g., the pennon of a Girl Scout troop); see also GOVERNMENTAL ARTIFACT

> Almorratxa
> > use ASPERGILLUM

CEREMONIAL ARTIFACT (cont.)

 ALTAR
 Altar cloth
 use FRONTAL
 ALTARPIECE
 ASPERGILLUM
 BALDACHIN
 BANNER
 BASKET, DANCE
 BASKET, WEDDING
 BOWL, LIBATION
 rt PHIALE
 BOWL, MARRIAGE
 BULL-ROARER
 BURSE
 CALUMET
 CASE, MUMMY
 rt COFFIN; SARCOPHAGUS
 Casket
 use COFFIN
 CATAFALQUE
 CENSER
 rt THURIBLE
 CHALICE
 CIBORIUM
 COFFIN
 rt SARCOPHAGUS; CASE, MUMMY
 CRECHE
 Cross
 use PLAQUE, RELIGIOUS
 Crucifix
 use STATUE, RELIGIOUS
 Diptych
 use ALTARPIECE
 DOLL
 note may be further subdivided to indicate specific
 type: e.g., DOLL, EFFIGY; -,KACHINA
 DOLMEN
 FLABELLUM
 FLAG
 FONT, BAPTISMAL
 FONT, HOLY WATER
 FRONTAL
 FRONTLET
 GONG
 GRAGER
 Gravestone
 use TOMBSTONE
 Headstone
 use TOMBSTONE
 JAR, CANOPIC
 Jar, Mortuary
 use URN, FUNEREAL

279

CEREMONIAL ARTIFACT (cont.)

 LAMP, MOSQUE
 LAVABO
 MASK
 MEDICINE BUNDLE
 Megalith
 use DOLMEN or MENHIR
 MENHIR
 MENORAH
 rt CANDELABRUM
 MEZUZAH
 Military standard
 use more specific term: e.g., PENNANT, PENNON
 MONSTRANCE
 MONUMENT
 Obelisk
 use MONUMENT
 PALL
 PATEN
 PENNANT
 PENNON
 PHIALE
 rt BOWL, LIBATION
 PI DISK
 Pipe, Peace
 use CALUMET
 PLAQUE
 PLATE, OFFERING
 PRAYER RUG
 PRAYER STICK
 PRAYER WHEEL
 PYX
 RATTLE
 RELIC, RELIGIOUS
 RELIQUARY
 rt SHRINE
 Rug, Prayer
 use PRAYER RUG
 SARCOPHAGUS
 rt COFFIN; CASE, MUMMY
 Shari vessel
 use RELIQUARY
 SHAWABTI
 SHOFAR
 SHRINE
 note may be further subdivided to indicate specific
 type: e.g., SHRINE, RELIGIOUS
 rt RELIQUARY
 STATUE, RELIGIOUS
 THURIBLE
 rt CENSER
 TIKI

CEREMONIAL ARTIFACT (cont.)

 TOMBSTONE
 TORAH, SEPHER
 TOTEM
 TOTEM POLE
 TRAY, CEREMONIAL
 Triptych
 use ALTARPIECE
 URN, FUNEREAL
 VASE, CEREMONIAL
 VASE, TEMPLE
 VEIL, CHALICE

EXCHANGE MEDIUM
 def An artifact originally created to be used as a medium of
 exchange (e.g., a coin, currency, shell money) or as an
 instrument for obtaining specially-defined services (e.g.,
 a postage stamp, a transportation token)

 CARD, STORE
 note use for a card exchanged for services during a
 time when there was limited currency available
 rt TOKEN, STORE
 COIN
 note may be further subdivided to indicate a
 specific coin name: e.g., COIN, DIME; -,PESO;
 -,SHILLING
 CURRENCY
 note use for paper money not coins
 MONEY ORDER
 Paper money
 use CURRENCY
 Scrip
 use CURRENCY
 SHELL MONEY
 STAMP, POSTAGE
 STAMP, TRADING
 TICKET
 TOKEN, STORE
 rt CARD, STORE
 TOKEN, TRANSPORTATION

GOVERNMENTAL ARTIFACT
 def An artifact originally created to be used in carrying on
 the non-ceremonial activities of a governmental
 organization; see also DOCUMENTARY ARTIFACT (Category 5)
 and CEREMONIAL ARTIFACT

 BOX, BALLOT
 VOTING BOOTH

281

GOVERNMENTAL ARTIFACT (cont.)

Voting box
 use BOX, BALLOT
VOTING MACHINE
WHEEL, JURY

Category 10: Packages and Containers
Artifacts originally created to be used for packing and shipping goods and commodities, and containers for which a precise function cannot be determined

PRODUCT PACKAGE
 <u>def</u> An artifact originally created to be a container for a known product usually when it is offered for sale

 <u>note</u> the first word(s) of the object name should be the type of container; further subdivisions may be used to indicate the class of product originally packaged in the container: e.g., TIN, CRACKER; BOTTLE, WHISKEY; BARREL, PICKLE

 BAG
 BARREL
 BOTTLE
 <u>rt</u> DEMIJOHN
 BOX
 CAN
 CARBOY
 CARTON
 CASE
 Cork
 <u>use</u> STOPPER, BOTTLE
 CRATE
 DEMIJOHN
 <u>rt</u> BOTTLE
 JAR
 JUG
 KEG
 Sack
 <u>use</u> BAG
 STOPPER, BOTTLE
 TIN
 TUB
 TUBE

UNCLASSIFIED CONTAINER
 <u>def</u> An artifact originally created to be a container for items which cannot be identified from an examination of the container

 <u>ref</u> (13)

 <u>note</u> more specialized container forms are classified according to their function: e.g., FOOD PROCESSING T&E, FOOD SERVICE T&E, PRODUCT PACKAGE; containers associated with specific kinds of objects are classified with those objects: e.g., VIOLIN CASE with VIOLIN in MUSICAL T&E, CARPENTER'S TOOL BOX in WOODWORKING T&E;

 <u>note</u> in addition to the specifically defined terms below, any of the object names from PRODUCT PACKAGE may be used for an UNCLASSIFIED CONTAINER

UNCLASSIFIED CONTAINER (cont.)

> BAG
>> <u>note</u> use for a relatively flexible container;
>> normally textile or hide construction
>
> BOWL
>> <u>note</u> use for a rounded vessel which is open to view
>> of the inside by reason of having an orifice
>> diameter that is usually the maximum body
>> diameter; normally subdivided to indicate
>> ceramic or basketry construction; see also JAR
>> and TRAY
>
> BOX
>> <u>note</u> use for a flat-bottomed, more-or-less
>> rectangular container; normally constructed of
>> wood
>
> JAR
>> <u>note</u> use for a rounded vessel which is nearly
>> closed to view of the inside by reason of
>> having an orifice diameter substantially
>> narrower than the maximum body diameter;
>> includes forms customarily referred to as
>> bottles, jugs, ollas, etc.; normally
>> subdivided to indicate ceramic or basketry
>> construction; see also BOWL and TRAY
>
> TRAY
>> <u>note</u> use for a flat or nearly flat BOWL; includes
>> forms customarily referred to as saucers,
>> platters, plates, etc.; normally subdivided to
>> show ceramic or basketry construction; see
>> also BOWL and JAR

Category 11: Unclassifiable Artifacts
Artifacts originally created to serve a human purpose
which cannot be identified at the time the object is
cataloged

ARTIFACT REMNANT
 <u>def</u> A segment or incomplete part of an artifact originally
 created to fulfill some human function which cannot be
 determined or even inferred from the fragment

 BASKETRY FRAGMENT
 BONE, WORKED
 BONE FRAGMENT
 CORDAGE FRAGMENT
 LITHIC FRAGMENT
 QUID
 Shard
 <u>use</u> SHERD
 SHELL FRAGMENT
 SHERD
 <u>note</u> may be further subdivided to indicate section
 of vessel: e.g., SHERD, RIM; -,NECK; -,BASE;
 -,BODY
 STONE, WORKED
 TEXTILE FRAGMENT
 <u>rt</u> BOLT, CLOTH; SALES SAMPLE, CLOTH; QUILT PIECE
 WOOD FRAGMENT

FUNCTION UNKNOWN
 <u>def</u> An artifact originally created to be used for some
 unidentified human activity

 PROBLEMATICAL

Chapter 7
Alphabetical Listing of Object Names

```
ABA...........................CLOTHING, OUTERWEAR
     rt   TOGA; CAFTAN
ABACUS........................DATA PROCESSING T&E
ABSORPTIONMETER...............OPTICAL T&E
ACCELERATOR...................NUCLEAR PHYSICS T&E
     note use only if specific type is unknown: e.g.,
          BETATRON, PROTONSYNCHROTRON, VAN DE GRAAF
ACCELERATOR, LINEAR...........NUCLEAR PHYSICS T&E
ACCELEROMETER.................MECHANICAL T&E
ACCORDION.....................MUSICAL T&E, UNCLASSIFIED
Accounting machine............DATA PROCESSING T&E
     use  BOOKKEEPING MACHINE
ACETOMETER....................CHEMICAL T&E
ACIDIMETER....................FOOD PROCESSING T&E
ACOUMETER.....................ACOUSTICAL T&E
Acousimeter...................ACOUSTICAL T&E
     use  AUDIOMETER
ACTINOGRAPH...................CHEMICAL T&E
ACTINOMETER...................CHEMICAL T&E
ACTUATOR......................ELECTRICAL & MAGNETIC T&E
ACUTOMETER....................MEDICAL & PSYCHOLOGICAL T&E
ADAPTER, BARREL...............ARMAMENT ACCESSORY
ADAPTER, GRIP.................ARMAMENT ACCESSORY
ADDING MACHINE................DATA PROCESSING T&E
ADENY'S APPARATUS.............CHEMICAL T&E
Adjuster, Hoof................ANIMAL HUSBANDRY T&E
     use  LEVELER, HOOF
ADJUSTING CONE................MEDICAL & PSYCHOLOGICAL T&E
ADZ...........................WOODWORKING T&E
     note use only if specific type is unknown
ADZ, BUNGING..................WOODWORKING T&E
ADZ, CARPENTER'S..............WOODWORKING T&E
ADZ, CLEAVING.................WOODWORKING T&E
ADZ, COOPER'S.................WOODWORKING T&E
ADZ, COOPER'S NAILING.........WOODWORKING T&E
ADZ, COOPER'S NOTCHING........WOODWORKING T&E
     rt   KNIFE, HOOP-NOTCHING
ADZ, COOPER'S ROUNDING........WOODWORKING T&E
Adz, Cooper's sharp...........WOODWORKING T&E
     use  ADZ, COOPER'S TRIMMING
```

```
ADZ, COOPER'S TRIMMING.........WOODWORKING T&E
Adz, Dubbing...................WOODWORKING T&E
     use  ADZ, LIPPED
ADZ, GUTTERING.................WOODWORKING T&E
     rt   PLANE, GUTTERING
ADZ, HOLLOWING.................WOODWORKING T&E
ADZ, LIPPED....................WOODWORKING T&E
ADZ, MARKING...................FORESTRY T&E
ADZ, SHIPWRIGHT'S..............WOODWORKING T&E
Adz, Spout.....................WOODWORKING T&E
     use  ADZ, GUTTERING
ADZ, TRUSSING..................WOODWORKING T&E
     rt   HAMMER, COOPER'S
ADZ, WHEELWRIGHT'S.............WOODWORKING T&E
AERATOR, MILK..................FOOD PROCESSING T&E
AERIAL RIGGING.................PUBLIC ENTERTAINMENT DEVICE
AEROMETER......................METEOROLOGICAL T&E
AEROSCOPE......................BIOLOGICAL T&E
AESTHESIOMETER.................BIOLOGICAL T&E
AETHRIOSCOPE...................ASTRONOMICAL T&E
AFTER-IMAGE APPARATUS..........MEDICAL & PSYCHOLOGICAL T&E
AGAL...........................CLOTHING ACCESSORY
AGITATOR, FLOUR-BLEACHING......FOOD PROCESSING T&E
Aiguillette....................PERSONAL SYMBOL
     use  SHOULDER LOOP
AIMING POST....................ARMAMENT ACCESSORY
AIRBRUSH.......................PAINTING T&E
Aircraft.......................AEROSPACE TRANSPORTATION EQUIPMENT
     use  more specific term: e.g., AIRPLANE, AIRSHIP,
          BALLOON
AIRCRAFT CARRIER...............WATER TRANSPORTATION EQUIPMENT
AIRFRAME.......................AEROSPACE TRANSPORTATION ACCESSORY
AIR LEG........................MINING T&E
AIRLOCK MODULE.................AEROSPACE TRANSPORTATION ACCESSORY
AIRPLANE.......................AEROSPACE TRANSPORTATION EQUIPMENT
     note may be further subdivided to indicate
          general type: e.g., AIRPLANE, CIVILIAN;
          -,MILITARY
AIR POISE......................METEOROLOGICAL T&E
AIRPORT........................BUILDING
     note use for the complex of a landing field and
          associated buildings: e.g., HANGAR;
          TERMINAL; TOWER, CONTROL
AIRSHIP........................AEROSPACE TRANSPORTATION EQUIPMENT
     note may be further subdivided to indicate
          specific type: e.g., AIRSHIP, BLIMP;
          -,NONRIGID; -,PRESSURE-RIGID; -,RIGID;
          -,SEMIRIGID
ALB............................CLOTHING, OUTERWEAR
Albemarle sound boat...........WATER TRANSPORTATION EQUIPMENT
     use  SEINE BOAT, SHAD
ALBUM, AUTOGRAPH...............DOCUMENTARY ARTIFACT
```

ALBUM, PHOTOGRAPH................DOCUMENTARY ARTIFACT
ALBUMINOMETER...................MEDICAL & PSYCHOLOGICAL T&E
ALCOHOLOMETER...................CHEMICAL T&E
Alembic........................CHEMICAL T&E
 use DISTILLING APPARATUS
ALEUROMETER....................FOOD PROCESSING T&E
ALIDADE........................SURVEYING & NAVIGATIONAL T&E
ALKALIMETER....................CHEMICAL T&E
Almorratxa.....................CEREMONIAL ARTIFACT
 use ASPERGILLUM
ALPENHORN......................ANIMAL HUSBANDRY T&E
ALPENSTOCK.....................SPORTS EQUIPMENT
ALTAR..........................CEREMONIAL ARTIFACT
Altar cloth....................CEREMONIAL ARTIFACT
 use FRONTAL
ALTARPIECE.....................CEREMONIAL ARTIFACT
ALTIMETER......................SURVEYING & NAVIGATIONAL T&E
Altiscope......................OPTICAL T&E
 use PERISCOPE
AMALGAMATOR....................MEDICAL & PSYCHOLOGICAL T&E
AMALGAMATOR....................METALWORKING T&E
 note use only if specific type is unknown: e.g.,
 TABLE, AMALGAMATING; BARREL, AMALGAMATING
AMALGAM CARRIER................MEDICAL & PSYCHOLOGICAL T&E
AMBLYOSCOPE....................MEDICAL & PSYCHOLOGICAL T&E
AMBROTYPE......................DOCUMENTARY ARTIFACT
AMBULANCE......................LTE, ANIMAL-POWERED
AMBULANCE......................LTE, MOTORIZED
 rt TRUCK, CRASH
AMBULANCE CAR..................MINING T&E
Ambulator......................SURVEYING & NAVIGATIONAL T&E
 use WHEEL, SURVEYOR'S
Amice..........................CLOTHING, HEADWEAR
 use HOOD
AMIGO..........................MINING T&E
AMMETER........................ELECTRICAL & MAGNETIC T&E
AMMONIA-ABSORPTION APPARATUS...BIOLOGICAL T&E
AMMONIAMETER...................CHEMICAL T&E
Ammunition belt................ARMAMENT ACCESSORY
 use BELT, AMMUNITION
AMMUNITION CARRIER.............LTE, MOTORIZED
Amphibian......................AEROSPACE TRANSPORTATION EQUIPMENT
 use AIRPLANE
AMPHITHEATER...................UNCLASSIFIED STRUCTURE
AMPLIFIER......................ELECTRICAL & MAGNETIC T&E
 note may be further subdivided to indicate
 specific type: e.g., AMPLIFIER, CARRIER;
 -,RADIO-FREQUENCY; -,DC
AMPLIFIER, AUDIO...............ACOUSTICAL T&E
 rt FUNNEL-HORN; RESONATOR
AMPLIFIER, AUDIO...............SOUND COMMUNICATION EQUIPMENT
AMPUL..........................MEDICAL & PSYCHOLOGICAL T&E

```
AMULET........................PERSONAL SYMBOL
AMUSEMENT RIDE................RECREATIONAL DEVICE
     note use for any ride not identified by another
          general term: e.g., ROLLER COASTER, FERRIS
          WHEEL, CAROUSEL
ANAGLYPH......................MEDICAL & PSYCHOLOGICAL T&E
ANALYZER......................DATA PROCESSING T&E
     note use only if specific type is unknown
     rt   COMPUTER, ANALOG
ANALYZER, DIFFERENTIAL........DATA PROCESSING T&E
ANALYZER, HARMONIC............DATA PROCESSING T&E
ANALYZER, NETWORK.............DATA PROCESSING T&E
ANALYZER, SOUND...............ACOUSTICAL T&E
ANALYZER/SYNTHESIZER, CLANG....ACOUSTICAL T&E
Anastigmat....................OPTICAL T&E
     use LENS, ANASTIGMATIC
ANATOMICAL MODEL..............MEDICAL & PSYCHOLOGICAL T&E
ANCHOR........................WATER TRANSPORTATION ACCESSORY
     note may be further subdivided to indicate
          specific type: e.g., ANCHOR, WOODEN STOCK;
          -,MUSHROOM
     rt   KILLICK
ANDIRON.......................TEMPERATURE CONTROL DEVICE
ANEMOGRAPH....................METEOROLOGICAL T&E
ANEMOMETER....................METEOROLOGICAL T&E
ANEMOSCOPE....................METEOROLOGICAL T&E
ANEROIDOGRAPH.................METEOROLOGICAL T&E
ANGLEOMETER...................DATA PROCESSING T&E
ANGON.........................ARMAMENT T&E, EDGED
ANIMAL........................TOY
ANIMAL, MECHANICAL............TOY
Animal springdom..............RECREATIONAL DEVICE
     use COILED-SPRING RIDER
ANIMAL STAND..................PUBLIC ENTERTAINMENT DEVICE
ANKLE BOOT, HORSE.............LAND TRANSPORTATION ACCESSORY
ANKLET........................ADORNMENT
ANOMOLOSCOPE..................MEDICAL & PSYCHOLOGICAL T&E
ANORTHOSCOPE..................OPTICAL T&E
ANTEFIX.......................BUILDING FRAGMENT
ANTENNA.......................TELECOMMUNICATION EQUIPMENT
     note may be further subdivided to indicate
          specific type: e.g., ANTENNA, RADIO;
          -,TELEVISION
ANTENNA, RADAR................SURVEYING & NAVIGATIONAL T&E
ANTHROCOMETER.................CHEMICAL T&E
ANTIMACASSAR..................HOUSEHOLD ACCESSORY
ANTIRRHEOSCOPE................MEDICAL & PSYCHOLOGICAL T&E
ANVIL.........................METALWORKING T&E
ANVIL.........................MUSICAL T&E, PERCUSSION
ANVIL, CONCAVE................METALWORKING T&E
ANVIL, NAILMAKER'S............METALWORKING T&E
ANVIL, SCYTHE-SHARPENING......METALWORKING T&E
     rt   STONE, SCYTHE-SHARPENING
```

APARTMENT.........................BUILDING
 rt PUEBLO
APERTOMETER.......................OPTICAL T&E
APIARY............................ANIMAL HUSBANDRY T&E
APOMECOMETER......................SURVEYING & NAVIGATIONAL T&E
APOPHOROMETER, CHEMICAL...........CHEMICAL T&E
Apparatus
 use only as a secondary word in a multi-word
 object name
APPLICATOR, SHOE-POLISH...........CLOTHING ACCESSORY
APRON.............................CLOTHING, OUTERWEAR
 note may be further subdivided according to
 functional activity if appropriate: e.g.,
 APRON, BLACKSMITH'S
Aqualung..........................SPORTS EQUIPMENT
 use TANK, SCUBA
AQUAMETER.........................CHEMICAL T&E
AQUAPLANE.........................SPORTS EQUIPMENT
AQUARIUM..........................BUILDING
AQUARIUM..........................HOUSEHOLD ACCESSORY
AQUEDUCT..........................UNCLASSIFIED STRUCTURE
ARCADE............................BUILDING FRAGMENT
ARCADE MACHINE....................RECREATIONAL DEVICE
 note use for any machine not identified by
 another general term: e.g., PINBALL MACHINE
ARCH..............................UNCLASSIFIED STRUCTURE
ARCH, PROSCENIUM..................PUBLIC ENTERTAINMENT DEVICE
ARCOGRAPH.........................DRAFTING T&E
ARGENTOMETER......................CHEMICAL T&E
ARMATURE..........................GLASS & PLASTICS T&E
ARMBAND, MOURNING.................PERSONAL SYMBOL
Armchair..........................FURNITURE
 use more specific term: e.g., CHAIR, EASY;
 -,DINING
ARMELTS...........................ARMAMENT T&E, BODY ARMOR
ARM GUARD.........................ARMAMENT ACCESSORY
ARMILLA...........................PERSONAL SYMBOL
ARMILLARY SPHERE..................ASTRONOMICAL T&E
ARMLET............................ADORNMENT
Armoire...........................FURNITURE
 use WARDROBE
ARMOR.............................ARMAMENT ACCESSORY
 note use only for entire suit of armor; see also
 separate items: e.g., HAUBERK, JAMBEAU,
 HEAUME
ARMOR, HORSE......................LAND TRANSPORTATION ACCESSORY
ARMOR, PARLOR.....................HOUSEHOLD ACCESSORY
ARMORY............................BUILDING
ARQUEBUS..........................ARMAMENT T&E, FIREARM
 rt MUSKET
ARRASTRA..........................METALWORKING T&E
ARROW.............................ARMAMENT T&E, EDGED

ARROWHEAD......................ARMAMENT T&E, EDGED
 rt PROJECTILE POINT
ARTICULATOR, DENTAL............MEDICAL & PSYCHOLOGICAL T&E
ARTIFICIAL HORIZON.............SURVEYING & NAVIGATIONAL T&E
ARTILLERY, BREECH-LOADING......ARMAMENT T&E, ARTILLERY
 note use only if specific type is unknown
ARTILLERY, MUZZLE-LOADING......ARMAMENT T&E, ARTILLERY
 note use only if specific type is unknown: e.g.,
 CARRONADE, FALCONET
Artist's model.................PAINTING T&E
 use LAY FIGURE
ASCOT..........................CLOTHING ACCESSORY
ASHPAN.........................HOUSEKEEPING T&E
ASHTRAY........................HOUSEHOLD ACCESSORY
ASPERGILLUM....................CEREMONIAL ARTIFACT
ASPIRATOR......................MEDICAL & PSYCHOLOGICAL T&E
ASPIRATOR......................UNCLASSIFIED T&E, GENERAL
ASSAY APPARATUS................MINING T&E
ASSEMBLAGE.....................ORIGINAL ART
ASSEMBLY UNIT..................DATA PROCESSING T&E
ASTRODICTICUM..................ASTRONOMICAL T&E
ASTROLABE......................ASTRONOMICAL T&E
ASTROLABE, MARINER'S...........SURVEYING & NAVIGATIONAL T&E
Astrolage......................ASTRONOMICAL T&E
 use ASTROLABE
ASTROMETEOROSCOPE..............MEDICAL & PSYCHOLOGICAL T&E
ASTROMETER.....................ASTRONOMICAL T&E
ASTROPATROTOMETER..............ASTRONOMICAL T&E
ASTROSCOPE.....................ASTRONOMICAL T&E
Atef...........................PERSONAL SYMBOL
 use PSCHENT
ATMOLYSER......................CHEMICAL T&E
ATOMIZER.......................TOILET ARTICLE
ATOMIZER.......................MEDICAL & PSYCHOLOGICAL T&E
Atom smasher...................NUCLEAR PHYSICS T&E
 use ACCELERATOR
ATTACHE CASE...................PERSONAL GEAR
Attachment
 use only as a secondary word in a multi-word
 object name
AUDIOMETER.....................ACOUSTICAL T&E
AUDIO-OSCILLATOR...............ACOUSTICAL T&E
AUDIO-RESPONSE UNIT............DATA PROCESSING T&E
AUDIPHONE......................MEDICAL & PSYCHOLOGICAL T&E
Auditory apparatus.............ACOUSTICAL T&E
 use more specific term: e.g., GENERATOR, SOUND;
 AMPLIFIER, AUDIO; ANALYZER, SOUND;
Auger..........................MINING T&E
 use DRILL, ROTARY
AUGER..........................WOODWORKING T&E
 note use only if specific type is unknown
 rt REAMER; BIT

```
Auger, Burn....................WOODWORKING T&E
    use  IRON, WHEELWRIGHT'S BURNING
Auger, Center-bit..............WOODWORKING T&E
    use  AUGER, SPIRAL
Auger, Cooper's bong-borer.....WOODWORKING T&E
    use  AUGER, TAPER
Auger, Expanding...............WOODWORKING T&E
    use  AUGER, SPIRAL
AUGER, FRUIT...................FOOD PROCESSING T&E
AUGER, FUZE....................ARMAMENT ACCESSORY
Auger, Nose....................WOODWORKING T&E
    use  AUGER, SHELL
Auger, Pipe....................WOODWORKING T&E
    use  AUGER, TAPER or AUGER, SHELL or AUGER, SNAIL
Auger, Pod.....................WOODWORKING T&E
    use  AUGER, SHELL or AUGER, SNAIL
AUGER, POST-HOLE...............UNCLASSIFIED T&E, GENERAL
    rt   DIGGER, POST-HOLE
Auger, Pump....................WOODWORKING T&E
    use  AUGER, TAPER or AUGER, SHELL or AUGER, SNAIL
AUGER, RAFT....................FORESTRY T&E
Auger, Screw...................WOODWORKING T&E
    use  AUGER, SPIRAL
AUGER, SHELL...................WOODWORKING T&E
AUGER, SNAIL...................WOODWORKING T&E
AUGER, SPIRAL..................WOODWORKING T&E
Auger, Tap.....................WOODWORKING T&E
    use  AUGER, TAPER
AUGER, TAPER...................WOODWORKING T&E
Auger, Twist...................WOODWORKING T&E
    use  AUGER, SPIRAL
AURISCOPE......................MEDICAL & PSYCHOLOGICAL T&E
AUTOCLAVE......................MEDICAL & PSYCHOLOGICAL T&E
AUTOCLAVE, CANNING.............FOOD PROCESSING T&E
AUTOGYRO.......................AEROSPACE TRANSPORTATION EQUIPMENT
AUTOHARP.......................MUSICAL T&E, STRINGED
AUTOMATIC PILOT................AEROSPACE TRANSPORTATION ACCESSORY
AUTOMATON......................DATA PROCESSING T&E
Automaton......................TOY
    use  DOLL, MECHANICAL or FIGURE, MECHANICAL or
         ANIMAL, MECHANICAL or MECHANICAL TOY
AUTOMOBILE.....................LTE, MOTORIZED
AUTOMOBILE HOOD ORNAMENT.......LAND TRANSPORTATION ACCESSORY
AUTOMOBILE VASE................LAND TRANSPORTATION ACCESSORY
AUXANOMETER....................BIOLOGICAL T&E
Avarrancator...................AGRICULTURAL T&E
    use  PRUNER, TREE
AVIARY.........................UNCLASSIFIED STRUCTURE
AVIARY.........................HOUSEHOLD ACCESSORY
AWL............................LEATHERWORKING T&E
    note may be further subdivided to indicate
         specific type: e.g., AWL, PEG; -,SCRATCH
```

AWL........................TEXTILEWORKING T&E
 rt FID
AWL........................WOODWORKING T&E
 note use only if specific type is unknown
AWL, ARMORER'S.............METALWORKING T&E
Awl, Brad..................WOODWORKING T&E
 use BRADAWL
Awl, Flooring..............WOODWORKING T&E
 use BRADAWL
AWL, MARKING...............WOODWORKING T&E
 rt KNIFE, MARKING; SCRIBER
Awl, Scratch...............WOODWORKING T&E
 use AWL, MARKING
Awl, Scribe................WOODWORKING T&E
 use AWL, MARKING
AWL, SQUARE................WOODWORKING T&E
AWNING.....................WINDOW OR DOOR COVERING
AX.........................WOODWORKING T&E
 note use only if specific type is unknown
 rt HATCHET
AX, BARKING................FORESTRY T&E
AX, BELT...................ARMAMENT T&E, EDGED
AX, BOARDING...............ARMAMENT T&E, EDGED
AX, BRICK..................MASONRY T&E
Ax, Broad..................WOODWORKING T&E
 use BROADAX
AX, COOPER'S...............WOODWORKING T&E
AX, CRATEMAKER'S...........WOODWORKING T&E
AX, FELLING................FORESTRY T&E
 rt AX, TURPENTINE
AX, FIRE...................UNCLASSIFIED T&E, SPECIAL
Ax, Goosewing..............WOODWORKING T&E
 use BROADAX
Ax, Hewing.................WOODWORKING T&E
 use BROADAX
AX, ICE....................UNCLASSIFIED T&E, SPECIAL
Ax, Killing................FOOD PROCESSING T&E
 use AX, SLAUGHTERING
AX, MARKING................FORESTRY T&E
AX, MASON'S................MASONRY T&E
AX, MAST & SPAR............WOODWORKING T&E
AX, MORTISING..............WOODWORKING T&E
AX, SHIPWRIGHT'S...........WOODWORKING T&E
AX, SIDE...................WOODWORKING T&E
 note use only if specific type is unknown: e.g.,
 BROADAX; AX, COOPER'S
AX, SLAUGHTERING...........FOOD PROCESSING T&E
Ax, Stone..................MASONRY T&E
 use AX, MASON'S
AX, TOOTH..................MASONRY T&E
AX, TURPENTINE.............FORESTRY T&E
 rt AX, FELLING

```
AXOMETER........................MEDICAL & PSYCHOLOGICAL T&E
AZOTOMETER......................CHEMICAL T&E
BACKFILLING MACHINE.............TEXTILEWORKING T&E
BACKGAMMON SET..................GAME
BACKHOE.........................CONSTRUCTION T&E
BACKHOE/FRONT-END LOADER........CONSTRUCTION T&E
BACKPACK........................PERSONAL GEAR
BACKPLATE.......................ARMAMENT T&E, BODY ARMOR
BACKREST........................FURNITURE
BACKSTAFF.......................SURVEYING & NAVIGATIONAL T&E
BACKSTRIPPING MACHINE...........PRINTING T&E
BACTERIOSCOPE...................BIOLOGICAL T&E
Badge...........................PERSONAL SYMBOL
    use  more specific term: e.g., PIN, PATCH or MEDAL
BADMINTON RACKET................SPORTS EQUIPMENT
BAG.............................PRODUCT PACKAGE
BAG.............................UNCLASSIFIED CONTAINER
    note use for a relatively flexible container;
         normally textile or hide construction
Bag, Beaded.....................PERSONAL GEAR
    use  PURSE
BAG, DITTY......................PERSONAL GEAR
BAG, DUFFLE.....................PERSONAL GEAR
Bag, Emery......................TEXTILEWORKING T&E
    use  CUSHION, EMERY
Bag, Hand.......................PERSONAL GEAR
    use  PURSE
BAG, HUNTING....................ARMAMENT ACCESSORY
BAG, ICE........................HOUSEHOLD ACCESSORY
Bag, Musette....................PERSONAL GEAR
    use  HAVERSACK
BAG, ORE........................MINING T&E
BAG, PASTRY.....................FOOD PROCESSING T&E
BAG, SALLY......................PERSONAL GEAR
BAG, SCHOOL.....................PERSONAL GEAR
Bag, Shoulder...................PERSONAL GEAR
    use  HAVERSACK
BAG, SLEEPING...................BEDDING
BAG, TAMPING....................MINING T&E
BAG, WATER......................LAND TRANSPORTATION ACCESSORY
BAGATELLE.......................GAME
BAG-CLOSING MACHINE.............FOOD PROCESSING T&E
BAG-FORMING MACHINE.............PAPERMAKING T&E
BAGGAGE CAR.....................RAIL TRANSPORTATION EQUIPMENT
BAGPIPE.........................MUSICAL T&E, WOODWIND
    note use only if specific type is unknown
BAGPIPE, FRENCH CORNEMUSE.......MUSICAL T&E, WOODWIND
BAGPIPE, FRENCH MUSETTE.........MUSICAL T&E, WOODWIND
BAGPIPE, IRISH UNION-PIPE.......MUSICAL T&E, WOODWIND
BAGPIPE, ITALIAN ZAMPOGNA.......MUSICAL T&E, WOODWIND
BAGPIPE, NORTHUMBRIAN SMALL-PIPE
    ............................MUSICAL T&E, WOODWIND
```

BAGPIPE, SCOTTISH HIGHLAND.....MUSICAL T&E, WOODWIND
BAGPIPE, SCOTTISH LOWLAND......MUSICAL T&E, WOODWIND
BAGPIPE, WESTERN FOLK..........MUSICAL T&E, WOODWIND
Bag-sewing machine.............FOOD PROCESSING T&E
 use BAG-CLOSING MACHINE
BAG-TYING MACHINE..............FOOD PROCESSING T&E
BAILER.........................MINING T&E
BAILER.........................WATER TRANSPORTATION ACCESSORY
BALALAIKA......................MUSICAL T&E, STRINGED
BALANCE........................WEIGHTS & MEASURES T&E
 note use only if specific type is unknown
BALANCE, ANALYTICAL............WEIGHTS & MEASURES T&E
BALANCE, ASSAY.................MINING T&E
BALANCE, BERANGER..............WEIGHTS & MEASURES T&E
BALANCE, BOB...................MINING T&E
BALANCE, DEMONSTRATION.........WEIGHTS & MEASURES T&E
BALANCE, GRAM-CHAIN............WEIGHTS & MEASURES T&E
BALANCE, ROBERVAL..............WEIGHTS & MEASURES T&E
BALANCE, SPECIFIC-GRAVITY......WEIGHTS & MEASURES T&E
BALANCE, TORSION...............WEIGHTS & MEASURES T&E
BALANCE, WATER.................MINING T&E
BALANCE BEAM...................SPORTS EQUIPMENT
 rt WALKING BOARD
BALANCE SCOOP..................WEIGHTS & MEASURES T&E
BALANCE WEIGHT.................WEIGHTS & MEASURES T&E
BALANCING POLE.................PUBLIC ENTERTAINMENT DEVICE
BALCONY........................BUILDING FRAGMENT
BALDACHIN......................CEREMONIAL ARTIFACT
BALDRIC........................ARMAMENT ACCESSORY
BALER, COTTON..................AGRICULTURAL T&E
BALER, HAY.....................AGRICULTURAL T&E
BALER, PICKUP HAY..............AGRICULTURAL T&E
Ball...........................SPORTS EQUIPMENT
 use more specific term: e.g., TENNIS BALL,
 BOWLING BALL
BALL...........................TOY
Ball, Headache.................CONSTRUCTION T&E
 use BALL, WRECKING
Ball, Minie....................ARMAMENT T&E, AMMUNITION
 use BULLET, MINIE
BALL, MUSKET...................ARMAMENT T&E, AMMUNITION
BALL, WRECKING.................CONSTRUCTION T&E
BALL-and-CHAIN.................BEHAVIORAL CONTROL DEVICE
BALLER.........................TEXTILEWORKING T&E
BALLISTA.......................ARMAMENT T&E, ARTILLERY
BALLOON........................AEROSPACE TRANSPORTATION EQUIPMENT
 note may be further subdivided to indicate major
 type: e.g., BALLOON, BARRAGE; -,CAPTIVE;
 -,FREE
BALLOON, WEATHER...............METEOROLOGICAL T&E
BALLOT.........................DOCUMENTARY ARTIFACT
BALUSTER.......................BUILDING FRAGMENT

BALUSTRADE SECTION..............BUILDING FRAGMENT
 rt HANDRAIL SECTION
BAND, DENTAL....................MEDICAL & PSYCHOLOGICAL T&E
BANDAGE.........................MEDICAL & PSYCHOLOGICAL T&E
Bandana.........................CLOTHING, HEADWEAR
 use KERCHIEF
BANDBOX.........................PERSONAL GEAR
BANDERILLA......................SPORTS EQUIPMENT
BANDING MACHINE.................PRINTING T&E
BANDOLIER.......................CLOTHING ACCESSORY
BANDOLIER.......................PERSONAL SYMBOL
BANDOLIER.......................ARMAMENT ACCESSORY
BAND SET........................ARMAMENT ACCESSORY
BAND SHELL......................BUILDING
Bandwagon, Circus...............LTE, ANIMAL-POWERED
 use WAGON, CIRCUS PARADE
Bangle..........................ADORNMENT
 use BRACELET
Banister........................BUILDING FRAGMENT
 use BALUSTRADE SECTION or BALUSTER
BANJO...........................MUSICAL T&E, STRINGED
BANK, MECHANICAL................TOY
BANK, SEMI-MECHANICAL...........TOY
BANK, STILL.....................TOY
BANKBOOK........................DOCUMENTARY ARTIFACT
BANK STATEMENT..................DOCUMENTARY ARTIFACT
BANNER..........................ADVERTISING MEDIUM
BANNER..........................CEREMONIAL ARTIFACT
BAR.............................BUILDING FRAGMENT
BAR.............................MINING T&E
BAR, BORING.....................MINING T&E
BAR, CLAYING....................MINING T&E
BAR, MINER'S....................MINING T&E
Bar, Pry........................WOODWORKING T&E
 use CROWBAR
BAR, QUARRY.....................MINING T&E
BAR, RIGGING....................MINING T&E
BAR, STRETCHER..................MINING T&E
BAR, TAMPING....................MINING T&E
BAR, TOMMY......................FORESTRY T&E
BAR, WAGON-PINCH................MINING T&E
Bar, Wrecking...................WOODWORKING T&E
 use CROWBAR
BARBELL.........................SPORTS EQUIPMENT
BARBETTE........................CLOTHING, HEADWEAR
BARBWIRE SECTION................SITE FEATURE
 rt FENCE SECTION
BARDICHE........................ARMAMENT T&E, EDGED
BARGE...........................WATER TRANSPORTATION EQUIPMENT
BARGE, TRAINING.................WATER TRANSPORTATION EQUIPMENT
BARGEBOARD SECTION..............BUILDING FRAGMENT

```
BARN......................BUILDING
     note may be further subdivided to indicate
          specific type: e.g., BARN, TOBACCO;
          -,HOPCURING
BARN......................MINING T&E
BAROGRAPH................METEOROLOGICAL T&E
BAROMETER................METEOROLOGICAL T&E
     note may be further subdivided to indicate
          specific type: e.g., BAROMETER, ANEROID;
          -,MERCURY
BAROMETER TUBE, SIPHON.........CHEMICAL T&E
BAROMETER TUBE, STRAIGHT.......CHEMICAL T&E
BAROSTAT..................METEOROLOGICAL T&E
BAROUCHE..................LTE, ANIMAL-POWERED
     rt   CALECHE
BAR RAIL..................BUILDING FRAGMENT
BARREL....................PRODUCT PACKAGE
BARREL, AMALGAMATING.........METALWORKING T&E
BARREL TOPPER.............WOODWORKING T&E
Barrette..................ADORNMENT
     use ORNAMENT, HAIR
BARROW....................LTE, HUMAN-POWERED
BARROW, APPLE.............AGRICULTURAL T&E
BARS, PARALLEL............SPORTS EQUIPMENT
BARSTOOL..................FURNITURE
BARYTON...................MUSICAL T&E, STRINGED
     rt   VIOL, BASS
BASCINETE.................ARMAMENT T&E, BODY ARMOR
BASEBALL..................SPORTS EQUIPMENT
BASEBALL BAT..............SPORTS EQUIPMENT
BASEBOARD SECTION.........BUILDING FRAGMENT
BASELARD..................ARMAMENT T&E, EDGED
BASIN.....................HOUSEHOLD ACCESSORY
BASIN, FLUSHING...........CHEMICAL T&E
BASIN, RINSING............CHEMICAL T&E
Basket, Berry.............AGRICULTURAL T&E
     use  BASKET, GATHERING
BASKET, BURDEN............PERSONAL GEAR
BASKET, CAKE..............FOOD SERVICE T&E
Basket, Cheese............FOOD PROCESSING T&E
     use  STRAINER, WHEY
BASKET, COOKING...........FOOD PROCESSING T&E
BASKET, COTTON............AGRICULTURAL T&E
BASKET, DANCE.............CEREMONIAL ARTIFACT
BASKET, DOUGH-RISING......FOOD PROCESSING T&E
Basket, Egg-gathering.....AGRICULTURAL T&E
     use  BASKET, GATHERING
Basket, Fire..............LIGHTING DEVICE
     use  CRESSET
Basket, Fruit-picking.....AGRICULTURAL T&E
     use  BASKET, GATHERING
BASKET, GATHERING.........AGRICULTURAL T&E
```

297

```
BASKET, LAUNDRY.................HOUSEKEEPING T&E
BASKET, MORTAR..................FOOD PROCESSING T&E
BASKET, ORE.....................MINING T&E
BASKET, PACK....................PERSONAL GEAR
BASKET, PICNIC..................FOOD SERVICE T&E
BASKET, RING....................FOOD PROCESSING T&E
BASKET, SEWING..................TEXTILEWORKING T&E
BASKET, STORAGE.................FOOD PROCESSING T&E
BASKET, TRINKET.................PERSONAL GEAR
BASKET, WEDDING.................CEREMONIAL ARTIFACT
BASKET, WINNOWING...............AGRICULTURAL T&E
BASKETBALL......................SPORTS EQUIPMENT
BASKETBALL BACKBOARD............SPORTS EQUIPMENT
BASKETBALL HOOP.................SPORTS EQUIPMENT
BASKETRY FRAGMENT...............ARTIFACT REMNANT
Basket stand....................FURNITURE
     use  TABLE, KNITTING
BASS, DOUBLE....................MUSICAL T&E, STRINGED
BASSINET........................FURNITURE
BASSOON.........................MUSICAL T&E, WOODWIND
BASSOON, DOUBLE.................MUSICAL T&E, WOODWIND
BASSOON, RUSSIAN................MUSICAL T&E, BRASS
BASTILLE........................ARMAMENT ACCESSORY
BATCHER/JOGGER MACHINE..........PRINTING T&E
BATCH PLANT.....................CONSTRUCTION T&E
BATEAU..........................WATER TRANSPORTATION EQUIPMENT
     note use only for a flat-bottomed vessel with
          fore-&-aft bottom planks
     rt   DORY, BANKS
Bateau, V-bottomed..............WATER TRANSPORTATION EQUIPMENT
     use  SKIPJACK
BATH, DEHYDRATING...............BIOLOGICAL T&E
BATH, EMBEDDING.................BIOLOGICAL T&E
Bath, Hip.......................PLUMBING FIXTURE
     use  BATH, SITZ
BATH, SITZ......................PLUMBING FIXTURE
BATH, WATER.....................CHEMICAL T&E
BATHOMETER......................SURVEYING & NAVIGATIONAL T&E
BATHROBE........................CLOTHING, OUTERWEAR
BATHTUB.........................PLUMBING FIXTURE
BATHYSCAPH......................WATER TRANSPORTATION EQUIPMENT
BATHYSPHERE.....................WATER TRANSPORTATION ACCESSORY
BATON...........................MUSICAL T&E, UNCLASSIFIED
BATOREOMETER....................MECHANICAL T&E
BATTEN..........................TEXTILEWORKING T&E
BATTERY, DRY-CELL...............ELECTRICAL & MAGNETIC T&E
BATTERY, GRAVITY................MECHANICAL T&E
BATTERY, SOLAR..................POWER PRODUCTION T&E
BATTLE-AX.......................ARMAMENT T&E, EDGED
BATTLEDORE......................GLASS & PLASTICS T&E
Battledore......................SPORTS EQUIPMENT
     use  BADMINTON RACKET
```

BATTLESHIP........................WATER TRANSPORTATION EQUIPMENT
BATT-MAKING MACHINE..............TEXTILEWORKING T&E
BAYONET, KNIFE...................ARMAMENT T&E, EDGED
BAYONET, PLUG....................ARMAMENT T&E, EDGED
BAYONET, SOCKET..................ARMAMENT T&E, EDGED
BAYONET, SWORD...................ARMAMENT T&E, EDGED
BAYONET, TRIANGULAR..............ARMAMENT T&E, EDGED
BAZOOKA..........................ARMAMENT T&E, ARTILLERY
BAZOOKA PANTS....................ARMAMENT ACCESSORY
Bb...............................ARMAMENT T&E, AMMUNITION
 use CAP, BB
BEACON, LIGHTHOUSE...............LIGHTING DEVICE
BEAD.............................ADORNMENT
BEADING MACHINE..................METALWORKING T&E
BEADS, ROSARY....................PERSONAL SYMBOL
BEADS, STRINGING.................TOY
BEAKER...........................CHEMICAL T&E
 note may be further subdivided to indicate
 specific type: e.g., BEAKER, GRIFFEN;
 -,BERZELIUS; -,PHILLIPS
BEAKIRON.........................METALWORKING T&E
 rt SWAGE, ANVIL
BEAM, CURRIER'S..................LEATHERWORKING T&E
BEAM, TANNER'S...................LEATHERWORKING T&E
BEAMER...........................TEXTILEWORKING T&E
BEAMING MACHINE..................LEATHERWORKING T&E
BEAM-TRANSPORT SYSTEM............NUCLEAR PHYSICS T&E
 note use for a system of magnets and/or
 electrostatic devices used to move particles
 from one point to another
BEANBAG..........................TOY
BEANIE...........................CLOTHING, HEADWEAR
 rt SKULLCAP
BEARDER, BARLEY..................AGRICULTURAL T&E
BEATER, BASKETMAKER'S............TEXTILEWORKING T&E
BEATER, HOLLANDER................PAPERMAKING T&E
BEATER, JORDAN...................PAPERMAKING T&E
BEATER, RUG......................HOUSEKEEPING T&E
BEATER, SEED.....................FOOD PROCESSING T&E
BEATING MACHINE..................LEATHERWORKING T&E
BED..............................FURNITURE
BED, BUNK........................FURNITURE
BED, CANOPY......................FURNITURE
BED, FIELD.......................FURNITURE
BED, FOLDING.....................FURNITURE
BED, FOUR-POSTER.................FURNITURE
BED, HALF-TESTER.................FURNITURE
Bed, Murphy......................FURNITURE
 use BED, FOLDING
Bed, Plantation..................FURNITURE
 use BED, CANOPY
BED, SLEIGH......................FURNITURE

BED, SOFA.........................FURNITURE
 note use for a sofa, lounge or similar item which
 folds out to become a bed
BED, TRUNDLE.....................FURNITURE
BED, WATER.......................FURNITURE
BEDDING MACHINE..................WOODWORKING T&E
BEDPAN...........................HOUSEHOLD ACCESSORY
BEDROOM SUITE....................FURNITURE
BEDSPREAD........................BEDDING
BEDSPRINGS.......................FURNITURE
BEEHIVE..........................ANIMAL HUSBANDRY T&E
BEEHIVE TOOL.....................FOOD PROCESSING T&E
BEE SMOKER.......................ANIMAL HUSBANDRY T&E
BEETLE...........................TEXTILEWORKING T&E
BEETLE...........................WOODWORKING T&E
 note use for a two-handed striking tool fitted
 with a wooden head
 rt MALLET; MAUL, POST
Belfry...........................BUILDING FRAGMENT
 use TOWER, BELL
BELL.............................MUSICAL T&E, PERCUSSION
BELL.............................SOUND COMMUNICATION EQUIPMENT
 note may be further subdivided to indicate
 specific type: e.g., BELL, CHURCH; -,SCHOOL
BELL, SERVICE....................FOOD SERVICE T&E
BELL, SHIP'S.....................WATER TRANSPORTATION ACCESSORY
Bell, wind.......................COMMERCIAL DECORATIVE ART
 use WIND-BELL
Bell jack........................FOOD PROCESSING T&E
 use BOTTLE JACK
BELLOWS..........................TEMPERATURE CONTROL DEVICE
BELLOWS, BLACKSMITH'S............METALWORKING T&E
 rt BLOWER, BLACKSMITH'S
BELLOWS, COOPER'S................WOODWORKING T&E
BELLPULL.........................HOUSEHOLD ACCESSORY
BELT.............................CLOTHING ACCESSORY
BELT, AMMUNITION.................ARMAMENT ACCESSORY
BELT, CARTRIDGE..................ARMAMENT ACCESSORY
BELT, CARTRIDGE-BOX..............ARMAMENT ACCESSORY
BELT, CHASTITY...................BEHAVIORAL CONTROL DEVICE
BELT, GARTER.....................CLOTHING, UNDERWEAR
BELT, LINK.......................ARMAMENT ACCESSORY
BELT, MONEY......................PERSONAL GEAR
BELT, ROCKET.....................AEROSPACE TRANSPORTATION EQUIPMENT
BELT, SAM BROWNE.................CLOTHING ACCESSORY
BELT, SWORD......................ARMAMENT ACCESSORY
Belvedere........................BUILDING
 use GAZEBO
BENCH............................FURNITURE
BENCH, BUCKET....................FURNITURE
BENCH, CARPENTER'S...............WOODWORKING T&E
BENCH, CIRCULAR..................FURNITURE

```
BENCH, COBBLER'S................LEATHERWORKING T&E
BENCH, GAFFER'S.................GLASS & PLASTICS T&E
BENCH, GARDEN...................FURNITURE
BENCH, HARNESS MAKER'S.........LEATHERWORKING T&E
Bench, Hooded..................FURNITURE
     use  SETTLE
BENCH, HORNWORKER'S............UNCLASSIFIED T&E, SPECIAL
Bench, Mammy...................FURNITURE
     use  CRADLE/ROCKER
BENCH, PARK....................FURNITURE
BENCH, PICNIC..................FURNITURE
BENCH, RIGGER'S................TEXTILEWORKING T&E
BENCH, SAILMAKER'S.............TEXTILEWORKING T&E
Bench, Saw-sharpening..........WOODWORKING T&E
     use  HORSE, SAW-SHARPENING
BENCH, WHEELWRIGHT'S...........WOODWORKING T&E
BENCH, WINDOW..................FURNITURE
BENCH-HOOK, RIGGER'S...........TEXTILEWORKING T&E
Bench mark.....................SURVEYING & NAVIGATIONAL T&E
     use  more specific term: e.g., CAIRN; STAKE;
          MARKER, CONCRETE
BENCH PLATE....................METALWORKING T&E
BENCH STOP.....................WOODWORKING T&E
BENDER, TIRE...................METALWORKING T&E
BERET..........................CLOTHING, HEADWEAR
     rt   TAM-O-SHANTER
BESIDOMETER....................MEDICAL & PSYCHOLOGICAL T&E
BETATRON.......................NUCLEAR PHYSICS T&E
BEVEL BLOCK....................WOODWORKING T&E
BEVELER, EDGE..................LEATHERWORKING T&E
BEVELER, SAFETY................LEATHERWORKING T&E
BEVERAGE SET...................FOOD SERVICE T&E
BIB............................CLOTHING ACCESSORY
Bickern........................METALWORKING T&E
     use  BEAKIRON
Bick iron......................METALWORKING T&E
     use  BEAKIRON
BICYCLE........................LTE, HUMAN-POWERED
     note use only if specific type is unknown: e.g.,
          VELOCIPEDE; BICYCLE, ORDINARY; -,SAFETY
BICYCLE, GASOLINE..............LTE, MOTORIZED
BICYCLE, ORDINARY..............LTE, HUMAN-POWERED
BICYCLE, SAFETY................LTE, HUMAN-POWERED
Bicycle, Side-by-side..........LTE, HUMAN-POWERED
     use  SOCIABLE
BICYCLE, STEAM.................LTE, MOTORIZED
BICYCLE, TANDEM................LTE, HUMAN-POWERED
BICYCLE BAG....................LAND TRANSPORTATION ACCESSORY
BICYCLE BELL...................LAND TRANSPORTATION ACCESSORY
BICYCLE LAMP...................LAND TRANSPORTATION ACCESSORY
BIDET..........................PLUMBING FIXTURE
BIGGIN.........................CLOTHING, HEADWEAR
```

Bilboquet.......................TOY
 use CUP AND BALL
BILL............................ARMAMENT T&E, EDGED
BILLBOARD.......................UNCLASSIFIED STRUCTURE
BILLET..........................MASONRY T&E
BILLETHEAD......................WATER TRANSPORTATION ACCESSORY
BILLHOOK........................AGRICULTURAL T&E
 rt HOOK, PRUNING
Bill hook.......................ARMAMENT T&E, EDGED
 use BILL
BILLIARD BALL...................SPORTS EQUIPMENT
BILLIARD BRIDGE.................SPORTS EQUIPMENT
BILLIARD CUE....................SPORTS EQUIPMENT
BILLIARD CUE RACK...............SPORTS EQUIPMENT
BILLIARD TABLE..................SPORTS EQUIPMENT
BILL-OF-SALE....................DOCUMENTARY ARTIFACT
BIN, ORE........................MINING T&E
BIN, STORAGE....................MERCHANDISING T&E
BINDER, CORN....................AGRICULTURAL T&E
BINDER, GRAIN...................AGRICULTURAL T&E
BINDER, OBSTETRICAL.............CLOTHING, UNDERWEAR
BINDER, RING....................WRITTEN COMMUNICATION EQUIPMENT
Binder, Row.....................AGRICULTURAL T&E
 use BINDER, CORN
Binder, Twine...................AGRICULTURAL T&E
 use BINDER, GRAIN
Binder, Wire....................AGRICULTURAL T&E
 use BINDER, GRAIN
BINDING BOARD...................PRINTING T&E
BINDING MACHINE.................PRINTING T&E
BINGO SET.......................GAME
 rt LOTTO SET
BINNACLE........................WATER TRANSPORTATION ACCESSORY
BINOCULARS......................OPTICAL T&E
BIOMETER........................MEDICAL & PSYCHOLOGICAL T&E
BIOSATELLITE....................AEROSPACE TRANSPORTATION EQUIPMENT
 rt SATELLITE
BIOSCOPE........................MEDICAL & PSYCHOLOGICAL T&E
BIPOD...........................ARMAMENT ACCESSORY
BIRDBATH........................SITE FEATURE
BIRDCAGE........................HOUSEHOLD ACCESSORY
BIRD FEEDER.....................SITE FEATURE
BIRDHOUSE.......................SITE FEATURE
BIRETTA.........................CLOTHING, HEADWEAR
BIT.............................METALWORKING T&E
 note use for a boring implement designed to be
 inserted in a DRILL; use only if specific
 type is unknown
BIT.............................MINING T&E
 note may be further subdivided to indicate
 specific type: e.g., BIT, CORE; -,DIAMOND;
 -,TUNGSTEN CARBIDE

```
BIT..............................WOODWORKING T&E
     note use for a boring implement designed to be
          inserted in a BRACE or DRILL; use only if
          specific type is unknown: e.g., BIT,
          ANNULAR; -,TWIST
     rt   AUGER; REAMER
BIT..............................LAND TRANSPORTATION ACCESSORY
BIT, ANNULAR.....................WOODWORKING T&E
     rt   SAW, CROWN
BIT, CENTER......................WOODWORKING T&E
BIT, COUNTERSINK.................WOODWORKING T&E
BIT, FLAT........................METALWORKING T&E
BIT, GIMLET......................WOODWORKING T&E
BIT, NOSE........................WOODWORKING T&E
BIT, SHELL.......................WOODWORKING T&E
BIT, STRAIGHT-FLUTED.............METALWORKING T&E
BIT, TUNGSTEN-CARBIDE............MASONRY T&E
BIT, TWIST.......................METALWORKING T&E
BIT, TWIST.......................WOODWORKING T&E
BITCHES, JOBBER'S SONS...........FORESTRY T&E
Bitstock.........................WOODWORKING T&E
     use  BRACE
BITT, MOORING....................WATER TRANSPORTATION ACCESSORY
Blackboard.......................WRITTEN COMMUNICATION EQUIPMENT
     use  CHALKBOARD
BLACKJACK........................ARMAMENT T&E, BLUDGEON
BLACKSMITH'S STAND...............METALWORKING T&E
Blade............................CONSTRUCTION T&E
     use  GRADER
BLANCHIMETER.....................CHEMICAL T&E
BLANKET..........................BEDDING
BLANKET, HORSE...................ANIMAL HUSBANDRY T&E
BLANKET, OFFSET..................PRINTING T&E
BLANKET, SHOULDER................PERSONAL SYMBOL
Blaster..........................MINING T&E
     use  DETONATOR
Bleacher.........................UNCLASSIFIED STRUCTURE
     use  GRANDSTAND
BLEACHING CELL...................PAPERMAKING T&E
BLEACHING MACHINE................TEXTILEWORKING T&E
BLENDER..........................FOOD PROCESSING T&E
BLENDER, FEEDER..................TEXTILEWORKING T&E
BLENDER, FLOUR...................FOOD PROCESSING T&E
BLENDER, PASTRY..................FOOD PROCESSING T&E
BLENDER, SANDWICH................TEXTILEWORKING T&E
BLENDER, STOCK...................PAPERMAKING T&E
Blimp............................AEROSPACE TRANSPORTATION EQUIPMENT
     use  AIRSHIP
BLIND, VENETIAN..................WINDOW OR DOOR COVERING
BLINDER..........................LAND TRANSPORTATION ACCESSORY
BLOCK............................WATER TRANSPORTATION ACCESSORY
     note may be further subdivided to indicate
          specific type: e.g., BLOCK, DOUBLE; -,SNATCH
```

```
BLOCK.........................TOY
BLOCK, PARQUETRY..............TOY
BLOCK, TELESCOPIC.............TOY
BLOCK CARRIAGE................GLASS & PLASTICS T&E
BLOCKHOUSE....................BUILDING
BLOCKING DUMMY................SPORTS EQUIPMENT
BLOCK ISLAND COWHORN..........WATER TRANSPORTATION EQUIPMENT
BLOOMERS......................CLOTHING, UNDERWEAR
BLOTTER.......................WRITTEN COMMUNICATION EQUIPMENT
BLOTTER ROLL..................PHOTOGRAPHIC T&E
BLOUSE........................CLOTHING, OUTERWEAR
BLOWER, BLACKSMITH'S..........METALWORKING T&E
     rt    BELLOWS, BLACKSMITH'S
BLOWER, ENSILAGE..............AGRICULTURAL T&E
Blower, Forage................AGRICULTURAL T&E
     use   BLOWER, ENSILAGE
Blower, Impeller..............AGRICULTURAL T&E
     use   BLOWER, ENSILAGE
Blower, Silage................AGRICULTURAL T&E
     use   BLOWER, ENSILAGE
Blower, Silo..................AGRICULTURAL T&E
     use   BLOWER, ENSILAGE
BLOWGUN.......................ARMAMENT T&E, EDGED
BLOWING ENGINE................METALWORKING T&E
BLOWING MACHINE...............MINING T&E
BLOWIRON......................GLASS & PLASTICS T&E
BLOWIRON RACK.................GLASS & PLASTICS T&E
BLOWPIPE......................BIOLOGICAL T&E
Blowpipe......................GLASS & PLASTICS T&E
     use   BLOWIRON
Blowtorch.....................METALWORKING T&E
     use   TORCH, GASOLINE; -,PROPANE; -,KEROSINE
BLUEPRINT.....................DOCUMENTARY ARTIFACT
BLUNDERBUSS...................ARMAMENT T&E, FIREARM
BLUNGER.......................GLASS & PLASTICS T&E
BOA...........................CLOTHING ACCESSORY
BOARD.........................BUILDING FRAGMENT
Board.........................GAME
     use   either as a secondary word following the
           name of a specific game (e.g., CRIBBAGE
           BOARD, PARCHESI BOARD) or for a
           multiple-game board use GAME BOARD
BOARD, GANGWAY................WATER TRANSPORTATION ACCESSORY
BOARD, NAME...................WATER TRANSPORTATION ACCESSORY
BOARD, QUARTER................WATER TRANSPORTATION ACCESSORY
BOARD, TRAIL..................WATER TRANSPORTATION ACCESSORY
Boat..........................WATER TRANSPORTATION EQUIPMENT
     use   only as a secondary term: e.g., CANAL BOAT,
           BULL BOAT, SEINE BOAT
Boat, Stone...................AGRICULTURAL T&E
     use   STONEBOAT
BOATER........................CLOTHING, HEADWEAR
```

BOBBIN.........................TEXTILEWORKING T&E
BOBSLED........................SPORTS EQUIPMENT
BODKIN.........................ADORNMENT
 rt ORNAMENT, HAIR
BODKIN.........................PRINTING T&E
BODKIN.........................TEXTILEWORKING T&E
 rt FID
BODY PROTECTOR.................SPORTS EQUIPMENT
BODYSTOCKING...................CLOTHING, UNDERWEAR
BOGIE..........................MINING T&E
BOILER.........................MINING T&E
 note may be further subdivided to indicate
 specific type: e.g., BOILER, CORNISH;
 -,HAYCOCK
BOILER, DOUBLE.................FOOD PROCESSING T&E
BOILER, FEED...................AGRICULTURAL T&E
BOILER, STEAM..................POWER PRODUCTION T&E
BOLA...........................ARMAMENT T&E, BLUDGEON
BOLERO.........................CLOTHING, OUTERWEAR
BOLLARD........................WATER TRANSPORTATION ACCESSORY
BOLO...........................ARMAMENT T&E, EDGED
BOLOMETER......................THERMAL T&E
BOLT...........................METALWORKING T&E
BOLT...........................WOODWORKING T&E
BOLT, CLOTH....................TEXTILEWORKING T&E
 rt TEXTILE FRAGMENT; SALES SAMPLE, CLOTH
BOLT, LEWIS....................MINING T&E
BOLT, RAG......................MINING T&E
BOLT, ROOF.....................MINING T&E
BOLT-CLIPPER MACHINE...........METALWORKING T&E
Bolt cutter....................METALWORKING T&E
 use CUTTER, BOLT
Bolter, Cloth..................FOOD PROCESSING T&E
 use BOLTER, SIEVE
BOLTER, SIEVE..................FOOD PROCESSING T&E
Bolt-header machine............METALWORKING T&E
 use HEADING MACHINE, BOLT
Bolt-heading tool..............METALWORKING T&E
 use HEADING TOOL, BOLT
BOMB, AIR-TO-AIR...............ARMAMENT T&E, AMMUNITION
BOMB, AIR-TO-SURFACE...........ARMAMENT T&E, AMMUNITION
BOMB, AIR-TO-UNDERWATER........ARMAMENT T&E, AMMUNITION
Bomb, Antiaircraft.............ARMAMENT T&E, AMMUNITION
 use BOMB, AIR-TO-AIR
BOMBACHAS......................CLOTHING, OUTERWEAR
Bombardon......................MUSICAL T&E, BRASS
 use TUBA
BOMB SHACKLE...................AEROSPACE TRANSPORTATION ACCESSORY
BOMB SHELTER...................SITE FEATURE
BOND...........................DOCUMENTARY ARTIFACT
BONDING MACHINE, FOAM-FLAME....TEXTILEWORKING T&E
BONDING MACHINE, WET-ADHESIVE..TEXTILEWORKING T&E

```
BONE, WORKED....................ARTIFACT REMNANT
BONE FOLDER.....................PRINTING T&E
BONE FRAGMENT...................ARTIFACT REMNANT
Boneshaker......................LTE, HUMAN-POWERED
    use  VELOCIPEDE
BONING ROD......................SURVEYING & NAVIGATIONAL T&E
BONNET..........................CLOTHING, HEADWEAR
Booby...........................LTE, ANIMAL-POWERED
    use  SLEIGH
BOOK............................DOCUMENTARY ARTIFACT
BOOK, ACCOUNT...................DOCUMENTARY ARTIFACT
BOOK, ADDRESS...................DOCUMENTARY ARTIFACT
BOOKCASE........................FURNITURE
BOOKEND.........................HOUSEHOLD ACCESSORY
BOOKKEEPING MACHINE.............DATA PROCESSING T&E
BOOKKEEPING MACHINE, MAGNETIC-CARD
    ...........................DATA PROCESSING T&E
BOOKLET.........................DOCUMENTARY ARTIFACT
BOOKMARK........................WRITTEN COMMUNICATION EQUIPMENT
BOOKPLATE.......................DOCUMENTARY ARTIFACT
Boom............................PUBLIC ENTERTAINMENT DEVICE
    use  BOOMERANG
BOOMERANG.......................ARMAMENT T&E, BLUDGEON
BOOMERANG.......................PUBLIC ENTERTAINMENT DEVICE
BOOT............................CLOTHING, FOOTWEAR
    note may be further subdivided to indicate
          specific type: e.g., BOOT, COWBOY; -,RIDING;
          -,HIP; -,SKI
BOOT, LAWN......................ANIMAL HUSBANDRY T&E
BOOTH, TELEPHONE................UNCLASSIFIED STRUCTURE
BOOTJACK........................HOUSEHOLD ACCESSORY
Borderlight.....................LIGHTING DEVICE
    use  STRIPLIGHT
BORER, CORK.....................UNCLASSIFIED T&E, SPECIAL
BORING MACHINE..................METALWORKING T&E
BORING MACHINE..................WOODWORKING T&E
BORING MACHINE, NAVE............WOODWORKING T&E
BORING TOOL.....................METALWORKING T&E
BOSS............................GLASS & PLASTICS T&E
Bottle
    note if the name of the object is not found under
          the word BOTTLE, look under a probable name
          using BOTTLE as a secondary word
BOTTLE..........................CHEMICAL T&E
    note may be further subdivided to indicate
          specific type: e.g., BOTTLE, ASPIRATOR;
          -,CENTRIFUGE; -,REAGENT; -,GAS-WASHING
BOTTLE..........................PRODUCT PACKAGE
    rt   DEMIJOHN
BOTTLE, APOTHECARY..............MERCHANDISING T&E
Bottle, Barber's................TOILET ARTICLE
    use  BOTTLE, TOILET
```

Bottle, Cologne.................TOILET ARTICLE
 use BOTTLE, TOILET
BOTTLE, CONDIMENT..............FOOD SERVICE T&E
BOTTLE, HOT-WATER..............HOUSEHOLD ACCESSORY
BOTTLE, NURSING................FOOD SERVICE T&E
Bottle, Perfume................TOILET ARTICLE
 use BOTTLE, TOILET
BOTTLE, PILGRIM................PERSONAL GEAR
BOTTLE, SERUM..................MEDICAL & PSYCHOLOGICAL T&E
BOTTLE, SMELLING...............PERSONAL GEAR
BOTTLE, SNUFF..................PERSONAL GEAR
BOTTLE, SPECIMEN...............MEDICAL & PSYCHOLOGICAL T&E
Bottle, Thermos................FOOD SERVICE T&E
 use BOTTLE, VACUUM
BOTTLE, TOILET.................TOILET ARTICLE
BOTTLE, VACUUM.................FOOD SERVICE T&E
BOTTLEBRUSH....................HOUSEKEEPING T&E
BOTTLE JACK....................FOOD PROCESSING T&E
BOTTLING MACHINE...............FOOD PROCESSING T&E
 rt CAPPER, BOTTLE
Boutonniere....................ADORNMENT
 use PIN, LAPEL
BOW............................ARMAMENT T&E, EDGED
BOW, FIRE......................HOUSEHOLD ACCESSORY
Bow, Horse.....................LAND TRANSPORTATION ACCESSORY
 use YOKE, ANIMAL
BOWL...........................FOOD PROCESSING T&E
BOWL...........................FOOD SERVICE T&E
BOWL...........................UNCLASSIFIED CONTAINER
 note use for a rounded vessel which is open to
 view of the inside by reason of having an
 orifice diameter that is usually the maximum
 body diameter; normally subdivided to
 indicate ceramic or basketry construction;
 see also JAR and TRAY
BOWL, BRIDE'S..................FOOD SERVICE T&E
BOWL, BULB.....................HOUSEHOLD ACCESSORY
BOWL, BUTTER-WORKING...........FOOD PROCESSING T&E
BOWL, CEREAL...................FOOD SERVICE T&E
BOWL, CHOPPING.................FOOD PROCESSING T&E
BOWL, FINGER...................FOOD SERVICE T&E
BOWL, FLOWER...................HOUSEHOLD ACCESSORY
BOWL, FRUIT....................FOOD SERVICE T&E
BOWL, LIBATION.................CEREMONIAL ARTIFACT
 rt PHIALE
BOWL, MARRIAGE.................CEREMONIAL ARTIFACT
BOWL, MIXING...................FOOD PROCESSING T&E
BOWL, PUNCH....................FOOD SERVICE T&E
BOWL, SALAD....................FOOD SERVICE T&E
BOWL, SCOURING.................TEXTILEWORKING T&E
BOWL, SOUP.....................FOOD SERVICE T&E
BOWL, SUGAR....................FOOD SERVICE T&E

```
Bowler..........................CLOTHING, HEADWEAR
     use DERBY
BOWLING BALL....................SPORTS EQUIPMENT
BOWLING PIN.....................SPORTS EQUIPMENT
Box
     note if the name of the object is not found under
          the word BOX, look under a probable name
          using BOX as a secondary word
BOX.............................PRODUCT PACKAGE
BOX.............................UNCLASSIFIED CONTAINER
     note use for a flat-bottomed, more-or-less
          rectangular container; normally constructed
          of wood
BOX, AMMUNITION.................ARMAMENT ACCESSORY
BOX, BALLOT.....................GOVERNMENTAL ARTIFACT
Box, Band.......................PERSONAL GEAR
     use BANDBOX
BOX, BEE........................ANIMAL HUSBANDRY T&E
BOX, BIBLE......................HOUSEHOLD ACCESSORY
BOX, BLACKSMITH'S TOOL..........METALWORKING T&E
BOX, BOOTBLACKING...............CLOTHING ACCESSORY
     rt SHOESHINE KIT
BOX, BREAD......................FOOD PROCESSING T&E
BOX, CARPENTER'S TOOL...........WOODWORKING T&E
BOX, CARTRIDGE..................ARMAMENT ACCESSORY
BOX, CHEESE.....................FOOD PROCESSING T&E
BOX, CHEST......................GLASS & PLASTICS T&E
BOX, CIGARETTE..................HOUSEHOLD ACCESSORY
BOX, CONTROL....................ELECTRICAL & MAGNETIC T&E
Box, Dealing....................GAME
     use SHOE
BOX, DEED.......................HOUSEHOLD ACCESSORY
BOX, FILE.......................WRITTEN COMMUNICATION EQUIPMENT
BOX, FIRE-ALARM.................TELECOMMUNICATION EQUIPMENT
BOX, JEWELRY....................HOUSEHOLD ACCESSORY
BOX, KNIFE......................FOOD SERVICE T&E
Box, Lunch......................FOOD SERVICE T&E
     use PAIL, DINNER
Box, Miter......................WOODWORKING T&E
     use MITER BOX
BOX, MONEY......................MERCHANDISING T&E
BOX, PATCH......................ARMAMENT ACCESSORY
Box, Pill.......................PERSONAL GEAR
     use PILLBOX
BOX, PIN........................TEXTILEWORKING T&E
BOX, POUNCE.....................WRITTEN COMMUNICATION EQUIPMENT
Box, Powder.....................TOILET ARTICLE
     use BOX, PUFF
BOX, PUFF.......................TOILET ARTICLE
BOX, SALT.......................FOOD PROCESSING T&E
BOX, SEWING.....................TEXTILEWORKING T&E
BOX, SHIPWRIGHT'S CAULKING......WOODWORKING T&E
```

```
BOX, SHIPWRIGHT'S OIL...........WOODWORKING T&E
Box, Snuff......................PERSONAL GEAR
     use  SNUFFBOX
BOX, STAMP......................WRITTEN COMMUNICATION EQUIPMENT
Box, Strong.....................HOUSEHOLD ACCESSORY
     use  STRONGBOX
BOX, TOBACCO....................PERSONAL GEAR
BOX, TOOL.......................UNCLASSIFIED T&E, GENERAL
BOX, TRINKET....................HOUSEHOLD ACCESSORY
Box, Writing....................WRITTEN COMMUNICATION EQUIPMENT
     use  DESK, PORTABLE
BOXCAR..........................RAIL TRANSPORTATION EQUIPMENT
BOXING GLOVE....................SPORTS EQUIPMENT
Box springs.....................FURNITURE
     use  BEDSPRINGS
BRACE...........................PERSONAL GEAR
BRACE...........................WOODWORKING T&E
     rt   DRILL
BRACELET........................ADORNMENT
BRACKET.........................BUILDING FRAGMENT
BRAD............................WOODWORKING T&E
BRADAWL.........................WOODWORKING T&E
BRADING MACHINE.................METALWORKING T&E
BRAID, MILITARY.................PERSONAL SYMBOL
BRAIDER.........................TEXTILEWORKING T&E
BRAKE...........................METALWORKING T&E
     rt   FOLDING MACHINE
Brake...........................LTE, ANIMAL-POWERED
     use  BREAK, SKELETON or BREAK, WAGONETTE
BRAKE, BAND.....................MECHANICAL T&E
Brake, Cleaving.................WOODWORKING T&E
     use  HORSE, FROE
BRAKE, MUZZLE...................ARMAMENT ACCESSORY
BRANDER, FREEZING...............ANIMAL HUSBANDRY T&E
BRANDER, HORN...................ANIMAL HUSBANDRY T&E
BRASSIERE.......................CLOTHING, UNDERWEAR
BRASS KNUCKLES..................ARMAMENT T&E, BLUDGEON
BRAYER..........................PRINTING T&E
BRAZIER.........................FOOD PROCESSING T&E
BRAZIER.........................METALWORKING T&E
BREAK, SKELETON.................LTE, ANIMAL-POWERED
BREAK, WAGONETTE................LTE, ANIMAL-POWERED
BREAKER, BALE...................TEXTILEWORKING T&E
BREAKER, CIRCUIT................ELECTRICAL & MAGNETIC T&E
BREAKER, FLAX...................TEXTILEWORKING T&E
Breakfront......................FURNITURE
     use  more specific term: e.g., BOOKCASE; CABINET,
          CHINA
BREASTPLATE.....................ARMAMENT T&E, BODY ARMOR
BREASTPLATE.....................WOODWORKING T&E
BREATHING APPARATUS.............MINING T&E
BREECHES........................CLOTHING, OUTERWEAR
```

309

Breeches, Jodhpur..............CLOTHING, OUTERWEAR
 use BREECHES, RIDING
BREECHES, RIDING...............CLOTHING, OUTERWEAR
BREECHES, TRUNK................CLOTHING, OUTERWEAR
BREECHING MACHINE..............METALWORKING T&E
BRELOQUE.......................ADORNMENT
BRIC-A-BRAC....................COMMERCIAL DECORATIVE ART
BRICK MACHINE..................MASONRY T&E
 note may be further subdivided to indicate
 specific type: e.g., BRICK MACHINE,
 CHAMBERLAIN
BRIDGE.........................UNCLASSIFIED STRUCTURE
 rt TRESTLE
BRIDGE, COVERED................UNCLASSIFIED STRUCTURE
BRIDGE, WHEATSTONE.............ELECTRICAL & MAGNETIC T&E
Bridge set.....................FOOD SERVICE T&E
 use LUNCHEON SET
BRIDLE.........................LAND TRANSPORTATION ACCESSORY
 note may be further subdivided to indicate
 specific type: e.g., BRIDLE, SINGLE; -,TEAM
BRIEFCASE......................PERSONAL GEAR
BRIEFS.........................CLOTHING, UNDERWEAR
BRIER..........................FORESTRY T&E
BROACH.........................METALWORKING T&E
BROACH.........................WOODWORKING T&E
 rt REAMER
BROACHING MACHINE..............METALWORKING T&E
BROADAX........................WOODWORKING T&E
Broadcaster, Aircraft..........AGRICULTURAL T&E
 use SEEDER, CENTRIFUGAL
Broadcaster, Centrifugal.......AGRICULTURAL T&E
 use SEEDER, CENTRIFUGAL or SEEDER, HAND
 CENTRIFUGAL
Broadcaster, Knapsack..........AGRICULTURAL T&E
 use SEEDER, HAND CENTRIFUGAL
Broadcaster, Rotary............AGRICULTURAL T&E
 use SEEDER, CENTRIFUGAL or SEEDER, HAND
 CENTRIFUGAL
Broadcaster, Seedbox...........AGRICULTURAL T&E
 use SEEDER, SEEDBOX or SEEDER, HAND SEEDBOX
Broadcaster, Wheelbarrow.......AGRICULTURAL T&E
 use SEEDER, HAND SEEDBOX
Broadside......................ADVERTISING MEDIUM
 use POSTER or HANDBILL
BROADSWORD.....................ARMAMENT T&E, EDGED
BROCHE.........................TEXTILEWORKING T&E
Brochure.......................DOCUMENTARY ARTIFACT
 use BOOKLET
BROILER........................FOOD PROCESSING T&E
BROOCH.........................ADORNMENT
BROODER, POULTRY...............ANIMAL HUSBANDRY T&E
BROOK'S CURVE..................DRAFTING T&E

```
BROOM..............................HOUSEKEEPING T&E
BROOM, ELECTRIC...................HOUSEKEEPING T&E
BROOM, FIREPLACE..................TEMPERATURE CONTROL DEVICE
BROOM, STABLE.....................ANIMAL HUSBANDRY T&E
BROOM, WHISK......................HOUSEKEEPING T&E
BROOM MACHINE.....................WOODWORKING T&E
BROUGHAM..........................LTE, ANIMAL-POWERED
BRUSH.............................CHEMICAL T&E
     note may be further subdivided to indicate
          specific type: e.g., BRUSH, PIPETTE;
          -,BURETTE
BRUSH, ANIMAL.....................ANIMAL HUSBANDRY T&E
BRUSH, CLOTHES....................CLOTHING ACCESSORY
BRUSH, KITCHEN....................FOOD PROCESSING T&E
BRUSH, LETTERING..................PAINTING T&E
BRUSH, NAIL.......................TOILET ARTICLE
BRUSH, PAINT......................PAINTING T&E
BRUSH, PET........................ANIMAL HUSBANDRY T&E
BRUSH, SCRUB......................HOUSEKEEPING T&E
BRUSH, SHAVING....................TOILET ARTICLE
BRUSH, WALLPAPER..................PAINTING T&E
BRUSH, WINDOW.....................HOUSEKEEPING T&E
BRUSH, WIRE.......................MUSICAL T&E, PERCUSSION
BRUSHING MACHINE..................LEATHERWORKING T&E
BRUSHING MACHINE..................TEXTILEWORKING T&E
BRUSH MACHINE.....................FOOD PROCESSING T&E
BUBBLE CHAMBER....................NUCLEAR PHYSICS T&E
BUCCIN............................MUSICAL T&E, BRASS
Buck-a-bout.......................RECREATIONAL DEVICE
     use  SEESAW, COILED-SPRING
BUCKBOARD.........................LTE, ANIMAL-POWERED
BUCKET............................ARMAMENT ACCESSORY
     note may be further subdivided to indicate
          specific type: e.g., BUCKET, TAR; -,GREASE
Bucket............................HOUSEKEEPING T&E
     use  PAIL
BUCKET, CLAMSHELL.................CONSTRUCTION T&E
BUCKET, DRAGLINE..................CONSTRUCTION T&E
BUCKET, ICE.......................FOOD SERVICE T&E
BUCKET, SAP.......................FORESTRY T&E
Bucket, Sinking...................MINING T&E
     use  KIBBLE
Bucket, Sugar.....................FORESTRY T&E
     use  BUCKET, SAP
BUCKLE............................CLOTHING ACCESSORY
BUCKLER...........................ARMAMENT ACCESSORY
BUCKSAW...........................FORESTRY T&E
BUFFER............................TOILET ARTICLE
BUFFER, HOOF......................ANIMAL HUSBANDRY T&E
Buffer, Peripheral................DATA PROCESSING T&E
     use  STORE, BUFFER
BUFFER, SHOE......................CLOTHING ACCESSORY
```

```
Buffet........................FURNITURE
    use  SIDEBOARD
BUFFING MACHINE...............LEATHERWORKING T&E
BUFFING MACHINE...............METALWORKING T&E
BUGEYE........................WATER TRANSPORTATION EQUIPMENT
Buggy.........................LTE, ANIMAL-POWERED
    use  RUNABOUT
BUGLE.........................MUSICAL T&E, BRASS
BUGLE, KEY....................MUSICAL T&E, BRASS
BUGLE, VALVE..................MUSICAL T&E, BRASS
Building, Ceremonial..........BUILDING
    use  more specific term: e.g., CHURCH,
         MEETINGHOUSE, TEMPLE
Building, Civic...............BUILDING
    use  more specific term: e.g., FIREHOUSE, POLICE
         STATION, JAIL, COURTHOUSE, POST OFFICE, TOWN
         HALL
Building, Commercial..........BUILDING
    use  more specific term (e.g., HOTEL, INN,
         RESTAURANT) or the word SHOP or STORE
         followed by the product or service sold
         (e.g., SHOP, BARBER; -,MILLINERY;
         -,BLACKSMITH; STORE, DRUG; -,GROCERY;
         -,FURNITURE)
Building, Cultural............BUILDING
    use  more specific term: e.g., MUSEUM, THEATER
Building, Defense.............BUILDING
    use  more specific term: e.g., ARMORY,
         BLOCKHOUSE, FORT
Building, Educational.........BUILDING
    use  more specific term: e.g., SCHOOL, LIBRARY,
         MUSEUM
Building, Farm................BUILDING
    use  more specific term (e.g., HOUSE; BARN; COOP,
         CHICKEN; CORNCRIB; SILO) or, for a group of
         related farm buildings, FARMSTEAD
Building, Health..............BUILDING
    use  more specific term: e.g., HOSPITAL
Building, Industrial..........BUILDING
    use  PLANT, INDUSTRIAL
BUILDING, OFFICE..............BUILDING
BUILDING, RECREATIONAL........BUILDING
Building, Residential.........BUILDING
    use  HOUSE or another more specific term: e.g.,
         HOGAN, WICKIUP
BUILDING, STORAGE.............BUILDING
Building, Transportation......BUILDING
    use  more specific term: e.g., AIRPORT, DEPOT,
         TERMINAL
BUILDING FACADE...............BUILDING FRAGMENT
BULB..........................CHEMICAL T&E
    note may be further subdivided to indicate
```

```
                  specific type: e.g., BULB, ABSORPTION;
                  -,CONNECTING
BULKHEAD........................BUILDING FRAGMENT
BULKING MACHINE.................TEXTILEWORKING T&E
BULL BOAT.......................WATER TRANSPORTATION EQUIPMENT
     rt   CORACLE
BULLDOZER.......................CONSTRUCTION T&E
     note use for composite unit: i.e., a TRACTOR with
          BULLDOZER BLADE attached
BULLDOZER BLADE.................CONSTRUCTION T&E
BULLET..........................ARMAMENT T&E, AMMUNITION
     note use only if specific type is unknown
BULLET, ARMOR-PIERCING..........ARMAMENT T&E, AMMUNITION
BULLET, CONTROLLED-EXPANSION....ARMAMENT T&E, AMMUNITION
BULLET, EXPANDING...............ARMAMENT T&E, AMMUNITION
BULLET, INCENDIARY..............ARMAMENT T&E, AMMUNITION
BULLET, MINIE...................ARMAMENT T&E, AMMUNITION
BULLET, TRACER..................ARMAMENT T&E, AMMUNITION
BULLHORN........................SOUND COMMUNICATION EQUIPMENT
BULL-ROARER.....................CEREMONIAL ARTIFACT
Bumper..........................WATER TRANSPORTATION ACCESSORY
     use  FENDER
BUMPER STICKER..................ADVERTISING MEDIUM
Bung flogger....................WOODWORKING T&E
     use  BUNGSTART
BUNGSTART.......................WOODWORKING T&E
BUNTING.........................CLOTHING, OUTERWEAR
BUOY, BREECHES..................WATER TRANSPORTATION ACCESSORY
BUOY, MOORING...................WATER TRANSPORTATION ACCESSORY
BUOY, NAVIGATIONAL..............SURVEYING & NAVIGATIONAL T&E
BUR, DENTAL.....................MEDICAL & PSYCHOLOGICAL T&E
Bureau..........................FURNITURE
     use  CHEST OF DRAWERS
BURETTE.........................CHEMICAL T&E
     note may be further subdivided to indicate
          specific type: e.g., BURETTE, MOHR;
          -,GEISSLER; -,STOPCOCK; -,TITRATION
BURGLAR ALARM...................SOUND COMMUNICATION EQUIPMENT
BURGONET........................ARMAMENT T&E, BODY ARMOR
BURIN...........................MASONRY T&E
     rt   GRAVER
BURKA...........................CLOTHING, OUTERWEAR
BURLING MACHINE.................TEXTILEWORKING T&E
BURNER..........................CHEMICAL T&E
     note may be further subdivided to indicate
          specific type: e.g., BURNER, ARGAND; -,BUNSEN
BURNER, INCENSE.................HOUSEHOLD ACCESSORY
BURNER TIP......................CHEMICAL T&E
BURNISHER.......................METALWORKING T&E
BURNISHER.......................PRINTING T&E
BURNISHER, DENTAL...............MEDICAL & PSYCHOLOGICAL T&E
BURNOUS.........................CLOTHING, OUTERWEAR
     rt   CLOAK
```

BURRING MACHINE.................METALWORKING T&E
BURR REMOVER, BREAST...........TEXTILEWORKING T&E
BURR REMOVER, CRUSHER..........TEXTILEWORKING T&E
BURR REMOVER, PICKER...........TEXTILEWORKING T&E
BURSE..........................CEREMONIAL ARTIFACT
BURSTER........................DATA PROCESSING T&E
BUS............................LTE, MOTORIZED
BUSHHAMMER.....................MASONRY T&E
BUSINESS CAR...................RAIL TRANSPORTATION EQUIPMENT
 note use for any car created for use by an
 executive or government official
BUST...........................COMMERCIAL DECORATIVE ART
BUST...........................ORIGINAL ART
BUSTLE.........................CLOTHING, UNDERWEAR
Butteris.......................ANIMAL HUSBANDRY T&E
 use TRIMMER, HORSE-HOOF
BUTTER WORKER..................FOOD PROCESSING T&E
BUTTON.........................CLOTHING ACCESSORY
BUTTON BREAKER.................TEXTILEWORKING T&E
BUTTONHOOK.....................CLOTHING ACCESSORY
BUTTRESS.......................BUILDING FRAGMENT
BUTYROMETER....................FOOD PROCESSING T&E
BUY BOAT, CHESAPEAKE BAY.......WATER TRANSPORTATION EQUIPMENT
BUZZER.........................SOUND COMMUNICATION EQUIPMENT
CAB............................LTE, ANIMAL-POWERED
CAB, HANSOM....................LTE, ANIMAL-POWERED
CABER..........................SPORTS EQUIPMENT
Cabin..........................BUILDING
 use HOUSE
CABINET........................FURNITURE
 rt CUPBOARD
CABINET, CHINA.................FURNITURE
CABINET, CORNER................FURNITURE
Cabinet, Creamery..............FOOD PROCESSING T&E
 use SEPARATOR, CREAM--GRAVITY
Cabinet, Curio.................FURNITURE
 use CABINET, VITRINE
CABINET, FILING................FURNITURE
CABINET, GUN...................FURNITURE
CABINET, MEDICINE..............BUILDING FRAGMENT
CABINET, MEDICINE..............FURNITURE
CABINET, PHONOGRAPH............FURNITURE
CABINET, RADIO.................FURNITURE
CABINET, VITRINE...............FURNITURE
CABLE..........................DATA PROCESSING T&E
CABLE..........................WATER TRANSPORTATION ACCESSORY
CABLE, SUBMARINE...............TELECOMMUNICATION EQUIPMENT
CABLE CAR......................RAIL TRANSPORTATION EQUIPMENT
CABLE RELEASE..................PHOTOGRAPHIC T&E
CABOOSE........................RAIL TRANSPORTATION EQUIPMENT
CABRIOLET......................LTE, ANIMAL-POWERED
 rt CHAISE; VICTORIA

CACHEPOT......................HOUSEHOLD ACCESSORY
CADDY.........................FOOD PROCESSING T&E
CADGER........................MINING T&E
CADRAN, GEMMOLOGIST'S.........UNCLASSIFIED T&E, SPECIAL
CAFTAN........................CLOTHING, OUTERWEAR
 rt ABA; TOGA
CAGE..........................MINING T&E
CAGE, ANIMAL..................UNCLASSIFIED STRUCTURE
CAGE, ANIMAL..................ANIMAL HUSBANDRY T&E
CAGE, DRYING..................LEATHERWORKING T&E
CAGE, MAN.....................MINING T&E
CAGE, SOUND...................ACOUSTICAL T&E
CAIRN.........................SURVEYING & NAVIGATIONAL T&E
CAISSON.......................LTE, ANIMAL-POWERED
CAKE DECORATOR................FOOD PROCESSING T&E
CAKE STAND....................FOOD SERVICE T&E
CALCIMETER....................CHEMICAL T&E
CALCULATING DISK, ACKERMANN'S..FOOD PROCESSING T&E
CALCULATING ROD...............DATA PROCESSING T&E
CALCULATOR....................DATA PROCESSING T&E
 note may be further subdivided to indicate
 specific type: e.g., CALCULATOR, DESK;
 -,POCKET
CALCULATOR, PROGRAMMABLE.......DATA PROCESSING T&E
CALDRON.......................FOOD PROCESSING T&E
Caldron, Scalding.............FOOD PROCESSING T&E
 use SCALDER, HOG
CALECHE.......................LTE, ANIMAL-POWERED
 rt BAROUCHE; CHAISE
CALENDAR......................DOCUMENTARY ARTIFACT
CALENDER......................GLASS & PLASTICS T&E
 rt COATING MACHINE
CALENDER......................PAPERMAKING T&E
CALENDER......................TEXTILEWORKING T&E
 note may be further subdivided to indicate
 specific type: e.g., CALENDER, EMBOSSING;
 -,MOIRE
CALIPERS......................WEIGHTS & MEASURES T&E
 note use only if specific type is unknown
CALIPERS, GUNNER'S............ARMAMENT ACCESSORY
CALIPERS, INSIDE..............WEIGHTS & MEASURES T&E
CALIPERS, OUTSIDE.............WEIGHTS & MEASURES T&E
CALIPERS, SHELL...............ARMAMENT ACCESSORY
CALIPERS, TIMBER..............FORESTRY T&E
CALKING GUN...................UNCLASSIFIED T&E, SPECIAL
CALL, GAME....................ARMAMENT ACCESSORY
Calling card tray.............HOUSEHOLD ACCESSORY
 use CARD RECEIVER
CALLIOPE......................MUSICAL T&E, WOODWIND
CALORIMETER...................THERMAL T&E
Calot.........................CLOTHING, HEADWEAR
 use BEANIE

```
CALTROP......................ARMAMENT ACCESSORY
CALUMET......................CEREMONIAL ARTIFACT
CAME.........................GLASS & PLASTICS T&E
Cameo........................ADORNMENT
     use  more specific term: e.g., BROOCH
CAMERA.......................PHOTOGRAPHIC T&E
CAMERA, BOX..................PHOTOGRAPHIC T&E
CAMERA, FOLDING..............PHOTOGRAPHIC T&E
CAMERA, MOTION-PICTURE.......PHOTOGRAPHIC T&E
CAMERA, OBSCURA..............PHOTOGRAPHIC T&E
CAMERA, RANGEFINDER..........PHOTOGRAPHIC T&E
CAMERA, SCHMIDT..............ASTRONOMICAL T&E
     rt   TELESCOPE, REFLECTING
CAMERA, SINGLE LENS REFLEX...PHOTOGRAPHIC T&E
CAMERA, STEREO...............PHOTOGRAPHIC T&E
CAMERA, TELEVISION...........TELECOMMUNICATION EQUIPMENT
CAMERA, VIEW.................PHOTOGRAPHIC T&E
CAMERA CASE..................PHOTOGRAPHIC T&E
CAMISOLE.....................CLOTHING, UNDERWEAR
CAMPAIGN BUTTON..............ADVERTISING MEDIUM
CAMPER.......................LTE, MOTORIZED
CAMPIMETER...................MEDICAL & PSYCHOLOGICAL T&E
CAMPYLOMETER.................DRAFTING T&E
CAN..........................PRODUCT PACKAGE
CAN, CREAM...................FOOD PROCESSING T&E
CAN, MILK....................FOOD PROCESSING T&E
CAN, SAFETY CARBIDE..........MINING T&E
CAN, TRASH...................HOUSEKEEPING T&E
CANAL BOAT...................WATER TRANSPORTATION EQUIPMENT
Canary.......................MINING T&E
     use  DETECTOR, GAS
CANDELABRUM..................LIGHTING DEVICE
     rt   CANDLESTICK; SCONCE; MENORAH
CANDLE.......................LIGHTING DEVICE
CANDLELIGHTER................LIGHTING DEVICE
Candlepin....................SPORTS EQUIPMENT
     use  BOWLING PIN
CANDLER, EGG.................FOOD PROCESSING T&E
CANDLESNUFFER................LIGHTING DEVICE
CANDLESTAND..................FURNITURE
CANDLESTICK..................LIGHTING DEVICE
     rt   CANDELABRUM; SCONCE
CANDLESTICK, MINER'S.........LIGHTING DEVICE
CANDY CONTAINER..............TOY
CANE.........................PERSONAL GEAR
CANE, BEATING................LEATHERWORKING T&E
CANE, STOCKMAN'S.............ANIMAL HUSBANDRY T&E
CANGUE.......................BEHAVIORAL CONTROL DEVICE
Canion.......................CLOTHING ACCESSORY
     use  GARTER
CANISTER.....................FOOD PROCESSING T&E
     note may be further subdivided to indicate
          specific type: e.g., CANISTER, SUGAR
```

316

```
CANISTER ROUND.................ARMAMENT T&E, AMMUNITION
CANNON.........................ARMAMENT T&E, ARTILLERY
CANNON, HAND...................ARMAMENT T&E, FIREARM
CANNON, PETRONEL...............ARMAMENT T&E, ARTILLERY
CANNON, SERPENTINE.............ARMAMENT T&E, ARTILLERY
CANNONBALL.....................ARMAMENT T&E, AMMUNITION
CANNULA........................MEDICAL & PSYCHOLOGICAL T&E
CANOE..........................WATER TRANSPORTATION EQUIPMENT
     note may be further subdivided to indicate
          specific type: e.g., CANOE, CANVAS-COVERED;
          -,CHESAPEAKE BAY LOG; -,DECKED; -,DUGOUT;
          -,FOLDING; -,OUTRIGGER; -,SAILING
CANOPY.........................BEDDING
Canopy.........................WINDOW OR DOOR COVERING
     use AWNING
CANTEEN........................PERSONAL GEAR
CANTERBURY.....................FURNITURE
     rt  RACK, MAGAZINE
CANTIR.........................FOOD SERVICE T&E
CAP............................CLOTHING, HEADWEAR
     note use only for objects which contain the word
          CAP in the name; may be further subdivided
          to indicate specific type: e.g., CAP,
          BATHING; -,FORAGE; -,GARRISON; -,GOB;
          -,MOURNING; -,MINER'S
CAP, BB........................ARMAMENT T&E, AMMUNITION
CAP, BLASTING..................MINING T&E
CAP, DUNCE.....................BEHAVIORAL CONTROL DEVICE
Cap, Flat......................CLOTHING, HEADWEAR
     use FLATCAP
CAP, MUSKET....................ARMAMENT ACCESSORY
CAP, MUZZLE....................ARMAMENT ACCESSORY
CAP, PERCUSSION................ARMAMENT ACCESSORY
CAP, TIMBER....................MINING T&E
CAPACITOR......................ELECTRICAL & MAGNETIC T&E
     note may be further subdivided to indicate
          specific type: e.g., CAPACITOR,
          ELECTROLYTIC; -,VARIABLE
CAPARISON......................LAND TRANSPORTATION ACCESSORY
CAPE...........................CLOTHING, OUTERWEAR
CAP EXPLODER...................TOY
CAP FRAME......................TEXTILEWORKING T&E
     note may be further subdivided to indicate
          specific type: e.g., CAP FRAME, DRAWING;
          -,SLUBBING; -,ROVING
CAPOTE.........................CLOTHING, OUTERWEAR
CAPPER, BOTTLE.................FOOD PROCESSING T&E
     rt  BOTTLING MACHINE
CAPPING MACHINE, CAN...........FOOD PROCESSING T&E
CAP PISTOL.....................TOY
CAPSTAN........................WATER TRANSPORTATION ACCESSORY
     rt  WINDLASS
```

Car.............................LTE, MOTORIZED
 use AUTOMOBILF
Car.............................RAIL TRANSPORTATION EQUIPMENT
 use only as a secondary term within this
 classification
CAR, ARMORED....................LTE, MOTORIZED
CARAFE..........................FOOD SERVICE T&E
 rt DECANTER
CARBINE.........................ARMAMENT T&E, FIREARM
 rt PETRONEL
CARBOLIMETER....................CHEMICAL T&E
CARBONOMETER....................CHEMICAL T&E
CARBOY..........................PRODUCT PACKAGE
CARBUROMETER....................CHEMICAL T&E
CARCASS.........................ARMAMENT T&E, AMMUNITION
CARD............................LEATHERWORKING T&E
CARD, CALLING...................DOCUMENTARY ARTIFACT
 rt CARD, TRADE
CARD, CREDIT....................DOCUMENTARY ARTIFACT
CARD, EDGE-NOTCH................DATA PROCESSING T&E
CARD, FLASH.....................DOCUMENTARY ARTIFACT
CARD, GREETING..................DOCUMENTARY ARTIFACT
CARD, HAND......................TEXTILEWORKING T&E
Card, Post......................DOCUMENTARY ARTIFACT
 use POSTCARD
CARD, PUNCH.....................DATA PROCESSING T&E
CARD, STORE.....................EXCHANGE MEDIUM
 note use for a card exchanged for services during
 a time when there was limited currency
 available
 rt TOKEN, STORE
CARD, TRADE.....................ADVERTISING MEDIUM
 rt CARD, CALLING
CARD, UNION.....................DOCUMENTARY ARTIFACT
CARD CLOTHING, FILLET...........TEXTILEWORKING T&E
CARD CLOTHING, SHEET............TEXTILEWORKING T&E
CARD CLOTHING MACHINE...........TEXTILEWORKING T&E
Card controller.................DATA PROCESSING T&E
 use PROCESSOR, CARD
CARD DECK.......................GAME
CARD DELIVERY, BAT-ROLLING......TEXTILEWORKING T&E
CARD DELIVERY, ROLL DRUM........TEXTILEWORKING T&E
 rt CONDENSER
CARD GRINDER....................TEXTILEWORKING T&E
CARDING MACHINE.................LEATHERWORKING T&E
CARDING MACHINE, COTTON.........TEXTILEWORKING T&E
CARDING MACHINE, WOOLEN.........TEXTILEWORKING T&E
CARDING MACHINE, WORSTED........TEXTILEWORKING T&E
CARDIOGRAPH.....................MEDICAL & PSYCHOLOGICAL T&E
CARD-PUNCHING MACHINE...........TEXTILEWORKING T&E
CARD RECEIVER...................HOUSEHOLD ACCESSORY
CARGO VESSEL, DRY-CARGO.........WATER TRANSPORTATION EQUIPMENT
 note use for carrier of dry bulk cargo

```
CARGO VESSEL, GENERAL..........WATER TRANSPORTATION EQUIPMENT
CARGO VESSEL, LNG..............WATER TRANSPORTATION EQUIPMENT
     note use for specialized cryogenic (e.g., liquid
          natural gas) carrier
CARGO VESSEL, OBO..............WATER TRANSPORTATION EQUIPMENT
     note use for multi-purpose bulk carrier (e.g.,
          wet or dry cargo; ore-bulk oil)
CARGO VESSEL, WET-CARGO.......WATER TRANSPORTATION EQUIPMENT
CAROM SET.....................GAME
CAROUSEL......................RECREATIONAL DEVICE
CAROUSEL ANIMAL...............RECREATIONAL DEVICE
CAROUSEL ORNAMENT.............RECREATIONAL DEVICE
Carpetbag.....................PERSONAL GEAR
     use  SUITCASE
CARPET SECTION................FLOOR COVERING
CARRIAGE......................LTE, ANIMAL-POWERED
     note use only if specific type is unknown: e.g.,
          PHAETON, BROUGHAM, BAROUCHE
CARRIAGE, BABY................LTE, HUMAN-POWERED
CARRIAGE, CANNON..............LTE, ANIMAL-POWERED
CARRIAGE, DOLL................TOY
CARRIAGE, TUNNEL..............MINING T&E
CARRIAGE APRON................LAND TRANSPORTATION ACCESSORY
CARRIAGE LAMP.................LAND TRANSPORTATION ACCESSORY
Carrick.......................CLOTHING, OUTERWEAR
     use  GREATCOAT
Carrier
     use  only as a secondary word in a multi-word
          object name
Carriole......................LTE, ANIMAL-POWERED
     use  SLEIGH
CARRONADE.....................ARMAMENT T&E, ARTILLERY
CART..........................LTE, ANIMAL-POWERED
     note use only if specific type is unknown
CART, BATCH...................GLASS & PLASTICS T&E
Cart, Breaking................LTE, ANIMAL-POWERED
     use  BREAK, SKELETON
CART, DOG.....................LTE, ANIMAL-POWERED
CART, GOVERNESS...............LTE, ANIMAL-POWERED
CART, IRISH JAUNTING..........LTE, ANIMAL-POWERED
CART, LIFE-SAVING BEACH.......LTE, ANIMAL-POWERED
Cart, Ox......................LTE, ANIMAL-POWERED
     use  OXCART
CART, TEA.....................FURNITURE
     rt   TABLE, TEA
Cart, Tractor grain...........AGRICULTURAL T&E
     use  TRAILER, FARM
CARTE-DE-VISITE...............DOCUMENTARY ARTIFACT
CARTON........................PRODUCT PACKAGE
Cartoning machine.............FOOD PROCESSING T&E
     use  PACKAGING MACHINE, DAIRY
```

```
CARTRIDGE......................ARMAMENT T&E, AMMUNITION
     note may be further subdivided according to
          ignition system: e.g., CARTRIDGE, RIM-FIRE
CARTRIDGE, CASELESS.............ARMAMENT T&E, AMMUNITION
CARTRIDGE, DUMMY...............ARMAMENT T&E, AMMUNITION
Cartridge belt.................ARMAMENT ACCESSORY
     use BELT, CARTRIDGE
CARVER, DENTAL.................MEDICAL & PSYCHOLOGICAL T&E
CARVING, CATHEAD...............WATER TRANSPORTATION ACCESSORY
CARVING, PADDLEBOX.............WATER TRANSPORTATION ACCESSORY
CARVING, STERN.................WATER TRANSPORTATION ACCESSORY
CARVING, TAFFRAIL..............WATER TRANSPORTATION ACCESSORY
CARVING SET....................FOOD SERVICE T&E
Case
     note if the name of the object is not found under
          the word CASE, look under a probable name
          using CASE as a secondary word
CASE...........................PRODUCT PACKAGE
CASE, CARD.....................PERSONAL GEAR
CASE, CARTRIDGE................ARMAMENT ACCESSORY
CASE, CHART....................WATER TRANSPORTATION ACCESSORY
CASE, CIGAR....................PERSONAL GEAR
CASE, CIGARETTE................PERSONAL GEAR
CASE, DAGUERREOTYPE............PHOTOGRAPHIC T&E
CASE, GUN......................ARMAMENT ACCESSORY
CASE, JEWELRY..................PERSONAL GEAR
CASE, KEY......................PERSONAL GEAR
CASE, MANICURE.................TOILET ARTICLE
CASE, MEDICINE.................PERSONAL GEAR
CASE, MUMMY....................CEREMONIAL ARTIFACT
     rt  COFFIN; SARCOPHAGUS
CASE, NEEDLE...................TEXTILEWORKING T&E
CASE, PENCIL...................WRITTEN COMMUNICATION EQUIPMENT
CASE, PHOTOGRAPH...............PERSONAL GEAR
CASE, TYPE.....................PRINTING T&E
CASE, WRITING..................WRITTEN COMMUNICATION EQUIPMENT
CASEMAKING MACHINE.............PRINTING T&E
CASH REGISTER..................MERCHANDISING T&E
CASING.........................MINING T&E
CASING-IN MACHINE..............PRINTING T&E
CASK, BREAD....................FOOD PROCESSING T&E
CASK, HARNESS..................WATER TRANSPORTATION ACCESSORY
CASK, WATER....................FOOD PROCESSING T&E
Casket.........................CEREMONIAL ARTIFACT
     use COFFIN
CASSEROLE......................FOOD PROCESSING T&E
CASSOCK........................CLOTHING, OUTERWEAR
CASTANETS......................MUSICAL T&E, PERCUSSION
CASTER.........................FOOD SERVICE T&E
CASTING MACHINE, DENTAL METALS
     .........................MEDICAL & PSYCHOLOGICAL T&E
CASTLE.........................BUILDING
```

```
CAT...............................ARMAMENT ACCESSORY
CATAFALQUE........................CEREMONIAL ARTIFACT
CATALOG...........................ADVERTISING MEDIUM
CATALYTIC APPARATUS...............CHEMICAL T&E
CATAMARAN.........................WATER TRANSPORTATION EQUIPMENT
CATAPULT..........................ARMAMENT T&E, ARTILLERY
CATBOAT, EASTERN..................WATER TRANSPORTATION EQUIPMENT
CATCHER, HOG......................ANIMAL HUSBANDRY T&E
CATCHER, POULTRY..................ANIMAL HUSBANDRY T&E
CATHETER..........................MEDICAL & PSYCHOLOGICAL T&E
CATHETOMETER......................CHEMICAL T&E
CATHETOMETER......................SURVEYING & NAVIGATIONAL T&E
Cat-o-nine-tails..................BEHAVIORAL CONTROL DEVICE
    use  WHIP
CATOPTER..........................OPTICAL T&E
Cattle leader.....................ANIMAL HUSBANDRY T&E
    use  LEADER, LIVESTOCK
Cattle prod.......................ANIMAL HUSBANDRY T&E
    use  PROD, STOCK
CAUL..............................CLOTHING, HEADWEAR
    rt  HAIRNET
CAVIL.............................MASONRY T&E
CEILING SECTION...................BUILDING FRAGMENT
CEILOMETER........................METEOROLOGICAL T&E
CELESTA...........................MUSICAL T&E, PERCUSSION
CELLAR, ROOT......................SITE FEATURE
CELLARETTE........................FURNITURE
Celt..............................WOODWORKING T&E
    use  AX or ADZ
CEMENT VICAT APPARATUS............CHEMICAL T&E
CENSER............................CEREMONIAL ARTIFACT
    rt  THURIBLE
CENTERDRILL.......................METALWORKING T&E
CENTRAL PROCESSOR.................DATA PROCESSING T&E
CENTRIFUGAL RAILWAY...............MECHANICAL T&E
CENTRIFUGE, CHEMICAL..............CHEMICAL T&E
CENTRIFUGE, CLINICAL..............CHEMICAL T&E
CENTRIFUGE, HUMAN.................BIOLOGICAL T&E
CENTROLINEAD......................DRAFTING T&E
CEPHALOMETER......................MEDICAL & PSYCHOLOGICAL T&E
CERTIFICATE, BAPTISMAL............DOCUMENTARY ARTIFACT
CERTIFICATE, BIRTH................DOCUMENTARY ARTIFACT
CERTIFICATE, DEATH................DOCUMENTARY ARTIFACT
CERTIFICATE, MARRIAGE.............DOCUMENTARY ARTIFACT
CERTIFICATE, MEMBERSHIP...........DOCUMENTARY ARTIFACT
CERTIFICATE, STOCK................DOCUMENTARY ARTIFACT
CHAD..............................DATA PROCESSING T&E
CHAIN, ANCHOR.....................WATER TRANSPORTATION ACCESSORY
CHAIN, CURB.......................ANIMAL HUSBANDRY T&E
CHAIN, KEY........................PERSONAL GEAR
CHAIN, OBSTETRICAL................ANIMAL HUSBANDRY T&E
CHAIN, SURVEYOR'S.................SURVEYING & NAVIGATIONAL T&E
```

```
CHAINS.........................MUSICAL T&E, PERCUSSION
CHAIR..........................FURNITURE
     note use only if specific type is unknown
CHAIR, ALTAR...................FURNITURE
Chair, Arm.....................FURNITURE
     use  more specific term: e.g., CHAIR, EASY;
          -,DINING
CHAIR, BALL-HOLDER'S...........GLASS & PLASTICS T&E
CHAIR, BALLROOM................FURNITURE
CHAIR, BARBER'S................FURNITURE
Chair, Bent-wire...............FURNITURE
     use  CHAIR, SODA FOUNTAIN
CHAIR, BOATSWAIN'S.............WATER TRANSPORTATION ACCESSORY
CHAIR, CHILD'S.................FURNITURE
     note may be further subdivided to indicate
          specific type: e.g., CHAIR, CHILD'S ROCKING
CHAIR, CORNER..................FURNITURE
Chair, Deck....................FURNITURE
     use  CHAIR, FOLDING
CHAIR, DENTIST'S...............FURNITURE
CHAIR, DESK....................FURNITURE
CHAIR, DINING..................FURNITURE
CHAIR, EASY....................FURNITURE
CHAIR, ELECTRIC................BEHAVIORAL CONTROL DEVICE
CHAIR, FIREPLACE...............FURNITURE
CHAIR, FOLDING.................FURNITURE
CHAIR, GAFFER'S................GLASS & PLASTICS T&E
CHAIR, GARDEN..................FURNITURE
Chair, Gondola.................FURNITURE
     use  CHAIR, DINING
CHAIR, HALL....................FURNITURE
Chair, High....................FURNITURE
     use  HIGHCHAIR
CHAIR, INVALID.................FURNITURE
Chair, Morris..................FURNITURE
     use  CHAIR, RECLINING
CHAIR, MUSIC...................FURNITURE
CHAIR, OCCASIONAL..............FURNITURE
     note use for any chair that is not part of a set
          and cannot be named by any other term in
          this list
CHAIR, PLATFORM ROCKING........FURNITURE
CHAIR, PORTER'S................FURNITURE
CHAIR, RECLINING...............FURNITURE
CHAIR, ROCKING.................FURNITURE
Chair, Side....................FURNITURE
     use  more specific term: e.g., CHAIR, HALL;
          -,DINING; -,OCCASIONAL
CHAIR, SLIPPER.................FURNITURE
CHAIR, SODA FOUNTAIN...........FURNITURE
Chair, Spa.....................FURNITURE
     use  CHAIR, TOURING
```

322

```
CHAIR, STENOGRAPHER'S..........FURNITURE
CHAIR, STEP....................FURNITURE
Chair, Swivel..................FURNITURE
     use  more specific term: e.g., CHAIR,
          STENOGRAPHER'S
CHAIR, TABLET-ARM..............FURNITURE
CHAIR, TOURING.................FURNITURE
CHAIR, WING....................FURNITURE
Chair car......................RAIL TRANSPORTATION EQUIPMENT
     use  COACH
CHAIR LIFT.....................AEROSPACE TRANSPORTATION EQUIPMENT
Chair-lounge car...............RAIL TRANSPORTATION EQUIPMENT
     use  COACH
CHAIR/TABLE....................FURNITURE
CHAIR THROW....................HOUSEHOLD ACCESSORY
CHAISE.........................LTE, ANIMAL-POWERED
     rt   CABRIOLET; CALECHE
CHAISE, POST...................LTE, ANIMAL-POWERED
Chaise lounge..................FURNITURE
     use  LOUNGE
Chalet.........................BUILDING
     use  HOUSE
CHALICE........................CEREMONIAL ARTIFACT
CHALK, TAILOR'S................TEXTILEWORKING T&E
CHALKBOARD.....................WRITTEN COMMUNICATION EQUIPMENT
CHALK LINE.....................WOODWORKING T&E
     rt   REEL, CHALK
CHALUMEAU......................MUSICAL T&E, WOODWIND
CHALWAR........................CLOTHING, OUTERWEAR
CHAMBER, HELIOTROPIC...........BIOLOGICAL T&E
CHANDELIER.....................LIGHTING DEVICE
     note normally subdivided according to fuel
     rt   LAMP
CHANGKOL.......................MINING T&E
CHANNELER......................MINING T&E
CHAPERON.......................CLOTHING, OUTERWEAR
CHAPS..........................CLOTHING, OUTERWEAR
Charactron.....................DATA PROCESSING T&E
     use  DISPLAY UNIT, VISUAL
CHARCOAL PIT...................MINING T&E
CHARGE, DEPTH..................ARMAMENT T&E, AMMUNITION
CHARGER........................FOOD SERVICE T&E
CHARGER, NIPPLE................ARMAMENT ACCESSORY
CHARGING BOX...................METALWORKING T&E
CHARGING MACHINE...............METALWORKING T&E
CHARIOT........................LTE, ANIMAL-POWERED
CHART, FLOW....................DOCUMENTARY ARTIFACT
CHART, NAVIGATIONAL............DOCUMENTARY ARTIFACT
CHART, VISUAL-ACUITY...........MEDICAL & PSYCHOLOGICAL T&E
CHARTOMETER....................DRAFTING T&E
CHASE..........................PRINTING T&E
CHASUBLE.......................CLOTHING, OUTERWEAR
```

323

CHATELAINE.......................ADORNMENT
CHATELAINE.......................PERSONAL GEAR
CHECK, BANK......................DOCUMENTARY ARTIFACT
CHECKER SET......................GAME
CHECK PROTECTOR..................WRITTEN COMMUNICATION EQUIPMENT
CHEESE-BOX MAKER.................WOODWORKING T&E
CHEILVANGROSCOPE.................MEDICAL & PSYCHOLOGICAL T&E
Chemise..........................CLOTHING, OUTERWEAR
 use DRESS
CHESS SET........................GAME
CHEST, AMMUNITION................ARMAMENT ACCESSORY
CHEST, BLANKET...................FURNITURE
CHEST, CAMPAIGN..................FURNITURE
Chest, High......................FURNITURE
 use CHEST OF DRAWERS
Chest, Hope......................FURNITURE
 use CHEST, BLANKET
CHEST, SEA.......................PERSONAL GEAR
CHEST, SHIP'S MEDICINE...........WATER TRANSPORTATION ACCESSORY
CHEST, SILVER....................FOOD SERVICE T&E
CHEST, TOOL......................UNCLASSIFIED T&E, GENERAL
CHEST OF DRAWERS.................FURNITURE
 rt CHIFFOROBE; DRESSING CASE; CHEST ON FRAME
Chest on chest...................FURNITURE
 use CHEST OF DRAWERS
CHEST ON FRAME...................FURNITURE
 rt CHEST OF DRAWERS
CHEVAL-DE-FRISE..................ARMAMENT ACCESSORY
Chiffonier.......................FURNITURE
 use CHEST OF DRAWERS
CHIFFOROBE.......................FURNITURE
 rt CHEST OF DRAWERS; WARDROBE
Child's furniture................FURNITURE
 use CHILD'S as a qualifier with any acceptable
 furniture term: e.g., CHAIR, CHILD'S ROCKING
Chime, Wind......................COMMERCIAL DECORATIVE ART
 use WIND-BELL
CHIMES...........................MUSICAL T&E, PERCUSSION
CHIMES, DOOR.....................BUILDING FRAGMENT
Chimney..........................BUILDING FRAGMENT
 use more specific term: e.g., CHIMNEY POT, FLUE,
 FIREPLACE
Chimneypiece.....................BUILDING FRAGMENT
 use OVERMANTEL
CHIMNEY POT......................BUILDING FRAGMENT
CHINCHILLA MACHINE...............TEXTILEWORKING T&E
CHINESE CHECKER SET..............GAME
Chinese puzzle...................TOY
 use BLOCK, PARQUETRY
CHIPPER..........................PAPERMAKING T&E
CHISEL...........................MASONRY T&E
 note use only if specific type is unknown

CHISEL.........................WOODWORKING T&E
 note use only if specific type is unknown
 rt SLICK; GOUGE
CHISEL, BARKING................FORESTRY T&E
CHISEL, BENT...................WOODWORKING T&E
Chisel, Broad..................WOODWORKING T&E
 use SLICK
Chisel, Bruzz..................WOODWORKING T&E
 use CHISEL, CORNER
Chisel, Cant...................WOODWORKING T&E
 use CHISEL, FIRMER
CHISEL, CARVING................WOODWORKING T&E
 note may be further subdivided to indicate chief
 variations in shape of blade and cutting edge
CHISEL, COLD...................METALWORKING T&E
 note use only if specific type is unknown: e.g.,
 CHISEL, CAPE; -,DIAMOND-POINT; -,FLAT
CHISEL, CORNER.................WOODWORKING T&E
CHISEL, CUTTING................MASONRY T&E
CHISEL, DENTAL.................MEDICAL & PSYCHOLOGICAL T&E
CHISEL, DIAGONAL-THONGING......LEATHERWORKING T&E
CHISEL, FIRMER.................WOODWORKING T&E
Chisel, Forming................WOODWORKING T&E
 use CHISEL, FIRMER
Chisel, Framing................WOODWORKING T&E
 use CHISEL, FIRMER
CHISEL, GOOSENECK..............WOODWORKING T&E
CHISEL, GRAFTING...............AGRICULTURAL T&E
CHISEL, HOOF...................ANIMAL HUSBANDRY T&E
CHISEL, HOT....................METALWORKING T&E
 rt CREASER, HOT
CHISEL, MORTISE................WOODWORKING T&E
CHISEL, OCTAGONAL..............MASONRY T&E
CHISEL, PARING.................WOODWORKING T&E
CHISEL, PARTING................WOODWORKING T&E
CHISEL, PITCHING...............MASONRY T&E
CHISEL, PRUNING................AGRICULTURAL T&E
CHISEL, RIPPING................WOODWORKING T&E
 rt WEDGE
CHISEL, SKEW...................WOODWORKING T&E
Chisel, Slice..................WOODWORKING T&E
 use SLICK
CHISEL, SPLITTING..............MASONRY T&E
CHISEL, STRAIGHT...............MASONRY T&E
CHISEL, THONGING...............LEATHERWORKING T&E
CHISEL, TOOTH..................MASONRY T&E
CHISEL, TURNING................WOODWORKING T&E
CHLOROMETER....................CHEMICAL T&E
CHOCK..........................WATER TRANSPORTATION ACCESSORY
Choli..........................CLOTHING, OUTERWEAR
 use BLOUSE
CHOPINE........................CLOTHING, FOOTWEAR

Chopper, Ensilage..............AGRICULTURAL T&E
 use CUTTER, ENSILAGE
CHOPPER, FEED..................AGRICULTURAL T&E
 rt CUTTER, ENSILAGE
Chopper, Fodder................AGRICULTURAL T&E
 use CHOPPER, FEED
CHOPPER, FOOD..................FOOD PROCESSING T&E
Chopper, Hay...................AGRICULTURAL T&E
 use CHOPPER, FEED
CHOPPER, POTATO................FOOD PROCESSING T&E
Chopper, Silage................AGRICULTURAL T&E
 use CUTTER, ENSILAGE
Chopper, Stalk.................AGRICULTURAL T&E
 use CHOPPER, FEED
Chopper, Stover................AGRICULTURAL T&E
 use CHOPPER, FEED
CHOPPING BLOCK, WHEELWRIGHT'S..WOODWORKING T&E
CHOPSTICK......................FOOD SERVICE T&E
CHOPSTICK CASE.................FOOD SERVICE T&E
CHOROGRAPH.....................SURVEYING & NAVIGATIONAL T&E
CHROMASCOPE....................OPTICAL T&E
CHROMATOMETER..................OPTICAL T&E
CHROMATOSCOPE..................ASTRONOMICAL T&E
CHROMATROPE....................BIOLOGICAL T&E
CHRONOGRAPH....................TIMEKEEPING T&E
CHRONOMETER....................SURVEYING & NAVIGATIONAL T&E
Chronometer, Solar.............TIMEKEEPING T&E
 use SUNDIAL
CHRONOSCOPE....................TIMEKEEPING T&E
CHRONOTHERMOMETER..............THERMAL T&E
CHUCK..........................WOODWORKING T&E
CHUCK, DRILL...................METALWORKING T&E
CHUCK, LATHE...................METALWORKING T&E
CHUCK, TAP.....................METALWORKING T&E
CHURCH.........................BUILDING
CHURN..........................FOOD PROCESSING T&E
 note may be further subdivided to indicate
 specific type: e.g., CHURN, BUTTER;
 -,OIL-TEST
CHYOMETER......................CHEMICAL T&E
CIBORIUM.......................CEREMONIAL ARTIFACT
CIMBALOM.......................MUSICAL T&E, STRINGED
 note may be further subdivided to indicate
 specific type: e.g., CIMBALOM, APPALACHIAN;
 -,HAMMERED
CINCH..........................LAND TRANSPORTATION ACCESSORY
CIRCUIT BOARD..................ELECTRICAL & MAGNETIC T&E
 note use only if specific function is unknown:
 e.g., OSCILLATOR
Circular.......................ADVERTISING MEDIUM
 use HANDBILL
CIRCUMFERENTOR.................SURVEYING & NAVIGATIONAL T&E
 rt GRAPHOMETER; QUADRANT; OCTANT

```
Circus equipment................PUBLIC ENTERTAINMENT DEVICE
     use   more specific term: e.g., BALANCING POLE;
           TRAPEZE; HIGH WIRE; ANIMAL STAND
CISTERN.........................SITE FEATURE
CITTERN.........................MUSICAL T&E, STRINGED
CLAMP...........................CHEMICAL T&E
     note may be further subdivided to indicate
           specific type: CLAMP, STOPCOCK; -,HOSECOCK;
           -,SUSPENSION
CLAMP...........................GLASS & PLASTICS T&E
CLAMP...........................WOODWORKING T&E
     note use only if specific type is unknown
CLAMP, BROOMMAKER'S.............WOODWORKING T&E
CLAMP, C........................WOODWORKING T&E
CLAMP, CORNER...................WOODWORKING T&E
CLAMP, DENTAL...................MEDICAL & PSYCHOLOGICAL T&E
CLAMP, FLOORING.................WOODWORKING T&E
CLAMP, FURNITURE................WOODWORKING T&E
Clamp, G........................WOODWORKING T&E
     use   CLAMP, C
CLAMP, HORNWORKER'S.............UNCLASSIFIED T&E, SPECIAL
CLAMP, JOINER'S.................WOODWORKING T&E
CLAMP, QUILTING-FRAME...........TEXTILEWORKING T&E
CLAMP, RIGGER'S.................TEXTILEWORKING T&E
CLAMP, SAW......................WOODWORKING T&E
CLAMP, SCREW....................WOODWORKING T&E
CLAMP, SEWING...................TEXTILEWORKING T&E
CLAMP, WINDING..................TEXTILEWORKING T&E
CLAPPER STICKS..................GLASS & PLASTICS T&E
CLARINET........................MUSICAL T&E, WOODWIND
CLASP...........................CLOTHING ACCESSORY
CLASSIFIER......................MINING T&E
CLAVES..........................MUSICAL T&E, PERCUSSION
CLAVICHORD......................MUSICAL T&E, STRINGED
CLAVICOR........................MUSICAL T&E, BRASS
CLAY BIRD.......................ARMAMENT ACCESSORY
CLAYMORE........................ARMAMENT T&E, EDGED
CLEANER, BAG....................FOOD PROCESSING T&E
CLEANER, COTTONSEED.............AGRICULTURAL T&E
CLEANER, DRAIN..................AGRICULTURAL T&E
Cleaner, Grain..................AGRICULTURAL T&E
     use   MILL, FANNING
CLEANER, VACUUM.................HOUSEKEEPING T&E
CLEANING ROD....................ARMAMENT ACCESSORY
CLEAT...........................WATER TRANSPORTATION ACCESSORY
CLEAVER.........................FOOD PROCESSING T&E
CLEAVER, BASKETMAKER'S..........TEXTILEWORKING T&E
Clepsydra.......................TIMEKEEPING T&E
     use   CLOCK, WATER
Clicker.........................LEATHERWORKING T&E
     use   DIE-CUTTING MACHINE
CLIMATOMETER....................MEDICAL & PSYCHOLOGICAL T&E
```

327

```
CLIMBER......................RECREATIONAL DEVICE
     note may be further subdivided to indicate
          specific type: e.g., CLIMBER, ARCH; -,DOME
CLIMBING NET.................RECREATIONAL DEVICE
CLIMBING ROPE...............SPORTS EQUIPMENT
Clinch......................ANIMAL HUSBANDRY T&E
     use CLINCHING BLOCK
Clincher....................ANIMAL HUSBANDRY T&E
     use TONGS, CLINCHING
CLINCHING BLOCK.............ANIMAL HUSBANDRY T&E
CLINOGRAPH..................SURVEYING & NAVIGATIONAL T&E
CLINOMETER..................SURVEYING & NAVIGATIONAL T&E
CLINOSTAT...................BIOLOGICAL T&E
CLIP, CARTRIDGE.............ARMAMENT ACCESSORY
Clip, Cow...................ANIMAL HUSBANDRY T&E
     use HOLDER, COW-TAIL
CLIP, MONEY.................PERSONAL GEAR
CLIP, PAPER.................WRITTEN COMMUNICATION EQUIPMENT
CLIPBOARD...................WRITTEN COMMUNICATION EQUIPMENT
Clipper.....................WATER TRANSPORTATION EQUIPMENT
     use only as a rigging term; see text
CLIPPER, ANIMAL.............ANIMAL HUSBANDRY T&E
Clipper, Bolt...............METALWORKING T&E
     use CUTTER, BOLT
CLIPPERS, HAIR..............TOILET ARTICLE
CLIPPERS, NAIL..............TOILET ARTICLE
CLOAK.......................CLOTHING, OUTERWEAR
     rt BURNOUS
CLOCK.......................TIMEKEEPING T&E
     note use only if specific type is unknown
Clock, Alarm................TIMEKEEPING T&E
     use more specific term
CLOCK, ASTRONOMICAL.........ASTRONOMICAL T&E
CLOCK, CASE.................TIMEKEEPING T&E
Clock, Grandfather..........TIMEKEEPING T&E
     use CLOCK, TALL CASE
Clock, Grandmother..........TIMEKEEPING T&E
     use CLOCK, CASE
CLOCK, SHELF................TIMEKEEPING T&E
     note use for any clock designed to stand on a
          shelf, table, mantle or bracket
CLOCK, SIDEREAL.............ASTRONOMICAL T&E
CLOCK, TALL CASE............TIMEKEEPING T&E
CLOCK, TRAVEL...............TIMEKEEPING T&E
CLOCK, TURRET...............TIMEKEEPING T&E
CLOCK, WALL.................TIMEKEEPING T&E
CLOCK, WATER................TIMEKEEPING T&E
CLOCK SET, GARNITURE........TIMEKEEPING T&E
CLOG........................CLOTHING, FOOTWEAR
CLOTHESHORSE................HOUSEHOLD ACCESSORY
CLOTHESPIN..................HOUSEKEEPING T&E
CLOTH PRESS, COLD...........TEXTILEWORKING T&E
```

```
CLOTH PRESS, HOT................TEXTILEWORKING T&E
CLOTH PRESS, ROTARY.............TEXTILEWORKING T&E
CLOTH PRESS, SCREW-TYPE.........TEXTILEWORKING T&E
CLOUD CHAMBER...................METEOROLOGICAL T&E
CLOUD CHAMBER...................NUCLEAR PHYSICS T&E
CLUB...........................ARMAMENT T&E, BLUDGEON
Club, Billy....................BEHAVIORAL CONTROL DEVICE
     use  NIGHTSTICK
COACH..........................LTE, ANIMAL-POWERED
     note use only if specific type is unknown
COACH..........................RAIL TRANSPORTATION EQUIPMENT
COACH, BERLIN..................LTE, ANIMAL-POWERED
COACH, CONCORD.................LTE, ANIMAL-POWERED
COACH, ROAD....................LTE, ANIMAL-POWERED
     rt   STAGECOACH; PARK DRAG
Coach, Stage...................LTE, ANIMAL-POWERED
     use  STAGECOACH
COACH, STATE...................LTE, ANIMAL-POWERED
Coach-and-four.................LTE, ANIMAL-POWERED
     use  more specific term: e.g., BREAK, WAGONETTE;
          COACH, ROAD
COAGULOMETER...................BIOLOGICAL T&E
COASTER........................FOOD SERVICE T&E
COAT...........................CLOTHING, OUTERWEAR
     note may be further subdivided to indicate
          specific type: e.g., COAT, CUTAWAY; -,FROCK;
          -,LABORATORY
Coat, Morning..................CLOTHING, OUTERWEAR
     use  COAT, CUTAWAY
COATEE.........................CLOTHING, OUTERWEAR
COATHANGER.....................HOUSEHOLD ACCESSORY
COATING MACHINE................GLASS & PLASTICS T&E
     note may be further subdivided to indicate
          specific type: e.g., COATING MACHINE, ROLL;
          -,SPREAD; -,METALLIZING
     rt   CALENDER
COATING MACHINE................PAPERMAKING T&E
COATING MACHINE................TEXTILEWORKING T&E
Coat of arms...................PERSONAL SYMBOL
     use  more specific term: e.g., RING, PLAQUE,
          SHIELD
COATRACK.......................FURNITURE
     rt   RACK, HAT
COAT-TREE......................FURNITURE
     rt   HALLSTAND
COCKCROFT WALTON...............NUCLEAR PHYSICS T&E
Cockle machine.................FOOD PROCESSING T&E
     use  CYLINDER, COCKLE
CODDLER........................FOOD PROCESSING T&E
CODPIECE.......................CLOTHING, OUTERWEAR
COFFEE MAKER...................FOOD PROCESSING T&E
     note use for any coffee-brewing utensil
```

```
COFFEEPOT....................FOOD SERVICE T&E
COFFIN.......................CEREMONIAL ARTIFACT
     rt   SARCOPHAGUS; CASE, MUMMY
COILED-SPRING RIDER...........RECREATIONAL DEVICE
COIN.........................EXCHANGE MEDIUM
     note may be further subdivided to indicate a
          specific coin name: e.g., COIN, DIME;
          -,PESO; -,SHILLING
COIN, COMMEMORATIVE...........DOCUMENTARY ARTIFACT
COLANDER.....................FOOD PROCESSING T&E
COLD FRAME...................AGRICULTURAL T&E
COLLAGE......................ORIGINAL ART
COLLAR.......................CLOTHING ACCESSORY
     rt   RUFF; RUCHE
Collar.......................ARMAMENT T&E, BODY ARMOR
     use  GORGET
COLLAR, BARK-TRAINING.........ANIMAL HUSBANDRY T&E
COLLAR, CHOKE................ANIMAL HUSBANDRY T&E
COLLAR, FLEA.................ANIMAL HUSBANDRY T&E
COLLAR, HORSE................LAND TRANSPORTATION ACCESSORY
COLLAR, PET.................ANIMAL HUSBANDRY T&E
COLLAR, ROMAN...............CLOTHING ACCESSORY
COLLATING MACHINE............PRINTING T&E
COLLATOR....................DATA PROCESSING T&E
Collection
     use  only as a secondary word in a multi-word
          object name
COLLIMATOR..................NUCLEAR PHYSICS T&E
COLLIMATOR..................OPTICAL T&E
Colorimeter.................CHEMICAL T&E
     use  COMPARATOR
COLORIMETER.................OPTICAL T&E
COLOR MIXER.................MEDICAL & PSYCHOLOGICAL T&E
COLUMN......................BUILDING FRAGMENT
COLUMN BASE.................BUILDING FRAGMENT
COLUMN CAPITOL..............BUILDING FRAGMENT
COLUMN SHAFT................BUILDING FRAGMENT
Comb........................ADORNMENT
     use  ORNAMENT, HAIR
COMB........................TOILET ARTICLE
COMB........................TEXTILEWORKING T&E
     note may be further subdivided to indicate
          specific type: e.g., COMB, NOBLE; -,FRENCH
COMB, BROOMMAKER'S...........WOODWORKING T&E
Comb, Curry.................ANIMAL HUSBANDRY T&E
     use  CURRYCOMB
COMB, GRAINING..............PAINTING T&E
COMB, HAND..................TEXTILEWORKING T&E
COMB, MANE..................ANIMAL HUSBANDRY T&E
COMB, PET...................ANIMAL HUSBANDRY T&E
COMBINE.....................AGRICULTURAL T&E
Combine, Corn picker/sheller...AGRICULTURAL T&E
     use  COMBINE
```

330

Combine, Corn-head.............AGRICULTURAL T&E
 use COMBINE
COMBINE, GREEN PEA.............AGRICULTURAL T&E
COMBINE, PEANUT................AGRICULTURAL T&E
Combine, Pull-type.............AGRICULTURAL T&E
 use COMBINE
Combine, Self-propelled........AGRICULTURAL T&E
 use COMBINE
Combine, Side-hill.............AGRICULTURAL T&E
 use COMBINE
COME-ALONG.....................MECHANICAL T&E
 rt JACK, PULLING
COMFORTER......................BEDDING
Commander......................WOODWORKING T&E
 use BEETLE
COMMODE........................FURNITURE
Commuter car...................RAIL TRANSPORTATION EQUIPMENT
 use COACH or SELF-PROPELLED CAR
COMPACT........................TOILET ARTICLE
Compacter......................CONSTRUCTION T&E
 use ROLLER or TAMPER
COMPARATOR.....................CHEMICAL T&E
 note may be further subdivided to indicate
 specific type: e.g., COMPARATOR,
 HIGH-PHOSPHATE SLIDE; -,HYDROGEN-ION;
 -,NESSLER TUBE
COMPARATOR.....................DATA PROCESSING T&E
COMPARATOR.....................WEIGHTS & MEASURES T&E
COMPASS........................SURVEYING & NAVIGATIONAL T&E
 rt GYRO-COMPASS
COMPASS, BEAM..................DRAFTING T&E
COMPASS, BOREHOLE..............SURVEYING & NAVIGATIONAL T&E
COMPASS, BOW...................DRAFTING T&E
COMPASS, CARLSON...............SURVEYING & NAVIGATIONAL T&E
COMPASS, DIP...................SURVEYING & NAVIGATIONAL T&E
COMPASS, PROPORTIONAL..........DRAFTING T&E
COMPASS, RADIO.................SURVEYING & NAVIGATIONAL T&E
COMPASS, SURVEYOR'S............SURVEYING & NAVIGATIONAL T&E
COMPENSATOR....................SURVEYING & NAVIGATIONAL T&E
Composing machine..............PRINTING T&E
 use TYPESETTER
COMPOSING STICK................PRINTING T&E
COMPOTE........................FOOD SERVICE T&E
COMPRESSOR.....................POWER PRODUCTION T&E
 note use only if specific type is unknown
COMPRESSOR, BLOWING-ENGINE.....POWER PRODUCTION T&E
COMPRESSOR, DUPLEX AIR.........POWER PRODUCTION T&E
COMPRESSOR, ROTARY.............POWER PRODUCTION T&E
COMPRESSOR, SULLIVAN ANGLE.....POWER PRODUCTION T&E
COMPRESSOR, TURBO..............POWER PRODUCTION T&E
COMPRESSOR/DEHYDRATOR, DENTAL..MEDICAL & PSYCHOLOGICAL T&E
COMPUTER, ANALOG...............DATA PROCESSING T&E
 rt ANALYZER

```
COMPUTER, DIGITAL...............DATA PROCESSING T&E
     note use for the composite system of the CENTRAL
          PROCESSING UNIT and associated peripheral
          equipment
COMPUTER, HYBRID...............DATA PROCESSING T&E
     note use for a computer which combines analog and
          digital features
Computer, Micro................DATA PROCESSING T&E
     use MICROCOMPUTER
Computer, Mini.................DATA PROCESSING T&E
     use MINICOMPUTER
Computer, Satellite............DATA PROCESSING T&E
     use more specific term for external processing
          unit: e.g., MINICOMPUTER
CONCENTRATOR....................METALWORKING T&E
     note use only if specific type is unknown
Concentrator....................MINING T&E
     note see METALWORKING T&E for concentrators
CONCENTRATOR, CYCLONE..........METALWORKING T&E
CONCENTRATOR, ELECTROMAGNETIC..METALWORKING T&E
CONCENTRATOR, FLOTATION........METALWORKING T&E
CONCENTRATOR, JIG..............METALWORKING T&E
CONCENTRATOR, SHAKING-TABLE....METALWORKING T&E
CONCHOMETER....................BIOLOGICAL T&E
Condenser......................ELECTRICAL & MAGNETIC T&E
     use CAPACITOR
CONDENSER......................OPTICAL T&E
CONDENSER......................TEXTILEWORKING T&E
     rt  CARD DELIVERY, ROLL DRUM
CONDENSER, COTTON..............TEXTILEWORKING T&E
CONDENSER, GOULDING............TEXTILEWORKING T&E
CONDENSER, MILK................FOOD PROCESSING T&E
CONDENSER, ROTATING............NUCLEAR PHYSICS T&E
CONDENSER, RUB-APRON...........TEXTILEWORKING T&E
CONDENSER, RUB-ROLL............TEXTILEWORKING T&E
CONDENSER, TAPE................TEXTILEWORKING T&E
CONDIMENT SET..................FOOD SERVICE T&E
     note use for a set consisting of mustard jar,
          saltshaker, pepperbox, etc.
CONDITIONER, AIR...............TEMPERATURE CONTROL DEVICE
CONDITIONER, GRAIN.............FOOD PROCESSING T&E
CONDITIONER, HAY...............AGRICULTURAL T&E
     rt  MOWER/CONDITIONER
CONDITIONER, WATER.............PLUMBING FIXTURE
Conditioner, Wheat.............FOOD PROCESSING T&E
     use CONDITIONER, GRAIN
CONE, IMHOFF...................CHEMICAL T&E
CONE MACHINE...................METALWORKING T&E
CONE SUPPORT, IMHOFF...........CHEMICAL T&E
CONFORMATEUR...................BIOLOGICAL T&E
CONOGRAPH......................DRAFTING T&E
     note use only if specific type is unknown: e.g.,
          ELLIPSOGRAPH
```

CONSOLE......................DATA PROCESSING T&E
CONSTRUCTION SET, METAL........TOY
CONSTRUCTION SET, WOODEN.......TOY
CONSTRUCTION TOY...............TOY
CONTACT-PRINTING FRAME.........PHOTOGRAPHIC T&E
Container
 use only as a secondary word in a multi-word
 object name
CONTINUOUS MINER...............MINING T&E
CONTOURING INSTRUMENT, DENTAL..MEDICAL & PSYCHOLOGICAL T&E
CONTRACT......................DOCUMENTARY ARTIFACT
Control board..................LIGHTING DEVICE
 use LIGHTING CONSOLE
CONTROL UNIT, PERIPHERAL.......DATA PROCESSING T&E
CONVERTER.....................DATA PROCESSING T&E
 note may be further subdivided to indicate
 specific type: e.g., CONVERTER,
 DIGITAL-TO-ANALOG; -,ANALOG-TO-DIGITAL;
 -,CARD-TO-TAPE
CONVERTER.....................METALWORKING T&E
CONVEYOR......................MECHANICAL T&E
 note may be further subdivided to indicate
 specific type: e.g., CONVEYOR, BUCKET; -,BELT
COOKER, FEED..................AGRICULTURAL T&E
COOKER, PRESSURE..............FOOD PROCESSING T&E
Cooler, Brine.................FOOD PROCESSING T&E
 use COOLER, DAIRY
COOLER, DAIRY.................FOOD PROCESSING T&E
COOLER, LARD..................FOOD PROCESSING T&E
Cooler, Milk..................FOOD PROCESSING T&E
 use COOLER, DAIRY
Cooler, Tubular...............FOOD PROCESSING T&E
 use COOLER, DAIRY
Cooler, Unit..................FOOD PROCESSING T&E
 use COOLER, DAIRY
COOLER, WATER.................FOOD SERVICE T&E
COOLER, WINE..................FOOD SERVICE T&E
Cooling cylinder, Lard........FOOD PROCESSING T&E
 use ROLL, LARD
COOP, CHICKEN.................BUILDING
COOP, POULTRY-SHIPPING........ANIMAL HUSBANDRY T&E
Cope..........................CLOTHING, OUTERWEAR
 use CLOAK
Copper, Soldering.............METALWORKING T&E
 use IRON, SOLDERING
Cor, Tenor....................MUSICAL T&E, BRASS
 use MELLOPHONE
CORACLE.......................WATER TRANSPORTATION EQUIPMENT
 rt BULL BOAT
Cor anglais...................MUSICAL T&E, WOODWIND
 use HORN, ENGLISH
CORDAGE FRAGMENT..............ARTIFACT REMNANT

```
CORER, APPLE....................FOOD PROCESSING T&E
CORER, PINEAPPLE................FOOD PROCESSING T&E
Cork............................PRODUCT PACKAGE
     use  STOPPER, BOTTLE
CORKER, BOTTLE..................FOOD PROCESSING T&E
CORKSCREW.......................FOOD PROCESSING T&E
CORNCRIB........................BUILDING
CORNET..........................CLOTHING, HEADWEAR
CORNET..........................MUSICAL T&E, BRASS
CORNETT.........................MUSICAL T&E, BRASS
CORNHUSKER, HAND................AGRICULTURAL T&E
CORNICE SECTION.................BUILDING FRAGMENT
Cornish roll....................MINING T&E
     use  CRUSHER, ROLLER
Cornopean.......................MUSICAL T&E, BRASS
     use  CORNET
CORONOGRAPH.....................ASTRONOMICAL T&E
CORSAGE.........................ADORNMENT
CORSET..........................CLOTHING, UNDERWEAR
COSMETIC CONTAINER..............TOILET ARTICLE
Cosmolabe.......................ASTRONOMICAL T&E
     use  ASTROLABE
COSMOSPHERE.....................ASTRONOMICAL T&E
COSTUME, CLOWN..................CLOTHING, OUTERWEAR
COSTUME, DANCE..................CLOTHING, OUTERWEAR
COSTUME, HALLOWEEN..............CLOTHING, OUTERWEAR
COSTUME, HARLEQUIN..............CLOTHING, OUTERWEAR
COSTUME, MAGICIAN'S.............CLOTHING, OUTERWEAR
COSTUME, SANTA CLAUS............CLOTHING, OUTERWEAR
COSTUME, THEATER................CLOTHING, OUTERWEAR
     note use for any article of clothing created for
          use in a theatrical performance
COT.............................LEATHERWORKING T&E
COTTA...........................CLOTHING, OUTERWEAR
Cottage.........................BUILDING
     use  HOUSE
Couch...........................FURNITURE
     use  SOFA
Couch, Fainting.................FURNITURE
     use  LOUNGE
COUNTER.........................MERCHANDISING T&E
COUNTER, BLOOD..................MEDICAL & PSYCHOLOGICAL T&E
COUNTERBORE.....................METALWORKING T&E
COUNTERSINK.....................METALWORKING T&E
COUNTING APPARATUS..............BIOLOGICAL T&E
COUNTING CHAMBER................MEDICAL & PSYCHOLOGICAL T&E
COUPLER.........................DATA PROCESSING T&E
COUPON..........................ADVERTISING MEDIUM
COURTHOUSE......................BUILDING
Cover
     use  only as a secondary word in a multi-word
          object name
```

```
COVERALLS.........................CLOTHING, OUTERWEAR
Coverlet..........................BEDDING
     use   BEDSPREAD
COWBELL...........................ANIMAL HUSBANDRY T&E
COWBELL...........................MUSICAL T&E, PERCUSSION
COZY..............................FOOD SERVICE T&E
CRABBING MACHINE..................TEXTILEWORKING T&E
CRAB BOAT, CHESAPEAKE BAY.........WATER TRANSPORTATION EQUIPMENT
CRADLE............................FURNITURE
Cradle, Barley....................AGRICULTURAL T&E
     use   SCYTHE, CRADLE
CRADLE, BASKET....................LTE, HUMAN-POWERED
CRADLE, BOARD.....................LTE, HUMAN-POWERED
CRADLE, BOAT......................WATER TRANSPORTATION ACCESSORY
CRADLE, CANNON....................ARMAMENT ACCESSORY
Cradle, Grain.....................AGRICULTURAL T&E
     use   SCYTHE, CRADLE
CRADLE, HUB.......................WOODWORKING T&E
CRADLE, SLAT......................LTE, HUMAN-POWERED
CRADLE/ROCKER.....................FURNITURE
CRADLE-WITH-SPIKES................BEHAVIORAL CONTROL DEVICE
CRAKOW............................CLOTHING, FOOTWEAR
Cramp.............................WOODWORKING T&E
     use   CLAMP
CRANE.............................MECHANICAL T&E
Crane, Gooseneck..................LTE, MOTORIZED
     use   ELEVATING PLATFORM
CRANIOMETER.......................BIOLOGICAL T&E
CRATE.............................PRODUCT PACKAGE
CRATE, HOG-BREEDING...............ANIMAL HUSBANDRY T&E
CRAVAT............................CLOTHING ACCESSORY
CRAYON............................PAINTING T&E
CRAYON, LITHOGRAPHIC..............PRINTING T&E
CREASER, EDGE.....................LEATHERWORKING T&E
CREASER, HOT......................METALWORKING T&E
     rt    CHISEL, HOT
CREASING MACHINE..................METALWORKING T&E
CRECHE............................CEREMONIAL ARTIFACT
Credenza..........................FURNITURE
     use   SIDEBOARD
CREEL.............................FISHING & TRAPPING T&E
CREEL.............................TEXTILEWORKING T&E
CREEPER...........................UNCLASSIFIED T&E, SPECIAL
CRESSET...........................LIGHTING DEVICE
CRESSET...........................WOODWORKING T&E
CRIB..............................FURNITURE
Crib, Corn........................BUILDING
     use   CORNCRIB
CRIB, CRIBBING....................MINING T&E
CRIB, TOOL........................BUILDING
CRIBBAGE SET......................GAME
CRICKET BAT.......................SPORTS EQUIPMENT
```

```
CRIMPER........................GLASS & PLASTICS T&E
Crimper........................METALWORKING T&E
     use  CRIMPING MACHINE
CRIMPER, BLASTING CAP..........MINING T&E
CRIMPING MACHINE...............METALWORKING T&E
CRIMPING MACHINE...............TEXTILEWORKING T&E
Crinoline......................CLOTHING, UNDERWEAR
     use  PETTICOAT
CROCHETING MACHINE.............TEXTILEWORKING T&E
CROCK..........................FOOD PROCESSING T&E
CROCK POT......................FOOD PROCESSING T&E
CROKINOLE SET..................GAME
CROOK, HAY.....................AGRICULTURAL T&E
CROOK, SHEPHERD'S..............ANIMAL HUSBANDRY T&E
Crook, Throw...................AGRICULTURAL T&E
     use  TIER, CORN SHOCK
CROQUET MALLET.................SPORTS EQUIPMENT
CROQUET WICKET.................SPORTS EQUIPMENT
CROSIER........................PERSONAL SYMBOL
Cross..........................PERSONAL SYMBOL
     use  PENDANT, RELIGIOUS
Cross..........................CEREMONIAL ARTIFACT
     use  PLAQUE, RELIGIOUS
Crossbar.......................MINING T&E
     use  CAP, TIMBER
CROSSBOW.......................ARMAMENT T&E, EDGED
CROSS-STAFF....................SURVEYING & NAVIGATIONAL T&E
     rt   GROMA
CROSSTIE.......................RAIL TRANSPORTATION ACCESSORY
CROWBAR........................WOODWORKING T&E
CROWN..........................PERSONAL SYMBOL
CROZE..........................WOODWORKING T&E
     rt   PLANE
CRUCIBLE.......................CHEMICAL T&E
Crucible.......................GLASS & PLASTICS T&E
     use  POT
Crucifix.......................PERSONAL SYMBOL
     use  PENDANT, RELIGIOUS or PLAQUE, RELIGIOUS
Crucifix.......................CEREMONIAL ARTIFACT
     use  STATUE, RELIGIOUS
CRUET..........................FOOD SERVICE T&E
CRUET STAND....................FOOD SERVICE T&E
CRUISER, GUIDED MISSILE........WATER TRANSPORTATION EQUIPMENT
CRUISER, HEAVY.................WATER TRANSPORTATION EQUIPMENT
CRUISER, LIGHT.................WATER TRANSPORTATION EQUIPMENT
CRUMHORN.......................MUSICAL T&E, WOODWIND
CRUSHER, BALL..................MINING T&E
Crusher, Chilean...............MINING T&E
     use  CRUSHER, ROLLER
Crusher, Corn-and-cob..........AGRICULTURAL T&E
     use  GRINDER, FEED
CRUSHER, COTTONSEED............FOOD PROCESSING T&E
```

```
CRUSHER, GYRATORY...............MINING T&E
CRUSHER, HAMMER.................MINING T&E
CRUSHER, ICE...................FOOD PROCESSING T&E
CRUSHER, JAW...................MINING T&E
CRUSHER, ORE...................MINING T&E
     note use only if specific type is unknown
CRUSHER, ROLLER................MINING T&E
CRUSHER, STAMP.................MINING T&E
CRUTCH.........................PERSONAL GEAR
CRUTCH, BOOM...................WATER TRANSPORTATION ACCESSORY
CRWTH..........................MUSICAL T&E, STRINGED
CRYOMETER......................THERMAL T&E
CRYOPHORUS.....................THERMAL T&E
CUBER, HAY.....................AGRICULTURAL T&E
Cudgel.........................WOODWORKING T&E
     use  FROE CLUB
CUFF...........................CLOTHING ACCESSORY
CUFF LINK......................CLOTHING ACCESSORY
CUIRASS........................MEDICAL & PSYCHOLOGICAL T&E
CULOTTES.......................CLOTHING, OUTERWEAR
Cultipacker....................AGRICULTURAL T&E
     use  ROLLER, LAND
CULTIVATOR.....................AGRICULTURAL T&E
     note use for an animal- or machine-drawn
          cultivator on which the operator rides; may
          be further subdivided to indicate size:
          e.g., CULTIVATOR, 4-ROW
Cultivator, Chisel.............AGRICULTURAL T&E
     use  CULTIVATOR, FIELD
CULTIVATOR, FIELD..............AGRICULTURAL T&E
     note use for an animal- or machine-drawn machine
          designed for field preparation rather than
          cultivation
CULTIVATOR, GARDEN.............AGRICULTURAL T&E
     note use for any cultivator pushed by hand
CULTIVATOR, HAND...............AGRICULTURAL T&E
     note use for a hand tool employed in garden
          cultivation
CULTIVATOR, ROTARY.............AGRICULTURAL T&E
     note use for a power-driven machine employed for
          weed control and shallow mulching between
          rows of closely-spaced row-crops
Cultivator, Straddle-row.......AGRICULTURAL T&E
     use  CULTIVATOR
CULTIVATOR, WALKING............AGRICULTURAL T&E
     note use for an animal-drawn cultivator behind
          which the operator walks
Cultivator, Wheel-hoe..........AGRICULTURAL T&E
     use  CULTIVATOR, GARDEN
CULTURE APPARATUS, ANAEROBIC...BIOLOGICAL T&E
CULVERIN.......................ARMAMENT T&E, ARTILLERY
Cummerbund.....................CLOTHING ACCESSORY
     use  SASH
```

337

```
CUP.................................FOOD SERVICE T&E
CUP, AMALGAM.......................MEDICAL & PSYCHOLOGICAL T&E
CUP, CAUDLE.......................FOOD SERVICE T&E
CUP, CHOCOLATE....................FOOD SERVICE T&E
Cup, Custard......................FOOD PROCESSING T&E
     use RAMEKIN
CUP, DEMITASSE....................FOOD SERVICE T&E
CUP, DENTAL WASTE.................MEDICAL & PSYCHOLOGICAL T&E
CUP, LOVING.......................PERSONAL SYMBOL
CUP, MEASURING....................FOOD PROCESSING T&E
CUP, MUSTACHE.....................FOOD SERVICE T&E
CUP, PALETTE......................PAINTING T&E
CUP, PUNCH........................FOOD SERVICE T&E
CUP, SAKI.........................FOOD SERVICE T&E
CUP, SLIP-TRAILING................GLASS & PLASTICS T&E
Cup, Tea..........................FOOD SERVICE T&E
     use TEACUP
CUP AND BALL......................TOY
CUP AND SAUCER....................FOOD SERVICE T&E
CUP AND SAUCER, DEMITASSE.........FOOD SERVICE T&E
CUPBOARD..........................FURNITURE
     rt  CABINET
CUPBOARD, CORNER..................FURNITURE
CUPBOARD, HANGING.................FURNITURE
CUPBOARD, PRESS...................FURNITURE
CUPOLA............................BUILDING FRAGMENT
CURETTE...........................MEDICAL & PSYCHOLOGICAL T&E
     note may be further subdivided to indicate
          specific type: e.g., CURETTE, ALVEOLAR;
          -,PERIODONTAL
CURING UNIT, DENTURE..............MEDICAL & PSYCHOLOGICAL T&E
CURLER............................TOILET ARTICLE
CURLER, BUTTER....................FOOD PROCESSING T&E
CURLING BROOM.....................SPORTS EQUIPMENT
CURLING STONE.....................SPORTS EQUIPMENT
CURRENCY..........................EXCHANGE MEDIUM
     note use for paper money not coins
CURRICLE..........................LTE, ANIMAL-POWERED
CURRYCOMB.........................ANIMAL HUSBANDRY T&E
CURTAIN...........................WINDOW OR DOOR COVERING
CURTAIN, STAGE....................PUBLIC ENTERTAINMENT DEVICE
CURTAIN ROD.......................WINDOW OR DOOR COVERING
CURTAL............................MUSICAL T&E, WOODWIND
CURVE.............................DRAFTING T&E
CUSHION...........................HOUSEHOLD ACCESSORY
CUSHION, AIR......................PERSONAL GEAR
CUSHION, EMERY....................TEXTILEWORKING T&E
CUSHION, GILDER'S.................PAINTING T&E
Cuspidor..........................HOUSEHOLD ACCESSORY
     use SPITTOON
CUT-DOWN BOARD....................GLASS & PLASTICS T&E
CUTLASS...........................ARMAMENT T&E, EDGED
```

```
CUT LINER....................GLASS & PLASTICS T&E
CUTTER......................PAPERMAKING T&E
     note may be further subdivided to indicate
           specific type: e.g., CUTTER, LEVER; -,ROTARY
CUTTER......................LTE, ANIMAL-POWERED
     note use only if specific type is unknown
CUTTER......................WATER TRANSPORTATION EQUIPMENT
CUTTER, ALBANY..............LTE, ANIMAL-POWERED
CUTTER, BAR.................METALWORKING T&E
CUTTER, BOARD...............PRINTING T&E
CUTTER, BOLT................METALWORKING T&E
CUTTER, BONE................FOOD PROCESSING T&E
CUTTER, BUTTER..............FOOD PROCESSING T&E
CUTTER, CAKE................ARMAMENT ACCESSORY
CUTTER, CHANNEL BAR.........MINING T&E
CUTTER, CIDER CHEESE........FOOD PROCESSING T&E
CUTTER, CIGAR...............HOUSEHOLD ACCESSORY
CUTTER, CLINCH..............LEATHERWORKING T&E
CUTTER, CLINCH..............METALWORKING T&E
CUTTER, COAL................MINING T&E
CUTTER, COOKIE..............FOOD PROCESSING T&E
CUTTER, COUNTRY.............LTE, ANIMAL-POWERED
Cutter, Curd................FOOD PROCESSING T&E
     use  KNIFE, CURD
CUTTER, EDGE................LEATHERWORKING T&E
CUTTER, EDGE................PAINTING T&E
CUTTER, ENSILAGE............AGRICULTURAL T&E
     rt   CHOPPER, FEED
Cutter, Feed................AGRICULTURAL T&E
     use  CHOPPER, FEED
Cutter, Flail...............AGRICULTURAL T&E
     use  SHREDDER, FLAIL
Cutter, Fodder..............AGRICULTURAL T&E
     use  CHOPPER, FEED
CUTTER, FUZE................ARMAMENT ACCESSORY
Cutter, Gear................METALWORKING T&E
     use  CUTTING MACHINE, GEAR
CUTTER, GLASS...............GLASS & PLASTICS T&E
Cutter, Green bone..........FOOD PROCESSING T&E
     use  CUTTER, BONE
CUTTER, JET-PIERCING........MINING T&E
Cutter, Lead................PRINTING T&E
     use  CUTTER, SLUG
CUTTER, MAT.................PAINTING T&E
Cutter, Nail................ANIMAL HUSBANDRY T&E
     use  NIPPERS, NAIL
Cutter, Nail................METALWORKING T&E
     use  NIPPERS, NAIL
CUTTER, NOODLE..............FOOD PROCESSING T&E
CUTTER, PAPER...............PRINTING T&E
CUTTER, PAPER...............WRITTEN COMMUNICATION EQUIPMENT
CUTTER, PEG.................WOODWORKING T&E
```

339

```
CUTTER, PIPE.....................METALWORKING T&E
CUTTER, PORTLAND.................LTE, ANIMAL-POWERED
CUTTER, POTATO SEED..............AGRICULTURAL T&E
CUTTER, REVOLVING-WHEEL..........LEATHERWORKING T&E
CUTTER, ROOT.....................AGRICULTURAL T&E
CUTTER, SHINGLE..................WOODWORKING T&E
Cutter, Silage...................AGRICULTURAL T&E
     use  CUTTER, ENSILAGE
CUTTER, SLAW.....................FOOD PROCESSING T&E
CUTTER, SLUG.....................PRINTING T&E
CUTTER, SPRUE....................ARMAMENT ACCESSORY
CUTTER, STALK....................AGRICULTURAL T&E
Cutter, Stover...................AGRICULTURAL T&E
     use  CHOPPER, FEED
Cutter, Thistle-and-dock.......AGRICULTURAL T&E
     use  SPUD, WEEDING
CUTTER, TOGGLE...................GLASS & PLASTICS T&E
Cutter, Vegetable................AGRICULTURAL T&E
     use  CUTTER, ROOT
CUTTER, WAD......................ARMAMENT ACCESSORY
CUTTER, WASHER...................METALWORKING T&E
CUTTER, WEED.....................AGRICULTURAL T&E
CUTTER, WIRE.....................METALWORKING T&E
Cutter and blower, Ensilage....AGRICULTURAL T&E
     use  BLOWER, ENSILAGE
CUTTERS, MOLAR...................ANIMAL HUSBANDRY T&E
CUTTING BOARD....................FOOD PROCESSING T&E
CUTTING MACHINE..................MINING T&E
Cutting machine, Die...........METALWORKING T&E
     use  DIE-CUTTING MACHINE
CUTTING MACHINE, FOAM..........GLASS & PLASTICS T&E
CUTTING MACHINE, GEAR..........METALWORKING T&E
CUTTING MACHINE, NAIL..........METALWORKING T&E
Cutting machine, Screw.........METALWORKING T&E
     use  SCREW-CUTTING MACHINE
CUTTING TOOL, FOAM.............GLASS & PLASTICS T&E
CYANOMETER.......................ASTRONOMICAL T&E
CYCLOIDOGRAPH....................DRAFTING T&E
CYCLOMETER.......................DRAFTING T&E
CYCLORAMA........................PUBLIC ENTERTAINMENT DEVICE
CYCLOTRON........................NUCLEAR PHYSICS T&E
     note may be further subdivided to indicate
          specific type: e.g., CYCLOTRON, AVF
CYLINDER, COCKLE.................FOOD PROCESSING T&E
CYLINDER, MUSIC-BOX.............SOUND COMMUNICATION EQUIPMENT
Cylinder machine................PAPERMAKING T&E
     use  PAPER MACHINE
CYMBAL...........................MUSICAL T&E, PERCUSSION
CYMOGRAPH........................DRAFTING T&E
CYST, STORAGE....................SITE FEATURE
Cystoscope.......................MEDICAL & PSYCHOLOGICAL T&E
     use  URETHROSCOPE
```

```
DABBER.......................PRINTING T&E
DAGGER.......................ARMAMENT T&E, EDGED
     note use only if specific type is unknown: e.g.,
          PONIARD, STILLETTO
DAGUERREOTYPE................DOCUMENTARY ARTIFACT
DALMATIC.....................CLOTHING, OUTERWEAR
DAM..........................UNCLASSIFIED STRUCTURE
Dandyhorse...................LTE, HUMAN-POWERED
     use  DRAISINE
DANDY ROLL...................PAPERMAKING T&E
Darby........................MASONRY T&E
     use  FLOAT, LONG
Darner.......................TEXTILEWORKING T&E
     use  DARNING EGG
DARNING EGG..................TEXTILEWORKING T&E
DART.........................ARMAMENT T&E, EDGED
DART, AERIAL.................ARMAMENT T&E, AMMUNITION
DART, SPRING.................MINING T&E
DARTS........................GAME
DASHER.......................FOOD PROCESSING T&E
Dashiki......................CLOTHING, OUTERWEAR
     use  BLOUSE
DASYMETER....................CHEMICAL T&E
Data phone...................DATA PROCESSING T&E
     use  COUPLER
Dataplotter..................DATA PROCESSING T&E
     use  PLOTTER
Data-processing machine......DATA PROCESSING T&E
     use  more specific term: e.g., COMPUTER, ANALOG
DATA SET.....................DATA PROCESSING T&E
Davenport....................FURNITURE
     use  SOFA
DAVIT, ANCHOR................WATER TRANSPORTATION ACCESSORY
DAVIT, BOAT..................WATER TRANSPORTATION ACCESSORY
DAYBED.......................FURNITURE
     rt  LOUNGE
DAYBOOK......................DOCUMENTARY ARTIFACT
DEADEYE......................WATER TRANSPORTATION ACCESSORY
DEBEAKER.....................ANIMAL HUSBANDRY T&E
DE-BURRING MACHINE...........LEATHERWORKING T&E
DECANTER.....................FOOD SERVICE T&E
     rt  CARAFE
DECATING MACHINE.............TEXTILEWORKING T&E
DECKLE.......................PAPERMAKING T&E
DECK TENNIS RING.............SPORTS EQUIPMENT
DECLINOMETER.................ELECTRICAL & MAGNETIC T&E
DECODER......................DATA PROCESSING T&E
DECOY........................ARMAMENT ACCESSORY
DEED.........................DOCUMENTARY ARTIFACT
DEFLECTOR....................NUCLEAR PHYSICS T&E
     note use for any device which distorts a particle
          orbit so it can be removed from the
          accelerator to strike a target
```

DEFLECTOR......................SURVEYING & NAVIGATIONAL T&E
DEHAIRING MACHINE..............LEATHERWORKING T&E
DEHORNER.......................ANIMAL HUSBANDRY T&E
DEHUMIDIFIER...................TEMPERATURE CONTROL DEVICE
DEHYDRATOR, DENTAL.............MEDICAL & PSYCHOLOGICAL T&E
DELAWARE DUCKER................WATER TRANSPORTATION EQUIPMENT
 rt SKIFF, GUNNING
DELAWARE RIVER TUCKUP..........WATER TRANSPORTATION EQUIPMENT
DEMI-CANNON....................ARMAMENT T&E, ARTILLERY
DEMI-CULVERIN..................ARMAMENT T&E, ARTILLERY
DEMIJOHN.......................PRODUCT PACKAGE
 rt BOTTLE
DEMITASSE SET..................FOOD SERVICE T&E
DENDROMETER....................FORESTRY T&E
DENSIMETER.....................MECHANICAL T&E
DENSITOMETER...................PHOTOGRAPHIC T&E
DENTAL DISK, ABRASIVE..........MEDICAL & PSYCHOLOGICAL T&E
DENTURES.......................PERSONAL GEAR
DEPOT..........................BUILDING
 rt TERMINAL
DERBY..........................CLOTHING, HEADWEAR
Derrick........................MECHANICAL T&E
 use CRANE
DERRICK........................MINING T&E
DERRICK, GRAIN-STACKING........AGRICULTURAL T&E
DERRINGER......................ARMAMENT T&E, FIREARM
 rt PISTOL
DESICCATOR, BALANCE............NUCLEAR PHYSICS T&E
DESK...........................FURNITURE
DESK, CAMPAIGN.................FURNITURE
DESK, DROP-FRONT...............FURNITURE
 rt SECRETARY
Desk, Lap......................WRITTEN COMMUNICATION EQUIPMENT
 use DESK, PORTABLE
DESK, PORTABLE.................WRITTEN COMMUNICATION EQUIPMENT
DESK, QUARTER-CYLINDER.........FURNITURE
DESK, ROLLTOP..................FURNITURE
DESK, SLANT-TOP................FURNITURE
DESK, TAMBOUR..................FURNITURE
DESK SET.......................WRITTEN COMMUNICATION EQUIPMENT
DESSICATOR.....................CHEMICAL T&E
DESTROYER......................WATER TRANSPORTATION EQUIPMENT
DESTROYER ESCORT...............WATER TRANSPORTATION EQUIPMENT
Detector, Firedamp.............MINING T&E
 use DETECTOR, GAS
DETECTOR, GAS..................MINING T&E
DETECTOR, HEATMOUNT............ANIMAL HUSBANDRY T&E
DETECTOR, MINE.................ARMAMENT ACCESSORY
DETONATOR......................MINING T&E
Device
 use only as a secondary word in a multi-word
 object name

DHOW.........................WATER TRANSPORTATION EQUIPMENT
DIABOLO......................TOY
 rt TOP
DIADEM.......................PERSONAL SYMBOL
DIAL, MINER'S................MINING T&E
DIAPER.......................CLOTHING, UNDERWEAR
DIAPHANOMETER................METEOROLOGICAL T&E
DIAPHRAGM....................PHOTOGRAPHIC T&E
DIARY........................DOCUMENTARY ARTIFACT
DIBBLE.......................AGRICULTURAL T&E
Dibble board.................AGRICULTURAL T&E
 use DIBBLE
DIBBLING MACHINE.............AGRICULTURAL T&E
DICE.........................GAME
DICE CUP.....................GAME
DICHROSCOPE..................OPTICAL T&E
DICKEY.......................CLOTHING ACCESSORY
DICTATING MACHINE............SOUND COMMUNICATION EQUIPMENT
DIE..........................METALWORKING T&E
DIE..........................GAME
DIE, BINDER..................PRINTING T&E
DIE, LOADING.................ARMAMENT ACCESSORY
 rt LOADING TOOL
DIE, TOE-CALK WELDING........METALWORKING T&E
DIE-CUTTING MACHINE..........LEATHERWORKING T&E
DIE-CUTTING MACHINE..........METALWORKING T&E
DIFFERENCE-TONE APPARATUS....ACOUSTICAL T&E
DIFFUSIOMETER................CHEMICAL T&E
DIGESTER.....................PAPERMAKING T&E
DIGGER, POST-HOLE............UNCLASSIFIED T&E, GENERAL
 rt AUGER, POST-HOLE
DIGGER, POTATO...............AGRICULTURAL T&E
Digger, Thistle..............AGRICULTURAL T&E
 use SPUD, WEEDING
DILATOMETER..................CHEMICAL T&E
Diligence....................LTE, ANIMAL-POWERED
 use STAGECOACH
DIMMER.......................LIGHTING DEVICE
Dingelstuck..................METALWORKING T&E
 use ANVIL, SCYTHE-SHARPENING
DINGHY.......................WATER TRANSPORTATION EQUIPMENT
 rt TENDER, YACHT
DINGHY, BAHAMA...............WATER TRANSPORTATION EQUIPMENT
DINGHY, SAILING..............WATER TRANSPORTATION EQUIPMENT
 note use only if specific type is unknown; see
 also SAILBOAT
DINING CAR...................RAIL TRANSPORTATION EQUIPMENT
 note use for any car designed to be used for food
 preparation and/or food service
DINING SUITE.................FURNITURE
DIORAMA......................DOCUMENTARY ARTIFACT
 rt ROOM, MINIATURE

DIORAMA, AUTOMATA................DOCUMENTARY ARTIFACT
Dip.............................WOODWORKING T&E
 use GAUGE ROD
DIP BOX.........................MINING T&E
DIPLEIDOSCOPE...................ASTRONOMICAL T&E
DIPLOMA.........................DOCUMENTARY ARTIFACT
DIPPER..........................FOOD PROCESSING T&E
DIPPER, TURPENTINE..............FORESTRY T&E
DIPPER, WHALE-OIL...............FISHING & TRAPPING T&E
Diptych.........................CEREMONIAL ARTIFACT
 use ALTARPIECE
DIRECTION FINDER................SURVEYING & NAVIGATIONAL T&E
DIRECTION FINDER, RADIO.........SURVEYING & NAVIGATIONAL T&E
Dirigible.......................AEROSPACE TRANSPORTATION EQUIPMENT
 use AIRSHIP
DIRK............................ARMAMENT T&E, EDGED
DIRNDL..........................CLOTHING, OUTERWEAR
DISC, MUSIC-BOX.................SOUND COMMUNICATION EQUIPMENT
DISCUS..........................SPORTS EQUIPMENT
DISH............................CHEMICAL T&E
 note may be further subdivided to indicate
 specific type: e.g., DISH, PETRI;
 -,EVAPORATING
DISH, BAKING....................FOOD PROCESSING T&E
DISH, BONBON....................FOOD SERVICE T&E
DISH, BONE......................FOOD SERVICE T&E
DISH, BUTTER....................FOOD SERVICE T&E
DISH, CANDY.....................FOOD SERVICE T&E
DISH, CELERY....................FOOD SERVICE T&E
DISH, CHAFING...................FOOD PROCESSING T&E
DISH, CHEESE....................FOOD SERVICE T&E
DISH, CHILD'S...................FOOD SERVICE T&E
DISH, CHILD'S FEEDING...........FOOD SERVICE T&E
DISH, CULTURE...................BIOLOGICAL T&E
DISH, PETRI.....................BIOLOGICAL T&E
DISH, RELISH....................FOOD SERVICE T&E
DISH, SOAP......................HOUSEHOLD ACCESSORY
DISH, SOUFFLE...................FOOD PROCESSING T&E
DISH, VEGETABLE.................FOOD SERVICE T&E
DISH, WASTE.....................FOOD SERVICE T&E
Dish set........................FOOD SERVICE T&E
 use TABLEWARE SET
DISK, MAGNETIC..................DATA PROCESSING T&E
DISK UNIT.......................DATA PROCESSING T&E
DISPENSER, CAP..................ARMAMENT ACCESSORY
DISPENSER, DENTAL...............MEDICAL & PSYCHOLOGICAL T&E
DISPLAY PIECE...................ADVERTISING MEDIUM
DISPLAY STAND...................MERCHANDISING T&E
DISPLAY UNIT, VISUAL............DATA PROCESSING T&E
 note use only for a CRT output display unit which
 cannot function as an interactive terminal
DISPOSER........................PLUMBING FIXTURE

```
DISTAFF...........................TEXTILEWORKING T&E
DISTANCE FINDER...................SURVEYING & NAVIGATIONAL T&E
DISTILLING APPARATUS..............CHEMICAL T&E
     rt   FLASK, DISTILLING; RECEIVER; RETORT
DISTRIBUTOR, FERTILIZER...........AGRICULTURAL T&E
Ditching machine..................CONSTRUCTION T&E
     use  TRENCHING MACHINE
Divan.............................FURNITURE
     use  SOFA, SETTEE or LOVE SEAT
DIVIDERS..........................DRAFTING T&E
DIVIDERS, CHART...................DRAFTING T&E
DIVIDING ENGINE...................DRAFTING T&E
DIVINING ROD......................MINING T&E
DOCK..............................UNCLASSIFIED STRUCTURE
DOCKER............................ANIMAL HUSBANDRY T&E
DOG...............................WOODWORKING T&E
Dog, Hewing.......................FORESTRY T&E
     use  DOG, LOG
DOG, HOOPING......................WOODWORKING T&E
DOG, JOINER'S.....................WOODWORKING T&E
DOG, LATHE........................METALWORKING T&E
     note may be further subdivided to indicate
          specific type: e.g., DOG, LATHE--BENT TAIL;
          -,LATHE--CLAMP
DOG, LOG..........................FORESTRY T&E
Dog, Post.........................FORESTRY T&E
     use  DOG, LOG
DOG, RAFT.........................FORESTRY T&E
DOG, RING.........................FORESTRY T&E
DOG, SPAN.........................FORESTRY T&E
DOG, SPOKE........................WOODWORKING T&E
Dog, Timber.......................FORESTRY T&E
     use  DOG, LOG
Dog, Tiring.......................METALWORKING T&E
     use  TONGS, TIRE-PULLING
DOGHOUSE..........................SITE FEATURE
DOGSLED...........................LTE, ANIMAL-POWERED
DOILY.............................HOUSEHOLD ACCESSORY
DOLL..............................TOY
     rt   LAY FIGURE; MANIKIN; MARIONETTE; PUPPET, HAND
DOLL..............................CEREMONIAL ARTIFACT
     note may be further subdivided to indicate
          specific type: e.g., DOLL, EFFIGY; -,KACHINA
DOLL, MECHANICAL..................TOY
Doll, Paper.......................TOY
     use  PAPER DOLL
DOLLHOUSE.........................TOY
DOLLY.............................METALWORKING T&E
DOLLY.............................LTE, HUMAN-POWERED
DOLLY.............................LTE, MOTORIZED
DOLLY, TIMBER.....................FORESTRY T&E
DOLMEN............................CEREMONIAL ARTIFACT
```

345

Dome, Cheese.....................FOOD SERVICE T&E
 use DOME, FOOD
DOME, FOOD.......................FOOD SERVICE T&E
DOMINOES.........................GAME
Donut............................NUCLEAR PHYSICS T&E
 use VACUUM CHAMBER
DOOR.............................BUILDING FRAGMENT
DOOR, ACCORDION..................BUILDING FRAGMENT
DOOR, SCREEN.....................BUILDING FRAGMENT
DOORBELL.........................BUILDING FRAGMENT
DOOR CAP.........................BUILDING FRAGMENT
DOORCASE.........................BUILDING FRAGMENT
DOOR ENFRAMEMENT.................BUILDING FRAGMENT
 note use for entire structure: i.e., DOORCASE and
 DOORFRAME plus, possibly, other parts such
 as the DOOR, FANLIGHT, SIDELIGHT, etc.
DOORFRAME........................BUILDING FRAGMENT
DOORKNOB.........................BUILDING FRAGMENT
DOORMAT..........................FLOOR COVERING
DOOR PANEL.......................BUILDING FRAGMENT
DOORSTOP.........................HOUSEHOLD ACCESSORY
DORMER...........................BUILDING FRAGMENT
DORY.............................WATER TRANSPORTATION EQUIPMENT
 note may be further subdivided to indicate
 specific type: e.g., DORY, BANKS;
 -,CHAMBERLAIN; -,SWAMPSCOTT
DOSIMETER........................CHEMICAL T&E
Double boiler....................FOOD PROCESSING T&E
 use BOILER, DOUBLE
DOUBLE-SEAMING MACHINE...........METALWORKING T&E
Doublet..........................CLOTHING, OUTERWEAR
 use JERKIN
DOVE-TAILING MACHINE.............WOODWORKING T&E
DOWEL............................WOODWORKING T&E
 rt TREENAIL; PEG
DOWEL CENTER.....................WOODWORKING T&E
Dowel cutter.....................WOODWORKING T&E
 use CUTTER, PEG
Dowel plate......................WOODWORKING T&E
 use CUTTER, PEG
DOWNSHAVE, COOPER'S..............WOODWORKING T&E
Dozer............................CONSTRUCTION T&E
 use BULLDOZER
DRAFTING MACHINE.................DRAFTING T&E
Drag, Hay........................AGRICULTURAL T&E
 use RAKE, HAY-BUNCHING
Drag, Plank......................AGRICULTURAL T&E
 use DRAG, SMOOTHING
DRAG, SMOOTHING..................AGRICULTURAL T&E
DRAISINE.........................LTE, HUMAN-POWERED
Drape............................WINDOW OR DOOR COVERING
 use DRAPERY

```
DRAPERY.............................WINDOW OR DOOR COVERING
DRAWERS.............................CLOTHING, UNDERWEAR
DRAWING.............................ORIGINAL ART
DRAWING FRAME.......................TEXTILEWORKING T&E
     note use only if specific type is unknown: e.g.,
           THROSTLE FRAME, DRAWING
DRAWING-IN MACHINE..................TEXTILEWORKING T&E
DRAWKNIFE...........................WOODWORKING T&E
     rt   DRAWSHAVE; JIGGER; SCORPER, CLOSED; SCORPER,
          OPEN; SPOKESHAVE
DRAWKNIFE, BACKING..................WOODWORKING T&E
DRAWKNIFE, BARKING..................WOODWORKING T&E
DRAWKNIFE, CHAMFERING...............WOODWORKING T&E
DRAWKNIFE, COOPER'S.................WOODWORKING T&E
DRAWKNIFE, HEADING..................WOODWORKING T&E
DRAWKNIFE, HOLLOWING................WOODWORKING T&E
DRAWKNIFE, HORNWORKER'S.............UNCLASSIFIED T&E, SPECIAL
DRAWKNIFE, WHEELWRIGHT'S............WOODWORKING T&E
DRAWSHAVE...........................WOODWORKING T&E
     rt   DRAWKNIFE; SPOKESHAVE
DRAY................................LTE, ANIMAL-POWERED
Dreadnought.........................WATER TRANSPORTATION EQUIPMENT
     use BATTLESHIP
DREDGE..............................MINING T&E
     note use only if specific type is unknown
DREDGE..............................WATER TRANSPORTATION EQUIPMENT
DREDGE, BUCKETLINE..................MINING T&E
DREDGE, CRAB........................FISHING & TRAPPING T&E
DREDGE, OYSTER......................FISHING & TRAPPING T&E
DREDGE, SCALLOP.....................FISHING & TRAPPING T&E
DREDGE, SUCTION.....................MINING T&E
DREDGE BOAT, CHESAPEAKE BAY.........WATER TRANSPORTATION EQUIPMENT
DREDGER.............................FOOD PROCESSING T&E
DRENCHER............................ANIMAL HUSBANDRY T&E
DRESS...............................CLOTHING, OUTERWEAR
     rt   GOWN
DRESS, FOLK.........................CLOTHING, OUTERWEAR
     note use for ethnic clothing worn on special
           occasions such as weddings and festivals
Dresser.............................FURNITURE
     use CHEST OF DRAWERS
DRESSER.............................TEXTILEWORKING T&E
DRESSER SET.........................TOILET ARTICLE
DRESS FORM..........................TEXTILEWORKING T&E
DRESSING CASE.......................FURNITURE
     rt   TABLE, DRESSING; CHEST OF DRAWERS
Dressing glass......................FURNITURE
     use MIRROR, CHEVAL
Dressing table......................FURNITURE
     use TABLE, DRESSING
DRIFT...............................METALWORKING T&E
     note use for a cutting tool; do not confuse with
           PIN, DRIFT or PUNCH, DRIFT
```

DRIFTSIGHT.....................SURVEYING & NAVIGATIONAL T&E
Drill..........................CONSTRUCTION T&E
 note see MINING T&E
DRILL..........................MASONRY T&E
 note may be further subdivided to indicate
 specific type: e.g., DRILL, OCTAGONAL;
 -,ROUND
DRILL..........................METALWORKING T&E
 note use for a rotating device designed to hold a
 BIT in a fixed position; use only if
 specific type is unknown; e.g., DRILL PRESS;
 DRILL, HAND
DRILL..........................MINING T&E
 note use only if specific type is unknown
 rt HANDSTEEL
DRILL..........................WOODWORKING T&E
 note use only for a rotating device designed to
 hold a BIT in a fixed position
 rt BRACE
Drill, Barrow..................AGRICULTURAL T&E
 use DRILL, SEED
Drill, Calyx...................MINING T&E
 use DRILL, SHOT
DRILL, CHURN...................MINING T&E
DRILL, CORE....................MINING T&E
 note use only if specific type is unknown
DRILL, DENTAL..................MEDICAL & PSYCHOLOGICAL T&E
DRILL, DIAMOND.................MINING T&E
Drill, Disk....................AGRICULTURAL T&E
 use DRILL, SEED
Drill, Drifter.................MINING T&E
 use DRILL, PERCUSSIVE AIR
DRILL, ELECTRIC PORTABLE.......METALWORKING T&E
Drill, Fertilizer..............AGRICULTURAL T&E
 use DRILL, SEED
DRILL, FIRE....................HOUSEHOLD ACCESSORY
DRILL, FLEXIBLE-SHAFT..........GLASS & PLASTICS T&E
DRILL, GANG....................MINING T&E
Drill, Garden..................AGRICULTURAL T&E
 use DRILL, SEED
Drill, Grain...................AGRICULTURAL T&E
 use DRILL, SEED
Drill, Hand....................AGRICULTURAL T&E
 use DRILL, SEED
DRILL, HAND....................METALWORKING T&E
Drill, Hoe.....................AGRICULTURAL T&E
 use DRILL, SEED
DRILL, JETTING.................MINING T&E
DRILL, PERCUSSIVE..............MINING T&E
 note may be further subdivided to indicate method
 of activation: e.g., DRILL, PERCUSSIVE AIR
Drill, Pole....................MINING T&E
 use DRILL, CHURN

```
Drill, Press.....................AGRICULTURAL T&E
     use  DRILL, SEED
DRILL, ROTARY....................MINING T&E
     note may be further subdivided to indicate method
          of activation: e.g., DRILL, ROTARY AIR;
          -,ROTARY HYDRAULIC
DRILL, SEED......................AGRICULTURAL T&E
Drill, Shoe......................AGRICULTURAL T&E
     use  DRILL, SEED
DRILL, SHOT......................MINING T&E
DRILL, SINKER....................MINING T&E
DRILL, STOPPER...................MINING T&E
DRILL, TURBO.....................MINING T&E
Drill, Walking...................AGRICULTURAL T&E
     use  DRILL, SEED
Drill, Well......................MINING T&E
     use  more specific term: e.g., DRILL, CHURN;
          -,ROTARY
Drill, Wheelbarrow...............AGRICULTURAL T&E
     use  DRILL, SEED
DRILL PRESS......................METALWORKING T&E
     note may be further subdivided to indicate
          specific type: e.g., DRILL PRESS,
          MULTIPLE-SPINDLE; -,SENSITIVE; -,GANG;
          -,BLACKSMITH'S
Drill stock......................WOODWORKING T&E
     use  DRILL
Drone............................AEROSPACE TRANSPORTATION EQUIPMENT
     use  AIRPLANE
DROP.............................PUBLIC ENTERTAINMENT DEVICE
     note may be further subdivided to indicate
          specific type: e.g., DROP, FLAT; -,ROLL;
          -,SCRIM
Drop forge.......................METALWORKING T&E
     use  HAMMER, DROP
Drop hammer......................METALWORKING T&E
     use  HAMMER, DROP
DROSHSKY.........................LTE, ANIMAL-POWERED
DROSOMETER.......................METEOROLOGICAL T&E
Drug.............................FORESTRY T&E
     use  DOLLY, TIMBER
DRUM.............................MUSICAL T&E, PERCUSSION
DRUM, BASS.......................MUSICAL T&E, PERCUSSION
DRUM, BONGO......................MUSICAL T&E, PERCUSSION
DRUM, MAGNETIC...................DATA PROCESSING T&E
DRUM, SAWDUST....................LEATHERWORKING T&E
DRUM, SIDE.......................MUSICAL T&E, PERCUSSION
DRUM, SNARE......................MUSICAL T&E, PERCUSSION
DRUM, TENOR......................MUSICAL T&E, PERCUSSION
DRY DOCK, FLOATING...............WATER TRANSPORTATION EQUIPMENT
DRYER............................HOUSEKEEPING T&E
DRYER............................PAPERMAKING T&E
```

DRYER........................TEXTILEWORKING T&E
 note may be further subdivided to indicate
 specific type: e.g., DRYER, LOOP; -,REEL
DRYER, CROP....................AGRICULTURAL T&E
DRYER, FILM....................PHOTOGRAPHIC T&E
Dryer, Grain...................AGRICULTURAL T&E
 use DRYER, CROP
DRYER, HAIR....................TOILET ARTICLE
Dryer, Milk....................FOOD PROCESSING T&E
 use EVAPORATOR, MILK
DRYER, PRINT...................PHOTOGRAPHIC T&E
DRYER, TANKAGE.................FOOD PROCESSING T&E
DRYING MACHINE.................LEATHERWORKING T&E
Drying rack....................HOUSEKEEPING T&E
 use RACK, DRYING
Duckpin........................SPORTS EQUIPMENT
 use BOWLING PIN
DUCTILEMETER...................MECHANICAL T&E
DULANG.........................MINING T&E
DULCIAN........................MUSICAL T&E, WOODWIND
DULCIMER.......................MUSICAL T&E, STRINGED
 note may be further subdivided to indicate
 specific type: e.g., DULCIMER, APPALACHIAN;
 -,HAMMERED
DUMBBELL.......................SPORTS EQUIPMENT
DUMBWAITER.....................BUILDING FRAGMENT
Dumbwaiter.....................FURNITURE
 use TABLE, TIER
DUMMY..........................GLASS & PLASTICS T&E
DUMMY, DIP.....................GLASS & PLASTICS T&E
DUPLEX.........................BUILDING
DUPLICATOR.....................PRINTING T&E
 rt MIMEOGRAPH
DUST COLLECTOR.................FOOD PROCESSING T&E
 note may be further subdivided to indicate
 specific type: e.g., DUST COLLECTOR,
 CYCLONE; -,TUBULAR
Duster.........................CLOTHING, OUTERWEAR
 use HOUSECOAT
DUSTER.........................TEXTILEWORKING T&E
 note may be further subdivided to indicate
 specific type: e.g., DUSTER, BOX; -,CONE
DUSTER, BRAN...................FOOD PROCESSING T&E
DUSTER, DRY-POWDER.............AGRICULTURAL T&E
Duster, Hand...................AGRICULTURAL T&E
 use DUSTER, DRY-POWDER
Duster, Potato.................AGRICULTURAL T&E
 use DUSTER, DRY-POWDER
Duster, Saddle-gun.............AGRICULTURAL T&E
 use DUSTER, DRY-POWDER
Duster, Tobacco................AGRICULTURAL T&E
 use DUSTER, DRY-POWDER

```
DUSTPAN...........................HOUSEKEEPING T&E
DUST RUFFLE.......................BEDDING
DYEING MACHINE....................TEXTILEWORKING T&E
DYNACTINOMETER....................OPTICAL T&E
DYNAMETER.........................OPTICAL T&E
Dynamo............................POWER PRODUCTION T&E
     use  GENERATOR
DYNAMOMETER.......................MECHANICAL T&E
EARMUFFS..........................CLOTHING, HEADWEAR
EARPHONE..........................PERSONAL GEAR
EARPHONE..........................SOUND COMMUNICATION EQUIPMENT
Earplug...........................ADORNMENT
     use  EAR SPOOL
EARPLUG...........................PERSONAL GEAR
EARRING...........................ADORNMENT
EAR SPOOL.........................ADORNMENT
EARTHWORK.........................UNCLASSIFIED STRUCTURE
EAR TRUMPET.......................PERSONAL GEAR
EASEL.............................FURNITURE
EASEL.............................PAINTING T&E
EASEL.............................PHOTOGRAPHIC T&E
EBULLIOSCOPE......................THERMAL T&E
ECCENTROLINEAD....................DRAFTING T&E
ECHOMETER.........................SURVEYING & NAVIGATIONAL T&E
ECHOPPE...........................PRINTING T&E
ECHOSCOPE.........................MEDICAL & PSYCHOLOGICAL T&E
ECLIPSAREON.......................ASTRONOMICAL T&E
Edger, Lawn.......................AGRICULTURAL T&E
     use  EDGER, TURF
EDGER, TURF.......................AGRICULTURAL T&E
EDGE RUNNER.......................PAPERMAKING T&E
EELPOT............................FISHING & TRAPPING T&E
Effigy............................FOOD SERVICE T&E
     use  only as a subdivision of another term: e.g.,
          BOWL, EFFIGY; PITCHER, EFFIGY
EFFLUENT SAMPLER..................CHEMICAL T&E
EGGBEATER.........................FOOD PROCESSING T&E
EGGCUP............................FOOD SERVICE T&E
Eidograph.........................DRAFTING T&E
     use  PANTOGRAPH
Eidoscope.........................TOY
     use  KALEIDOSCOPE
EIKONOMETER.......................OPTICAL T&E
ELACOMETER........................CHEMICAL T&E
ELECTRIFIER, FLOUR-BLEACHING......FOOD PROCESSING T&E
ELECTRODE.........................ELECTRICAL & MAGNETIC T&E
ELECTROMETER......................ELECTRICAL & MAGNETIC T&E
ELEVATING BAR.....................ARMAMENT ACCESSORY
ELEVATOR..........................BUILDING FRAGMENT
ELEVATOR, AUGER...................AGRICULTURAL T&E
ELEVATOR, BALE....................AGRICULTURAL T&E
ELEVATOR, GRAIN...................FOOD PROCESSING T&E
```

```
ELEVATOR, HYDRAULIC............MINING T&E
ELEVATOR, MALAR................MEDICAL & PSYCHOLOGICAL T&E
ELEVATOR, PERIOSTEAL...........MEDICAL & PSYCHOLOGICAL T&E
ELEVATOR, ROOT.................MEDICAL & PSYCHOLOGICAL T&E
ELLIPSOGRAPH...................DRAFTING T&E
Elliptograph..................DRAFTING T&E
     use  ELLIPSOGRAPH
E-machine.....................MINING T&E
     use  BLOWING MACHINE
EMASCULATOR...................ANIMAL HUSBANDRY T&E
Emblem........................PERSONAL SYMBOL
     use  more specific term: e.g., PIN, PATCH or MEDAL
EMBROIDERY MACHINE............TEXTILEWORKING T&E
Emulsior, Milk................FOOD PROCESSING T&E
     use  HOMOGENIZER, MILK
ENCODER.......................DATA PROCESSING T&E
ENDOSCOPE.....................MEDICAL & PSYCHOLOGICAL T&E
ENGINE........................AEROSPACE TRANSPORTATION ACCESSORY
     note may be further subdivided to indicate
          specific type: e.g., ENGINE, RADIAL;
          -,RECIPROCATING; -,TURBOJET; -,TURBOPROP
Engine........................RAIL TRANSPORTATION EQUIPMENT
     use  LOCOMOTIVE
Engine, Blowing...............METALWORKING T&E
     use  BLOWING ENGINE
Engine, Compression-ignition...POWER PRODUCTION T&E
     use  ENGINE, DIESEL
ENGINE, DIESEL................POWER PRODUCTION T&E
ENGINE, GAS...................POWER PRODUCTION T&E
ENGINE, GASOLINE..............POWER PRODUCTION T&E
ENGINE, HOT-AIR...............POWER PRODUCTION T&E
ENGINE, LIQUID-FUEL...........POWER PRODUCTION T&E
     note use only if specific type is unknown: e.g.,
          ENGINE, GASOLINE
ENGINE, MAN...................MINING T&E
ENGINE, OIL-TRACTION..........POWER PRODUCTION T&E
ENGINE, RAMJET................POWER PRODUCTION T&E
ENGINE, STEAM.................POWER PRODUCTION T&E
ENGINE, STEAM.................TOY
ENGINE, STEAM-GAS.............POWER PRODUCTION T&E
ENGINE, STEAM-TRACTION........POWER PRODUCTION T&E
Engine, Train.................TOY
     use  LOCOMOTIVE
Engiscope.....................OPTICAL T&E
     use  MICROSCOPE
ENGRAVER'S BLOCK..............PRINTING T&E
ENGRAVING MACHINE.............GLASS & PLASTICS T&E
ENGRAVING PLATE...............PRINTING T&E
     rt   WOOD BLOCK
ENLARGER......................PHOTOGRAPHIC T&E
ENTABLATURE...................BUILDING FRAGMENT
EPAULET.......................PERSONAL SYMBOL
```

```
EPERGNE......................FOOD SERVICE T&E
Ephemera.....................DOCUMENTARY ARTIFACT
     use  more specific term: e.g., PROGRAM,
          INVITATION, LETTER
EQUINOCTIAL..................MEDICAL & PSYCHOLOGICAL T&E
Equipment
     use  only as a secondary word in a multi-word
          object name
ERASER.......................WRITTEN COMMUNICATION EQUIPMENT
Erector set..................TOY
     use  CONSTRUCTION SET, METAL
ERIOMETER....................WEIGHTS & MEASURES T&E
ESPADRILLE...................CLOTHING, FOOTWEAR
Esthesiometer................BIOLOGICAL T&E
     use  AESTHESIOMETER
ESTOQUE......................SPORTS EQUIPMENT
ETAGERE......................FURNITURE
     rt   WHATNOT
ETUI.........................PERSONAL GEAR
EUPHONIUM....................MUSICAL T&E, BRASS
EVACUATOR, DENTAL............MEDICAL & PSYCHOLOGICAL T&E
EVAPORATOR, MILK.............FOOD PROCESSING T&E
EVAPORATOR, SUGAR............FOOD PROCESSING T&E
EVAPORIMETER.................THERMAL T&E
Ewer.........................FOOD SERVICE T&E
     use  PITCHER
Excavator....................CONSTRUCTION T&E
     use  more specific term: e.g., BACKHOE, TRENCHING
          MACHINE
EXCAVATOR, DENTAL............MEDICAL & PSYCHOLOGICAL T&E
EXCITER......................POWER PRODUCTION T&E
EXCURSION VESSEL.............WATER TRANSPORTATION EQUIPMENT
Exercise equipment...........SPORTS EQUIPMENT
     use  more specific term: e.g., DUMBBELL, BARBELL,
          ROWING MACHINE, INDIAN CLUB
Exploder.....................MINING T&E
     use  DETONATOR
EXPLORER, DENTAL.............MEDICAL & PSYCHOLOGICAL T&E
Express car..................RAIL TRANSPORTATION EQUIPMENT
     use  BAGGAGE CAR
EXTENSOMETER.................WEIGHTS & MEASURES T&E
EXTINGUISHER, CANDLE.........LIGHTING DEVICE
EXTINGUISHER, FIRE...........UNCLASSIFIED T&E, SPECIAL
EXTRACTOR....................CHEMICAL T&E
EXTRACTOR, CALK..............ANIMAL HUSBANDRY T&E
EXTRACTOR, FETAL.............ANIMAL HUSBANDRY T&E
EXTRACTOR, FUZE..............ARMAMENT ACCESSORY
EXTRACTOR, HONEY.............FOOD PROCESSING T&E
EXTRACTOR HOOP...............ARMAMENT ACCESSORY
EXTRUDER.....................GLASS & PLASTICS T&E
EXTRUDER.....................METALWORKING T&E
EYECUP.......................TOILET ARTICLE
```

EYEDROPPER....................TOILET ARTICLE
EYEGLASSES....................PERSONAL GEAR
EYESHADE......................CLOTHING, HEADWEAR
FACIOMETER....................MEDICAL & PSYCHOLOGICAL T&E
Factory.......................BUILDING
 use PLANT, INDUSTRIAL
FADEOMETER....................TEXTILEWORKING T&E
FAIRLEAD......................WATER TRANSPORTATION ACCESSORY
FALCON........................ARMAMENT T&E, ARTILLERY
FALCONET......................ARMAMENT T&E, ARTILLERY
FALL MACHINE..................MECHANICAL T&E
FALSE MUZZLE..................ARMAMENT ACCESSORY
False teeth...................PERSONAL GEAR
 use DENTURES
FAN...........................PERSONAL GEAR
Fan, Dutch....................AGRICULTURAL T&E
 use MILL, FANNING
FAN, ELECTRIC.................TEMPERATURE CONTROL DEVICE
FAN, VENTILATION..............MINING T&E
Fan, Winnowing................AGRICULTURAL T&E
 use BASKET, WINNOWING or MILL, FANNING
FANLIGHT......................BUILDING FRAGMENT
 rt WINDOW SASH
FARMSTEAD.....................BUILDING
 note use for the buildings and adjacent service
 areas of a farm; broadly, a farm with its
 buildings
FARTHINGALE...................CLOTHING, UNDERWEAR
FATHOMETER....................SURVEYING & NAVIGATIONAL T&E
FAUCET........................PLUMBING FIXTURE
FEATHER.......................MASONRY T&E
FEATHER, TIPPING..............LEATHERWORKING T&E
FECALYZER.....................ANIMAL HUSBANDRY T&E
FEDORA........................CLOTHING, HEADWEAR
FEED, CARDING.................TEXTILEWORKING T&E
FEEDBAG.......................ANIMAL HUSBANDRY T&E
FEED BUNKS....................ANIMAL HUSBANDRY T&E
FEED CARRIER..................ANIMAL HUSBANDRY T&E
Feeder, Bird..................SITE FEATURE
 use BIRD FEEDER
FEEDER, BLENDING..............FOOD PROCESSING T&E
FEEDER, ESOPHAGEAL............ANIMAL HUSBANDRY T&E
FEEDER, FLOUR-BLEACHING.......FOOD PROCESSING T&E
FEEDER, LIVESTOCK.............ANIMAL HUSBANDRY T&E
FEEDER, POULTRY...............ANIMAL HUSBANDRY T&E
FEEDER, ROLL..................FOOD PROCESSING T&E
FEEDER, ROOT..................AGRICULTURAL T&E
FELTING MACHINE...............TEXTILEWORKING T&E
FELUCCA.......................WATER TRANSPORTATION EQUIPMENT
FENCE CHARGER.................ANIMAL HUSBANDRY T&E
FENCE SECTION.................SITE FEATURE
 rt BARBWIRE SECTION

```
FENCING EPEE...................SPORTS EQUIPMENT
     rt  SABER, FENCING
FENCING FOIL...................SPORTS EQUIPMENT
     rt  SABER, FENCING
FENCING GLOVE..................SPORTS EQUIPMENT
FENCING MASK...................SPORTS EQUIPMENT
FENDER.........................FURNITURE
FENDER.........................WATER TRANSPORTATION ACCESSORY
FERRIS WHEEL...................RECREATIONAL DEVICE
FERRONIERE.....................ADORNMENT
FERROTYPE PLATE................PHOTOGRAPHIC T&E
FERRY..........................WATER TRANSPORTATION EQUIPMENT
Festoon........................WINDOW OR DOOR COVERING
     use  SWAG
FEZ............................CLOTHING, HEADWEAR
FIBULA.........................CLOTHING ACCESSORY
FICHU..........................CLOTHING ACCESSORY
FID............................LEATHERWORKING T&E
FID............................TEXTILEWORKING T&E
     rt  AWL; BODKIN
FIELD GLASSES..................OPTICAL T&E
FIFE...........................MUSICAL T&E, WOODWIND
FIGURE.........................TOY
FIGURE, MECHANICAL.............TOY
     rt  MECHANICAL TOY
FIGUREHEAD.....................WATER TRANSPORTATION ACCESSORY
FIGURINE.......................COMMERCIAL DECORATIVE ART
     note may be further subdivided to indicate
          non-human forms: e.g., FIGURINE, ANIMAL;
          -,BIRD
FIGURINE.......................ORIGINAL ART
     note may be further subdivided to indicate
          non-human forms: e.g., FIGURINE, ANIMAL;
          -,BIRD
FIGURINE GROUP.................COMMERCIAL DECORATIVE ART
FILE...........................METALWORKING T&E
     note may be further subdivided to indicate
          specific type: e.g., FILE, FLAT; -,MILL;
          -,SQUARE
FILE...........................WOODWORKING T&E
     rt  RASP; FLOAT
FILE, DENTAL...................MEDICAL & PSYCHOLOGICAL T&E
FILE, NAIL.....................TOILET ARTICLE
FILE, PORTABLE.................WRITTEN COMMUNICATION EQUIPMENT
FILLER, MILK-BOTTLE............FOOD PROCESSING T&E
Filler, Silo...................AGRICULTURAL T&E
     use  BLOWER, ENSILAGE
FILLET.........................PRINTING T&E
FILTER.........................PHOTOGRAPHIC T&E
FILTER, MEAT-EXTRACT...........FOOD PROCESSING T&E
FILTER, SEITZ..................BIOLOGICAL T&E
FILTER, SERUM..................BIOLOGICAL T&E
```

Fingerstall.....................**LEATHERWORKING T&E**
 <u>use</u> COT
FINGER TABS.....................**SPORTS EQUIPMENT**
FINGERTIP.......................**UNCLASSIFIED T&E, GENERAL**
FINIAL..........................**BUILDING FRAGMENT**
FINIAL..........................**LIGHTING DEVICE**
FINISHER........................**PAPERMAKING T&E**
 <u>note</u> may be further subdivided to indicate
 specific type: e.g., FINISHER, PEBBLING;
 -,FLINT-GLAZING
Finishing machine...............**TEXTILEWORKING T&E**
 <u>use</u> more specific term: e.g., DECATING MACHINE;
 CALENDER, EMBOSSING
FINISHING MACHINE, CONCRETE.....**MASONRY T&E**
FIRE ALARM......................**SOUND COMMUNICATION EQUIPMENT**
FIRE-ALARM SYSTEM...............**TELECOMMUNICATION EQUIPMENT**
FIRE APPARATUS..................**LTE, ANIMAL-POWERED**
 <u>note</u> use only if specific type is unknown: e.g.,
 WAGON, HOOK-AND-LADDER
FIRE APPARATUS..................**LTE, MOTORIZED**
 <u>note</u> use only if specific type is unknown: e.g.,
 TRUCK, PUMPER; -,PUMPER/LADDER
Fire bell.......................**SOUND COMMUNICATION EQUIPMENT**
 <u>use</u> FIRE ALARM
FIREBOARD.......................**TEMPERATURE CONTROL DEVICE**
FIREBOAT........................**WATER TRANSPORTATION EQUIPMENT**
Firedog.........................**TEMPERATURE CONTROL DEVICE**
 <u>use</u> ANDIRON
FIRE ESCAPE.....................**BUILDING FRAGMENT**
Fireguard.......................**FURNITURE**
 <u>use</u> FENDER
FIREHOUSE.......................**BUILDING**
FIREPIT.........................**SITE FEATURE**
FIREPLACE.......................**BUILDING FRAGMENT**
 <u>note</u> use only for entire structure: i.e.,
 brickwork and FIREPLACE FACADE or MANTEL;
 see also TEMPERATURE CONTROL DEVICE
 (Category 2)
FIREPLACE FACADE................**BUILDING FRAGMENT**
 <u>note</u> use for composite interior face consisting
 of the MANTEL, the interior decoration below
 the MANTEL, and OVERMANTEL if present
Fireplug........................**UNCLASSIFIED STRUCTURE**
 <u>use</u> HYDRANT
FIREPOLE........................**BUILDING FRAGMENT**
FIRESET.........................**TEMPERATURE CONTROL DEVICE**
FIRESET STAND...................**TEMPERATURE CONTROL DEVICE**
Fire siren......................**SOUND COMMUNICATION EQUIPMENT**
 <u>use</u> FIRE ALARM
FIRKIN..........................**FOOD PROCESSING T&E**
FIRST AID KIT...................**MEDICAL & PSYCHOLOGICAL T&E**
FISHERMAN.......................**WATER TRANSPORTATION EQUIPMENT**

```
FISHHOOK......................FISHING & TRAPPING T&E
FISHING ROD...................FISHING & TRAPPING T&E
FISHING TOOL..................MINING T&E
FISHPLATE.....................MINING T&E
FLABELLUM.....................PERSONAL GEAR
FLABELLUM.....................CEREMONIAL ARTIFACT
FLAG..........................CEREMONIAL ARTIFACT
FLAG, CODE....................VISUAL COMMUNICATION EQUIPMENT
FLAG, SEMAPHORE...............VISUAL COMMUNICATION EQUIPMENT
FLAG, SIGNAL..................VISUAL COMMUNICATION EQUIPMENT
FLAG, WIND....................ARMAMENT ACCESSORY
FLAGEOLET.....................MUSICAL T&E, WOODWIND
FLAGEOLET, DOUBLE.............MUSICAL T&E, WOODWIND
FLAGEOLET, TRIPLE.............MUSICAL T&E, WOODWIND
FLAGON........................FOOD SERVICE T&E
FLAGPOLE......................SITE FEATURE
FLAIL.........................AGRICULTURAL T&E
Flail, Threshing..............AGRICULTURAL T&E
    use  FLAIL
Flamethrower..................AGRICULTURAL T&E
    use  WEEDER, FLAME
FLAMETHROWER..................ARMAMENT T&E, FIREARM
FLANGE........................GLASS & PLASTICS T&E
FLANGE........................METALWORKING T&E
FLARE, DISTRESS...............VISUAL COMMUNICATION EQUIPMENT
FLARING TOOL..................GLASS & PLASTICS T&E
FLASH ATTACHMENT..............PHOTOGRAPHIC T&E
FLASH ATTACHMENT, ELECTRONIC...PHOTOGRAPHIC T&E
FLASH HIDER...................ARMAMENT ACCESSORY
FLASHLIGHT....................LIGHTING DEVICE
FLASH SUPPRESSOR..............ARMAMENT ACCESSORY
FLASK.........................CHEMICAL T&E
    note may be further subdivided to indicate
         specific type: e.g., FLASK, BOILING;
         -,CULTURE; -,DISTILLING; -,ERLENMEYER;
         -,FILTERING
FLASK, CULTURE................BIOLOGICAL T&E
FLASK, POCKET.................PERSONAL GEAR
FLASK, POWDER.................ARMAMENT ACCESSORY
FLASK, PRIMING................ARMAMENT ACCESSORY
FLASK, SHOT...................ARMAMENT ACCESSORY
FLASK, SNAP...................GLASS & PLASTICS T&E
Flat..........................PUBLIC ENTERTAINMENT DEVICE
    use  DROP, FLAT
FLATCAP.......................CLOTHING, HEADWEAR
FLATCAR.......................RAIL TRANSPORTATION EQUIPMENT
FLATTER.......................METALWORKING T&E
    rt   HAMMER, SET
FLATWARE SET..................FOOD SERVICE T&E
FLATWARE SET, CHILD'S.........FOOD SERVICE T&E
FLEES' BOX....................MEDICAL & PSYCHOLOGICAL T&E
FLESHING MACHINE..............LEATHERWORKING T&E
```

Flier.........................ADVERTISING MEDIUM
 use HANDBILL or CATALOG
Flight gear...................AEROSPACE TRANSPORTATION ACCESSORY
 use more specific term elsewhere in lexicon; see
 also CLOTHING
FLIPPER-FLOPPER...............TOY
FLOAT.........................FISHING & TRAPPING T&E
FLOAT.........................MASONRY T&E
FLOAT.........................WOODWORKING T&E
 rt RASP; FILE
FLOAT, DENTAL.................ANIMAL HUSBANDRY T&E
FLOAT, LONG...................MASONRY T&E
FLOAT-CUTTING MACHINE.........TEXTILEWORKING T&E
FLOAT TEST APPARATUS..........CHEMICAL T&E
FLOCKING MACHINE..............TEXTILEWORKING T&E
Flogger.......................WOODWORKING T&E
 use BUNGSTART
FLOODGATE.....................UNCLASSIFIED STRUCTURE
FLOODLIGHT....................LIGHTING DEVICE
FLORAL BOUQUET................COMMERCIAL DECORATIVE ART
FLORAL WREATH.................COMMERCIAL DECORATIVE ART
FLOTATION CELL................MINING T&E
FLOWER, ARTIFICIAL............COMMERCIAL DECORATIVE ART
FLOWERPOT.....................HOUSEHOLD ACCESSORY
FLUE..........................BUILDING FRAGMENT
Flugelhorn....................MUSICAL T&E, BRASS
 use BUGLE, VALVE
FLUME.........................UNCLASSIFIED STRUCTURE
 rt SLUICE; PENSTOCK
FLUOROSCOPE...................MEDICAL & PSYCHOLOGICAL T&E
FLUTE.........................MUSICAL T&E, WOODWIND
FLUXMETER.....................ELECTRICAL & MAGNETIC T&E
Flying boat...................AEROSPACE TRANSPORTATION EQUIPMENT
 use AIRPLANE
FLYWHEEL......................MECHANICAL T&E
FOAM MACHINE..................GLASS & PLASTICS T&E
FOB...........................PERSONAL GEAR
FOCOMETER.....................OPTICAL T&E
FOGHORN.......................SOUND COMMUNICATION EQUIPMENT
FOLDER, FILE..................WRITTEN COMMUNICATION EQUIPMENT
FOLDING MACHINE...............METALWORKING T&E
 rt BRAKE
FOLDING MACHINE...............PRINTING T&E
FOLDING MACHINE...............TEXTILEWORKING T&E
FONT, BAPTISMAL...............CEREMONIAL ARTIFACT
FONT, HOLY WATER..............CEREMONIAL ARTIFACT
FOOD COVER....................FOOD PROCESSING T&E
FOOTBALL......................SPORTS EQUIPMENT
FOOTBALL HELMET...............SPORTS EQUIPMENT
FOOTBATH......................PLUMBING FIXTURE
FOOTLIGHT.....................LIGHTING DEVICE
FOOTSCRAPER...................HOUSEHOLD ACCESSORY

FOOTSTICKS......................GLASS & PLASTICS T&E
FOOTSTOOL.......................FURNITURE
 rt OTTOMAN; HASSOCK
FORCEPS.........................MEDICAL & PSYCHOLOGICAL T&E
FORCEPS, CATCH..................MEDICAL & PSYCHOLOGICAL T&E
FORCEPS, DENTAL.................MEDICAL & PSYCHOLOGICAL T&E
FORCEPS, DISSECTING.............BIOLOGICAL T&E
FORCEPS, SPENCER WELLS..........MEDICAL & PSYCHOLOGICAL T&E
FORGE, AMERICAN.................METALWORKING T&E
FORGE, BLACKSMITH'S.............METALWORKING T&E
FORGE, CATALAN..................METALWORKING T&E
FORGE, CHAMPLAIN................METALWORKING T&E
Forge, Drop.....................METALWORKING T&E
 use HAMMER, DROP
FORK............................AGRICULTURAL T&E
 note use only if specific type is unknown
FORK............................FOOD SERVICE T&E
FORK, ALFALFA...................AGRICULTURAL T&E
FORK, BAILING-PRESS.............AGRICULTURAL T&E
FORK, BARLEY....................AGRICULTURAL T&E
FORK, BEET......................AGRICULTURAL T&E
FORK, BERRY.....................FOOD SERVICE T&E
FORK, BLUBBER...................FISHING & TRAPPING T&E
FORK, CABBAGE-HARVESTING........AGRICULTURAL T&E
FORK, CARVING...................FOOD SERVICE T&E
Fork, Chaff.....................AGRICULTURAL T&E
 use FORK, HEADER
FORK, CHILD'S...................FOOD SERVICE T&E
FORK, COLD-MEAT.................FOOD SERVICE T&E
FORK, COTTONSEED................AGRICULTURAL T&E
FORK, CURD......................FOOD PROCESSING T&E
FORK, DESSERT...................FOOD SERVICE T&E
Fork, Digging...................AGRICULTURAL T&E
 use FORK, SPADING
FORK, DINNER....................FOOD SERVICE T&E
FORK, ENSILAGE..................AGRICULTURAL T&E
FORK, FISH......................FOOD SERVICE T&E
FORK, FISH-SERVING..............FOOD SERVICE T&E
Fork, Garden....................AGRICULTURAL T&E
 use FORK, SPADING
Fork, Grain.....................AGRICULTURAL T&E
 use FORK, HEADER
Fork, Grapple...................AGRICULTURAL T&E
 use FORK, HAY-LIFTING
Fork, Harpoon...................AGRICULTURAL T&E
 use FORK, HAY-LIFTING
Fork, Hay.......................AGRICULTURAL T&E
 use HAYFORK
FORK, HAY-LIFTING...............AGRICULTURAL T&E
FORK, HEADER....................AGRICULTURAL T&E
Fork, Horse hay.................AGRICULTURAL T&E
 use FORK, HAY-LIFTING

```
FORK, HOT-SHOT...................ARMAMENT ACCESSORY
FORK, LEMON......................FOOD SERVICE T&E
Fork, Lock-lever.................AGRICULTURAL T&E
     use FORK, HAY-LIFTING
FORK, LUNCHEON...................FOOD SERVICE T&E
FORK, MANURE.....................AGRICULTURAL T&E
FORK, OYSTER.....................FOOD SERVICE T&E
FORK, PICKLE.....................FOOD SERVICE T&E
Fork, Pitch......................AGRICULTURAL T&E
     use HAYFORK or FORK, MANURE
FORK, POTATO-DIGGING.............AGRICULTURAL T&E
FORK, SALAD......................FOOD SERVICE T&E
FORK, SARDINE....................FOOD SERVICE T&E
Fork, Silage.....................AGRICULTURAL T&E
     use FORK, ENSILAGE
FORK, SLUICE.....................MINING T&E
FORK, SPADING....................AGRICULTURAL T&E
Fork, Straw......................AGRICULTURAL T&E
     use FORK, BARLEY
Fork, Table......................FOOD SERVICE T&E
     use FORK, DINNER
FORK, TOASTING...................FOOD PROCESSING T&E
FORK, VEGETABLE SCOOP............AGRICULTURAL T&E
FORKLIFT.........................LTE, MOTORIZED
FORMING BLOCK....................GLASS & PLASTICS T&E
FORMING MACHINE..................GLASS & PLASTICS T&E
     note may be further subdivided to indicate
          specific type: e.g., FORMING MACHINE,
          VACUUM; -,PRESSURE; -,DRAPE
FORMING MACHINE..................METALWORKING T&E
FORT.............................BUILDING
FOUNTAIN.........................PLUMBING FIXTURE
FOUNTAIN, DRINKING...............PLUMBING FIXTURE
FOUNTAIN, DRINKING...............FOOD SERVICE T&E
Fountain, Poultry................ANIMAL HUSBANDRY T&E
     use WATERER, POULTRY
FOUNTAIN, SODA...................FOOD SERVICE T&E
Fountain, Stock..................ANIMAL HUSBANDRY T&E
     use WATERER, LIVESTOCK
Fourdrinier machine..............PAPERMAKING T&E
     use PAPER MACHINE
Four-in-hand.....................LTE, ANIMAL-POWERED
     use BREAK, WAGONETTE
FOWLER...........................ARMAMENT T&E, FIREARM
Fractur
     note refer to text for discussion of the way this
          concept should be handled
Fragment
     use only as a secondary word in a multi-word
          object name
Frame
     use only as a secondary word in a multi-word
          object name
```

```
FRAMING BLOCK....................WOODWORKING T&E
FREEZER.........................FOOD PROCESSING T&E
Freezer, Brine..................FOOD PROCESSING T&E
     use  FREEZER, ICE-CREAM
Freezer, Direct-expansion.......FOOD PROCESSING T&E
     use  FREEZER, ICE-CREAM
FREEZER, ICE-CREAM..............FOOD PROCESSING T&E
FREIGHT CAR.....................RAIL TRANSPORTATION EQUIPMENT
     note use only if specific type is unknown: e.g.,
          BOXCAR, STOCKCAR, FLATCAR, HOPPER CAR
FRETSAW.........................WOODWORKING T&E
     rt  SAW, COPING
FRICTION SLIDE..................MECHANICAL T&E
FRIENDSHIP SLOOP................WATER TRANSPORTATION EQUIPMENT
FRIGATE.........................WATER TRANSPORTATION EQUIPMENT
FRISBEE.........................SPORTS EQUIPMENT
FRISKET.........................PRINTING T&E
FROE............................WOODWORKING T&E
FROE, COOPER'S..................WOODWORKING T&E
FROE, KNIFE.....................WOODWORKING T&E
FROE, LATHMAKER'S...............WOODWORKING T&E
FROE CLUB.......................WOODWORKING T&E
     rt  MALLET
FROG............................HOUSEHOLD ACCESSORY
FRONTAL.........................CEREMONIAL ARTIFACT
FRONTLET........................ADORNMENT
FRONTLET........................CEREMONIAL ARTIFACT
Frow............................WOODWORKING T&E
     use  FROE
FRUIT, ARTIFICIAL...............COMMERCIAL DECORATIVE ART
FRYER, DEEP-FAT.................FOOD PROCESSING T&E
FULLER..........................METALWORKING T&E
     note may be further subdivided to indicate
          specific type: e.g., FULLER, TOP; -,CREASING
FULLING MACHINE.................TEXTILEWORKING T&E
FUNNEL..........................CHEMICAL T&E
FUNNEL..........................FOOD PROCESSING T&E
FUNNEL-HORN.....................ACOUSTICAL T&E
     rt  AMPLIFIER, AUDIO
FURNACE.........................TEMPERATURE CONTROL DEVICE
Furnace, Agricultural...........AGRICULTURAL T&E
     use  BOILER, FEED
FURNACE, ANNEALING..............GLASS & PLASTICS T&E
FURNACE, ANNEALING..............METALWORKING T&E
FURNACE, BASIC OXYGEN...........METALWORKING T&E
FURNACE, BLAST..................METALWORKING T&E
FURNACE, CEMENT-TEST............CHEMICAL T&E
FURNACE, ELECTRIC...............METALWORKING T&E
FURNACE, HEARTH.................METALWORKING T&E
FURNACE, MELTING................GLASS & PLASTICS T&E
FURNACE, MUFFLE.................METALWORKING T&E
FURNACE, REHEATING..............GLASS & PLASTICS T&E
```

361

```
FURNACE, REVERBERATORY.........METALWORKING T&E
Furnace, Shaft.................METALWORKING T&E
    use  FORGE, CATALAN
FURNACE, SOLAR.................POWER PRODUCTION T&E
FURNACE, SOLDERING.............METALWORKING T&E
FUSE, DETONATING...............MINING T&E
FUSIL..........................ARMAMENT T&E, FIREARM
    rt   MUSKET
GAD............................MINING T&E
    rt   MOIL
GADDER.........................MINING T&E
GAFF, FISH.....................FISHING & TRAPPING T&E
Gaff, Hay......................AGRICULTURAL T&E
    use  CROOK, HAY
GAFF, SEALING..................FISHING & TRAPPING T&E
GAFFER.........................PHOTOGRAPHIC T&E
GAG, CANINE MOUTH..............ANIMAL HUSBANDRY T&E
Gage...........................METALWORKING T&E
    use  GAUGE
GAITER.........................CLOTHING, FOOTWEAR
GALACTOMETER...................FOOD PROCESSING T&E
GALLERY........................BUILDING FRAGMENT
GALLEY.........................PRINTING T&E
GALLEY.........................WATER TRANSPORTATION EQUIPMENT
GALLIPOT.......................MEDICAL & PSYCHOLOGICAL T&E
GALLOWS........................BEHAVIORAL CONTROL DEVICE
GALVANOMETER...................ELECTRICAL & MAGNETIC T&E
GALVANOMETER, BLASTING.........MINING T&E
GALVANOSCOPE...................ELECTRICAL & MAGNETIC T&E
GALVANOTHERMOMETER.............THERMAL T&E
GAMBREL........................FOOD PROCESSING T&E
GAME BOARD.....................GAME
    note use for a board utilized in multiple games
         or if specific game is unknown
GAME BOX.......................GAME
GAME PIECE.....................GAME
    note use for a piece utilized in multiple games
         or if specific game is unknown
GAME SET.......................GAME
    note use for a set of games or if specific game
         is unknown
GANGPLANK......................WATER TRANSPORTATION ACCESSORY
GARAGE.........................BUILDING
Garbage disposal...............PLUMBING FIXTURE
    use  DISPOSER
GARGOYLE.......................BUILDING FRAGMENT
GARNETT MACHINE................TEXTILEWORKING T&E
GARTER.........................CLOTHING ACCESSORY
GARVEY.........................WATER TRANSPORTATION EQUIPMENT
Gas detector...................MINING T&E
    use  DETECTOR, GAS
Gasolier.......................LIGHTING DEVICE
    use  CHANDELIER with an appropriate subdivision
```

GATE.............................SITE FEATURE
GATEHOUSE........................BUILDING
GATEWAY..........................SITE FEATURE
Gatherer, Fruit..................AGRICULTURAL T&E
 use PICKER, FRUIT
GAUGE............................MECHANICAL T&E
 note normally subdivided to indicate substance
 being measured: e.g., GAUGE, STEAM-PRESSURE
GAUGE............................METALWORKING T&E
 note may be further subdivided to indicate
 specific type: e.g., GAUGE, CENTER; -,DRILL;
 -,SCREW-PITCH; -,THREAD; -,WIRE
GAUGE............................WEIGHTS & MEASURES T&E
GAUGE............................WOODWORKING T&E
 note use only if specific type is unknown
GAUGE, AMMONIA...................CHEMICAL T&E
GAUGE, BULLET....................ARMAMENT ACCESSORY
Gauge, Butt......................WOODWORKING T&E
 use GAUGE, MARKING
GAUGE, CUTTING...................WOODWORKING T&E
GAUGE, DRAW......................LEATHERWORKING T&E
 rt GAUGE, PLOUGH
Gauge, Grasshopper...............WOODWORKING T&E
 use GAUGE, MONKEY
Gauge, Handrail..................WOODWORKING T&E
 use GAUGE, MONKEY
GAUGE, LINE......................PRINTING T&E
GAUGE, MARKING...................WOODWORKING T&E
GAUGE, MONKEY....................WOODWORKING T&E
Gauge, Mortise...................WOODWORKING T&E
 use GAUGE, MARKING
GAUGE, NET.......................TEXTILEWORKING T&E
Gauge, Panel.....................WOODWORKING T&E
 use GAUGE, MARKING
Gauge, Patternmaker's............WOODWORKING T&E
 use GAUGE, MONKEY
GAUGE, PLATE.....................PRINTING T&E
GAUGE, PLOUGH....................LEATHERWORKING T&E
 rt GAUGE, DRAW
GAUGE, PRECIPITATION.............METEOROLOGICAL T&E
GAUGE, RABBET....................WOODWORKING T&E
GAUGE, RAILWAY...................WEIGHTS & MEASURES T&E
GAUGE, SAW.......................PRINTING T&E
Gauge, Slitting..................WOODWORKING T&E
 use GAUGE, CUTTING
GAUGE, STAVE.....................WOODWORKING T&E
Gauge, Thumb.....................WOODWORKING T&E
 use GAUGE, MARKING
Gauge, Tiring....................METALWORKING T&E
 use TRAVELER
GAUGE, TURNER'S..................WOODWORKING T&E
GAUGE, TYPE HIGH.................PRINTING T&E

```
GAUGE, VENT...................ARMAMENT ACCESSORY
GAUGE, WHEELWRIGHT'S ANGLE.....WOODWORKING T&E
GAUGE, WHEELWRIGHT'S RIM.......WOODWORKING T&E
GAUGE, WIND...................ARMAMENT ACCESSORY
GAUGE ROD....................WOODWORKING T&E
GAUNTLET.....................ARMAMENT T&E, BODY ARMOR
GAVEL........................PERSONAL SYMBOL
GAZEBO.......................BUILDING
Gear-cutting machine..........METALWORKING T&E
     use  CUTTING MACHINE, GEAR
GEIGER COUNTER...............MINING T&E
GENERATOR....................DATA PROCESSING T&E
     note may be further subdivided to indicate
          specific type: e.g., GENERATOR, FUNCTION;
          -,PRIME NUMBER
GENERATOR....................POWER PRODUCTION T&E
     note may be further subdivided according to
          source of power: e.g., GENERATOR, GASOLINE;
          -,STEAM -,WATER
GENERATOR, ELECTROSTATIC......ELECTRICAL & MAGNETIC T&E
GENERATOR, SOUND.............ACOUSTICAL T&E
GEODESCOPE...................ASTRONOMICAL T&E
Geometric model..............DRAFTING T&E
     use  INSTRUCTIONAL MODEL
GEOPHONE.....................MINING T&E
GEOTHERMOMETER...............THERMAL T&E
GERMINATION BOX..............BIOLOGICAL T&E
GERMINATOR...................AGRICULTURAL T&E
GETA.........................CLOTHING, FOOTWEAR
Giant, Hydraulic.............MINING T&E
     use  MONITOR, HYDRAULIC
Gibus........................CLOTHING, HEADWEAR
     use  HAT, TOP
Gig..........................ARMAMENT T&E, EDGED
     use  SPEAR
GIG..........................LTE, ANIMAL-POWERED
GIGGING MACHINE..............TEXTILEWORKING T&E
GILL BOX.....................TEXTILEWORKING T&E
GIMLET.......................WOODWORKING T&E
GIMLET, FUZE.................ARMAMENT ACCESSORY
GIMLET, GUNNER'S.............ARMAMENT ACCESSORY
Gin..........................MINING T&E
     use  HOIST, MINE
GIN, COTTON..................TEXTILEWORKING T&E
GIN POLE.....................MINING T&E
GIRANDOLE....................LIGHTING DEVICE
GIRDLE.......................CLOTHING, UNDERWEAR
GIRT.........................MINING T&E
GIRTH........................LAND TRANSPORTATION ACCESSORY
GLARIMETER...................PAPERMAKING T&E
GLASS........................FOOD SERVICE T&E
Glass, Ale...................FOOD SERVICE T&E
     use  GLASS, MALT-BEVERAGE
```

Glass, Beer...................FOOD SERVICE T&E
 use GLASS, MALT-BEVERAGE
GLASS, CHAMPAGNE..............FOOD SERVICE T&E
GLASS, COCKTAIL...............FOOD SERVICE T&E
GLASS, CORDIAL................FOOD SERVICE T&E
Glass, Flip...................FOOD SERVICE T&E
 use BEAKER
Glass, Flute..................FOOD SERVICE T&E
 use GLASS, CHAMPAGNE
Glass, Goblet.................FOOD SERVICE T&E
 use GOBLET
Glass, Hock...................FOOD SERVICE T&E
 use GLASS, WINE
Glass, Liqueur................FOOD SERVICE T&E
 use GLASS, CORDIAL
GLASS, MALT-BEVERAGE..........FOOD SERVICE T&E
 rt STEIN; TANKARD
GLASS, PARFAIT................FOOD SERVICE T&E
GLASS, SHERBET................FOOD SERVICE T&E
GLASS, SHOT...................FOOD SERVICE T&E
 rt JIGGER
GLASS, SODA FOUNTAIN..........FOOD SERVICE T&E
GLASS, SWEETMEAT..............FOOD SERVICE T&E
GLASS, TRICK..................FOOD SERVICE T&E
GLASS, WINE...................FOOD SERVICE T&E
Glasses, Eye..................PERSONAL GEAR
 use EYEGLASSES
GLASSES, OPERA................PERSONAL GEAR
Glasspaper....................WOODWORKING T&E
 use SANDPAPER
GLIDER........................FURNITURE
GLIDER........................AEROSPACE TRANSPORTATION EQUIPMENT
GLIDER........................RECREATIONAL DEVICE
GLOBE.........................DOCUMENTARY ARTIFACT
GLOBULIMETER..................MEDICAL & PSYCHOLOGICAL T&E
GLOCKENSPIEL..................MUSICAL T&E, PERCUSSION
Glory hole....................GLASS & PLASTICS T&E
 use FURNACE, REHEATING
GLOVE.........................CLOTHING ACCESSORY
GLOVE, FIELDER'S..............SPORTS EQUIPMENT
GLOVE, GOALIE'S...............SPORTS EQUIPMENT
GLOVE, TARGET SHOOTER'S.......ARMAMENT ACCESSORY
GLUCOMETER....................FOOD PROCESSING T&E
GLUE PLATE....................WOODWORKING T&E
GLUE POT......................WOODWORKING T&E
GLUING MACHINE................PRINTING T&E
GNOMON........................WEIGHTS & MEASURES T&E
GOBLET........................FOOD SERVICE T&E
GO-DEVIL......................FORESTRY T&E
GOFFER........................PRINTING T&E
GOGGLES.......................PERSONAL GEAR
 note may be further subdivided to indicate
 specific type: e.g., GOGGLES, WELDER'S

```
GOLD-FOIL CARRIER.................MEDICAL & PSYCHOLOGICAL T&E
GOLF CART.........................SPORTS EQUIPMENT
GOLF CLUB.........................SPORTS EQUIPMENT
GOLF GLOVE........................SPORTS EQUIPMENT
GONDOLA...........................WATER TRANSPORTATION EQUIPMENT
GONDOLA CAR.......................LTE, MOTORIZED
GONG..............................FOOD SERVICE T&E
GONG..............................MUSICAL T&E, PERCUSSION
GONG..............................CEREMONIAL ARTIFACT
GONIOMETER........................MEDICAL & PSYCHOLOGICAL T&E
Goniometer........................SURVEYING & NAVIGATIONAL T&E
     use  DIRECTION FINDER
GONIOMETER........................WEIGHTS & MEASURES T&E
GONIOPHOTOMETER...................OPTICAL T&E
GONIOSCOPE........................MEDICAL & PSYCHOLOGICAL T&E
GONIOSTAT.........................UNCLASSIFIED T&E, SPECIAL
GORGET............................ADORNMENT
GORGET............................PERSONAL SYMBOL
GORGET............................ARMAMENT T&E, BODY ARMOR
GOUGE.............................WOODWORKING T&E
     note use only if specific type is unknown
     rt   CHISEL
GOUGE, ADJUSTABLE.................LEATHERWORKING T&E
GOUGE, ADJUSTABLE-V...............LEATHERWORKING T&E
GOUGE, CARVING....................WOODWORKING T&E
GOUGE, FIRMER.....................WOODWORKING T&E
GOUGE, FUZE.......................ARMAMENT ACCESSORY
GOUGE, PARING.....................WOODWORKING T&E
GOUGE, TURNING....................WOODWORKING T&E
GOUGE, WHEELWRIGHT'S..............WOODWORKING T&E
GOVERNOR..........................MINING T&E
GOVERNOR..........................POWER PRODUCTION T&E
GOWN..............................CLOTHING, OUTERWEAR
     note may be further subdivided to indicate
          specific type: e.g., GOWN, BAPTISMAL;
          -,DRESSING; -,EVENING; -,WEDDING
GOWN, ACADEMIC....................PERSONAL SYMBOL
Gown, Night.......................CLOTHING, OUTERWEAR
     use NIGHTGOWN
GRADER............................CONSTRUCTION T&E
Grader, Bean......................FOOD PROCESSING T&E
     use SORTER, BEAN
GRADER, EGG.......................FOOD PROCESSING T&E
GRADIOMETER.......................SURVEYING & NAVIGATIONAL T&E
GRADUATE..........................CHEMICAL T&E
GRADUATOR.........................DATA PROCESSING T&E
GRAGER............................CEREMONIAL ARTIFACT
GRAIL, HORNWORKER'S...............UNCLASSIFIED T&E, SPECIAL
     rt   FILE
GRAIN.............................ARMAMENT T&E, EDGED
GRANDSTAND........................UNCLASSIFIED STRUCTURE
GRANOMETER........................BIOLOGICAL T&E
```

GRAPESHOT........................ARMAMENT T&E, AMMUNITION
GRAPHITE SLAB....................GLASS & PLASTICS T&E
GRAPHOMETER......................SURVEYING & NAVIGATIONAL T&E
 rt CIRCUMFERENTOR; QUADRANT
GRAPHOSCOPE......................VISUAL COMMUNICATION EQUIPMENT
GRAPNEL..........................MINING T&E
GRATE, FIREPLACE.................TEMPERATURE CONTROL DEVICE
GRATE, HOT SHOT..................ARMAMENT ACCESSORY
GRATER...........................FOOD PROCESSING T&E
GRAVER...........................MASONRY T&E
 rt BURIN
Gravestone.......................CEREMONIAL ARTIFACT
 use TOMBSTONE
GRAVIMETER.......................MECHANICAL T&E
Gravy boat.......................FOOD SERVICE T&E
 use SAUCEBOAT
GREATCOAT........................CLOTHING, OUTERWEAR
GREENHOUSE.......................BUILDING
GRENADE, ANTIPERSONNEL...........ARMAMENT T&E, AMMUNITION
GRENADE, ANTITANK................ARMAMENT T&E, AMMUNITION
GRENADE, INCENDIARY..............ARMAMENT T&E, AMMUNITION
GRENADE, TEAR GAS................BEHAVIORAL CONTROL DEVICE
GRIDDLE..........................FOOD PROCESSING T&E
GRIDIRON.........................PUBLIC ENTERTAINMENT DEVICE
GRILL............................BUILDING FRAGMENT
GRILL, VENTILATOR................BUILDING FRAGMENT
GRILL, WINDOW....................BUILDING FRAGMENT
GRINDER..........................METALWORKING T&E
 rt GRINDSTONE
Grinder..........................PAPERMAKING T&E
 use CHIPPER
GRINDER, BONE....................FOOD PROCESSING T&E
GRINDER, BRAN....................FOOD PROCESSING T&E
GRINDER, CYLINDRICAL.............METALWORKING T&E
GRINDER, FEED....................AGRICULTURAL T&E
GRINDER, MEAT....................FOOD PROCESSING T&E
Grinder, Middlings...............FOOD PROCESSING T&E
 use MILL, MIDDLINGS
GRINDER, MOWER-KNIFE.............METALWORKING T&E
GRINDER, PLANER KNIFE............METALWORKING T&E
GRINDER, SOIL....................AGRICULTURAL T&E
GRINDER, SURFACE.................METALWORKING T&E
GRINDER, TOOL....................METALWORKING T&E
GRINDER/MIXER, FEED..............AGRICULTURAL T&E
GRINDSTONE.......................METALWORKING T&E
 rt GRINDER
GRIZZLY..........................MINING T&E
GROMA............................SURVEYING & NAVIGATIONAL T&E
 rt CROSS-STAFF; OPTICAL SQUARE
GROOVER, HAND....................METALWORKING T&E
GROOVER, HOOF....................ANIMAL HUSBANDRY T&E
GROOVING MACHINE.................METALWORKING T&E

```
GROUND CLOTH....................BEDDING
Ground support equipment.......AEROSPACE TRANSPORTATION ACCESSORY
     use  more specific term elsewhere in lexicon; see
           also UNCLASSIFIED STRUCTURE, Communication
           Artifacts and LTE, MOTORIZED
Grout machine...................MINING T&E
     use  INJECTOR, CEMENT
Grozer..........................GLASS & PLASTICS T&E
     use  PLIERS, GLASS
GUARDRAIL SECTION...............UNCLASSIFIED STRUCTURE
GUDGEON, RUDDER.................WATER TRANSPORTATION ACCESSORY
GUIDEBOAT, ADIRONDACK...........WATER TRANSPORTATION EQUIPMENT
Guidepost.......................VISUAL COMMUNICATION EQUIPMENT
     use  SIGN, TRAFFIC
Guillotine......................PAPERMAKING T&E
     use  CUTTER
GUILLOTINE......................BEHAVIORAL CONTROL DEVICE
GUITAR..........................MUSICAL T&E, STRINGED
Gum, Bee........................ANIMAL HUSBANDRY T&E
     use  BEEHIVE
GUN, ANTIAIRCRAFT...............ARMAMENT T&E, ARTILLERY
GUN, ANTITANK...................ARMAMENT T&E, ARTILLERY
GUN, BALLING....................ANIMAL HUSBANDRY T&E
Gun, Bird.......................ARMAMENT T&E, FIREARM
     use  more specific term: e.g., RIFLE, SHOTGUN
Gun, Burp.......................ARMAMENT T&E, FIREARM
     use  GUN, SUBMACHINE
Gun, Capture....................ARMAMENT T&E, FIREARM
     use  GUN, TRANQUILIZER
GUN, COMBINATION................ARMAMENT T&E, FIREARM
GUN, DART.......................ARMAMENT T&E, FIREARM
Gun, Dose.......................ANIMAL HUSBANDRY T&E
     use  DRENCHER
Gun, Dusting....................AGRICULTURAL T&E
     use  DUSTER, DRY-POWDER
GUN, FIELD......................ARMAMENT T&E, ARTILLERY
GUN, FLARE......................VISUAL COMMUNICATION EQUIPMENT
GUN, FOLDING....................ARMAMENT T&E, FIREARM
Gun, Game.......................ARMAMENT T&E, FIREARM
     use  more specific term: e.g., RIFLE, SHOTGUN
GUN, GARRISON...................ARMAMENT T&E, ARTILLERY
GUN, GATLING....................ARMAMENT T&E, ARTILLERY
Gun, Grease.....................ARMAMENT T&E, FIREARM
     use  GUN, SUBMACHINE
GUN, HARPOON....................ARMAMENT T&E, FIREARM
Gun, Insect powder..............AGRICULTURAL T&E
     use  DUSTER, DRY-POWDER
GUN, LINE-THROWING..............WATER TRANSPORTATION ACCESSORY
GUN, LYLE.......................WATER TRANSPORTATION ACCESSORY
GUN, MACHINE....................ARMAMENT T&E, FIREARM
     note may be further subdivided according to size:
           e.g., GUN, LIGHT MACHINE; GUN, MEDIUM
           MACHINE; GUN, HEAVY MACHINE
```

368

GUN, MARKING.....................ANIMAL HUSBANDRY T&E
GUN, PRESENTATION................PERSONAL SYMBOL
GUN, RAILWAY.....................ARMAMENT T&E, ARTILLERY
GUN, RECOILESS...................ARMAMENT T&E, ARTILLERY
GUN, SEA-COAST...................ARMAMENT T&E, ARTILLERY
GUN, SEIGE.......................ARMAMENT T&E, ARTILLERY
GUN, SELF-PROPELLED..............ARMAMENT T&E, ARTILLERY
GUN, SPRAY.......................GLASS & PLASTICS T&E
GUN, SPRAY.......................PAINTING T&E
GUN, SUBMACHINE..................ARMAMENT T&E, FIREARM
GUN, SWIVEL......................ARMAMENT T&E, ARTILLERY
GUN, TATTOO......................ANIMAL HUSBANDRY T&E
GUN, TRANQUILIZER................ARMAMENT T&E, FIREARM
Gun, Whaling.....................ARMAMENT T&E, FIREARM
 use GUN, HARPOON
GUN-CLEANING KIT.................ARMAMENT ACCESSORY
GUN/HOWITZER.....................ARMAMENT T&E, ARTILLERY
GUNNITE MACHINE..................CONSTRUCTION T&E
GYRO-COMPASS.....................SURVEYING & NAVIGATIONAL T&E
 rt COMPASS
GYROJET..........................ARMAMENT ACCESSORY
GYROSCOPE........................MECHANICAL T&E
Gyrostat.........................MECHANICAL T&E
 use GYROSCOPE
HABIT............................CLOTHING, OUTERWEAR
 note may be further subdivided to indicate
 specific type: e.g., HABIT, MONK'S; -,NUN'S
Hack.............................LTE, ANIMAL-POWERED
 use CAB or CAB, HANSOM
HACK, TURPENTINE.................FORESTRY T&E
Hackle...........................TEXTILEWORKING T&E
 use HATCHEL
HACKSAW..........................METALWORKING T&E
HACKSAW, POWER...................METALWORKING T&E
HACK STAND.......................TEXTILEWORKING T&E
HAEDROMOGRAPH....................MEDICAL & PSYCHOLOGICAL T&E
HAEMACHROMETER...................MEDICAL & PSYCHOLOGICAL T&E
HAEMACYTOMETER...................MEDICAL & PSYCHOLOGICAL T&E
HAEMATOMETER.....................MEDICAL & PSYCHOLOGICAL T&E
HAEMOSCOPE.......................MEDICAL & PSYCHOLOGICAL T&E
HAFT, SEWING.....................LEATHERWORKING T&E
HAIRBRUSH........................TOILET ARTICLE
HAIRNET..........................CLOTHING, HEADWEAR
 rt CAUL
HAIRPIECE........................ADORNMENT
 rt WIG
HAIRPIN..........................TOILET ARTICLE
HAIR RECEIVER....................TOILET ARTICLE
HALBERD..........................ARMAMENT T&E, EDGED
HALLSTAND........................FURNITURE
 rt COAT-TREE
Hall-tree........................FURNITURE
 use COAT-TREE

```
HALOMETER.....................CHEMICAL T&E
HALTER........................LAND TRANSPORTATION ACCESSORY
HALTER, CATTLE................ANIMAL HUSBANDRY T&E
HAM, TAILOR'S.................TEXTILEWORKING T&E
HAME..........................LAND TRANSPORTATION ACCESSORY
     note may be further subdivided to indicate
          specific type: e.g., HAME, COVERED; -,PLATED
HAMMER........................METALWORKING T&E
     note use only if specific type is unknown
     rt  SLEDGE
HAMMER........................WOODWORKING T&E
     note use only if specific type is unknown
HAMMER........................UNCLASSIFIED T&E, GENERAL
HAMMER........................SPORTS EQUIPMENT
Hammer, Air...................MINING T&E
     use  DRILL, PERCUSSIVE AIR
HAMMER, AX....................MASONRY T&E
HAMMER, BACKING...............PRINTING T&E
HAMMER, BALL-PEEN.............METALWORKING T&E
     note use only if specific type is unknown
HAMMER, BLAST.................METALWORKING T&E
Hammer, Board.................METALWORKING T&E
     use  HAMMER, DROP
Hammer, Bush..................MASONRY T&E
     use  BUSHHAMMER
Hammer, Chipping..............METALWORKING T&E
     use  more specific term: e.g., HAMMER, BALL-PEEN;
          HAMMER, STRAIGHT-PEEN
HAMMER, CLAW..................WOODWORKING T&E
HAMMER, CLENCH................WOODWORKING T&E
HAMMER, COBBLER'S.............LEATHERWORKING T&E
HAMMER, COOPER'S..............WOODWORKING T&E
     rt  ADZ, TRUSSING
HAMMER, CRANDALL..............MASONRY T&E
HAMMER, CROSS-PEEN............METALWORKING T&E
     note use only if specific type is unknown
HAMMER, DROP..................METALWORKING T&E
HAMMER, FACE..................MASONRY T&E
HAMMER, FARRIER'S DRIVING.....ANIMAL HUSBANDRY T&E
HAMMER, FARRIER'S FITTING.....ANIMAL HUSBANDRY T&E
HAMMER, FARRIER'S SHARPENING..METALWORKING T&E
HAMMER, FARRIER'S TURNING.....METALWORKING T&E
HAMMER, FILE-CUTTER'S.........METALWORKING T&E
Hammer, Flooring..............WOODWORKING T&E
     use  HAMMER, CLENCH
HAMMER, FOOT-POWERED..........METALWORKING T&E
HAMMER, FRAMING...............WOODWORKING T&E
HAMMER, HAND..................MINING T&E
HAMMER, HEEL..................LEATHERWORKING T&E
HAMMER, HELVE.................METALWORKING T&E
HAMMER, JOINER'S..............WOODWORKING T&E
Hammer, Killing...............FOOD PROCESSING T&E
     use  HAMMER, SLAUGHTERING
```

370

HAMMER, MARKING...................FORESTRY T&E
HAMMER, PATENT....................MASONRY T&E
HAMMER, PATTERNMAKER'S............WOODWORKING T&E
HAMMER, PLANISHING................METALWORKING T&E
HAMMER, PLOW......................METALWORKING T&E
Hammer, Power.....................METALWORKING T&E
 use more specific term: e.g., HAMMER, HELVE or
 TRIP-HAMMER
HAMMER, RAISING...................METALWORKING T&E
HAMMER, RIVETING..................METALWORKING T&E
Hammer, Roofing...................WOODWORKING T&E
 use HAMMER, CLENCH
Hammer, Rounding..................METALWORKING T&E
 use HAMMER, FARRIER'S TURNING
HAMMER, SET.......................METALWORKING T&E
 rt FLATTER
HAMMER, SETTING...................METALWORKING T&E
 rt HAMMER, SWAGE
Hammer, Ship's maul...............WOODWORKING T&E
 use HAMMER, TOP MAUL
Hammer, Shoe-turning..............METALWORKING T&E
 use HAMMER, FARRIER'S TURNING
Hammer, Shoeing...................ANIMAL HUSBANDRY T&E
 use HAMMER, FARRIER'S DRIVING
HAMMER, SLAUGHTERING..............FOOD PROCESSING T&E
Hammer, Sledge....................METALWORKING T&E
 use SLEDGE
HAMMER, SOUND.....................ACOUSTICAL T&E
HAMMER, STEAK.....................FOOD PROCESSING T&E
HAMMER, STEAM.....................METALWORKING T&E
HAMMER, STRAIGHT-PEEN.............METALWORKING T&E
 note use only if specific type is unknown
Hammer, Striking..................METALWORKING T&E
 use SLEDGE
HAMMER, SWAGE.....................METALWORKING T&E
 rt HAMMER, SETTING
HAMMER, TACK......................WOODWORKING T&E
Hammer, Tilt......................METALWORKING T&E
 use HAMMER, HELVE
HAMMER, TOP MAUL..................WOODWORKING T&E
Hammer, Trip......................METALWORKING T&E
 use TRIP-HAMMER
HAMMER, TURN-SHOE.................LEATHERWORKING T&E
HAMMER, VENEER....................WOODWORKING T&E
HAMMER, WAR.......................ARMAMENT T&E, BLUDGEON
HAMMER, WHEELWRIGHT'S IRONING.....METALWORKING T&E
HAMMERSTONE.......................UNCLASSIFIED T&E, GENERAL
HAMMOCK...........................BEDDING
HAMPER............................HOUSEKEEPING T&E
HAMPTON BOAT......................WATER TRANSPORTATION EQUIPMENT
Handbag...........................PERSONAL GEAR
 use PURSE

HANDBALL......................SPORTS EQUIPMENT
HANDBILL......................ADVERTISING MEDIUM
 rt POSTER
HANDCAR.......................RAIL TRANSPORTATION EQUIPMENT
 rt VELOCIPEDE CAR
HANDCUFFS.....................BEHAVIORAL CONTROL DEVICE
HAND GUARD, BROOMMAKER'S.......WOODWORKING T&E
Handgun.......................ARMAMENT T&E, FIREARM
 use more specific term: e.g., PISTOL, REVOLVER
HANDKERCHIEF..................PERSONAL GEAR
HANDPRESS.....................PRINTING T&E
HANDRAIL SECTION..............BUILDING FRAGMENT
 rt BALUSTRADE SECTION
Handsaw.......................MASONRY T&E
 use SAW, STONE
Handsaw.......................WOODWORKING T&E
 use more specific term: e.g., SAW, CROSSCUT;
 RIPSAW
HANDSPIKE.....................ARMAMENT ACCESSORY
HANDSTEEL.....................MINING T&E
 rt DRILL
HANGER........................GLASS & PLASTICS T&E
HANGER, SHAFT.................POWER PRODUCTION T&E
HANGING.......................ORIGINAL ART
 note use for macrame, needlework, weaving and
 other non-utilitarian craft items not
 otherwise named (e.g., SAMPLER, TAPESTRY)
HARBOR CRAFT..................WATER TRANSPORTATION EQUIPMENT
 note may be further subdivided to indicate
 specific type: e.g., HARBOR CRAFT, LIGHTER;
 -,REVENUE; -,SCOW; -,WATER HOY
HARDY.........................METALWORKING T&E
 note may be further subdivided to indicate
 specific type: e.g., HARDY, SIDE-CUTTING;
 -,STRAIGHT
HARMONICA.....................MUSICAL T&E, UNCLASSIFIED
HARMONICA, GLASS..............MUSICAL T&E, UNCLASSIFIED
HARMONOMETER..................ACOUSTICAL T&E
HARNESS.......................LAND TRANSPORTATION ACCESSORY
 note use for a general transportation harness;
 normally subdivided to indicate vehicle
 pulled: e.g., HARNESS, BUGGY; -,RUNABOUT
HARNESS, DOG..................LAND TRANSPORTATION ACCESSORY
HARNESS, DONKEY...............LAND TRANSPORTATION ACCESSORY
HARNESS, EXPRESS..............LAND TRANSPORTATION ACCESSORY
HARNESS, FARM.................LAND TRANSPORTATION ACCESSORY
Harness, Heavy truck..........LAND TRANSPORTATION ACCESSORY
 use HARNESS, EXPRESS
HARNESS, PONY.................LAND TRANSPORTATION ACCESSORY
Harness, Team.................LAND TRANSPORTATION ACCESSORY
 use HARNESS, FARM
HARNESS, TRACK................LAND TRANSPORTATION ACCESSORY

```
HARP.............................MUSICAL T&E, STRINGED
HARP, JEW'S......................MUSICAL T&E, UNCLASSIFIED
HARPOON..........................ARMAMENT T&E, EDGED
HARPSICHORD......................MUSICAL T&E, STRINGED
Harquebus........................ARMAMENT T&E, FIREARM
     use  ARQUEBUS
HARROW, ACME.....................AGRICULTURAL T&E
HARROW, DISK.....................AGRICULTURAL T&E
Harrow, Drag.....................AGRICULTURAL T&E
     use  HARROW, SPIKE-TOOTH
Harrow, Spading..................AGRICULTURAL T&E
     use  HOE, ROTARY
HARROW, SPIKE-TOOTH..............AGRICULTURAL T&E
HARROW, SPRING-TOOTH.............AGRICULTURAL T&E
HARROW, TINE-TOOTH...............AGRICULTURAL T&E
HARVESTER, BEAN..................AGRICULTURAL T&E
HARVESTER, CORN SLED.............AGRICULTURAL T&E
HARVESTER, FORAGE................AGRICULTURAL T&E
HARVESTER, ONION.................AGRICULTURAL T&E
HARVESTER, POTATO................AGRICULTURAL T&E
HARVESTER, SUGAR-BEET............AGRICULTURAL T&E
HARVESTER, SUGARCANE.............AGRICULTURAL T&E
HARVESTER, TOMATO................AGRICULTURAL T&E
Harvester/thresher...............AGRICULTURAL T&E
     use  COMBINE
HASP.............................BUILDING FRAGMENT
HASSOCK..........................FURNITURE
     rt  OTTOMAN; FOOTSTOOL
HAT..............................CLOTHING, HEADWEAR
     note use only for objects which contain the word
          HAT in the name; may be further subdivided
          to indicate specific type: e.g., HAT, HARD;
          -,PANAMA; -,PICTURE; -,TOP; -,TRICORN
Hat, Derby.......................CLOTHING, HEADWEAR
     use  DERBY
HAT, ECCLESIASTIC................PERSONAL SYMBOL
Hat, Homberg.....................CLOTHING, HEADWEAR
     use  HOMBERG
HAT, KETTLE......................ARMAMENT T&E, BODY ARMOR
Hat, Safety......................CLOTHING, HEADWEAR
     use  more specific term: e.g., HAT, HARD
HATBAND..........................CLOTHING, HEADWEAR
HATBOX...........................PERSONAL GEAR
HATCHEL..........................TEXTILEWORKING T&E
HATCHEL, BROOMMAKER'S............WOODWORKING T&E
HATCHER, POULTRY.................ANIMAL HUSBANDRY T&E
HATCHET..........................WOODWORKING T&E
     note use only if specific type is unknown
     rt  AX
HATCHET, CLAW....................WOODWORKING T&E
HATCHET, HEWING..................WOODWORKING T&E
HATCHET, LATHING.................WOODWORKING T&E
```

373

HATCHET, SHINGLING.............WOODWORKING T&E
HATPIN.........................CLOTHING ACCESSORY
Hautboy........................MUSICAL T&E, WOODWIND
 use OBOE
HAVELOCK.......................CLOTHING, HEADWEAR
HAVERSACK......................PERSONAL GEAR
HAVERSACK, GUNNER'S............ARMAMENT ACCESSORY
HAWK...........................MASONRY T&E
HAWSE PIPE.....................WATER TRANSPORTATION ACCESSORY
HAYFORK........................AGRICULTURAL T&E
HAY-LOADER.....................AGRICULTURAL T&E
HAY-LOADER, BALE...............AGRICULTURAL T&E
HEADBAND.......................CLOTHING, HEADWEAR
HEADBAND, TIGHTENING...........BEHAVIORAL CONTROL DEVICE
HEADDRESS......................PERSONAL SYMBOL
HEADER, GRAIN..................AGRICULTURAL T&E
HEADING MACHINE, BOLT..........METALWORKING T&E
HEADING TOOL...................METALWORKING T&E
 note use only if specific type is unknown
HEADING TOOL, BOLT.............METALWORKING T&E
HEADING TOOL, NAIL.............METALWORKING T&E
Headkerchief...................CLOTHING, HEADWEAR
 use KERCHIEF
HEADREST.......................BEDDING
HEADRING.......................PERSONAL GEAR
Headstone......................CEREMONIAL ARTIFACT
 use TOMBSTONE
HEARING AID....................PERSONAL GEAR
HEARSE.........................LTE, ANIMAL-POWERED
HEARSE.........................LTE, MOTORIZED
HEATER.........................TEMPERATURE CONTROL DEVICE
 note normally subdivided according to fuel used:
 e.g., HEATER, COAL; -,OIL; -,NATURAL GAS;
 -,BASEBOARD WATER
HEATER, BRANDING-IRON..........METALWORKING T&E
HEATER, CALROD.................GLASS & PLASTICS T&E
HEATER, MILK...................FOOD PROCESSING T&E
HEATER, STRIP..................GLASS & PLASTICS T&E
HEATER, WATER..................PLUMBING FIXTURE
Heater, Wheat..................FOOD PROCESSING T&E
 use CONDITIONER, GRAIN
HEAT-SETTING MACHINE...........TEXTILEWORKING T&E
Heckle.........................TEXTILEWORKING T&E
 use HATCHEL
HECTOGRAPH.....................PRINTING T&E
HELICOGRAPH....................DRAFTING T&E
HELICOPTER.....................AEROSPACE TRANSPORTATION EQUIPMENT
HELIOGRAPH.....................VISUAL COMMUNICATION EQUIPMENT
HELIOMETER.....................ASTRONOMICAL T&E
HELIOSCOPE.....................ASTRONOMICAL T&E
Heliostat......................SURVEYING & NAVIGATIONAL T&E
 use HELIOTROPE

HELIOTROPE.....................SURVEYING & NAVIGATIONAL T&E
HELM..........................ARMAMENT T&E, BODY ARMOR
HELMET........................CLOTHING, HEADWEAR
 note may be further subdivided to indicate
 specific type: e.g., HELMET, CRASH;
 -,DIVER'S: -,PITH
HELMET........................ARMAMENT T&E, BODY ARMOR
HELMET, SOUND.................ACOUSTICAL T&E
HEMACYTOMETER.................BIOLOGICAL T&E
HEMAGLOBINOMETER..............BIOLOGICAL T&E
HEM RIPPER....................TEXTILEWORKING T&E
HENNIN........................CLOTHING, HEADWEAR
Hetchel.......................TEXTILEWORKING T&E
 use HATCHEL
Highboy.......................FURNITURE
 use CHEST OF DRAWERS
HIGHCHAIR.....................FURNITURE
Highwheeler...................LTE, HUMAN-POWERED
 use BICYCLE, ORDINARY
High wire.....................PUBLIC ENTERTAINMENT DEVICE
 use AERIAL RIGGING
Hilac.........................NUCLEAR PHYSICS T&E
 use ACCELERATOR, LINEAR--HEAVY ION
HINGE.........................BUILDING FRAGMENT
HOBBLE........................ANIMAL HUSBANDRY T&E
Hobbyhorse....................LTE, HUMAN-POWERED
 use DRAISINE
HOBBYHORSE....................TOY
 note use for a stick horse and not for a rocking
 horse
HOCKEY PUCK...................SPORTS EQUIPMENT
HOCKEY STICK..................SPORTS EQUIPMENT
HOD...........................MASONRY T&E
Hodometer.....................SURVEYING & NAVIGATIONAL T&E
 use WHEEL, SURVEYOR'S
HOE...........................AGRICULTURAL T&E
 note use only if specific type is unknown
HOE, BEET-THINNING............AGRICULTURAL T&E
Hoe, Bog......................AGRICULTURAL T&E
 use HOE, GRUB
Hoe, Broad....................AGRICULTURAL T&E
 use HOE, GARDEN
Hoe, Bunching.................AGRICULTURAL T&E
 use HOE, BEET-THINNING
HOE, CELERY...................AGRICULTURAL T&E
HOE, CLAMMING.................FISHING & TRAPPING T&E
HOE, CORN.....................AGRICULTURAL T&E
HOE, COTTON...................AGRICULTURAL T&E
Hoe, Cultivator...............AGRICULTURAL T&E
 use HOE, WEEDING
Hoe, Dutch....................AGRICULTURAL T&E
 use HOE, SCUFFLE

```
HOE, GARDEN....................AGRICULTURAL T&E
HOE, GRAPE.....................AGRICULTURAL T&E
Hoe, Grass.....................AGRICULTURAL T&E
    use  HOE, MEADOW
HOE, GRUB......................AGRICULTURAL T&E
HOE, HOP.......................AGRICULTURAL T&E
Hoe, Horse.....................AGRICULTURAL T&E
    use  CULTIVATOR, ROW-CROP
HOE, MATTOCK...................AGRICULTURAL T&E
HOE, MEADOW....................AGRICULTURAL T&E
Hoe, Narrow....................AGRICULTURAL T&E
    use  HOE, GRUB
HOE, NURSERY...................AGRICULTURAL T&E
HOE, PERIODONTAL...............MEDICAL & PSYCHOLOGICAL T&E
Hoe, Plantation................AGRICULTURAL T&E
    use  HOE, COTTON
Hoe, Planter...................AGRICULTURAL T&E
    use  HOE, COTTON
HOE, ROTARY....................AGRICULTURAL T&E
HOE, SCUFFLE...................AGRICULTURAL T&E
Hoe, Shuffle...................AGRICULTURAL T&E
    use  HOE, SCUFFLE
HOE, SUGAR BEET................AGRICULTURAL T&E
HOE, TOBACCO...................AGRICULTURAL T&E
HOE, TURNIP....................AGRICULTURAL T&E
HOE, WARREN....................AGRICULTURAL T&E
HOE, WEEDING...................AGRICULTURAL T&E
Hoe, Wheel.....................AGRICULTURAL T&E
    use  CULTIVATOR, WHEEL
HOGAN..........................BUILDING
HOIST..........................MECHANICAL T&E
    note use for any lifting machine which operates
         with ropes and pulleys
    rt   WINDLASS
HOIST, DRESSING................FOOD PROCESSING T&E
HOIST, MINE....................MINING T&E
Holdback.......................WINDOW OR DOOR COVERING
    use  TIEBACK
HOLDER, BAG....................FOOD PROCESSING T&E
HOLDER, BRUSH..................WRITTEN COMMUNICATION EQUIPMENT
Holder, Candle.................LIGHTING DEVICE
    use  CANDELABRUM or CANDLESTICK or SCONCE
HOLDER, CARTRIDGE..............ARMAMENT ACCESSORY
HOLDER, CIGAR..................PERSONAL GEAR
HOLDER, CIGARETTE..............PERSONAL GEAR
HOLDER, COW-TAIL...............ANIMAL HUSBANDRY T&E
HOLDER, CUT-FILM...............PHOTOGRAPHIC T&E
HOLDER, DIE....................METALWORKING T&E
Holder, Grain bag..............FOOD PROCESSING T&E
    use  HOLDER, BAG
HOLDER, HATPIN.................CLOTHING ACCESSORY
HOLDER, LAMP...................LIGHTING DEVICE
```

```
HOLDER, MATCH....................HOUSEHOLD ACCESSORY
HOLDER, NAPKIN...................FOOD SERVICE T&E
HOLDER, PEN......................WRITTEN COMMUNICATION EQUIPMENT
HOLDER, PLACECARD................FOOD SERVICE T&E
Holder, Plate....................PHOTOGRAPHIC T&E
     use   PLATEHOLDER
HOLDER, RETORT...................CHEMICAL T&E
HOLDER, ROLL-FILM................PHOTOGRAPHIC T&E
HOLDER, RUSHLIGHT................LIGHTING DEVICE
     rt   HOLDER, TAPER
HOLDER, SCYTHE-SHARPENER.........METALWORKING T&E
HOLDER, SHELL....................ARMAMENT ACCESSORY
HOLDER, SPILL....................HOUSEHOLD ACCESSORY
HOLDER, SPLINT...................LIGHTING DEVICE
Holder, Spoon....................FOOD SERVICE T&E
     use   SPOONER
HOLDER, STRING...................MERCHANDISING T&E
HOLDER, TAPER....................LIGHTING DEVICE
     rt   HOLDER, RUSHLIGHT
HOLDER, TISSUE...................HOUSEHOLD ACCESSORY
HOLDER, TOOTHPICK................FOOD SERVICE T&E
HOLDER, TORCH....................LIGHTING DEVICE
HOLDER, WATCH....................HOUSEHOLD ACCESSORY
HOLDFAST.........................WOODWORKING T&E
HOLOMETER........................DATA PROCESSING T&E
HOLOPHOTE........................OPTICAL T&E
HOLSTER..........................ARMAMENT ACCESSORY
HOLY STONE.......................WATER TRANSPORTATION ACCESSORY
HOMBERG..........................CLOTHING, HEADWEAR
HOMOGENIZER, MILK................FOOD PROCESSING T&E
Hone.............................METALWORKING T&E
     use   WHETSTONE
HOOD.............................CLOTHING, HEADWEAR
HOOD, ACADEMIC...................PERSONAL SYMBOL
HOOD, SWEAT......................ANIMAL HUSBANDRY T&E
Hook, Bagging....................AGRICULTURAL T&E
     use   HOOK, REAPING
HOOK, BENCH......................WOODWORKING T&E
Hook, Bill.......................AGRICULTURAL T&E
     use   BILLHOOK
HOOK, BLUBBER....................FISHING & TRAPPING T&E
HOOK, BOAT.......................WATER TRANSPORTATION ACCESSORY
Hook, Bramble....................AGRICULTURAL T&E
     use   HOOK, BRUSH
HOOK, BRUSH......................AGRICULTURAL T&E
Hook, Bush.......................AGRICULTURAL T&E
     use   HOOK, BRUSH
Hook, Button.....................CLOTHING ACCESSORY
     use   BUTTONHOOK
HOOK, CANT.......................FORESTRY T&E
HOOK, CEILING....................UNCLASSIFIED T&E, GENERAL
HOOK, CORN.......................AGRICULTURAL T&E
     rt   KNIFE, CORN
```

HOOK, CROCHET...................TEXTILEWORKING T&E
Hook, Fagging...................AGRICULTURAL T&E
 use HOOK, REAPING
Hook, Garden...................AGRICULTURAL T&E
 use HOOK, NURSERY
HOOK, GRAB.....................MINING T&E
HOOK, GRASS....................AGRICULTURAL T&E
Hook, Grub.....................AGRICULTURAL T&E
 use HOOK, POTATO
Hook, Hay......................AGRICULTURAL T&E
 use CROOK, HAY
HOOK, HAY-BALE.................AGRICULTURAL T&E
HOOK, HEDGE....................AGRICULTURAL T&E
Hook, Husking..................AGRICULTURAL T&E
 use CORNHUSKER, HAND
HOOK, JACK.....................UNCLASSIFIED T&E, SPECIAL
HOOK, JAMB.....................UNCLASSIFIED T&E, GENERAL
HOOK, MANURE...................AGRICULTURAL T&E
HOOK, NURSERY..................AGRICULTURAL T&E
HOOK, OX.......................ANIMAL HUSBANDRY T&E
HOOK, POTATO...................AGRICULTURAL T&E
HOOK, PRUNING..................AGRICULTURAL T&E
 rt BILLHOOK
HOOK, REAPING..................AGRICULTURAL T&E
 rt SICKLE
HOOK, RUG......................TEXTILEWORKING T&E
HOOK, SHELL....................ARMAMENT ACCESSORY
Hook, Shrubbery................AGRICULTURAL T&E
 use HOOK, NURSERY
Hook, Sith.....................AGRICULTURAL T&E
 use MATHOOK
HOOK, SWAMP....................FORESTRY T&E
HOOK, TAMBOUR..................TEXTILEWORKING T&E
Hook, Vine.....................AGRICULTURAL T&E
 use HOOK, NURSERY
HOOK, WELL.....................UNCLASSIFIED T&E, SPECIAL
HOOKAH.........................PERSONAL GEAR
HOOKAH.........................MINING T&E
Hoola hoop.....................TOY
 use HOOP
HOOP...........................TOY
HOOP, EMBROIDERY...............TEXTILEWORKING T&E
HOOP, MAST.....................WATER TRANSPORTATION ACCESSORY
HOOP DRIVER....................WOODWORKING T&E
HOPPER CAR.....................RAIL TRANSPORTATION EQUIPMENT
Hoppit.........................MINING T&E
 use KIBBLE
HORIZONTAL BAR.................SPORTS EQUIPMENT
HORN...........................MUSICAL T&E, BRASS
HORN...........................LAND TRANSPORTATION ACCESSORY
HORN, ALTO.....................MUSICAL T&E, BRASS
HORN, BARITONE.................MUSICAL T&E, BRASS

```
HORN, BASS.......................MUSICAL T&E, BRASS
HORN, BASSET.....................MUSICAL T&E, WOODWIND
HORN, COACH......................MUSICAL T&E, BRASS
HORN, DRINKING...................FOOD SERVICE T&E
HORN, ENGLISH....................MUSICAL T&E, WOODWIND
HORN, FRENCH.....................MUSICAL T&E, BRASS
HORN, HUNTING....................MUSICAL T&E, BRASS
HORN, MINER'S....................MINING T&E
Horn, Mower's....................METALWORKING T&E
    use  HOLDER, SCYTHE-SHARPENER
HORN, POST.......................MUSICAL T&E, BRASS
HORN, POWDER.....................ARMAMENT ACCESSORY
HORN, TENOR......................MUSICAL T&E, BRASS
HOROMETER........................TIMEKEEPING T&E
HORSE, FROE......................WOODWORKING T&E
    rt   HORSE, SHAVING
HORSE, HORNWORKER'S..............UNCLASSIFIED T&E, SPECIAL
HORSE, NAILMAKER'S ANVIL.........METALWORKING T&E
Horse, Saw.......................WOODWORKING T&E
    use  SAWHORSE
HORSE, SAW-SHARPENING............WOODWORKING T&E
HORSE, SHAVING...................WOODWORKING T&E
    rt   SHAVING BLOCK; HORSE, FROE
Horse, Shingling.................WOODWORKING T&E
    use  HORSE, FROE
HORSESHOE........................ANIMAL HUSBANDRY T&E
    note may be further subdivided to indicate
         specific type: e.g., HORSESHOE, COACH;
         -,HINGED; -,FRONT; -,MUD
HORSESHOE........................SPORTS EQUIPMENT
HORSESHOE PAD....................ANIMAL HUSBANDRY T&E
Hose, Trunk......................CLOTHING, OUTERWEAR
    use  BREECHES, TRUNK
HOSPITAL.........................BUILDING
HOTEL............................BUILDING
HOT EXTRACTION APPARATUS.........CHEMICAL T&E
HOT WATER GEYSER.................CHEMICAL T&E
    note use for apparatus attached to wall with
         water and gas tap
HOUSE............................BUILDING
HOUSE, CHARNEL...................BUILDING
    rt   MAUSOLEUM
House, Doll......................TOY
    use  DOLLHOUSE
HOUSE, FRUIT-DRYING..............BUILDING
HOUSE, HOG.......................BUILDING
HOUSE, POWDER....................BUILDING
HOUSE, TOLL......................BUILDING
HOUSECOAT........................CLOTHING, OUTERWEAR
HOVERCRAFT.......................WATER TRANSPORTATION EQUIPMENT
HOWDAH...........................LTE, ANIMAL-POWERED
HOWITZER.........................ARMAMENT T&E, ARTILLERY
```

HUARACHE........................CLOTHING, FOOTWEAR
HULLER, BEAN....................FOOD PROCESSING T&E
HULLER, CLOVER..................FOOD PROCESSING T&E
Huller, Pea.....................FOOD PROCESSING T&E
 use HULLER, BEAN
HUMIDIFIER......................TEMPERATURE CONTROL DEVICE
HUMIDOR.........................HOUSEHOLD ACCESSORY
Hummeler........................AGRICULTURAL T&E
 use BEARDER, BARLEY
HUNT BOARD......................FURNITURE
 rt SIDEBOARD
HURDLE..........................SPORTS EQUIPMENT
HURDY-GURDY.....................MINING T&E
HURDY-GURDY.....................MUSICAL T&E, STRINGED
Husker, Corn....................AGRICULTURAL T&E
 use CORNHUSKER, HAND or HUSKER/SHREDDER, CORN
HUSKER/SHREDDER, CORN...........AGRICULTURAL T&E
Husking machine.................AGRICULTURAL T&E
 use HUSKER-SHREDDER, CORN
HUSLA...........................MUSICAL T&E, STRINGED
Hutch...........................FURNITURE
 use more specific term: e.g., CABINET, CORNER;
 CABINET, CHINA
HYALOGRAPH......................DRAFTING T&E
HYDRANT.........................UNCLASSIFIED STRUCTURE
HYDRIA..........................HOUSEHOLD ACCESSORY
 rt JAR, WATER
HYDRODYNAMOMETER................MECHANICAL T&E
HYDROFOIL.......................WATER TRANSPORTATION EQUIPMENT
HYDROMETER......................MECHANICAL T&E
HYDROPHORE......................CHEMICAL T&E
HYDROPLANE......................WATER TRANSPORTATION EQUIPMENT
 rt RUNABOUT
Hydropyrometer..................THERMAL T&E
 use PYROMETER
HYDROSCOPE......................CHEMICAL T&E
HYGROGRAPH......................METEOROLOGICAL T&E
HYGROMETER......................METEOROLOGICAL T&E
Hygrophant......................METEOROLOGICAL T&E
 use HYGROMETER
HYPSOMETER......................THERMAL T&E
ICEBOAT.........................WATER TRANSPORTATION EQUIPMENT
ICEBOX..........................FOOD PROCESSING T&E
ICEBREAKER......................WATER TRANSPORTATION EQUIPMENT
ICEHOUSE........................BUILDING
IDLER...........................POWER PRODUCTION T&E
Igniter.........................MINING T&E
 use DETONATOR
IMPACTOR........................METALWORKING T&E
IMPOSING STONE..................PRINTING T&E
INCISING TOOL...................GLASS & PLASTICS T&E
INCLINED PLANE..................MECHANICAL T&E

```
INCLINOMETER....................SURVEYING & NAVIGATIONAL T&E
INCUBATOR.......................BIOLOGICAL T&E
INCUBATOR, POULTRY..............ANIMAL HUSBANDRY T&E
INDIAN CLUB.....................SPORTS EQUIPMENT
INDICATOR, AIRSPEED.............SURVEYING & NAVIGATIONAL T&E
INDICATOR, BANK.................SURVEYING & NAVIGATIONAL T&E
INDICATOR, CLIMB................SURVEYING & NAVIGATIONAL T&E
INDICATOR, DRIFT................MINING T&E
INDICATOR, DRIFT................SURVEYING & NAVIGATIONAL T&E
INDICATOR, ENGINE-ROOM TELEGRAPH
    ............................WATER TRANSPORTATION ACCESSORY
INDICATOR, POSITION.............SURVEYING & NAVIGATIONAL T&E
INDICATOR, RATE-OF-CLIMB........SURVEYING & NAVIGATIONAL T&E
INDICATOR, RUDDER-POSITION......WATER TRANSPORTATION ACCESSORY
INDICATOR, TURN.................SURVEYING & NAVIGATIONAL T&E
Indicator, Vertical-speed.......SURVEYING & NAVIGATIONAL T&E
    use  INDICATOR, RATE-OF-CLIMB
INDICATOR, VOLUME-CHANGE........CHEMICAL T&E
INDICATOR, WATER-STABILITY......CHEMICAL T&E
INDIGOMETER.....................ELECTRICAL & MAGNETIC T&E
Indiscope.......................MEDICAL & PSYCHOLOGICAL T&E
    use  OPHTHALMOSCOPE
INDUCTOMETER....................ELECTRICAL & MAGNETIC T&E
INFLATABLE BOAT.................WATER TRANSPORTATION EQUIPMENT
INFUSER, TEA....................FOOD PROCESSING T&E
INHALATOR.......................MEDICAL & PSYCHOLOGICAL T&E
INHALER.........................MEDICAL & PSYCHOLOGICAL T&E
INJECTOR, CEMENT................MINING T&E
INJECTOR, FERTILIZER............AGRICULTURAL T&E
INKBALL.........................PRINTING T&E
INKPAD..........................WRITTEN COMMUNICATION EQUIPMENT
INKSTAND........................WRITTEN COMMUNICATION EQUIPMENT
INKWELL.........................WRITTEN COMMUNICATION EQUIPMENT
INKWELL LINER...................WRITTEN COMMUNICATION EQUIPMENT
INN.............................BUILDING
Inro............................PERSONAL GEAR
    use  CASE, MEDICINE
INSEMINATION KIT................ANIMAL HUSBANDRY T&E
INSTRUCTIONAL MODEL
    note refer to text for method of classifying this
         object
Instrument, Flight..............AEROSPACE TRANSPORTATION ACCESSORY
    use  a term from SURVEYING & NAVIGATIONAL T&E or
         TELECOMMUNICATION EQUIPMENT for the name of
         a specific instrument
INSULATOR.......................ELECTRICAL & MAGNETIC T&E
INSULATOR.......................POWER PRODUCTION T&E
INTEGRATOR......................DATA PROCESSING T&E
    rt  PLANIMETER
INTERCOM........................SOUND COMMUNICATION EQUIPMENT
INTERFEROMETER..................OPTICAL T&E
INTERFEROMETER, RADIO...........ASTRONOMICAL T&E
```

```
Interurban...................RAIL TRANSPORTATION EQUIPMENT
     use  SELF-PROPELLED CAR, ELECTRIC
INVENTIONSHORN................MUSICAL T&E, BRASS
INVITATION...................DOCUMENTARY ARTIFACT
Irish mail...................LTE, HUMAN-POWERED
     use  QUADRICYCLE
IRISH MAIL...................TOY
IRON.........................HOUSEKEEPING T&E
IRON, BARKING................FORESTRY T&E
IRON, BRANDING...............ANIMAL HUSBANDRY T&E
IRON, BUCKING................MINING T&E
IRON, CHINCING...............WOODWORKING T&E
IRON, COOPER'S BURNING.......WOODWORKING T&E
IRON, CURLING................TOILET ARTICLE
IRON, FLAGGING...............WOODWORKING T&E
IRON, FLUTING................HOUSEKEEPING T&E
IRON, GATHERING..............GLASS & PLASTICS T&E
IRON, GRAFTING...............AGRICULTURAL T&E
IRON, KNOCKING-DOWN..........PRINTING T&E
Iron, Knocking-up............WOODWORKING T&E
     use  JUMPER
IRON, MARKING................WOODWORKING T&E
IRON, PATTY..................FOOD PROCESSING T&E
IRON, RAISING................WOODWORKING T&E
     rt   JUMPER
IRON, ROSETTE................FOOD PROCESSING T&E
IRON, SHIPWRIGHT'S CAULKING...WOODWORKING T&E
IRON, SNARLING...............METALWORKING T&E
IRON, SOLDERING..............METALWORKING T&E
IRON, TACKING................PHOTOGRAPHIC T&E
IRON, WAFER..................FOOD PROCESSING T&E
IRON, WAFFLE.................FOOD PROCESSING T&E
IRON, WHEELWRIGHT'S BURNING...WOODWORKING T&E
IRONING BOARD................HOUSEKEEPING T&E
IRONING MACHINE..............LEATHERWORKING T&E
IRON LUNG....................MEDICAL & PSYCHOLOGICAL T&E
ISOCHRONOUS..................NUCLEAR PHYSICS T&E
ISOGRAPH.....................DRAFTING T&E
ITA..........................MINING T&E
IV SET, LARGE-ANIMAL.........ANIMAL HUSBANDRY T&E
JABOT........................CLOTHING ACCESSORY
Jack.........................GLASS & PLASTICS T&E
     use  PUCELLAS
JACK.........................LAND TRANSPORTATION ACCESSORY
     note may be further subdivided to indicate
          specific type: e.g., JACK, STAGECOACH;
          -,WAGON
JACK, FENCE..................UNCLASSIFIED T&E, SPECIAL
JACK, GLAZING................LEATHERWORKING T&E
JACK, HOISTING...............MECHANICAL T&E
JACK, LAST...................LEATHERWORKING T&E
JACK, LIFTING................MECHANICAL T&E
```

```
JACK, MITER.....................WOODWORKING T&E
JACK, PULLING...................MECHANICAL T&E
     rt   COME-ALONG
JACKBOOT........................CLOTHING, FOOTWEAR
JACKET.........................CLOTHING, OUTERWEAR
     note may be further subdivided to indicate
          specific type: e.g., JACKET, BUSH; -,MESS;
          -,PEA; -,SMOKING
Jacket, Dinner.................CLOTHING, OUTERWEAR
     use  TUXEDO
JACKET, LIFE...................WATER TRANSPORTATION ACCESSORY
JACKET, TARGET SHOOTER'S.......ARMAMENT ACCESSORY
Jackhammer.....................CONSTRUCTION T&E
     use  DRILL, PERCUSSIVE AIR under MINING T&E
Jackhammer.....................MINING T&E
     use  DRILL, PERCUSSIVE AIR
JACK-IN-THE-BOX................TOY
Jackknife......................PERSONAL GEAR
     use  KNIFE, POCKET
Jackleg........................MINING T&E
     use  AIR LEG
JACKS..........................GAME
Jackscrew......................FOOD PROCESSING T&E
     use  BOTTLE JACK
JACKSHAFT......................POWER PRODUCTION T&E
JACKSTRAWS.....................GAME
Jacob's ladder.................TOY
     use  FLIPPER-FLOPPER
JAG............................ARMAMENT ACCESSORY
JAI ALAI BASKET................SPORTS EQUIPMENT
JAIL...........................BUILDING
JAMB PLATE.....................METALWORKING T&E
     rt   SCREW PLATE
JAR............................PRODUCT PACKAGE
JAR............................UNCLASSIFIED CONTAINER
     note use for a rounded vessel which is nearly
          closed to view of the inside by reason of
          having an orifice diameter substantially
          narrower than the maximum body diameter;
          includes forms customarily referred to as
          bottles, jugs, ollas, etc.; normally
          subdivided to indicate ceramic or basketry
          construction; see also BOWL and TRAY
JAR, APOTHECARY................MERCHANDISING T&E
JAR, BATTERY...................ELECTRICAL & MAGNETIC T&E
JAR, BELL......................HOUSEHOLD ACCESSORY
JAR, CANNING...................FOOD PROCESSING T&E
JAR, CANOPIC...................CEREMONIAL ARTIFACT
JAR, CONFECTIONARY.............MERCHANDISING T&E
JAR, COOKIE....................FOOD PROCESSING T&E
JAR, FOOD-STORAGE..............FOOD PROCESSING T&E
     note use only if specific product stored is
          unknown
```

```
JAR, GINGER.....................FOOD SERVICE T&E
Jar, Mortuary...................CEREMONIAL ARTIFACT
     use  URN, FUNEREAL
Jar, Mustard....................FOOD SERVICE T&E
     use  POT, MUSTARD
JAR, PICKLE.....................FOOD SERVICE T&E
Jar, Ring.......................MERCHANDISING T&E
     use  JAR, CONFECTIONARY
JAR, SEED.......................AGRICULTURAL T&E
JAR, SLOP.......................HOUSEHOLD ACCESSORY
JAR, SPECIMEN...................MEDICAL & PSYCHOLOGICAL T&E
JAR, SPICE......................FOOD PROCESSING T&E
Jar, Tobacco....................HOUSEHOLD ACCESSORY
     use  HUMIDOR
JAR, VACUUM.....................MECHANICAL T&E
JAR, WATCH......................HOUSEHOLD ACCESSORY
JAR, WATER......................HOUSEHOLD ACCESSORY
     rt  HYDRIA
JAR, WINE.......................FOOD SERVICE T&E
JARDINIERE......................HOUSEHOLD ACCESSORY
     rt  PLANTER
JARDINIERE BASE.................HOUSEHOLD ACCESSORY
JAVELIN.........................SPORTS EQUIPMENT
JERKIN..........................CLOTHING, OUTERWEAR
JETHRO..........................FORESTRY T&E
JIG.............................FISHING & TRAPPING T&E
JIG.............................METALWORKING T&E
JIGGER..........................FOOD SERVICE T&E
     rt  GLASS, SHOT
JIGGER..........................WOODWORKING T&E
     rt  DRAWKNIFE
JIGSAW..........................WOODWORKING T&E
JINGLES.........................MUSICAL T&E, PERCUSSION
Job stick.......................PRINTING T&E
     use  COMPOSING STICK
JOINTER.........................MASONRY T&E
JOINTER.........................WOODWORKING T&E
JOINTER-PLANER..................WOODWORKING T&E
JOURNAL.........................DOCUMENTARY ARTIFACT
JUG.............................FOOD PROCESSING T&E
Jug.............................FOOD SERVICE T&E
     use  PITCHER
JUG.............................PRODUCT PACKAGE
Juicer..........................FOOD PROCESSING T&E
     use  REAMER, JUICE
JUKEBOX.........................RECREATIONAL DEVICE
     rt  NICKELODEON
JUMBO...........................MINING T&E
JUMPER..........................CLOTHING, OUTERWEAR
Jumper..........................MASONRY T&E
     use  DRILL
JUMPER..........................WOODWORKING T&E
     rt  IRON, RAISING
```

```
JUMP ROPE........................TOY
Jungle gym.......................RECREATIONAL DEVICE
     use  CLIMBER
JUNK.............................WATER TRANSPORTATION EQUIPMENT
KAHN TEST APPARATUS..............BIOLOGICAL T&E
KALEIDOSCOPE.....................TOY
Kanzashi.........................ADORNMENT
     use  ORNAMENT, HAIR
Kas..............................FURNITURE
     use  WARDROBE
KAYAK............................WATER TRANSPORTATION EQUIPMENT
     rt   UMIAK
KAZOO............................MUSICAL T&E, UNCLASSIFIED
Keeve............................METALWORKING T&E
     use  CONCENTRATOR
KEG..............................MINING T&E
KEG..............................PRODUCT PACKAGE
KEG, POWDER......................ARMAMENT ACCESSORY
KELLEY...........................MINING T&E
KENNEL...........................BUILDING
Kepi.............................CLOTHING, HEADWEAR
     use  CAP, FORAGE
KERATOME.........................MEDICAL & PSYCHOLOGICAL T&E
KERATOMETER......................MEDICAL & PSYCHOLOGICAL T&E
KERCHIEF.........................CLOTHING, HEADWEAR
KETTLE...........................FOOD PROCESSING T&E
KETTLE, DYEING...................TEXTILEWORKING T&E
KETTLE, HORNWORKER'S.............UNCLASSIFIED T&E, SPECIAL
KETTLE, LARD-RENDERING...........FOOD PROCESSING T&E
Kettle, Lard-settling...........FOOD PROCESSING T&E
     use  TANK, LARD-SETTLING
Kettle, Tea......................FOOD PROCESSING T&E
     use  TEAKETTLE
Kettledrum.......................MUSICAL T&E, PERCUSSION
     use  TIMPANUM
Kettle plate.....................GLASS & PLASTICS T&E
     use  PLATE, CUT-OFF
KEY..............................HOUSEHOLD ACCESSORY
Key, Cotter......................METALWORKING T&E
     use  PIN, COTTER
Key, Nipple......................ARMAMENT ACCESSORY
     use  WRENCH, NIPPLE
Keypunch.........................DATA PROCESSING T&E
     use  PUNCH, KEYBOARD
KIBBLE...........................MINING T&E
KICKER...........................LEATHERWORKING T&E
KICK STOP........................ANIMAL HUSBANDRY T&E
KIDDIE CAR.......................TOY
KIDNEY...........................GLASS & PLASTICS T&E
KILLICK..........................WATER TRANSPORTATION ACCESSORY
     rt   ANCHOR
```

385

```
KILN................................GLASS & PLASTICS T&E
     note may be subdivided according to fuel: e.g.,
           KILN, ELECTRIC; -,GAS; -,WOOD
KILN................................UNCLASSIFIED T&E, SPECIAL
KILN, BRICK.........................MASONRY T&E
KILN, LIME..........................MASONRY T&E
KILN, MOLD..........................GLASS & PLASTICS T&E
KILN, POT...........................GLASS & PLASTICS T&E
KILT................................CLOTHING, OUTERWEAR
KIMONO..............................CLOTHING, OUTERWEAR
KINEGRAPH...........................MECHANICAL T&E
KINETOSCOPE.........................VISUAL COMMUNICATION EQUIPMENT
Kit
     use  in a multi-word object name only as a
          secondary word
KIT.................................MUSICAL T&E, STRINGED
     rt  VIOLIN
KITE................................AEROSPACE TRANSPORTATION EQUIPMENT
     note use for a heavier-than-air aircraft
          propelled by a towline
KITE................................TOY
KIVA................................BUILDING
Klismos.............................FURNITURE
     use CHAIR, DINING
Klomp...............................CLOTHING, FOOTWEAR
     use SABOT
KLYSTRON............................NUCLEAR PHYSICS T&E
KNAPSACK............................PERSONAL GEAR
KNEE CAP, HORSE.....................LAND TRANSPORTATION ACCESSORY
KNEE DEVELOPER......................SPORTS EQUIPMENT
KNICKERS............................CLOTHING, OUTERWEAR
Knick-knack.........................COMMERCIAL DECORATIVE ART
     use  BRIC-A-BRAC
KNIFE...............................FOOD SERVICE T&E
KNIFE, BAND-CUTTER..................AGRICULTURAL T&E
KNIFE, BASKETMAKER'S PICKING........TEXTILEWORKING T&E
KNIFE, BEAMING......................LEATHERWORKING T&E
KNIFE, BEET-TOPPING.................AGRICULTURAL T&E
Knife, Bench........................WOODWORKING T&E
     use  KNIFE, BLOCK
KNIFE, BEVEL-POINT SKIVING..........LEATHERWORKING T&E
KNIFE, BLOCK........................WOODWORKING T&E
KNIFE, BONING.......................FOOD PROCESSING T&E
KNIFE, BOWIE........................ARMAMENT T&E, EDGED
KNIFE, BREAD........................FOOD PROCESSING T&E
Knife, Budding......................AGRICULTURAL T&E
     use  KNIFE, GRAFTING
KNIFE, BUTCHER......................FOOD PROCESSING T&E
KNIFE, BUTTER.......................FOOD SERVICE T&E
KNIFE, CAKE.........................FOOD SERVICE T&E
KNIFE, CARVING......................FOOD SERVICE T&E
KNIFE, CARVING......................WOODWORKING T&E
```

386

Knife, Chamfer.....................WOODWORKING T&E
 use DRAWKNIFE, CHAMFERING
KNIFE, CHEESE.....................FOOD PROCESSING T&E
KNIFE, CHEF'S.....................FOOD PROCESSING T&E
KNIFE, CHEST......................GLASS & PLASTICS T&E
KNIFE, CHOPPING...................FOOD PROCESSING T&E
KNIFE, CORN.......................AGRICULTURAL T&E
 rt HOOK, CORN
KNIFE, CURD.......................FOOD PROCESSING T&E
Knife, Dehorning..................ANIMAL HUSBANDRY T&E
 use DEHORNER
KNIFE, DESSERT....................FOOD SERVICE T&E
KNIFE, DINNER.....................FOOD SERVICE T&E
KNIFE, ELECTRIC...................GLASS & PLASTICS T&E
KNIFE, ETCHING....................PRINTING T&E
Knife, Farrier's..................ANIMAL HUSBANDRY T&E
 use more specific term: e.g., KNIFE, HOOF;
 KNIFE, TOE
KNIFE, FETTLING...................GLASS & PLASTICS T&E
KNIFE, FILM.......................PHOTOGRAPHIC T&E
KNIFE, FISH.......................FOOD SERVICE T&E
KNIFE, FLESHING...................LEATHERWORKING T&E
KNIFE, FOLDING....................PRINTING T&E
Knife, Froe.......................WOODWORKING T&E
 use FROE, KNIFE
KNIFE, FRUIT......................FOOD SERVICE T&E
KNIFE, GRAFTING...................AGRICULTURAL T&E
KNIFE, GRAPEFRUIT.................FOOD PROCESSING T&E
KNIFE, HAM........................FOOD PROCESSING T&E
KNIFE, HAY........................AGRICULTURAL T&E
 rt SPADE, HAY
KNIFE, HEAD.......................LEATHERWORKING T&E
KNIFE, HOOF.......................ANIMAL HUSBANDRY T&E
KNIFE, HOOP-NOTCHING..............WOODWORKING T&E
 rt ADZ, COOPER'S NOTCHING
KNIFE, ICE-CREAM..................FOOD SERVICE T&E
Knife, Lathmaker's................WOODWORKING T&E
 use FROE, KNIFE
KNIFE, LUNCHEON...................FOOD SERVICE T&E
KNIFE, MARKING....................WOODWORKING T&E
 rt AWL, MARKING
KNIFE, MAT........................PAINTING T&E
KNIFE, MINCING....................FISHING & TRAPPING T&E
KNIFE, OYSTER.....................FOOD PROCESSING T&E
KNIFE, PAINTING...................PAINTING T&E
KNIFE, PALETTE....................PAINTING T&E
KNIFE, PAPER......................PRINTING T&E
KNIFE, PAPER......................WRITTEN COMMUNICATION EQUIPMENT
KNIFE, PARING.....................FOOD PROCESSING T&E
KNIFE, PIPE.......................PERSONAL GEAR
KNIFE, POCKET.....................PERSONAL GEAR
Knife, Potato.....................AGRICULTURAL T&E
 use CUTTER, POTATO-SEED

387

KNIFE, POULTRY-KILLING.........FOOD PROCESSING T&E
KNIFE, PRUNING.................AGRICULTURAL T&E
KNIFE, PUTTY...................PAINTING T&E
Knife, Race....................FORESTRY T&E
 use SCRIBE, TIMBER
KNIFE, ROUND-HEAD..............LEATHERWORKING T&E
KNIFE, SCUTCHING...............TEXTILEWORKING T&E
KNIFE, SHEETER.................PRINTING T&E
Knife, Shoeing.................ANIMAL HUSBANDRY T&E
 use KNIFE, HOOF
KNIFE, SKINNING................FOOD PROCESSING T&E
KNIFE, SKIVING.................LEATHERWORKING T&E
KNIFE, SKIVING.................PRINTING T&E
Knife, Slaughtering............FOOD PROCESSING T&E
 use KNIFE, STICKING
KNIFE, SOLE....................ANIMAL HUSBANDRY T&E
KNIFE, SQUARE-POINT............LEATHERWORKING T&E
KNIFE, STEAK...................FOOD SERVICE T&E
KNIFE, STICKING................FOOD PROCESSING T&E
KNIFE, STOPPING................GLASS & PLASTICS T&E
KNIFE, STRETCHING..............LEATHERWORKING T&E
KNIFE, SUGARCANE...............AGRICULTURAL T&E
 rt MACHETE
Knife, Swingling...............TEXTILEWORKING T&E
 use KNIFE, SCUTCHING
KNIFE, TAB-CUTTER..............PRINTING T&E
Knife, Table...................FOOD SERVICE T&E
 use KNIFE, DINNER
KNIFE, TEAT....................ANIMAL HUSBANDRY T&E
KNIFE, THROWING................ARMAMENT T&E, EDGED
KNIFE, TOBACCO.................AGRICULTURAL T&E
KNIFE, TOE.....................ANIMAL HUSBANDRY T&E
KNIFE, TRIMMER.................PRINTING T&E
KNIFE, UNHAIRING...............LEATHERWORKING T&E
KNIFE, UTILITY.................UNCLASSIFIED T&E, GENERAL
KNIFE, WILLOW..................TEXTILEWORKING T&E
Knife, X-acto..................UNCLASSIFIED T&E, GENERAL
 use KNIFE, UTILITY
KNIFE REST.....................FOOD SERVICE T&E
KNIT/SEW MACHINE...............TEXTILEWORKING T&E
KNITTING MACHINE...............TEXTILEWORKING T&E
 note use only if specific type is unknown
KNITTING MACHINE, CIRCULAR.....TEXTILEWORKING T&E
KNITTING MACHINE, FLAT.........TEXTILEWORKING T&E
KNITTING MACHINE, LATCH-TYPE...TEXTILEWORKING T&E
KNITTING MACHINE, SPRING-NEEDLE
.............................TEXTILEWORKING T&E
KNITTING MACHINE, WARP-TYPE....TEXTILEWORKING T&E
KNOCKER........................BUILDING FRAGMENT
KNOCKOUT ROD...................ARMAMENT ACCESSORY
KNOTTER........................TEXTILEWORKING T&E
KNURLING TOOL..................METALWORKING T&E

```
Kogai.............................ADORNMENT
     use ORNAMENT, HAIR
KONISCOPE.........................METEOROLOGICAL T&E
KRIS..............................ARMAMENT T&E, EDGED
KUA...............................MINING T&E
KYMOSCOPE.........................ACOUSTICAL T&E
LABEL MAKER.......................WRITTEN COMMUNICATION EQUIPMENT
LABRET............................ADORNMENT
LACING PONY.......................LEATHERWORKING T&E
LACROSSE HELMET...................SPORTS EQUIPMENT
LACROSSE RACKET...................SPORTS EQUIPMENT
LACROSSE STICK....................SPORTS EQUIPMENT
LACTOBUTYROMETER..................FOOD PROCESSING T&E
LACTOMETER........................FOOD PROCESSING T&E
LACTORIUM.........................BUILDING FRAGMENT
LADDER............................HOUSEHOLD ACCESSORY
LADDER, FRUIT-PICKING.............AGRICULTURAL T&E
LADDER, HORIZONTAL................RECREATIONAL DEVICE
LADDER, JACOB'S...................WATER TRANSPORTATION ACCESSORY
LADDER, ROPE......................RECREATIONAL DEVICE
Ladder, Step......................HOUSEHOLD ACCESSORY
     use STEPLADDER
LADLE.............................FOOD PROCESSING T&E
LADLE.............................FOOD SERVICE T&E
     note use only if specific type is unknown
LADLE.............................GLASS & PLASTICS T&E
     note may be further subdivided to indicate
          specific type: e.g., LADLE, WAX
LADLE.............................METALWORKING T&E
     note use only if specific type is unknown
LADLE, BUTTER.....................FOOD PROCESSING T&E
LADLE, CINDER.....................METALWORKING T&E
LADLE, GRAVY......................FOOD SERVICE T&E
LADLE, HOT-METAL..................METALWORKING T&E
LADLE, MAYONNAISE.................FOOD SERVICE T&E
LADLE, MILK.......................FOOD PROCESSING T&E
LADLE, PUNCH......................FOOD SERVICE T&E
LADLE, SAUCE......................FOOD SERVICE T&E
LADLE, SHIPWRIGHT'S CAULKING...WOODWORKING T&E
LADLE, SLAG.......................METALWORKING T&E
LADLE, SOUP.......................FOOD SERVICE T&E
LAGGING...........................MINING T&E
LAGYNOS...........................FOOD SERVICE T&E
     rt PITCHER
LAMBREQUIN........................HOUSEHOLD ACCESSORY
LAMELLA...........................ACOUSTICAL T&E
LAMP..............................LIGHTING DEVICE
     note normally subdivided according to fuel; may
          be further subdivided to indicate placement
          or use: e.g., LAMP, KEROSINE TABLE;
          -,ELECTRIC FLOOR; -,ELECTRIC SAFETY (i.e., a
          miner's safety lamp)
```

389

rt LANTERN; CHANDELIER
LAMP, ALDIS.....................VISUAL COMMUNICATION EQUIPMENT
Lamp, Argand....................LIGHTING DEVICE
 use LAMP, OIL
Lamp, Astral....................LIGHTING DEVICE
 use LAMP, OIL
Lamp, Betty.....................LIGHTING DEVICE
 use LAMP, SEMILIQUID
LAMP, BURNING-FLUID.............LIGHTING DEVICE
 note use for any lamp designed to burn a mixture
 of alcohol and camphene
LAMP, CAMPHENE..................LIGHTING DEVICE
Lamp, Carcel....................LIGHTING DEVICE
 use LAMP, OIL
Lamp, Crusie....................LIGHTING DEVICE
 use LAMP, SEMILIQUID
LAMP, ELECTRIC..................LIGHTING DEVICE
LAMP, GAS.......................LIGHTING DEVICE
 note use for any lamp designed to burn acetylene,
 coal gas, water gas or natural gas
Lamp, Hitchcock.................LIGHTING DEVICE
 use LAMP, OIL
LAMP, KEROSINE..................LIGHTING DEVICE
Lamp, Mantel....................LIGHTING DEVICE
 use more specifc term: e.g., LAMP, KEROSINE;
 -,OIL
Lamp, Moderator.................LIGHTING DEVICE
 use LAMP, OIL
LAMP, MOSQUE....................CEREMONIAL ARTIFACT
LAMP, OIL.......................LIGHTING DEVICE
 note use for any lamp designed to burn whale oil,
 seal oil, colza oil, or rosin oil
Lamp, Rumford...................LIGHTING DEVICE
 use LAMP, OIL
LAMP, SEMILIQUID................LIGHTING DEVICE
 note use for any lamp designed to burn lard,
 tallow, grease
Lamp, Solid-fuel................LIGHTING DEVICE
 use more specific term: e.g., CANDLE, RUSHLIGHT,
 SPLINT
LAMP, SPIRIT....................CHEMICAL T&E
Lamp, Wanzer....................LIGHTING DEVICE
 use LAMP, OIL
LAMP BASE.......................LIGHTING DEVICE
Lamp bulb.......................LIGHTING DEVICE
 use LIGHT BULB
LAMP BURNER.....................LIGHTING DEVICE
LAMP CHIMNEY....................LIGHTING DEVICE
LAMP FONT.......................LIGHTING DEVICE
LAMP GLOBE......................LIGHTING DEVICE
LAMP HARP.......................LIGHTING DEVICE
LAMP MANTLE.....................LIGHTING DEVICE

```
LAMP PENDANT....................LIGHTING DEVICE
LAMP REFLECTOR..................LIGHTING DEVICE
LAMP SHADE......................LIGHTING DEVICE
Lamp stand......................LIGHTING DEVICE
      use  HOLDER, LAMP
LANCE...........................ARMAMENT T&E, EDGED
LANCE, WHALE....................ARMAMENT T&E, EDGED
LANCET, BLOOD...................MEDICAL & PSYCHOLOGICAL T&E
LANDAU..........................LTE, ANIMAL-POWERED
LANDAULET.......................LTE, ANIMAL-POWERED
LANDING CRAFT, PERSONNEL........WATER TRANSPORTATION EQUIPMENT
LANDING CRAFT, UTILITY..........WATER TRANSPORTATION EQUIPMENT
LANDING SHIP, DOCK..............WATER TRANSPORTATION EQUIPMENT
LANDING SHIP, UTILITY...........WATER TRANSPORTATION EQUIPMENT
LANTERN.........................LIGHTING DEVICE
      note normally subdivided according to fuel: e.g.,
           LANTERN, KEROSINE; -,ELECTRIC
      rt   LAMP
LANTERN, BATTLE.................VISUAL COMMUNICATION EQUIPMENT
LANTERN, PAPER..................COMMERCIAL DECORATIVE ART
LANTERN, RAILROAD...............VISUAL COMMUNICATION EQUIPMENT
Lantern slide...................DOCUMENTARY ARTIFACT
      use  TRANSPARENCY, LANTERN-SLIDE
LAPBOARD........................WRITTEN COMMUNICATION EQUIPMENT
LAP BOARD, BASKETMAKER'S........TEXTILEWORKING T&E
LAPPET..........................CLOTHING, HEADWEAR
LAP ROBE........................LAND TRANSPORTATION ACCESSORY
LARYNGOSCOPE....................MEDICAL & PSYCHOLOGICAL T&E
LAST............................LEATHERWORKING T&E
LATCH...........................BUILDING FRAGMENT
LATHE...........................GLASS & PLASTICS T&E
LATHE...........................METALWORKING T&E
      note use only if specific type is unknown
LATHE...........................WOODWORKING T&E
LATHE, BORING...................WOODWORKING T&E
LATHE, CHUCKING.................METALWORKING T&E
      note use for a lathe that turns work held on a
           face plate or chuck, rather than work turned
           between centers
LATHE, DUPLICATING..............WOODWORKING T&E
LATHE, ENGINE...................METALWORKING T&E
      note use for a lathe which has a slide rest and a
           power feed on the carriage
LATHE, FOOT.....................METALWORKING T&E
      note use for a lathe operated by a treadle
LATHE, HAND.....................METALWORKING T&E
      note use for a lathe in which the lathe tool is
           hand-held
LATHE, SCREW-CUTTING............METALWORKING T&E
      note use for a lathe with a second feed on the
           carriage to allow for cutting threads
LATHE, SPOKE....................WOODWORKING T&E
```

391

LATHE, TURRET...................METALWORKING T&E
 note use for a multi-tooled lathe
LAUNCH, GASOLINE...............WATER TRANSPORTATION EQUIPMENT
 rt RUNABOUT
LAUNCH, NAPTHA.................WATER TRANSPORTATION EQUIPMENT
LAUNCH, STEAM..................WATER TRANSPORTATION EQUIPMENT
LAUNCHER, GRENADE..............ARMAMENT T&E, FIREARM
LAVABO.........................CEREMONIAL ARTIFACT
LAVALIERE......................ADORNMENT
Lavatory.......................PLUMBING FIXTURE
 use more specific term: e.g., TOILET, SINK
LAWN...........................GLASS & PLASTICS T&E
LAY FIGURE.....................PAINTING T&E
 rt DOLL
LEAD, SOUNDING.................WATER TRANSPORTATION ACCESSORY
LEADER, LIVESTOCK..............ANIMAL HUSBANDRY T&E
Leaflet........................ADVERTISING MEDIUM
 use HANDBILL
LEAFLET........................DOCUMENTARY ARTIFACT
LEAN-TO........................BUILDING
LEASH..........................ANIMAL HUSBANDRY T&E
Lectern........................FURNITURE
 use PODIUM
Lederhosen.....................CLOTHING, OUTERWEAR
 use SHORTS
LEDGER.........................DOCUMENTARY ARTIFACT
LEGGING........................CLOTHING, OUTERWEAR
LEG-HARNESS....................ARMAMENT T&E, BODY ARMOR
Lemonade set...................FOOD SERVICE T&E
 use BEVERAGE SET
LENCOSCOPE.....................MEDICAL & PSYCHOLOGICAL T&E
LENS...........................OPTICAL T&E
LENS...........................PHOTOGRAPHIC T&E
LENS, ANASTIGMATIC.............OPTICAL T&E
LENS, CONTACT..................PERSONAL GEAR
LENS, STENOPAIC................MEDICAL & PSYCHOLOGICAL T&E
LENS, WATER....................OPTICAL T&E
LENS AND DIAPHRAGM.............PHOTOGRAPHIC T&E
LENS AND SHUTTER...............PHOTOGRAPHIC T&E
LENS SET.......................MEDICAL & PSYCHOLOGICAL T&E
 note use for visual testing apparatus including
 lenses and disks (red, blank, pin-hole, etc.)
LENS, SHUTTER AND DIAPHRAGM....PHOTOGRAPHIC T&E
Leotard........................CLOTHING, UNDERWEAR
 use BODYSTOCKING
LETTER.........................DOCUMENTARY ARTIFACT
LETTERPRESS....................PRINTING T&E
Levando........................METALWORKING T&E
 use CONCENTRATOR
LEVEL..........................WOODWORKING T&E
LEVEL, GUNNER'S................ARMAMENT ACCESSORY
LEVEL, MASON'S.................MASONRY T&E

```
LEVEL, PLUMB.....................WOODWORKING T&E
Level, Spirit...................WOODWORKING T&E
     use  LEVEL
LEVEL, SURVEYOR'S...............SURVEYING & NAVIGATIONAL T&E
LEVELER, HOOF...................ANIMAL HUSBANDRY T&E
LEVELER, LAND...................AGRICULTURAL T&E
LEVELING BOARD..................CHEMICAL T&E
LEVER...........................MECHANICAL T&E
LEVIGATOR.......................PRINTING T&E
LEWIS...........................MASONRY T&E
LIBRARY.........................BUILDING
LICENSE PLATE...................LAND TRANSPORTATION ACCESSORY
LIFEBOAT, COASTAL RESCUE........WATER TRANSPORTATION EQUIPMENT
     rt   SURFBOAT; LIFECAR
LIFEBOAT, SHIP'S................WATER TRANSPORTATION EQUIPMENT
LIFECAR.........................WATER TRANSPORTATION EQUIPMENT
     rt   LIFEBOAT, COASTAL RESCUE; SURFBOAT
LIFT, COW.......................ANIMAL HUSBANDRY T&E
LIFT, DRAWING...................MINING T&E
LIFT, HYDRAULIC.................MECHANICAL T&E
LIFTER, SOD.....................AGRICULTURAL T&E
Lifter, Stump...................AGRICULTURAL T&E
     use  PULLER, STUMP
LIFTER, TODDY...................FOOD SERVICE T&E
LIGHT, AIRCRAFT.................AEROSPACE TRANSPORTATION ACCESSORY
LIGHT, ANCHOR...................WATER TRANSPORTATION ACCESSORY
LIGHT, MASTHEAD.................WATER TRANSPORTATION ACCESSORY
LIGHT, RUNNING..................WATER TRANSPORTATION ACCESSORY
LIGHT, SHIP'S...................WATER TRANSPORTATION ACCESSORY
     note use only if specific type is unknown
LIGHT, STERN....................WATER TRANSPORTATION ACCESSORY
Light, Traffic..................VISUAL COMMUNICATION EQUIPMENT
     use  SIGNAL, TRAFFIC
LIGHT BULB......................LIGHTING DEVICE
LIGHTER.........................PERSONAL GEAR
LIGHTHOUSE......................BUILDING
LIGHTING CONSOLE................LIGHTING DEVICE
LIGHTNING ROD...................BUILDING FRAGMENT
LIGHTSHIP.......................WATER TRANSPORTATION EQUIPMENT
LILY IRON, SWORDFISH............FISHING & TRAPPING T&E
Linac...........................NUCLEAR PHYSICS T&E
     use  ACCELERATOR, LINEAR
LINE............................AEROSPACE TRANSPORTATION ACCESSORY
     note may be further subdivided to indicate
          specific type: e.g., LINE, CONTROL; -,MAIN
          MOORING; -,MAST YAW
LINEN PROVER....................TEXTILEWORKING T&E
LINE PIN........................MASONRY T&E
LINESHAFT.......................POWER PRODUCTION T&E
LINOLEUM BLOCK..................PRINTING T&E
LINOLEUM SECTION................BUILDING FRAGMENT
LINSTOCK........................ARMAMENT ACCESSORY
```

393

```
LINTEL.........................BUILDING FRAGMENT
Linter, Cottonseed.............AGRICULTURAL T&E
     use  CLEANER, COTTONSEED
LIRA...........................MUSICAL T&E, STRINGED
     rt   VIOLA
LITHIC FRAGMENT................ARTIFACT REMNANT
LITHOGRAPHIC POINT.............PRINTING T&E
LITHOGRAPH STONE...............PRINTING T&E
LITHO-PRESS....................PRINTING T&E
LITHOTRITE.....................MEDICAL & PSYCHOLOGICAL T&E
LITRAMETER.....................MECHANICAL T&E
LITTER.........................LTE, ANIMAL-POWERED
     rt   TRAVOIS
LITTER.........................LTE, HUMAN-POWERED
LITTER CARRIER.................ANIMAL HUSBANDRY T&E
LOADER.........................MINING T&E
LOADER, CORN-SHOCK.............AGRICULTURAL T&E
LOADER, FRONT-END..............CONSTRUCTION T&E
Loader, Hay....................AGRICULTURAL T&E
     use  HAY-LOADER
LOADING MACHINE................MINING T&E
LOADING TOOL...................ARMAMENT ACCESSORY
     rt   DIE, LOADING
LOAFER.........................CLOTHING, FOOTWEAR
LOBSTER BOAT...................WATER TRANSPORTATION EQUIPMENT
LOCK...........................UNCLASSIFIED STRUCTURE
LOCK, CANNON...................ARMAMENT ACCESSORY
LOCK, DOOR.....................BUILDING FRAGMENT
LOCK, WINDOW...................BUILDING FRAGMENT
LOCKER, ARMS...................ARMAMENT ACCESSORY
LOCKET.........................ADORNMENT
LOCOMOTIVE.....................RAIL TRANSPORTATION EQUIPMENT
LOCOMOTIVE.....................TOY
LOCOMOTIVE, DIESEL-ELECTRIC....RAIL TRANSPORTATION EQUIPMENT
LOCOMOTIVE, DIESEL-HYDRAULIC...RAIL TRANSPORTATION EQUIPMENT
LOCOMOTIVE, ELECTRIC...........RAIL TRANSPORTATION EQUIPMENT
LOCOMOTIVE, GASOLINE...........RAIL TRANSPORTATION EQUIPMENT
LOCOMOTIVE, GASOLINE-ELECTRIC..RAIL TRANSPORTATION EQUIPMENT
LOCOMOTIVE, MINE...............MINING T&E
LOCOMOTIVE, STEAM..............RAIL TRANSPORTATION EQUIPMENT
LOCOMOTIVE, TURBINE............RAIL TRANSPORTATION EQUIPMENT
LODGE..........................BUILDING
LOG............................MINING T&E
     note may be further subdivided to indicate
          specific type: e.g., LOG, NEUTRON
LOG............................DOCUMENTARY ARTIFACT
LOG............................WATER TRANSPORTATION ACCESSORY
     note may be further subdivided to indicate
          specific type: e.g., LOG, TAFFRAIL
LOG, SHIP'S....................DOCUMENTARY ARTIFACT
LOG CARRIER....................TEMPERATURE CONTROL DEVICE
LOGOGRAPH......................ACOUSTICAL T&E
```

LOGOMETER......................CHEMICAL T&E
LOINCLOTH......................CLOTHING, OUTERWEAR
LONGBOAT.......................WATER TRANSPORTATION EQUIPMENT
LONGLINE.......................FISHING & TRAPPING T&E
Long tom.......................MINING T&E
 use SEPARATOR
Looking glass..................FURNITURE
 use MIRROR, CHEVAL
LOOM...........................TEXTILEWORKING T&E
 note use only if specific type is unknown
LOOM, BACKSTRAP................TEXTILEWORKING T&E
LOOM, BELT.....................TEXTILEWORKING T&E
LOOM, BROAD....................TEXTILEWORKING T&E
 note use for any loom designed to weave a fabric
 54" or more in width
LOOM, CAM......................TEXTILEWORKING T&E
LOOM, CARPET...................TEXTILEWORKING T&E
LOOM, COUNTER-BALANCE..........TEXTILEWORKING T&E
LOOM, COUNTER-MARCH............TEXTILEWORKING T&E
LOOM, DOBBY....................TEXTILEWORKING T&E
Loom, Doup.....................TEXTILEWORKING T&E
 use LOOM, LENO
LOOM, DRAW.....................TEXTILEWORKING T&E
LOOM, HAND.....................TEXTILEWORKING T&E
 note use for any loom on which the actions of
 shedding, picking and beating are performed
 solely by hand and/or foot power; use only
 if specific type is unknown: e.g., LOOM,
 BELT; LOOM, COUNTER-BALANCE; LOOM,
 COUNTER-MARCH; LOOM, DRAW; LOOM, JACK
LOOM, JACK.....................TEXTILEWORKING T&E
LOOM, JACQUARD.................TEXTILEWORKING T&E
LOOM, LACE.....................TEXTILEWORKING T&E
LOOM, LENO.....................TEXTILEWORKING T&E
LOOM, PILE FABRIC..............TEXTILEWORKING T&E
LOOM, RAPIER...................TEXTILEWORKING T&E
LOOM, RIGID HEDDLE.............TEXTILEWORKING T&E
LOOM, SHUTTLELESS..............TEXTILEWORKING T&E
LOOM, SWIVEL...................TEXTILEWORKING T&E
LOOM, TABLET...................TEXTILEWORKING T&E
LOOM, TAPE.....................TEXTILEWORKING T&E
LOOM, WARP WEIGHTED............TEXTILEWORKING T&E
LOOM, WATER-JET................TEXTILEWORKING T&E
LOOP TOOL......................GLASS & PLASTICS T&E
LOTTO SET......................GAME
 rt BINGO SET
LOUNGE.........................FURNITURE
 rt DAYBED
LOUNGE CAR.....................RAIL TRANSPORTATION EQUIPMENT
LOVE SEAT......................FURNITURE
 note use for any chair, settee or sofa seating
 two persons side-by-side

```
     rt    SOFA, CONVERSATIONAL
Lowboy......................FURNITURE
     use   TABLE, DRESSING
LUBRICATOR-SIZER..............ARMAMENT ACCESSORY
LUCET........................TEXTILEWORKING T&E
Lucimeter....................OPTICAL T&E
     use   PHOTOMETER
LUGE........................SPORTS EQUIPMENT
LUGGAGE CARRIER...............LAND TRANSPORTATION ACCESSORY
LUNCHEON SET.................FOOD SERVICE T&E
     note  use for matching set of place mats,
           coasters, centerpiece, etc., or for a
           relatively small tablecloth and matching
           napkins
     rt    TABLECLOTH SET
LURE........................FISHING & TRAPPING T&E
LUSTER......................COMMERCIAL DECORATIVE ART
LUTE........................MUSICAL T&E, STRINGED
     rt    THEOROBO
LYRE........................MUSICAL T&E, STRINGED
LYRE-GUITAR.................MUSICAL T&E, STRINGED
LYSIMETER...................BIOLOGICAL T&E
MACE........................PERSONAL SYMBOL
MACE........................ARMAMENT T&E, BLUDGEON
MACE-HEAD...................PRINTING T&E
MACHETE.....................AGRICULTURAL T&E
     rt    KNIFE, SUGARCANE
Machine
     use   only as a secondary word when identifying a
           particular type of machine: e.g., MILKING
           MACHINE
MACHINE REST................ARMAMENT ACCESSORY
MACKINAW....................CLOTHING, OUTERWEAR
MAGAZINE....................ARMAMENT ACCESSORY
MAGAZINE....................DOCUMENTARY ARTIFACT
MAGAZINE AD.................ADVERTISING MEDIUM
Magician's equipment........PUBLIC ENTERTAINMENT DEVICE
     use   PROPERTIES, MAGICIAN'S
Magic lantern...............VISUAL COMMUNICATION EQUIPMENT
     use   PROJECTOR, LANTERN-SLIDE
MAGIC LANTERN...............TOY
MAGNET......................ELECTRICAL & MAGNETIC T&E
MAGNET......................TOY
MAGNET, BENDING.............NUCLEAR PHYSICS T&E
MAGNET, QUADRUPOLE..........NUCLEAR PHYSICS T&E
MAGNET, SEXTUPOLE...........NUCLEAR PHYSICS T&E
MAGNET, SPOUT...............FOOD PROCESSING T&E
MAGNETOGRAPH................ASTRONOMICAL T&E
MAGNETOMETER...............SURVEYING & NAVIGATIONAL T&E
MAGNIFYING GLASS............OPTICAL T&E
MAH-JONGG..................GAME
Mahlstick..................PAINTING T&E
     use   MAULSTICK
```

```
MAIL.........................ARMAMENT T&E, BODY ARMOR
MAILBAG......................WRITTEN COMMUNICATION EQUIPMENT
MAILBOX......................WRITTEN COMMUNICATION EQUIPMENT
MAIL CAR.....................RAIL TRANSPORTATION EQUIPMENT
MAIL CRANE...................RAIL TRANSPORTATION ACCESSORY
MAILING MACHINE..............WRITTEN COMMUNICATION EQUIPMENT
MAIL SLOT....................BUILDING FRAGMENT
Main frame...................DATA PROCESSING T&E
     use   CENTRAL PROCESSOR
Maker
     use   only as a secondary word in a multi-word
           object name
MALLET.......................PRINTING T&E
MALLET.......................WOODWORKING T&E
     note use for a one-handed striking tool fitted
          with a relatively soft (wooden, plastic or
          leather) head
     rt    BEETLE; FROE CLUB
MALLET, CARPENTER'S..........WOODWORKING T&E
MALLET, CARVER'S.............WOODWORKING T&E
MALLET, FUZE.................ARMAMENT ACCESSORY
MALLET, GRAFTING.............AGRICULTURAL T&E
MALLET, ORAL SURGERY.........MEDICAL & PSYCHOLOGICAL T&E
MALLET, SERVING..............TEXTILEWORKING T&E
MALLET, SHIPWRIGHT'S.........WOODWORKING T&E
MALLET, SHIPWRIGHT'S CAULKING..WOODWORKING T&E
Manacle......................BEHAVIORAL CONTROL DEVICE
     use   SHACKLE
MAN CAR......................MINING T&E
Man car......................MINING T&E
     use   MINE CAR
MANDOLIN.....................MUSICAL T&E, STRINGED
     rt    MANDORE
MANDORE......................MUSICAL T&E, STRINGED
     rt    MANDOLIN
MANDREL......................METALWORKING T&E
MANDREL, HORNWORKER'S........UNCLASSIFIED T&E, SPECIAL
MANGLE.......................HOUSEKEEPING T&E
MANGONEL.....................ARMAMENT T&E, ARTILLERY
MANHOLE COVER................UNCLASSIFIED STRUCTURE
MANICURE SET.................TOILET ARTICLE
MANIKIN......................MERCHANDISING T&E
     rt    DOLL
MANIPLE......................CLOTHING, OUTERWEAR
MANO.........................FOOD PROCESSING T&E
MAN-OF-WAR...................WATER TRANSPORTATION EQUIPMENT
     note use only for a full-rigged ship of the line
MANOMETER....................CHEMICAL T&E
MANOPTOSCOPE.................MEDICAL & PSYCHOLOGICAL T&E
MANTEL.......................BUILDING FRAGMENT
Mantelshelf..................BUILDING FRAGMENT
     use   MANTEL
```

Mantilla.........................CLOTHING, HEADWEAR
 use SCARF
Manual...........................DOCUMENTARY ARTIFACT
 use BOOK or BOOKLET
MANUSCRIPT.......................DOCUMENTARY ARTIFACT
MAP..............................DOCUMENTARY ARTIFACT
MARACAS..........................MUSICAL T&E, PERCUSSION
MARBLE...........................GAME
MARIMBA..........................MUSICAL T&E, PERCUSSION
MARIONETTE.......................PUBLIC ENTERTAINMENT DEVICE
 rt DOLL; PUPPET, HAND
MARIONETTE.......................TOY
 rt DOLL; PUPPET, HAND
MARKER, ANIMAL...................ANIMAL HUSBANDRY T&E
 note use only if specific type is unknown:.e.g.,
 GUN, MARKING; IRON, BRANDING
MARKER, CONCRETE.................SURVEYING & NAVIGATIONAL T&E
MARKER, REAM.....................PAPERMAKING T&E
MARLINSPIKE......................TEXTILEWORKING T&E
MAROTTE..........................TOY
MARQUEE..........................ADVERTISING MEDIUM
MARVER...........................GLASS & PLASTICS T&E
MASHER...........................FOOD PROCESSING T&E
 note may be further subdivided to indicate
 specific type: e.g., MASHER, POTATO
MASK.............................GLASS & PLASTICS T&E
 note may be further subdivided to indicate
 specific type: e.g., MASK, LIP; -,CAP; -,PLUG
MASK.............................PUBLIC ENTERTAINMENT DEVICE
MASK.............................CEREMONIAL ARTIFACT
MASK, CATCHER'S..................SPORTS EQUIPMENT
MASK, GAS........................UNCLASSIFIED T&E, SPECIAL
MASK, GOALIE'S...................SPORTS EQUIPMENT
MASK, SURGICAL...................MEDICAL & PSYCHOLOGICAL T&E
MASK, WELDER'S...................METALWORKING T&E
MASKER...........................ACOUSTICAL T&E
MAT..............................FLOOR COVERING
MAT, BATH........................FLOOR COVERING
MAT, PLACE.......................FOOD SERVICE T&E
MAT, SLEEPING....................BEDDING
MAT, TABLE.......................HOUSEHOLD ACCESSORY
MATHOOK..........................AGRICULTURAL T&E
MATTOCK..........................AGRICULTURAL T&E
MATTRESS.........................FURNITURE
MATTRESS COVER...................BEDDING
MAUL, MEAT.......................FOOD PROCESSING T&E
MAUL, POST.......................WOODWORKING T&E
 note use for a two-handed striking tool fitted
 with a cylindrical steel head
 rt BEETLE; SLEDGE
MAUL, RAWHIDE....................LEATHERWORKING T&E
MAUL, SPIKE......................METALWORKING T&E

```
MAULSTICK......................PAINTING T&E
MAUSOLEUM......................BUILDING
     rt   HOUSE, CHARNEL
MEASURE, POWDER................ARMAMENT ACCESSORY
MEASURE, TAPE..................WEIGHTS & MEASURES T&E
     rt   RULE, RETRACTABLE
MEASURER, SOUND................ACOUSTICAL T&E
     note use for a sound generator with scales
Meat-ax........................FOOD PROCESSING T&E
     use  CLEAVER
Meatoscope.....................MEDICAL & PSYCHOLOGICAL T&E
     use  SPECULUM
Mechanical doll................TOY
     use  DOLL, MECHANICAL
Mechanical miner...............MINING T&E
     use  CONTINUOUS MINER
MECHANICAL TOY.................TOY
     note use only for a mechanically-activated toy
          which cannot be named by a more specific
          term in this classification (e.g., FIGURE,
          MECHANICAL; PULL TOY) or, for a
          representational object, by a term from some
          other classification (e.g., ROLLER COASTER;
          WAGON, FARM); normally used to name a
          mechanically-activated group of figures
          and/or animals
MEDAL..........................PERSONAL SYMBOL
     note may be further subdivided to indicate
          specific type: e.g., MEDAL, GOOD CONDUCT;
          -,FRATERNAL; -,OLYMPIC; -,RELIGIOUS
MEDAL, COMMEMORATIVE...........DOCUMENTARY ARTIFACT
Medallion......................PERSONAL SYMBOL
     use  MEDAL
MEDICINE BALL..................SPORTS EQUIPMENT
MEDICINE BUNDLE................CEREMONIAL ARTIFACT
MEETINGHOUSE...................BUILDING
Megalith.......................CEREMONIAL ARTIFACT
     use  DOLMEN or MENHIR
MEGALITHOSCOPE.................VISUAL COMMUNICATION EQUIPMENT
MEGAPHONE......................SOUND COMMUNICATION EQUIPMENT
Megascope......................VISUAL COMMUNICATION EQUIPMENT
     use  PROJECTOR, LANTERN-SLIDE
MELANOSCOPE....................CHEMICAL T&E
MELLOPHONE.....................MUSICAL T&E, BRASS
Melodeon.......................MUSICAL T&E, UNCLASSIFIED
     use  ORGAN, REED
MELON SEED.....................WATER TRANSPORTATION EQUIPMENT
     rt   SKIFF, GUNNING
Mememto
     note refer to text for discussion of the way this
          concept should be handled
MEMORANDUM.....................DOCUMENTARY ARTIFACT
```

Memorial
 <u>use</u> more specific term: e.g., ALTAR; MONUMENT
Memory.........................DATA PROCESSING T&E
 <u>use</u> more specific term: e.g., CORE; DISK; DRUM,
 MAGNETIC
Menat..........................PERSONAL SYMBOL
 <u>use</u> AMULET
MENHIR.........................CEREMONIAL ARTIFACT
MENORAH........................CEREMONIAL ARTIFACT
 rt CANDELABRUM
MERCERIZING MACHINE............TEXTILEWORKING T&E
MERIDIAN CIRCLE................ASTRONOMICAL T&E
Meridienne.....................FURNITURE
 <u>use</u> LOUNGE
Merit badge....................PERSONAL SYMBOL
 <u>use</u> PATCH, MERIT-BADGE
Merry-go-round.................RECREATIONAL DEVICE
 <u>use</u> CAROUSEL
MESS KIT.......................FOOD SERVICE T&E
METABOLISM APPARATUS...........MEDICAL & PSYCHOLOGICAL T&E
METATE.........................FOOD PROCESSING T&E
METATE, BASIN..................SITE FEATURE
METEOROGRAPH...................METEOROLOGICAL T&E
METEOROMETER...................METEOROLOGICAL T&E
METEOROSCOPE...................ASTRONOMICAL T&E
METER, AIR.....................METEOROLOGICAL T&E
METER, ANGLE...................SURVEYING & NAVIGATIONAL T&E
METER, LIGHT...................PHOTOGRAPHIC T&E
METER, PARKING.................LAND TRANSPORTATION ACCESSORY
METER, POSTAGE.................WRITTEN COMMUNICATION EQUIPMENT
METER, YAW.....................SURVEYING & NAVIGATIONAL T&E
METERING MACHINE...............GLASS & PLASTICS T&E
METER STICK....................WEIGHTS & MEASURES T&E
METROCHROME....................OPTICAL T&E
METRONOME......................TIMEKEEPING T&E
METROSCOPE.....................MEDICAL & PSYCHOLOGICAL T&E
MEZUZAH........................CEREMONIAL ARTIFACT
MICROCOMPUTER..................DATA PROCESSING T&E
MICROFICHE.....................DOCUMENTARY ARTIFACT
MICROFILM......................DOCUMENTARY ARTIFACT
MICROGRAPH.....................DRAFTING T&E
Micromanometer.................CHEMICAL T&E
 <u>use</u> MANOMETER
MICROMETER.....................WEIGHTS & MEASURES T&E
MICROPHONE.....................SOUND COMMUNICATION EQUIPMENT
MICROSCOPE.....................OPTICAL T&E
MICROSCOPE, BINOCULAR..........OPTICAL T&E
MICROSCOPE, ELECTRON...........OPTICAL T&E
MICROSPECTROSCOPE..............OPTICAL T&E
MICROTOME......................BIOLOGICAL T&E
MIDDLEBUSTER...................AGRICULTURAL T&E

Military insignia................PERSONAL SYMBOL
 use more specific term: e.g., GORGET, SHOULDER
 LOOP, SHOULDER MARK, PIN, PATCH, or MEDAL
Military standard...............CEREMONIAL ARTIFACT
 use more specific term: e.g., PENNANT, PENNON
MILKING MACHINE.................FOOD PROCESSING T&E
MILKING PARLOR..................BUILDING FRAGMENT
MILK TUBE, SELF-RETAINING.......ANIMAL HUSBANDRY T&E
MILL............................BUILDING
MILL............................MINING T&E
 note may be further subdivided to indicate
 specific type: e.g., MILL, FLINT; -,STAMP
MILL, APPLE.....................FOOD PROCESSING T&E
Mill, Attrition.................AGRICULTURAL T&E
 use GRINDER, FEED
MILL, BALL......................PAINTING T&E
MILL, BARK......................FORESTRY T&E
Mill, Bone-grinding.............FOOD PROCESSING T&E
 use CUTTER, BONE
MILL, BUHR......................FOOD PROCESSING T&E
MILL, COFFEE....................FOOD PROCESSING T&E
Mill, Colloid milk..............FOOD PROCESSING T&E
 use HOMOGENIZER, MILK
MILL, CURD......................FOOD PROCESSING T&E
Mill, Fan.......................AGRICULTURAL T&E
 use MILL, FANNING
MILL, FANNING...................AGRICULTURAL T&E
Mill, Feed......................AGRICULTURAL T&E
 use GRINDER, FEED
MILL, FLOUR.....................FOOD PROCESSING T&E
MILL, FULLING...................TEXTILEWORKING T&E
Mill, Hammer....................AGRICULTURAL T&E
 use GRINDER, FEED
MILL, HAMMER....................FOOD PROCESSING T&E
MILL, MIDDLINGS.................FOOD PROCESSING T&E
MILL, NUT.......................FOOD PROCESSING T&E
MILL, PEPPER....................FOOD SERVICE T&E
MILL, PUG.......................GLASS & PLASTICS T&E
Mill, Quartz....................MINING T&E
 use MILL, STAMP
MILL, RAIL......................METALWORKING T&E
MILL, ROLLER....................FOOD PROCESSING T&E
MILL, ROLLER....................PAINTING T&E
MILL, ROLLING...................METALWORKING T&E
MILL, SAMPLING..................METALWORKING T&E
MILL, SLITTING..................METALWORKING T&E
MILL, STAMPING..................METALWORKING T&E
MILL, STEEL.....................METALWORKING T&E
Mill, Steel.....................MINING T&E
 use MILL, FLINT
Mill, Stone.....................FOOD PROCESSING T&E
 use MILL, BUHR

401

Mill, Tread...................POWER PRODUCTION T&E
 use TREAD, ANIMAL-POWERED or TREAD, HUMAN-POWERED
MILL, TUBE....................METALWORKING T&E
Mill, Winnowing...............AGRICULTURAL T&E
 use MILL, FANNING
MILL, WIRE....................METALWORKING T&E
MILLBRACE.....................MINING T&E
MILLER INDEX..................METALWORKING T&E
MILLING MACHINE...............METALWORKING T&E
 note may be further subdivided to indicate
 specific type: e.g., MILLING MACHINE,
 DUPLEX; -,HORIZONTAL SPINDLE; -,VERTICAL
 SPINDLE
Mimeograph....................PRINTING T&E
 use DUPLICATOR
MINE..........................UNCLASSIFIED STRUCTURE
MINE..........................ARMAMENT T&E, AMMUNITION
 note may be further subdivided by LAND or SEA and
 PORTABLE or FIXED: e.g., MINE, PORTABLE LAND
MINE CAR......................MINING T&E
MINELAYER.....................WATER TRANSPORTATION EQUIPMENT
MINESWEEPER...................WATER TRANSPORTATION EQUIPMENT
Miniature
 note refer to text for discussion of the way this
 concept should be handled
MINICOMPUTER..................DATA PROCESSING T&E
Minieball.....................ARMAMENT T&E, AMMUNITION
 use BULLET, MINIE
MINION........................ARMAMENT T&E, ARTILLERY
MIRROR........................FURNITURE
 note use only if specific type is unknown
MIRROR........................ASTRONOMICAL T&E
MIRROR, CHEVAL................FURNITURE
MIRROR, CLOUD.................METEOROLOGICAL T&E
Mirror, Dressing..............FURNITURE
 use MIRROR, CHEVAL
MIRROR, EYE-OBSERVATION.......MEDICAL & PSYCHOLOGICAL T&E
Mirror, Girandole.............FURNITURE
 use MIRROR, WALL
MIRROR, HAND..................TOILET ARTICLE
Mirror, Mantel................FURNITURE
 use MIRROR, WALL
MIRROR, MOUTH-EXAMINING.......MEDICAL & PSYCHOLOGICAL T&E
Mirror, Tabernacle............FURNITURE
 use MIRROR, WALL
MIRROR, WALL..................FURNITURE
Misericord....................ARMAMENT T&E, EDGED
 use DAGGER
MISSILE, AIR-TO-AIR...........ARMAMENT T&E, AMMUNITION
MISSILE, AIR-TO-SURFACE.......ARMAMENT T&E, AMMUNITION
MISSILE, AIR-TO-UNDERWATER....ARMAMENT T&E, AMMUNITION
MISSILE, AIR-TO-WATER.........ARMAMENT T&E, AMMUNITION

```
Missile, Antiaircraft..........ARMAMENT T&E, AMMUNITION
     use  MISSILE, SURFACE-TO-AIR
Missile, Antimissile...........ARMAMENT T&E, AMMUNITION
     use  MISSILE, SURFACE-TO-AIR or MISSILE,
          AIR-TO-AIR
Missile, Ballistic.............ARMAMENT T&E, AMMUNITION
     use  more specific term: e.g., MISSILE, AIR-TO-AIR
MISSILE, SURFACE-TO-AIR........ARMAMENT T&E, AMMUNITION
MISSILE, SURFACE-TO-SURFACE....ARMAMENT T&E, AMMUNITION
MISSILE, UNDERWATER-TO-SURFACE
     ..........................ARMAMENT T&E, AMMUNITION
MITER..........................PERSONAL SYMBOL
MITER BLOCK....................WOODWORKING T&E
MITER BOX......................WOODWORKING T&E
MITERING MACHINE...............PRINTING T&E
Miter jack.....................WOODWORKING T&E
     use  JACK, MITER
Miter-shooting block...........WOODWORKING T&E
     use  JACK, MITER
MITER-SHOOTING BOARD...........WOODWORKING T&E
     rt   SHOOTING BOARD
MITT...........................CLOTHING ACCESSORY
MITT, BASEMAN'S................SPORTS EQUIPMENT
MITT, CATCHER'S................SPORTS EQUIPMENT
MITTEN.........................CLOTHING ACCESSORY
MITTEN, ASBESTOS...............UNCLASSIFIED T&E, GENERAL
MITTEN, TARGET SHOOTER'S.......ARMAMENT ACCESSORY
MIXER, CEMENT..................MASONRY T&E
MIXER, DENTAL-CASTING..........MEDICAL & PSYCHOLOGICAL T&E
MIXER, FEED....................AGRICULTURAL T&E
MIXER, ICE-CREAM...............FOOD PROCESSING T&E
MIXING SLAB, DENTAL............MEDICAL & PSYCHOLOGICAL T&E
MOBILE.........................COMMERCIAL DECORATIVE ART
MOBILE.........................ORIGINAL ART
MOCCASIN.......................CLOTHING, FOOTWEAR
Model
     note refer to text for discussion of the way this
          concept should be handled
Modeling tool..................GLASS & PLASTICS T&E
     use  more specific term: e.g., LOOP TOOL; RIB TOOL
MODULATOR......................ELECTRICAL & MAGNETIC T&E
MODULATOR, SINGLE SIDE-BAND....ELECTRICAL & MAGNETIC T&E
MOIL...........................MINING T&E
     rt   GAD
MOISTENER......................WRITTEN COMMUNICATION EQUIPMENT
MOLD...........................GLASS & PLASTICS T&E
     note may be further subdivided to indicate
          specific type: e.g., MOLD, PREPEG; -,MAT;
          -,TRANSFER; -,PIG
MOLD...........................METALWORKING T&E
     note may be further subdivided to indicate
          specific type: e.g., MOLD, BASIN; -,BUTTON;
          -,PIG; -,TEASPOON
```

403

MOLD, BALL.......................ARMAMENT ACCESSORY
MOLD, BRICK......................MASONRY T&E
MOLD, BULLET.....................ARMAMENT ACCESSORY
MOLD, BUTTER.....................FOOD PROCESSING T&E
MOLD, CANDLE.....................GLASS & PLASTICS T&E
MOLD, CANDY......................FOOD PROCESSING T&E
Mold, Chocolate..................FOOD PROCESSING T&E
 use MOLD, CANDY
MOLD, CIGAR......................UNCLASSIFIED T&E, SPECIAL
MOLD, DIP........................GLASS & PLASTICS T&E
MOLD, FUZE.......................ARMAMENT ACCESSORY
MOLD, GELATIN....................FOOD PROCESSING T&E
MOLD, ICE-CREAM..................FOOD PROCESSING T&E
MOLD, JELLY......................FOOD PROCESSING T&E
MOLD, PORTFIRE...................ARMAMENT ACCESSORY
MOLD, PRESS......................GLASS & PLASTICS T&E
MOLD, ROCKET.....................ARMAMENT ACCESSORY
MOLD, WAD........................ARMAMENT ACCESSORY
MOLDING BOX......................WOODWORKING T&E
MOLDING MACHINE, BLOW............GLASS & PLASTICS T&E
MOLDING MACHINE, COMPRESSION.....GLASS & PLASTICS T&E
MOLDING MACHINE, INJECTION.......GLASS & PLASTICS T&E
MOLDING MACHINE, ROTATIONAL......GLASS & PLASTICS T&E
MOLDING MACHINE, SLUSH...........GLASS & PLASTICS T&E
MOLDING SECTION..................BUILDING FRAGMENT
MONEY CHANGER....................MERCHANDISING T&E
MONEY ORDER......................EXCHANGE MEDIUM
MONITOR, HYDRAULIC...............MINING T&E
Monkey bars......................RECREATIONAL DEVICE
 use LADDER, HORIZONTAL
MONOCLE..........................PERSONAL GEAR
 rt QUIZZING GLASS
MONOPOLY SET.....................GAME
MONORAIL CAR.....................RAIL TRANSPORTATION EQUIPMENT
MONSTRANCE.......................CEREMONIAL ARTIFACT
MONTAGE..........................ORIGINAL ART
MONTERA..........................CLOTHING, HEADWEAR
MONUMENT.........................BUILDING
 rt SHRINE
MONUMENT.........................CEREMONIAL ARTIFACT
MOP..............................HOUSEKEEPING T&E
MORION...........................ARMAMENT T&E, BODY ARMOR
MORTAR...........................ARMAMENT T&E, ARTILLERY
MORTAR...........................CHEMICAL T&E
MORTAR...........................FOOD PROCESSING T&E
Mortar, Samp.....................FOOD PROCESSING T&E
 use MORTAR, STAMP
MORTAR, STAMP....................FOOD PROCESSING T&E
MORTAR AND PESTLE................FOOD PROCESSING T&E
MORTARBOARD......................PERSONAL SYMBOL
MORTGAGE.........................DOCUMENTARY ARTIFACT
MORTISER.........................WOODWORKING T&E

```
MORTISING MACHINE.............WOODWORKING T&E
Motor.........................MINING T&E
     use  LOCOMOTIVE, MINE
MOTOR, ELECTRIC...............POWER PRODUCTION T&E
MOTOR, ELECTRIC...............TOY
MOTOR, OUTBOARD...............WATER TRANSPORTATION ACCESSORY
Motorbike.....................LTE, MOTORIZED
     use  BICYCLE, GASOLINE
MOTORCYCLE....................LTE, MOTORIZED
MOTORCYCLE SIDECAR............LTE, MOTORIZED
MOTOR SCOOTER.................LTE, MOTORIZED
Mould
     use  MOLD
MOULDER.......................WOODWORKING T&E
MOUND.........................UNCLASSIFIED STRUCTURE
MOUSETRAP.....................HOUSEHOLD ACCESSORY
MOUTHPIECE, SALIVA-EJECTOR....MEDICAL & PSYCHOLOGICAL T&E
MOWER.........................AGRICULTURAL T&E
MOWER, GANG-REEL..............AGRICULTURAL T&E
MOWER, LAWN...................AGRICULTURAL T&E
Mower, Semimounted............AGRICULTURAL T&E
     use  MOWER
Mower, Tractor-drawn..........AGRICULTURAL T&E
     use  MOWER or MOWER, GANG-REEL
Mower, Tractor-mounted........AGRICULTURAL T&E
     use  MOWER
MOWER/CONDITIONER.............AGRICULTURAL T&E
     rt   CONDITIONER, HAY
Mowing machine................AGRICULTURAL T&E
     use  MOWER
Mucking machine...............MINING T&E
     use  LOADER
MUFF..........................CLOTHING ACCESSORY
Muffineer.....................FOOD SERVICE T&E
     use  SHAKER, SUGAR
MUFFLER.......................CLOTHING ACCESSORY
     rt   SCARF, NECK
MUG...........................FOOD SERVICE T&E
MUG, SHAVING..................TOILET ARTICLE
MUKLUK........................CLOTHING, FOOTWEAR
Mule..........................CLOTHING, FOOTWEAR
     use  SLIPPER
MULETA........................SPORTS EQUIPMENT
MULLER........................PAINTING T&E
MULTIPLE-IMAGE APPARATUS......MEDICAL & PSYCHOLOGICAL T&E
MULTIPLE ROD, MADDOX..........MEDICAL & PSYCHOLOGICAL T&E
MULTIPLEXOR...................DATA PROCESSING T&E
     rt   VARIOPLEX
MUSEUM........................BUILDING
MUSIC, SHEET..................DOCUMENTARY ARTIFACT
MUSIC BOX.....................COMMERCIAL DECORATIVE ART
MUSIC BOX, CYLINDER...........SOUND COMMUNICATION EQUIPMENT
```

MUSIC BOX, DISC................SOUND COMMUNICATION EQUIPMENT
MUSIC STAND...................MUSICAL T&E, UNCLASSIFIED
MUSKET.......................ARMAMENT T&E, FIREARM
 rt ARQUEBUS; FUSIL
MUSKETOON....................ARMAMENT T&E, FIREARM
MUTASCOPE....................RECREATIONAL DEVICE
 rt PEEP-SHOW MACHINE
MUU-MUU......................CLOTHING, OUTERWEAR
MUZZLE.......................ANIMAL HUSBANDRY T&E
MYDYNAMOMETER................MEDICAL & PSYCHOLOGICAL T&E
MYOGRAPH.....................MEDICAL & PSYCHOLOGICAL T&E
Myrioscope...................TOY
 use KALEIDOSCOPE
NAIL.........................WOODWORKING T&E
NAIL, HORSESHOE..............ANIMAL HUSBANDRY T&E
Nail-cutting machine.........METALWORKING T&E
 use CUTTING MACHINE, NAIL
Nail header..................METALWORKING T&E
 use HEADING TOOL, NAIL
Napier's bones...............DATA PROCESSING T&E
 use CALCULATING ROD
NAPKIN.......................FOOD SERVICE T&E
NAPPER.......................TEXTILEWORKING T&E
NAPPING GIG..................TEXTILEWORKING T&E
NAPPY........................FOOD SERVICE T&E
NATROMETER...................CHEMICAL T&E
NECKERCHIEF..................CLOTHING ACCESSORY
NECKLACE.....................ADORNMENT
NECKTIE......................CLOTHING ACCESSORY
NEEDLE.......................LEATHERWORKING T&E
 note may be further subdivided to indicate
 specific type: e.g., NEEDLE, SPLIT-LACING;
 -,LACING
NEEDLE, BLOOD-COLLECTING......MEDICAL & PSYCHOLOGICAL T&E
NEEDLE, BROOMMAKER'S..........WOODWORKING T&E
NEEDLE, DARNING..............TEXTILEWORKING T&E
NEEDLE, DIPPING..............MINING T&E
NEEDLE, DISSECTING...........BIOLOGICAL T&E
NEEDLE, ETCHING..............PRINTING T&E
NEEDLE, GILLMORE.............CHEMICAL T&E
NEEDLE, INOCULATING..........MEDICAL & PSYCHOLOGICAL T&E
NEEDLE, KNITTING.............TEXTILEWORKING T&E
NEEDLE, LOOPER...............PRINTING T&E
NEEDLE, NETMAKING............TEXTILEWORKING T&E
NEEDLE, SAILMAKER'S..........TEXTILEWORKING T&E
NEEDLE, SEWING...............TEXTILEWORKING T&E
NEEDLE, SUTERING.............MEDICAL & PSYCHOLOGICAL T&E
NEEDLE TOOL..................GLASS & PLASTICS T&E
NEGATIVE, FILM...............DOCUMENTARY ARTIFACT
NEGATIVE, GLASS-PLATE........DOCUMENTARY ARTIFACT
Negligee.....................CLOTHING, OUTERWEAR
 use NIGHTGOWN

```
NEPHOSCOPE......................METEOROLOGICAL T&E
NET.............................FISHING & TRAPPING T&E
NET, ANIMAL.....................ANIMAL HUSBANDRY T&E
NET, BLANKET....................FISHING & TRAPPING T&E
NET, BOTTOM-SET.................FISHING & TRAPPING T&E
NET, BRAIL......................FISHING & TRAPPING T&E
NET, CASTING....................FISHING & TRAPPING T&E
NET, CRAB.......................FISHING & TRAPPING T&E
NET, DIP........................FISHING & TRAPPING T&E
NET, DRIFT......................FISHING & TRAPPING T&E
NET, FYKE.......................FISHING & TRAPPING T&E
NET, GILL.......................FISHING & TRAPPING T&E
Net, Hoop.......................FISHING & TRAPPING T&E
     use  NET, CRAB
NET, MOSQUITO...................BEDDING
NET, POUND......................FISHING & TRAPPING T&E
     rt   TRAP, FISH
NET, PURSE SEINE................FISHING & TRAPPING T&E
NET, REEF.......................FISHING & TRAPPING T&E
Net, Scoop......................FISHING & TRAPPING T&E
     use  NET, DIP
NET, SEINE......................FISHING & TRAPPING T&E
NET, THROW......................FISHING & TRAPPING T&E
NET, TRAWL......................FISHING & TRAPPING T&E
NETSUKE.........................PERSONAL GEAR
NEWEL...........................BUILDING FRAGMENT
NEWSPAPER.......................DOCUMENTARY ARTIFACT
NEWSPAPER AD....................ADVERTISING MEDIUM
NEWSPAPER CLIPPING..............DOCUMENTARY ARTIFACT
NICKELODEON.....................RECREATIONAL DEVICE
     rt   JUKEBOX
NIDDY NODDY.....................TEXTILEWORKING T&E
NIGHTCAP........................CLOTHING, HEADWEAR
NIGHTGOWN.......................CLOTHING, OUTERWEAR
Nightstand......................FURNITURE
     use  TABLE, NIGHT
NIGHTSTICK......................BEHAVIORAL CONTROL DEVICE
NIPPERS, BAND...................PRINTING T&E
Nippers, Hoof...................ANIMAL HUSBANDRY T&E
     use  PARER, HOOF
NIPPERS, NAIL...................ANIMAL HUSBANDRY T&E
     note use for tool to cut the toe nails of small
          animals
NIPPERS, NAIL...................METALWORKING T&E
NIPPERS, PULLING................METALWORKING T&E
NIPPERS, SHEET METALWORKER'S...METALWORKING T&E
NIPPERS, TICKET.................MERCHANDISING T&E
NIPPERS, TILE...................MASONRY T&E
NITROMETER......................CHEMICAL T&E
NOANK SLOOP.....................WATER TRANSPORTATION EQUIPMENT
Nocturnal.......................SURVEYING & NAVIGATIONAL T&E
     use  ASTROLABE, MARINER'S
```

```
NOISE MAKER...................TOY
NO-MAN'S-LAND BOAT............WATER TRANSPORTATION EQUIPMENT
Nosebag.......................ANIMAL HUSBANDRY T&E
     use FEEDBAG
NOSE CONE.....................AEROSPACE TRANSPORTATION ACCESSORY
NOSE PLUG.....................ADORNMENT
NOSE PLUG.....................PERSONAL GEAR
NOTCHER, EAR..................ANIMAL HUSBANDRY T&E
NOTE..........................DOCUMENTARY ARTIFACT
NOTEBOOK......................DOCUMENTARY ARTIFACT
NOVELTY.......................ADVERTISING MEDIUM
NOVELTY.......................TOY
NUMBERING MACHINE.............PRINTING T&E
NUT...........................METALWORKING T&E
NUT...........................WOODWORKING T&E
NUTCRACKER....................FOOD SERVICE T&E
NUTPICK.......................FOOD SERVICE T&E
NUT-TAPPER MACHINE............METALWORKING T&E
Nylon.........................CLOTHING, FOOTWEAR
     use STOCKING
OAR...........................WATER TRANSPORTATION ACCESSORY
     rt SWEEP
OAR, SCULLING.................WATER TRANSPORTATION ACCESSORY
     rt YULOH
OAR, STEERING.................WATER TRANSPORTATION ACCESSORY
OARLOCK.......................WATER TRANSPORTATION ACCESSORY
Obelisk.......................CEREMONIAL ARTIFACT
     use MONUMENT
Obi...........................CLOTHING ACCESSORY
     use SASH
OBOE..........................MUSICAL T&E, WOODWIND
OBOE D'AMORE..................MUSICAL T&E, WOODWIND
OBSERVATORY, ORBITING SOLAR...AEROSPACE TRANSPORTATION EQUIPMENT
     rt SATELLITE
OCARINA.......................MUSICAL T&E, WOODWIND
OCTANT........................SURVEYING & NAVIGATIONAL T&E
     rt CIRCUMFERENTOR; SEXTANT
OCTAVIN.......................MUSICAL T&E, WOODWIND
Odometer......................SURVEYING & NAVIGATIONAL T&E
     use WHEEL, SURVEYOR'S
ODONTOGRAPH...................DRAFTING T&E
OENOMETER.....................FOOD PROCESSING T&E
OILSKINS......................CLOTHING, OUTERWEAR
     rt RAINCOAT; SLICKER
Oilstone......................METALWORKING T&E
     use WHETSTONE
OINTMENT CONTAINER............TOILET ARTICLE
Okimono.......................ORIGINAL ART
     use FIGURINE
Oleometer.....................MECHANICAL T&E
     use HYDROMETER
Olla..........................FOOD PROCESSING T&E
     use JAR, FOOD-STORAGE
```

```
OMBROMETER...................METEOROLOGICAL T&E
OMNIBUS......................LTE, ANIMAL-POWERED
Omnimeter....................SURVEYING & NAVIGATIONAL T&E
     use  THEODOLITE
ONCOMETER....................MEDICAL & PSYCHOLOGICAL T&E
Oomiak.......................WATER TRANSPORTATION EQUIPMENT
     use  UMIAK
OPACIMETER...................PAPERMAKING T&E
OPEIDOSCOPE..................ACOUSTICAL T&E
OPENER, BOTTLE...............FOOD PROCESSING T&E
OPENER, CAN..................FOOD PROCESSING T&E
OPENER, FID-LEAD.............GLASS & PLASTICS T&E
Opener, Letter...............WRITTEN COMMUNICATION EQUIPMENT
     use  KNIFE, PAPER
Opener-picker................TEXTILEWORKING T&E
     use  PICKER
OPERAMETER...................MECHANICAL T&E
OPHICLEIDE...................MUSICAL T&E, BRASS
OPHTHALMOMETER...............MEDICAL & PSYCHOLOGICAL T&E
OPHTHALMOSCOPE...............MEDICAL & PSYCHOLOGICAL T&E
OPISOMETER...................SURVEYING & NAVIGATIONAL T&E
OPSIOMETER...................MEDICAL & PSYCHOLOGICAL T&E
OPTICAL SQUARE...............SURVEYING & NAVIGATIONAL T&E
     rt  GROMA
Optic toy....................TOY
     use  more specific term: e.g., KALEIDOSCOPE,
           THAUMATROPE, ZOETROPE
Optometer....................MEDICAL & PSYCHOLOGICAL T&E
     use  OPSIOMETER
ORB..........................PERSONAL SYMBOL
ORCHESTRION..................MUSICAL T&E, UNCLASSIFIED
Ordinary.....................LTE, HUMAN-POWERED
     use  BICYCLE, ORDINARY
Ore car......................MINING T&E
     use  MINE CAR
ORGAN, BARREL................MUSICAL T&E, WOODWIND
ORGAN, ELECTRONIC............MUSICAL T&E, UNCLASSIFIED
ORGAN, LABORATORY............ACOUSTICAL T&E
ORGAN, PIPE..................MUSICAL T&E, WOODWIND
ORGAN, REED..................MUSICAL T&E, UNCLASSIFIED
ORGANETTE....................MUSICAL T&E, UNCLASSIFIED
ORIENTATOR...................SURVEYING & NAVIGATIONAL T&E
ORLE.........................CLOTHING, HEADWEAR
ORNAMENT.....................COMMERCIAL DECORATIVE ART
     note may be further subdivided to indicate
           specific type: e.g., ORNAMENT, CHANUKAH;
           -,CHRISTMAS TREE
ORNAMENT, CEILING............BUILDING FRAGMENT
ORNAMENT, GARDEN.............COMMERCIAL DECORATIVE ART
ORNAMENT, HAIR...............ADORNMENT
     rt  BODKIN
ORNAMENT, MASTHEAD...........WATER TRANSPORTATION ACCESSORY
```

```
ORNAMENT, PILOT-HOUSE..........WATER TRANSPORTATION ACCESSORY
ORNITHOPTER....................AEROSPACE TRANSPORTATION EQUIPMENT
OROGRAPH.......................SURVEYING & NAVIGATIONAL T&E
ORRERY.........................ASTRONOMICAL T&E
ORTHOSCANNER...................DATA PROCESSING T&E
     rt   READER, CHARACTER
ORTHOSCOPE.....................MEDICAL & PSYCHOLOGICAL T&E
OSCILLATING TABLE..............MECHANICAL T&E
OSCILLATOR.....................ELECTRICAL & MAGNETIC T&E
OSCILLOGRAPH...................ELECTRICAL & MAGNETIC T&E
OSCILLOMETER...................SURVEYING & NAVIGATIONAL T&E
OSCILLOSCOPE...................ELECTRICAL & MAGNETIC T&E
OSMOMETER......................CHEMICAL T&E
OSMOSCOPE......................BIOLOGICAL T&E
OSTEOPHONE.....................MEDICAL & PSYCHOLOGICAL T&E
OTACOUSTIC.....................MEDICAL & PSYCHOLOGICAL T&E
OTHEOSCOPE.....................OPTICAL T&E
OTOSCOPE.......................MEDICAL & PSYCHOLOGICAL T&E
OTTOMAN........................FURNITURE
     rt   HASSOCK; FOOTSTOOL
OUIJA SET......................GAME
OUTHOUSE.......................BUILDING
OVEN, BEEHIVE..................SITE FEATURE
OVEN, COKE.....................METALWORKING T&E
OVEN, CURING...................GLASS & PLASTICS T&E
Oven, Dutch....................FOOD PROCESSING T&E
     use  PAN, ROASTING
OVEN, MICROWAVE................FOOD PROCESSING T&E
OVERALLS.......................CLOTHING, OUTERWEAR
     note may be further subdivided according to
          functional activity if appropriate: e.g.,
          OVERALLS, PAINTER'S; -,CARPENTER'S
OVERCOAT.......................CLOTHING, OUTERWEAR
OVERMANTEL.....................BUILDING FRAGMENT
Oxbow..........................LAND TRANSPORTATION ACCESSORY
     use  YOKE, ANIMAL
OXCART.........................LTE, ANIMAL-POWERED
OXSHOE.........................ANIMAL HUSBANDRY T&E
OX-SHOEING FRAME...............ANIMAL HUSBANDRY T&E
OZONOMETER.....................METEOROLOGICAL T&E
PAC............................CLOTHING, FOOTWEAR
PACEMAKER......................MEDICAL & PSYCHOLOGICAL T&E
PACHYMETER.....................WEIGHTS & MEASURES T&E
PACIFIC CONVERTER..............TEXTILEWORKING T&E
PACIFIER.......................PERSONAL GEAR
PACKAGE-CHANGING MACHINE.......TEXTILEWORKING T&E
     note use only if specific type is unknown: e.g.,
          SPOOLER, WINDER, REEL
PACKAGING MACHINE, DAIRY.......FOOD PROCESSING T&E
     note use for a machine that packages any dairy
          product
PACKER, BARREL.................FOOD PROCESSING T&E
```

Packer, Bran....................FOOD PROCESSING T&E
 use PACKER, BARREL
PACKER, BUTTER..................FOOD PROCESSING T&E
Packer, Feed....................FOOD PROCESSING T&E
 use PACKER, BARREL
Packer, Flour...................FOOD PROCESSING T&E
 use PACKER, BARREL
Packer, Surface.................AGRICULTURAL T&E
 use ROLLER, LAND
PACKET..........................WATER TRANSPORTATION EQUIPMENT
PACK FRAME......................PERSONAL GEAR
PACKING MACHINE, BLISTER........PAPERMAKING T&E
PACKING MACHINE, CAN............FOOD PROCESSING T&E
PACKING MACHINE, SKIN...........PAPERMAKING T&E
PAD, TABLE......................FOOD SERVICE T&E
PADDLE..........................FOOD PROCESSING T&E
 note may be further subdivided to indicate
 specific type: e.g., PADDLE, APPLE BUTTER
Paddle..........................GLASS & PLASTICS T&E
 use BATTLEDORE
PADDLE..........................WATER TRANSPORTATION ACCESSORY
PADDLE..........................BEHAVIORAL CONTROL DEVICE
Paddle, Butter..................FOOD PROCESSING T&E
 use SPADE, BUTTER-WORKING
PADDLE, CANOE...................WATER TRANSPORTATION ACCESSORY
PADDLE, CROUPIER'S..............GAME
PADDLE, DOUBLE-BLADED...........WATER TRANSPORTATION ACCESSORY
PADDLE BOAT.....................WATER TRANSPORTATION EQUIPMENT
PADDOCK.........................BUILDING
Paddy wagon.....................LTE, ANIMAL-POWERED
 use WAGON, POLICE PATROL
PADLOCK.........................HOUSEHOLD ACCESSORY
PAD MACHINE.....................TEXTILEWORKING T&E
PADS, HIP.......................SPORTS EQUIPMENT
PADS, SHOULDER..................SPORTS EQUIPMENT
Pagoda..........................BUILDING
 use TEMPLE
PAGOSCOPE.......................METEOROLOGICAL T&E
PAIL............................HOUSEKEEPING T&E
PAIL, DINNER....................FOOD SERVICE T&E
PAIL, MILKING...................FOOD PROCESSING T&E
PAINTING........................ORIGINAL ART
PAJAMAS.........................CLOTHING, OUTERWEAR
PALANQUIN.......................LTE, HUMAN-POWERED
PALETTE.........................PAINTING T&E
PALINURUS.......................SURVEYING & NAVIGATIONAL T&E
PALISADE........................UNCLASSIFIED STRUCTURE
PALL............................CEREMONIAL ARTIFACT
PALLET..........................PRINTING T&E
PALM, SAILMAKER'S...............TEXTILEWORKING T&E
Paltock.........................CLOTHING, OUTERWEAR
 use TUNIC

```
Pamphlet.......................DOCUMENTARY ARTIFACT
    use   BOOKLET
Pan............................FOOD PROCESSING T&E
    use   SAUCEPAN
PAN, AMALGAMATING..............METALWORKING T&E
PAN, ANGEL FOOD CAKE...........FOOD PROCESSING T&E
PAN, BLOCKING..................GLASS & PLASTICS T&E
PAN, BREAD.....................FOOD PROCESSING T&E
PAN, BUNDT.....................FOOD PROCESSING T&E
PAN, CAKE......................FOOD PROCESSING T&E
PAN, CREPE.....................FOOD PROCESSING T&E
PAN, DOUCHE....................HOUSEHOLD ACCESSORY
PAN, DRIP......................GLASS & PLASTICS T&E
PAN, FRYING....................FOOD PROCESSING T&E
    rt    SPIDER
PAN, JELLY ROLL................FOOD PROCESSING T&E
PAN, MILK......................FOOD PROCESSING T&E
PAN, MINER'S...................MINING T&E
PAN, MUFFIN....................FOOD PROCESSING T&E
PAN, OMELET....................FOOD PROCESSING T&E
PAN, PIE.......................FOOD PROCESSING T&E
PAN, ROASTING..................FOOD PROCESSING T&E
PAN, SPRING-FORM...............FOOD PROCESSING T&E
PANEL, SOLAR...................POWER PRODUCTION T&E
PANELING SECTION...............BUILDING FRAGMENT
PANNIER........................CLOTHING, OUTERWEAR
PANNIER........................CLOTHING, UNDERWEAR
PANNIER........................LAND TRANSPORTATION ACCESSORY
PANPIPE........................MUSICAL T&E, WOODWIND
PANTALETTES....................CLOTHING, UNDERWEAR
Pantaloons.....................CLOTHING, OUTERWEAR
    use   PANTS
PANTIES........................CLOTHING, UNDERWEAR
PANTOGRAPH.....................DRAFTING T&E
PANTOMETER.....................SURVEYING & NAVIGATIONAL T&E
PANTS..........................CLOTHING, OUTERWEAR
PANTSUIT.......................CLOTHING, OUTERWEAR
PANTYHOSE......................CLOTHING, UNDERWEAR
PANYOCHROMETER.................WEIGHTS & MEASURES T&E
PAPER DOLL.....................TOY
PAPER MACHINE..................PAPERMAKING T&E
Paper-making machine...........PAPERMAKING T&E
    use   PAPER MACHINE
Paper money....................EXCHANGE MEDIUM
    use   CURRENCY
PAPER TOY......................TOY
PAPERWEIGHT....................WRITTEN COMMUNICATION EQUIPMENT
PARACHUTE......................AEROSPACE TRANSPORTATION ACCESSORY
    note  may be further subdivided to indicate
          specific type: e.g., PARACHUTE, CARGO;
          -,DROGUE; -,PERSONNEL
PARASOL........................PERSONAL GEAR
```

```
PARBUCKLE......................FORESTRY T&E
PARCHESI SET...................GAME
PARER, FRUIT...................FOOD PROCESSING T&E
PARER, HOOF....................ANIMAL HUSBANDRY T&E
PARKA..........................CLOTHING, OUTERWEAR
PARK DRAG......................LTE, ANIMAL-POWERED
     rt   COACH, ROAD
PARLOR SUITE...................FURNITURE
PARTISAN.......................ARMAMENT T&E, EDGED
PASSENGER VESSEL...............WATER TRANSPORTATION EQUIPMENT
Passglas.......................FOOD SERVICE T&E
     use  BEAKER
Passometer.....................SPORTS EQUIPMENT
     use  PEDOMETER
PASSPORT.......................DOCUMENTARY ARTIFACT
PASTEURIZER, MILK..............FOOD PROCESSING T&E
PATCH..........................PERSONAL SYMBOL
     note use for cloth badge or emblem sewn to a
          sleeve or bandolier; may be further
          subdivided to indicate specific type: e.g.,
          PATCH, REGIMENTAL; -,MERIT-BADGE
PATCH..........................DATA PROCESSING T&E
PATEN..........................CEREMONIAL ARTIFACT
PATENT.........................DOCUMENTARY ARTIFACT
PATROL GUNBOAT.................WATER TRANSPORTATION EQUIPMENT
PATROL TORPEDO BOAT............WATER TRANSPORTATION EQUIPMENT
Patten.........................CLOTHING, FOOTWEAR
     use  CLOG
PATTERN........................TEXTILEWORKING T&E
     note may be further subdivided to indicate
          specific item: e.g., PATTERN, STUFFED
          ANIMAL; -,PILLOW
PATTERN........................WOODWORKING T&E
     rt   TEMPLATE
PATTERN, CARTRIDGE.............ARMAMENT ACCESSORY
PATTERN, EAR...................ANIMAL HUSBANDRY T&E
PAULDRON.......................ARMAMENT T&E, BODY ARMOR
PAVEMENT SECTION...............UNCLASSIFIED STRUCTURE
PAVILLION......................BUILDING
PEAPOD.........................WATER TRANSPORTATION EQUIPMENT
PEAVY..........................FORESTRY T&E
PEDAL CAR......................TOY
PEDESTAL.......................FURNITURE
PEDOMETER......................SPORTS EQUIPMENT
PEEL...........................FOOD PROCESSING T&E
PEEL...........................PRINTING T&E
PEELER, VEGETABLE..............FOOD PROCESSING T&E
PEEP-SHOW MACHINE..............RECREATIONAL DEVICE
     rt   MUTASCOPE
PEG............................WOODWORKING T&E
     rt   TREENAIL; DOWEL
Peg, Husking...................AGRICULTURAL T&E
     use  CORNHUSKER, HAND
```

413

Peignoir........................CLOTHING, OUTERWEAR
 use NIGHTGOWN or GOWN, DRESSING
PELVIMETER......................MEDICAL & PSYCHOLOGICAL T&E
PEN.............................WRITTEN COMMUNICATION EQUIPMENT
PEN, BALL-POINT.................WRITTEN COMMUNICATION EQUIPMENT
PEN, FOUNTAIN...................WRITTEN COMMUNICATION EQUIPMENT
PEN, LETTERING..................PAINTING T&E
Pen, Light......................DATA PROCESSING T&E
 use STYLUS, LIGHT
PEN, PYROGRAPHY.................LEATHERWORKING T&E
PEN, RULING.....................DRAFTING T&E
PENCIL..........................WRITTEN COMMUNICATION EQUIPMENT
PENCIL, EYEBROW.................TOILET ARTICLE
PENCIL, SKIN-MARKING............BIOLOGICAL T&E
PENDANT.........................ADORNMENT
PENDANT, RELIGIOUS..............PERSONAL SYMBOL
PENDULUM........................MECHANICAL T&E
PENDULUM, BALLISTIC.............ARMAMENT ACCESSORY
PENDULUM, SOUND.................ACOUSTICAL T&E
PENETROMETER....................CHEMICAL T&E
Penknife........................PERSONAL GEAR
 use KNIFE, POCKET
PENNANT.........................CEREMONIAL ARTIFACT
PENNON..........................CEREMONIAL ARTIFACT
Penny farthing..................LTE, HUMAN-POWERED
 use BICYCLE, ORDINARY
PENSTOCK........................POWER PRODUCTION T&E
 rt FLUME
PEN WIPE........................WRITTEN COMMUNICATION EQUIPMENT
PEPPERBOX.......................ARMAMENT T&E, FIREARM
Pepperbox.......................FOOD SERVICE T&E
 use SHAKER, PEPPER
Perambulator....................SURVEYING & NAVIGATIONAL T&E
 use WHEEL, SURVEYOR'S
Perambulator....................LTE, HUMAN-POWERED
 use CARRIAGE, BABY
PERCOLATOR......................CHEMICAL T&E
Percolator......................FOOD PROCESSING T&E
 use COFFEE MAKER
PERCUSSION TUBE.................ARMAMENT ACCESSORY
PERFORATOR......................DATA PROCESSING T&E
PERFORATOR......................PRINTING T&E
PERGOLA.........................BUILDING
PERIAKTOS.......................PUBLIC ENTERTAINMENT DEVICE
PERIMETER.......................MEDICAL & PSYCHOLOGICAL T&E
PERIMETER, SOUND................ACOUSTICAL T&E
Peripheral equipment............DATA PROCESSING T&E
 use more specific term: e.g., DRIVE, DISK;
 READER, OPTICAL CHARACTER
PERISCOPE.......................OPTICAL T&E
PERIWIG.........................CLOTHING, HEADWEAR
PERLOCK MACHINE.................TEXTILEWORKING T&E

414

PERRIER........................ARMAMENT T&E, ARTILLERY
PERSONNEL CARRIER..............LTE, MOTORIZED
PERSPECTOGRAPH.................DRAFTING T&E
PERSPECTOSCOPE.................MEDICAL & PSYCHOLOGICAL T&E
Peruke.........................CLOTHING, HEADWEAR
 use PERIWIG
PESTLE.........................CHEMICAL T&E
PESTLE.........................FOOD PROCESSING T&E
PETARD.........................ARMAMENT T&E, ARTILLERY
PETROLEUM-SERVICE VESSEL.......WATER TRANSPORTATION EQUIPMENT
 note use for offshore station tender
PETRONEL.......................ARMAMENT T&E, FIREARM
 rt CARBINE
PETTICOAT......................CLOTHING, UNDERWEAR
PEW............................FURNITURE
PHAETON........................LTE, ANIMAL-POWERED
 note may be further subdivided to indicate
 specific type: e.g., PHAETON, SPIDER;
 -,STANHOPE; -,GEORGE IV
PHANAROGRISONMETER.............MINING T&E
Phantoscope....................TOY
 use KALEIDOSCOPE
PHENAKISTOSCOPE................MEDICAL & PSYCHOLOGICAL T&E
PHIALE.........................CEREMONIAL ARTIFACT
 rt BOWL, LIBATION
PHONEIDOSCOPE..................OPTICAL T&E
PHONELESCOPE...................ACOUSTICAL T&E
PHONODEIK......................ACOUSTICAL T&E
PHONOGRAPH.....................SOUND COMMUNICATION EQUIPMENT
Phonometer.....................ACOUSTICAL T&E
 use ACOUMETER
PHONO-PROJECTOSCOPE............ACOUSTICAL T&E
PHONORGANON....................ACOUSTICAL T&E
PHONOSCOPE.....................ACOUSTICAL T&E
PHOSPHOROSCOPE.................CHEMICAL T&E
PHOTOCLINOMETER................MINING T&E
Photocomposing machine.........PRINTING T&E
 use PHOTOTYPESETTER
PHOTOCOPIER....................PRINTING T&E
PHOTODROME.....................OPTICAL T&E
Photograph.....................DOCUMENTARY ARTIFACT
 use more specific term: e.g., PRINT,
 PHOTOGRAPHIC; TINTYPE; DAGUERREOTYPE;
 CARTE-DE-VISITE; PHOTOGRAPH, CABINET
PHOTOGRAPH, CABINET............DOCUMENTARY ARTIFACT
PHOTOHELIOGRAPH................ASTRONOMICAL T&E
PHOTOMETER.....................OPTICAL T&E
PHOTOMETER, PHOTOELECTRIC......ASTRONOMICAL T&E
PHOTOMETER, POLARIZING.........OPTICAL T&E
PHOTOPHONE.....................ACOUSTICAL T&E
PHOTOSYNTHOMETER...............BIOLOGICAL T&E
PHOTOTYPESETTER................PRINTING T&E

```
PHRENOGRAPH......................MEDICAL & PSYCHOLOGICAL T&E
PIANO, BARREL....................MUSICAL T&E, STRINGED
PIANO, GRAND.....................MUSICAL T&E, STRINGED
PIANO, PLAYER....................MUSICAL T&E, STRINGED
Piano, Reproducing...............MUSICAL T&E, STRINGED
     use  PIANO, PLAYER
PIANO, SQUARE....................MUSICAL T&E, STRINGED
PIANO, UPRIGHT...................MUSICAL T&E, STRINGED
PIANO BENCH......................MUSICAL T&E, STRINGED
PIANO STOOL......................MUSICAL T&E, STRINGED
PICCOLO..........................MUSICAL T&E, WOODWIND
PICK.............................MINING T&E
PICK, DOUBLE-POINTED.............MINING T&E
PICK, DRIFTING...................MINING T&E
PICK, FLINTING...................MASONRY T&E
Pick, Holing.....................MINING T&E
     use  PICK, UNDERCUTTING
PICK, HOOF.......................ANIMAL HUSBANDRY T&E
PICK, MASON'S....................MASONRY T&E
PICK, MILL.......................MASONRY T&E
PICK, POLL.......................MINING T&E
PICK, UNDERCUTTING...............MINING T&E
PICKAROON........................FORESTRY T&E
PICKER...........................MINING T&E
PICKER...........................TEXTILEWORKING T&E
PICKER, CORN.....................AGRICULTURAL T&E
PICKER, COTTON...................AGRICULTURAL T&E
PICKER, FRUIT....................AGRICULTURAL T&E
PICKER, SWEET CORN...............AGRICULTURAL T&E
PICKER/HUSKER, CORN..............AGRICULTURAL T&E
PICKER/SHELLER, CORN.............AGRICULTURAL T&E
PICKET POLE......................SURVEYING & NAVIGATIONAL T&E
Pickup...........................LTE, MOTORIZED
     use  TRUCK, PICKUP
Pick up sticks...................GAME
     use  JACKSTRAWS
PICTURE..........................DOCUMENTARY ARTIFACT
     note use for any painting or drawing which is
          primarily documentary rather than an art
          object
PICTURE..........................COMMERCIAL DECORATIVE ART
     note may be further subdivided to indicate
          material or technique: e.g., PICTURE, WOVEN
PICTURE..........................ORIGINAL ART
     note may be further subdivided to indicate
          material or technique: e.g., PICTURE,
          CUT-PAPER; -,HAIR; -,SHELL
PICTURE FRAME....................COMMERCIAL DECORATIVE ART
PI DISK..........................CEREMONIAL ARTIFACT
PIER.............................UNCLASSIFIED STRUCTURE
PIEZOMETER.......................MECHANICAL T&E
PIG..............................GLASS & PLASTICS T&E
```

```
Pig.............................METALWORKING T&E
     use  MOLD, PIG
Piggin, Milking.................FOOD PROCESSING T&E
     use  PAIL, MILKING
PIGGYBACK CAR...................RAIL TRANSPORTATION EQUIPMENT
PIKE............................ARMAMENT T&E, EDGED
PIKE, AWL.......................ARMAMENT T&E, EDGED
PIKE, BOARDING..................ARMAMENT T&E, EDGED
PIKE, JAM.......................FORESTRY T&E
PIKE, POLE......................FORESTRY T&E
PILASTER........................BUILDING FRAGMENT
PILE DRIVER.....................CONSTRUCTION T&E
PILL AID........................ANIMAL HUSBANDRY T&E
PILLAR..........................BUILDING FRAGMENT
PILLBOX.........................CLOTHING, HEADWEAR
PILLBOX.........................PERSONAL GEAR
PILLORY.........................BEHAVIORAL CONTROL DEVICE
PILLOW..........................BEDDING
PILLOW, THROW...................BEDDING
PILLOWCASE......................BEDDING
PILLOW RIDE.....................RECREATIONAL DEVICE
PILLOW SHAM.....................BEDDING
PILOT BOAT......................WATER TRANSPORTATION EQUIPMENT
PIN.............................PERSONAL SYMBOL
     note may be further subdivided to indicate
          specific type: e.g., PIN, SORORITY;
          -,CAPTAIN'S
Pin.............................WOODWORKING T&E
     use  DOWEL or PEG
PIN, BELAYING...................WATER TRANSPORTATION ACCESSORY
PIN, BOBBY......................TOILET ARTICLE
PIN, COTTER.....................METALWORKING T&E
PIN, DRIFT......................METALWORKING T&E
Pin, Husking....................AGRICULTURAL T&E
     use  CORNHUSKER, HAND
PIN, LAPEL......................ADORNMENT
PIN, PROLAPSE...................ANIMAL HUSBANDRY T&E
PIN, SAFETY.....................TEXTILEWORKING T&E
PIN, SCATTER....................ADORNMENT
PIN, STRAIGHT...................TEXTILEWORKING T&E
PIN, THOLE......................WATER TRANSPORTATION ACCESSORY
PINAFORE........................CLOTHING, OUTERWEAR
PINBALL MACHINE.................RECREATIONAL DEVICE
PINBOARD........................DATA PROCESSING T&E
PINBOARD MACHINE................DATA PROCESSING T&E
Pince-nez.......................PERSONAL GEAR
     use  EYEGLASSES
PINCERS.........................GLASS & PLASTICS T&E
PINCERS.........................WOODWORKING T&E
PINCERS, FARRIER'S..............ANIMAL HUSBANDRY T&E
PINCERS, GUNNER'S...............ARMAMENT ACCESSORY
PINCERS, LASTING................LEATHERWORKING T&E
```

```
PINCHBAR......................UNCLASSIFIED T&E, GENERAL
PINCUSHION....................TEXTILEWORKING T&E
Ping pong paddle..............SPORTS EQUIPMENT
     use  TABLE TENNIS PADDLE
PINKY.........................WATER TRANSPORTATION EQUIPMENT
PINKY, CROTCH ISLAND..........WATER TRANSPORTATION EQUIPMENT
PINTLE, RUDDER................WATER TRANSPORTATION ACCESSORY
PINWHEEL......................TOY
PIOSCOPE......................FOOD PROCESSING T&E
PIPE..........................BUILDING FRAGMENT
PIPE..........................PERSONAL GEAR
Pipe..........................MUSICAL T&E, WOODWIND
     use  BAGPIPE, FIFE or PANPIPE
PIPE, BUBBLE..................TOY
PIPE, DRAUGHT.................CHEMICAL T&E
     note use for funnel collecting gases over
          experiment table
Pipe, Peace...................CEREMONIAL ARTIFACT
     use  CALUMET
PIPE, PITCH...................MUSICAL T&E, WOODWIND
PIPE, TABOR...................MUSICAL T&E, WOODWIND
PIPE, WHISTLE.................TOY
PIPE CASE.....................PERSONAL GEAR
PIPETTE.......................CHEMICAL T&E
     note may be further subdivided to indicate
          specific type: e.g., PIPETTE, ABSORPTION;
          -,VOLUMETRIC
PIPETTE, INTRAUTERINE.........ANIMAL HUSBANDRY T&E
Pirogue.......................WATER TRANSPORTATION EQUIPMENT
     use  CANOE, DUGOUT
PISTOL........................ARMAMENT T&E, FIREARM
     note use only if specific type is unknown
     rt   REVOLVER; DERRINGER
PISTOL, AUTOMATIC.............ARMAMENT T&E, FIREARM
Pistol, Cap...................TOY
     use  CAP PISTOL
PISTOL, DUELLING..............ARMAMENT T&E, FIREARM
PISTOL, HORSEMAN'S............ARMAMENT T&E, FIREARM
Pistol, Machine...............ARMAMENT T&E, FIREARM
     use  GUN, SUBMACHINE
Pistol, Paint-pellet..........ANIMAL HUSBANDRY T&E
     use  GUN, MARKING
PISTOL, POCKET................ARMAMENT T&E, FIREARM
PISTOL, SIGNAL................VISUAL COMMUNICATION EQUIPMENT
PISTOL, TARGET................ARMAMENT T&E, FIREARM
Pistol, Tinder................TEMPERATURE CONTROL DEVICE
     use  TINDERPISTOL
Pistol, Very..................VISUAL COMMUNICATION EQUIPMENT
     use  PISTOL, SIGNAL
PISTOL/AX.....................ARMAMENT T&E, FIREARM
PISTOL/CARBINE................ARMAMENT T&E, FIREARM
PISTOL/CUTLASS................ARMAMENT T&E, FIREARM
```

```
PISTOL/KNIFE....................ARMAMENT T&E, FIREARM
PISTOL/SWORD....................ARMAMENT T&E, FIREARM
PITCHER.........................HOUSEHOLD ACCESSORY
PITCHER.........................FOOD SERVICE T&E
PITCHER, CREAM..................FOOD SERVICE T&E
PITCHER, SYRUP..................FOOD SERVICE T&E
PITCHER, WATER..................FOOD SERVICE T&E
Pitchfork.......................AGRICULTURAL T&E
     use  HAYFORK or FORK, MANURE
PITON...........................SPORTS EQUIPMENT
PITTER, CHERRY..................FOOD PROCESSING T&E
Placard.........................ADVERTISING MEDIUM
     use  POSTER
Plagiograph.....................DRAFTING T&E
     use  PANTOGRAPH
PLANE...........................WOODWORKING T&E
     note use only if specific type is unknown
     rt   CROZE
PLANE, ASTRAGAL.................WOODWORKING T&E
Plane, Badger...................WOODWORKING T&E
     use  PLANE, RABBET
PLANE, BANDING..................WOODWORKING T&E
Plane, Beading..................WOODWORKING T&E
     use  PLANE, ASTRAGAL
PLANE, BLOCK....................WOODWORKING T&E
PLANE, BULLNOSE.................WOODWORKING T&E
PLANE, CENTERBOARD..............WOODWORKING T&E
Plane, Chisel...................WOODWORKING T&E
     use  PLANE, EDGE
Plane, Chiv.....................WOODWORKING T&E
     use  PLANE, HOWELL
PLANE, COMBINATION..............WOODWORKING T&E
PLANE, COMPASS..................WOODWORKING T&E
PLANE, COOPER'S STOUP...........WOODWORKING T&E
PLANE, CORNICE..................WOODWORKING T&E
Plane, Crown....................WOODWORKING T&E
     use  PLANE, CORNICE
Plane, Croze....................WOODWORKING T&E
     use  CROZE
PLANE, DADO.....................WOODWORKING T&E
     rt   PLANE, GROOVING
PLANE, EDGE.....................WOODWORKING T&E
PLANE, FILLISTER................WOODWORKING T&E
PLANE, FLOOR....................WOODWORKING T&E
Plane, Fore.....................WOODWORKING T&E
     use  PLANE, JACK
PLANE, GROOVING.................WOODWORKING T&E
     rt   PLANE, PLOW; PLANE, DADO
PLANE, GUTTERING................WOODWORKING T&E
     rt   ADZ, GUTTERING
Plane, Handrail.................WOODWORKING T&E
     use  PLANE, STAIRBUILDER'S
```

419

PLANE, HOLLOW...................WOODWORKING T&E
 rt PLANE, ROUND
PLANE, HOWELL...................WOODWORKING T&E
PLANE, JACK.....................WOODWORKING T&E
Plane, Jointer..................WOODWORKING T&E
 use PLANE, LONG-JOINTER or PLANE, SHORT-JOINTER
Plane, Leveling.................WOODWORKING T&E
 use PLANE, SUN
PLANE, LONG-JOINTER.............WOODWORKING T&E
 rt PLANE, TRYING; PLANE, SHORT-JOINTER
PLANE, MITER....................WOODWORKING T&E
PLANE, MODELING.................WOODWORKING T&E
PLANE, MOLDING..................WOODWORKING T&E
 note use unless the PLANE can be identified as
 one of the following major sub-categories
 under MOLDING: PLANE, ASTRAGAL; PLANE,
 CENTERBOARD; PLANE, CORNICE; PLANE, HOLLOW;
 PLANE, ROUND
Plane, Nosing...................WOODWORKING T&E
 use PLANE, MOLDING
Plane, Old woman's tooth........WOODWORKING T&E
 use PLANE, ROUTER
PLANE, PANEL....................WOODWORKING T&E
Plane, Panel-fielding...........WOODWORKING T&E
 use PLANE, RAISING
Plane, Plough...................WOODWORKING T&E
 use PLANE, PLOW
PLANE, PLOW.....................WOODWORKING T&E
 rt PLANE, GROOVING
Plane, Pull.....................WOODWORKING T&E
 use PLANE, SHORT-JOINTER
PLANE, RABBET...................WOODWORKING T&E
 note use unless the PLANE can be identified as
 one of the following major sub-categories
 under RABBET: PLANE, FILLISTER; PLANE,
 PANEL; PLANE, RAISING; PLANE, SHOULDER
 rt SAW, RABBET
PLANE, RAISING..................WOODWORKING T&E
Plane, Rebate...................WOODWORKING T&E
 use PLANE, RABBET
PLANE, ROUGHING.................WOODWORKING T&E
PLANE, ROUND....................WOODWORKING T&E
 rt PLANE, HOLLOW
PLANE, ROUNDER..................WOODWORKING T&E
PLANE, ROUTER...................WOODWORKING T&E
 rt ROUTER
PLANE, SASH.....................WOODWORKING T&E
Plane, Scaleboard...............WOODWORKING T&E
 use PLANE, SPLINT
PLANE, SCOOPMAKER...............WOODWORKING T&E
PLANE, SHORT-JOINTER............WOODWORKING T&E
 rt PLANE, TRYING; PLANE, LONG-JOINTER

```
PLANE, SHOULDER.................WOODWORKING T&E
Plane, Skew.....................WOODWORKING T&E
     use  PLANE, RABBET
PLANE, SMOOTHING................WOODWORKING T&E
PLANE, SPLINT...................WOODWORKING T&E
PLANE, STAIRBUILDER'S...........WOODWORKING T&E
PLANE, SUN......................WOODWORKING T&E
PLANE, TONGUE-AND-GROOVE........WOODWORKING T&E
PLANE, TOOTHING.................WOODWORKING T&E
Plane, Topping..................WOODWORKING T&E
     use  PLANE, SUN
PLANE, TRYING...................WOODWORKING T&E
     rt   PLANE, LONG-JOINTER; PLANE, SHORT-JOINTER
PLANE, VIOLINMAKER'S............WOODWORKING T&E
Plane, Witchet..................WOODWORKING T&E
     use  PLANE, ROUNDER
PLANER..........................METALWORKING T&E
     rt   SHAPER
PLANER..........................WOODWORKING T&E
Plane table.....................SURVEYING & NAVIGATIONAL T&E
     use  TABLE, PLANE
PLANETARIUM.....................BUILDING
PLANETARIUM.....................ASTRONOMICAL T&E
Planigraph......................DRAFTING T&E
     use  PANTOGRAPH
PLANIMETER......................DATA PROCESSING T&E
     rt   INTEGRATOR
PLANIMETER......................SURVEYING & NAVIGATIONAL T&E
PLANISPHERE.....................ASTRONOMICAL T&E
PLANSIFTER......................FOOD PROCESSING T&E
PLANT, INDUSTRIAL...............BUILDING
PLANTER.........................HOUSEHOLD ACCESSORY
     rt   JARDINIERE
PLANTER.........................AGRICULTURAL T&E
     note use for a horse-drawn planter on which the
          operator rides and for a machine-drawn
          planter; may be further subdivided to
          indicate specific crop: e.g., PLANTER, POTATO
Planter, Bed....................AGRICULTURAL T&E
     use  PLANTER or PLANTER, WALKING
Planter, Drill..................AGRICULTURAL T&E
     use  PLANTER or PLANTER, WALKING or PLANTER,
          GARDEN
PLANTER, GARDEN.................AGRICULTURAL T&E
     note use for a planter pushed by hand
PLANTER, HAND...................AGRICULTURAL T&E
     note use for a planter carried by hand
Planter, Lister.................AGRICULTURAL T&E
     use  PLANTER or PLANTER, WALKING
Planter, Precision..............AGRICULTURAL T&E
     use  PLANTER
Planter, Riding.................AGRICULTURAL T&E
     use  PLANTER
```

PLANTER, WALKING...............AGRICULTURAL T&E
 note use for an animal-drawn planter behind which
 the operator walks
Planter, Walking-stick.........AGRICULTURAL T&E
 use PLANTER, HAND
Planter, Wheel.................AGRICULTURAL T&E
 use PLANTER, GARDEN
Planting bar...................AGRICULTURAL T&E
 use DIBBLE
Planting spud dibble...........AGRICULTURAL T&E
 use DIBBLE
Planting stick.................AGRICULTURAL T&E
 use DIBBLE
PLAQUE.........................PERSONAL SYMBOL
 note may be further subdivided to indicate
 specific type: e.g., PLAQUE, RELIGIOUS
PLAQUE.........................COMMERCIAL DECORATIVE ART
PLAQUE.........................ORIGINAL ART
PLAQUE.........................CEREMONIAL ARTIFACT
Plastograph....................MEDICAL & PSYCHOLOGICAL T&E
 use ANAGLYPH
PLASTRON.......................SPORTS EQUIPMENT
PLATE..........................ARMAMENT T&E, BODY ARMOR
Plate, Amalgam.................METALWORKING T&E
 use TABLE, AMALGAMATING
PLATE, BUTTER..................FOOD SERVICE T&E
PLATE, BUTTER-PAT..............FOOD SERVICE T&E
PLATE, CUP.....................FOOD SERVICE T&E
PLATE, CUT-OFF.................GLASS & PLASTICS T&E
PLATE, DESSERT.................FOOD SERVICE T&E
PLATE, DINNER..................FOOD SERVICE T&E
PLATE, HOT.....................FOOD PROCESSING T&E
PLATE, LUNCHEON................FOOD SERVICE T&E
PLATE, OFFERING................CEREMONIAL ARTIFACT
PLATE, OFFSET..................PRINTING T&E
Plate, Pie.....................FOOD PROCESSING T&E
 use PAN, PIE
PLATE, SALAD...................FOOD SERVICE T&E
PLATE, SERVING.................FOOD SERVICE T&E
PLATE, SOUP....................FOOD SERVICE T&E
PLATE, VEGETABLE...............FOOD SERVICE T&E
PLATEAU........................FOOD SERVICE T&E
PLATEHOLDER....................PHOTOGRAPHIC T&E
PLATOMETER.....................SURVEYING & NAVIGATIONAL T&E
PLATTER........................FOOD SERVICE T&E
PLATYMETER.....................ELECTRICAL & MAGNETIC T&E
Playbill.......................DOCUMENTARY ARTIFACT
 use PROGRAM, THEATER
PLAYER PIANO ROLL..............MUSICAL T&E, STRINGED
Playground equipment...........RECREATIONAL DEVICE
 use more specific term: e.g.,
PLAYPEN........................FURNITURE

PLEATING MACHINE................TEXTILEWORKING T&E
PLETHYSMOGRAPH..................MEDICAL & PSYCHOLOGICAL T&E
PLIERS..........................UNCLASSIFIED T&E, GENERAL
 note may be further subdivided to indicate
 specific type: e.g., PLIERS, VISE-GRIP
PLIERS, ELECTRICIAN'S...........ELECTRICAL & MAGNETIC T&E
PLIERS, GLASS...................GLASS & PLASTICS T&E
PLIERS, LACING..................LEATHERWORKING T&E
PLIERS, NEEDLENOSE..............ELECTRICAL & MAGNETIC T&E
PLIERS, STRETCHING..............PAINTING T&E
PLOTTER.........................DATA PROCESSING T&E
PLOUGH..........................PRINTING T&E
PLOW............................FISHING & TRAPPING T&E
Plow............................WOODWORKING T&E
 use PLANE, PLOW
PLOW, BOG-CUTTER................AGRICULTURAL T&E
Plow, Chisel....................AGRICULTURAL T&E
 use PLOW, SUBSOIL
PLOW, DISK......................AGRICULTURAL T&E
PLOW, GARDEN....................AGRICULTURAL T&E
Plow, Lister....................AGRICULTURAL T&E
 use MIDDLEBUSTER
Plow, Middlebuster..............AGRICULTURAL T&E
 use MIDDLEBUSTER
PLOW, MOLDBOARD.................AGRICULTURAL T&E
Plow, One-way wheatland.........AGRICULTURAL T&E
 use PLOW, DISK
Plow, Peat......................AGRICULTURAL T&E
 use PLOW, BOG-CUTTER
PLOW, SHOVEL....................AGRICULTURAL T&E
PLOW, SNOW......................LTE, ANIMAL-POWERED
PLOW, SNOW......................LTE, MOTORIZED
PLOW, SUBSOIL...................AGRICULTURAL T&E
PLUG............................MASONRY T&E
Plug board......................DATA PROCESSING T&E
 use PATCH
PLUMB BOB.......................UNCLASSIFIED T&E, GENERAL
PLUVIOGRAPH.....................METEOROLOGICAL T&E
PLUVIOMETER.....................METEOROLOGICAL T&E
Pneometer.......................MEDICAL & PSYCHOLOGICAL T&E
 use SPIROMETER
POACHER.........................FOOD PROCESSING T&E
POCKET..........................PERSONAL GEAR
Pod.............................LTE, ANIMAL-POWERED
 use SLEIGH
PODIUM..........................FURNITURE
POGAMOGGAN......................ARMAMENT T&E, BLUDGEON
POGO STICK......................TOY
POINT...........................MASONRY T&E
POINT, PYROGRAPHY...............LEATHERWORKING T&E
Pokal...........................FOOD SERVICE T&E
 use GOBLET

```
POKE.............................ANIMAL HUSBANDRY T&E
POKER............................TEMPERATURE CONTROL DEVICE
POKER............................METALWORKING T&E
POKER CHIP.......................GAME
POKER CHIP BLOCK.................GAME
POLARIMETER......................OPTICAL T&E
     rt  POLARISCOPE
POLARISCOPE......................OPTICAL T&E
     rt  POLARIMETER
Pole
     use  only as a secondary word in a multi-word
          object name
Pole.............................WATER TRANSPORTATION ACCESSORY
     use  QUANT
POLEAX...........................ARMAMENT T&E, EDGED
Poleax...........................FOOD PROCESSING T&E
     use  AX, SLAUGHTERING
POLEMOSCOPE......................VISUAL COMMUNICATION EQUIPMENT
POLICE STATION...................BUILDING
POLISHING MACHINE................METALWORKING T&E
POLLUTION-CONTROL DEVICE.........UNCLASSIFIED T&E, GENERAL
     note may be further subdivided to indicate
          specific type: e.g., POLLUTION-CONTROL
          DEVICE, FILTER; -,PRECIPITATOR; -,SEPARATOR
Polygonoscope....................TOY
     use  KALEIDOSCOPE
POLYGRAPH........................MEDICAL & PSYCHOLOGICAL T&E
POLYTROPE........................MECHANICAL T&E
POMANDER.........................TOILET ARTICLE
PONCHO...........................CLOTHING, OUTERWEAR
PONIARD..........................ARMAMENT T&E, EDGED
PONTIL...........................GLASS & PLASTICS T&E
POOL, SWIMMING...................UNCLASSIFIED STRUCTURE
POOL, WADING.....................RECREATIONAL DEVICE
POOL TABLE.......................SPORTS EQUIPMENT
POPGUN...........................TOY
POPPER, CORN.....................FOOD PROCESSING T&E
PORCH............................BUILDING FRAGMENT
PORRINGER........................FOOD SERVICE T&E
PORRO............................FOOD SERVICE T&E
PORTFIRE STOCK...................ARMAMENT ACCESSORY
PORTFOLIO........................WRITTEN COMMUNICATION EQUIPMENT
PORTICO..........................BUILDING FRAGMENT
PORTIERE.........................WINDOW OR DOOR COVERING
Portmanteau......................PERSONAL GEAR
     use  SUITCASE
POST, FENCE......................SITE FEATURE
POST, HITCHING...................SITE FEATURE
POSTCARD.........................DOCUMENTARY ARTIFACT
POSTER...........................ADVERTISING MEDIUM
     rt  HANDBILL
Posting machine..................DATA PROCESSING T&E
     use  BOOKKEEPING MACHINE
```

```
POST OFFICE...................BUILDING
POSTUROMETER..................BIOLOGICAL T&E
Pot...........................FOOD PROCESSING T&E
     use  SAUCEPAN
POT...........................GLASS & PLASTICS T&E
POT, CHAMBER..................HOUSEHOLD ACCESSORY
POT, CHOCOLATE................FOOD SERVICE T&E
Pot, Coffee...................FOOD SERVICE T&E
     use  COFFEEPOT
POT, CRAB.....................FISHING & TRAPPING T&E
Pot, Eel......................FISHING & TRAPPING T&E
     use  EELPOT
POT, FISH.....................FISHING & TRAPPING T&E
     rt   TRAP, FISH
POT, GLUE.....................PRINTING T&E
POT, HOT-WATER................FOOD SERVICE T&E
POT, LOBSTER..................FISHING & TRAPPING T&E
POT, MUSTARD..................FOOD SERVICE T&E
Pot, Pepper...................FOOD SERVICE T&E
     use  PEPPERBOX
POT, POSSET...................FOOD SERVICE T&E
POT, SMUDGE...................AGRICULTURAL T&E
POT, SMUDGE...................VISUAL COMMUNICATION EQUIPMENT
Pot, Tea......................FOOD SERVICE T&E
     use  TEAPOT
POT, TRY......................FISHING & TRAPPING T&E
POTENTIOMETER.................ELECTRICAL & MAGNETIC T&E
POTHOLDER.....................FOOD PROCESSING T&E
POTOMETER.....................BIOLOGICAL T&E
POT-SETTING CARRIAGE..........GLASS & PLASTICS T&E
POT-SETTING TOOL..............GLASS & PLASTICS T&E
POUCH, CAP....................ARMAMENT ACCESSORY
POUCH, GUNNER'S...............ARMAMENT ACCESSORY
POUCH, PRIMER.................ARMAMENT ACCESSORY
POUCH, SHOT...................ARMAMENT ACCESSORY
POUCH, TOBACCO................PERSONAL GEAR
Poulaine......................CLOTHING, FOOTWEAR
     use  CRAKOW
Poultry killer................FOOD PROCESSING T&E
     use  KNIFE, POULTRY-KILLING
POWER-PLANT, NUCLEAR..........POWER PRODUCTION T&E
PRAIRIE SCHOONER..............LTE, ANIMAL-POWERED
     rt   WAGON, CONESTOGA
PRAM..........................WATER TRANSPORTATION EQUIPMENT
PRAM, SAILING.................WATER TRANSPORTATION EQUIPMENT
PRAXINOSCOPE..................TOY
PRAYER RUG....................CEREMONIAL ARTIFACT
PRAYER STICK..................CEREMONIAL ARTIFACT
PRAYER WHEEL..................CEREMONIAL ARTIFACT
PREFORM, PROJECTILE-POINT.....ARMAMENT T&E, EDGED
PREFORM MACHINE...............GLASS & PLASTICS T&E
```

PREMIUM.......................ADVERTISING MEDIUM
 note use only for a non-utilitarian object given
 as a premium which cannot be named by a more
 specific object name; may be further
 subdivided to indicate the product package
 in which the premium was originally
 enclosed: e.g., PREMIUM, CIGARETTE
PRESS.........................FOOD PROCESSING T&E
 note may be further subdivided to indicate
 specific type: e.g., PRESS, FRUIT; -,LARD;
 -,BUTTER; -,CHEESE; -,BEESWAX; -,ANIMAL-OIL;
 -,TANKAGE
Press, Arming.................PRINTING T&E
 use PRESS, BLOCKING
PRESS, BLOCKING...............PRINTING T&E
PRESS, BOOK...................PRINTING T&E
PRESS, CARTRIDGE-CASE.........ARMAMENT ACCESSORY
PRESS, CORK...................UNCLASSIFIED T&E, SPECIAL
PRESS, CUTTING................PRINTING T&E
PRESS, CYLINDER...............PRINTING T&E
Press, Drill..................METALWORKING T&E
 use DRILL PRESS
PRESS, DRY-MOUNTING...........PHOTOGRAPHIC T&E
PRESS, EMBOSSING..............PRINTING T&E
PRESS, ETCHING................PRINTING T&E
Press, Fly....................PRINTING T&E
 use PRESS, EMBOSSING
Press, Hand...................PRINTING T&E
 use HANDPRESS
Press, Hay-baling.............AGRICULTURAL T&E
 use BALER, HAY
PRESS, HORNWORKER'S...........UNCLASSIFIED T&E, SPECIAL
PRESS, HOT-HEAD...............TEXTILEWORKING T&E
Press, Job....................PRINTING T&E
 use more specific term: e.g., LETTERPRESS
Press, Knuckle-joint..........FOOD PROCESSING T&E
 use PRESS, ANIMAL-OIL
Press, Letter.................PRINTING T&E
 use LETTERPRESS
Press, Linen..................FURNITURE
 use CUPBOARD, PRESS
PRESS, LINEN..................HOUSEKEEPING T&E
PRESS, LYING..................PRINTING T&E
PRESS, MOLD...................GLASS & PLASTICS T&E
PRESS, NEWSPAPER..............PRINTING T&E
PRESS, NIPPING................PRINTING T&E
PRESS, OFFSET.................PRINTING T&E
PRESS, PLATEN.................PRINTING T&E
PRESS, PRIMING................ARMAMENT ACCESSORY
PRESS, PUNCH..................METALWORKING T&E
PRESS, SMOOTHING..............PAPERMAKING T&E
PRESS, STAMPING...............METALWORKING T&E

```
PRESS, STANDING................PRINTING T&E
PRESS, VACUUM..................GLASS & PLASTICS T&E
PRESS, VENEER..................WOODWORKING T&E
PRESSING MACHINE...............MINING T&E
PRESSING MACHINE, BULLET.......METALWORKING T&E
PRICKER........................ARMAMENT ACCESSORY
PRICKER........................MINING T&E
PRIE-DIEU......................FURNITURE
PRIMER.........................ARMAMENT T&E, AMMUNITION
PRIMER, NIPPLE.................ARMAMENT ACCESSORY
PRIMING WIRE...................ARMAMENT ACCESSORY
PRINT..........................COMMERCIAL DECORATIVE ART
PRINT..........................ORIGINAL ART
PRINT, PHOTOGRAPHIC............DOCUMENTARY ARTIFACT
PRINT, PHOTOGRAPHIC............ORIGINAL ART
     note other photographic objects included within
          the DOCUMENTARY ARTIFACT classification
          (Category 5) may also be used as acceptable
          ORIGINAL ART object names when appropriate
PRINTER........................DATA PROCESSING T&E
     note may be further subdivided to indicate
          specific type: e.g., PRINTER, MATRIX;
          -,LINE; -,ON-THE-FLY; -,SERIAL
Printer, Butter................FOOD PROCESSING T&E
     use PRESS, BUTTER
PRINTER, CONTACT...............PHOTOGRAPHIC T&E
Printer, Electrostatic.........PRINTING T&E
     use PHOTOCOPIER
PRINTER, KEYBOARD..............DATA PROCESSING T&E
Printer, Xerographic...........PRINTING T&E
     use PHOTOCOPIER
PRINTING BLOCK.................LEATHERWORKING T&E
Printing equipment.............TEXTILEWORKING T&E
     use  more specific term from PRINTING T&E
PRISM, OBJECTIVE...............ASTRONOMICAL T&E
PRITCHEL.......................METALWORKING T&E
PRIVATEER......................WATER TRANSPORTATION EQUIPMENT
     note use for any privately-armed vessel
Privy..........................BUILDING
     use  OUTHOUSE
PRIZE RING.....................SPORTS EQUIPMENT
PROBE..........................MEDICAL & PSYCHOLOGICAL T&E
PROBLEMATICAL..................FUNCTION UNKNOWN
PROCESSING MACHINE, OFFSET-PLATE
     ..........................PRINTING T&E
Processor, Central.............DATA PROCESSING T&E
     use  CENTRAL PROCESSOR
PROD, STOCK....................ANIMAL HUSBANDRY T&E
PRODUCT MODEL..................ADVERTISING MEDIUM
PROFILING MACHINE..............WOODWORKING T&E
PROGRAM........................DOCUMENTARY ARTIFACT
```

note may be further subdivided to indicate
 specific type: e.g., PROGRAM, THEATER;
 -,DANCE
PROJECTILE, LYLE GUN...........WATER TRANSPORTATION ACCESSORY
PROJECTILE POINT...............ARMAMENT T&E, EDGED
 rt ARROWHEAD
PROJECTOR, FILM STRIP..........VISUAL COMMUNICATION EQUIPMENT
PROJECTOR, LANTERN-SLIDE.......VISUAL COMMUNICATION EQUIPMENT
Projector, Lantern-slide.......TOY
 use MAGIC LANTERN
PROJECTOR, MOTION-PICTURE......VISUAL COMMUNICATION EQUIPMENT
PROJECTOR, OPAQUE..............VISUAL COMMUNICATION EQUIPMENT
PROJECTOR, SLIDE...............VISUAL COMMUNICATION EQUIPMENT
Projector, Sound...............SOUND COMMUNICATION EQUIPMENT
 use BULLHORN or AMPLIFIER, AUDIO
PROP, SAWYER'S.................WOODWORKING T&E
 rt SAWBUCK; SAWHORSE; SAWING TACKLE
PROPELLER......................AEROSPACE TRANSPORTATION ACCESSORY
note may be subdivided to indicate specific type:
 e.g., PROPELLER, ADJUSTABLE-PITCH;
 -,FIXED-PITCH
PROPELLER......................WATER TRANSPORTATION ACCESSORY
PROPERTIES.....................PUBLIC ENTERTAINMENT DEVICE
note use for any decorative, floor or hand object
 that provides a realistic effect in a public
 production
PROPERTIES, ANIMAL.............PUBLIC ENTERTAINMENT DEVICE
note use for the general object category or if
 specific type is unknown: e.g., ANIMAL STAND
PROPERTIES, MAGICIAN'S.........PUBLIC ENTERTAINMENT DEVICE
PROPHYLAXIS UNIT, DENTAL.......MEDICAL & PSYCHOLOGICAL T&E
Props..........................PUBLIC ENTERTAINMENT DEVICE
 use PROPERTIES
PROSTHESIS.....................PERSONAL GEAR
PROTONSYNCHROTRON..............NUCLEAR PHYSICS T&E
PROTRACTOR.....................DRAFTING T&E
PROTRACTOR, HOOF...............ANIMAL HUSBANDRY T&E
PRUNER, TREE...................AGRICULTURAL T&E
PSCHENT........................PERSONAL SYMBOL
PSEUDOPHONE....................ACOUSTICAL T&E
PSEUDOSCOPE....................OPTICAL T&E
PSEUDOSCOPE, LENTICULAR........MEDICAL & PSYCHOLOGICAL T&E
 rt STEREOSCOPE
Psychrometer...................MECHANICAL T&E
 use HYDROMETER
PUCELLAS.......................GLASS & PLASTICS T&E
PUEBLO.........................BUILDING
 rt APARTMENT
PUFF, POWDER...................TOILET ARTICLE
Pull-a-way.....................RECREATIONAL DEVICE
 use WHIRL
PULLER, BULLET.................ARMAMENT ACCESSORY

428

```
PULLER, CALF....................ANIMAL HUSBANDRY T&E
PULLER, NAIL....................WOODWORKING T&E
PULLER, STUMP...................AGRICULTURAL T&E
Pullers, Shoe...................ANIMAL HUSBANDRY T&E
     use  PINCERS, FARRIER'S
PULLEY..........................MECHANICAL T&E
PULLING MACHINE.................LEATHERWORKING T&E
Pullman car.....................RAIL TRANSPORTATION EQUIPMENT
     use  SLEEPING CAR
PULL TOY........................TOY
PULPER..........................PAPERMAKING T&E
PULPIT..........................BUILDING FRAGMENT
Pulverizer, Surface.............AGRICULTURAL T&E
     use  ROLLER, LAND
PUMP............................CLOTHING, FOOTWEAR
PUMP............................MINING T&E
     note may be further subdivided to indicate
          specific type: e.g., PUMP, CENTRIFUGAL;
          -,DOUBLE-ACTION; -,SUBMERSIBLE
PUMP............................LAND TRANSPORTATION ACCESSORY
     note may be further subdivided to indicate
          specific type: e.g., PUMP, BICYCLE;
          -,AUTOMOBILE
PUMP, BILGE.....................WATER TRANSPORTATION ACCESSORY
PUMP, BREAST....................MEDICAL & PSYCHOLOGICAL T&E
PUMP, FUEL......................LAND TRANSPORTATION ACCESSORY
PUMP, MILK......................FOOD PROCESSING T&E
PUMP, SUMP......................PLUMBING FIXTURE
PUMP, WATER.....................PLUMBING FIXTURE
PUMPER, HAND....................LTE, ANIMAL-POWERED
PUMPER, HAND....................LTE, HUMAN-POWERED
PUMPER, STEAM...................LTE, ANIMAL-POWERED
PUMPER, STEAM...................LTE, HUMAN-POWERED
PUMPHOUSE.......................BUILDING
PUMPING MACHINE.................GLASS & PLASTICS T&E
PUNCH, ARCH.....................LEATHERWORKING T&E
PUNCH, BACKING-OUT..............METALWORKING T&E
Punch, Belt.....................LEATHERWORKING T&E
     use  PUNCH, REVOLVING
Punch, Bob......................METALWORKING T&E
     use  COUNTERSINK
Punch, Card.....................DATA PROCESSING T&E
     use  PUNCH, KEYBOARD
PUNCH, CARVER'S.................WOODWORKING T&E
PUNCH, CENTER...................METALWORKING T&E
PUNCH, COOPER'S.................WOODWORKING T&E
PUNCH, DRIFT....................METALWORKING T&E
PUNCH, DRIVE CALK...............METALWORKING T&E
Punch, Ear......................ANIMAL HUSBANDRY T&E
     use  NOTCHER, EAR
PUNCH, FORE.....................METALWORKING T&E
PUNCH, GANG.....................DATA PROCESSING T&E
```

```
PUNCH, GROMMET...................TEXTILEWORKING T&E
PUNCH, HANDRAIL..................WOODWORKING T&E
PUNCH, HOLLOW....................METALWORKING T&E
PUNCH, KEYBOARD..................DATA PROCESSING T&E
PUNCH, MARKING...................WOODWORKING T&E
PUNCH, NAIL......................WOODWORKING T&E
PUNCH, OBLONG....................LEATHERWORKING T&E
PUNCH, OVAL DRIVE................LEATHERWORKING T&E
PUNCH, PAPER.....................WRITTEN COMMUNICATION EQUIPMENT
Punch, Pin.......................METALWORKING T&E
     use  PUNCH, BACKING-OUT
PUNCH, PRICK.....................METALWORKING T&E
PUNCH, REVOLVING.................LEATHERWORKING T&E
Punch, Rivet.....................WOODWORKING T&E
     use  PUNCH, STARTING
PUNCH, ROUND DRIVE...............LEATHERWORKING T&E
PUNCH, ROUND-HOLE................LEATHERWORKING T&E
PUNCH, SHINGLE...................WOODWORKING T&E
PUNCH, SPOT......................DATA PROCESSING T&E
PUNCH, STARTING..................WOODWORKING T&E
PUNCH, STRAP-END.................LEATHERWORKING T&E
PUNCH, STRAP-END V...............LEATHERWORKING T&E
PUNCH, SUMMARY...................DATA PROCESSING T&E
PUNCH, VENEER....................WOODWORKING T&E
PUNCH, VENT......................ARMAMENT ACCESSORY
PUNCH, WOOD......................WOODWORKING T&E
PUNCHBOARD.......................DATA PROCESSING T&E
PUNCHING BAG.....................SPORTS EQUIPMENT
Pung.............................LTE, ANIMAL-POWERED
     use  SLEIGH
PUNKA............................TEMPERATURE CONTROL DEVICE
PUNT.............................WATER TRANSPORTATION EQUIPMENT
Punty............................GLASS & PLASTICS T&E
     use  PONTIL
PUPILOMETER......................MEDICAL & PSYCHOLOGICAL T&E
PUPPET, HAND.....................PUBLIC ENTERTAINMENT DEVICE
     rt   DOLL; MARIONETTE
PUPPET, HAND.....................TOY
     rt   DOLL; MARIONETTE
PURIFIER, MIDDLINGS..............FOOD PROCESSING T&E
PURSE............................PERSONAL GEAR
Pushcart.........................LTE, HUMAN-POWERED
     use  BARROW
Push toy.........................TOY
     use  TRUNDLE TOY
Puttee...........................CLOTHING, OUTERWEAR
     use  LEGGING
PUZZLE...........................TOY
PYCNOMETER.......................MECHANICAL T&E
PYRAMID, DESSERT.................FOOD SERVICE T&E
PYRHELIOMETER....................ASTRONOMICAL T&E
PYROMETER........................THERMAL T&E
     rt   THERMOMETER
```

```
PYX.............................CEREMONIAL ARTIFACT
QUADRANT........................SURVEYING & NAVIGATIONAL T&E
     rt   CIRCUMFERENTOR; GRAPHOMETER
QUADRANT, ASTRONOMICAL..........ASTRONOMICAL T&E
QUADRICYCLE.....................LTE, HUMAN-POWERED
Quadruple.......................LTE, MOTORIZED
     use  more specific term: e.g., TRUCK,
          PUMPER/LADDER
QUANT...........................WATER TRANSPORTATION ACCESSORY
QUARNET, HORNWORKER'S...........UNCLASSIFIED T&E, SPECIAL
QUARRY..........................UNCLASSIFIED STRUCTURE
QUARRYING MACHINE...............MINING T&E
     note use only if specific type is unknown: e.g.,
          DRILL, GANG; CUTTER, CHANNEL BAR; CUTTER,
          JET-PIERCING
Quern...........................FOOD PROCESSING T&E
     use  METATE or PESTLE
QUID............................ARTIFACT REMNANT
QUILLER.........................TEXTILEWORKING T&E
QUILT...........................BEDDING
QUILTING FRAME..................TEXTILEWORKING T&E
QUILTING MACHINE................TEXTILEWORKING T&E
QUILT PIECE.....................TEXTILEWORKING T&E
     rt   TEXTILE FRAGMENT; SALES SAMPLE, CLOTH
QUIRT...........................LAND TRANSPORTATION ACCESSORY
QUIVER..........................ARMAMENT ACCESSORY
QUIZZING GLASS..................PERSONAL GEAR
     rt   MONOCLE
QUOIN...........................ARMAMENT ACCESSORY
QUOIN...........................PRINTING T&E
QUOITS..........................GAME
Rabbet..........................WOODWORKING T&E
     use  PLANE, RABBET
Rabbit..........................WOODWORKING T&E
     use  PLANE, RABBET
RABBLE..........................METALWORKING T&E
Race............................UNCLASSIFIED STRUCTURE
     use  FLUME
RACING CAR......................LTE, MOTORIZED
RACK, ARMS......................ARMAMENT ACCESSORY
RACK, BOMB......................ARMAMENT ACCESSORY
RACK, DISPLAY...................MERCHANDISING T&E
RACK, DRYING....................HOUSEKEEPING T&E
RACK, GUN.......................FURNITURE
RACK, HAT.......................FURNITURE
     rt   COATRACK
RACK, HORSE-SHOEING.............ANIMAL HUSBANDRY T&E
RACK, LETTER....................WRITTEN COMMUNICATION EQUIPMENT
RACK, LUGGAGE...................FURNITURE
RACK, MAGAZINE..................FURNITURE
     rt   CANTERBURY
RACK, PIPE......................HOUSEHOLD ACCESSORY
```

```
RACK, PLATE...................HOUSEHOLD ACCESSORY
RACK, RECORD..................HOUSEHOLD ACCESSORY
RACK, SPICE...................FOOD PROCESSING T&E
RACK, SPOON...................HOUSEHOLD ACCESSORY
RACK, TOAST...................FOOD SERVICE T&E
RACK, TOWEL...................FURNITURE
RACK, WINE....................FOOD PROCESSING T&E
RACKET........................MUSICAL T&E, WOODWIND
Radar unit....................SURVEYING & NAVIGATIONAL T&E
     use  RECEIVER/DISPLAY, RADAR or RECEIVER/DISPLAY,
           LORAN
RADIATOR......................TEMPERATURE CONTROL DEVICE
RADIATOR CASE.................BUILDING FRAGMENT
RADIO.........................TELECOMMUNICATION EQUIPMENT
     note use for any instrument used for the
          reception of audio messages only
Radio, Cb.....................TELECOMMUNICATION EQUIPMENT
     use  TRANSCEIVER
RADIOMETER....................ELECTRICAL & MAGNETIC T&E
RADIOPHONE....................ACOUSTICAL T&E
RADIOSONDE....................METEOROLOGICAL T&E
RAFT..........................WATER TRANSPORTATION EQUIPMENT
RAIL, FIFE....................WATER TRANSPORTATION ACCESSORY
RAIL BENDER...................MINING T&E
RAINCOAT......................CLOTHING, OUTERWEAR
     rt   SLICKER; OILSKINS
RAKE..........................AGRICULTURAL T&E
     note use only if specific type is unknown
RAKE..........................GLASS & PLASTICS T&E
RAKE, BLACKSMITH'S............METALWORKING T&E
Rake, Buck....................AGRICULTURAL T&E
     use  RAKE, HAY-BUNCHING
Rake, Bull....................AGRICULTURAL T&E
     use  RAKE, HAND HAY
RAKE, CLOVER..................AGRICULTURAL T&E
RAKE, COMMON HAY..............AGRICULTURAL T&E
RAKE, CRANBERRY...............AGRICULTURAL T&E
RAKE, CURD....................FOOD PROCESSING T&E
RAKE, DUMP HAY................AGRICULTURAL T&E
RAKE, FINGER-WHEEL HAY........AGRICULTURAL T&E
Rake, Flip-flop...............AGRICULTURAL T&E
     use  RAKE, REVOLVING HAY
Rake, Floral..................AGRICULTURAL T&E
     use  RAKE, GARDEN
RAKE, GARDEN..................AGRICULTURAL T&E
RAKE, GRADING.................CONSTRUCTION T&E
Rake, Grain...................AGRICULTURAL T&E
     use  RAKE, HAND HAY
RAKE, GRAIN-BINDER'S..........AGRICULTURAL T&E
RAKE, HAND HAY................AGRICULTURAL T&E
RAKE, HAY-BUNCHING............AGRICULTURAL T&E
RAKE, HERRING.................FISHING & TRAPPING T&E
```

```
RAKE, HOT-SHOT...................ARMAMENT ACCESSORY
RAKE, LAWN.......................AGRICULTURAL T&E
Rake, Man........................AGRICULTURAL T&E
     use  RAKE, HAND HAY
RAKE, ONION......................AGRICULTURAL T&E
RAKE, POMACE.....................FOOD PROCESSING T&E
RAKE, REAPER-PLATFORM............AGRICULTURAL T&E
Rake, Reel-type hay..............AGRICULTURAL T&E
     use  RAKE, SIDE-DELIVERY HAY
RAKE, REVOLVING HAY..............AGRICULTURAL T&E
RAKE, SHELLFISH..................FISHING & TRAPPING T&E
RAKE, SIDE-DELIVERY HAY..........AGRICULTURAL T&E
Rake, Spring-tooth hay...........AGRICULTURAL T&E
     use  RAKE, DUMP HAY
Rake, Sweep......................AGRICULTURAL T&E
     use  RAKE, HAY-BUNCHING
RAKER............................MASONRY T&E
RAM, BATTERING...................ARMAMENT T&E, ARTILLERY
RAMEKIN..........................FOOD PROCESSING T&E
RAMPART SECTION..................BUILDING FRAGMENT
RANGE FINDER.....................SURVEYING & NAVIGATIONAL T&E
RANGE FINDER, RADIO..............SURVEYING & NAVIGATIONAL T&E
RANGELEY BOAT....................WATER TRANSPORTATION EQUIPMENT
RAPIER...........................ARMAMENT T&E, EDGED
RASP.............................WOODWORKING T&E
     rt   FILE; FLOAT
RASP, HOOF.......................ANIMAL HUSBANDRY T&E
Rasp, Tooth......................ANIMAL HUSBANDRY T&E
     use  FLOAT, DENTAL
RATCHET..........................MUSICAL T&E, PERCUSSION
RATTLE...........................MUSICAL T&E, PERCUSSION
RATTLE...........................TOY
RATTLE...........................CEREMONIAL ARTIFACT
RATTLE, GAS......................SOUND COMMUNICATION EQUIPMENT
RAWIN SET........................METEOROLOGICAL T&E
RAZOR............................TOILET ARTICLE
RAZOR BOX........................TOILET ARTICLE
READER, CARD.....................DATA PROCESSING T&E
READER, CHARACTER................DATA PROCESSING T&E
     rt   ORTHOSCANNER
READER, MICROFICHE...............VISUAL COMMUNICATION EQUIPMENT
READER, MICROFILM................VISUAL COMMUNICATION EQUIPMENT
READER, TAPE.....................DATA PROCESSING T&E
REAMER...........................GLASS & PLASTICS T&E
REAMER...........................METALWORKING T&E
     note may be further subdivided to indicate
          specific type: e.g., REAMER, PIPE-BURRING
REAMER...........................WOODWORKING T&E
     rt   AUGER; BIT; BROACH
REAMER, CHAMBER..................ARMAMENT ACCESSORY
REAMER, FUZE-PLUG................ARMAMENT ACCESSORY
REAMER, JUICE....................FOOD PROCESSING T&E
```

433

REAPER.......................AGRICULTURAL T&E
Reaper, Hand-rake.............AGRICULTURAL T&E
 use REAPER
Reaper, Self-rake.............AGRICULTURAL T&E
 use REAPER
Reaper/mower..................AGRICULTURAL T&E
 use REAPER
REBEC........................MUSICAL T&E, STRINGED
 rt VIOLIN
Recamier.....................FURNITURE
 use LOUNGE
RECEIVER.....................CHEMICAL T&E
 rt DISTILLING APPARATUS
RECEIVER.........................SURVEYING & NAVIGATIONAL T&E
 note may be further subdivided to indicate
 specific type: e.g., RECEIVER, LONG-WAVE
 BEACON; -,OMNI
RECEIVER, SOUND................ACOUSTICAL T&E
RECEIVER/DISPLAY, LORAN........SURVEYING & NAVIGATIONAL T&E
RECEIVER/DISPLAY, RADAR........SURVEYING & NAVIGATIONAL T&E
RECOIL BUFFER..................ARMAMENT ACCESSORY
RECORD, PHONOGRAPH.............SOUND COMMUNICATION EQUIPMENT
RECORDER......................MUSICAL T&E, WOODWIND
RECORDER, FILM................DATA PROCESSING T&E
RECORDER, FIRE-ALARM..........TELECOMMUNICATION EQUIPMENT
RECORDER, FLIGHT..............AEROSPACE TRANSPORTATION ACCESSORY
RECORDER, SCEPTRE.............SURVEYING & NAVIGATIONAL T&E
RECORDER, SOUND...............ACOUSTICAL T&E
RECORDER, SUNSHINE............METEOROLOGICAL T&E
RECORDER, TAPE................SOUND COMMUNICATION EQUIPMENT
Record player.................SOUND COMMUNICATION EQUIPMENT
 use PHONOGRAPH
REDUCING GLASS................OPTICAL T&E
REED.........................TEXTILEWORKING T&E
REEL.........................TEXTILEWORKING T&E
REEL, CANDLE-DIPPING..........GLASS & PLASTICS T&E
REEL, CENTRIFUGAL.............FOOD PROCESSING T&E
REEL, CHALK..................WOODWORKING T&E
REEL, CLOCK..................TEXTILEWORKING T&E
 rt SWIFT
REEL, FISHING................FISHING & TRAPPING T&E
REEL, HEXAGONAL..............FOOD PROCESSING T&E
REEL, HOSE...................LTE, ANIMAL-POWERED
 rt WAGON, HOSE
REEL, ROUND..................FOOD PROCESSING T&E
REFLECTING CIRCLE.............SURVEYING & NAVIGATIONAL T&E
REFLECTOR, SOLAR..............POWER PRODUCTION T&E
REFRACTOMETER.................OPTICAL T&E
REFRIGERATOR..................FOOD PROCESSING T&E
Refrigerator, Dairy...........FOOD PROCESSING T&E
 use COOLER, DAIRY
REFRIGERATOR CAR..............RAIL TRANSPORTATION EQUIPMENT

REFRIGERATOR VESSEL................WATER TRANSPORTATION EQUIPMENT
REGULATOR, SCUBA.................SPORTS EQUIPMENT
REGULATOR, VOLTAGE.............ELECTRICAL & MAGNETIC T&E
REINS.............................LAND TRANSPORTATION ACCESSORY
 note may be further subdivided to indicate
 specific type: e.g., REINS, CHECK
REJON...........................SPORTS EQUIPMENT
RELAY...........................ELECTRICAL & MAGNETIC T&E
RELIC, RELIGIOUS...............CEREMONIAL ARTIFACT
RELIQUARY......................CEREMONIAL ARTIFACT
 rt SHRINE
REMOVER, CASE.................ARMAMENT ACCESSORY
REMOVER, DENT.................ARMAMENT ACCESSORY
REPEATING CIRCLE..............SURVEYING & NAVIGATIONAL T&E
Replica
 note refer to text for discussion of the way this
 concept should be handled
REPRODUCER, CARD..............DATA PROCESSING T&E
REPRODUCER, SOUND.............ACOUSTICAL T&E
REPRODUCER, TAPE..............DATA PROCESSING T&E
Reproduction
 note refer to text for discussion of the way this
 concept should be handled
RESEARCH VESSEL...............WATER TRANSPORTATION EQUIPMENT
 rt SUBMARINE, RESEARCH
RESERVOIR.....................UNCLASSIFIED STRUCTURE
RESISTOR......................ELECTRICAL & MAGNETIC T&E
RESONATOR.....................ACOUSTICAL T&E
 rt AMPLIFIER, AUDIO
RESPIRATOR....................UNCLASSIFIED T&E, GENERAL
RESPIROMETER..................BIOLOGICAL T&E
RESTAURANT....................BUILDING
RESUSCITATOR..................MEDICAL & PSYCHOLOGICAL T&E
Reticule......................PERSONAL GEAR
 use PURSE
RETINOSCOPE...................MEDICAL & PSYCHOLOGICAL T&E
RETORT........................CHEMICAL T&E
 rt DISTILLING APPARATUS
RETORT, AMALGAM...............METALWORKING T&E
RETORT, CANNING...............FOOD PROCESSING T&E
RETRACTORS....................MEDICAL & PSYCHOLOGICAL T&E
REVOLVER......................ARMAMENT T&E, FIREARM
 rt PISTOL
REWINDER......................PAPERMAKING T&E
RHEOMETER.....................ELECTRICAL & MAGNETIC T&E
RHEOSCOPE.....................ELECTRICAL & MAGNETIC T&E
RHEOSTAT......................ELECTRICAL & MAGNETIC T&E
RHEOTOME......................ELECTRICAL & MAGNETIC T&E
RHINOSCOPE....................MEDICAL & PSYCHOLOGICAL T&E
RHUMBOSCOPE...................DRAFTING T&E
RHYTHMOMETER..................MUSICAL T&E, UNCLASSIFIED
Rhyton........................FOOD SERVICE T&E
 use HORN, DRINKING

```
RIBBON, CAMPAIGN................PERSONAL SYMBOL
RIBBON, COMMEMORATIVE..........DOCUMENTARY ARTIFACT
RIBBON, PRIZE...................PERSONAL SYMBOL
Ribbon leader...................TEXTILEWORKING T&E
      use  BODKIN
RIB TOOL........................GLASS & PLASTICS T&E
RICER...........................FOOD PROCESSING T&E
RICKSHAW........................LTE, HUMAN-POWERED
RIDDLE, GRAIN...................AGRICULTURAL T&E
Riddle, winnowing...............AGRICULTURAL T&E
      use  RIDDLE, GRAIN
Riffler.........................WOODWORKING T&E
      use  FILE or RASP
RIFFLES.........................MINING T&E
RIFLE...........................ARMAMENT T&E, FIREARM
RIFLE, FIELD....................ARMAMENT T&E, ARTILLERY
Rifle, Kentucky.................ARMAMENT T&E, FIREARM
      use  RIFLE, LONG
RIFLE, LONG.....................ARMAMENT T&E, FIREARM
RIFLE, MILITARY.................ARMAMENT T&E, FIREARM
Rifle, Pennsylvania.............ARMAMENT T&E, FIREARM
      use  RIFLE, LONG
RIFLE, PLAINS...................ARMAMENT T&E, FIREARM
RIFLE, SEA-COAST................ARMAMENT T&E, ARTILLERY
RIFLE, TARGET...................ARMAMENT T&E, FIREARM
RIFLE/AX........................ARMAMENT T&E, FIREARM
RIFLE/MUSKET....................ARMAMENT T&E, FIREARM
RIFLE/SHOTGUN...................ARMAMENT T&E, FIREARM
RIFLING MACHINE.................METALWORKING T&E
RING............................ADORNMENT
RING............................PERSONAL SYMBOL
      note may be further subdivided to indicate
            specific type: e.g., RING, FRATERNAL;
            -,SIGNET
RING, ANIMAL-NOSE...............ANIMAL HUSBANDRY T&E
RING, KEY.......................PERSONAL GEAR
RING, LIFE......................WATER TRANSPORTATION ACCESSORY
RING, NAPKIN....................FOOD SERVICE T&E
RING, NOSE......................ADORNMENT
RING, RECTAL....................ANIMAL HUSBANDRY T&E
RING, SNUB......................FORESTRY T&E
RING, TEETHING..................PERSONAL GEAR
RING, TONG......................METALWORKING T&E
RINGER, ANIMAL-NOSE.............ANIMAL HUSBANDRY T&E
RING FRAME......................TEXTILEWORKING T&E
      note may be further subdivided to indicate
            specific type: e.g., RING FRAME, DRAWING;
            -,SLUBBING; -,ROVING
RIPSAW..........................WOODWORKING T&E
RIVET...........................LEATHERWORKING T&E
RIVET...........................METALWORKING T&E
RIVETING MACHINE................LEATHERWORKING T&E
```

```
RIVET-MAKING MACHINE............METALWORKING T&E
ROASTER.........................METALWORKING T&E
Robe............................CLOTHING, OUTERWEAR
     use  BATHROBE or GOWN, DRESSSING
ROBINET.........................ARMAMENT T&E, ARTILLERY
ROCHET..........................PERSONAL SYMBOL
ROCKAWAY........................LTE, ANIMAL-POWERED
Rocker..........................MINING T&E
     use  SEPARATOR
ROCKER..........................PRINTING T&E
Rocket..........................ARMAMENT T&E, AMMUNITION
     use  MISSILE
ROCKET, SIGNAL..................VISUAL COMMUNICATION EQUIPMENT
ROCKET-DRIVING MACHINE..........ARMAMENT ACCESSORY
ROCKING HORSE...................TOY
Rod
     use  only as a secondary word in a multi-word
          object name
Rod.............................SURVEYING & NAVIGATIONAL T&E
     use  STADIA ROD
Roemer..........................FOOD SERVICE T&E
     use  GOBLET
ROLL, LARD......................FOOD PROCESSING T&E
ROLLER..........................CONSTRUCTION T&E
ROLLER..........................METALWORKING T&E
ROLLER..........................PAINTING T&E
Roller, Corrugated..............AGRICULTURAL T&E
     use  ROLLER, LAND
ROLLER, GARDEN..................AGRICULTURAL T&E
ROLLER, IMPREGNATING............GLASS & PLASTICS T&E
ROLLER, JOINT...................PAINTING T&E
ROLLER, LAND....................AGRICULTURAL T&E
Roller, Lawn....................AGRICULTURAL T&E
     use  ROLLER, GARDEN
ROLLER, SNOW....................LTE, ANIMAL-POWERED
ROLLER COASTER..................RECREATIONAL DEVICE
ROLLING MACHINE.................PRINTING T&E
ROLLING MACHINE, FLAT GLASS.....MINING T&E
ROLLING PIN.....................FOOD PROCESSING T&E
ROLLY-DOLL......................TOY
ROMPER..........................CLOTHING, OUTERWEAR
ROOF SECTION....................BUILDING FRAGMENT
ROOM, MINIATURE.................DOCUMENTARY ARTIFACT
     rt  DIORAMA
ROPE............................WATER TRANSPORTATION ACCESSORY
     note use only if specific type is unknown: e.g.,
          JIB SHEET; ANCHOR RODE
ROPE-MAKING MACHINE.............TEXTILEWORKING T&E
ROTAMETER.......................DRAFTING T&E
ROTISSERIE......................FOOD PROCESSING T&E
ROULETTE........................PAINTING T&E
ROULETTE........................PRINTING T&E
```

```
ROULETTE WHEEL...................GAME
ROUND-BACKING MACHINE...........PRINTING T&E
ROUND-CORNERING MACHINE.........PRINTING T&E
ROUNDER.........................WOODWORKING T&E
ROUNDHOUSE......................BUILDING
Rounding cradle.................WOODWORKING T&E
     use  BEVEL BLOCK
Round shave.....................WOODWORKING T&E
     use  SCORPER, CLOSED or SCORPER, OPEN
ROUTER..........................WOODWORKING T&E
     rt   PLANE, ROUTER
ROVING FRAME....................TEXTILEWORKING T&E
     note use only if specific type in unknown: e.g.,
          RING FRAME, ROVING
ROWBOAT.........................WATER TRANSPORTATION EQUIPMENT
     note use only if specific type is unknown: e.g.,
          DORY, SKIFF, DINGHY
ROWING MACHINE..................SPORTS EQUIPMENT
Rowlock.........................WATER TRANSPORTATION ACCESSORY
     use  OARLOCK
RUBBER..........................CLOTHING, FOOTWEAR
RUCHE...........................CLOTHING ACCESSORY
     rt   COLLAR
RUFF............................CLOTHING ACCESSORY
     rt   COLLAR
RUG.............................FLOOR COVERING
RUG, LINOLEUM...................FLOOR COVERING
Rug, Prayer.....................CEREMONIAL ARTIFACT
     use  PRAYER RUG
Rug, Scatter....................FLOOR COVERING
     use  RUG, THROW
RUG, THROW......................FLOOR COVERING
RULE, CALIPER...................WOODWORKING T&E
RULE, FOLDING...................WEIGHTS & MEASURES T&E
RULE, JOINTING..................MASONRY T&E
RULE, LOG.......................FORESTRY T&E
RULE, PARALLEL..................DRAFTING T&E
RULE, PATTERNMAKER'S............WOODWORKING T&E
RULE, PROTRACTOR................WOODWORKING T&E
RULE, RETRACTRABLE..............WEIGHTS & MEASURES T&E
     rt   MEASURE, TAPE
RULE, TRUNNION..................ARMAMENT ACCESSORY
RULER...........................WEIGHTS & MEASURES T&E
RULING ENGINE...................DRAFTING T&E
RULING MACHINE..................PRINTING T&E
Rummer..........................FOOD SERVICE T&E
     use  GOBLET
RUNABOUT........................LTE, ANIMAL-POWERED
RUNABOUT........................WATER TRANSPORTATION EQUIPMENT
     rt   HYDROPLANE; LAUNCH, GASOLINE
RUNNER..........................FLOOR COVERING
RUSHLIGHT.......................LIGHTING DEVICE
```

SABER.........................ARMAMENT T&E, EDGED
SABER, FENCING................ARMAMENT T&E, EDGED
 rt FENCING EPEE; FENCING FOIL
SABOT.........................CLOTHING, FOOTWEAR
SABOTON.......................ARMAMENT T&E, BODY ARMOR
SACCHARIMETER.................CHEMICAL T&E
SACHET........................CLOTHING ACCESSORY
Sack..........................PRODUCT PACKAGE
 use BAG
Sackbut.......................MUSICAL T&E, BRASS
 use TROMBONE
SADDLE........................LAND TRANSPORTATION ACCESSORY
 note may be further subdivided to indicate
 specific type: e.g., SADDLE, RIDING;
 -,STOCK; -,PACK
SADDLEBAG.....................LAND TRANSPORTATION ACCESSORY
SADDLE BLANKET................LAND TRANSPORTATION ACCESSORY
Saddle mate...................RECREATIONAL DEVICE
 use COILED-SPRING RIDER
SADDLE PAD....................LAND TRANSPORTATION ACCESSORY
SADDLE TREE...................LAND TRANSPORTATION ACCESSORY
SADIRON.......................HOUSEKEEPING T&E
SAFE..........................FURNITURE
SAFE, CANDLE..................LIGHTING DEVICE
SAFE, MATCH...................PERSONAL GEAR
SAFELIGHT.....................PHOTOGRAPHIC T&E
SAFETY, GRIP..................ARMAMENT ACCESSORY
SAGGER........................GLASS & PLASTICS T&E
SAIL..........................WATER TRANSPORTATION ACCESSORY
 note use only if specific type is unknown: e.g.,
 JIB, SPINNAKER, SPANKER, MAINSAIL
SAILBOAT......................WATER TRANSPORTATION EQUIPMENT
 note use only (1) with subdivision to indicate
 class name (e.g., SAILBOAT, COMET;
 -,PENGUIN) or (2) if specific type is
 unknown (e.g., PRAM; DINGHY, SAILING;
 CATAMARAN)
Sailor's valentine............ORIGINAL ART
 use PICTURE, SHELL
Sailplane.....................AEROSPACE TRANSPORTATION EQUIPMENT
 use GLIDER
SAKER.........................ARMAMENT T&E, ARTILLERY
SALES SAMPLE..................MERCHANDISING T&E
 note normally subdivided to indicate type of
 product: e.g., SALES SAMPLE, CLOTH
SALES-SAMPLE CASE.............MERCHANDISING T&E
 note normally subdivided to indicate type of
 product: e.g., SALES-SAMPLE CASE, BUTTON
SALES-SAMPLE KIT..............MERCHANDISING T&E
 note normally subdivided to indicate type of
 product: e.g., SALES-SAMPLE KIT, COSMETICS
SALIMETER.....................CHEMICAL T&E

```
Salinometer......................CHEMICAL T&E
     use  SALIMETER
SALLET...........................ARMAMENT T&E, BODY ARMOR
SALOON...........................BUILDING
SALTCELLAR.......................FOOD SERVICE T&E
SALT & PEPPER SET................FOOD SERVICE T&E
SALTSHAKER.......................FOOD SERVICE T&E
SALVER...........................FOOD SERVICE T&E
Samovar..........................FOOD SERVICE T&E
     use  URN, COFFEE
SAMPAN...........................WATER TRANSPORTATION EQUIPMENT
SAMPLER..........................ORIGINAL ART
SAMPLER, MILK....................FOOD PROCESSING T&E
SAMPLER, SIDEWALL................MINING T&E
SANDAL...........................CLOTHING, FOOTWEAR
SANDBAGGER, HUDSON RIVER.........WATER TRANSPORTATION EQUIPMENT
Sandbox..........................WRITTEN COMMUNICATION EQUIPMENT
     use  BOX, POUNCE
SANDBOX..........................RECREATIONAL DEVICE
SANDER...........................WOODWORKING T&E
     note may be further subdivided to indicate
          specific type: e.g., SANDER, BELT; -,DISK
SANDPAPER........................WOODWORKING T&E
Sand toy.........................TOY
     use  more specific object name
SANDWICH BOARD...................ADVERTISING MEDIUM
Sarape...........................CLOTHING, OUTERWEAR
     use  PONCHO
SARCOPHAGUS......................CEREMONIAL ARTIFACT
     rt   COFFIN; CASE, MUMMY
SARI.............................CLOTHING, OUTERWEAR
SARONG...........................CLOTHING, OUTERWEAR
SARRUSOPHONE.....................MUSICAL T&E, WOODWIND
SASH.............................CLOTHING ACCESSORY
Sash.............................PERSONAL SYMBOL
     use  BANDOLIER
SATCHEL..........................PERSONAL GEAR
SATELLITE........................AEROSPACE TRANSPORTATION EQUIPMENT
     rt   BIOSATELLITE; OBSERVATORY, ORBITING SOLAR
SATELLITE, COMMUNICATIONS........AEROSPACE TRANSPORTATION EQUIPMENT
SATELLITE, DATASPHERE............AEROSPACE TRANSPORTATION EQUIPMENT
SATELLITE, METEOROLOGICAL........AEROSPACE TRANSPORTATION EQUIPMENT
SAUCEBOAT........................FOOD SERVICE T&E
SAUCEPAN.........................FOOD PROCESSING T&E
SAUCER...........................FOOD SERVICE T&E
SAUCER, NEST.....................PAINTING T&E
Sautoir..........................ADORNMENT
     use  PENDANT
SAVE-ALL.........................PAPERMAKING T&E
SAW..............................WOODWORKING T&E
     note use only if specific type is unknown
SAW, ANGLE.......................WOODWORKING T&E
```

```
SAW, BACK.......................WOODWORKING T&E
     note use only if specific type is unknown: e.g.,
          SAW, BEAD; SAW, DOVETAIL
SAW, BAND.......................METALWORKING T&E
SAW, BAND.......................WOODWORKING T&E
SAW, BEAD.......................WOODWORKING T&E
SAW, BENCH......................WOODWORKING T&E
Saw, Board......................WOODWORKING T&E
     use  SAW, OPEN-PIT or SAW, FRAMED-PIT
SAW, BOW........................WOODWORKING T&E
Saw, Bracket....................WOODWORKING T&E
     use  FRETSAW
SAW, BRICK......................MASONRY T&E
Saw, Buck.......................FORESTRY T&E
     use  BUCKSAW
Saw, Buhl.......................WOODWORKING T&E
     use  FRETSAW
SAW, CARCASS....................WOODWORKING T&E
SAW, CHAIN......................FORESTRY T&E
Saw, Chairmaker's...............WOODWORKING T&E
     use  SAW, FELLOE
SAW, CIRCULAR...................METALWORKING T&E
Saw, Circular...................WOODWORKING T&E
     use  SAW, BENCH or SAW, RADIAL-ARM or SAW,
          ELECTRIC-PORTABLE
SAW, COMPASS....................WOODWORKING T&E
     rt  SAW, KEYHOLE
SAW, CONCRETE...................CONSTRUCTION T&E
SAW, COPING.....................WOODWORKING T&E
     rt  FRETSAW
SAW, CROSSCUT...................WOODWORKING T&E
SAW, CROWN......................WOODWORKING T&E
     rt  BIT, ANNULAR
Saw, Dehorning..................ANIMAL HUSBANDRY T&E
     use  DEHORNER
SAW, DENTAL.....................MEDICAL & PSYCHOLOGICAL T&E
SAW, DOVETAIL...................WOODWORKING T&E
SAW, ELECTRIC-PORTABLE..........WOODWORKING T&E
SAW, FELLOE.....................WOODWORKING T&E
SAW, FRAME......................WOODWORKING T&E
     note use only if specific type is unknown: e.g.,
          SAW, BOW; SAW, COPING
SAW, FRAMED VENEER..............WOODWORKING T&E
     rt  SAW, VENEER
SAW, FRAMED-PIT.................WOODWORKING T&E
     rt  SAW, OPEN-PIT
Saw, Fret.......................WOODWORKING T&E
     use  FRETSAW
SAW, FUZE.......................ARMAMENT ACCESSORY
SAW, GAUGE-LEAF.................UNCLASSIFIED T&E, SPECIAL
Saw, Hack.......................METALWORKING T&E
     use  HACKSAW
```

```
SAW, ICE......................UNCLASSIFIED T&E, SPECIAL
Saw, Jig......................WOODWORKING T&E
    use  JIGSAW
SAW, KEYHOLE..................WOODWORKING T&E
    rt   SAW, COMPASS
Saw, Lock.....................WOODWORKING T&E
    use  SAW, KEYHOLE
Saw, Long.....................WOODWORKING T&E
    use  SAW, CROSSCUT
SAW, MITER-BOX................WOODWORKING T&E
SAW, MUSICAL..................MUSICAL T&E, UNCLASSIFIED
SAW, OPEN-PIT.................WOODWORKING T&E
    rt   SAW, FRAMED-PIT
SAW, PATTERNMAKER'S...........WOODWORKING T&E
Saw, Pit......................WOODWORKING T&E
    use  SAW, OPEN-PIT or SAW, FRAMED-PIT
SAW, PRUNING..................AGRICULTURAL T&E
SAW, RABBET...................WOODWORKING T&E
    rt   PLANE, RABBET
SAW, RADIAL-ARM...............WOODWORKING T&E
Saw, Rip......................WOODWORKING T&E
    use  RIPSAW
SAW, SABRE....................WOODWORKING T&E
SAW, SALLY....................FORESTRY T&E
Saw, Scroll...................WOODWORKING T&E
    use  FRETSAW
Saw, Skill....................WOODWORKING T&E
    use  SAW, ELECTRIC PORTABLE
SAW, STAIRBUILDER'S...........WOODWORKING T&E
SAW, STONE....................MASONRY T&E
SAW, SURGICAL.................MEDICAL & PSYCHOLOGICAL T&E
SAW, TENON....................WOODWORKING T&E
Saw, Thwart...................WOODWORKING T&E
    use  SAW, CROSSCUT
SAW, TWO-HANDED CROSSCUT.......FORESTRY T&E
SAW, VELLUM...................WOODWORKING T&E
SAW, VENEER...................WOODWORKING T&E
    note use for a saw to cut or shape veneers
    rt   SAW, FRAMED VENEER
Saw, Woodcutter's.............FORESTRY T&E
    use  BUCKSAW
SAWBUCK.......................WOODWORKING T&E
    rt   PROP, SAWYER'S; SAWHORSE; SAWING TACKLE
SAWHORSE......................WOODWORKING T&E
    rt   SAWBUCK; PROP, SAWYER'S; SAWING TACKLE
SAWING TACKLE.................WOODWORKING T&E
    rt   PROP, SAWYER'S; SAWBUCK; SAWHORSE
SAWMILL, BAND.................WOODWORKING T&E
SAWMILL, CIRCULAR.............WOODWORKING T&E
SAWMILL, GANG.................WOODWORKING T&E
SAWMILL, GATE-TYPE............WOODWORKING T&E
SAWMILL, MULEY................WOODWORKING T&E
```

```
SAWMILL, UP-AND-DOWN...........WOODWORKING T&E
SAW-SET........................WOODWORKING T&E
     rt   SAW WREST
SAW WREST......................WOODWORKING T&E
     rt   SAW-SET
SAXHORN........................MUSICAL T&E, BRASS
SAXOPHONE......................MUSICAL T&E, WOODWIND
SCABBARD.......................ARMAMENT ACCESSORY
     note may be further subdivided to indicate weapon
          held: e.g., SCABBARD, DAGGER
SCALDER, HOG...................FOOD PROCESSING T&E
SCALE..........................DATA PROCESSING T&E
SCALE, ARCHITECT'S.............DRAFTING T&E
SCALE, AUTOMATIC MILL..........FOOD PROCESSING T&E
SCALE, BALANCE.................WEIGHTS & MEASURES T&E
SCALE, BALLINGS BEER...........FOOD PROCESSING T&E
SCALE, BATHROOM................WEIGHTS & MEASURES T&E
SCALE, COMPUTING...............WEIGHTS & MEASURES T&E
SCALE, CYLINDER................WEIGHTS & MEASURES T&E
Scale, Drum....................WEIGHTS & MEASURES T&E
     use  SCALE, CYLINDER
SCALE, GRAIN...................FOOD PROCESSING T&E
Scale, Hopper..................FOOD PROCESSING T&E
     use  SCALE, GRAIN
SCALE, LEVER...................WEIGHTS & MEASURES T&E
SCALE, LIVESTOCK...............ANIMAL HUSBANDRY T&E
SCALE, MILK....................FOOD PROCESSING T&E
SCALE, NAVIGATIONAL............SURVEYING & NAVIGATIONAL T&E
SCALE, PLATFORM................WEIGHTS & MEASURES T&E
SCALE, SPRING..................WEIGHTS & MEASURES T&E
SCALE, TIMBER..................FORESTRY T&E
SCALE, TRIANGULAR..............WEIGHTS & MEASURES T&E
SCALE, TRUCK...................LAND TRANSPORTATION ACCESSORY
SCALPEL........................MEDICAL & PSYCHOLOGICAL T&E
Scanner, Optical...............DATA PROCESSING T&E
     use  READER, CHARACTER
Scapular.......................PERSONAL SYMBOL
     use  PENDANT, RELIGIOUS
SCARF..........................CLOTHING, HEADWEAR
SCARF, BUREAU..................HOUSEHOLD ACCESSORY
SCARF, NECK....................CLOTHING ACCESSORY
     rt   MUFFLER
SCARF, PIANO...................HOUSEHOLD ACCESSORY
SCARIFICATOR...................MEDICAL & PSYCHOLOGICAL T&E
SCARIFIER......................CONSTRUCTION T&E
SCAVENGER'S DAUGHTER...........BEHAVIORAL CONTROL DEVICE
Scenery........................PUBLIC ENTERTAINMENT DEVICE
     use  more specific term: e.g., FLAT, DROP,
          CYCLORAMA
Scenery unit...................PUBLIC ENTERTAINMENT DEVICE
     use  FLAT
SCEPTER........................PERSONAL SYMBOL
```

```
SCHOOL......................BUILDING
SCIOPTICON..................PUBLIC ENTERTAINMENT DEVICE
SCISSORS....................TEXTILEWORKING T&E
     rt   SHEARS
SCISSORS....................UNCLASSIFIED T&E, GENERAL
SCISSORS, BANDAGE...........MEDICAL & PSYCHOLOGICAL T&E
SCISSORS, BARBER'S..........TOILET ARTICLE
SCISSORS, BUTTONHOLE........TEXTILEWORKING T&E
SCISSORS, DISSECTING........BIOLOGICAL T&E
SCISSORS, EMBROIDERY........TEXTILEWORKING T&E
SCISSORS, MANICURE..........TOILET ARTICLE
SCISSORS, SURGICAL..........MEDICAL & PSYCHOLOGICAL T&E
SCISSORS, VINE..............AGRICULTURAL T&E
SCLEROMETER.................MECHANICAL T&E
SCONCE......................LIGHTING DEVICE
     rt   CANDELABRUM; CANDLESTICK
SCONCE, MIRRORED............LIGHTING DEVICE
SCOOP.......................FOOD PROCESSING T&E
     note may be further subdivided to indicate
          specific type: e.g., SCOOP, ICE-CREAM;
          -,MARROW; -,CRANBERRY; -,CURD
SCOOP, ALMOND...............FOOD SERVICE T&E
SCOOP, CHEESE...............FOOD SERVICE T&E
SCOOP, FEED.................AGRICULTURAL T&E
Scoop, Grain................AGRICULTURAL T&E
     use SHOVEL, GRAIN
Scoop, Potato...............AGRICULTURAL T&E
     use FORK, VEGETABLE SCOOP
SCOOP, SANI.................ANIMAL HUSBANDRY T&E
Scoop, Winnowing............AGRICULTURAL T&E
     use BASKET, WINNOWING
SCOOTER.....................TOY
Scope, Rangefinder..........ARMAMENT ACCESSORY
     use SIGHT, TELESCOPE
Scope, Sniper's.............ARMAMENT ACCESSORY
     use SIGHT, TELESCOPE
Scope, Target...............ARMAMENT ACCESSORY
     use SIGHT, TELESCOPE
SCORECARD...................DOCUMENTARY ARTIFACT
SCORING MACHINE.............PAPERMAKING T&E
SCORPER, CLOSED.............WOODWORKING T&E
     rt   DRAWKNIFE
SCORPER, OPEN...............WOODWORKING T&E
     rt   DRAWKNIFE
SCOTCH HAND.................FOOD PROCESSING T&E
SCOTOSCOPE..................OPTICAL T&E
SCOURER, GRAIN..............FOOD PROCESSING T&E
Scourer, Wheat..............FOOD PROCESSING T&E
     use SCOURER, GRAIN
SCOURING TRAIN..............TEXTILEWORKING T&E
SCOW........................WATER TRANSPORTATION EQUIPMENT
SCRAPBOOK...................DOCUMENTARY ARTIFACT
```

```
SCRAPER...........................CONSTRUCTION T&E
SCRAPER...........................GLASS & PLASTICS T&E
SCRAPER...........................LEATHERWORKING T&E
SCRAPER...........................METALWORKING T&E
      note may be further subdivided to indicate
           specific type: e.g., SCRAPER, FLAT;
           -,HALF-ROUND; -,HOOK; -,THREE-CORNERED
SCRAPER...........................PRINTING T&E
SCRAPER...........................WOODWORKING T&E
SCRAPER, BAND.....................ARMAMENT ACCESSORY
SCRAPER, BARREL...................ARMAMENT ACCESSORY
SCRAPER, CORN.....................FOOD PROCESSING T&E
SCRAPER, COTTON...................AGRICULTURAL T&E
SCRAPER, HOE......................MINING T&E
SCRAPER, HOG......................FOOD PROCESSING T&E
SCRAPER, MORTAR...................ARMAMENT ACCESSORY
SCRAPER, SHELL....................ARMAMENT ACCESSORY
SCRAPER, SWEAT....................ANIMAL HUSBANDRY T&E
SCRAPER, TREE.....................FORESTRY T&E
SCRAPER, TURPENTINE...............FORESTRY T&E
SCRAPER, WALL.....................PAINTING T&E
SCRATCHER, BACK...................TOILET ARTICLE
SCREED............................MASONRY T&E
SCREEN............................FURNITURE
SCREEN............................METALWORKING T&E
SCREEN, FIRE......................TEMPERATURE CONTROL DEVICE
SCREEN, POLE......................FURNITURE
Screen, Revolving.................FOOD PROCESSING T&E
      use  SCREEN, ROLLING
SCREEN, ROLLING...................FOOD PROCESSING T&E
SCREEN, TROMMEL...................MINING T&E
SCREEN, WINDOW....................BUILDING FRAGMENT
Screen door.......................BUILDING FRAGMENT
      use  DOOR, SCREEN
SCREW.............................METALWORKING T&E
      note may be further subdivided to indicate
           specific type: e.g., SCREW, MACHINE; -,SHEET
           METAL
SCREW.............................WOODWORKING T&E
SCREW, ARCHIMEDIAN................MECHANICAL T&E
SCREW BOX.........................WOODWORKING T&E
      rt   SCREW TAP
SCREW-CUTTING MACHINE.............METALWORKING T&E
SCREWDRIVER.......................UNCLASSIFIED T&E, GENERAL
SCREWDRIVER, OFFSET...............UNCLASSIFIED T&E, GENERAL
SCREWDRIVER, PHILLIPS.............UNCLASSIFIED T&E, GENERAL
SCREWDRIVER, RATCHET..............UNCLASSIFIED T&E, GENERAL
SCREW PLATE.......................METALWORKING T&E
      rt   JAMB PLATE
SCREW TAP.........................WOODWORKING T&E
      rt   SCREW BOX
SCRIBE, TIMBER....................FORESTRY T&E
```

SCRIBER........................WOODWORKING T&E
 rt AWL, MARKING
SCRIBE SET.....................PERSONAL GEAR
Scrimshaw
 note refer to text for discussion of the way this
 concept should be handled
Scrip..........................EXCHANGE MEDIUM
 use CURRENCY
SCROLL.........................DOCUMENTARY ARTIFACT
SCROLLER.......................GLASS & PLASTICS T&E
Scuff..........................CLOTHING, FOOTWEAR
 use SLIPPER
Scull..........................WATER TRANSPORTATION EQUIPMENT
 use SHELL, SINGLE SCULL
Sculpture......................ORIGINAL ART
 use more specific term: e.g., BUST, FIGURINE,
 STATUE
SCUTCHEON......................BUILDING FRAGMENT
Scutcher, Flax.................TEXTILEWORKING T&E
 use KNIFE, SCUTCHING
SCUTCHING BOARD................TEXTILEWORKING T&E
SCUTTLE, COAL..................TEMPERATURE CONTROL DEVICE
SCYTHE.........................AGRICULTURAL T&E
Scythe, Brush..................AGRICULTURAL T&E
 use SCYTHE
SCYTHE, CRADLE.................AGRICULTURAL T&E
SCYTHE, FLEMISH................AGRICULTURAL T&E
Scythe, Grass..................AGRICULTURAL T&E
 use SCYTHE
Scythe, Hainault...............AGRICULTURAL T&E
 use SCYTHE, FLEMISH
Scythe, Weed...................AGRICULTURAL T&E
 use SCYTHE
Scythe sharpener...............METALWORKING T&E
 use ANVIL, SCYTHE-SHARPENING or STONE,
 SCYTHE-SHARPENING
Seal...........................PERSONAL SYMBOL
 use more specific term: e.g., RING, SIGNET
Seaplane.......................AEROSPACE TRANSPORTATION EQUIPMENT
 use AIRPLANE
SEARCHER, VENT.................ARMAMENT ACCESSORY
SEARCHLIGHT....................LIGHTING DEVICE
SEAT, GARDEN...................FURNITURE
SEAT, WINDOW...................BUILDING FRAGMENT
SEATER, BULLET.................ARMAMENT ACCESSORY
SECRETARY......................FURNITURE
 rt DESK, DROP-FRONT
Section
 use only as a secondary word in a multi-word
 object name
SECTOGRAPH.....................DRAFTING T&E
SECTOR.........................DRAFTING T&E

```
SEDAN..........................LTE, HUMAN-POWERED
Sedan chair....................LTE, HUMAN-POWERED
     use  SEDAN
Seeder, Broadcast..............AGRICULTURAL T&E
     use  SEEDER, CENTRIFUGAL; SEEDER, HAND
          CENTRIFUGAL; SEEDER, HAND SEEDBOX; or
          SEEDER, SEEDBOX
SEEDER, CENTRIFUGAL............AGRICULTURAL T&E
     note use for an animal- or machine-powered
          centrifugal seeder
Seeder, Endgate................AGRICULTURAL T&E
     use  SEEDER, CENTRIFUGAL
SEEDER, HAND CENTRIFUGAL.......AGRICULTURAL T&E
     note use for a hand-powered centrifugal seeder
SEEDER, HAND SEEDBOX...........AGRICULTURAL T&E
     note use for a hand-carried or -pushed seedbox
          seeder
Seeder, Rotary.................AGRICULTURAL T&E
     use  SEEDER, CENTRIFUGAL or SEEDER, HAND
          CENTRIFUGAL
SEEDER, SEEDBOX................AGRICULTURAL T&E
     note use for an animal- or machine-powered
          seedbox seeder
Seeder, Wheelbarrow............AGRICULTURAL T&E
     use  SEEDER, HAND SEEDBOX
SEESAW.........................RECREATIONAL DEVICE
Seine..........................FISHING & TRAPPING T&E
     use  NET, SEINE or NET, PURSE SEINE
SEINE BOAT, MACKEREL...........WATER TRANSPORTATION EQUIPMENT
SEINE BOAT, SHAD...............WATER TRANSPORTATION EQUIPMENT
SEISMOGRAPH....................METEOROLOGICAL T&E
SEISMOPHONE....................METEOROLOGICAL T&E
SELENOTROPE....................ASTRONOMICAL T&E
SELF-PROPELLED CAR, DIESEL.....RAIL TRANSPORTATION EQUIPMENT
SELF-PROPELLED CAR, ELECTRIC...RAIL TRANSPORTATION EQUIPMENT
     rt   STREETCAR, ELECTRIC
SELF-PROPELLED CAR, GAS-ELECTRIC
     ..........................RAIL TRANSPORTATION EQUIPMENT
SELF-PROPELLED CAR, GASOLINE...RAIL TRANSPORTATION EQUIPMENT
SEMAPHORE......................VISUAL COMMUNICATION EQUIPMENT
     note may be further subdivided to indicate
          specific type: e.g., SEMAPHORE, RAILROAD
SEMICIRCLE.....................SURVEYING & NAVIGATIONAL T&E
SEMICIRCUMFERENTOR.............SURVEYING & NAVIGATIONAL T&E
SEMITRAILER....................LTE, MOTORIZED
     rt   TRAILER
SENSING/PUNCHING UNIT, CARD....DATA PROCESSING T&E
Separator......................AGRICULTURAL T&E
     use  THRESHER/SEPARATOR
Separator......................METALWORKING T&E
     note see Mining T&E for separators for metals
SEPARATOR......................MINING T&E
     note use only if specific type is unknown
```

447

SEPARATOR, BEAM.................NUCLEAR PHYSICS T&E
SEPARATOR, CRADLE..............MINING T&E
SEPARATOR, CREAM................FOOD PROCESSING T&E
SEPARATOR, DISK.................FOOD PROCESSING T&E
SEPARATOR, ELECTROMAGNETIC.....MINING T&E
SEPARATOR, ELECTROSTATIC.......MINING T&E
SEPARATOR, FRAME...............MINING T&E
SEPARATOR, GRADING.............FOOD PROCESSING T&E
SEPARATOR, JIGGING-MACHINE.....MINING T&E
SEPARATOR, MAGNETIC............FOOD PROCESSING T&E
SEPARATOR, MILLING.............FOOD PROCESSING T&E
SEPARATOR, OAT.................FOOD PROCESSING T&E
SEPARATOR, RECEIVING...........FOOD PROCESSING T&E
Separator, Warehouse...........FOOD PROCESSING T&E
 use SEPARATOR, RECEIVING
SEPARATOR, WASHER..............MINING T&E
SERPENT........................MUSICAL T&E, BRASS
Server.........................FURNITURE
 use TABLE, SERVING
SERVER, CHEESE.................FOOD SERVICE T&E
SERVER, PIE....................FOOD SERVICE T&E
SERVER, TOMATO.................FOOD SERVICE T&E
SERVICE CAR....................RAIL TRANSPORTATION EQUIPMENT
 note may be further subdivided to indicate
 specific type: e.g., SERVICE CAR,
 DYNAMOMETER; -,INSTRUCTIONAL; -,SNOWPLOW
Serviette......................FOOD SERVICE T&E
 use NAPKIN
Set
 use in a multi-word object name only as a
 secondary word
SET............................PUBLIC ENTERTAINMENT DEVICE
 note use for a constructed stage setting, usually
 of painted scenes or hangings with their
 accessories
SETTEE.........................FURNITURE
 note use for a sofa that is all wood with an open
 or upholstered back
 rt SOFA
SETTER.........................LEATHERWORKING T&E
 note may be further subdivided to indicate
 specific type: e.g., SETTER, GROMMET; -,RIVET
SETTER, FUZE...................ARMAMENT ACCESSORY
SETTER, SEEDLING...............AGRICULTURAL T&E
SETTING-DOWN MACHINE...........METALWORKING T&E
SETTLE.........................FURNITURE
Sewing bird....................TEXTILEWORKING T&E
 use CLAMP, SEWING
SEWING CARD....................TOY
SEWING FRAME...................PRINTING T&E
SEWING KEY.....................PRINTING T&E
SEWING MACHINE.................LEATHERWORKING T&E

```
SEWING MACHINE...................TEXTILEWORKING T&E
SEWING MACHINE, BOOK............PRINTING T&E
SEWING SUPPLIES.................TEXTILEWORKING T&E
     note use for any small object used in sewing or
          weaving: e.g., a needle, fasteners, eyelets,
          bias tape, ribbon
SEXTANT.........................SURVEYING & NAVIGATIONAL T&E
     rt   OCTANT
SHACKLE.........................WATER TRANSPORTATION ACCESSORY
SHACKLE.........................BEHAVIORAL CONTROL DEVICE
Shackle, Drag...................FORESTRY T&E
     use DOG, SPAN
SHACKLE, RAFT...................FORESTRY T&E
SHACKLE, SWIVEL.................WATER TRANSPORTATION ACCESSORY
SHADE, ROMAN....................WINDOW OR DOOR COVERING
SHADE, SPRING-PULL..............WINDOW OR DOOR COVERING
SHADE PULL......................WINDOW OR DOOR COVERING
SHAFTHOUSE......................BUILDING
SHAFTSET........................MINING T&E
SHAFT STAND, WHEELWRIGHT'S......WOODWORKING T&E
SHAKER, COCKTAIL................FOOD SERVICE T&E
SHAKER, FLOUR...................FOOD PROCESSING T&E
SHAKER, PEPPER..................FOOD SERVICE T&E
SHAKER, PIPETTE.................CHEMICAL T&E
Shaker, Salt....................FOOD SERVICE T&E
     use SALTSHAKER
SHAKER, SUGAR...................FOOD SERVICE T&E
SHAKER, TREE....................AGRICULTURAL T&E
SHAKER, WATER BATH..............CHEMICAL T&E
SHAKING APPARATUS...............BIOLOGICAL T&E
SHAKO...........................CLOTHING, HEADWEAR
SHAPER..........................METALWORKING T&E
     rt   PLANER
SHAPER..........................WOODWORKING T&E
Shard...........................ARTIFACT REMNANT
     use SHERD
Shari vessel....................CEREMONIAL ARTIFACT
     use RELIQUARY
Sharpener, Knife................METALWORKING T&E
     use STEEL or WHETSTONE
Sharpener, Scythe...............METALWORKING T&E
     use STONE, SCYTHE-SHARPENING or ANVIL,
          SCYTHE-SHARPENING
Sharpener, Sickle-bar...........METALWORKING T&E
     use GRINDER, MOWER-KNIFE
SHARPIE.........................WATER TRANSPORTATION EQUIPMENT
SHARPIE, NEW HAVEN..............WATER TRANSPORTATION EQUIPMENT
Shave...........................WOODWORKING T&E
     use DRAWSHAVE or SPOKESHAVE
SHAVE, BASKET...................TEXTILEWORKING T&E
SHAVE, BASKETMAKER'S UPRIGHT....TEXTILEWORKING T&E
SHAVING BLOCK...................WOODWORKING T&E
     rt   HORSE, SHAVING
```

SHAVING MACHINE.................WOODWORKING T&E
SHAVING STAND..................FURNITURE
SHAWABTI.......................CEREMONIAL ARTIFACT
SHAWL..........................CLOTHING, OUTERWEAR
SHAWM..........................MUSICAL T&E, WOODWIND
Shay...........................LTE, ANIMAL-POWERED
 use CHAISE
SHEARING MACHINE...............LEATHERWORKING T&E
SHEARING MACHINE...............METALWORKING T&E
 note use only if specific type is unknown: e.g.,
 SHEARS, CIRCLE; SHEARS, LEVER; SHEARS,
 SQUARING
SHEARING MACHINE...............TEXTILEWORKING T&E
SHEARS.........................GLASS & PLASTICS T&E
SHEARS.........................TEXTILEWORKING T&E
 rt SCISSORS
SHEARS, BENCH..................METALWORKING T&E
SHEARS, BENCH..................PRINTING T&E
SHEARS, BROOMMAKER'S...........WOODWORKING T&E
SHEARS, CIRCLE.................METALWORKING T&E
SHEARS, DRESSMAKER'S...........TEXTILEWORKING T&E
SHEARS, FETLOCK................ANIMAL HUSBANDRY T&E
Shears, Garden.................AGRICULTURAL T&E
 use SHEARS, HEDGE
SHEARS, GRAPE..................FOOD SERVICE T&E
SHEARS, HEDGE..................AGRICULTURAL T&E
SHEARS, LEATHER................LEATHERWORKING T&E
SHEARS, LEVER..................METALWORKING T&E
SHEARS, PINKING................TEXTILEWORKING T&E
SHEARS, PORTFIRE...............ARMAMENT ACCESSORY
SHEARS, SHEEP..................ANIMAL HUSBANDRY T&E
SHEARS, SQUARING...............METALWORKING T&E
SHEARS, THINNING...............TOILET ARTICLE
SHEATH.........................ARMAMENT ACCESSORY
SHEAVE.........................WATER TRANSPORTATION ACCESSORY
SHEAVE, WINDING................MINING T&E
SHED...........................BUILDING
 note may be further subdivided to indicate
 specific type: e.g., SHED, CATTLE; -,SHEEP
SHEET..........................BEDDING
SHEET, COOKIE..................FOOD PROCESSING T&E
SHEET, PLATE-BACKING...........PRINTING T&E
SHELL..........................WATER TRANSPORTATION EQUIPMENT
 note may be further subdivided to indicate
 specific type: e.g., SHELL, EIGHT-OARED;
 -,FOUR-OARED; -,PAIR with COXSWAIN;
 -,PAIR-OARED; -,PRACTICE WHERRY; -,SINGLE
 SCULL
SHELL, ARTILLERY...............ARMAMENT T&E, AMMUNITION
SHELL, SHOTGUN.................ARMAMENT T&E, AMMUNITION
SHELLER, CORN..................AGRICULTURAL T&E
SHELL FRAGMENT.................ARTIFACT REMNANT

SHELL MONEY....................EXCHANGE MEDIUM
SHERD.........................ARTIFACT REMNANT
 note may be further subdivided to indicate
 section of vessel: e.g., SHERD, RIM; -,NECK;
 -,BASE; -,BODY
SHIELD........................ARMAMENT ACCESSORY
SHIELD........................MINING T&E
SHIELD, HEAT..................AEROSPACE TRANSPORTATION ACCESSORY
SHIELD, MAGNETIC..............ELECTRICAL & MAGNETIC T&E
SHIELD, SOLAR.................POWER PRODUCTION T&E
SHILLELAGH....................ARMAMENT T&E, BLUDGEON
SHINGLE.......................BUILDING FRAGMENT
SHINGLE BUTTER................WOODWORKING T&E
SHIN GUARD....................SPORTS EQUIPMENT
SHIRT.........................CLOTHING, OUTERWEAR
 note may be further subdivided to indicate
 specific type: e.g., SHIRT, POLO
Shirt, T......................CLOTHING, OUTERWEAR
 use T-SHIRT
SHOCKER, CORN.................AGRICULTURAL T&E
SHOE..........................CLOTHING, FOOTWEAR
 note use only for objects which contain the word
 SHOE in the name; may be further subdivided
 to indicate specific type: e.g., SHOE, TOE;
 -,TRACK; -,TENNIS; -,DECK
SHOE..........................GAME
SHOEHORN......................CLOTHING ACCESSORY
SHOEING BOX...................ANIMAL HUSBANDRY T&E
SHOEING STAND.................ANIMAL HUSBANDRY T&E
SHOESHINE KIT.................CLOTHING ACCESSORY
 rt BOX, BOOTBLACKING
SHOESHINE KIT.................PERSONAL GEAR
Shoe spreader.................ANIMAL HUSBANDRY T&E
 use TONGS, SHOE-SPREADING
SHOE TREE.....................CLOTHING ACCESSORY
SHOFAR........................CEREMONIAL ARTIFACT
SHOOTING BOARD................WOODWORKING T&E
 rt MITER SHOOTING BOARD
SHOOTING STICK................PERSONAL GEAR
SHOOTING STICK................PRINTING T&E
SHOP..........................BUILDING
 note normally subdivided according to product or
 service sold: e.g., SHOP, BAKERY; -,SHOE
SHORTS........................CLOTHING, OUTERWEAR
SHORTS........................CLOTHING, UNDERWEAR
SHORTS, BOXER.................CLOTHING, UNDERWEAR
SHOT, BAR.....................ARMAMENT T&E, AMMUNITION
SHOT, CASE....................ARMAMENT T&E, AMMUNITION
SHOTGUN.......................ARMAMENT T&E, FIREARM
 note any form of SHOTGUN may be further
 subdivided to indicate the number of
 barrels: e.g., SHOTGUN, SINGLE-BARREL;

```
                     -,DOUBLE-BARREL; -,MULTI-BARREL; -,REPEATING
                     SINGLE-BARREL
SHOTGUN, REPEATING.............ARMAMENT T&E, FIREARM
SHOTGUN, SKEET.................ARMAMENT T&E, FIREARM
SHOTGUN, TRAP.................ARMAMENT T&E, FIREARM
SHOTPUT......................SPORTS EQUIPMENT
SHOULDER LOOP................PERSONAL SYMBOL
SHOULDER MARK...............PERSONAL SYMBOL
SHOVEL......................UNCLASSIFIED T&E, GENERAL
SHOVEL, BLACKSMITH'S.........METALWORKING T&E
SHOVEL, ENTRENCHING.........UNCLASSIFIED T&E, GENERAL
SHOVEL, FIREPLACE...........TEMPERATURE CONTROL DEVICE
SHOVEL, GRAIN...............AGRICULTURAL T&E
Shovel, Potato.............AGRICULTURAL T&E
     use  FORK, VEGETABLE SCOOP
SHOVEL, POWER..............CONSTRUCTION T&E
SHOW STICK................ANIMAL HUSBANDRY T&E
Shrank...................FURNITURE
     use  WARDROBE
SHREDDER, FLAIL............AGRICULTURAL T&E
Shredder, Stalk...........AGRICULTURAL T&E
     use  CUTTER, STALK
SHRINE...................BUILDING
     rt   MONUMENT
SHRINE...................CEREMONIAL ARTIFACT
     note may be further subdivided to indicate
          specific type: e.g., SHRINE, RELIGIOUS
     rt   RELIQUARY
Shrinker, Tire/axle..........METALWORKING T&E
     use  UPSETTER, TIRE/AXLE
SHRINKING MACHINE, COMPRESSIVE
     ........................TEXTILEWORKING T&E
SHROUD...................PERSONAL SYMBOL
SHUFFLEBOARD CUE.............SPORTS EQUIPMENT
SHUFFLEBOARD DISK...........SPORTS EQUIPMENT
SHUTTER..................WINDOW OR DOOR COVERING
SHUTTER..................PHOTOGRAPHIC T&E
SHUTTER AND DIAPHRAGM.........PHOTOGRAPHIC T&E
SHUTTLE..................TEXTILEWORKING T&E
SHUTTLE, NETTING...........TEXTILEWORKING T&E
SHUTTLECOCK..............SPORTS EQUIPMENT
SICKLE...................AGRICULTURAL T&E
     rt   HOOK, REAPING
Sickle, Grass.............AGRICULTURAL T&E
     use  HOOK, GRASS
SIDEBOARD................FURNITURE
     rt   HUNT BOARD
SIDE HORSE...............SPORTS EQUIPMENT
SIDELIGHT................BUILDING FRAGMENT
     rt   WINDOW SASH
SIDEROSCOPE.............ELECTRICAL & MAGNETIC T&E
SIDEROSTAT..............ASTRONOMICAL T&E
```

```
SIEVE.........................FOOD PROCESSING T&E
     rt   SIFTER
Sieve, Grain..................AGRICULTURAL T&E
     use  RIDDLE, GRAIN
Sieve, Winnowing..............AGRICULTURAL T&E
     use  RIDDLE, GRAIN
SIFTER........................FOOD PROCESSING T&E
     rt   SIEVE
SIFTER, SQUARE................FOOD PROCESSING T&E
SIGHT.........................ARMAMENT ACCESSORY
     note may be further subdivided to indicate
          specific type: e.g., SIGHT, GLOBE;
          -,MICROMETER; -,MILITARY; -,TANG;
          -,TELESCOPE; -,VERNIER; -,WINDGAUGE
SIGHT DISK....................ARMAMENT ACCESSORY
SIGHT EXTENSION...............ARMAMENT ACCESSORY
SIGHT MOUNT...................ARMAMENT ACCESSORY
SIGN, TRADE...................ADVERTISING MEDIUM
SIGN, TRAFFIC.................VISUAL COMMUNICATION EQUIPMENT
     rt   SIGNAL, TRAFFIC
SIGNAL, RAILROAD..............VISUAL COMMUNICATION EQUIPMENT
     note use only if specific type is unknown: e.g.,
          SEMAPHORE, RAILROAD
SIGNAL, TRAFFIC...............VISUAL COMMUNICATION EQUIPMENT
     rt   SIGN, TRAFFIC
SIGNET........................WRITTEN COMMUNICATION EQUIPMENT
     rt   RING, SIGNET
SILENCER......................ARMAMENT ACCESSORY
SILENT BUTLER.................FOOD SERVICE T&E
SILL..........................BUILDING FRAGMENT
SILO..........................BUILDING
SIMPLEX MACHINE...............TEXTILEWORKING T&E
SIMULATOR.....................DATA PROCESSING T&E
SIMULATOR, AIR-FLIGHT.........AEROSPACE TRANSPORTATION ACCESSORY
SIMULATOR, SOUND-EFFECTS......SOUND COMMUNICATION EQUIPMENT
SIMULATOR, SPACE-FLIGHT.......AEROSPACE TRANSPORTATION ACCESSORY
Single jack...................MINING T&E
     use  HAMMER, HAND
SINK..........................PLUMBING FIXTURE
SINK, DRY.....................FOOD PROCESSING T&E
SINKER........................FISHING & TRAPPING T&E
     rt   WEIGHT, NET
SINTERING MACHINE.............METALWORKING T&E
SIPHON........................CHEMICAL T&E
SIREN.........................SOUND COMMUNICATION EQUIPMENT
SITAR.........................MUSICAL T&E, STRINGED
Sith..........................AGRICULTURAL T&E
     use  SCYTHE, FLEMISH
Sizer, Potato.................FOOD PROCESSING T&E
     use  SORTER, POTATO
SKATE, ICE....................SPORTS EQUIPMENT
SKATE, ROLLER.................SPORTS EQUIPMENT
```

```
SKATE BOARD.....................SPORTS EQUIPMENT
Skeeter.........................WATER TRANSPORTATION EQUIPMENT
    use  ICEBOAT
SKEINER.........................TEXTILEWORKING T&E
Skep, Bee.......................ANIMAL HUSBANDRY T&E
    use  BEEHIVE
SKEWER..........................FOOD PROCESSING T&E
SKI, ALPINE.....................LTE, HUMAN-POWERED
SKI, CROSS-COUNTRY..............LTE, HUMAN-POWERED
SKI, WATER......................SPORTS EQUIPMENT
SKID............................PAPERMAKING T&E
Skiddle stick...................SPORTS EQUIPMENT
    use  BOWLING PIN
Skife...........................LEATHERWORKING T&E
    use  BEVELER, SAFETY
SKIFF...........................WATER TRANSPORTATION EQUIPMENT
    note use only if specific type is unknown
SKIFF, CHESAPEAKE BAY...........WATER TRANSPORTATION EQUIPMENT
Skiff, Crab.....................WATER TRANSPORTATION EQUIPMENT
    use  SKIFF, CHESAPEAKE BAY
SKIFF, FLATIRON.................WATER TRANSPORTATION EQUIPMENT
SKIFF, GUNNING..................WATER TRANSPORTATION EQUIPMENT
    rt   DELAWARE DUCKER; MELON SEED
Skiff, Oyster...................WATER TRANSPORTATION EQUIPMENT
    use  SKIFF, CHESAPEAKE BAY
SKIFF, SEABRIGHT................WATER TRANSPORTATION EQUIPMENT
SKIFF, ST. LAWRENCE RIVER.......WATER TRANSPORTATION EQUIPMENT
SKIFF, YANKEE...................WATER TRANSPORTATION EQUIPMENT
Skillet.........................FOOD PROCESSING T&E
    use  SPIDER or PAN, FRYING
SKIMMER.........................FOOD PROCESSING T&E
SKIMMER.........................METALWORKING T&E
SKIMMER, CREAM..................FOOD PROCESSING T&E
SKIMMER, WHALE-OIL..............FISHING & TRAPPING T&E
SKIP............................MINING T&E
SKIPJACK........................WATER TRANSPORTATION EQUIPMENT
SKI POLE........................LTE, HUMAN-POWERED
SKIRT...........................CLOTHING, OUTERWEAR
    note may be further subdivided to indicate
         specific type: e.g., SKIRT, HOOP; -,HULA
SKIVING MACHINE.................LEATHERWORKING T&E
SKULLCAP........................CLOTHING, HEADWEAR
    rt   BEANIE
SKYLIGHT........................BUILDING FRAGMENT
    rt   WINDOW SASH
Slacks..........................CLOTHING, OUTERWEAR
    use  PANTS
SLAG CAR........................METALWORKING T&E
SLAPPER, LIVESTOCK..............ANIMAL HUSBANDRY T&E
SLASHER.........................TEXTILEWORKING T&E
Slate...........................WRITTEN COMMUNICATION EQUIPMENT
    use  CHALKBOARD
```

Sled.............................LTE, ANIMAL-POWERED
 use SLEIGH
SLED.............................SPORTS EQUIPMENT
SLED, ARTILLERY..................ARMAMENT ACCESSORY
SLED, LOG........................FORESTRY T&E
SLED, ROCKET.....................AEROSPACE TRANSPORTATION ACCESSORY
SLEDGE...........................METALWORKING T&E
 note use for a large, usually two-handed, hammer;
 may be further subdivided to indicate
 specific type: e.g., SLEDGE, CROSS-PEEN;
 -,DOUBLE-FACE; -,STRAIGHT-PEEN
 rt HAMMER; MAUL, POST
SLEDGE...........................LTE, ANIMAL-POWERED
SLEDGE...........................LTE, HUMAN-POWERED
 rt STONEBOAT
SLEDGE, SHOE-TURNING.............METALWORKING T&E
Sledgehammer.....................METALWORKING T&E
 use SLEDGE
SLEEPING CAR.....................RAIL TRANSPORTATION EQUIPMENT
SLEEPING/LOUNGE CAR..............RAIL TRANSPORTATION EQUIPMENT
SLEEVE, GUNNER'S.................ARMAMENT ACCESSORY
SLEIGH...........................LTE, ANIMAL-POWERED
 note may be further subdivided to indicate
 specific type: e.g., SLEIGH, SURREY;
 -,RUNABOUT
SLICER, CHEESE...................FOOD PROCESSING T&E
SLICER, EAR-CORN.................AGRICULTURAL T&E
SLICER, FRUIT....................FOOD PROCESSING T&E
SLICK............................WOODWORKING T&E
 rt CHISEL
SLICKER..........................CLOTHING, OUTERWEAR
 rt RAINCOAT; OILSKINS
SLICKER..........................LEATHERWORKING T&E
 note may be further subdivided to indicate
 specific type: e.g., SLICKER, CIRCLE EDGE
Slide............................DOCUMENTARY ARTIFACT
 use TRANSPARENCY, LANTERN-SLIDE or TRANSPARENCY,
 SLIDE
SLIDE............................RECREATIONAL DEVICE
SLIDE RULE.......................DATA PROCESSING T&E
SLIDING POLE.....................RECREATIONAL DEVICE
SLING............................ARMAMENT ACCESSORY
Sling, Grain.....................AGRICULTURAL T&E
 use SLING, HAY
SLING, HAY.......................AGRICULTURAL T&E
SLING KEEPER.....................ARMAMENT ACCESSORY
SLINGSHOT........................ARMAMENT T&E, BLUDGEON
SLINKY...........................TOY
SLIP.............................CLOTHING, UNDERWEAR
SLIPPER..........................CLOTHING, FOOTWEAR
SLIPPER, BALLET..................CLOTHING, FOOTWEAR
Slip trailer.....................GLASS & PLASTICS T&E
 use CUP, SLIP-TRAILING

```
SLITTER....................PAPERMAKING T&E
SLITTER, TEAT..............ANIMAL HUSBANDRY T&E
SLOT MACHINE...............GAME
SLUBBER....................TEXTILEWORKING T&E
SLUBBING BILLY.............TEXTILEWORKING T&E
SLUBBING FRAME.............TEXTILEWORKING T&E
    note use only if specific type is unknown: e.g.,
         CAP FRAME, SLUBBING
SLUICE.....................UNCLASSIFIED STRUCTURE
    rt  FLUME
SLUICE BOX.................MINING T&E
SLUSHER....................MINING T&E
SMASHING MACHINE, BOOK.....PRINTING T&E
SMOCK......................CLOTHING, OUTERWEAR
SMOKE ALARM................SOUND COMMUNICATION EQUIPMENT
SMOKEHOUSE.................BUILDING
Smokejack..................FOOD PROCESSING T&E
    use BOTTLE JACK
SMOKER'S STAND.............HOUSEHOLD ACCESSORY
Smokestack.................BUILDING FRAGMENT
    use FLUE
SMUTTER....................FOOD PROCESSING T&E
SNAP CAP...................ARMAMENT ACCESSORY
SNAPDRAGON.................GLASS & PLASTICS T&E
Snapper, Corn..............AGRICULTURAL T&E
    use PICKER, CORN
Snapshot...................DOCUMENTARY ARTIFACT
    use PRINT, PHOTOGRAPHIC
SNARE......................FISHING & TRAPPING T&E
SNATCH PLATE...............MINING T&E
SNEAK BOX..................WATER TRANSPORTATION EQUIPMENT
Sneaker....................CLOTHING, FOOTWEAR
    use SHOE with suitable qualifier: e.g., SHOE,
         TENNIS
SNIFTER....................FOOD SERVICE T&E
SNIPS, SHEET METALWORKER'S.....METALWORKING T&E
Snood......................CLOTHING, HEADWEAR
    use HAIRNET
SNORE......................MINING T&E
Snorkel....................LTE, MOTORIZED
    use ELEVATING PLATFORM
SNORKEL....................SPORTS EQUIPMENT
SNOW KNOCKER...............UNCLASSIFIED T&E, SPECIAL
SNOWMOBILE.................LTE, MOTORIZED
SNOWSHED...................BUILDING
SNOWSHOE...................LTE, HUMAN-POWERED
SNUFFBOX...................PERSONAL GEAR
Snuffer, Candle............LIGHTING DEVICE
    use CANDLESNUFFER
SOCCER BALL................SPORTS EQUIPMENT
SOCIABLE...................LTE, ANIMAL-POWERED
SOCIABLE...................LTE, HUMAN-POWERED
```

```
SOCK.............................CLOTHING, FOOTWEAR
SOCKET, TUBE.....................ELECTRICAL & MAGNETIC T&E
SOCKET SET.......................METALWORKING T&E
SOFA.............................FURNITURE
     rt   SETTEE
SOFA, CONVERSATIONAL.............FURNITURE
     note use for a sofa that seats two persons facing
          in opposite directions
     rt   LOVE SEAT
Sofa bed.........................FURNITURE
     use  BED, SOFA
SOFTBALL.........................SPORTS EQUIPMENT
SOIL-TESTING KIT.................AGRICULTURAL T&E
SOLANDER.........................WRITTEN COMMUNICATION EQUIPMENT
SOLDERING MACHINE, CAN...........METALWORKING T&E
Solenoid.........................ELECTRICAL & MAGNETIC T&E
     use  SWITCH, SOLENOID
SOMBRERO.........................CLOTHING, HEADWEAR
Sonar unit.......................SURVEYING & NAVIGATIONAL T&E
     use  BATHOMETER or ECHOMETER
SONDOGRAPH.......................SURVEYING & NAVIGATIONAL T&E
SONOMETER........................ACOUSTICAL T&E
SORTER, BEAN.....................FOOD PROCESSING T&E
SORTER, CARD.....................DATA PROCESSING T&E
Sorter, Pea......................FOOD PROCESSING T&E
     use  SORTER, BEAN
SORTER, POTATO...................FOOD PROCESSING T&E
Sousaphone.......................MUSICAL T&E, BRASS
     use  TUBA
Souvenir
     note refer to text for discussion of the way this
          concept should be handled
Sower, Broadcast.................AGRICULTURAL T&E
     use  SEEDER, CENTRIFUGAL or SEEDER, SEEDBOX
Sower, Seedbox...................AGRICULTURAL T&E
     use  SEEDER, SEEDBOX
SPACECRAFT.......................AEROSPACE TRANSPORTATION EQUIPMENT
SPACECRAFT, MANNED COMMAND-MODULE
 ................................AEROSPACE TRANSPORTATION EQUIPMENT
SPACECRAFT, MANNED LUNAR-MODULE
 ................................AEROSPACE TRANSPORTATION EQUIPMENT
SPACECRAFT, MANNED ORBITAL-WORKSHOP
 ................................AEROSPACE TRANSPORTATION EQUIPMENT
Spacecraft, Unmanned.............AEROSPACE TRANSPORTATION EQUIPMENT
     use  SPACEPROBE
SPACEPROBE.......................AEROSPACE TRANSPORTATION EQUIPMENT
SPACER...........................ARMAMENT ACCESSORY
SPADE, BLUBBER...................FISHING & TRAPPING T&E
SPADE, BONE......................FISHING & TRAPPING T&E
SPADE, BUTTER-WORKING............FOOD PROCESSING T&E
SPADE, DITCHING..................AGRICULTURAL T&E
SPADE, DRAIN-TILE................AGRICULTURAL T&E
```

```
SPADE, GARDEN.....................AGRICULTURAL T&E
SPADE, GRAFTING...................MINING T&E
SPADE, HAY........................AGRICULTURAL T&E
     rt  KNIFE, HAY
SPADE, PEAT.......................AGRICULTURAL T&E
Spade, Turf.......................AGRICULTURAL T&E
     use  LIFTER, SOD
Spark guard.......................TEMPERATURE CONTROL DEVICE
     use  SCREEN, FIRE
SPAT..............................CLOTHING, FOOTWEAR
Spatterdash.......................CLOTHING, OUTERWEAR
     use  LEGGING
SPATULA...........................FOOD PROCESSING T&E
SPATULA...........................GLASS & PLASTICS T&E
SPATULA...........................PAINTING T&E
SPATULA, DENTAL...................MEDICAL & PSYCHOLOGICAL T&E
SPAUDLER..........................ARMAMENT T&E, BODY ARMOR
SPEAKER...........................SOUND COMMUNICATION EQUIPMENT
SPEAR.............................ARMAMENT T&E, EDGED
SPEAR, EEL........................ARMAMENT T&E, EDGED
SPEAR, FISH.......................ARMAMENT T&E, EDGED
SPEAR, SQUID......................ARMAMENT T&E, EDGED
SPECTROGRAM, SOUND................ACOUSTICAL T&E
SPECTROGRAPH......................OPTICAL T&E
SPECTROGRAPH, MASS................NUCLEAR PHYSICS T&E
SPECTROGRAPH, SOUND...............ACOUSTICAL T&E
SPECTROHELIOGRAPH.................ASTRONOMICAL T&E
SPECTROMETER......................OPTICAL T&E
SPECTROMETER, MASS................NUCLEAR PHYSICS T&E
SPECTROPHOTOMETER.................OPTICAL T&E
SPECTROSCOPE......................OPTICAL T&E
Speculum..........................ASTRONOMICAL T&E
     use  MIRROR
SPECULUM..........................MEDICAL & PSYCHOLOGICAL T&E
SPEEDBALL.........................SPORTS EQUIPMENT
Speedboat.........................WATER TRANSPORTATION EQUIPMENT
     use  RUNABOUT
SPHEROGRAPH.......................SURVEYING & NAVIGATIONAL T&E
SPHEROMETER.......................DATA PROCESSING T&E
SPHEROSCOPE.......................ASTRONOMICAL T&E
SPHYGMOMANOMETER..................MEDICAL & PSYCHOLOGICAL T&E
SPIDER............................FOOD PROCESSING T&E
     rt  PAN, FRYING
SPIKE.............................WOODWORKING T&E
SPIKE.............................RAIL TRANSPORTATION ACCESSORY
SPIKE, CANNON.....................ARMAMENT ACCESSORY
Spile.............................FORESTRY T&E
     use  SPOUT, SAP
SPILLWAY..........................UNCLASSIFIED STRUCTURE
SPINDLE...........................TEXTILEWORKING T&E
SPINDLE...........................WRITTEN COMMUNICATION EQUIPMENT
SPINDLE WHORL.....................TEXTILEWORKING T&E
```

```
SPINET.........................MUSICAL T&E, STRINGED
SPINNERET......................TEXTILEWORKING T&E
SPINNING FRAME.................TEXTILEWORKING T&E
     note use only for general category or if specific
          type is unknown: e.g., THROSTLE FRAME, CAP
          FRAME, RING FRAME
SPINNING JACK..................TEXTILEWORKING T&E
SPINNING JENNY.................TEXTILEWORKING T&E
SPINNING LINE..................MINING T&E
SPINNING MULE..................TEXTILEWORKING T&E
SPINNING WHEEL.................TEXTILEWORKING T&E
     note may be further subdivided to indicate
          specific type: e.g., SPINNING WHEEL, FLAX;
          -,WOOL
SPINTHARISCOPE.................CHEMICAL T&E
SPIRAL WORM....................MINING T&E
SPIRE..........................BUILDING FRAGMENT
SPIROGRAPH.....................DRAFTING T&E
SPIROGRAPH.....................MEDICAL & PSYCHOLOGICAL T&E
SPIROMETER.....................MEDICAL & PSYCHOLOGICAL T&E
SPITTOON.......................HOUSEHOLD ACCESSORY
SPLICER, FILM..................PHOTOGRAPHIC T&E
SPLINT.........................LIGHTING DEVICE
SPLINT, JAW....................MEDICAL & PSYCHOLOGICAL T&E
SPLINT, THOMAS.................MEDICAL & PSYCHOLOGICAL T&E
SPLINT SET, ARCHWIRE...........MEDICAL & PSYCHOLOGICAL T&E
SPLITTER, SAMPLE...............MINING T&E
SPLITTING MACHINE..............LEATHERWORKING T&E
SPLITTING MACHINE, HORNWORKER'S
     .........................UNCLASSIFIED T&E, SPECIAL
SPOKESHAVE.....................WOODWORKING T&E
     rt   DRAWKNIFE; DRAWSHAVE
SPONTOON.......................ARMAMENT T&E, EDGED
SPOOL..........................TEXTILEWORKING T&E
SPOOLER........................TEXTILEWORKING T&E
SPOON..........................FOOD SERVICE T&E
SPOON..........................MINING T&E
SPOON, BABY....................FOOD SERVICE T&E
SPOON, BASTING.................FOOD PROCESSING T&E
SPOON, BERRY...................FOOD SERVICE T&E
SPOON, BLACKSMITH'S............METALWORKING T&E
SPOON, BONBON..................FOOD SERVICE T&E
SPOON, CADDY...................FOOD PROCESSING T&E
SPOON, CHILD'S.................FOOD SERVICE T&E
SPOON, CLARET..................FOOD SERVICE T&E
SPOON, DEMITASSE...............FOOD SERVICE T&E
SPOON, DESSERT.................FOOD SERVICE T&E
SPOON, FRUIT...................FOOD SERVICE T&E
SPOON, GRAPEFRUIT..............FOOD SERVICE T&E
SPOON, MEASURING...............FOOD PROCESSING T&E
SPOON, MUD.....................MASONRY T&E
SPOON, MUSTARD.................FOOD SERVICE T&E
```

```
SPOON, OLIVE....................FOOD SERVICE T&E
SPOON, PIERCED SERVING.........FOOD SERVICE T&E
SPOON, SALT....................FOOD SERVICE T&E
SPOON, SERVING.................FOOD SERVICE T&E
SPOON, SHERBET.................FOOD SERVICE T&E
SPOON, SODA....................FOOD SERVICE T&E
SPOON, SOUP....................FOOD SERVICE T&E
SPOON, SUGAR...................FOOD SERVICE T&E
Spoon, Table...................FOOD SERVICE T&E
     use  TABLESPOON
Spoon, Tea.....................FOOD SERVICE T&E
     use  TEASPOON
SPOON AND SALT SET.............FOOD SERVICE T&E
SPOONER........................FOOD SERVICE T&E
SPOTLIGHT......................LIGHTING DEVICE
Spotting board.................AGRICULTURAL T&E
     use  DIBBLE
SPOTTING MACHINE...............WOODWORKING T&E
SPOUT, SAP.....................FORESTRY T&E
Sprayer, Bucket................AGRICULTURAL T&E
     use  SPRAYER, HAND
Sprayer, Flame.................AGRICULTURAL T&E
     use  WEEDER, FLAME
SPRAYER, HAND..................AGRICULTURAL T&E
Sprayer, Knapsack..............AGRICULTURAL T&E
     use  SPRAYER, HAND
SPRAYER, POWER.................AGRICULTURAL T&E
Sprayer, Wheelbarrow...........AGRICULTURAL T&E
     use  SPRAYER, HAND
SPREADER, ASPHALT..............CONSTRUCTION T&E
Spreader, Garden manure........AGRICULTURAL T&E
     use  SPREADER, WHEELBARROW
SPREADER, JAW..................MEDICAL & PSYCHOLOGICAL T&E
SPREADER, MANURE...............AGRICULTURAL T&E
     note use for an animal- or machine-drawn spreader
SPREADER, WHEELBARROW..........AGRICULTURAL T&E
     note use for a hand-pushed spreader
SPRING, SPIRAL.................MECHANICAL T&E
SPRING BOW.....................DRAFTING T&E
SPRINGHOUSE....................BUILDING
SPRING POLE....................MINING T&E
SPRINKLER......................HOUSEKEEPING T&E
SPRINKLER, BLACKSMITH'S........METALWORKING T&E
SPRINKLER, IRRIGATION..........AGRICULTURAL T&E
Sprinkler, Knapsack............AGRICULTURAL T&E
     use  SPRAYER, HAND
SPRINKLER HEAD.................PLUMBING FIXTURE
SPUD...........................MINING T&E
SPUD, BARKING..................FORESTRY T&E
Spud, Dandelion................AGRICULTURAL T&E
     use  SPUD, WEEDING
SPUD, WEEDING..................AGRICULTURAL T&E
```

SPUR.............................LAND TRANSPORTATION ACCESSORY
Squails..........................GAME
 use TIDDLYWINK SET
SQUARE...........................WOODWORKING T&E
SQUARE, BEVEL....................WOODWORKING T&E
SQUARE, CARPENTER'S..............WOODWORKING T&E
SQUARE, MITER....................WOODWORKING T&E
SQUARE, SET......................WOODWORKING T&E
SQUARE, TRY......................WOODWORKING T&E
SQUEAKER.........................TOY
SQUEEGEE.........................PRINTING T&E
SQUEEZER, LEMON..................FOOD PROCESSING T&E
SQUIB, MINER'S...................MINING T&E
STABILIZER.......................ARMAMENT ACCESSORY
STABLE...........................BUILDING
STABLE, LIVERY...................BUILDING
Stacker, Cable...................AGRICULTURAL T&E
 use STACKER, HAY
Stacker, Derrick.................AGRICULTURAL T&E
 use STACKER, HAY
STACKER, HAY.....................AGRICULTURAL T&E
Stacker, Overshot................AGRICULTURAL T&E
 use STACKER, HAY
Stacker, Swinging................AGRICULTURAL T&E
 use STACKER, HAY
Stacker, Tripod..................AGRICULTURAL T&E
 use STACKER, HAY
STACK-MAKER, HAY.................AGRICULTURAL T&E
STADIA ROD.......................SURVEYING & NAVIGATIONAL T&E
STADIMETER.......................SURVEYING & NAVIGATIONAL T&E
STADIUM..........................UNCLASSIFIED STRUCTURE
Staff
 use only as a secondary word in a multi-word
 object name
STAGE............................BUILDING FRAGMENT
STAGE, JACKKNIFE.................PUBLIC ENTERTAINMENT DEVICE
STAGE, PUPPET....................PUBLIC ENTERTAINMENT DEVICE
STAGE, REVOLVING.................PUBLIC ENTERTAINMENT DEVICE
STAGE, SLIP......................PUBLIC ENTERTAINMENT DEVICE
STAGECOACH.......................LTE, ANIMAL-POWERED
 rt COACH, ROAD
Stained glass window.............BUILDING FRAGMENT
 use WINDOWPANE, LEADED
STAINING APPARATUS...............BIOLOGICAL T&E
STAIRCASE........................BUILDING FRAGMENT
STAIR ROD........................FLOOR COVERING
STAIR TREAD......................FLOOR COVERING
STAKE............................METALWORKING T&E
 note use only if specific type is unknown
STAKE............................SURVEYING & NAVIGATIONAL T&E
STAKE, BLOWHORN..................METALWORKING T&E
STAKE, CANDLEMOLD................METALWORKING T&E

STAKE, CREASING.................METALWORKING T&E
STAKE, DOUBLE-CREASING.........METALWORKING T&E
STAKE, HATCHET.................METALWORKING T&E
STAKE, HOLLOW-MANDREL..........METALWORKING T&E
STAKE, NEEDLE CASE.............METALWORKING T&E
STAKE, PLANISHING..............METALWORKING T&E
STAKE, SQUARE..................METALWORKING T&E
STALAGMOMETER..................MEDICAL & PSYCHOLOGICAL T&E
STALL, CATTLE..................BUILDING FRAGMENT
STALL BAR......................SPORTS EQUIPMENT
STAMP..........................METALWORKING T&E
STAMP..........................WRITTEN COMMUNICATION EQUIPMENT
 note may be further subdivided to indicate
 specific type: e.g., STAMP, DATE; -,NOTARY;
 -,MARKING
STAMP, POSTAGE.................EXCHANGE MEDIUM
STAMP, TRADING.................EXCHANGE MEDIUM
Stamper........................PAPERMAKING T&E
 use PULPER
STAMPING MACHINE...............GLASS & PLASTICS T&E
STANCHION......................BUILDING FRAGMENT
Stand
 use only as a secondary word in a multi-word
 object name
STAPLER........................WRITTEN COMMUNICATION EQUIPMENT
Stapler, Break-stretch.........TEXTILEWORKING T&E
 use PERLOCK MACHINE
Stapler, Diagonal-cutting......TEXTILEWORKING T&E
 use PACIFIC CONVERTER
Stapler, Turbo.................TEXTILEWORKING T&E
 use PERLOCK MACHINE
STARTER, BULLET................ARMAMENT ACCESSORY
STARTING BLOCK.................SPORTS EQUIPMENT
STATIC ELIMINATOR, BALANCE.....NUCLEAR PHYSICS T&E
STATION POINTER................SURVEYING & NAVIGATIONAL T&E
STATION STAFF..................SURVEYING & NAVIGATIONAL T&E
STATUE.........................ORIGINAL ART
STATUE, RELIGIOUS..............CEREMONIAL ARTIFACT
STATUETTE TROPHY...............PERSONAL SYMBOL
STAUROSCOPE....................OPTICAL T&E
STAY...........................CLOTHING, UNDERWEAR
STEAMER........................FOOD PROCESSING T&E
Steamer, Wheat.................FOOD PROCESSING T&E
 use CONDITIONER, GRAIN
Steamroller....................CONSTRUCTION T&E
 use ROLLER
STEAM STICK....................GLASS & PLASTICS T&E
STEEL..........................TEMPERATURE CONTROL DEVICE
STEEL..........................METALWORKING T&E
 rt WHETSTONE
STEEL, FINGER..................LEATHERWORKING T&E
STEEL, TURNING.................LEATHERWORKING T&E

STEELYARD....................WEIGHTS & MEASURES T&E
STEIN........................FOOD SERVICE T&E
 rt TANKARD; GLASS, MALT-BEVERAGE
STEMMER, TAMPING-BAR.........MINING T&E
STENCIL......................LEATHERWORKING T&E
 note use for a silkscreeen or metal stencil in
 the process of spotting or marking furskins
STEPLADDER...................HOUSEHOLD ACCESSORY
STEPS, BED...................FURNITURE
STEPS, LIBRARY...............FURNITURE
STEREOGRAM...................MEDICAL & PSYCHOLOGICAL T&E
STEREOGRAPH..................MEDICAL & PSYCHOLOGICAL T&E
STEREOGRAPH..................DOCUMENTARY ARTIFACT
 note use for the pictorial object viewed in a
 stereoscope
STEREOMETER..................MECHANICAL T&E
Stereopticon.................VISUAL COMMUNICATION EQUIPMENT
 use PROJECTOR, LANTERN-SLIDE
STEREOSCOPE..................MEDICAL & PSYCHOLOGICAL T&E
 rt PSEUDOSCOPE, LENTICULAR
STEREOSCOPE..................VISUAL COMMUNICATION EQUIPMENT
STEREOSCOPE/PSEUDOSCOPE......MEDICAL & PSYCHOLOGICAL T&E
STEREOVIEW...................DOCUMENTARY ARTIFACT
 note use for the pictorial object viewed in a
 modern stereoviewer
STEREOVIEWER.................VISUAL COMMUNICATION EQUIPMENT
 note use only for a "modern" stereoviewer
Sterilizer...................MEDICAL & PSYCHOLOGICAL T&E
 use AUTOCLAVE
Sterilizer, Bottle...........FOOD PROCESSING T&E
 use WASHER, MILK-BOTTLE
STETHOGONIOMETER.............BIOLOGICAL T&E
STETHOMETER..................MEDICAL & PSYCHOLOGICAL T&E
STETHOSCOPE..................MEDICAL & PSYCHOLOGICAL T&E
Stevengraph..................COMMERCIAL DECORATIVE ART
 use PICTURE, WOVEN
Stick
 use only as a secondary word in a multi-word
 object name
Stick horse..................TOY
 use HOBBYHORSE
STICKPIN.....................CLOTHING ACCESSORY
STILETTO.....................TEXTILEWORKING T&E
STILL........................FOOD PROCESSING T&E
STILL, SOLAR.................FOOD PROCESSING T&E
STILLETTO....................ARMAMENT T&E, EDGED
STILT........................GLASS & PLASTICS T&E
STILT........................TOY
STIMULATOR, SOUND............ACOUSTICAL T&E
STIRRER......................CHEMICAL T&E
STIRRER......................FOOD PROCESSING T&E
 note may be further subdivided to indicate

 specific type: e.g., STIRRER, APPLE BUTTER;
 -,CURD
STIRRING ROD...................PHOTOGRAPHIC T&E
STIRRUP........................LAND TRANSPORTATION ACCESSORY
STITCH-HEAVER, RIGGER'S........TEXTILEWORKING T&E
STITCHING GROOVER..............LEATHERWORKING T&E
STOCK CAR......................RAIL TRANSPORTATION EQUIPMENT
STOCK-COMPRESSING MACHINE......PRINTING T&E
STOCKING.......................CLOTHING, FOOTWEAR
STOCKS.........................BEHAVIORAL CONTROL DEVICE
STOCK TICKER...................TELECOMMUNICATION EQUIPMENT
STOLE..........................CLOTHING, OUTERWEAR
STOMATOSCOPE...................MEDICAL & PSYCHOLOGICAL T&E
STONE, SCYTHE-SHARPENING.......METALWORKING T&E
 rt ANVIL, SCYTHE-SHARPENING
STONE, WORKED..................ARTIFACT REMNANT
STONEBOAT......................AGRICULTURAL T&E
 rt SLEDGE
STOOL..........................FURNITURE
Stool, Bar.....................FURNITURE
 use BARSTOOL
Stool, Camp....................FURNITURE
 use STOOL, FOLDING
STOOL, DUCKING.................BEHAVIORAL CONTROL DEVICE
STOOL, FOLDING.................FURNITURE
STOOL, GOUT....................FURNITURE
STOOL, KITCHEN.................FURNITURE
STOOL, MILKING.................FURNITURE
STOOL, STEP....................FURNITURE
STOOP..........................BUILDING FRAGMENT
STOPCOCK.......................CHEMICAL T&E
STOPPER, BOTTLE................PRODUCT PACKAGE
STOPWATCH......................TIMEKEEPING T&E
Storage........................DATA PROCESSING T&E
 use STORE or more specific term: e.g., DISK,
 MAGNETIC
STORE..........................BUILDING
 note normally subdivided according to product or
 service sold: e.g., STORE, DEPARTMENT;
 -,HARDWARE; -,GROCERY
STORE..........................DATA PROCESSING T&E
 note use only if specific type is unknown: e.g.,
 DISK, MAGNETIC; TAPE, MAGNETIC; DRUM,
 MAGNETIC
STORE, BUFFER..................DATA PROCESSING T&E
Store, Retail..................BUILDING
 use more specific term: e.g., STORE, GROCERY
STOVE..........................TEMPERATURE CONTROL DEVICE
 note normally subdivided according to fuel used:
 e.g., STOVE, WOOD; -, COAL
STOVE..........................FOOD PROCESSING T&E
 note may be further subdivided according to fuel
 used: e.g., STOVE, GAS; -,WOOD; -,ELECTRIC

```
STOVE, FINISHING................PRINTING T&E
STOVE, PORTABLE.................FOOD PROCESSING T&E
    note may be further subdivided to indicate fuel
          used: e.g., STOVE, PORTABLE ALCOHOL;
          -,PORTABLE GAS
STRABISMOMETER..................MEDICAL & PSYCHOLOGICAL T&E
STRAIGHTENER, CLOTH.............TEXTILEWORKING T&E
STRAIGHTENING MACHINE...........METALWORKING T&E
Strainer, Cream.................FOOD PROCESSING T&E
    use STRAINER, MILK
STRAINER, GRAVY.................FOOD PROCESSING T&E
STRAINER, MILK..................FOOD PROCESSING T&E
STRAINER, WHEY..................FOOD PROCESSING T&E
STRAITJACKET....................BEHAVIORAL CONTROL DEVICE
STRAKE, BLANKET.................MINING T&E
STRAPPADO.......................BEHAVIORAL CONTROL DEVICE
STREETCAR.......................RAIL TRANSPORTATION EQUIPMENT
STREETCAR, ELECTRIC.............RAIL TRANSPORTATION EQUIPMENT
    rt   SELF-PROPELLED CAR, ELECTRIC
STREETCAR, HORSE-DRAWN..........RAIL TRANSPORTATION EQUIPMENT
STREETLAMP......................LIGHTING DEVICE
STRETCHER.......................LTE, HUMAN-POWERED
STRETCHER, CURTAIN..............HOUSEKEEPING T&E
STRETCHER, FENCE-WIRE...........UNCLASSIFIED T&E, SPECIAL
Stretcher, Shoe.................CLOTHING ACCESSORY
    use SHOE TREE
STRETCHING MACHINE..............LEATHERWORKING T&E
Strickle........................METALWORKING T&E
    use STONE, SCYTHE-SHARPENING
STRIGIL.........................TOILET ARTICLE
STRIKER BOAT, MENHADEN..........WATER TRANSPORTATION EQUIPMENT
STRIKING BAG....................SPORTS EQUIPMENT
STRIPLIGHT......................LIGHTING DEVICE
STRIPPER, BASKETMAKER'S.........TEXTILEWORKING T&E
STRIPPER, COTTON................AGRICULTURAL T&E
STRIPPER, GRAIN.................AGRICULTURAL T&E
STRIPPER, WIRE..................ELECTRICAL & MAGNETIC T&E
Strip ease......................LEATHERWORKING T&E
    use GAUGE, DRAW
Strobe light....................PHOTOGRAPHIC T&E
    use FLASH ATTACHMENT, ELECTRONIC
STROBILION......................ACOUSTICAL T&E
    note use for an instrument that records
          vibrational patterns
STROBOSCOPE.....................MECHANICAL T&E
STROBOSCOPE.....................TOY
STROLLER........................LTE, HUMAN-POWERED
STRONGBOX.......................HOUSEHOLD ACCESSORY
STROP...........................TOILET ARTICLE
STUD............................CLOTHING ACCESSORY
STUFFED TOY.....................TOY
STUFFER, SAUSAGE................FOOD PROCESSING T&E
```

STUFFER BOX....................TEXTILEWORKING T&E
STUFFING BOX...................MINING T&E
STULL.........................MINING T&E
STUMP.........................PAINTING T&E
STYLOGRAPH....................PAINTING T&E
STYLUS........................DRAFTING T&E
STYLUS........................GLASS & PLASTICS T&E
STYLUS, LIGHT.................DATA PROCESSING T&E
SUBMARINE.....................WATER TRANSPORTATION EQUIPMENT
SUBMARINE, ATTACK.............WATER TRANSPORTATION EQUIPMENT
SUBMARINE, BALLISTIC MISSILE...WATER TRANSPORTATION EQUIPMENT
SUBMARINE, COMMERCIAL.........WATER TRANSPORTATION EQUIPMENT
SUBMARINE, RESEARCH...........WATER TRANSPORTATION EQUIPMENT
 rt RESEARCH VESSEL
SUBMARINE CHASER..............WATER TRANSPORTATION EQUIPMENT
Submarine tender..............WATER TRANSPORTATION EQUIPMENT
 use TENDER, SUBMARINE
Subsoiler.....................AGRICULTURAL T&E
 use PLOW, SUBSOIL
SUBWAY CAR....................RAIL TRANSPORTATION EQUIPMENT
SUCKER ROD....................MINING T&E
SUCTION BOX...................PAPERMAKING T&E
SUEDING MACHINE...............TEXTILEWORKING T&E
SUGAR AND CREAMER.............FOOD SERVICE T&E
Sugar shell...................FOOD SERVICE T&E
 use SPOON, SUGAR
SUIT..........................CLOTHING, OUTERWEAR
 note may be further subdivided to indicate
 specific type: e.g., SUIT, BATHING;
 -,EXPOSURE; -,DIVER'S; -,SPACE
Suit, Pants...................CLOTHING, OUTERWEAR
 use PANTSUIT
SUIT, UNION...................CLOTHING, UNDERWEAR
SUITCASE......................PERSONAL GEAR
SULKY.........................LTE, ANIMAL-POWERED
SUNDIAL.......................TIMEKEEPING T&E
SUNSUIT.......................CLOTHING, OUTERWEAR
SUPERCALENDER.................PAPERMAKING T&E
SUPPORTER.....................CLOTHING, UNDERWEAR
SUPPORTS, POWERED.............MINING T&E
Surcingle.....................LAND TRANSPORTATION ACCESSORY
 use GIRTH
SURFACER, SLUG................PRINTING T&E
SURFBOARD.....................SPORTS EQUIPMENT
SURFBOAT......................WATER TRANSPORTATION EQUIPMENT
 rt LIFEBOAT, COASTAL RESCUE; LIFECAR
SURPLICE......................CLOTHING, OUTERWEAR
Surprise box..................TOY
 use JACK-IN-THE-BOX
SURREY........................LTE, ANIMAL-POWERED
SURVEY VESSEL.................WATER TRANSPORTATION EQUIPMENT
SUSPENDERS....................CLOTHING ACCESSORY

```
SWAG.................................WINDOW OR DOOR COVERING
SWAGE................................METALWORKING T&E
      note use only if specific type is unknown
SWAGE, ANVIL........................METALWORKING T&E
      rt    BEAKIRON
SWAGE, BOLT-HEADING.................METALWORKING T&E
SWAGE, BOTTOM.......................METALWORKING T&E
SWAGE, COLLENDER....................METALWORKING T&E
SWAGE, CREASING.....................METALWORKING T&E
SWAGE, FORMING......................METALWORKING T&E
SWAGE, HALF-ROUND TOP...............METALWORKING T&E
SWAGE, HATCHET......................METALWORKING T&E
SWAGE, MANDREL......................METALWORKING T&E
SWAGE, NECKING......................METALWORKING T&E
SWAGE, NUT..........................METALWORKING T&E
SWAGE, SPRING.......................METALWORKING T&E
SWAGE, TOP..........................METALWORKING T&E
SWAGE, TOP-AND-BOTTOM...............METALWORKING T&E
SWAGE, TOP-AND-BOTTOM-JOINED.......METALWORKING T&E
SWAGE, V-SHAPED.....................METALWORKING T&E
SWAGE BLOCK.........................METALWORKING T&E
SWAGGER STICK.......................PERSONAL GEAR
Swatch..............................TEXTILEWORKING T&E
      use   SALES SAMPLE, CLOTH or TEXTILE FRAGMENT or
            QUILT PIECE
SWATTER, FLY........................HOUSEHOLD ACCESSORY
SWEATBAND...........................CLOTHING, HEADWEAR
SWEATER.............................CLOTHING, OUTERWEAR
Swedge..............................METALWORKING T&E
      use   SWAGE
SWEEP...............................WATER TRANSPORTATION ACCESSORY
      rt    OAR
SWEEP, ANIMAL-POWERED...............POWER PRODUCTION T&E
SWEEP, HUMAN-POWERED................POWER PRODUCTION T&E
SWEEPER, CARPET.....................HOUSEKEEPING T&E
SWEEPER, CRUMB......................FOOD SERVICE T&E
SWEEPER, STREET.....................LTE, MOTORIZED
SWIFT...............................TEXTILEWORKING T&E
      rt    REEL, CLOCK
SWIM FIN............................SPORTS EQUIPMENT
SWIM MASK...........................SPORTS EQUIPMENT
SWING...............................RECREATIONAL DEVICE
SWING, CIRCLE.......................RECREATIONAL DEVICE
SWINGING GATE.......................RECREATIONAL DEVICE
SWINGING ROPE.......................SPORTS EQUIPMENT
Swingle, Flax.......................TEXTILEWORKING T&E
      use   KNIFE, SCUTCHING
SWITCH..............................ELECTRICAL & MAGNETIC T&E
SWITCH..............................MUSICAL T&E, PERCUSSION
SWITCH, FLY.........................ANIMAL HUSBANDRY T&E
SWITCH, SOLENOID....................ELECTRICAL & MAGNETIC T&E
SWITCH IRON.........................RAIL TRANSPORTATION ACCESSORY
```

467

```
SWIZZLE STICK..................FOOD SERVICE T&E
SWORD..........................ARMAMENT T&E, EDGED
     note use only if specific type is unknown: e.g.,
          SABER, CLAYMORE
Sword, Court...................PERSONAL SYMBOL
     use  SWORD, PRESENTATION
SWORD, HUNTING.................ARMAMENT T&E, EDGED
SWORD, PRESENTATION............PERSONAL SYMBOL
SYMBOL, TRADE..................ADVERTISING MEDIUM
     note use for an object which by custom is
          considered as a visual symbol of a product
          or service: e.g., a barber pole, a cigar
          store figure
Sympiesometer..................METEOROLOGICAL T&E
     use  BAROMETER
SYNAGOGUE......................BUILDING
SYNCHROCYCLOTRON...............NUCLEAR PHYSICS T&E
SYNCHROTRON....................NUCLEAR PHYSICS T&E
     note may be further subdivided to indicate
          specific type: e.g., SYNCHROTRON,
          ALTERNATING-GRADIENT; -,CONSTANT-GRADIENT;
          -,ZERO-GRADIENT
SYNTHESIZER....................MUSICAL T&E, UNCLASSIFIED
SYRINGE........................GLASS & PLASTICS T&E
SYRINGE........................MEDICAL & PSYCHOLOGICAL T&E
SYRINGE, DOSE..................ANIMAL HUSBANDRY T&E
TABARD.........................CLOTHING, OUTERWEAR
TAB-CUTTING MACHINE............PRINTING T&E
TABI...........................CLOTHING, FOOTWEAR
TABLE..........................FURNITURE
     note use only if specific type is unknown; any
          table name may be further subdivided to
          indicate table structure: e.g., TABLE,
          DINING TRESTLE; -,CENTER PEDESTAL; -,COFFEE
          BUTTERFLY
Table, Air.....................METALWORKING T&E
     use  CONCENTRATOR
TABLE, AMALGAMATING............METALWORKING T&E
TABLE, ANIMAL-POWERED..........POWER PRODUCTION T&E
Table, Banquet.................FURNITURE
     use  TABLE, DINING
TABLE, BINDERY.................PRINTING T&E
Table, Butler's................FURNITURE
     use  TABLE, TIER
TABLE, CARD....................FURNITURE
TABLE, CENTER..................FURNITURE
Table, Chair...................FURNITURE
     use  CHAIR-TABLE
TABLE, COFFEE..................FURNITURE
TABLE, CORNER..................FURNITURE
TABLE, DINING..................FURNITURE
TABLE, DISPLAY.................MERCHANDISING T&E
```

```
TABLE, DRAFTING................DRAFTING T&E
TABLE, DRESSING................FURNITURE
     note use for a small table or stand with drawers
          or compartments mounted on legs which may
          sometimes have an attached mirror
     rt   DRESSING CASE
Table, Drop-leaf...............FURNITURE
     use  more specific term: e.g., TABLE, DINING
TABLE, DRUM....................FURNITURE
Table, End.....................FURNITURE
     use  more specific term: e.g., TABLE, WRITING;
          TABLE, CORNER
TABLE, ETCHING.................PRINTING T&E
TABLE, FLOW....................CHEMICAL T&E
TABLE, GAME....................FURNITURE
TABLE, GARDEN..................FURNITURE
TABLE, GROOMING................FURNITURE
TABLE, IMPOSING................PRINTING T&E
TABLE, KITCHEN.................FURNITURE
Table, Kneading................FOOD PROCESSING T&E
     use  TROUGH, DOUGH
TABLE, KNITTING................FURNITURE
TABLE, LAYOUT/STRIPPING........PRINTING T&E
TABLE, LIBRARY.................FURNITURE
TABLE, LIGHT...................PRINTING T&E
TABLE, MESS....................WATER TRANSPORTATION ACCESSORY
TABLE, NESTING.................FURNITURE
TABLE, NIGHT...................FURNITURE
TABLE, PEMBROKE................FURNITURE
TABLE, PICNIC..................FURNITURE
TABLE, PIER....................FURNITURE
TABLE, PLANE...................SURVEYING & NAVIGATIONAL T&E
TABLE, RENT....................FURNITURE
TABLE, SERVING.................FURNITURE
TABLE, SEWING..................FURNITURE
Table, Side....................FURNITURE
     use  more specific term: e.g., TABLE, NIGHT;
          TABLE, TIER
TABLE, SOFA....................FURNITURE
Table, Stacking................FURNITURE
     use  TABLE, NESTING
TABLE, STEAM...................FOOD PROCESSING T&E
TABLE, TEA.....................FURNITURE
     rt   CART, TEA
TABLE, TIER....................FURNITURE
TABLE, TILT-TOP................FURNITURE
TABLE, TRIPOD..................FURNITURE
TABLE, VESTING.................FURNITURE
Table, Work....................FURNITURE
     use  TABLE, SEWING
TABLE, WRITING.................FURNITURE
TABLECLOTH.....................FOOD SERVICE T&E
```

TABLECLOTH SET..................FOOD SERVICE T&E
 note use for a matching set of napkins and
 tablecloth
 rt LUNCHEON SET
TABLE COVER.....................HOUSEHOLD ACCESSORY
Table mat.......................HOUSEHOLD ACCESSORY
 use MAT, TABLE
TABLE RUNNER....................HOUSEHOLD ACCESSORY
TABLESPOON......................FOOD SERVICE T&E
TABLE TENNIS PADDLE.............SPORTS EQUIPMENT
TABLEWARE SET...................FOOD SERVICE T&E
 note use for any matched set of cups, saucers,
 plates, etc.
TABOR...........................MUSICAL T&E, PERCUSSION
TABORET.........................FURNITURE
TABULATING MACHINE..............DATA PROCESSING T&E
TACHISTOSCOPE...................OPTICAL T&E
TACHOMETER......................MECHANICAL T&E
Tachymeter......................SURVEYING & NAVIGATIONAL T&E
 use THEODOLITE or ALIDADE or TRANSIT
Tackle..........................MECHANICAL T&E
 use HOIST
TACKLING DUMMY..................SPORTS EQUIPMENT
TAG, ANIMAL.....................ANIMAL HUSBANDRY T&E
TAG, EAR........................ANIMAL HUSBANDRY T&E
TAG, MERCHANDISE................DOCUMENTARY ARTIFACT
TAILRACE........................UNCLASSIFIED STRUCTURE
TAJ.............................CLOTHING, HEADWEAR
TALISMAN........................PERSONAL SYMBOL
TALLITH.........................PERSONAL SYMBOL
Tally-ho........................LTE, ANIMAL-POWERED
 use COACH, ROAD
Tambour.........................TEXTILEWORKING T&E
 use HOOP, EMBROIDERY
TAMBOURINE......................MUSICAL T&E, PERCUSSION
TAM-O-SHANTER...................CLOTHING, HEADWEAR
 rt BERET
TAMPER..........................CONSTRUCTION T&E
TAM-TAM.........................MUSICAL T&E, PERCUSSION
TANDEM MACHINE..................NUCLEAR PHYSICS T&E
TANK............................LTE, MOTORIZED
Tank, Cooling...................FOOD PROCESSING T&E
 use TANK, MILK STORAGE
Tank, Diver's...................SPORTS EQUIPMENT
 use TANK, SCUBA
TANK, FILM-PROCESSING...........PHOTOGRAPHIC T&E
TANK, LARD-BLEACHING............FOOD PROCESSING T&E
TANK, LARD-RENDERING............FOOD PROCESSING T&E
TANK, LARD-SETTLING.............FOOD PROCESSING T&E
TANK, MEAT-EXTRACT..............FOOD PROCESSING T&E
TANK, SCUBA.....................SPORTS EQUIPMENT

TANK, STORAGE....................FOOD PROCESSING T&E
 note use only if specific product stored is
 unknown
TANKARD.........................FOOD SERVICE T&E
 rt STEIN; GLASS, MALT-BEVERAGE
TANK CAR........................RAIL TRANSPORTATION EQUIPMENT
TANK DESTROYER..................ARMAMENT T&E, ARTILLERY
TANTALUS........................FOOD SERVICE T&E
TAP.............................METALWORKING T&E
 note may be further subdivided to indicate
 specific type: e.g., TAP, BOTTOM; -,PLUG;
 -,TAPER
Tap.............................WOODWORKING T&E
 use SCREW TAP
TAP, FUZE.......................ARMAMENT ACCESSORY
TAP AND DIE SET.................METALWORKING T&E
TAPE............................SOUND COMMUNICATION EQUIPMENT
TAPE, MAGNETIC..................DATA PROCESSING T&E
TAPE, PAPER.....................DATA PROCESSING T&E
Tape, Steel.....................WEIGHTS & MEASURES T&E
 use MEASURE, TAPE or RULE, RETRACTABLE
TAPE CARTRIDGE..................SOUND COMMUNICATION EQUIPMENT
TAPE DECK.......................SOUND COMMUNICATION EQUIPMENT
Taper...........................LIGHTING DEVICE
 use CANDLE
TAPESTRY........................ORIGINAL ART
TAPE UNIT.......................DATA PROCESSING T&E
TAPPING MACHINE.................METALWORKING T&E
TARGET..........................ARMAMENT ACCESSORY
 note may be further subdivided to indicate
 specific type: e.g., TARGET, ARCHERY; -,SKEET
TARGET, GALLERY.................RECREATIONAL DEVICE
TAROGATO........................MUSICAL T&E, WOODWIND
TARPOT..........................LAND TRANSPORTATION ACCESSORY
TASEOMETER......................BIOLOGICAL T&E
TASIMETER.......................METEOROLOGICAL T&E
TATTOO SET......................ANIMAL HUSBANDRY T&E
TAVERN..........................BUILDING
TAXIMETER.......................LAND TRANSPORTATION ACCESSORY
TAZZA...........................FOOD SERVICE T&E
TEA BALL........................FOOD SERVICE T&E
Tea caddy.......................FOOD PROCESSING T&E
 use CADDY
TEACHING MACHINE................DATA PROCESSING T&E
TEACUP..........................FOOD SERVICE T&E
TEAKETTLE.......................FOOD PROCESSING T&E
TEAPOT..........................FOOD SERVICE T&E
Teasel frame....................TEXTILEWORKING T&E
 use NAPPER
Teasel gig......................TEXTILEWORKING T&E
 use NAPPING GIG
TEA SERVICE.....................FOOD SERVICE T&E

```
Tea set.......................FOOD SERVICE T&E
     use   TEA SERVICE
TEASLE CROSS..................TEXTILEWORKING T&E
TEASPOON......................FOOD SERVICE T&E
TEDDER, HAY...................AGRICULTURAL T&E
Teeter-totter.................RECREATIONAL DEVICE
     use   SEESAW
TEINOSCOPE....................OPTICAL T&E
TELEGRAM......................DOCUMENTARY ARTIFACT
TELEGRAPH KEY.................TELECOMMUNICATION EQUIPMENT
TELENGISCOPE..................ASTRONOMICAL T&E
TELEPHONE.....................TELECOMMUNICATION EQUIPMENT
TELEPOLARISCOPE...............ASTRONOMICAL T&E
TELEPRINTER...................DATA PROCESSING T&E
TELESCOPE.....................ASTRONOMICAL T&E
TELESCOPE.....................OPTICAL T&E
TELESCOPE, ACHROMATIC.........ASTRONOMICAL T&E
TELESCOPE, CASSEGRAIN.........ASTRONOMICAL T&E
TELESCOPE, EQUATORIAL.........ASTRONOMICAL T&E
TELESCOPE, GALILEAN...........ASTRONOMICAL T&E
TELESCOPE, ORBITING...........ASTRONOMICAL T&E
TELESCOPE, RADIO..............ASTRONOMICAL T&E
TELESCOPE, REFLECTING.........ASTRONOMICAL T&E
     note use only if specific type is unknown: e.g.,
          TELESCOPE, CASSEGRAIN
TELESCOPE, REFRACTING.........ASTRONOMICAL T&E
     note use only if specific type is unknown: e.g.,
          TELESCOPE, ACHROMATIC; TELESCOPE, GALILEAN
Telescope, Schmidt............ASTRONOMICAL T&E
     use   CAMERA, SCHMIDT
TELESCOPE, SOLAR..............ASTRONOMICAL T&E
TELESCOPE, SPOTTING...........ARMAMENT ACCESSORY
Telescoping platform..........LTE, MOTORIZED
     use   ELEVATING PLATFORM
TELESPECTROSCOPE..............ASTRONOMICAL T&E
Telethermometer...............THERMAL T&E
     use   PYROMETER
TELEVISION....................TELECOMMUNICATION EQUIPMENT
     note use for any instrument used for the
          reception of both audio and video messages
TELLTALE......................WATER TRANSPORTATION ACCESSORY
TELPHER.......................LTE, MOTORIZED
TEMPLATE......................METALWORKING T&E
TEMPLATE......................WOODWORKING T&E
     rt    PATTERN
TEMPLATE, DENTAL..............MEDICAL & PSYCHOLOGICAL T&E
TEMPLE........................BUILDING
TEMPLE........................TEXTILEWORKING T&E
TENACULUM.....................MEDICAL & PSYCHOLOGICAL T&E
TENDER........................RAIL TRANSPORTATION EQUIPMENT
TENDER, BUOY..................WATER TRANSPORTATION EQUIPMENT
TENDER, SUBMARINE.............WATER TRANSPORTATION EQUIPMENT
```

```
TENDER, YACHT....................WATER TRANSPORTATION EQUIPMENT
     rt   DINGHY
TENNIS BALL.....................SPORTS EQUIPMENT
TENNIS PADDLE...................SPORTS EQUIPMENT
TENNIS RACKET...................SPORTS EQUIPMENT
TENONING MACHINE................WOODWORKING T&E
TENOROON........................MUSICAL T&E, WOODWIND
Tenpin..........................SPORTS EQUIPMENT
     use  BOWLING PIN
TENSIMETER......................MECHANICAL T&E
TENSIOMETER.....................MECHANICAL T&E
TENT............................BUILDING
TENTER FRAME....................TEXTILEWORKING T&E
TEPEE...........................BUILDING
TERMINAL........................BUILDING
     rt   DEPOT
TERMINAL........................DATA PROCESSING T&E
     note may be further subdivided to indicate
          specific type: e.g., TERMINAL, CRT;
          -,TYPEWRITER; -,MAGNETIC-TAPE
TERRY LOOP MACHINE..............TEXTILEWORKING T&E
TEST, COLOR-PERCEPTION..........MEDICAL & PSYCHOLOGICAL T&E
TESTER, ACIDITY.................FOOD PROCESSING T&E
Tester, Babcock.................FOOD PROCESSING T&E
     use  TESTER, MILK
TESTER, BURST...................TEXTILEWORKING T&E
TESTER, CIRCUIT.................ELECTRICAL & MAGNETIC T&E
TESTER, COLOR-SENSE.............MEDICAL & PSYCHOLOGICAL T&E
TESTER, CRIMP...................TEXTILEWORKING T&E
TESTER, FINENESS................CHEMICAL T&E
TESTER, FINENESS................TEXTILEWORKING T&E
TESTER, FIRE-RESISTANCE.........TEXTILEWORKING T&E
TESTER, HOOF....................ANIMAL HUSBANDRY T&E
TESTER, MILK....................FOOD PROCESSING T&E
TESTER, MULLEN..................PAPERMAKING T&E
TESTER, NEP.....................TEXTILEWORKING T&E
TESTER, OVERRUN.................FOOD PROCESSING T&E
TESTER, POWDER..................ARMAMENT ACCESSORY
TESTER, SCHOPPER................PAPERMAKING T&E
TESTER, SCORCH..................TEXTILEWORKING T&E
TESTER, SEDIMENT................FOOD PROCESSING T&E
TESTER, SHRINKAGE...............TEXTILEWORKING T&E
TESTER, SLIVER..................TEXTILEWORKING T&E
TESTER, SOUNDNESS...............CHEMICAL T&E
TESTER, TEAR....................TEXTILEWORKING T&E
TESTER, TUBE....................ELECTRICAL & MAGNETIC T&E
TESTER, TWIST...................TEXTILEWORKING T&E
TESTER, WASHFASTNESS............TEXTILEWORKING T&E
TESTING EQUIPMENT...............TEXTILEWORKING T&E
     note use only if specific type is unknown: e.g.,
          TESTER, NEP; FADEOMETER
TEST-SCORING DEVICE.............DATA PROCESSING T&E
```

```
TESTUDO.........................ARMAMENT ACCESSORY
TETANOMETER.....................MEDICAL & PSYCHOLOGICAL T&E
Tete-a-tete.....................FURNITURE
     use  SOFA, CONVERSATIONAL
TETHERBALL......................SPORTS EQUIPMENT
Tetrahedron.....................ARMAMENT ACCESSORY
     use  CALTROP
TEXTILE FRAGMENT................ARTIFACT REMNANT
     rt   BOLT, CLOTH; SALES SAMPLE, CLOTH; QUILT PIECE
TEXTURING MACHINE, AIR JET......TEXTILEWORKING T&E
TEXTURING MACHINE, STEAM JET....TEXTILEWORKING T&E
THAUMATROPE.....................MEDICAL & PSYCHOLOGICAL T&E
THAUMATROPE.....................TOY
THEATER.........................BUILDING
THEODOLITE......................SURVEYING & NAVIGATIONAL T&E
     rt   TRANSIT
THEOROBO........................MUSICAL T&E, STRINGED
     rt   LUTE
THEREMIN........................MUSICAL T&E, UNCLASSIFIED
THERMOAMMETER...................ELECTRICAL & MAGNETIC T&E
THERMOCOUPLE....................THERMAL T&E
THERMOGRAPH.....................THERMAL T&E
THERMOHYDROMETER................THERMAL T&E
THERMOMETER.....................FOOD PROCESSING T&E
     note may be further subdivided to indicate
          specific type: e.g., THERMOMETER, MEAT:
          -,MILK; -,CANDY
THERMOMETER.....................MEDICAL & PSYCHOLOGICAL T&E
THERMOMETER.....................METEOROLOGICAL T&E
THERMOMETER.....................PHOTOGRAPHIC T&E
THERMOMETER, INCUBATOR..........ANIMAL HUSBANDRY T&E
THERMOMETOGRAPH.................THERMAL T&E
THERMOMULTIPLIER................THERMAL T&E
THERMOSCOPE.....................THERMAL T&E
THERMOSTAT......................THERMAL T&E
THICKENING MACHINE..............PAPERMAKING T&E
THIMBLE.........................TEXTILEWORKING T&E
THOLIA..........................CLOTHING, HEADWEAR
THONG...........................CLOTHING, FOOTWEAR
THREAD COUNTER..................TEXTILEWORKING T&E
THREADER........................TEXTILEWORKING T&E
THREADING MACHINE, PIPE.........METALWORKING T&E
Thresher, Groundhog.............AGRICULTURAL T&E
     use  THRESHING MACHINE
Thresher, Peanut................AGRICULTURAL T&E
     use  THRESHING MACHINE
Thresher, Portable..............AGRICULTURAL T&E
     use  THRESHER/SEPARATOR
Thresher, Simple................AGRICULTURAL T&E
     use  THRESHING MACHINE
Thresher, Stationary............AGRICULTURAL T&E
     use  THRESHER/SEPARATOR
```

```
THRESHER/SEPARATOR.............AGRICULTURAL T&E
THRESHING MACHINE.............AGRICULTURAL T&E
THROAT PROTECTOR..............ARMAMENT ACCESSORY
THROSTLE FRAME................TEXTILEWORKING T&E
     note may be further subdivided to indicate
            specific type: e.g., THROSTLE FRAME,
            DRAWING; -,SLUBBING; -,ROVING
THROWING MACHINE..............TEXTILEWORKING T&E
THUMBSCREW....................BEHAVIORAL CONTROL DEVICE
THUMBSTALL....................ARMAMENT ACCESSORY
THURIBLE......................CEREMONIAL ARTIFACT
     rt   CENSER
TIARA.........................ADORNMENT
TICKET........................EXCHANGE MEDIUM
TIDDLYWINK SET................GAME
Tidy..........................HOUSEHOLD ACCESSORY
     use  ANTIMACASSAR
TIE, BOW......................CLOTHING ACCESSORY
TIE, CATTLE...................ANIMAL HUSBANDRY T&E
Tie, Neck.....................CLOTHING ACCESSORY
     use  NECKTIE
TIE, SLEEPERS.................MINING T&E
TIE, STRING...................CLOTHING ACCESSORY
TIEBACK.......................WINDOW OR DOOR COVERING
TIE CLIP......................CLOTHING ACCESSORY
Tiepin........................CLOTHING ACCESSORY
     use  STICKPIN
Tier, Corn....................AGRICULTURAL T&E
     use  TIER, CORN-SHOCK
Tier, Corn-fodder.............AGRICULTURAL T&E
     use  TIER, CORN-SHOCK
TIER, CORN-SHOCK..............AGRICULTURAL T&E
TIERING MACHINE...............CONSTRUCTION T&E
TIE TACK......................CLOTHING ACCESSORY
TIGHTS........................CLOTHING, OUTERWEAR
TIKI..........................CEREMONIAL ARTIFACT
TILBURY.......................LTE, ANIMAL-POWERED
TILE..........................BUILDING FRAGMENT
Till..........................MERCHANDISING T&E
     use  BOX, MONEY
TILLER........................MINING T&E
TILLER, GARDEN ROTARY.........AGRICULTURAL T&E
TILLER, ROTARY................AGRICULTURAL T&E
TIMBER SET....................MINING T&E
TIMER, DARKROOM...............PHOTOGRAPHIC T&E
TIMER, KITCHEN................FOOD PROCESSING T&E
TIMETABLE.....................DOCUMENTARY ARTIFACT
TIMPANUM......................MUSICAL T&E, PERCUSSION
TIN...........................PRODUCT PACKAGE
TINDERBOX.....................TEMPERATURE CONTROL DEVICE
TINDERBOX.....................ARMAMENT ACCESSORY
TINDERBOX, POCKET.............ARMAMENT ACCESSORY
```

```
TINDERPISTOL....................TEMPERATURE CONTROL DEVICE
Tinker toys.....................TOY
     use  CONSTRUCTION SET, WOODEN
TINTOMETER......................TEXTILEWORKING T&E
TINTYPE.........................DOCUMENTARY ARTIFACT
TIP, GILDER'S...................PAINTING T&E
TIPPING MACHINE.................PRINTING T&E
TIRE-BENDING MACHINE............METALWORKING T&E
TITHONOMETER....................CHEMICAL T&E
TITRATOR........................CHEMICAL T&E
TITROMETER......................CHEMICAL T&E
TIVOLI..........................GAME
TOASTER.........................FOOD PROCESSING T&E
TOBOGGAN........................SPORTS EQUIPMENT
Toddy stick.....................FOOD SERVICE T&E
     use  SWIZZLE STICK
TOGA............................CLOTHING, OUTERWEAR
     rt   ABA; CAFTAN
Toggle bead.....................PERSONAL GEAR
     use  NETSUKE
TOGGLING FRAME..................LEATHERWORKING T&E
TOILET..........................PLUMBING FIXTURE
TOILET SET......................HOUSEHOLD ACCESSORY
TOKEN, STORE....................EXCHANGE MEDIUM
     rt   CARD, STORE
TOKEN, TRANSPORTATION...........EXCHANGE MEDIUM
TOMAHAWK........................ARMAMENT T&E, EDGED
TOMBSTONE.......................CEREMONIAL ARTIFACT
TOM TOM.........................MUSICAL T&E, PERCUSSION
TONGING BOAT, CHESAPEAKE BAY....WATER TRANSPORTATION EQUIPMENT
TONGS...........................CHEMICAL T&E
     note may be further subdivided to indicate
          specific type: e.g., TONGS, FLASK; -,BEAKER;
          -,MERCURY; -,CASSEROLE; -,UTILITY
TONGS...........................FORESTRY T&E
TONGS...........................METALWORKING T&E
     note use only if specific type is unknown
Tongs, Anvil....................METALWORKING T&E
     use  TONGS, PICKUP
TONGS, ASPARAGUS................FOOD SERVICE T&E
TONGS, BENDING..................METALWORKING T&E
TONGS, BOLT.....................METALWORKING T&E
     rt   TONGS, HOLLOW-BIT; TONGS, ROUND-LIP
TONGS, BOX......................METALWORKING T&E
     rt   TONGS, DOUBLE BOX
TONGS, BOX HAMMER...............METALWORKING T&E
     rt   TONGS, HAMMER
TONGS, BRAZING..................METALWORKING T&E
TONGS, CHAIN....................METALWORKING T&E
TONGS, CLAM.....................FISHING & TRAPPING T&E
TONGS, CLINCHING................ANIMAL HUSBANDRY T&E
TONGS, CLIP.....................METALWORKING T&E
```

```
TONGS, CROOK-BIT................METALWORKING T&E
     rt   TONGS, SIDE
TONGS, DIPPING..................GLASS & PLASTICS T&E
TONGS, DOUBLE BOX...............METALWORKING T&E
     rt   TONGS, BOX
TONGS, DRAWING..................METALWORKING T&E
TONGS, DROP HAMMER FORGING......METALWORKING T&E
Tongs, Eye......................METALWORKING T&E
     use  TONGS, HAMMER
Tongs, Farrier's................ANIMAL HUSBANDRY T&E
     use  more specific term: e.g., TONGS, CLINCHING;
          TONGS, SHOE-SPREADING
TONGS, FIREPLACE................TEMPERATURE CONTROL DEVICE
TONGS, FLAT.....................METALWORKING T&E
TONGS, GAD......................METALWORKING T&E
TONGS, HALF-ROUND...............METALWORKING T&E
TONGS, HAMMER...................METALWORKING T&E
     rt   TONGS, BOX HAMMER
TONGS, HOLLOW-BIT...............METALWORKING T&E
     rt   TONGS, BOLT; TONGS, ROUND-LIP
TONGS, HOOP.....................METALWORKING T&E
TONGS, ICE......................FOOD SERVICE T&E
TONGS, ICE......................UNCLASSIFIED T&E, SPECIAL
TONGS, LOADING..................ARMAMENT ACCESSORY
TONGS, NAIL.....................METALWORKING T&E
TONGS, OYSTER...................FISHING & TRAPPING T&E
TONGS, PICKUP...................METALWORKING T&E
     note may be further subdivided to indicate
          specific type: e.g., TONGS, PICKUP-SINGLE;
          -,PICKUP-LIGHT; -,PICKUP-DOUBLE
TONGS, PINCER...................METALWORKING T&E
TONGS, RAKU.....................GLASS & PLASTICS T&E
Tongs, Right-angle bit..........METALWORKING T&E
     use  TONGS, SIDE
TONGS, ROCKET...................ARMAMENT ACCESSORY
TONGS, ROOFING..................METALWORKING T&E
TONGS, ROUND-LIP................METALWORKING T&E
     rt   TONGS, BOLT; TONGS, HOLLOW-BIT
TONGS, SANDWICH.................FOOD SERVICE T&E
TONGS, SHOE.....................METALWORKING T&E
TONGS, SHOE-SPREADING...........ANIMAL HUSBANDRY T&E
TONGS, SIDE.....................METALWORKING T&E
     rt   TONGS, CROOK-BIT
TONGS, SKIDDING.................FORESTRY T&E
Tongs, Straight-lip.............METALWORKING T&E
     use  TONGS, FLAT
TONGS, SUGAR....................FOOD SERVICE T&E
TONGS, TIRE.....................METALWORKING T&E
TONGS, TIRE-PULLING.............METALWORKING T&E
Tongs, V-lip....................METALWORKING T&E
     use  TONGS, HOLLOW-BIT
TONG TOOL.......................ARMAMENT ACCESSORY
```

```
TONGUE-AND-GROOVE MACHINE......WOODWORKING T&E
TONOMETER......................ACOUSTICAL T&E
TONOMETER......................MECHANICAL T&E
TONOMETER......................MEDICAL & PSYCHOLOGICAL T&E
TONOSCOPE......................ACOUSTICAL T&E
TONSILLOTOME...................MEDICAL & PSYCHOLOGICAL T&E
TOOL BOARD.....................GLASS & PLASTICS T&E
TOOL KIT.......................LAND TRANSPORTATION ACCESSORY
     note may be further subdivided to indicate
          specific type: e.g., TOOL KIT, BICYCLE
TOOTHBRUSH.....................TOILET ARTICLE
Tooth key......................ANIMAL HUSBANDRY T&E
     use SPECULUM, ANIMAL
TOOTHPICK......................TOILET ARTICLE
TOP............................TOY
     rt  DIABOLO
TOP, BOWSTRING.................TOY
TOP, GYROSCOPE.................TOY
TOP, INERTIA...................MECHANICAL T&E
TOP, PEG.......................TOY
TOP, WHIP......................TOY
Topcoat........................CLOTHING, OUTERWEAR
     use OVERCOAT
Topee..........................CLOTHING, HEADWEAR
     use HELMET, PITH
TOPOGRAPHIC MODEL..............DOCUMENTARY ARTIFACT
TOPOPHONE......................ACOUSTICAL T&E
TOPPER, HORNWORKER'S...........UNCLASSIFIED T&E, SPECIAL
TOQUE..........................CLOTHING, HEADWEAR
TORAH, SEPHER..................CEREMONIAL ARTIFACT
TORCH..........................METALWORKING T&E
     note may be further subdivided according to fuel
          used: e.g., TORCH, ACETYLENE; -,PROPANE;
          -,GASOLINE; -,KEROSINE; -,OXYACETYLENE;
          -,OXYHYDROGEN
Torchere.......................FURNITURE
     use CANDLESTAND
TORPEDO........................ARMAMENT T&E, AMMUNITION
TORPEDO........................MINING T&E
TORPEDO, AERIAL................ARMAMENT T&E, AMMUNITION
TOTEM..........................CEREMONIAL ARTIFACT
TOTEM POLE.....................CEREMONIAL ARTIFACT
Toupee.........................ADORNMENT
     use HAIRPIECE
TOURNIQUET, JUGULAR-VEIN.......ANIMAL HUSBANDRY T&E
TOWEL, BATH....................TOILET ARTICLE
TOWEL, BEACH...................TOILET ARTICLE
TOWEL, DISH....................FOOD PROCESSING T&E
TOWEL, FACE....................TOILET ARTICLE
TOWEL, FINGERTIP...............TOILET ARTICLE
TOWEL, HAND....................TOILET ARTICLE
TOWER..........................BUILDING FRAGMENT
```

TOWER...................................UNCLASSIFIED STRUCTURE
 note may be further subdivided to indicate
 specific type: e.g., TOWER, TRANSMITTING;
 -,WATER; -,OBSERVATION
TOWER, BELL........................BUILDING FRAGMENT
TOWER, CONTROL.....................BUILDING
TOWN HALL..........................BUILDING
Toy soldier........................TOY
 use FIGURE
TRACER.............................GLASS & PLASTICS T&E
TRACER, CURVE......................DRAFTING T&E
TRACK SECTION......................RAIL TRANSPORTATION ACCESSORY
TRACTOR............................CONSTRUCTION T&E
TRACTOR, ARTILLERY.............LTE, MOTORIZED
TRACTOR, FARM..................AGRICULTURAL T&E
TRACTOR, GARDEN................AGRICULTURAL T&E
Trade card.........................ADVERTISING MEDIUM
 use CARD, TRADE
TRAILER............................LTE, MOTORIZED
 rt SEMITRAILER
TRAILER, BOAT..................LTE, MOTORIZED
TRAILER, FARM..................AGRICULTURAL T&E
TRAILER, HOUSE.................LTE, MOTORIZED
Trailer, Tractor-drawn.........AGRICULTURAL T&E
 use TRAILER, FARM
TRAIN..............................RAIL TRANSPORTATION EQUIPMENT
 note use only when cataloging a complete rail
 unit of locomotive(s) and cars
TRAM...............................MINING T&E
Tram...............................RAIL TRANSPORTATION EQUIPMENT
 use STREETCAR
TRAMMEL............................FOOD PROCESSING T&E
Trammel points.....................DRAFTING T&E
 use COMPASS, BEAM
TRAMPOLINE.........................SPORTS EQUIPMENT
TRANSCEIVER........................TELECOMMUNICATION EQUIPMENT
 note use for any instrument that permits
 transmission and reception of audio messages
TRANSFORMER........................ELECTRICAL & MAGNETIC T&E
TRANSFORMER........................POWER PRODUCTION T&E
TRANSFORMER, IMPEDENCE.........ELECTRICAL & MAGNETIC T&E
TRANSISTOR.........................ELECTRICAL & MAGNETIC T&E
TRANSIT............................SURVEYING & NAVIGATIONAL T&E
 rt THEODOLITE
TRANSMITTER........................TELECOMMUNICATION EQUIPMENT
 note may be further subdivided to indicate
 specific type: e.g., TRANSMITTER, RADIO;
 -,TELEVISION
TRANSMITTER, SOUND.............ACOUSTICAL T&E
TRANSPARENCY, LANTERN-SLIDE....DOCUMENTARY ARTIFACT
TRANSPARENCY, ROLL-FILM........DOCUMENTARY ARTIFACT
TRANSPARENCY, SLIDE............DOCUMENTARY ARTIFACT

TRANSPLANTER, HAND..............AGRICULTURAL T&E
TRANSPLANTING MACHINE..........AGRICULTURAL T&E
 note may be further subdivided to indicate
 specific crop transplanted: e.g.,
 TRANSPLANTING MACHINE, TOBACCO
TRANSPORT......................WATER TRANSPORTATION EQUIPMENT
TRAP...........................ARMAMENT ACCESSORY
TRAP...........................FISHING & TRAPPING T&E
 note may be further subdivided to indicate
 specific type: e.g., TRAP, BEAR; -,BEAVER;
 -,MOLE
TRAP...........................LTE, ANIMAL-POWERED
TRAP, BULLET...................ARMAMENT ACCESSORY
Trap, Cartridge................ARMAMENT ACCESSORY
 use TRAP, BULLET
TRAP, CRAB.....................FISHING & TRAPPING T&E
TRAP, FISH.....................FISHING & TRAPPING T&E
 rt NET, POUND; POT, FISH
TRAP, HAND.....................ARMAMENT ACCESSORY
Trap, Lobster..................FISHING & TRAPPING T&E
 use POT, LOBSTER
Trap, Mouse....................HOUSEHOLD ACCESSORY
 use MOUSETRAP
Trapeze........................PUBLIC ENTERTAINMENT DEVICE
 use AERIAL RIGGING
TRAPEZE........................RECREATIONAL DEVICE
TRAVELER.......................METALWORKING T&E
TRAVOIS........................LTE, ANIMAL-POWERED
 rt LITTER
Trawl..........................FISHING & TRAPPING T&E
 use LONGLINE or NET, TRAWL
Trawler........................WATER TRANSPORTATION EQUIPMENT
 use FISHERMAN
TRAY...........................UNCLASSIFIED CONTAINER
 note use for a flat or nearly flat BOWL; includes
 forms customarily referred to as saucers,
 platters, plates, etc.; normally subdivided
 to show ceramic or basketry construction;
 see also BOWL and JAR
TRAY, BALL.....................ARMAMENT ACCESSORY
TRAY, BED......................FOOD SERVICE T&E
TRAY, BREAD....................FOOD SERVICE T&E
Tray, Calling card.............HOUSEHOLD ACCESSORY
 use CARD RECEIVER
TRAY, CEREMONIAL...............CEREMONIAL ARTIFACT
TRAY, CUT-OFF..................GLASS & PLASTICS T&E
TRAY, DENTAL ACCESSORY.........MEDICAL & PSYCHOLOGICAL T&E
TRAY, DRESSER..................TOILET ARTICLE
TRAY, GAMBLING.................GAME
TRAY, ORE......................MINING T&E
TRAY, PEN......................WRITTEN COMMUNICATION EQUIPMENT
TRAY, PIN......................TEXTILEWORKING T&E

```
TRAY, PRINT-PROCESSING.........PHOTOGRAPHIC T&E
TRAY, SERVING..................FOOD SERVICE T&E
TRAY, SPOON....................FOOD SERVICE T&E
TREAD, ANIMAL-POWERED..........POWER PRODUCTION T&E
TREAD, HUMAN-POWERED...........POWER PRODUCTION T&E
Treadmill......................POWER PRODUCTION T&E
      use  TREAD, ANIMAL-POWERED or TREAD, HUMAN-POWERED
TREBUCKET......................ARMAMENT T&E, ARTILLERY
Trechometer....................SURVEYING & NAVIGATIONAL T&E
      use  ODOMETER
TREENAIL.......................WOODWORKING T&E
      rt   PEG; DOWEL
TREENAILING MACHINE............WOODWORKING T&E
TRELLIS........................SITE FEATURE
Trenail........................WOODWORKING T&E
      use  TREENAIL
Trencher.......................FOOD SERVICE T&E
      use  PLATTER
TRENCHING MACHINE..............CONSTRUCTION T&E
TRENCHING MACHINE, ROTARY......CONSTRUCTION T&E
TREPHINE.......................MEDICAL & PSYCHOLOGICAL T&E
TRESTLE........................UNCLASSIFIED STRUCTURE
      rt   BRIDGE
TRIANGLE.......................DRAFTING T&E
TRIANGLE.......................MUSICAL T&E, PERCUSSION
Tribometer.....................MECHANICAL T&E
      use  DYNAMOMETER
TRICYCLE.......................LTE, HUMAN-POWERED
TRICYCLE.......................TOY
TRICYCLE, GASOLINE.............LTE, MOTORIZED
Tricycle, Side-by-side.........LTE, HUMAN-POWERED
      use  SOCIABLE
TRICYCLE, STEAM................LTE, MOTORIZED
TRICYCLE, TANDEM...............LTE, HUMAN-POWERED
TRICYCLE, TWO-TRACK............LTE, HUMAN-POWERED
Trier, Butter..................FOOD PROCESSING T&E
      use  TRIER, CHEESE
TRIER, CHEESE..................FOOD PROCESSING T&E
TRIGGER SHOE...................ARMAMENT ACCESSORY
TRIMARAN.......................WATER TRANSPORTATION EQUIPMENT
TRIMMER........................PAPERMAKING T&E
TRIMMER, BRACKET...............PAPERMAKING T&E
TRIMMER, EAR...................ANIMAL HUSBANDRY T&E
TRIMMER, GINGIVAL..............MEDICAL & PSYCHOLOGICAL T&E
TRIMMER, HORSE-HOOF............ANIMAL HUSBANDRY T&E
TRIMMER, OX-HOOF...............ANIMAL HUSBANDRY T&E
TRIMMING MACHINE...............WOODWORKING T&E
TRIMMING MACHINE, BOOK.........PRINTING T&E
TRIP-HAMMER....................METALWORKING T&E
TRIP-HAMMER....................PAPERMAKING T&E
Triple.........................LTE, MOTORIZED
      use  more specific term: e.g., TRUCK,
           PUMPER/LADDER
```

481

```
TRIPOD..........................ARMAMENT ACCESSORY
TRIPOD..........................CHEMICAL T&E
TRIPOD..........................MINING T&E
TRIPOD..........................PHOTOGRAPHIC T&E
Triptych........................CEREMONIAL ARTIFACT
    use  ALTARPIECE
TRIVET..........................FOOD SERVICE T&E
TRIVET..........................HOUSEKEEPING T&E
TROCAR..........................ANIMAL HUSBANDRY T&E
Trolley.........................RAIL TRANSPORTATION EQUIPMENT
    use  STREETCAR, ELECTRIC
Trolley, Trackless..............LTE, ANIMAL-POWERED
    use  OMNIBUS
TROMBONE........................MUSICAL T&E, BRASS
TROMBONE, VALVE.................MUSICAL T&E, BRASS
TROMOMETER......................METEOROLOGICAL T&E
Trophy..........................PERSONAL SYMBOL
    use  CUP, LOVING; STATUETTE TROPHY or other
         object name from lexicon (e.g., TRAY,
         SERVING)
TROPOSTEREOSCOPE................MEDICAL & PSYCHOLOGICAL T&E
TROUGH, DOUGH...................FOOD PROCESSING T&E
Trough, Feed....................ANIMAL HUSBANDRY T&E
    use  FEEDER, LIVESTOCK
TROUGH, MEAT-SALTING............FOOD PROCESSING T&E
TROUGH, MIXING..................MASONRY T&E
TROUGH, PNEUMATIC...............CHEMICAL T&E
Trough, Poultry water...........ANIMAL HUSBANDRY T&E
    use  WATERER, POULTRY
Trough, Scalding................FOOD PROCESSING T&E
    use  SCALDER, HOG
Trough, Watering................ANIMAL HUSBANDRY T&E
    use  WATERER, LIVESTOCK
Trousers........................CLOTHING, OUTERWEAR
    use  PANTS
TROWEL..........................MASONRY T&E
    note may be further subdivided to indicate
         specific type: e.g., TROWEL, POINTING;
         -,SMOOTHING; -,GROUTING
TROWEL, GARDEN..................AGRICULTURAL T&E
Trowel, Nursery.................AGRICULTURAL T&E
    use  TROWEL, GARDEN
TRUCK...........................LTE, MOTORIZED
TRUCK, AERIAL LADDER............LTE, MOTORIZED
Truck, Bag-holder...............FOOD PROCESSING T&E
    use  HOLDER, BAG
TRUCK, CRASH....................LTE, MOTORIZED
    rt  AMBULANCE
Truck, Delivery.................LTE, MOTORIZED
    use  specific body type: e.g., TRUCK, DUMP;
         -,PANEL; -,TANK
TRUCK, DUMP.....................LTE, MOTORIZED
```

```
TRUCK, FLATBED...................LTE, MOTORIZED
TRUCK, HOOK-AND-LADDER..........LTE, MOTORIZED
Truck, Ladder...................LTE, MOTORIZED
     use  TRUCK, HOOK-AND-LADDER
TRUCK, LIGHTING.................LTE, MOTORIZED
TRUCK, ORDNANCE WORKSHOP........LTE, MOTORIZED
TRUCK, PANEL....................LTE, MOTORIZED
TRUCK, PICKUP...................LTE, MOTORIZED
TRUCK, PUMPER...................LTE, MOTORIZED
TRUCK, PUMPER/AERIAL LADDER.....LTE, MOTORIZED
TRUCK, PUMPER/LADDER............LTE, MOTORIZED
TRUCK, SMOKE EJECTOR............LTE, MOTORIZED
TRUCK, STAKE....................LTE, MOTORIZED
TRUCK, TANK.....................LTE, MOTORIZED
TRUCK, TOW......................LTE, MOTORIZED
TRUCK, TROOP....................LTE, MOTORIZED
TRUCK TRACTOR...................LTE, MOTORIZED
TRUMPET, CURVED.................MUSICAL T&E, BRASS
TRUMPET, FIREMAN'S..............SOUND COMMUNICATION EQUIPMENT
TRUMPET, KEY....................MUSICAL T&E, BRASS
TRUMPET, NATURAL................MUSICAL T&E, BRASS
TRUMPET, SLIDE..................MUSICAL T&E, BRASS
TRUMPET, VALVE..................MUSICAL T&E, BRASS
TRUMPET MARINE..................MUSICAL T&E, STRINGED
TRUNDLE TOY.....................TOY
TRUNK...........................PERSONAL GEAR
Trunnel.........................WOODWORKING T&E
     use  TREENAIL
TRUNNION........................ARMAMENT ACCESSORY
TRUSS...........................PERSONAL GEAR
T-SHIRT.........................CLOTHING, OUTERWEAR
T-SQUARE........................DRAFTING T&E
TUB.............................PRODUCT PACKAGE
Tub, Ball-holder's..............GLASS & PLASTICS T&E
     use  TUB, IRON-COOLING
TUB, IRON-COOLING...............GLASS & PLASTICS T&E
TUB, LAUNDRY....................PLUMBING FIXTURE
TUB, SLACK......................METALWORKING T&E
TUBA............................MUSICAL T&E, BRASS
TUBE............................CHEMICAL T&E
     note may be further subdivided to indicate
          specific type: e.g., TUBE, CENTRIFUGE;
          -,COMBUSTION; -,CULTURE; -,TEST
TUBE............................PRODUCT PACKAGE
TUBE, CULTURE...................BIOLOGICAL T&E
TUBE, MILK......................FOOD PROCESSING T&E
TUBE, QUINCKE'S.................ACOUSTICAL T&E
TUBE, STOMACH...................MEDICAL & PSYCHOLOGICAL T&E
Tube, Teat......................FOOD PROCESSING T&E
     use  TUBE, MILK
TUBE, VACUUM....................ELECTRICAL & MAGNETIC T&E
```

```
TUBING.............................CHEMICAL T&E
      note may be further subdivided to indicate
           specific type: e.g., TUBING, ADAPTER
TUFTING MACHINE...................TEXTILEWORKING T&E
TUG-TOWBOAT.......................WATER TRANSPORTATION EQUIPMENT
TUMBLER...........................FOOD SERVICE T&E
TUNGSTEN ROD......................GLASS & PLASTICS T&E
TUNIC.............................CLOTHING, OUTERWEAR
TUNING FORK.......................ACOUSTICAL T&E
TUNNEL............................RECREATIONAL DEVICE
TURBAN............................CLOTHING, HEADWEAR
TURBIDIMETER......................MECHANICAL T&E
TURBINE, HYDRAULIC................POWER PRODUCTION T&E
TURBINE, IMPULSE..................POWER PRODUCTION T&E
TURBINE, INTERNAL-COMBUSTION...POWER PRODUCTION T&E
TURBINE, STEAM....................POWER PRODUCTION T&E
Turbine, Tub......................POWER PRODUCTION T&E
      use  WATERWHEEL, TUB
TUREEN............................FOOD SERVICE T&E
TURNBUCKLE........................MECHANICAL T&E
Turning box.......................WOODWORKING T&E
      use  MOLDING BOX
TURNING MACHINE...................METALWORKING T&E
TURNING TOOL......................GLASS & PLASTICS T&E
TURNSTILE.........................MERCHANDISING T&E
TURNTABLE.........................SOUND COMMUNICATION EQUIPMENT
TURRET............................BUILDING FRAGMENT
TURRET, MACHINE GUN...............ARMAMENT ACCESSORY
Tus...............................PERSONAL GEAR
      use  CANTEEN
Tutu..............................CLOTHING, OUTERWEAR
      use  COSTUME, DANCE
TUXEDO............................CLOTHING, OUTERWEAR
TWEEZERS..........................TOILET ARTICLE
TWEEZERS..........................GLASS & PLASTICS T&E
TWIBIL............................WOODWORKING T&E
TWINNING MACHINE, HORNWORKER'S
      ............................UNCLASSIFIED T&E, SPECIAL
TWISTER...........................TEXTILEWORKING T&E
TWISTER, NOSE.....................ANIMAL HUSBANDRY T&E
TWISTING FRAME....................TEXTILEWORKING T&E
Twitch, Nose......................ANIMAL HUSBANDRY T&E
      use  TWISTER, NOSE
TYG...............................FOOD SERVICE T&E
TYING-IN MACHINE..................TEXTILEWORKING T&E
TYPE..............................PRINTING T&E
TYPE-CASTING MACHINE..............PRINTING T&E
TYPESETTER, COMPUTER..............PRINTING T&E
TYPESETTER, KEYBOARD..............PRINTING T&E
Typesetter, Linotype..............PRINTING T&E
      use  TYPESETTER, KEYBOARD
Typesetter, Monotype..............PRINTING T&E
      use  TYPESETTER, KEYBOARD
```

Typesetter, Photo................PRINTING T&E
 use PHOTOTYPESETTER
TYPEWRITER......................DATA PROCESSING T&E
 note should be further subdivided to indicate
 specific type: e.g., TYPEWRITER, CONSOLE;
 -,MAGNETIC-CARD; -,MAGNETIC-TAPE
TYPEWRITER......................WRITTEN COMMUNICATION EQUIPMENT
 note may be further subdivided to indicate
 specific type: e.g., TYPEWRITER, ELECTRIC;
 -,MANUAL
TYPEWRITER RIBBON..............WRITTEN COMMUNICATION EQUIPMENT
UDOMETER.......................METEOROLOGICAL T&E
UMBRELLA.......................PERSONAL GEAR
UMIAK..........................WATER TRANSPORTATION EQUIPMENT
 rt KAYAK
UNDERCURRENT...................MINING T&E
UNDERSHIRT.....................CLOTHING, UNDERWEAR
UNICYCLE.......................LTE, HUMAN-POWERED
UNIFORM........................CLOTHING, OUTERWEAR
 note may be further subdivided to indicate
 specific type: e.g., UNIFORM, NURSE'S;
 -,NAVAL OFFICER'S
UPSETTER, TIRE/AXLE............METALWORKING T&E
UREA APPARATUS.................MEDICAL & PSYCHOLOGICAL T&E
UREOMETER......................MEDICAL & PSYCHOLOGICAL T&E
URETHROSCOPE...................MEDICAL & PSYCHOLOGICAL T&E
URICOMETER.....................MEDICAL & PSYCHOLOGICAL T&E
URINAL.........................HOUSEHOLD ACCESSORY
URINOMETER.....................MEDICAL & PSYCHOLOGICAL T&E
URINO-PYCNOMETER...............MEDICAL & PSYCHOLOGICAL T&E
URN............................HOUSEHOLD ACCESSORY
URN, COFFEE....................FOOD SERVICE T&E
URN, FUNEREAL..................CEREMONIAL ARTIFACT
URN, TEA.......................FOOD SERVICE T&E
UTILITY POLE...................UNCLASSIFIED STRUCTURE
VACUUM CHAMBER.................NUCLEAR PHYSICS T&E
VALANCE........................WINDOW OR DOOR COVERING
VALET..........................FURNITURE
Valise.........................PERSONAL GEAR
 use SUITCASE
VAMBRACE.......................ARMAMENT T&E, BODY ARMOR
VAN............................LTE, MOTORIZED
Van............................RAIL TRANSPORTATION EQUIPMENT
 use CABOOSE
VAN DE GRAAF...................NUCLEAR PHYSICS T&E
Vanity.........................FURNITURE
 use TABLE, DRESSING
Vanner.........................MINING T&E
 use SEPARATOR
VAN SLYKE APPARATUS............BIOLOGICAL T&E
VAPORIMETER....................CHEMICAL T&E
VAPORIZER......................MEDICAL & PSYCHOLOGICAL T&E

VARIATOR, STERN...................ACOUSTICAL T&E
VARIOPLEX........................DATA PROCESSING T&E
 rt MULTIPLEXOR
VASE............................HOUSEHOLD ACCESSORY
 note may be further subdivided to indicate
 specific type: e.g., VASE, BUD; -,WEED
VASE, CELERY....................FOOD SERVICE T&E
VASE, CEREMONIAL................CEREMONIAL ARTIFACT
VASE, TEMPLE....................CEREMONIAL ARTIFACT
VAT.............................LEATHERWORKING T&E
 note may be further subdivided to indicate
 specific type: e.g., VAT, BLEACHING;
 -,DYEING; -,PICKLING
VAT.............................PAPERMAKING T&E
VAT.............................TEXTILEWORKING T&E
VAT, CHEESE.....................FOOD PROCESSING T&E
Vat, Cooling....................FOOD PROCESSING T&E
 use VAT, STORAGE
Vat, Cream......................FOOD PROCESSING T&E
 use VAT, CHEESE
VAT, CYANIDATION................MINING T&E
VAT, MEAT-BOILING...............FOOD PROCESSING T&E
VAT, MEAT-PICKLING..............FOOD PROCESSING T&E
VAT, PICKLING...................FOOD PROCESSING T&E
VAT, STORAGE....................FOOD PROCESSING T&E
VAULTING HORSE..................SPORTS EQUIPMENT
VAULTING POLE...................SPORTS EQUIPMENT
V-BLOCK.........................GLASS & PLASTICS T&E
VEHICLE, LUNAR ROVING...........LTE, MOTORIZED
VEIL............................CLOTHING, HEADWEAR
VEIL, CHALICE...................CEREMONIAL ARTIFACT
VELOCIMETER.....................MECHANICAL T&E
VELOCIPEDE......................LTE, HUMAN-POWERED
Velocipede......................LTE, MOTORIZED
 use BICYCLE, STEAM
VELOCIPEDE CAR..................RAIL TRANSPORTATION EQUIPMENT
 rt HANDCAR
VENDING MACHINE.................MERCHANDISING T&E
 note may be further subdivided to indicate
 product: e.g., VENDING MACHINE, CANDY;
 -,CARD; -,CIGARETTE
VENT COVER......................ARMAMENT ACCESSORY
VENTILATOR......................BUILDING FRAGMENT
VERANDA.........................BUILDING FRAGMENT
VERIFIER........................DATA PROCESSING T&E
VERTIMETER......................SURVEYING & NAVIGATIONAL T&E
VEST............................CLOTHING, OUTERWEAR
VEST, BULLETPROOF...............ARMAMENT T&E, BODY ARMOR
VEST, FLAK......................ARMAMENT T&E, BODY ARMOR
VIBRAPHONE......................MUSICAL T&E, PERCUSSION
VIBRATION DAMPER, BALANCE.......NUCLEAR PHYSICS T&E
VIBROSCOPE......................ACOUSTICAL T&E

VICTORIA..............................LTE, ANIMAL-POWERED
 rt CABRIOLET
Vinaigrette.......................PERSONAL GEAR
 use BOTTLE, SMELLING
VINER, PEA........................AGRICULTURAL T&E
VIOL.............................MUSICAL T&E, STRINGED
VIOL, BASS.......................MUSICAL T&E, STRINGED
 rt BARYTON
VIOL, CITHER.....................MUSICAL T&E, STRINGED
VIOL, LYRA.......................MUSICAL T&E, STRINGED
VIOLA............................MUSICAL T&E, STRINGED
 rt LIRA
VIOLA D'AMORE....................MUSICAL T&E, STRINGED
VIOLIN...........................MUSICAL T&E, STRINGED
 rt KIT; REBEC
VIOLONCELLO......................MUSICAL T&E, STRINGED
VIRGINAL.........................MUSICAL T&E, STRINGED
VIS-A-VIS........................LTE, ANIMAL-POWERED
VISCOMETER.......................MECHANICAL T&E
Viscosimeter.....................MECHANICAL T&E
 use VISCOMETER
VISE.............................METALWORKING T&E
 note may be further subdivided to indicate
 specific type: e.g., VISE, BLACKSMITH'S;
 -,BENCH; -,LEG; -,FARRIER'S WELDING
VISE.............................WOODWORKING T&E
 note may be further subdivided to indicate
 specific type: e.g., VISE, BROOMMAKER'S
VISE.............................UNCLASSIFIED T&E, GENERAL
VISE, BREECHING..................ARMAMENT ACCESSORY
VISE, LOCK-SPRING................ARMAMENT ACCESSORY
VISE, MACHINE....................METALWORKING T&E
VISIOMETER.......................MEDICAL & PSYCHOLOGICAL T&E
Vivascope........................OPTICAL T&E
 use TELESCOPE
Vizard...........................PUBLIC ENTERTAINMENT DEVICE
 use MASK
VOLLEYBALL.......................SPORTS EQUIPMENT
VOLTMETER........................ELECTRICAL & MAGNETIC T&E
VOLUMINOMETER....................MECHANICAL T&E
VOTING BOOTH.....................GOVERNMENTAL ARTIFACT
Voting box.......................GOVERNMENTAL ARTIFACT
 use BOX, BALLOT
VOTING MACHINE...................GOVERNMENTAL ARTIFACT
WAGNER TUBEN.....................MUSICAL T&E, BRASS
WAGON............................LTE, ANIMAL-POWERED
 note use only if specific type is unknown
WAGON............................TOY
WAGON, BATTERY...................LTE, ANIMAL-POWERED
WAGON, CHEMICAL..................LTE, ANIMAL-POWERED
WAGON, CIRCUS PARADE.............LTE, ANIMAL-POWERED
WAGON, CONESTOGA.................LTE, ANIMAL-POWERED
 rt PRAIRIE SCHOONER

487

```
WAGON, DELIVERY.................LTE, ANIMAL-POWERED
WAGON, FARM.....................LTE, ANIMAL-POWERED
WAGON, HOOK-AND-LADDER..........LTE, ANIMAL-POWERED
WAGON, HOSE....................LTE, ANIMAL-POWERED
     rt   REEL, HOSE
WAGON, MORTAR..................LTE, ANIMAL-POWERED
WAGON, MOUNTAIN................LTE, ANIMAL-POWERED
WAGON, PEDDLER'S...............LTE, ANIMAL-POWERED
WAGON, POLICE PATROL...........LTE, ANIMAL-POWERED
Wagon, Tea.....................FURNITURE
     use  CART, TEA
Wagon, Tractor-drawn...........AGRICULTURAL T&E
     use  TRAILER, FARM
WAIF...........................FISHING & TRAPPING T&E
WAISTCOAT......................CLOTHING, OUTERWEAR
WALKER.........................PERSONAL GEAR
WALKING BOARD..................RECREATIONAL DEVICE
     rt   BALANCE BEAM
Walking stick..................PERSONAL GEAR
     use  CANE
WALLET.........................PERSONAL GEAR
WALLPAPER FRAGMENT.............BUILDING FRAGMENT
WALL POCKET....................HOUSEHOLD ACCESSORY
WALL SECTION...................BUILDING FRAGMENT
WANAGAN........................FORESTRY T&E
WARDROBE.......................FURNITURE
     rt   CHIFFOROBE
Warehouse......................BUILDING
     use  BUILDING, STORAGE
WARMER, BED....................HOUSEHOLD ACCESSORY
WARMER, FOOT...................HOUSEHOLD ACCESSORY
WARMER, HAND...................PERSONAL GEAR
WARMER, PLATE..................FOOD PROCESSING T&E
WARPING BAR....................TEXTILEWORKING T&E
Washbasin......................HOUSEHOLD ACCESSORY
     use  BASIN
WASHBOARD......................HOUSEKEEPING T&E
WASHCLOTH......................TOILET ARTICLE
WASHER.........................MINING T&E
WASHER.........................WOODWORKING T&E
WASHER, DRY....................MINING T&E
WASHER, EGG....................FOOD PROCESSING T&E
WASHER, FILM...................PHOTOGRAPHIC T&E
WASHER, GLASSWARE..............CHEMICAL T&E
WASHER, GRAIN..................FOOD PROCESSING T&E
WASHER, MILK-BOTTLE............FOOD PROCESSING T&E
WASHER, MILK-CAN...............FOOD PROCESSING T&E
WASHER, PRINT..................PHOTOGRAPHIC T&E
Washer, Wheat..................FOOD PROCESSING T&E
     use  WASHER, GRAIN
WASHING MACHINE................HOUSEKEEPING T&E
WASHING MACHINE................PAPERMAKING T&E
```

```
WASHSTAND........................FURNITURE
WASTEBASKET......................HOUSEHOLD ACCESSORY
WASTE MACHINE....................TEXTILEWORKING T&E
Waster...........................FOOD SERVICE T&E
     use DISH, WASTE
WATCH, PENDANT...................TIMEKEEPING T&E
WATCH, POCKET....................TIMEKEEPING T&E
Watch, Wrist.....................TIMEKEEPING T&E
     use WRISTWATCH
WATCH GLASS......................CHEMICAL T&E
WATER ANALYSIS SET...............CHEMICAL T&E
     note use for composite unit: i.e., reagents,
          flask, tongs, measuring cylinders, color
          standards, etc.
WATERER, LIVESTOCK...............ANIMAL HUSBANDRY T&E
WATERER, POULTRY.................ANIMAL HUSBANDRY T&E
Water set........................FOOD SERVICE T&E
     use BEVERAGE SET
WATER TOWER......................LTE, ANIMAL-POWERED
WATER TOWER......................LTE, MOTORIZED
WATERWHEEL, BREAST...............POWER PRODUCTION T&E
WATERWHEEL, OVERSHOT.............POWER PRODUCTION T&E
WATERWHEEL, TUB..................POWER PRODUCTION T&E
WATERWHEEL, UNDERSHOT............POWER PRODUCTION T&E
Wax jack.........................LIGHTING DEVICE
     use HOLDER, TAPER
Waywiser.........................SURVEYING & NAVIGATIONAL T&E
     use WHEEL, SURVEYOR'S
WEANER, CALF.....................ANIMAL HUSBANDRY T&E
Weapon, Automatic................ARMAMENT T&E, FIREARM
     use GUN, MACHINE or GUN, SUBMACHINE
WEATHERVANE......................METEOROLOGICAL T&E
WEDGE............................MECHANICAL T&E
WEDGE............................WOODWORKING T&E
     rt CHISEL, RIPPING
WEDGE, DEFLECTION................MINING T&E
WEEDER, FLAME....................AGRICULTURAL T&E
WEEDER, ROD......................AGRICULTURAL T&E
WEEDER, SPRING-TOOTH.............AGRICULTURAL T&E
Weight, Barrel...................ARMAMENT ACCESSORY
     use STABILIZER
WEIGHT, HORN.....................ANIMAL HUSBANDRY T&E
WEIGHT, NET......................FISHING & TRAPPING T&E
     rt SINKER
WEIGHT, TOE......................ANIMAL HUSBANDRY T&E
WEIR.............................FISHING & TRAPPING T&E
Welder, Arc......................METALWORKING T&E
     use WELDER, ELECTRIC
WELDER, ELECTRIC.................METALWORKING T&E
Welder, Gas......................METALWORKING T&E
     use TORCH, GASOLINE or TORCH, PROPANE
WHALEBOAT........................WATER TRANSPORTATION EQUIPMENT
```

```
WHALER..........................WATER TRANSPORTATION EQUIPMENT
WHALER, TANCOOK.................WATER TRANSPORTATION EQUIPMENT
WHARF...........................UNCLASSIFIED STRUCTURE
WHATNOT.........................FURNITURE
     rt   ETAGERE
WHATNOT SHELF...................FURNITURE
Wheel
     note if the name of the object is not found under
          the word WHEEL, look under a probable name
          using WHEEL as a secondary word
WHEEL, BANDING..................GLASS & PLASTICS T&E
WHEEL, BENCH....................GLASS & PLASTICS T&E
WHEEL, COPPER-ENGRAVING.........GLASS & PLASTICS T&E
WHEEL, CUTTING..................GLASS & PLASTICS T&E
WHEEL, FISH.....................FISHING & TRAPPING T&E
Wheel, Godet....................TEXTILEWORKING T&E
     use  WHEEL, STRETCHING
WHEEL, GRINDING.................GLASS & PLASTICS T&E
     rt   WHEEL, LAPPING
WHEEL, HAND.....................TEXTILEWORKING T&E
WHEEL, JAGGING..................FOOD PROCESSING T&E
WHEEL, JURY.....................GOVERNMENTAL ARTIFACT
WHEEL, KICK.....................GLASS & PLASTICS T&E
WHEEL, LAPPING..................GLASS & PLASTICS T&E
     rt   WHEEL, GRINDING
Wheel, Pelton...................POWER PRODUCTION T&E
     use  TURBINE, IMPULSE
WHEEL, POLISHING................GLASS & PLASTICS T&E
WHEEL, POLISHING/SANDING........LEATHERWORKING T&E
Wheel, Potter's.................GLASS & PLASTICS T&E
     use  more specific term: e.g., WHEEL, BENCH;
          WHEEL, KICK
WHEEL, QUILLING.................TEXTILEWORKING T&E
WHEEL, SAVART...................ACOUSTICAL T&E
WHEEL, STEERING.................WATER TRANSPORTATION ACCESSORY
WHEEL, STRETCHING...............TEXTILEWORKING T&E
WHEEL, SURVEYOR'S...............SURVEYING & NAVIGATIONAL T&E
WHEEL, TABLESTAND...............GLASS & PLASTICS T&E
Wheel, Tire-measuring...........METALWORKING T&E
     use  TRAVELER
WHEEL, TRACING..................TEXTILEWORKING T&E
WHEELBARROW.....................LTE, HUMAN-POWERED
WHEELCHAIR......................PERSONAL GEAR
WHEEL FRAME, WHEELWRIGHT'S......WOODWORKING T&E
WHEELMAKING MACHINE.............WOODWORKING T&E
     note may be further subdivided to indicate
          specific type: e.g., WHEELMAKING MACHINE,
          SPOKE-TENONING; -,HUB-BORING; -,RIM-PLANING
Wheel of life...................TOY
     use  ZOETROPE
WHEELS, LOG.....................FORESTRY T&E
Wheels, Timber..................FORESTRY T&E
     use  WHEELS, LOG
```

WHERRY, SALMON................WATER TRANSPORTATION EQUIPMENT
WHETSTONE.....................METALWORKING T&E
 rt STEEL
WHIMSY........................ORIGINAL ART
WHIP..........................MUSICAL T&E, PERCUSSION
WHIP..........................LAND TRANSPORTATION ACCESSORY
 note may be further subdivided to indicate
 specific type: e.g., WHIP, BUGGY; -,COACH;
 -,RIDING
WHIP..........................BEHAVIORAL CONTROL DEVICE
Whip, Brush...................AGRICULTURAL T&E
 use CUTTER, WEED
Whip, Egg.....................FOOD PROCESSING T&E
 use WHISK
Whipstock.....................MINING T&E
 use WEDGE, DEFLECTION
WHIRL.........................RECREATIONAL DEVICE
WHIRLIGIG.....................ORIGINAL ART
WHIRLIGIG.....................TOY
WHISK.........................FOOD PROCESSING T&E
WHISKY........................LTE, ANIMAL-POWERED
WHISTLE.......................SOUND COMMUNICATION EQUIPMENT
WHISTLE, GALTON...............ACOUSTICAL T&E
WHISTLE, STEAM................WATER TRANSPORTATION ACCESSORY
WHITEHALL.....................WATER TRANSPORTATION EQUIPMENT
WICK..........................LIGHTING DEVICE
WICKIUP.......................BUILDING
Widowmaker....................MINING T&E
 use DRILL
WIG...........................ADORNMENT
 rt HAIRPIECE
WIG, BARRISTER'S..............PERSONAL SYMBOL
WIG STAND.....................ADORNMENT
WIGWAM........................BUILDING
Wimple........................CLOTHING, HEADWEAR
 use KERCHIEF
Winch.........................MECHANICAL T&E
 use HOIST or WINDLASS
WIND-BELL.....................COMMERCIAL DECORATIVE ART
WINDER........................TEXTILEWORKING T&E
 note may be further subdivided to indicate
 specific type: e.g., WINDER, CONE; -,BOBBIN;
 -,SPOOL
Winding engine................MECHANICAL T&E
 use WINDLASS
WINDING MACHINE, FILAMENT......GLASS & PLASTICS T&E
WINDLASS......................MECHANICAL T&E
 note use for a hauling or lifting drum around
 which a rope or chain is wound
 rt HOIST
WINDLASS......................WATER TRANSPORTATION ACCESSORY
 rt CAPSTAN

```
Windlass, Slaughtering.........FOOD PROCESSING T&E
     use  HOIST, DRESSING
WINDMILL.......................POWER PRODUCTION T&E
WINDOW.........................BUILDING FRAGMENT
     note use for the composite structure: i.e.,
          WINDOW FRAME, WINDOW SASH, WINDOW CAP, etc.
WINDOW CAP.....................BUILDING FRAGMENT
Window card....................ADVERTISING MEDIUM
     use  POSTER
WINDOW FRAME...................BUILDING FRAGMENT
WINDOWPANE.....................BUILDING FRAGMENT
WINDOWPANE, LEADED.............BUILDING FRAGMENT
WINDOW SASH....................BUILDING FRAGMENT
     rt   FANLIGHT; SIDELIGHT; SKYLIGHT
Window seat....................BUILDING FRAGMENT
     use  SEAT, WINDOW
WINDOW SILL....................BUILDING FRAGMENT
WINDROWER......................AGRICULTURAL T&E
WIND SOCK......................AEROSPACE TRANSPORTATION ACCESSORY
WIND TUNNEL....................MECHANICAL T&E
Winnower.......................AGRICULTURAL T&E
     use  BASKET, WINNOWING or MILL, FANNING
Winnowing machine..............AGRICULTURAL T&E
     use  MILL, FANNING
WIRE...........................AEROSPACE TRANSPORTATION ACCESSORY
     note may be further subdivided to indicate
          specific type: e.g., WIRE, ANTIDRAG;
          -,ANTIFLUTTER; -,FAIRING; -,STAGGER
WIRING MACHINE.................METALWORKING T&E
WOK............................FOOD PROCESSING T&E
WOODBIN........................TEMPERATURE CONTROL DEVICE
WOODBLOCK......................MUSICAL T&E, PERCUSSION
WOOD BLOCK.....................PRINTING T&E
     rt   ENGRAVING PLATE
Woodcut........................PRINTING T&E
     use  WOOD BLOCK
WOOD FRAGMENT..................ARTIFACT REMNANT
WOODSHED.......................BUILDING
Workbasket.....................TEXTILEWORKING T&E
     use  BASKET, SEWING
WORKBENCH......................UNCLASSIFIED T&E, GENERAL
WORM...........................ARMAMENT ACCESSORY
Wrapper........................CLOTHING, OUTERWEAR
     use  GOWN, DRESSING
WRAPPER........................FORESTRY T&E
Wrapping machine...............FOOD PROCESSING T&E
     use  PACKAGING MACHINE, DAIRY
Wrench, Adjustable-end.........METALWORKING T&E
     use  WRENCH, CRESCENT
WRENCH, BREECHING..............ARMAMENT ACCESSORY
WRENCH, CARRIAGE NUT...........METALWORKING T&E
WRENCH, COCK...................ARMAMENT ACCESSORY
```

```
WRENCH, COCK-AND-HAMMER........ARMAMENT ACCESSORY
WRENCH, CRESCENT...............METALWORKING T&E
WRENCH, FRONT-SIGHT............ARMAMENT ACCESSORY
WRENCH, FUZE...................ARMAMENT ACCESSORY
WRENCH, GUN-CARRIAGE...........ARMAMENT ACCESSORY
WRENCH, MONKEY.................METALWORKING T&E
WRENCH, MUZZLE.................ARMAMENT ACCESSORY
WRENCH, NIPPLE.................ARMAMENT ACCESSORY
WRENCH, OPEN-END...............METALWORKING T&E
WRENCH, PIPE...................METALWORKING T&E
WRENCH, SOCKET.................METALWORKING T&E
WRENCH, TAP....................METALWORKING T&E
WRINGER........................LEATHERWORKING T&E
WRINGER, CLOTHES...............HOUSEKEEPING T&E
WRINGER, MOP...................HOUSEKEEPING T&E
WRIST DEVELOPER................SPORTS EQUIPMENT
WRIST GUARD....................ARMAMENT ACCESSORY
WRISTLET.......................CLOTHING ACCESSORY
WRISTWATCH.....................TIMEKEEPING T&E
XYLOPHONE......................MUSICAL T&E, PERCUSSION
YACHT..........................WATER TRANSPORTATION EQUIPMENT
Yankee machine.................PAPERMAKING T&E
     use  PAPER MACHINE
YARDSTICK......................WEIGHTS & MEASURES T&E
Yarmulke.......................CLOTHING, HEADWEAR
     use  SKULLCAP
Yarn reel......................TEXTILEWORKING T&E
     use  REEL, CLOCK
Yashmak........................CLOTHING, HEADWEAR
     use  VEIL
Yatate.........................PERSONAL GEAR
     use  SCRIBE SET
YAWL-BOAT......................WATER TRANSPORTATION EQUIPMENT
YOKE...........................LTE, HUMAN-POWERED
YOKE, ANIMAL...................LAND TRANSPORTATION ACCESSORY
YO-YO..........................TOY
YULOH..........................WATER TRANSPORTATION ACCESSORY
     rt   OAR, SCULLING
ZAX............................MASONRY T&E
ZENOMETER......................SURVEYING & NAVIGATIONAL T&E
ZISCHAGGE......................ARMAMENT T&E, BODY ARMOR
ZITHER.........................MUSICAL T&E, STRINGED
ZOETROPE.......................TOY
ZOOPRAXINOSCOPE................OPTICAL T&E
ZYMOSISMETER...................FOOD PROCESSING T&E
```

References

1 Adney, Edwin Tappan & Howard I. Chapelle
 The Bark Canoes and Skin Boats of North America
 Washington : Smithsonian Institution Press, 1964

2 The American Heritage Dictionary of the English Language /
 William Morris, ed.
 New York : American Heritage Publishing Co., 1975

3 American Institute of Physics
 Glossary of Terms Frequently Used Concerning Accelerators
 New York : The Institute, 1964

4 American Institute of Physics
 Glossary of Terms Frequently Used in Nuclear Physics
 New York : The Institute, 1961

5 American National Standards Institute
 American National Standard Guidelines for Thesaurus
 Structure, Construction, and Use
 New York : The Institute, 1974

6 Appleton's Cyclopaedia of Applied Mechanics
 New York : Appleton, 1880
 (2 vols. & 1892 supplement)

7 Ardrey, Robert L.
 American Agricultural Implements
 New York : Arno, 1972
 Reprint of 1894 ed.

8 Association of American Railroads. Mechanical Division
 Car and Locomotive Cyclopedia of American Practice. 3d ed.
 New York : Simmons-Boardman, 1974

9 Atwood, James P.
 The Daggers and Edged Weapons of Hitler's Germany
 Savannah : Miltaria Publications, 1965

10 Aviation and Space Dictionary. 5th ed.
 Glendale, CA : Aero Publishers, 1974
 Title varies : Baughman's Aviation Dictionary and
 Reference Guide

11 Baines, Anthony
 European and American Musical Instruments
 New York : Viking, 1966

12 Baughman, Harold E.
 Aviation Dictionary and Reference Guide. 2d ed.
 Glendale, CA : Aero Publishers, 1942

13 Bennett, M. Ann
 Basic Ceramic Analysis
 Portales, NM : Eastern New Mexico University, 1974
 (Contributions in Anthropology; v.6, no. 1)

14 Blackmore, Howard L.
 Guns and Rifles of the World
 New York : Viking, 1965

15 Blackmore, Howard L.
 Hunting Weapons
 London : Barrie & Jenkins, 1971

16 Blair, Carvel Hall & Willits Dyer Ansel
 A Guide to Fishing Boats and Their Gear
 Cambridge, MD : Cornell Maritime Press, 1968

17 Blair, Claude E.
 European Armour
 New York : Viking, 1958

18 Blair, Claude
 Pistols of the World
 New York : Viking, 1968

19 Blumenson, John J. G.
 Identifying American Architecture : a Pictorial Guide to
 Styles and Terms, 1600-1945
 Nashville : American Association for State and Local
 History, c. 1977

20 Boise Cascade Paper Group
 The Paper Handbook
 Portland, OR : The Group, 1974

21 Bowers, Q. David
 Encyclopedia of Automatic Musical Instruments
 Vestal, NY : Vestal Press, 1972

22 Bradley (Milton) Company
 Catalogue of Bradley Games, 1918-19
 Springfield, MA : The Company, 1918

23 Bradley (Milton) Company
 Catalogue of Games and Novelties, 1909
 Springfield, MA : The Company, 1909?

24 Brantlinger, Rita, Norma P. H. Jenkins & Catherine D.
 Mack, comp.
 List of Subject Headings for Glass Technology
 Pittsburgh : Pittsburgh Plate Glass Co., Glass Division
 Research Laboratories, 1954

25 Brewington, Marion V.
 Shipcarvers of North America
 Barre, MA : Barre Publishing Company, 1962

26 Brown, Rodney H.
 American Polearms, 1526-1865
 New Milford, CT : N. Flayderman, 1967

27 Burcaw, G. Ellis
 Introduction to Museum Work
 Nashville : American Association for State and Local
 History, 1975

28 Butler Brothers
 Catalog, October 1908
 Chicago : Butler Brothers, 1908

29 Carmichael, W. L., George E. Linton & Isaac Price
 Callaway Textile Dictionary. 1st ed.
 La Grange, GA : Callaway Mills, 1947

30 Central Scientific Company
 General Catalog of Laboratory Apparatus and Scientific
 Instruments
 Chicago : The Company, 1936

31 Chapelle, Howard I.
 American Small Sailing Craft, Their Design, Development,
 and Construction
 New York : Norton, 1951

32 Chapelle, Howard I.
 The National Watercraft Collection
 Washington : Smithsonian Institution Press, 1976

33 Chenhall, Robert G.
 Museum Cataloging in the Computer Age
 Nashville : American Association for State and Local
 History, 1975

34 Chinn, George M.
 The Machine Gun
 Washington : U.S. Govt. Print. Off., 1951

35 Davidson, Marshall B.
 The American Heritage History of American Antiques from
 the Revolution to the Civil War
 New York : American Heritage Publishing Co., 1968

36 Davidson, Marshall B.
 The American Heritage History of Antiques from the Civil
 War to World War I
 New York : American Heritage Publishing Co., 1969

37 Davidson, Marshall B.
 The American Heritage History of Colonial Antiques
 New York : American Heritage Publishing Co., 1967

38 Davis, Audrey B. & Uta C. Merzbach
 Early Auditory Studies : Activities in the Psychology
 Laboratories of American Universities
 Washington : Smithsonian Institution Press, 1975

39 Dover Stamping Company
 Illustrated Catalog and Historical Introduction
 Princeton : Pyne Press, 1971
 Reprint of 1869 Catalog

40 Duckett, Kenneth W.
 Modern Manuscripts
 Nashville : American Association for State and Local
 History, 1975

41 Edwards (Jas. W.) Company
 Dental Furniture, Instruments and Supplies Catalog.
 6th ed.
 San Francisco : The Company, 1915?

42 EEM : Electronic Engineers Master. 871 Manufacturers
 Catalog
 Garden City, NY : United Technical Publications, 1969

43 Eimer & Amend, Firm
 Biological, Chemical and Metallurgical Laboratory
 Apparatus, Catalog BCM, 1927
 New York : The Firm, 1927

44 Encyclopaedia Britannica
 Chicago : Encylopaedia Britannica, 1972

45 Farm Implement News Buyer's Guide : A Classified Directory
 of Manufacturers of Farm and Garden Implements...
 Chicago : Farm Implement News Co., 1888-

46 Fleming, John, Hugh Honour & Nikolaus Pevsner
 The Penquin Dictionary of Architecture
 Baltimore : Penquin, 1966

47 Forsythe, Robert
 The Blast Furnace and the Manufacture of Pig Iron
 New York : David Williams Co., 1908

48 Gamage (A. W.) Ltd., London
 Gamage's Christmas Bazaar, 1913
 North Pomfret, VT : David and Charles Reprints, 1974

49 Gluckman, Arcadi
 Identifying Old U.S. Muskets, Rifles and Carbines
 Harrisburg, PA : Stackpole Co., 1965

50 Gluckman, Arcadi
 United States Martial Pistols and Revolvers
 Buffalo, NY : Otto Ulbrich, 1939

51 Gould, Douglas W.
 The Top
 New York : Clarkson N. Potter, 1973

52 Greenwood, William H.
 Steel and Iron. 3d ed.
 New York : Cassel and Company Ltd., 1887

53 Griffin, Al
 Step Right Up, Folks!
 Chicago : Henry Reqnery Co., 1974

54 Groves, Sylvia
 The History of Needlework Tools and Accessories
 New York : Arco, 1973

55 Gurley (W. & L. E.)
 Gurley's Manual of Surveying Instruments. 39th ed.
 Troy, NY : Gurley, 1905
 Title varies : 1855-1921, A Manual of the Principal
 Instruments Used in American Engineering and Surveying

56 Heffner, Hubert C.
 Modern Theatre Practice
 New York : Appleton-Century-Crofts, 1973

57 Hollen, Norma & Jane Saddler
 Textiles
 New York : Macmillan, 1973

58 Howe & French, Inc.
 Laboratory Apparatus and Chemicals. Catalog E41
 Boston : The Company, 1941

59 Hummel, Charles F.
 With Hammer in Hand : the Dominy Craftsman of East
 Hampton, New York
 Charlottesville, VA : Published for the Henry Francis
 du Pont Winterthur Museum by the University Press of
 Virginia, 1968

60 Jane's Fighting Ships
 Bridgeport, CT : Key Book Service, 1972

61 Johnson, George B. & Hans Bert Lockhaven
 International Armament with History, Data, Technical
 Information and Photographs of over 400 Weapons
 Cologne : International Small Arms Publishers, 1965
 2 vols.

62 Joint Technical Committee on Terminology
 IFIP-ICC Vocabulary of Information Processing
 Amsterdam : North-Holland Publishing Co., 1966

63 Kaplan, Harry
 Furskin Processing
 Oxford, NY : Pergamon Press, 1971

64 Keuffel & Esser Company
 Catalogue. 38th ed.
 New York : The Company, 1936

65 Knight, Edward H.
 Knight's American Mechanical Dictionary
 New York : J. B. Ford and Co., 1874-76
 3 vols. Several editions published later.

66 Kohl (Max) A. G.
 Catalog : Physical Apparatus Manufacturers Equipment of
 Class Rooms; Physical Apparatus for Mechanics, Wave
 Theory, Acoustics and Optics. Price List #100, I & II
 Chemnitz, Germany : The Company, 1928

67 Kohl (Max) A. G.
 Scientific Instrument Manufacturers Physical Apparatus for
 Heat, Meteorology, Cosmology, Magnetism and Electricity.
 Price List #100, III
 Chemnitz, Germany : The Company, 1927

68 Laking, Guy Francis, Sir
 A Record of European Armour and Arms
 London : G. Bell & Sons, 1920
 5 vols.

69 Linton, George E.
 The Modern Textile Dictionary. 3d ed.
 New York : Duell, Sloan and Pearce, 1963

70 Ludwig, Oswald A.
 Metal Work, Technology and Practice, An Introductory
 Course to the Metal Trades...
 Bloomington, IL : McKnight & McKnight, 1943

71 Marks, Robert W., ed.
 The New Dictionary & Handbook of Aerospace
 New York : Praeger, 1969

72 Mayer, Ralph
 A Dictionary of Art Terms and Techniques
 New York : Crowell, 1969

73 McEwen, William A. & A. H. Lewis
 Encyclopedia of Nautical Knowledge
 Cambridge, MD : Cornell Maritime Press, 1953

74 McKee, Harley J.
 Introduction to Early American Masonry, Stone, Brick,
 Mortar and Plaster
 Washington : National Trust for Historic Preservation, 1973

75 Meek, Chester L.
 SHARE Glossary
 Redondo Beach, CA : TRW Systems, 1967

76 Mercer, Henry Chapman
 Ancient Carpenters' Tools. 3d ed.
 Doylestown, PA : The Bucks County Historical Society, 1960

77 Montgomery Ward and Company
 Catalogue, #56, 1894-95
 Northfield, IL : The Gun Digest Co., 1970

78 Moseman (C. M.) and Brother
 Moseman's Illustrated Guide for Purchasers of Horse
 Furnishing Goods, Novelties, and Stable Appointments
 New York : Arco, 1976
 Reprint of 1892? ed.

79 Murdock, George P., et al.
 Outline of Cultural Materials. 4th rev. ed.
 New Haven, CT : Human Relations Area Files, Inc., 1961

80 National Air and Space Museum
 Aircraft in Museums around the World. Section I :
 Alphabetical by Design Firm
 Washington : Smithsonian Institution Press, 1975

81 National Workshop on Equipment and Supplies for Athletics,
 Physical Education and Recreation, Michigan State
 University, 1959
 Equipment and Supplies for Athletics, Physical Education
 and Recreation / by Participants in National Conference
 Chicago : Athletic Institute, 1960

82 Nelson, Thomas B.
 The World's Submachine Guns (Machine Pistols)
 Cologne : International Small Arms Publishers, 1963

83 Newman, Thelma R.
 Plastics As Design Form
 Philadelphia : Chilton Book Co., 1972

84 Nonte, George C., Jr.
 Firearms Encyclopedia
 New York : Harper & Row, 1973

85 Oliver, Smith H.
 Catalog of the Cycle Collection of the Division of
 Engineering, United States National Museum
 Washington : U.S. Govt. Print. Off., 1953
 (United States. National Museum. Bulletin, v.204)

86 Oliver, Smith H. & Donald H. Berkebile
 The Smithsonian Collection of Automobiles and Motorcycles
 Washington : Smithsonian Institution Press, 1968

87 Oliver, Smith H. & Donald H. Berkebile
 Wheels and Wheeling
 Washington : Smithsonian Institution Press, 1974

88 Parker, John H.
 A Concise Glossary of Terms Used in Grecian, Roman,
 Italian and Gothic Architecture
 London : James Parker & Co., 1896

89 Peck & Snyder, New York
 Sporting Goods, 1886
 Princeton, NJ : Pyne Press, 1971

90 Peterson, Harold L.
 American Indian Tomahawks
 New York : Museum of the American Indian, 1965

91 Peterson, Harold L.
 American Knives
 New York : Scribner, 1958

92 Peterson, Harold L.
 The American Sword, 1775-1945
 Philadelphia : Ray Riling Arms Book Co., 1965

93 Peterson, Harold L.
 Arms and Armor in Colonial America, 1526-1783
 Harrisburg, PA : Stackpole Co., 1956

94 Peterson, Harold L.
 Book of the Continental Soldier...
 Harrisburg, PA : Stackpole Co., 1968

95 Peterson, Harold L., ed.
 Encyclopedia of Firearms
 New York : Dutton, 1964

96 Phipps & Bird, Inc.
 Laboratory Apparatus and Chemicals. Catalog R-60
 Richmond, VA : The Company, 1959

97 Quick, John
 Dictionary of Weapons and Military Terms
 New York : McGraw-Hill, 1973

98 Rogin, Leo
 The Introduction of Farm Machinery in Its Relation to the
 Productivity of Labor in the Agriculture of the U.S.
 During the 19th Century
 New York : Johnson Reprint Corp., 1966
 Reprint of 1931 ed.

99 Rounsefell, George A. & W. Harry Everhart
 Fishery Science : Its Methods and Applications
 New York : Wiley, 1953

100 Russell, Carl P.
 Firearms, Traps, & Tools of the Mountain Men
 New York : Knopf, 1967

101 Russell, Carl P.
 Guns on the Early Frontiers
 Berkeley : University of California Press, 1962

102 Russell, Loris S.
 A Heritage of Light
 Toronto : University of Toronto Press, 1968

103 Salaman, R. A.
 Dictionary of Tools Used in Woodworking and Allied Trades
 New York : Scribner, 1975

104 Schroeder, Joseph J., comp.
 The Wonderful World of Toys, Games and Dolls, 1860-1930
 Chicago : Follett, 1971

105 Sears, Roebuck and Company
 Catalog, Spring-Summer, 1965. 230th ed.
 Philadelphia : The Company, 1965

106 Sears, Roebuck and Company
 Catalogue, #117, 1908
 Northfield, IL : Digest Books, 1971

107 Shahn, Ben
 The Shape of Content
 New York : Random House of Canada, Ltd., 1957

108 Shannan (Jacob) & Company
 Contractor's Supplies. Catalogue #15
 Philadelphia : The Company, 1900?-1905?

109 Sippl, Charles J.
 Computer Dictionary and Handbook
 Indianapolis : H. W. Sams & Co., 1966

110 Smith, H. R. Bradley
 Blacksmiths' and Farriers' Tools at Shelburne Museum
 Shelburne, VT : Shelburne Museum, 1966

111 Smith, Walter H. B.
 Small Arms of the World. 10th rev. ed.
 Harrisburg, PA : Stackpole Co., 1973

112 Standard Ceramic Supply Company
 Catalogue, 1972-1973
 Pittsburg : The Company, 1972?

113 Steindler, R. A.
 The Firearms Dictionary
 Harrisburg, PA : Stackpole Books, 1970

114 Stoelting (C. H.) Company
 Psychological and Physiological Apparatus and Supplies
 Chicago : The Company, 1936

115 Stone, George C.
 A Glossary of the Construction, Decoration and Use of Arms
 and Armor...
 New York : J. Brussel, 1961

116 Struve, Otto & Velta Zebergs
 Astronomy of the 20th Century
 New York : Macmillan, 1962

117 Studio Dictionary of Design & Decoration
 New York : Viking, 1973

118 Suffolk Museum
 Catalogue of Vehicles of the Carriage House of the Suffolk
 Museum
 Stony Brook, NY : The Museum, 1954

119 Textile Institute, Manchester, Eng.
 Textile Terms and Definitions. 5th ed.
 Manchester : The Institute, 1963

120 Thomas, John C.
 Connecticut Pewter and Pewterers
 Hartford : Connecticut Historical Society, 1976

121 Thrush, Paul W.
 Dictionary of Mining, Minerals and Related Terms
 Washington : U.S. Bureau of Mines, 1968

122 Truax, Greene & Company
 Physicians' Supplies, Surgical Instruments. 6th Columbian
 ed.
 Chicago : The Company, 1893

123 United States. Defense Logistics Services Center
 Dental Instruments, Equipment and Supplies
 Battle Creek, MI : U.S. Dept. of Defense, Defense
 Logistics Agency, Defense Logistics Service Center, 1971-
 (Federal Item Identification Guide FIIG; v. T243)

124 United States. Defense Logistics Services Center
 Medical and Surgical Instruments, Equipment and Supplies
 Battle Creek, MI : U.S. Dept. of Defense, Defense
 Logistics Agency, Defense Logistics Service Center, 1971-
 (Federal Item Identification Guide FIIG; v. T133)

125 United States. Library of Congress
 Papermaking : Art and Craft
 Washington : The Library, 1968

126 Von Boehm, Max
 Ornaments : Lace, Fans, Gloves, Walking-sticks, Parasols,
 Jewelry, and Trinkets
 New York : B. Blom, 1970
 Reprint of 1929 ed. published under title : Modes &
 Manners : Ornaments

127 Waters, David W.
 The Art of Navigation in England in Elizabethan and Early
 Stuart Times
 New Haven : Yale University Press, 1958

128 Webster's Third New International Dictionary of the
 English Language, Unabridged
 Springfield, MA : G. & C. Merriam Co., 1971

129 Welch (W. M.) Scientific Company
 Welch Catalog of Scientific Apparatus, Chemicals &
 Supplies for Physics, Chemistry, Biology, and General
 Science
 Chicago : The Company, 1942

130 Wheeling, Kenneth E.
 Horse-Drawn Vehicles at the Shelburne Museum
 Shelburne, VT : The Museum, 1974

131 Whiffen, Marcus
 American Architecture since 1780 : Guide to the Styles
 Cambridge, MA : M.I.T. Press, 1969

132 Wilcox, Ruth T.
 The Dictionary of Costume
 New York : Scribner, 1969

133 Wildung, Frank H.
 Woodworking Tools at Shelburne Museum
 Shelburne, VT : The Museum, 1957

134 Willcox, Donald J.
 Modern Leather Design
 New York : Waston-Guptill, 1969

135 Winburne, John N, ed.
 A Dictionary of Agricultural and Allied Terminology
 East Lansing : Michigan State University Press, 1962

136 Windrow, Martin C. & Gerry Embleton
 Military Dress of North America, 1665-1970
 New York : Scribner, 1973

137 Zweng, Charles A., ed.
 The Zweng Aviation Dictionary
 North Hollywood, CA : Pan American Navigation Service, 1944

Index

HOW TO USE THIS BOOK

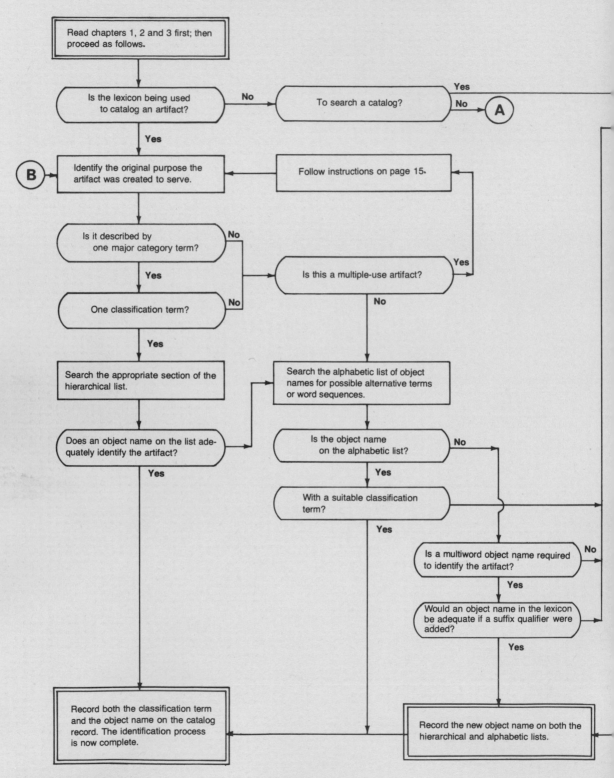

Read chapters 1, 2 and 3 first; then proceed as follows.

Is the lexicon being used to catalog an artifact?

No → To search a catalog?

Yes

No → A

Yes ↓

B → Identify the original purpose the artifact was created to serve. ← Follow instructions on page 15.

Is it described by one major category term?

No → Is this a multiple-use artifact?

Yes

Yes

No

One classification term?

No

Yes

No ↓

Search the appropriate section of the hierarchical list.

Search the alphabetic list of object names for possible alternative terms or word sequences.

Does an object name on the list adequately identify the artifact?

Is the object name on the alphabetic list?

No

Yes

Yes

With a suitable classification term?

Yes

Is a multiword object name required to identify the artifact?

No

Yes

Would an object name in the lexicon be adequate if a suffix qualifier were added?

Yes

Record both the classification term and the object name on the catalog record. The identification process is now complete.

Record the new object name on both the hierarchical and alphabetic lists.